RODIN *Rediscovered*

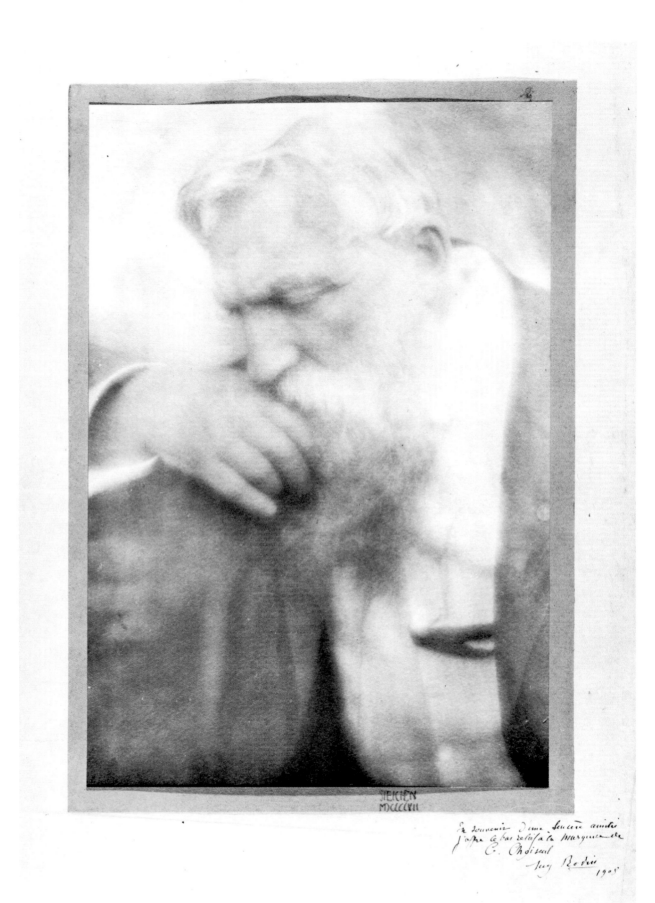

STEICHEN
MDCCCVII

En souvenir d'une sincère amitié
j'offre le bas relief à la Marquise de
C. Choiseul
Aug Rodin
1905

RODIN
Rediscovered

ALBERT E. ELSEN

editor

with contributions by

ALBERT ALHADEFF CLAUDIE JUDRIN

RUTH BUTLER MONIQUE LAURENT

JEAN CHATELAIN JOANNE CULLER PARADISE

ALBERT E. ELSEN ANNE PINGEOT

SIDNEY GEIST DANIEL ROSENFELD

ROSALYN FRANKEL JAMISON KIRK VARNEDOE

National Gallery of Art, Washington

This publication was produced by the Editors Office, National Gallery of Art, Washington.
Printed at Schneidereith & Sons, Baltimore, Md. Set in Electra by Monotype Composition Inc., Baltimore, Md. and Composition Systems Inc., Arlington, Va. The text paper is LOE Dull with matching cover.
Designed by Melanie B. Ness, edited by Mei Su Teng, assistance with translation by Margaret Morgan.

Exhibition dates are June 28, 1981—May 2, 1982.

Cover: detail of *Meditation without Arms*, plaster, Musée Rodin, Paris (S680), cat. no. 48.
Frontispiece: Edward Steichen, *Rodin*, platinum print, Musée Rodin, Paris (M.R.ph238), cat. no. 169.

LIBRARY OF CONGRESS CATALOGING IN PUBLICATION DATA
Main entry under title:

Rodin rediscovered.

Issued in conjunction with an exhibition at National Gallery of Art, Washington, D.C., June 1981-May 1982.
"Catalogue of the exhibition": p. 313
Includes bibliographical references and index.
Supt. of Docs. no.: SI 8.2:R61
1. Rodin, Auguste, 1840-1917—Addresses, essays, lectures. I. Elsen, Albert Edward, 1927- . II. Alhadeff, Albert. III. National Gallery of Art (U.S.)
NB553.R7R74 720'.92'4 81-9576

ISBN 0-89468-000-5
ISBN 0-89468-001-3 (pbk.) AACR2

The hardcover edition of this catalogue is being distributed as a New York Graphic Society Book by Little, Brown and Co., Boston.

Note: In this catalogue, unless otherwise indicated, all works illustrated and listed are by Auguste Rodin.

CONTENTS

FOREWORD

A titan in the history of art, with a titanic reputation in his own day, Auguste Rodin has suffered from his own success. Some of his work has become so familiar as to be very difficult to see.

Time has at last given us perspective and the opportunity to reassess this great romantic genius, who in the span of his career not only summed up the past but also helped impel the transition to twentieth-century modernism.

The National Gallery has a distinguished collection of its own of Rodin's work in bronze, plaster, and terra cotta, the nucleus of which is the collection given by Mrs. John W. Simpson, who sat for Rodin and was his intimate friend. In 1971, the Gallery held a loan exhibition, *Rodin Drawings, True and False*, which invited the visitor in the final room to test what he had learned from the show in spotting Rodin forgeries.

The present exhibition has been in gestation for a very long time. What the Gallery wanted was more than a mere chronological survey; it desired instead to present a report on the latest in modern scholarship, and a fresh opportunity to examine Rodin's contribution in the context of what we have learned about his own epoch.

In 1916 Rodin willed all of his art and reproduction rights to the French government. He had saved an enormous number of his drawings, photographs, and plasters, as well as some marbles and bronze casts. This material was housed in the Hôtel Biron, the beautiful eighteenth-century building in Paris's *quartier noble* which the French government bought for the purpose, as well as in Rodin's house and studio/museum in the industrial suburb of Meudon. His house has been, until quite recently, closed to the public, and it has only been in the last few years that all the resources of the Musée Rodin in both locations have been fully opened to scholars.

In this new climate modern research has been able to obtain fresh insights into Rodin's work. This catalogue contains fourteen essays on various aspects of Rodin, and the exhibition presents the most comprehensive showing of his work ever mounted, with period photographs and examples in marble, plaster, drawing, and watercolor as well as bronze. Some fifty drawings, fifty photographs, and forty pieces of sculpture will be exhibited here for the first time. Among the latter are plasters, revealing Rodin's creative process, that have hitherto been unexhibited and unreproduced.

The team of scholars selecting the exhibition and working out its themes has included Monique Laurent, curator of the Musée Rodin, Paris, and has been led by Albert Elsen, Haas Professor of Art History at Stanford University, a noted authority on Rodin and modern sculpture who has many exhibitions and books on Rodin to his credit. Kirk Varnedoe of the Institute of Fine Arts, New York University, and Ruth Butler of the University of Massachusetts, Boston, have also worked particularly closely with Gaillard Ravenel, Mark Leithauser, Dodge Thompson, Mary Jane Pagan, and other members of the Gallery's staff in mounting the exhibition.

The exhibition has been organized thematically, rather than chronologically, as this catalogue reflects. The recreation of the kind of salon in which Rodin started his career brings to light a variety of work in a style that until very recently has been scanted owing to the vicissitudes of taste. The section on Rodin in his studio examines his creativity in the light of nineteenth-century norms, which did not include the modern-day concept of an edition of bronze originals limited to a specific number.

The monumental *Gates of Hell* will be an integral part of the exhibition, the first time they have been so seen since the original plaster was exhibited in the *exposition universelle* in 1900, where it was shown in an incomplete form. The *Gates* were never cast in bronze in Rodin's lifetime. He willed the right to do so to the Musée Rodin, which has a strict policy of allowing only twelve casts from any Rodin plaster. Until recently only four of the *Gates* had been attempted. The fifth and latest cast, just completed and exhibited here for the first

time, was produced under the auspices of the French government by the Fondation Coubertin as a result of three years' effort and is believed to be the closest yet to the plaster Rodin made. The most complex single work Rodin produced, the *Gates* contain many of his most famous sculptures, including *The Thinker, The Kiss, Adam, Eve,* and *The Walking Man.*

It is not just the scholarship in this exhibition that represents an innovative approach; the installation in the Gallery's East Building also breaks new ground. In the early planning stages of the East Building, the architect and the writer had envisioned that the design should provide the Gallery with an option of installing works of art in a vertical sequence as well as horizontally between the towers. The imaginative layout of Mr. Ravenel and his colleagues in the Gallery's Department of Installation and Design has produced a solution that allows the early salon to be exhibited in overhead natural lighting similar to that of its original location; the carved sculpture to be seen in the round, in the skylit main space of the building; *The Gates of Hell* to be experienced from above, below, and a variety of viewpoints in between; and the end of the exhibition to occur close to the audiovisual theater where a film on the techniques of lost-wax casting, as seen in the spectacular instance of *The Gates of Hell,* can be seen.

To the many lenders from Europe and America, we owe our deepest gratitude. The lender of the greatest number of objects is the Musée Rodin. Under the able leadership of Jean Chatelain, professor at the University of Paris and former director of the Museums of France, and Mme. Laurent, both of whom have contributed important scholarly essays to this catalogue, the Musée Rodin has collaborated on this undertaking over a long period and been enormously generous in lending to it.

We are also particularly grateful to Mr. and Mrs. B. Gerald Cantor for their help. Mr. Cantor, who has assembled in his personal collection and that of his foundation and corporation the largest number of Rodin works outside the Musée Rodin, has for years lent his sculptures and financial support to many Rodin exhibitions, including those focused on the monuments to Balzac and *The Burghers of Calais.* He and his foundation have funded substantial Rodin research and publication, and he has funded the film on *The Gates of Hell,* in whose making Mrs. Cantor has been very closely involved.

The mounting of a sculpture exhibition is a particularly expensive undertaking, and it is safe to say that without the public-spirited generosity of the IBM Corporation, this exhibition would have never taken place. Over the long preparation period of the show, the costs of transportation and construction, both dependent on the cost of energy, have skyrocketed, and we are therefore particularly grateful to IBM, its new Chief Executive Officer, John R. Opel, and its Vice President of Communications, Victor J. Goldberg, for their willingness to help make this exhibition a reality.

When the National Gallery introduced the *Civilisation* films to the United States a decade ago, audiences were struck by Lord Clark's focus on Rodin as the quintessential artist of the romantic era, an era which he defined as lasting to our own day. The monumental statue of Balzac he called "the greatest piece of sculpture of the nineteenth century—indeed the greatest since Michelangelo." The image of Rodin has been marred by inept and unauthorized casts, the difficulty of assessing creativity in the form of plaster, and the sheer fame of certain pieces. It is our hope that this exhibition will allow Rodin to be discovered, or better still, rediscovered, with fresh eyes.

J. CARTER BROWN
Director
National Gallery of Art

LENDERS TO THE EXHIBITION

Mr. and Mrs. James W. Alsdorf

Mr. and Mrs. Harry W. Anderson

The Art Institute of Chicago

The Baltimore Museum of Art

The Andrew H. and Walter R. Beardsley Foundation
Ruthmere, Elkhart, Indiana

Mr. and Mrs. Howard Berkowitz

B. G. Cantor Art Foundation

B. G. Cantor Collections

Jay S. Cantor

The Cleveland Museum of Art

Collections de la Comédie Française, Paris

Mr. David Daniels

Mr. Ben C. Deane

The Denver Art Museum

Des Moines Art Center

Mrs. Katharine Graham

Hirshhorn Museum and Sculpture Garden
Smithsonian Institution

Indianapolis Museum of Art

Professor Andrew S. Keck

Dr. and Mrs. Jules Lane

Los Angeles County Museum of Art

Leon and Molly Lyon

Menil Foundation Collection, Houston

The Metropolitan Museum of Art, New York

The Minneapolis Institute of Arts

Musée de l'Ardenne et Musée Arthur-Rimbaud
Charleville-Mézières

Musée de Beaux-Arts, Marseilles

Musée du Louvre, Paris

Musée du Petit Palais, Paris

Musée Rodin, Paris

Museum of Fine Arts, Boston

The Museum of Modern Art, New York

The City of New York

Ny Carlsberg Glyptothek, Copenhagen

The City of Paris

Philadelphia Museum of Art, Rodin Museum

The Art Museum, Princeton University

Princeton University

Mrs. A. N. Pritzker

The St. Louis Art Museum

The Fine Arts Museums of San Francisco

San Francisco Museum of Modern Art

The Stanford University Museum of Art

Mr. and Mrs. A. Steinberg

The Swiss Confederation

Mr. and Mrs. John P. Terranova

The University Art Museum
The University of Texas at Austin

Victoria and Albert Museum, London

The Louis A. Warren Lincoln Library and Museum
Fort Wayne, Indiana

Mr. Sam Weisbord

Lydia and Harry L. Winston Collection
(Dr. and Mrs. Barnett Malbin), New York

and

Private Collections

ACKNOWLEDGMENTS

This entire project depended heavily upon the cooperation and expertise of the Musée Rodin staff, headed by Jean Chatelain and Monique Laurent. Without their leadership, the success of our venture should have been significantly compromised. Claudie Judrin and Hélène Pinet were also especially helpful to us in preparing the exhibition. We owe each a debt of gratitude.

We should also like to acknowledge the kind cooperation of Jean-René Gaborit of the sculpture department at the Musée du Louvre in creating the salon section of *Rodin Rediscovered*. The realization of this aspect of the exhibition would hardly have been possible were it not for the knowledge and generosity of Anne Pingeot, curator of sculpture at the Musée d'Orsay. We are also grateful to Thérèse Burollet, curator of the Dépot de Sculptures d'Ivry and of the Musée Cognacq-Jay, for her instructive help.

The excellent research done by Bruce Bassett and Giselle Delmotte in the making of the film on Rodin's *Gates of Hell* was made available in the best spirit of scholarship. Vera Green, curator of the B.G. Cantor Art Foundation, was extraordinarily helpful and patient with the complications of working on a project of this size. Jean Bernard of the Fondation Coubertin, where the new cast of *The Gates of Hell* was made, was a marvelous source of technical information. We would also like to thank Geneviève Monnier, of the Cabinet des Dessins at the Musée du Louvre; Hélène Baltrusaitis, of the United States Information Service in Paris; Alex Ross and his staff at the Stanford University Art Library; and Nancy Bavor, registrar of the Stanford University Art Museum; and Hugues Texier, François Braunschweig, and Patricia Elsen. Special thanks go to the graduate students who helped with research: Marion Hare, Jo-Anne Paradise, Rosalyn Jamison, Bette Talvacchia, and Neal Benezra.

RUTH BUTLER
ALBERT E. ELSEN
KIRK VARNEDOE

INTRODUCTION

Our aim in preparing this catalogue was to present the latest Rodin research. The cooperation of the Musée Rodin administration has permitted considerable archival work that has led to essays on some subjects not previously covered and others now studied in greater depth and with more accuracy. In the same way that he would have us look at his sculpture, Rodin now appears to us with a sharper and fuller image—in the round so to speak.

Ruth Butler sets Rodin's art into the context of the Third Republic salons of the 1870s. When Rodin broke into the salons, he chose to do so at first with portraits that gratified the vanity of the art-conscious middle class. The critical success of serious patriotic works—by such contemporaries as Mercié, Frémiet, and Bartholdi—Butler argues, encouraged Rodin to express the disillusionment experienced by France after her defeat in the Franco-Prussian War. His naturally serious temperament found its true outlet in the role of sculptor as public educator and spokesman for the people.

The closeness with which the sculpture salons reflected the government's views and middle-class taste owed much to the sponsorship of the first and the patronage of the second. Butler quotes passages from contemporary reviews and interprets the changing thematic significance of works exhibited by Rodin's peers. She discusses several artists presently little known, such as Mercié, Peinte, Barrias, and Falguière, who at the time rivaled Rodin for public attention and acclaim. Repeatedly, we are reminded of how in Rodin's day sculptors were seriously credited as thinkers, philosophers, and psychologists; that Rodin was thought of in these terms was not a unique phenomenon.

Rodin emerges from this essay as determined to be a *French* sculptor, to express in art his patriotism and moral concerns and to stay attuned to the art-political system. This last consideration was critical for him in obtaining the commission for *The Gates of Hell*. Butler shows that in the content of this commission he was responding to the serious moralizing climate of the time and the taste for themes of sin and guilt.

Complementing Butler's narrative of Rodin's early career as an exhibiting *statuaire* is Albert Alhadeff's detective work in recovering more of the artist's decorative masks made for an employer named Legrain in connection with the fountain, later destroyed, that stood in front of the old Trocadéro Museum. The masks Rodin made for the project did not bear his name, and the critical praise they later won caused him to regret the anonymity his employer had imposed. Legrain, in fact, won a medal for the masks, of which Alhadeff has found prints. (Daniel Rosenfeld has found evidence that Rodin carved at least some of them.) The case for Rodin's authorship of these decorative works is supplemented by an interpretation whose patriotic implications link Rodin's decorative art with his salon sculpture of the 1870s.

Using previously unpublished architectural drawings, old photographs, and documents from the Musée Rodin archives, I have tried to establish a clearer idea of how *The Gates of Hell* were made, as well as to secure a chronology for the various stages through which they passed. With Rodin's encouragement, we have previously looked at the *Gates* as Rodin's lifelong work. It now seems that he may have spent a total of eight or nine years of intensive work on them between 1880–1889 and 1899–1900. For long periods of time they served only as a bank of figural motifs from which he drew for freestanding sculptures.

Documents show that an enormous amount of work was done on the portal during the year ending in May 1900, when Rodin presented the plaster portal to the public for the first time in his great one-man exhibition. From what we can see of the assembled portal in studio photographs made in 1899 or 1900 and from photographs of the exhibition, it appears that the *Gates* as we know them today were completed by the 1900 exhibition. Undoubtedly, there were details of the architecture that did not satisfy Rodin until the day he died, but there is no evidence that he made any changes on the great doors after the spring of 1900. Rodin's continued dissatisfaction with these architectural details stemmed from his drive

to win a new, modern decorative unity between sculpture and architecture. The design for the architectural frame of the *Gates*, on which Rodin had the help of at least one professional architect, evolved from complex to simple. The unity Rodin did achieve was recognized by only a few contemporaries and since his death has gone either unacknowledged or unappreciated; and yet it is one of Rodin's greatest audacities.

After Rodin's death, nothing seems to have annoyed his critics more than the skill, sentiment, and beauty which his carved works exhibit. Alexander Calder compared them to shaving cream piled on the floor. In one of our conversations about Rodin, Henry Moore spoke of the marbles as being "smarmy." In the early 1960s, an eminent American critic wrote that to know Rodin as an artist one had to forget the marbles, and a former director of the Musée Rodin agreed. Victims of the truth-to-the-medium/direct-carving ethic of modern sculpture of the twenties and thirties, the marbles were rejected as not by Rodin's hand and untrue to the nature of the material and carving process. The public, however, has not shared this revisionist ethic, and such works as *The Kiss* in the Tate Gallery have long been admired by people of all ages. In recent years the market price for Rodin marbles has soared; they are coveted internationally by collectors and museums alike. Since Rodin's lifetime, however, with rare exception, critics have avoided addressing the marbles. To promote their rediscovery, Daniel Rosenfeld discusses the marbles' importance to Rodin, especially the crucial role they played in the late 1880s, when his reputation was being established. Rosenfeld gives a detailed account of the division of labor by which Rodin's carvings were produced and the technical tradition out of which they arose.

Rosenfeld describes how, until late in his career, Rodin sustained rigorous standards of quality and exercised tough supervision over his many assistants. Quoting from contemporary critics, Rosenfeld shows that Rodin's marbles caused him to be seen as a "revolutionary" who was also "a great traditionalist." None of Rodin's peers was credited with imparting the gift of life to his material with equal or greater profundity and intensity. Partly because they were unique and handcrafted, the marbles were more esteemed and sought after before 1917 than the bronzes.

One of Rodin's most famous works is the marble version of *The Hand of God*, a reminder that no sculptor before Rodin was so fascinated with creation or made it the explicit subject of so many works. In her essay, "Rodin's Humanization of the Muse," Rosalyn Jamison describes how Rodin's study of nature and ancient art helped to shape his images of creation. She examines the paradox of the artist's slow, hard work and empirical approach to creation on the one hand and the expression in his art, on the other, of the importance of the muse. Rodin transformed the traditional external agent of inspiration, expanding and personalizing her role to signify both the artist's own imagination as well as the elusive forces of creative thought which surround him. Typical of Rodin's genius was the blurring of distinctions between abstractions and life, between an allegorical figure and a deeply introverted or suffering woman. Not surprisingly, Rodin explored the erotic implications of the communion between sculptor and muse. Depicting the consoling nature of the muse involved Rodin in revelations of his private anguish as a creator and identification with the crucified Christ and bound Prometheus.

In Rodin's *Balzac* the creator himself takes on the characteristics of the humanized muse. Following his shock and disappointment over the public reception of the *Balzac*, Rodin turned away from symbolizing creation to more customary memorial themes such as fame and glory. He reworked ancient personifications of the muses in the spirit advocated by Mallarmé: to revitalize rather than preserve the ancient symbols and to fill them with modern significance. Jamison explains that in making the muse a personal symbol, Rodin was proclaiming the spiritual functon of art that he felt was imperative in an age of disbelief.

The world knows Rodin through his bronze and marble sculpture. In his lifetime, however, he worked amidst his own world of white plasters. Today, there are still a large number of less than life-size plasters uncast in bronze and unseen since the artist's death in 1917. Their present exhibition and publication is consistent with Rodin's intention, for he donated every work he owned to the state with the wish that all of his art be available to the public. Some of the previously unknown plasters, discussed in my essay, "When the Sculptures Were White," bring us closer to the private thought and ways of making art of a prodigious worker. A few of those chosen are heretofore unknown models for public works, but the rest show us Rodin free from self-conscious striving and the will to heroic form.

By the liberties he took with the human form and the sculptural process, even at this late date Rodin's art has the power to astonish. For economy of effort and to win new effects and new beginnings for different interpretations, Rodin seems to have invented a process of dip-casting, immersing plasters in liquid plaster to give them a fresh, more fluid skin. Studies for portraits such as

those of Hanako and Clémentel reveal that after achieving physical likeness Rodin often sacrificed cosmetic attractiveness for the expression won by touches and indentations which conscripted light and shadow to his purpose. Close to what he felt for portraiture was Rodin's passion for coupling his plaster figures, small and large, and small with large. Artistic logic, rather than consistency of mode and scale, produced provocative pairings, expressions of mutual awareness, which defied sculptural tradition.

For early modern sculpture, Rodin's most influential work was the partial figure. In answer to the crucial question What can sculpture do without?, Rodin offered less than the whole figure, showing that the well-made part can have the beauty and expressiveness of the whole. The plasters offer fresh discoveries of Rodin's meditations on sculpture as well as his resistance to an obvious and consistent formula by which to strip the figure of the unessential. Along with *The Gates of Hell*, Rodin's plaster figures call into question the view early argued by Matisse and Roger Fry that Rodin was only an inductive thinker, marvelous in making the parts, but lacking an artistic sense of or feeling for the whole. It is not only in Rodin's plasters that one may personally test these conclusions, but also in his drawings.

We may never know how many drawings Rodin made, but the collection of almost eight thousand in the Musée Rodin argues that drawing was a lifelong preoccupation engaged in with passion. Kirk Varnedoe is one of the few who have studied all of these drawings, and his essay is the occasion for seeing the collection "symphonically, as a life's work." Varnedoe orchestrates the two basic modes of Rodin's drawings, those done from imagination and those done from life, as "complementary expressions of a single mind." The two modes shared some procedural similarities, from rough sketching to open-ended editing, which narrowed and tightened a drawing's form and meaning. Varnedoe examines the broad evolution of the drawing style and the artist's ways of knowing the figure, from pure delineation to the shadowed black style to the final linearity that won new unities for the body. In the section on the early drawings he constructs a more continuous evolution from student work to the imaginative drawings that precede and overlap the beginnings of *The Gates of Hell*. There is a revealing discourse on the differences between the conceptual and visual processes of creation in the early and late styles, as well as their concomitant themes. The thematic evolution is shown to be from a preoccupation with civilization's dilemma, suffering caused by the contradictions of the heroic and consciousness of guilt, to concern with the condition of unconstrained instinctual life. Varnedoe then puts the late erotic drawings into the context of the entire artistic mode, arguing that erotic curiosity is not voyeurism but the "mainspring" of Rodin's art.

One of the most fascinating of Varnedoe's discoveries is the identity of many schematic notations made by Rodin on his Italian trip of 1875. These abstracted representations reveal what the sculptor sought in terms of salient gestures and figural compositions. Rodin's method of preserving his notes by montage speaks of a lifetime habit of continually reflecting on and reinterpreting things done and seen when he recognized other possibilities for a motif.

A motif that Rodin explored with enthusiasm for many years in drawing and sculpture was Dante's Ugolino and his sons. The recently rediscovered first sculpture version, a seated partial figure, dates from at least 1877. After 1900, Rodin enlarged the original small version made for *The Gates of Hell* twenty years earlier. Still another seated version of the Ugolino is to be found in the Meudon Reserve. As if these works alone did not certify Rodin's fascination with the theme, the existence of more than thirty drawings of the subject show that he deeply identified with the father who destroyed his family. Claudie Judrin, curator of drawings at the Musée Rodin, has identified and assembled these drawings in her essay. She has shown how they follow the temporal sequence of the tragedy as given in Dante. In view of Rodin's practice of not making sculpture from his drawings, it is not surprising, as Judrin points out, that only one drawing resembles the sculpture in the *Gates*. Judrin believes that these drawings date from the period 1875–1880, thus predating the sculpture in the great portal. She also reminds us that Rodin sold and gave away many drawings, and still other interpretations of Ugolino may turn up in the future.

Kirk Varnedoe's "Rodin and Photography" expands our understanding of Rodin's vision of his own work. Rodin used photography to open his studio to the world and to direct his viewers' way of seeing art. Varnedoe gives us a sense of the individuality of the photographers Rodin engaged as well as their business relationships with him. He presents a chronology of the evolution of Rodin's use of photography to document, interpret, and glamorize his art. By examining drawings, sculpture, and photographs, Varnedoe finds new unities in Rodin's aesthetic. This may be the first time since Rodin's 1900 exhibition that photographs in such number have been exhibited simultaneously with sculpture and drawings, so that viewers may test these unities for themselves.

In my essay, "Rodin's 'Perfect Collaborator,' Henri

Lebossé," we are again reminded of Rodin's tough standards and demanding nature, his extensive, critical involvement in the reproduction of his art. Just as there were changes of states in photography, so, too, in the enlarging process Rodin saw his work alter its character. Neither with his photographers nor with Lebossé was Rodin interested in mere mechanical repetition. He expected an assistant to put his heart and soul into the work, to draw on both his technical skills and his resources as an artist. Lebossé may have been Rodin's most important assistant, for today many of the big public works made subsequent to *The Burghers of Calais*—such as *The Monument to Balzac, The Thinker,* and *The Walking Man*—issued from his hands.

In a catalogue in which Rodin is interpreted by living scholars, it seems appropriate also to have the views of one of his contemporaries, the critic Gustave Geffroy. So accustomed are we to formalist criticism of modern sculpture that Geffroy's humanistic approach may come as a surprise. JoAnne Paradise's selections and analysis of Geffroy's criticism show his span of interest from craft to psychological penetration of the subject.

One of the lasting values of Geffroy's criticism, according to Paradise, is that it fixes some of the distinctive qualities of Rodin's art, notably in two areas: that of form arising before or simultaneously with theme and that of interest in the "animal life of man." In Geffroy's day, while "literary" was used as a pejorative term, an artist was not precluded from working from literature, but rather from using clichés of pose, attitude, allegory, and anecdote. Geffroy understood the modern aspect of Rodin's fusion of past and present in the use of fauns and satyrs to show the timelessness of "sorrowful lust," "the joy of being at the same time as the terror of mystery," and the discovery in the actions of the living the presence of the past. Geffroy was a critic such as is rare in our day, one who enjoyed writing about what the artist had to say. Yet, Paradise points out, he was aware of line and modeling, artistic as well as human form, by which expression was to be won. More than any other critic or historian, then or now, Geffroy understood Rodin's affinity with impressionism. He saw a mutual pursuit of the "fugitive durable" in nature and the unity of the figure with its environment. Sensitive not only to the power of the part in a Rodin sculpture, Geffroy also appreciated the artist's gifts in arriving at the ensemble, the whole as an aesthetic as well as psychological and emotional unity.

For many, Rodin's art still seems the antithesis of early modern sculpture. His credo of imitating nature ran counter to the insistence of young sculptors on invention, on imposing the intellect and intuition upon nature. Yet, there was not a major modern figure sculptor before the First World War who was not touched by the implications of Rodin's partial figures. In his essay, Sidney Geist reiterates this influence on Brancusi and shows how in other ways, including the titling of many works, the young Rumanian artist responded to Rodin. Geist also confirms that for a short period of time in early 1907, Brancusi actually worked for Rodin at Meudon. To what Geist has written, I would like to add the suggestion that Brancusi's practice of carving pedestals for his works, pedestals that were at times architectural in feeling, may have been a response to Rodin's custom, highly visible at Meudon, of occasionally mounting figures on plaster casts of ancient columns and capitals. By inventing his own pedestals (although some show traces of Rumanian vernacular architecture, as Edith Balas has demonstrated), Brancusi not only succeeded in raising his sculpture exactly to the desired height and avoiding the shock of its form against the neutrality of a cubic pedestal, but also may have shown in another way that he could be more imaginative and inventive than the old master. Perhaps Brancusi's occasional practice of vertically stacking disparate and separately made forms may have been inspired by seeing at Meudon such placements as the small original version of *The Walking Man* atop a column or one figure atop another in *The Juggler.*

As much as possible in organizing this exhibition we have attempted to use lifetime bronze casts of Rodin's work. In some instances these casts were not available. The difficulty in establishing what is and is not a lifetime cast made under Rodin's authorization derives from the absence of dates on the casts made while he was alive. Furthermore, he used the Alexis Rudier Foundry from around 1902, and its casts before and after 1917 are not distinguishable from one another. To identify lifetime casts, one must rely upon documented ownership from before 1917 or upon certain foundry marks where it is known the foundry did not cast Rodin's sculpture after 1917.

In 1916, Rodin gave to the French nation all of his art and its rights of reproduction. Before the French government accepted the donation, the question had been raised of how the Musée Rodin would support itself. The government looked to the anticipated income from museum casts for the solution to this problem. Rodin was given the right to continue to do his own casting while he lived, but the Musée Rodin began to sell casts even before his death in November 1917. The Alexis Rudier Foundry continued to be used by the administration of the Musée Rodin until 1952, when it

closed after Eugène Rudier's death. Thereafter and until recently, most of the posthumous castings, authorized by Rodin's will, were made at the Georges Rudier Foundry. This excellent founder had worked in his uncle's foundry before it closed, and he took with him some of the most experienced technicians who had known Rodin. For many years the finest patinas on the Georges Rudier casts were made by the son of Rodin's preferred *patineur*, Jean Limet. In about 1953, the Musée Rodin began to number its editions on the casts, and to give the notice of its copyright. This has not been a consistent practice, however. The Conseil d'Administration of the Musée Rodin determined that no work should be cast in an edition larger than twelve and so warrants to purchasers of their casts. In recent years, in addition to Georges Rudier, the Musée Rodin has turned to other foundries, such as Susse and the excellent Fondation Coubertin, for its casting.

Part of the confusion about the posthumous casts comes from the view that authentic casts must come only from *molds* made in Rodin's lifetime. Actually, what is crucial are the plaster *models* Rodin left, rather than the molds. Molds can break during casting. It is the continued existence of the plaster models, from which the mold is made or repaired, that is crucial for authentic and accurate casting, as well as legal authorization.

To the best of our knowledge Rodin did not actually participate in the casting and finishing of his bronzes. He left that to specialists who knew his high standards. Except for its initial salon exhibition and the first bronze cast that fulfilled an important commission, such as that of the *Age of Bronze*, the *St. John the Baptist*, *The Thinker*, and *The Walking Man*, Rodin does not seem to have consistently inspected each bronze himself. No doubt he was more involved before rather than after 1900 with the finished casts. For more than fifteen years, he trusted Jean Limet to patinate most of his important casts and report on their quality. (A communication from Limet to Rodin indicates that the artist preferred not to have the same patina put on two or more casts of the same bronze.) Contrary to current rumors spread by those attempting to sell either faked, forged, or spurious casts without foundry marks, Rodin did not have a secret foundry in Normandy or anywhere else. He left bronze casting to professionals. Although on one occasion he gave a client (Anthony Roux) authorization in writing to cast from the plasters in his possession, Rodin made it clear that he regarded unauthorized casts from his plasters as *not genuine*.

In this country, the *Statement of Standards on the Reproduction of Sculptures*, subscribed to by the College Art Association, Art Dealer's Association of America, Association of Art Museum Directors, and Artists Equity, in 1974 established conditions of authenticity and desirability for bronze casts. Posthumous casts by the Musée Rodin are unquestionably authentic in terms of the sculptor's intent and his grant of the right of reproduction to the state. (The posthumous casts are viewed by these standards as less desirable than those made in Rodin's lifetime.) Recent unauthorized casts that have appeared on the American art market are consequently undesirable and counterfeit.

Many of the bronzes in this exhibition were not cast by Rodin during his lifetime. As a spectacular example, *The Gates of Hell* were still in plaster at his death. All five casts have been made posthumously. As with the sculpture of Degas (all bronzes of which are posthumous), without such casting the world would not know or have access to major works by these great artists. That so many Rodin plasters were never cast is partly explainable by the fact that he customarily cast on demand. Rodin did not work for a dealer and did not personally cast editions on speculation. He contracted with bronze editors for unlimited replicas of popular works such as *The Kiss*, *Eternal Spring*, and *Victor Hugo*. Consistent with his peers, Rodin did not usually cast in limited editions, a practice that seems to have been introduced at the turn of the century by art dealers such as Ambroise Vollard. By bronze casting previously uncast plasters, the Musée Rodin administration has been fulfilling its purpose in exposing the world to the breadth and depth of Rodin's art. Whether or not one prefers a lifetime cast to an authorized posthumous cast on historical or ethical grounds, there is no question but that the latter casts do perform an important educational function. Rodin's lifetime bronzes were not all of equal quality. So, too, posthumous casts must be judged on their individual merits.

It is a common experience for members of the public, upon seeing a second, third, or fourth cast of *The Thinker*, to ask, "But which is the original?" In his essay, "An Original in Sculpture," Jean Chatelain of the Sorbonne and the Ecole du Louvre (and a delegate to the Conseil d'Administration of the Musée Rodin) discusses the broad question of what is an original work of art as the term applies to works involving a division of labor, or "compound art," to use his term. Against a background of French law and history, Chatelain explains the complexity of the problem and the limitations of previous solutions. He develops the distinction between an original work of art and an original *edition*, which is appropriate to Rodin's bronzes. He stresses the importance of the existence of the artist's original plaster model

from which molds are made and the claims presented for the finished bronze by the vendor. As bronze is a reproductive medium, unless finished personally by the artist "original" is an awkward word at best to apply to work cast in this material. (As Charles Blanc pointed out in 1883, only the clay is original to a work cast in plaster and then bronze.)

Welcome to collectors, curators, and scholars will be the essay by Monique Laurent, "Observations on Rodin and His Founders." From the Musée Rodin's archives she has begun gathering the names of the foundries with which Rodin worked, the periods of the relationships, and the titles of many works cast. The records are incomplete, however, as some foundries known to have been used by Rodin are not represented in the Musée Rodin archives. The dossiers are often vague as to the identity of a cast, silent on the dimensions of the bronzes, and lacking full accounting of work done. Laurent characterizes Rodin's practices—his simultaneous contracting for unlimited editions for popular works, casting on demand for individual clients with occasional promises of exclusivity, and occasionally authorizing limited editions—as normal for his era. Responsive to the diverse needs of his clientele, Rodin was obliged to call on many different founders, and so far Laurent has identified twenty-eight founders who worked for him. (There may have been four others, but the documentation is uncertain.) Perhaps of greatest interest is the absence of any document in the museum's archives which confirms a personal collaborative relationship between Rodin and the founder Alexis Rudier. Although the Alexis Rudier Foundry cast more Rodins than any other, it appears that before 1902 Rodin worked with Alexis's brother, François Rudier, whose foundry marks on Rodin bronzes are rare. From 1902 until 1916, it was Alexis's son Eugène who worked closely with Rodin, while retaining his father's name for the foundry. It was not until 1913 that the Alexis Rudier Foundry became the exclusive foundry to cast Rodin's bronzes, and it remained so when the Musée Rodin was established in 1917. After Eugène Rudier's death, his nephew Georges established his own foundry and began casting under his own name for the Musée Rodin. Laurent points out that Rodin's signatures on the bronzes were traced by the founders and the patinas were done in another foundry or by a specialist such as Jean Limet. Admittedly much remains to be done on the archaeology of Rodin's casts, but Laurent has broken the ground.

In her section of the catalogue, Anne Pingeot, too, makes a significant contribution. Curator at the Musée d'Orsay in Paris, Pingeot gives us documentary infor-mation on selected pieces from the salons of the 1870s. Out of her archival research, she provides material on the works of various contemporaries of Rodin, expanding our appreciation of their origins and histories. This study of the works through documents opens a new avenue into the world of French nineteenth-century sculpture and widens our path to a rediscovery of Rodin.

In sum, these essays do not simplify our knowledge of Rodin or help to categorize his art. They complicate as well as enrich our understanding by showing how much more complex he was as an artist and businessman than we had thought. Rodin was both traditional and innovative, of and ahead of his time. His work is a dramatic reminder of how modern figure sculpture was not a complete break with the past. Adjectives such as realist, impressionist, or symbolist do not sit comfortably next to his name. As the essays show, he pursued as many of art's possibilities as he could, thereby matching his sculpture and drawing with the range of his thought and feeling.

ALBERT E. ELSEN

1.13 The Salon of 1872 (detail).

1. Rodin and the Paris Salon

Ruth Butler

During his lifetime Rodin's prodigious success took on mythic dimensions. Things happened that should not have happened, and things that looked like failure, in the end, were full of fortune. For instance, an artist of Rodin's talent *should* have been accepted at the Ecole des Beaux-Arts. He tried three times to gain admission to that school and each time he failed. By 1863 Rodin had his own studio, he was a regular working sculptor, and he *should* have been placing works in the imperial salons. He never did. Rodin's work first appeared in the Paris Salon of 1875, the year which many historians give as the actual beginning of the Third Republic (see note 44). He was thirty-five years old.

In retrospect these failures appear strangely "right." That Rodin began his public career in France in the republican salons of the 1870s is right on three counts. First, there was an issue of class in Rodin's initial exclusion. His was a modest family that could claim no significant connections among the *haute bourgeoisie* who ran the artistic system of imperial France. Second, there was a seriousness about the salons of the 1870s. Key to understanding them is the idea of art's having a special mission to serve "the people." Had Rodin known success in the 1860s he might have lingered in the pretty, crowd-pleasing style of the Second Empire. Yet by temperament, Rodin was serious. He became committed to a nondecorative, forthright venture built upon nature's own frankness and capable of making statements about man's condition upon earth, statements appropriate to republican thinking. Third, the salons of the 1870s were the most exciting exhibitions for sculpture during the entire nineteenth century. They were the only salons in which sculpture was consistently acknowledged as superior to painting.[1]

Georges Dufour, a lawyer in the Ministry of Finance during the 1870s, found the painting and sculpture of his day to be "our best books. We have a population without time to read or to meditate. Every exhibition that opens, every museum that is inaugurated opens a

door to light."[2] But it was particularly at the salon that he found *the* format for contemporary artists. It was equivalent to the printing establishment in the lives of writers. All things became possible through the salons: "Thanks to our annual exhibitions, paintings and statues . . . are put before the public on the big opening day. . . . Our salons are among the most successful consequences of the modern system of disseminating information, this great guarantee of freedom for the people in a democratic society."[3] The salons of the seventies were the perfect format for Rodin to meet the French public for the first time.

Rodin began working on his first salon piece in 1863, just as the controversy of the century erupted over the salon. More than four thousand works had been rejected that year, bringing into existence the celebrated Salon des Refusés. We can imagine the hopes of a young artist, recognizing that the issue of rejection had become the most talked-about artistic concern in the journals, ministries, and cafés of Paris. He could have hoped that the jury which examined his entry in 1864 would have felt the weight of its responsibility with a special force.[4] In fact, the juries for all the salon sections were more prudent than their predecessors. Rejections fell from seventy to thirty percent. But Rodin's entry, the *Man with the Broken Nose*, was in the thirty percent. This must have been brutal for him, because the works rejected by the more liberal jury of 1864 were considered to be clearly "trop faibles pour participer au concours des recompenses."[5] In 1864, as in 1863, there was a Salon des Refusés, but it had neither the éclat nor the notoriety of its predecessor. Rodin chose not to allow the *Man with the Broken Nose* to remain among the "refusés."

What did the jury see when they approached Rodin's entry, and why did they reject it? They found a highly expressive plaster head of a bearded man with a broken nose. It terminated at the neck and had no back, for the clay model had frozen in Rodin's unheated studio and had split. Enough hair remained that the fillet Rodin

had drawn about the head was still visible. Perhaps it was the combination of the break, of the work's being merely a head, not a bust, of the unusually fluid and expressive modeling, and of the subject, a nameless individual (portraits of well-known personalities fared best at the salon), that made the head so unprepossessing as to be classified among the "faible." Modern critics, however, have always agreed with Rodin's own judgment of the work: "It was the first good piece of modeling I ever did."[6]

We might consider the parallels between Rodin's situation in 1864 and that of Edouard Manet five years earlier when the painter first attempted to enter the salon. Manet sent his *Absinthe Drinker* to the Salon of 1859, and it was rejected. Manet explained: "I painted a Parisian character whom I had studied in Paris, and I executed it with the technical simplicity I discovered in Velasquez. No one understands it. If I painted a Spanish type, it would be more comprehensible."[7] If we replace "Velasquez" and "Spanish type" with "Greek portraiture" and "classical type," we have a statement that Rodin could well have made in 1864. Just as Manet wanted to make an image of the ragpicker Colardet, a simple man he had seen loitering around the Louvre, Rodin found the face of Bibi, the neighborhood odd-job man, to be unusually rich. Both artists wanted to create works in the new realist style, but works which also revealed their awareness of past traditions. The difference between the two stories is how they end. When Manet submitted two paintings to the next salon, they were accepted; when Rodin tried again in 1865, he was turned down.[8]

Why did Manet and Rodin fare so differently in the imperial salons? The major reason is that Manet was a painter and Rodin a sculptor. Paintings, not sculpture, were the center of every salon during the Second Empire, just as they had been in the salons of the July Monarchy. We have Baudelaire's famous remark made while discussing Delacroix's work at the Salon of 1846, in which he chastised all those who jeered at Delacroix's draftsmanship, "particularly the sculptors, men more partial and purblind than they have a right to be, whose judgment is worth no more than half that of an architect. . . ."[9] 1846 or 1864—it was all the same; this was the attitude which Rodin and every other sculptor had to confront. Even Manet's most forceful critics recognized "l'esprit" in his work, while the most frequently used adjective with regard to sculpture was "banal." "Sculptors in general have fewer ideas than painters," Paul Mantz pointed out in 1865.[10] People saw sculpture as unsuited for the portrayal of modern life; they saw it as a "primitive language, difficult to handle, existing for the purpose of expressing large and simple ideas. To ask a sculptor to be subtle . . . is to turn him from his true path, to diminish, to disfigure what he does. . . . Everyone, more or less, can appreciate painting, an art of color and passion, quickly conceived and executed, but how many people are truly capable of seeing a work of sculpture that has come into being through so much labor?"[11]

Another major difference between Rodin and Manet was their training. Manet was from a recognized atelier, that of Thomas Couture. Further, his was a bourgeois family with enough connections to enable him to know that Delacroix had voted in favor of his painting in 1859. Rodin received no such encouragement. Worse than that, he had no master. One glance at a nineteenth-century salon catalogue is enough to make it clear how important the line beneath an artist's name was; it read "élève de M. . . ." Rodin finally made his way into the salon in 1875 as "élève de M.M. Barye et Carrier-Belleuse." But it is unlikely that he used either name in 1864, for although he made the acquaintance of the two older masters sometime during that year, the entry blanks had to be submitted by March.

Rodin's rejections in the sixties were catastrophic. Truman Bartlett, the American sculptor who met and wrote about him in the 1880s, understood the full dimension of the disaster: ". . . a blow as cruel as it was injust. It hurt his pride so much that he did not try again to exhibit anything at the Salon. It cut off whatever benefit these exhibitions might have brought him, and prevented all professional recognition. Its effect, for a long time, condemned him to the life of a workman. He had, so far, been unable to form any relationship that could help him along in the world, either as a man or as an artist. The refusal of the Salon to accept the mask deprived him of his last and only hope."[12] Rejection meant that the aspiring Rodin would turn thirty, not as an independent artist, but as a *praticien*, a worker who executed commissions for others. It meant he was the last to get work and when the economic conditions following the Franco-Prussian War became as severe as they did, he, not Chapu, Mercié, or Aubé, was forced to leave home and go abroad in order to work. So it was that Rodin's first experience of showing in a salon and executing public commissions took place not in Paris, but in Brussels.

Rodin arrived in Belgium in February or March of 1871. Before the year was out, he had shown in the salons of Ghent, Antwerp, and Brussels. He put his *Man with the Broken Nose* into the Brussels Salon of 1872. The following year, with his Belgian partner, Van Rasbourg, he showed eleven works in the International

1.1 *Man with the Broken Nose*, 1863-1875. Marble. Musée Rodin, Paris. Cat. no. 20, plaster.

1.2 *Bust of M. Garnier*, 1875. Terra cotta. Musée Rodin, Paris. Cat. no. 19.

Exhibition of London and Vienna.[13] He was in the salons of Ghent and Brussels in 1874, and in the Exposition générale des Beaux-Arts in Brussels in 1875, as well as in the International Exhibition at Albert Hall in London.

By 1875 Rodin felt ready to try Paris once more. Again he entered the *Broken Nose*, but in a new form: a cool, symmetrical, finished marble (fig. 1.1), at some remove from the lively inspiration of Bibi's face. Rodin had ordered it from a Parisian *praticien* named Bernard. It was a commission that represented considerable expense for him.[14] Rodin also placed a second entry in the Salon of 1875. A terra-cotta bust of the Parisian businessman M.L. Garnier (fig. 1.2), done during the difficult winter of 1870, it was Rodin's first attempt at a naturalistic rendering of a bourgeois sitter. He had created busts in the same mode in Brussels even better in quality, especially *Dr. Thiriar*, which was in the salon of Ghent in 1874, and one of the Brussels apothecary Vanderkaeler, which Rodin himself considered "one of the best I ever executed."[15] But he chose *Garnier* to accompany the *Broken Nose*. Not only was it already in Paris,[16] but also people might go to see it because they knew the sitter.

Rodin, like so many of his contemporaries, responded to the new awareness of a middle-class public intent upon their own figures and faces. More people than ever

before wanted their own portraits. Earlier in the century enthusiasm for this genre had been more subdued. Attention to individuality contradicted the neoclassical artist's desire for perfection. But by the second half of the century, spurred on by new portrait studies made by photographers, the demand for busts increased. In Second Empire salons one quarter of the paintings were portraits, as were one third of all the sculptures (including busts and medallions). The number continued to rise during the early years of the Third Republic.[17] In 1874 the salon critic and sculpture enthusiast Henry Jouin found the busts to be the most striking part of the entire exhibition: ". . . they are the works that, by number and by general effect, have received the most praise. A bust can be a work of genius. If the artist is truly endowed with an idea when he approaches the person to be represented, the head that he sculpts in marble may well merit the appellation chef-d'oeuvre. Is not the head the most important part of a person's body?"[18] The critic and political writer Jules-Antoine Castagnary pointed out after seeing the Salon of 1875, ". . . the busts stand out in terms of quantity and quality. Since French artists have broken with academism, they have become ever more able to render human physiognomy in the liveliest and most accentuated fashion. Instead of generalizing, thus depersonalizing the model, as was once done under

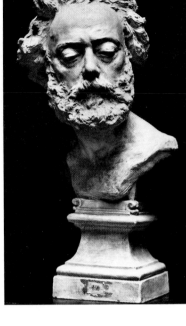

1.3 Anatole Marquet de Vasselot. *Balzac*, 1875. Marble. Comédie Française, Paris. Cat no. 18.

1.4 Jean-Baptiste Carpeaux, *Alexandre Dumas fils*, 1873. Marble. Comédie Française, Paris. Cat. no. 16, bronze.

1.5 Jean-Baptiste Carpeaux. *Bruno Chérier*, 1875. Plaster. Musée des Beaux-Arts, Valenciennes. Cat. no. 13, different plaster.

the pretext of style, sculptors today desire to penetrate the person, and, thus, to liberate the individual. . . ."[19]

Each of Rodin's entries in the Salon of 1875 responded to expectations articulated by these two critics. Jouin believed that if an artist could successfully infuse an idea into marble (for critics like Jouin marble remained *the* material of sculpture), a masterpiece could result. In the case of the *Man with the Broken Nose*, Rodin had taken an idea—that of fashioning the image of a classical philosopher from a living face—and given it shape as a nude bust placed upon an angular plinth. As a type, it compares with Marquet de Vasselot's *Balzac* (fig. 1.3), one of the most highly praised portraits at the Salon of 1875. People responded to this marble bust because it captured the novelist's features without emphasizing his ugliness. Both Marquet's and Rodin's busts revealed the individual in a way that classicizing busts of the early nineteenth century had not. They may appear conservative today, but in the 1870s they looked thoroughly contemporary.

In his second entry, *M. Garnier*, Rodin presented an example of modern portraiture that sought to "liberate the individual." He drew the buttoned shirt, the tie, the vest and coat; he textured the beard and hair; he scooped out the pupils. This is Carpeaux's kind of portraiture.

We might compare *Garnier* to Carpeaux's *Alexandre Dumas* (Salon of 1874) (fig. 1.4) and *Bruno Chérier* (Salon of 1875) (fig. 1.5) in order to see examples of the type. In so doing, we discover how tentative Rodin's portrait of Garnier was. The fourth male portrait we know from his hand, *Garnier* was the first in which Rodin tried to strike a contemporary note. Rodin was to learn a great deal during the 1870s from Carpeaux about portraiture, but when he made *Garnier* in 1870, he had not yet mastered the technique of rendering that delicate inflection into the clay which could transform a bust into a living portrayal.

Reticent, conventional—we might use these words to describe Rodin's first entries into the Paris salon. Yet they were his most important works in 1874. He had shown bacchantes, Floras, and Alsatian girls in Antwerp, London, and Vienna. But for the Paris salon he needed something weighty, so he chose the two male heads. We must emphasize the "maleness." There is a *Mme. Garnier*, but Rodin did not consider it for the salon. Although Rodin made far more portraits of women during the 1860s and 1870s than he did of men, with the exception of Rose Beuret and Mme. Garnier, we know none of the sitters' names. The female busts were decorative and unworthy of the salon. The male portraits

left: 1.6 *The Vanquished One*, 1877? Pen and ink? Location unknown.

right 1.7 *The Age of Bronze*, 1875-1877. Bronze. Albright-Knox Art Gallery, Buffalo. Cat. no. 21, different cast.

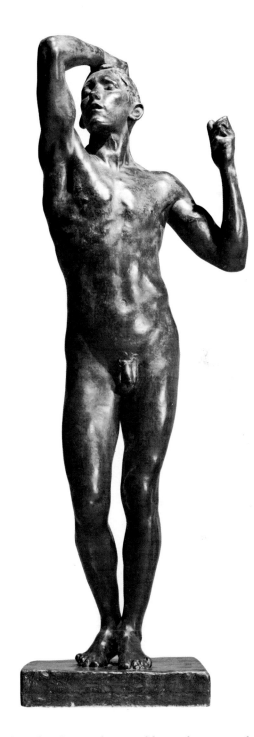

were different. Eleven remain from the years between 1860 and 1880. We know each sitter's name, and as a group the works constitute a serious artistic statement. It was in response to Rodin's portraits of his male friends that critics first began to see him as the most promising sculptor of his generation, "one who is capable of succeeding over all the other debutants. . . ."[20]

Actually being admitted to the Paris salon and seeing his work in the exhibition must have made an enormous difference for Rodin. In all likelihood he began thinking about his next entry while the salon was still open to the public. Finally he could believe he would not be turned away and could think seriously about his first "salon figure." That Rodin was thirty-five before this consideration was a realistic one remains one of the greatest anomalies of his career.

Rodin returned to Brussels for the summer of 1875. Soon after his arrival he went to an officer in the Belgian army and asked for one of his best-built men. The soldier, Auguste Neyt, became his model. This choice indicates the direction Rodin's mind was taking as he began to conceptualize his figure. He knew that no decision would be more important than the one he made about subject, and he decided on the war as the context and theme for his statue. Over the next eighteen months

he developed a figure that could stand as a symbol for the most difficult reality facing Frenchmen during the 1870s—defeat. Rodin completed his statue in December 1876, calling it *Le Vaincu—The Vanquished One* (fig. 1.6).

What Rodin set out to do in 1875 and what has come to be known as *The Age of Bronze* (fig. 1.7) are two different realities. The figure was initially conceived as a tribute to the suffering of the French people in the wake of the Franco-Prussian War.[21] It is not surprising

that Rodin should have felt so strongly. Although he was not a political exile, it was, nevertheless, the war and resulting economic conditions which had forced Rodin to leave home. When he began his figure he did not know when or under what circumstances he would return to Paris. But the choice to create *Le Vaincu* arose out of more than just Rodin's personal situation. He knew from such journals as the popular weekly *L'Illustration* that most of the contemporary sculpture which was illustrated focused on patriotic themes—works such as Mercié's *Gloria Victis*,[22] Bartholdi's *Lion of Belfort*,[23] Frémiet's *Jeanne d'Arc*,[24] and the various war memorials erected by public subscription all over France during the early seventies. The same works had the greatest success in the sculpture sections of the salons. A second issue that would not have escaped Rodin's notice was that most of this highly nationalistic sculpture was created under the influence of the great masterpieces of the Italian Renaissance.[25]

We do not know if Rodin saw the Salons of 1872, 1873, and 1874. The trip between Brussels and Paris by train was not difficult. Whether he viewed them or not, he certainly read the reviews, and the most fervent note on the lips of critics as they wrote about the salons of the early Third Republic was that of nationalism. "Where are we? . . . Have we lost supremacy in the field of art as we lost it on the field of battle?" was George Lafenestre's opening query in his 1872 review.[26] Then, as the call for a reestablishment of the high mission of art and an abandonment of the lighthearted, decorative ways of the Second Empire was articulated ever more consciously, an amazing thing happened: for the first time in fifty years, critics found sculpture to be more satisfying than painting. They recognized that, with the help of Donatello and Michelangelo, sculptors were finding their way to a seriousness of purpose and a *"sentiment grave"* that spoke directly to the people of the new republic.

Castagnary set the tone in the first sentences of his 1872 review: "Opening as it opens, after a two-year interruption, immediately following upon the misfortunes that have laid bare our weaknesses, the Salon of 1872 should be an inquest, nothing more and nothing less. It is necessary that we purify ourselves, that there be an absolute and violent thrust in favor of making a dignified choice to be played before the eyes of this difficult public. What is necessary is something exact, sincere, and complete."[27] Among the 233 sculptures in the salon he found at least ten that were inspired by recent events. Most had just been finished and were still in plaster. Only Bartholdi's *Curse of Alsace* was in final form in bronze and marble, made possible by money

raised through a popular subscription in Alsace. The two allegories based upon the war that enjoyed greatest success were Paul Cabet's *Mil-huit-cent-soixant-et-onze* (fig. 1.8) and Moulin's *Victoria, Mors* (fig. 1.9). Lafenestre pointed out that no one could look at Cabet's figure "without feeling transported into profound sadness," and Jules Claretie believed that he recognized in the face of Moulin's allegory the feaures of "Napoleon I, that great killer of men." On a par with these actively antiwar images were other sculptures that compelled similar feelings in a contemporary audience, especially Mercié's *David* (fig. 1.10), Chapu's *Jeanne d'Arc* (fig. 1.11), and Barrias's *Oath of Spartacus* (fig. 1.12). Even though Chapu created *Jeanne d'Arc* in 1869–1870 and showed it in the last imperial salon, her reappearance was seen as particularly relevant, for no one had understood France's need to purge herself of foreign invaders better than Jeanne. And her simple natural beauty set the tone for the new style in sculpture. These works were all exhibited in the shadow of Carpeaux's gigantic plaster for the *Observatory Fountain* (fig. 1.13). Even this took on a serious air in 1872. Critics recognized a new moment emerging in French sculpture. Arthur Duparc advised if those who came to the Salon of 1872 were unhappy with the painting galleries, they might go to the sculpture section where ". . . we are offered truly exquisite works. They are dignified and in a rare taste that captures our attention."[28]

Rodin must have been encouraged by the tone set here. There were also individual works he might have remembered when he began his own figure. Two in particular were Moulin's *Victoria, Mors* and Mercié's *David*. Moulin employed the same compositional device of a standing allegorical figure holding a weapon in the left hand that Rodin was to try three years later in *Le Vaincu*. But it was Mercié's *David* that surely meant the most to him, for here we have a superb naturalistic rendering of the male nude, one that echoes the Renaissance masterpiece of Donatello. How much of a prefiguration Mercié's *David* was for Rodin's life-size nude is illuminated upon reading in Duparc's review: so real that "it seems it is cast from life. . . ."[29] This is just what was said of Rodin's statue five years later.

The Salon of 1873 provided no single work that we can consider as part of the patrimony of *Le Vaincu*. The exhibition interests us chiefly as a continuing statement of sculpture's primacy. Castagnary called it "the stronger and more solid of our national arts,"[30] and Jouin, "the most elevated and the most popular."[31] Various other statements bring into view the political role of modern sculpture and account for the popularity of works such

1.8 Paul Cabet. *Mil-huit-cent-soixante-et-onze*, 1872. Plaster. Musée du Louvre, Paris. Cat. no. 2, marble.

1.9 Hippolyte-Alexandre-Julien Moulin. *Victoria, Mors*, 1872. Engraving from *L'Illustration*, 22 June 1872, 395.

1.11 Henri Chapu. *Jeanne d'Arc*, 1870-1872. Marble. Musée du Louvre, Paris. Cat. no. 4.

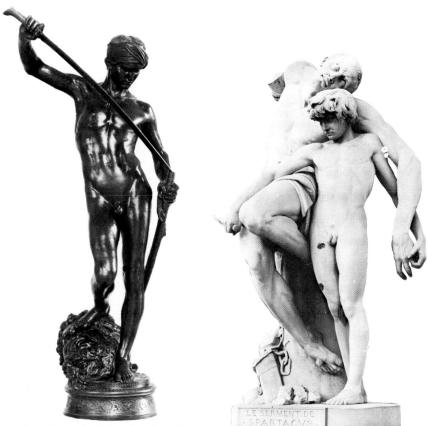

1.10 Antonin Mercié. *David*, 1869-1872. Bronze. Musée du Louvre, Paris. Cat. no. 14.

1.12 Louis-Ernest Barrias. *Oath of Spartacus*, 1872. Tuileries Gardens, Paris.

1.13 The Salon of 1872 (detail).

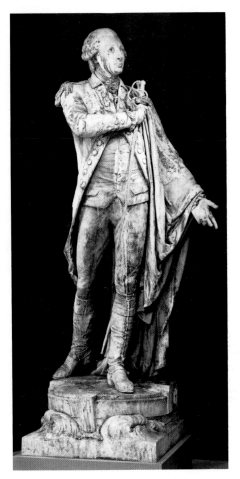

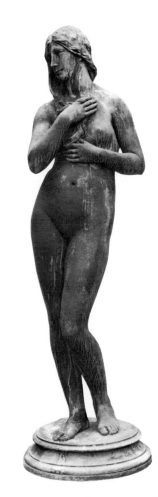

top left: 1.14 Frédéric Auguste Bartholdi. *Lafayette Arriving in America*, 1872-1873. Bronze. City of New York. Cat. no. 1.

top right: 1.15 Paul Dubois. *Newborn Eve*, 1873. Bronze. Musée du Petit-Palais, Paris. Cat. no. 5.

bottom left: 1.16 Antonin Mercié, *Gloria Victis*, 1872-1875. Bronze. Musée du Petit-Palais, Paris. Cat. no. 11.

bottom right: 1.17 Paul Dubois, *Narcissus*, 1862-1867. Marble. Musée du Louvre, Paris. Cat. no. 6.

as Bartholdi's *Lafayette Arriving in America* (fig. 1.14).[32] The favorite work in 1873, however, was not politically inspired. Paul Dubois's *New-Born Eve* (fig. 1.15) captivated the salon audience because of its pure poetry. The figure is Eve, "absolutely nude, artlessly lacking in knowledge about the beauty of her body. With a charming gesture she folds her arms, catching her long hair floating over her breasts, inclines her head in astonishment and delight . . . the first living woman stands before the wonder of the world."[33] Seven years later, with equal simplicity and power, Rodin depicted Eve at the moment of her first experience of guilt. No doubt he was influenced by Michelangelo's Eve in the Sistine Ceiling, but he was also familiar with modern images, and surely Dubois's figure made a significant impression on him.

It is not surprising that political statements were less in evidence in 1873 than they had been the previous year, for the political climate was profoundly uncertain. The salon had been open less than a month when the Thiers government fell and the right-wing government of Marshal MacMahon took over. There was fear that the Third Republic might die even more quickly than its two predecessors. Castagnary ended his "Salon of 1873" by indicating that "public attention turns away

from art and returns to the grave problems of our destiny. . . . In a few days there will not be a soul at the Palais des Champs-Elysées, and no one in Paris or in France will speak any more of art."[34]

With the victory of the Right, political battles intensified. Not only was the Left pitted against the Right, but conflicts broke out within each of the opposing factions as well: the Legitimists fought the moderate Royalists, and even Bonapartism, now that Napoleon III was dead (9 January 1873), hesitantly lifted itself back into the political arena. The peasants feared Monarchists and Republicans alike. When the Salon of 1874 opened in May, political tensions had mounted to such a pitch that on the twenty-third *Le Figaro* announced that the Assembly was in the process of committing suicide.

And politics were back in the salon, very pointedly in Marquet de Vasselot's *Patrie*, a carefully executed life-size marble nude figure reminiscent of an Italian Renaissance risen Christ. He holds the flag of France and bears upon his shoulders the head of Napoleon Bonaparte.[35] Jean Rousseau, art critic for *Le Figaro*, stated that he did not even want to try to understand the intentions in this figure, but he felt Marquet had "chosen badly in his means of formulating political beliefs."[36]

Then there was Doublemard's *Mourning France*, a phantom holding a broken sword, and Chatrousse's *Crimes of War*, a complicated group in which an old man, a battered woman, and a dead child reveal the ravages of war. Nearby a winged allegorical figure by Hiolle knelt to lay crowns upon the earth for those whose only victory was in death.

Another sculpture at the Salon of 1874 shared the sentiments of these three works but stated them so eloquently that it drew the attention of every person who walked through the door. It was Mercié's *Gloria Victis* (fig. 1.16) and its importance went well beyond the exhibition hall. Castagnary stated it most clearly: "While the monarchists quarrel over the debris of our battered fortunes, while foreigners look at us, amazement mingled with irony, and our statesmen go through their gymnastics and exhibit indifference to everything save their own personal ambition, there exists a young sculptor who has ascended to the highest realm of thought and who has undertaken to speak directly to our nation and to console

our people who have suffered so much and to whom no one else has listened. . . ." Castagnary considered *Gloria Victis* in a broader context as well, recognizing in the figure of the soldier a symbol of "progress" having died at the hands of "imbeciles." "The continent of Europe has vaguely understood that civilization is in peril. In silence and resignation she has witnessed this sinister conflict. . . . So be it, if Europe wishes to commit suicide, art will speak."[37] One visitor found that upon seeing *Gloria Victis* his heart began to beat too fast, his throat choked up, and he was "obliged to turn away, for [he] was overcome with patriotic emotion."[38] An American saw the work a few years later at the Universal Exhibition and stated his belief that "no effort of French genius since Sedan—no poem, romance, oration, or work of art—has given so much solace to the defeated nation as this statue. . . ."[39]

Otherwise, most critics agreed after they saw the Salon of 1874 that if Mercié's group had not been present, Dubois's *Narcissus* (fig. 1.17), a work conceived in 1863,

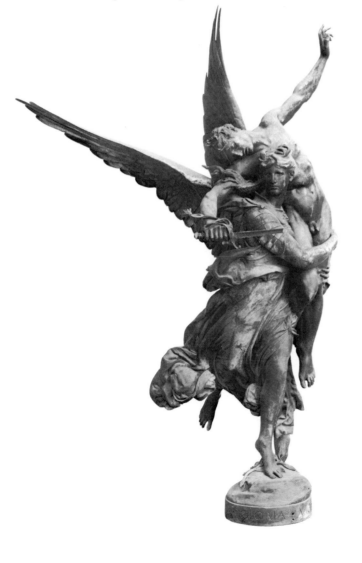

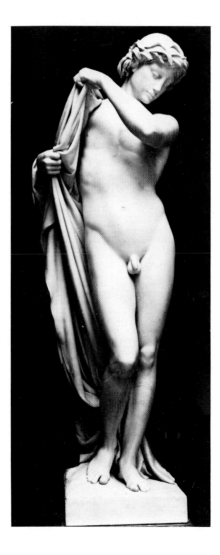

would have earned the Medal of Honor. They considered this male nude of a perfection seldom seen in modern times. *Narcissus's* elegant grace was such that a viewer could "believe that he [would] descend from his pedestal and on marble feet walk once again into the deepest grove of the sacred wood. . . ."[40]

1.18 Albert-Ernest Carrier-Belleuse. *Mlle. Croizette*, 1874. Terra cotta. Comédie-Française, Paris.

Critics also spent considerable time examining the large number of busts. Jean Rousseau's first visit to the Salon of 1874 gave him a migraine, but he did find pleasure in the busts, "especially of people I know, those capable of introducing one to a chef d'oeuvre of life and spirit and composition, busts such as *Mlle. Croizette* (fig. 1.18) by Carrier-Belleuse."[41] Not everyone agreed. Some found it vulgar, but La Croizette herself had just stunned Paris in her role in *La Sphinx* and no one could ignore her portrait. Carpeaux's bust of Alexandre Dumas (fig. 1.4) had a similar controversial success, alternately being found "mediocre, excessively rumpled, and superficial"[42] or a remarkably strong interpretation of one of the most lively personalities in Paris.[43]

1874 was Rodin's busiest year yet in Belgium. He was working on sculpture at the Royal Conservatory of Music and the Palace of Academies, both in Brussels, and on the Loos Monument in Antwerp. He showed his *Man with the Broken Nose* in Ghent and Brussels and the bust of his physician, Doctor Thiriar, also in Ghent. Some-

time during the winter, after his return from Antwerp, Rodin decided to aim for the Paris salon again the following spring.

When the salon opened its doors in 1875, the French people could say unequivocally, as they had not been able to do during the preceding three years, that they lived in a republic.[44] A safe time for the old republican, Castagnary, to complain about the lack of evidence of republican principles in the Fine Arts administration. He noted how artists continued to be divided into classes. The aristocracy was composed of members of the Institute and recipients of prizes. He counted 1,155 in 1875. In the plebeian class were thousands of artists with but one right—that of being turned down. It was the standard complaint, yet Castagnary himself admitted that the 2,484 artists who showed in 1875 constituted a broad representative group. And he was particularly satisfied with the sculptors.[45] So was Lafenestre, who walked around the Salon of 1875 imagining himself being able to address each artist in the show. The question he posed was always the same: "Are you sincere?" Too often the painters proposed old romantic literary solutions which apeared decadent and most insincere. But, "les esprits sincères" were readily at hand among the sculptors.[46]

In 1875, as in 1874, one work captured everyone's heart, including the jury's. This time it was a figure by Henri Chapu, *Youth* (fig. 1.19). The catalogue indicated that it was for a monument to be erected at the Ecole des Beaux-Arts to honor Henri Regnault and other students from the Ecole who had lost their lives in the war. Some found it not sufficiently funerary in atmosphere, but for most, Chapu's figure was a major statement, an allegory before which a person could "feel his emotions rise slowly, surely, without violence, in order that they might penetrate his entire being."[47]

Among the works in 1875 most often mentioned we find *Gloria Victis*, in bronze, once again an enormous success. Delaplanche's *Maternal Education* (fig. 1.20), the mother as powerful as a Sistine sibyl, appeared to make a serious statement about modern family life, and Falguière's *The Swiss People Welcoming the French Army* (fig. 1.21) was seen as so remarkable that "by itself it would implant 1875 in memory."[48] Then there was Frémiet's curiosity, *The Age of Stone* (fig. 1.22). People noticed it because of its unusual subject and because of the circumstances of its conception, which were reported in the press. Frémiet had resided in Poitiers when the city was under siege during the Franco-Prussian War and spent his time studying the arm bones and skull of a skeleton lent to him by the scientist Brouillet. They are the origin of *The Age of Stone* and he proudly inscribed

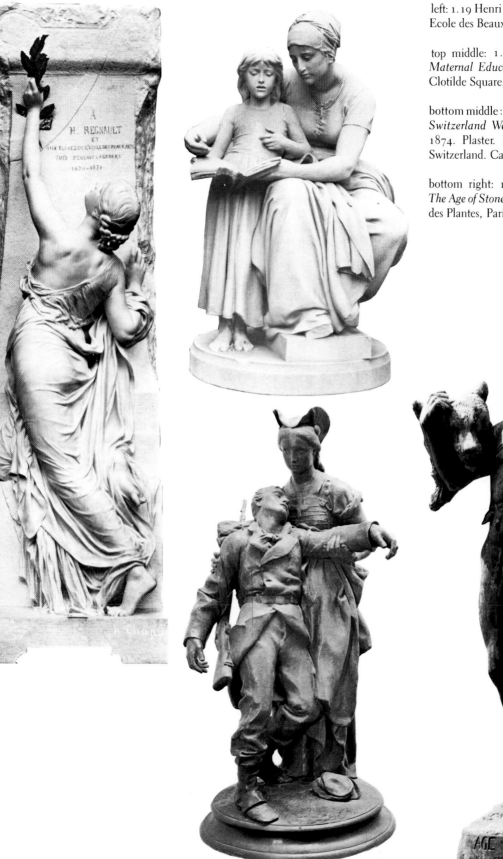

left: 1.19 Henri Chapu. *Youth*, 1875. Marble. Ecole des Beaux-Arts, Paris.

top middle: 1.20 Eugène Delaplanche. *Maternal Education*, 1875. Marble. Saint Clotilde Square, Paris.

bottom middle: 1.21 Alexandre Falguière. *Switzerland Welcoming the French Army*, 1874. Plaster. Military Clinic, Novaggio, Switzerland. Cat. no. 7.

bottom right: 1.22 Emmanuel Frémiet. *The Age of Stone*, 1872-1875. Bronze. Jardin des Plantes, Paris.

the base: "Skull and arms copied from relics of the period." Today the figure, placed at the intersection of paths in the Paris Zoo, has a wonderful ebullient narrative lightness to it, but to the audience of 1875, it was a genuine attempt at advancing modern understanding of primitive man.[49]

The Salon of 1875 also had its share of busts. People took note first of the men of distinction: Archbishop Darboy of Paris, killed as a hostage on 4 April 1871; Napoleon III; the sculptor Moitte; the painters Prud'hon and Henner; the encyclopedist Larousse; the architect Labrouste; writers Dumas *père* and Balzac; Fine Arts administrator Edmund Turquet; politicians and military men; and, of course, Rodin's businessman M. Garnier.

1.23 Jean-Baptiste Carpeaux. *Mme. Alexandre Dumas*, 1873-1875. Plaster. Musée du Louvre, Paris.

Paul Leroi wrote his first review for *L'Art*, the important new journal of which he was editor, on the Salon of 1875. In discussing the sculpture, he moved quickly to the portraits. His favorites were Carpeaux's spectacular busts of Bruno Chérier (fig. 1.5) and of the wife of Alexandre Dumas *fils* (fig. 1.23). He found *Mme. Alexandre Dumas* "neither young nor pretty, but . . . intelligent and . . .spirit[ed], allurements that are not transitory. Another artist would have hesitated before such a problem." Leroi thought only the great Carpeaux capable of fashioning a portrait that was both stylish and a true resemblance. "Carpeaux's manner is one of accomplished French virtuosity; no one has continued so gloriously the elegant and powerful tradition of our eighteenth-century masters."[50] Leroi's review must have

given solace to Carpeaux, who was in Courbevoie dying of cancer and who probably never saw the Salon of 1875. He was estranged from his family and friends, including the Dumas with whom he had been close until the previous year. Bruno Chérier was one of the few friends who remained. In celebration of their friendship, they had each entered a portrait of the other in the Salon of 1875. The jury refused Chérier's painting. When Carpeaux learned of this he wrote: "I cried when I read your letter, Refused! Am I to believe this? Is it possible? I have never heard of such an injustice. But it is not your work that they have refused. It is I. . . ."[51]

This then was the situation when Rodin first showed in the Paris salon: France had clearly settled into her new republican form, sculpture was widely acknowledged as a democratic art eminently able to satisfy both patriotic and personal needs; and France's greatest modern sculptor, J. B. Carpeaux, was to present his final exhibition in 1875.

Rodin went to Paris for the Salon of 1875, but it is doubtful that he returned in 1876. He was too busy—not only was he working on "his figure," but also he was preparing eight works for shipment to the Belgian exhibition at the American Centennial in Philadelphia, and he was working on an entry for the Lord Byron competition, a monument proposed for London's Green Park.

Rodin would have relied upon reviews in order to learn about the Salon of 1876. Since he intended that his work would be there in 1877, he probably read them quite closely. As he told the young sculptors with whom he worked in Van Rasbourg's atelier: "An artist needs only one good work in order to establish his reputation."[52]

The general tone of the reviews continued to be encouraging. Charles Beaurin opened his article about the Salon of 1876 hailing art as the most precious flower in human society, and "sculpture before all others. . . . If Art is a Priesthood, let sculpture be its first trustee. Sculpture surpasses architecture for it is an art without utilitarian role."[53] What a change from Baudelaire's views in 1846!

As critics focused on sculpture, the basic issues were discussed ever more vigorously. And, surprising as it may seem today, nothing was more basic to sculpture than the clothing issue. Should a sculptured figure be nude or clothed? If clothed, how? Posing these questions brings into view the whole scheme of the classic/romantic opposition. Many aspects of that controversy were argued in the reviews of the Salons of 1876 and 1877 when two important over-life-size figures were on exhibition. Rodin must have thought back to them when he faced the

1.25 *Lamartine*.

1.24 Alexandre Falguière. *Lamartine*,
1876-1877. Bronze. Mâcon.

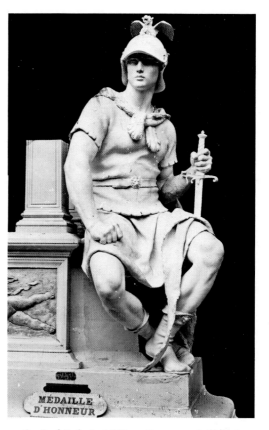

1.26 Paul Dubois. *Military Courage*, 1876. Plaster.
Musée des Beaux-Arts, Angers.

problem of creating public monuments dedicated to
individuals after he received commissions for the *Victor
Hugo Monument* and the *Balzac Monument*.

Falguière showed *Lamartine* (figs. 1.24 and 1.25)
dressed in a heavy greatcoat blowing in the wind. His
booted stance is that of a man of action, but he holds a
book in his hand as we might expect of a poet. Beaurin
felt Falguière had missed the point: "By means of a
sudden wind stirring the coat I believe [he] wishes to
represent inspiration [but] . . . in truth the dominant
aspect of the great poet and eminent philosopher was
that of meditation." As Beaurin concluded his description
of *Lamartine* he moved on to a larger issue: "Being above
all the art form that represents life, sculptured figures
ought to be nude, they ought to tell the truth of the
organic model, the reality of the epidermis. Complete
nudity is not necessary, but there should be at least
partial nudity."[54] He knew that contemporary figures
could not be represented nude and admitted that good
subjects for nude statues were hard to find. He felt
probably the answer lay in allegory. At this point Beaurin
moved to discuss the most popular figures in the Salon
of 1876, which were indeed allegories: Paul Dubois's
Military Courage (fig. 1.26) and *Charity* (fig. 1.27). But
neither was nude, so he preferred Mercié's *David before*

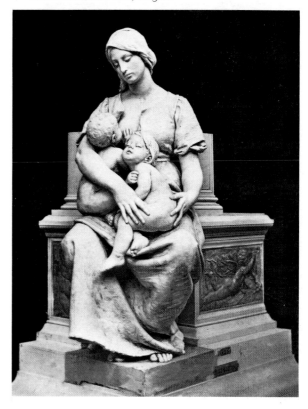

1.27 Paul Dubois. *Charity*, 1876. Plaster. Musée des Beaux-
Arts, Troyes.

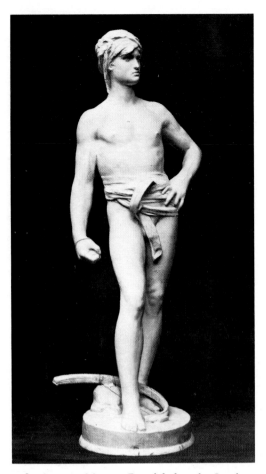

1.28 Antonin Mercié. *David before the Combat*, 1876. Plaster. Location unknown. Photo, Bibliothèque Nationale.

1.29 Henri Chapu. *Alexandre Dumas père*, 1876. Marble. Comédie-Française, Paris. Cat. no. 17.

1.30 Aristide Onesyme Croisy. *Paolo Malatesta and Francesca da Rimini*, 1876. Plaster. Musées de Charleville-Mézières. Cat. no. 26.

the Combat (fig. 1.28). As in his first *David*, Mercié sought to create the epitome of a beautiful male figure, but now more vigorous and alive. Although the work was only a statuette, Mercié realized a figure of true grandeur and monumentality. For Beaurin this was a chef d'oeuvre in every sense. The only work of comparable quality he could find at the Salon of 1876 was Chapu's bust of Alexandre Dumas *père* (fig. 1.29). We cannot disagree. Chapu's *Alexandre Dumas* is one of the great portraits of the nineteenth century—monumental and solid, yet moving and vigorous—giving us a frank view of the wily sensualist whose double heritage from an aristocratic Frenchman and a black woman plays across his vivid face.

One more work to mention from the Salon of 1876 is Aristide Croisy's *Paolo Malatesta and Francesca da Rimini* (fig. 1.30). The catalogue quoted the relevant passage from canto 5 of Dante's *Inferno*: "One day, for pastime, we read of Lancelot, how love constrained him; we were alone, suspecting nothing. Several times that reading urged our eyes to meet and took the color from

our faces. . . ." Croisy presented his Italian lovers in medieval dress, moving toward one another and leaning over their book. It is a delicately formed work, but critics took no notice. Rodin, however, must have thought about it when examining the catalogue, if only for its theme, for by this time he was reading Dante with much attention and was at work on a figure of his own inspired by the *Inferno*—his first *Ugolino*.

Rodin probably worked more hours on the single figure we know as *The Age of Bronze* than he did on any other statue he ever created. Auguste Neyt has given an account of their sessions together: "Rodin did not want any exaggerated muscle, he wanted naturalness. I worked two, three, and even four hours a day and sometimes an hour at a stretch. Rodin was very pleased and would encourage me by saying: 'just a little longer.' "[55] Yet it did not come easily; Rodin spoke of his deep "despair about that figure," saying, "I worked so intensely on it, trying to get what I wanted, that there are at least four figures in it."[56] We cannot know the four figures with any precision, but we can consider the stages of work in the sculpture and how its appearance must have changed as it developed. We know that Rodin was working on the figure in 1875 before he left for Italy. When he arrived there he found an ancient statue of Apollo "with a leg in exactly the same pose as that of the figure on which I had spent months of labor."[57] Rodin's primary purpose in going to Italy was not to study antiquity, however, but to learn from Michelangelo. Later he wrote, "It was Michelangelo who called me to Italy, it was he who gave me the most precious insights . . .,"[58] and it was Michelangelo who "liberated me from academicism. . . ."[59] The work by Michelangelo which Rodin's figure most nearly parallels is the *Dying Slave* (figs. 1.31 and 1.32). Both are dependent on a classically derived contrapposto system, and they share the gesture of the raised arm with a hand placed upon the head. But the actual body type of Rodin's figure is different from anything we find in the sixteenth-century artist's work. This agile, moving, slender young body, with its numerous subtle transitions, is more naturalistic than Michelangelo's *Slave*. The figure it most resembles is the warrior in Mercié's *Gloria Victis* (fig. 1.33), a work in which Mercié was also rethinking a famous sixteenth-century Italian model— Giovanni da Bologna's *Rape of the Sabine Women*. Both the warrior and Rodin's figure have a vigorously observed anatomy, long limbs and neck, and graceful motion in their arms moving away from their bodies.

It is not surprising to find Rodin's figure more intimately linked with this brilliant new work. *Gloria Victis* was undoubtedly the most successful sculpture created

1.31 Michelangelo. *Dying Slave*, 1513. Marble. Musée du Louvre, Paris.

1.32 *The Age of Bronze*, 1875-1877. Bronze. Albright-Knox Art Gallery, Buffalo. Cat. no. 21, different cast.

1.33 Antonin Mercié. *Gloria Victis* (detail), 1872-1875. Bronze. Musée du Petit-Palais. Cat. no. 11.

in France since Rodin had left his homeland, and he began his own figure shortly after seeing it in bronze at the Salon of 1875. Rodin's figure type, his subject, as well as his chosen title, "Le Vaincu," all reveal a debt to Mercié.

A standing warrior, holding a spear at the moment in which he tries to grasp the meaning of defeat—this was the figure Rodin had ready to show to the public in Brussels in late 1876. But before he put it on view he removed the spear. In doing so he turned it into a new figure. He acted in order to achieve another look, one that would enable the viewer to read the profiles better. This became a characteristic approach for Rodin—taking something away, removing part of the logic—thus creating a more daring visual experience and opening the work to wider interpretation. For a twentieth-century audience the psychological implications of a work suggesting ambivalence and permitting more than one interpretation are compelling. For a nineteenth-century audience it presented major difficulties. The way the figure holds his head, parts his lips, slowly closes the fingers of his left hand, while moving toward the right, all lead us to consider questions about the nature of suffering and about man's inner life. Such a presentation was both powerful and unusual for the audience of the 1870s. In the first review to appear after Le Vaincu went on exhibition, a critic stated: "We simply wanted to bring the figure of a man in which the state of physical and moral collapse has been so expressively portrayed, to your attention. Without having any indication other than the work itself, it seems to us that the artist wished to represent a man on the verge of suicide."[60] Another indicated that "naturally there are questions, even strong criticism: What is the meaning of the half-closed eyes and the raised hand? Can this be the statue of a sleep-walker?" The critics found uncertainty worth grappling with, however, because they saw that the figure was not ordinary: "If it initially attracts attention by its oddness, it holds it by a quality that is as rare as it is precious: life." Jean Rousseau thought it "very beautiful and extraordinarily original. This is realism, a realism that comes directly from the Greeks. . . ."[61]

Rodin was affected by the criticism, yet he did not want to compromise his figure, so he tried to fix it by changing the title. He sent it to Paris as The Age of Bronze. It was an ingenious solution, for it placed the work within the familiar context of the four ages of man. The Bronze Age was the third stage of man's development as he descended from the Golden Age. During the Bronze Age injustice entered the world and men began to war with one another, yet it was not a time of crime

and vice such as that which occurred during the Iron Age (a subject treated by Lanson in the Salon of 1882). So part of the original sense of Rodin's work, that of a human being awakening to loss resulting from war, was still included by the new title. But it did not help. The Parisian critics had read the Belgian critics; they already knew there were issues that did not favor Rodin's figure.

What kind of context did the Salon of 1877 provide for The Age of Bronze? Like the Salon of 1876, it was not as overtly political as those of 1872 and 1874. France was moving toward a more stable, moderate republican government. As she did so, nationalistic statements like Gloria Victis were less in order. The reviewer for the Gazette des Beaux-Arts even greeted the final marble version of Cabet's Mil-huit-cent-soixante-et-onze in the Salon of 1877 in a critical fashion: "Can it really be a year that cries over a tomb? A year cannot know such profound sorrow," and he mistakenly called it "Année 1872."[62] France now looked to the future, specifically to the Universal Exhibition of 1878, which would mark the nation's recovery and the time when she would demonstrate her new conciliatory policy toward Germany.

Again critics pressed the cause of sculpture. They indicated that painting fell more and more into the role of amusing the crowds. Sculpture alone combined beautiful forms and noble thoughts. Even more important, sculpture was thought to be "more French." "What we want, what we demand at the present time, are modern ideas, expressed as clearly as possible through the use of French forms. It is precisely this character that invades modern sculpture. This spirit bursts forth at the Salon of 1877. It is a particularly French salon."[63]

Dominating the sculpture section of the salon were statues of great men. If we look at a view of the left side of the gallery (fig. 1.34), we see Jouffroy's St. Bernard in marble. It had been commissioned by the Ministry of Fine Arts for St.-Geneviève (the Panthéon), a fact that made Castagnary sputter with disbelief: what was a republican government doing commissioning and paying for Christian saints to be placed in a public building? In the center of the gallery we see Félix Martin's bronze group of L'Abbé de l'Epée and a deaf-mute learning how to sign the name of God, and to the far right we see Chapu's statue of the lawyer, Berryer. It was already in marble, soon to be completed by allegorical figures of Fidelity and Eloquence for the Universal Exhibition before being installed at the Palais de Justice. Dominating the right-hand side was Falguière's Lamartine (fig. 1.35), now completed in bronze. Critics invariably compared the two statues of great modern figures known to all who

1.34 Left side of the Salon of 1877.

1.35 Right side of the Salon of 1877.

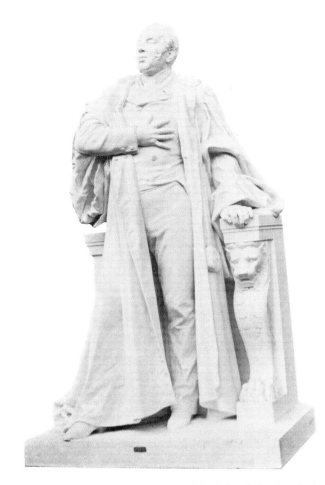

1.36 Henri Chapu. *Berryer*, 1877. Marble. Palais de Justice, Paris.

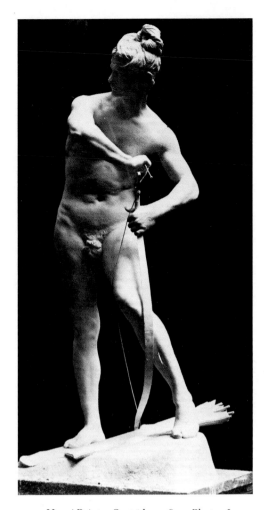

1.37 Henri Peinte. *Sarpédon*, 1877. Plaster. Location unknown.

visited the salon. Most found *Lamartine* to be less successful: "Where is the dreamer poet, the Homer of our century?"[64] "There are a number of things that cannot be explained here. Is it the poet or is it the orator that the artist wanted to represent? . . . Why does the wind blow the coat with so much force? Is it that the artist wished to portray storms in public squares?"[65] They preferred *Berryer* (fig. 1.36), stating that Chapu had successfully captured his prowess as thinker and as orator. The judges agreed, awarding it the Medal of Honor.

The standard of judgment for critics and visitors to the salon was primarily based on matching—matching the realization of an idea to the original choice of subject. Subject was always the first consideration, and whether it was a contemporary figure, an historical personality, a mythological being, or an allegorical image, the process of matching remained constant.

The most impressive life-size male nudes in the Salon of 1877 were both in plaster: Rodin's *The Age of Bronze* and Henri Peinte's *Sarpédon* (fig. 1.37). Both artists had concentrated on careful study of the nude, developing

their figures through unusual poses. The public understood better why Peinte's statue was so daring, for he had represented Homer's exotic King of Lycia, a subject rarely seen in the sculpture section of the salon. But as to *The Age of Bronze*, it was less clear: "Why 'The Age Bronze'? M. Rodin wanted to symbolize the trials of war. But he forgot to give his statue an attribute that would make the meaning clear," complained Charles Tardieu in *L'Art*. Tardieu also pointed out that Rodin was "extraordinarily preoccupied with life, and that is a great deal."[66] Charles Timbal in the *Gazette des Beaux-Arts* was briefer and more dismissive, summing up his thoughts on *The Age of Bronze* by saying, ". . . let us accept it for what it is: a curious atelier study with a very pretentious name."[67]

Only a small percentage of the hundreds of works shown annually were ever mentioned in reviews and Rodin's work had been discussed in two of the leading art journals of Paris. Even so he was not pleased. Every

reference to his figure, in Brussels as well as Paris, had used one word that made him sick at heart. They said his statue might be a "cast," that "this work, so remarkably real, [bears] within it the traces of a cast from life."[68] Casting from life was not unusual among nineteenth-century sculptors and when a life-size figure was particularly realistic this was an easy conjecture. Critics had said the same thing about Mercié's *David* in 1872. Mercié ignored the comments. Rodin could not. It took three years to have the stigma removed from his statue. In the process he contacted a number of officials and many sculptors, including Chapu, Delaplanche, Dubois and Falguière, all of whom came to his studio to examine the statue. His efforts won him attention, sympathy, and ultimately the most important commission of his life, the doors for the new Museum of Decorative Arts.

The spring of 1877 introduced excitement and frustration on a new level of intensity into Rodin's life. Once the salon closed its doors, Rodin turned to practical matters: moving back to Paris, locating a studio, and finding work. Again he looked for employers who could put his talents to work on decorative sculpture. One of them was Eugène Legrain, who had a contract for work on the exterior of the Trocadéro Palace, the neo-oriental extravaganza being built for the Universal Exhibition.

Universal exhibitions provide nations with the opportunity to make some sort of summary statement about their place in the universe. In 1878 France created a festival of the Third Republic. It marked the beginning of a new era of peace, a triumph for the regenerated French economy, and a recognition of the formidable contributions made by French industry and French art. In the visual arts it was *the* exhibition of sculpture. Anatole de Montaiglon wrote: "French sculpture is stronger than painting; it is better than every other school of sculpture; its primacy cannot be put in jeopardy." He recognized French painting as having been great in fits and starts, depending upon who was the leading master of a particular time, but sculpture was different, for it was "ancient, well-founded, constant and durable. At every moment there have been masters and real works. There have been no gaps or failures in the history of our sculpture."[69]

In 1878 Castagnary told his readers that several days before he had gone to see the Salon of 1878 and made a parody on Dante in saying "Lasciate ogni speranza, poveri pittori." When he said it he had no idea how dramatic a statement it was, for he had not yet heard that the jury was to give *both* medals of honor to sculptors that year. He was so appalled he felt the need to review the entire history of the double medal of honor for the

salons. It began in 1864 because sculpture, being inferior to painting, had no chance. The administration thought this would be the way to help sculptors. Now they took everything. It was a violation and a dangerous precedent.[70]

One of the medals went to Delaplanche for his *Virgin of the Lily*, a "gracious" work, the ultimate "personification of chastity," "elegant and noble," but there was so little enthusiasm about it that not a single major journal devoted an illustration to it—very unusual for a medal of honor recipient. Everyone turned his attention to the other winner, Barrias's *First Funeral* (fig. 1.38). The theme of this work—man's first confrontation with death—fascinated people. Critics had the usual reservations about its being too complicated, and they found Adam too common, too contemporary to represent the father of all humanity, but the idea was superb. Barrias was hailed a "thinker, philosopher, poet" for conceiving "the first of our race" in such a fashion.[71] Barrias's group was invariably linked to another in the Salon of 1878—*Paradise Lost* by Gautherin, in which Eve crouches

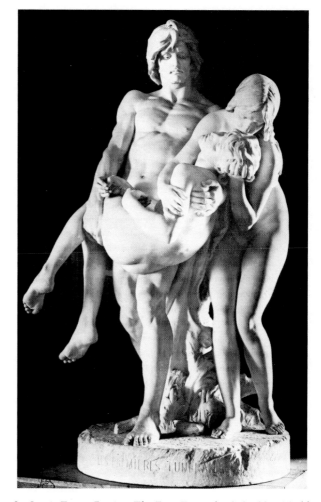

1.38 Louis-Ernest Barrias. *The First Funeral*, 1878-1883. Marble. Hospital of Saint Anne, Paris.

left: 1.39 *Man with the Broken Nose*, 1863-1875. Bronze. Philadelphia Museum of Art. Cat. no. 20, plaster.

middle 1.40 Attributed to Daniele da Volterra. *Portrait of Michelangelo*, mid-16th century. Bronze. Musée du Louvre, Paris.

right: 1.41 Truman Bartlett. *Abraham Lincoln*, 1878. Bronze. Louis A. Warren Lincoln Library and Museum, Fort Wayne, Indiana. Cat. no. 27.

against the body of her mate, hiding, unable to fathom the judgment that has befallen her. Many people liked it better than the Barrias group. It was purer and more elegant in form, its subject matter just as probing and serious.

Rodin's entry in the Salon of 1878 was a bronze cast of the *Man with the Broken Nose*, indicated in the catalogue as "Portrait of M***" (fig. 1.39). It struck many people as being similar to a head most of them had just seen at the Universal Exhibition in a show of Italian sculpture from private collections: the sixteenth-century portrait of Michelangelo (fig. 1.40). Eugène Véron wrote: "This head . . . bears a resemblance to *Michelangelo* because the nose of Buonarotti, which was broken by Torrigiani, is identical to that of *M****, as are the forehead and features of the great genius of Florence. There is thought and nobility in this beautiful head; it is not in vain that a person bears a resemblance to a great man."[72] If we think about Bibi and Rodin's desire to capture the features of a humble workman, we understand the degree of transformation that was taking place. The coincidence of looking like *Michelangelo* was part of the process.

Viewers noticed another work in the Salon of 1878 on the basis of resemblance—in this case to a man rather than to a sculpture. It was a statuette by Rodin's future friend, the American sculptor, Truman Bartlett. He

exhibited a plaster figure of Abraham Lincoln (fig. 1.41), which the French liked because they liked Lincoln. They knew him as a true republican.

The important enterprise in Rodin's life in 1878, however, was his new figure, *St. John the Baptist*. The earliest description of how the statue came about is in Bartlett's articles: ". . . he wanted justice. Satisfied that it was impossible for the present to get it for 'The Age of Brass' [*sic*], he thought that the only way by which he could get it for himself was to make another statue, this time larger than life. . . . Selecting the subject of 'St. John Preaching,' he began a sketch. . . ."[73] We probably should accept Bartlett's statement literally. Rodin surely

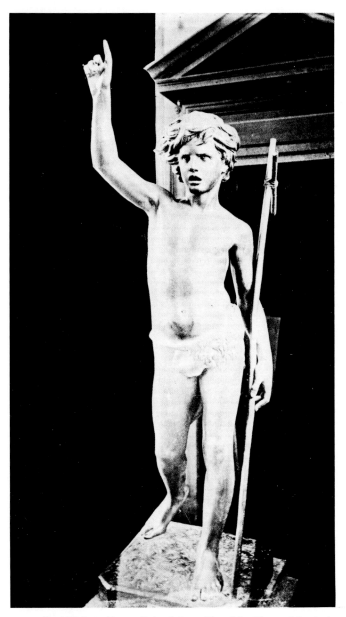

1.42 Paul Dubois. *Young Saint John*, 1861-1863. Plaster. Musée de Troyes.

did not want to lose his critics a second time because of subject matter. He chose to do a St. John, one of the most familiar Biblical figures in contemporary salons. In 1878, in fact, there were three representations of John the Baptist in the sculpture section, the most successful, an adolescent figure in marble by Jules Lafrance. Audiences of the period loved this Giovannino in the tradition of Donatello and his followers—a thin nervous mystic immersed at an early age in his restless penitential struggle. Paul Dubois had set the tone with his *Young Saint John* (fig. 1.42) which had been in the Salons of 1863 and 1864. In it he reconsidered the Renaissance prototypes, phrasing his figure as dramatically as he

possibly could. The body is classically beautiful, but the vigorous gesture, the transfixed eyes, the cry emanating from the mouth, the hair blown by a desert wind, all convey the passion of John's prophetic knowledge with which, according to tradition, he was endowed even in his youth.

Rodin worked along more traditional lines with a mature St. John. He stated that he intended to make a figure "larger than life." An older St. John lent itself better to this goal, and besides, adolescence never appealed much to Rodin.[74] Renaissance sculpture provided as many prototypes for an adult John the Baptist as it had for the young St. John. There were statues by Donatello, Luca della Robbia, Michelozzo, and Rustici, all showing a hoary bearded John dressed in camel skin, gesturing with his right hand.

Before considering Rodin's approach, we might reflect for a moment on what his ideas would have been about the subject. In the 1860s Ernest Renan had published an enthusiastic account of John's sermons, noting especially their severity and sharpness, and in 1877 Flaubert published "Herodias," which contained a wonderful description:"His eyes blazed; his voice roared; he raised his arms, as if to bring down the thunder!"[75] Recently a scholar has suggested that St. John was the unacknowledged patron of avant-garde artists in the late nineteenth century because he was the eternal outsider, the disreputable one setting out to preach a message too difficult for most people to understand.[76] St. John was an excellent choice for Rodin's second salon figure. The selection was traditional but implied no compromise.

Rodin's choice of model was as significant for him as was his choice of subject. No element so distinguished his work from that of his contemporaries as did his emphasis on naturalism. Just as he had in 1875, he chose a model with no previous experience. Throughout his life Rodin preferred working with people who had not learned the classic poses of sculpture. In this case he found a forty-two-year-old peasant from the Abruzzi whose name was Pignatelli. There is some uncertainty as to when Pignatelli started to work for Rodin—whether before or after he had decided upon his subject. The first time Bartlett mentions the figure is in a March article in which he states that Rodin has selected the subject and begun a sketch. Three months later, in June, Bartlett seemingly contradicts his earlier report, saying: "The origin of the St. John is interesting as an illustration of the simplicity of the workings of the artist's mind on this occasion. When the model had taken off his garments, he assumed of himself a position natural to him. This position suggested to the sculptor the subject of *St. John*;

1.43 *St. John the Baptist Preaching*, 1880. Pen and ink. Grenville Winthrop Bequest, Fogg Art Museum, Cambridge, Mass. Cat. no. 22, bronze.

1.44 *Torso*, 1878. Bronze. Musée du Petit Palais, Paris. Cat. no. 358.

1.45 *St. John*, 1878. Plaster. Musée Rodin, Meudon.

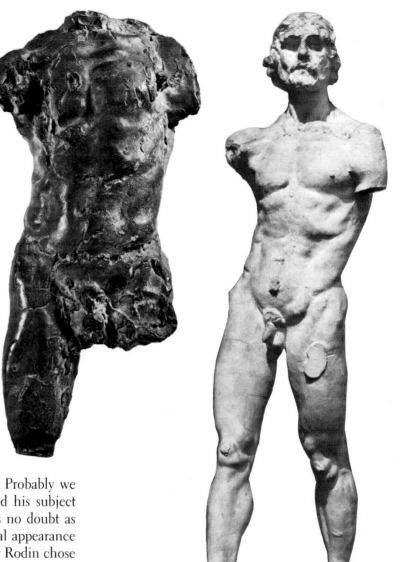

he emphasized it and made the statue."[77] Probably we shall never know whether Rodin identified his subject before or after he met Pignatelli. There is no doubt as to the importance of the model for the final appearance of the statue; there is equally no doubt that Rodin chose the subject in a specific way. It appears Rodin even considered putting a cross in John's left hand, as we see in a drawing executed after the statue's completion (fig. 1.43). And Bénédite reported that "the *Saint John* carried a cross on his left shoulder which gave emphasis to the shoulder in that it supported the thin shaft. Fortunately it was done away with in the bronze."[78]

Rodin said he worked so hard on *The Age of Bronze* that there were at least four figures in it. He could have said the same thing of *St. John the Baptist Preaching*. With the second figure at least we know something of the stages. First we have the *Torso* (fig. 1.44).[79] Pitted, broken, and reworked, it gives us a fascinating view of Rodin's struggle to achieve a close approximation to nature. Next there is the half-life-size study, lacking only its arms, presumably the one to which Bartlett referred (fig. 1.45).[80] Sometime in 1878, probably late in the year, Rodin decided to develop the head (fig. 1.46) as a separate bust (fig. 1.47)[81] which was exhibited in the

Salon of 1879 (fig. 1.48). For it Rodin received an Honorable Mention. It was his first salon recognition. Véron liked this head, he favored the way it was "raised, showing the Precursor preaching strongly. His eyes are filled with faith and he dominates those who follow him, and with his open mouth he eloquently proclaims the coming of the Messiah."[82]

Véron also liked Rodin's second entry in 1879. He found *Mme. A.C.* (fig. 1.49) "beautifully coiffed and dressed, with her mouth open in a way that gives to her an air of ecstasy. This lovely terra cotta makes a wonderful

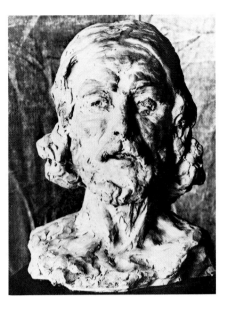

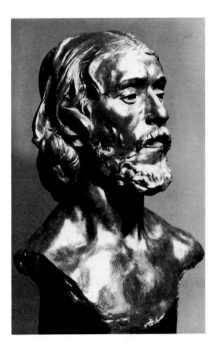

top left: 1.46 *Head of St. John*, 1878. Plaster. Musée Rodin, Meudon. Cat. nos. 65, 66, 80.

top middle: 1.47 *Head of St. John*, 1878. Terracotta? Location unknown. Photo, Bibliothèque Nationale.

top right: 1.48 *Head of St. John*, 1878. Bronze. Musée Rodin, Paris.

left: 1.49 *Mme. A.C.*, 1879. Terra cotta. Musée Rodin, Paris.

1.50 René de Saint-Marceaux. *Genius Guarding the Secret of the Tomb*, 1879. Plaster. Musée du Louvre, Paris.

impression." Véron was right. This highly successful bust, which Rodin executed in a style reminiscent of Carpeaux, is an excellent work. It comes as a welcome surprise for, with the exception of Rodin's bust of Rose Beuret from the late 1860s, he had not created a feminine portrayal of real character until this one.

Aside from Véron, no one paid any attention to Rodin's busts in 1879, in spite of the Honorable Mention. The critics applauded the usual stars: Chapu, Falguière, Dubois, and Mercié. The man who had the biggest success in 1879, however, was a sculptor seldom mentioned before, although he had begun his career ten years earlier with a figure of *The Young Dante*. In 1879 Saint-Marceaux showed his *Genius Guarding the Secret of the Tomb* (fig. 1.50), a pastiche of Michelangelo's nude

youths on the Sistine Ceiling, which pleased contemporary audiences enormously: ". . . let him add Michelangelo's name to Jouffroy's in the catalogue of his master," suggested the critic for the *Gazette des Beaux-Arts*.[83]

Critics were changing their tone in 1879; enthusiasm for sculpture was on the wane. Even a die-hard enthusiast like Véron began his review by indicating that "For many years sculpture at the salon has been superior to painting. Today the roles have changed; sculpture takes second place."[84] Avant-garde writer J.-K. Huysmans looked at the whole show, not just the sculpture, and said that it was all "train-train," his expression for anyone who had been schooled in the Beaux-Arts tradition. He thought the naturalists (the impressionists) were the only artists creating real works of art. And there were wonderful new things from architects and engineers—railroad stations, markets, the new hippodrome. He also rated new music very high, but two of the arts were stuck: poetry and sculpture. Of sculpture he said: "There are only two possibilities: it can become part of modern life or it can't. If it can, then let it take up real subjects and we shall at least know where we are. And if it can't—well! . . . it's better not to crowd the salons with those productions."[85]

Huysmans had something else to say that accounts for a changing atmosphere; in his review of the Salon of 1879, he wrote, "I find patriotism to be a negative quality in art."[86] The post-war period was drawing to a close. France was strong again and the reconciliation with Germany under way. Yet the memory of what was past had not totally disappeared. In the spring of 1879 the Préfecture de la Seine outlined the program for the major Parisian monument dedicated to those who lost their lives fighting the Prussians. Rodin entered the competition with a powerful allegorical group depicting death and outrage (fig. 1.51). Such a passionate statement, though, reminiscent of both Mercié's *Gloria Victis* and Rude's *Marseillaise*, was not in order in the new climate of moderation and peace. Rodin's group was not considered among the finalists. The jury chose one submitted by Barrias in which a contemporary maiden, wearing a miniature city wall for a crown and a National Guard coat to cover her classical gown, stands serenely, while a tattered Parisian boy sits at her feet holding a musket. The runners-up were groups by Moreau and Lequien, showing warriors who were alive and able to return to the fight.

The "Monument to the Defense of Paris" was not the only patriotic competition that Rodin entered in 1879. He was one of the seventy-seven sculptors to create a bust of the Republic for the new *mairie* of the 13ᵉ

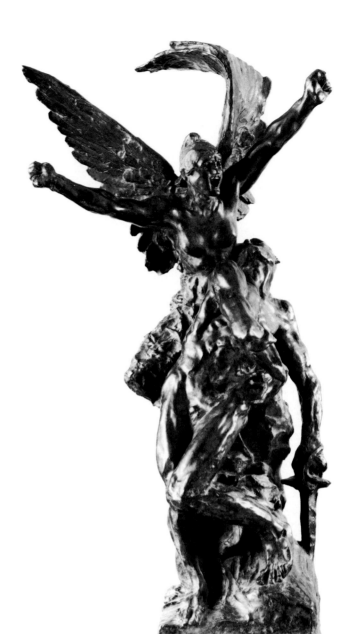

1.51 *The Call to Arms*, 1879. Bronze. Musée Rodin, Paris. Cat. no. 23.

arrondissement. Again he miscalculated. His entry was stern (fig. 1.52); everyone wanted something pleasant: "No, it is certainly not here that we find our amiable Republic," remarked one of the critics when he saw Rodin's head during the competition showing at the Ecole des Beaux-Arts.[87]

Rodin's political instinct did go into operation, however, when it came to fostering personal relations with administrators and the press. When he returned to France in 1877, the Director of the Beaux-Arts administration was the Marquis de Chennevières. Rodin attempted to enlist his aid in the cause of *The Age of Bronze*. This

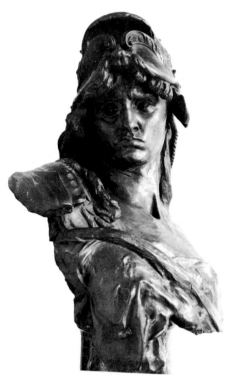

1.52 *Bellona*, 1879. Bronze. Musée Rodin, Paris. Cat. no. 24, different cast.

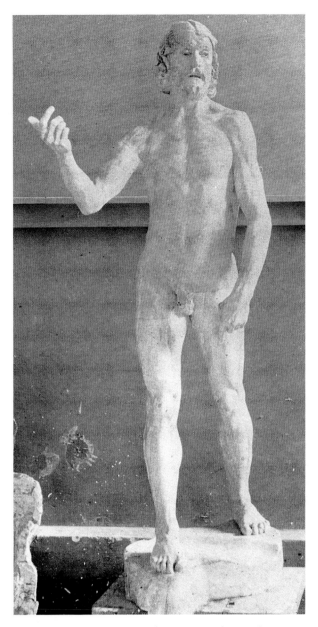

1.53 *St. John the Baptist Preaching*, 1878. Plaster. Photo Braun? Cat. no. 22, bronze.

effort yielded nothing. Chennevières resigned after a controversy surrounding the Fine Arts section of the Universal Exhibition and in February 1879 Edmund Turquet took over. He was an outspoken republican, a man often viewed as headstrong and impetuous, one who was immediately embroiled in conflicts with both artists and bureaucrats over the Salon of 1879.[88] Rodin must have known Turquet could be difficult, but no matter, he also knew that the administrator admired *The Age of Bronze*. When Turquet came into office, Rodin finally had "a friend in court," as Bartlett put it. Rodin requested a meeting early in 1880. After their meeting, he wrote Turquet a long letter in which he reviewed all the difficulties he had experienced with *The Age of Bronze* and in which he also mentioned his new *St. John*. He closed by thanking Turquet "from the bottom of my heart for the friendly welcome I received from you; I always hoped that one day a liberal minister would come to office and do me justice. Entirely devoted to my work, I did not know that what I hoped for was so close."[89] The state purchased the plaster of *The Age of Bronze* and had it cast for the Salon of 1880.

When he was not working on his competition projects in 1879, Rodin was preparing his *St. John the Baptist Preaching* for the Salon of 1880. He focused on three areas of the figure as he transformed his study into an over-life-size figure (fig. 1.53). All three changes enriched the expressive content of the figure, enhancing the image of St. John as the herald of a new dispensation: the head, the forward movement of the legs, and the position of the arms and the hands. The head, which did so much to create the *look* of the Precursor, with its distantly-focused eyes under heavy lids, its open mouth, its beard and mustache, was now more defined and had a greater surface richness. When Rodin placed this new head on the torso, he turned it to increase the tension between body and head; the sense of there being a direction toward which John looked thus took on additional force.

Then Rodin changed the relationship of the legs to the torso, tilting the torso forward. Finally he raised the right arm away from the firm triangle of the body that it might slash through the air. In the tradition of "he who points the way," the index finger is separated from the rest of the fingers. From Rustici's sixteenth-century John the Baptist on the Florentine Baptistery[90] to Dubois's figure in the Salon of 1863, the isolated finger is John's gesture. Rodin went further. He repeated the gesture, showing the left hand pointing to the walking legs. Here the path taken by the messenger becomes as important as the message he bears. This new interpretation appears to have autobiographical overtones. Bartlett did, indeed, believe that Rodin was saying something about himself in both his early statues: "If *The Age of Brass* [sic] is the sculptor himself concealed in the figure of a young warrior waking from the half-sleep of unknown strength, in the *St. John* he is fully manifest as the matured chieftain heralding the coming of a new and reviving force in art."[91]

Rodin's work at the Salon of 1880 looked strong, and, in fact, he won a third-class medal for *The Age of Bronze*. The criticism was another matter. The reviewer for *Le Soir* pointed out that *St. John*'s body was out of kilter due to a "defective left leg." He felt there was not enough flesh on the figure's muscles, while the physique of *The Age of Bronze* was "too flabby."[92] The critic for *Le Figaro* stated that "*St. John Preaching* is the worst-built man in the world."[93] A conservative critic, Frédéric de Syène, wrote the best review. After seeing Rodin's figures in the Salon of 1880, he indicated that he expected new tendencies and true originality to issue from Rodin's future work.[94]

What would have been Rodin's sense of his career while the Salon of 1880 was in progress? Perhaps we can gain some insight about that from a letter written to him by one of his closest friends, Gustave Biot, a Belgian engraver, on June fourth: "Yesterday evening news came of your success; we drank to your health. Everyone was there including Lieutenant Herrier, who was enchanted with the good news and asked me to add his congratulations. . . . I suppose you should have done better than a third-class medal, nevertheless, you must be content. . . ." Biot ended his letter by saying, ". . . so, dear friend, finally things go better and better, and I have no doubt that is the way they will continue."[95]

Actually what most engaged Rodin's imagination in these months was not the salon as much as a potential commission. He had known since the beginning of the year that the state was planning a monumental bronze door for the entrance of the future Museum of Decorative

Arts. Maurice Haquette, a friend and colleague at the Sèvres porcelain factory, who happened to be Edmund Turquet's brother-in-law, had been encouraging Rodin to try to secure the commission. Perhaps the door was even the real reason Rodin began to court Turquet in January. Biot wrote Rodin a second letter in June, saying: "Enclosed you will find the letter you have asked of me for M. Turquet. You may show it to his brother-in-law as well. If the reaction has not been good, this letter ought to change it."[96] Biot's letter clearly recommended that Rodin receive the commission. Although the official decision was not made public until August sixteenth, by July Rodin knew the commission was his, and he had moved into what was to become one of the world's most famous ateliers—Studio M at the Dépôt des Marbres, 182, rue de l'Université. Rodin wrote to the Fine Arts Committee: "Confirming your letter of 17 July 1880, informing me that you have desired to commission a decorative door representing an ensemble of bas-reliefs drawn from the cantos of Dante (*Divine Comedy*) at the price of 8,000 francs, I have begun to work."[97]

This work, which we know as *The Gates of Hell*, freed Rodin from the need to show in the salon, to submit annually to the "system." Within a few years the best critics were flocking to the Dépôt des Marbres to write about his recent work after they had seen it in the studio. Its revolutionary nature was quickly perceived: "Just now the artist is engaged upon a pair of colossal bronze doors for the Palais des Arts Décoratifs. The subject is the *Divine Comedy*, and the work will be in relief. Some parts of it exist already in the round—a superhuman 'Dante'; a lovely and affecting 'Paolo and Francesca'; a terrifying 'Ugolino.' There is nothing like them in modern sculpture."[98]

Rodin's figures may have looked like nothing else in modern sculpture, but the ideas were related to themes and subjects he had encountered in the salons of the seventies. Rodin had always made it clear that the choice of subject matter for the door had been his own. In the late 1880s he explained the way he had gone about choosing a subject to Bartlett: "I had no idea of interpreting Dante, though I was glad to accept the *Inferno* as a starting-point, because I wished to do something in small, nude figures."[99] Actually drawings exist from the late 1870s and the early 1880s which contradict this disclaimer; they show that Rodin did think about specific figures and exact scenes from Dante's poem. Rodin's attraction to the subject has always been considered in the context of nineteenth-century romanticism and the general fascination with Dante,[100] but it should be seen even more specifically as being related to the tendencies

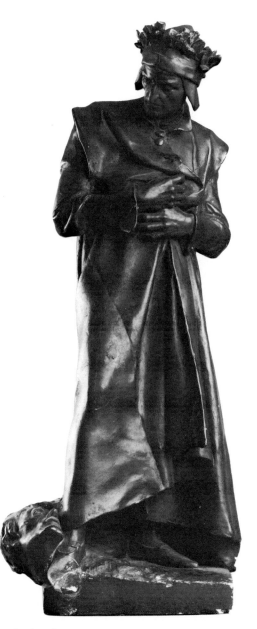

1.54 Paul Aubé. *Dante*, 1879. Bronze. Square of the Collège de France, Paris. Cat. no. 28.

of the 1870s.

The two most prominent works of the Second Empire inspired by Dante's poem were Carpeaux's *Ugolin* (1860) and Gustave Doré's illustrations for the *Inferno* (1861). In general, there was not as broad an interest in Dante as there had been on the part of the previous generation of romantic artists. Nor do we find paintings and sculptures based on Dantesque themes in the first salons of the Third Republic. Renewed interest did not begin before the Salon of 1875, when Gustave Doré showed his *Dante and Virgil in the Seventh Chasm* and an Ingres student, Louis Janmot, exhibited *Dante's Dream*. From then on we find Dante and Vergil, Paolo and Francesca,

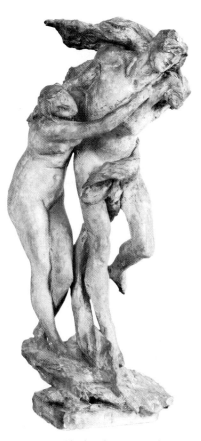

1.55 Jean-Baptiste Hugues. *Shades of Francesca da Rimini and Paolo Malatesta*, 1877. Plaster. Musée du Louvre, Paris. Cat. no. 25.

and Ugolino in the painting and the sculpture sections for the rest of the decade. The major work of sculpture based on the image of Dante was Paul Aubé's figure in the Salons of 1879 and 1880. Here the medieval poet peers into the face of a damned soul at his feet (fig. 1.54). Rodin would have liked Aubé's monumental figure with its fragmented head, but he would have enjoyed Jean-Baptiste Hugues's group of the *Shades of Francesca da Rimini and Paolo Malatesta* (fig. 1.55) in the Salon of 1879 even more.

Rodin had begun reading the *Divine Comedy* and considering the possibility of creating works inspired by its vision around 1875.[101] General interest in Dante gradually emerged as part of the seriousness of the postwar period. During the second half of the decade of the 1870s it became an attractive alternative to the war-related subjects which had begun to recede from popularity, while the climate for serious moralizing subjects remained. Another source for such subjects was the Book of Genesis. Adam, Eve, Cain, and Abel were ever-present in the salons during these years.[102] The same trend renewed interest in Dantesque subjects, and it is part of a larger impulse to understand human transgression and the presence of guilt in the world. This is the

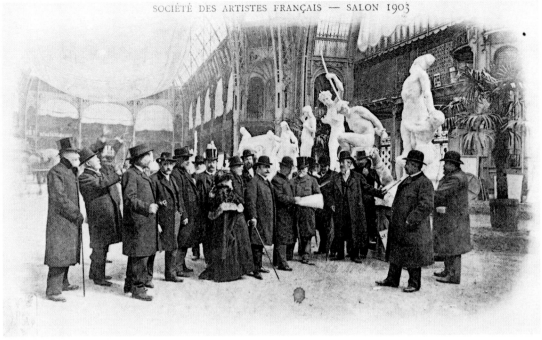

1.56 The Jury for Sculpture, Société des Artistes Français, Salon of 1903.

background for the ideas that Rodin was pursuing in *The Gates of Hell*, ideas which he encountered repeatedly in the salons of the seventies.

By 1882 writers were regularly visiting Rodin in his studio to inspect the portal. In that year he also exhibited for the first time in one of the new "artistic circles" which were springing up around Paris. It was a good time to develop options for exhibition; the salon system was coming apart. By 1881 juries had been accused of bias so many times that the Administration decided to bow out altogether. Artists themselves took over the management of the salon. They laid down new rules, and by 1882 they had formed the Société des Artistes français to continue the salon tradition. The men who controlled it have been called the "juste-milieu artists of the Third Republic."[103] By the end of the decade the best-known among its members had defected from the society and founded a second annual exhibition. Now there were two salons: the Société des Artistes français, essentially a reincarnation of the old, and the splinter group's new Société Nationale des Beaux-Arts. Among the artists who created the Nationale were Puvis de Chavannes, Carolus-Duran, Besnard, Carrière, Alfred Roll, and Rodin.

By the 1890s Rodin had achieved a considerable reputation, as well as having won some of the most desirable commissions to be had by a sculptor, most notably the monuments to Victor Hugo, Balzac, and Claude Lorrain. We might well expect him to have turned his back on the salon just as the impressionist painters had done a decade earlier. Not so. Rodin showed regularly at the Nationale until 1913, and from 1897 to

1905 he was president of the sculpture section. In that position he exercised considerable influence over younger sculptors as they entered the world of public exhibition. As he had been judged, so he judged. Maillol, Brancusi, and Lipchitz all sent work to the Nationale while Rodin was president. More surprising than his participation in the Nationale is Rodin's relationship to the Société des Artistes français. Once he and the others had left in 1889, this exhibition was often little more than an art bazaar open to all comers, a space for every hackneyed eclectic trend. How surprising then to find Rodin on its jury! But it is clear that Rodin loved "the system." He adored the panoply; we even suspect he enjoyed the rules and the procedures, once he himself was in a position to influence their workings. He had spent twenty years as an outsider, too long for him not to taste pleasure in his public success and official position. Another aspect of his continuing participation, in strong contrast to the behavior of his contemporaries Monet and Cézanne, was his life as a sculptor—his sense of the profession, the craft, its organizational aspects, the participation in group enterprises, as well as the public nature of the greater part of his work. These considerations remained constant, and they help us to understand Rodin's presence on the Grand Jury of the Société des Artistes français for 1902, 1903, and 1904, alongside Aubé, Barrias, Dubois, Frémiet, Mercié, and Saint-Marceaux, some of whom we see here (fig. 1.56) attentively following the directions of Bartholdi as they judge the Salon of 1903. Rodin stands right in the middle, looking just like one of his sculptures—like no one else in the salon.

NOTES

I did most of my research on Rodin in the archives of the Musée Rodin. I am grateful to Monique Laurent and to her staff for their help. I drew the ideas for the essay together and began the writing while I was a fellow at the Bunting Institute of Radcliffe College and with funding from the American Council of Learned Societies. Without either I should not have been able to do what I have done here. And two persons with enormous knowledge of nineteenth-century sculpture have continuously fed me photos, locations, and inspiration: Anne Pingeot and H. W. Janson. I am extremely grateful to them both. I would also like to thank D. J. Janson for her editorial suggestions. I wish to thank Al Elsen for reading my essay and offering pointed and helpful criticism, but even more for being the guiding light of *Rodin Rediscovered* from its inception to its realization. For this we are all in his debt.

1. The first thing a person familiar with the period will say at this point is: "Yes, but the best painters of the period were deserting the official salon at just this time." True. Once we have acknowledged this, however, we must also recognize that the almost unanimous exaltation of sculpture coming from the critics publishing in the most serious journals in the early 1870s must have had a powerful effect on sculptors and on their audience. The following are but a few examples:
"More than ever, and with great energy, sculptors preserve the honor of French art. The large number of works in the present exhibition constitute one of the most glorious ever assembled. One cannot remember having seen, side by side, four or five works by younger sculptors of such great worth and so full of promise." Georges Lafenestre, "Salon de 1872," *Revue de France*, 30 June 1872, 632.
"Sculpture attracts attention because it is at once the most elevated and the most popular of the arts. . . . A painting is entirely conventional, while a sculpture draws near to nature herself. It takes our form, its movements are true; the space it occupies is not a substitute for what is true. Sculpture is truly a model of man, and, like him, she lives and palpitates." Henry Jouin, *La sculpture au salon de 1873* (Paris, 1874), 9.
"Sculpture remains the solid, strong part of our national art. In it one does not know financial success. One works, ponders, one searches the difficult medium in order to put onself into the marble. There is no surprise, nothing unforeseen." J.-A. Castagnary, "Salon de 1873," *Salons*, vol. 2 (Paris, 1892), 94. Castagnary makes these comments in praise of sculpture. During the previous period the same qualities were often seen as defects (see text pp. 5–6).
". . . sculpture . . . holds together better . . . than painting [at the salon] because it is three-dimensional and because it is more compatible with the temperament of the French people. . . ." Anatole de Montaiglon, "Salon de 1875," *Gazette des Beaux-Arts*, 2nd period, 12 (1875): 36.
"Sculpture is clearly in better health than painting. It betrays less of that scattered, showy individuality. The sculpture show is more unified and there are a considerable number of serious works executed within the context of an elevated tendency." M.F. Lagenevais, "Le Salon de 1875," *Revue des Deux Mondes*, 3rd period, 9 (15 June 1875): 934.
2. Georges Dufour, *Des Beaux-arts dans la politique* (Paris, 1875), 19.
3. Dufour, *Des Beaux-arts*, 136.
4. After the scandal of 1863 the government took the control of the salon away from the Institute and gave it to the Director-General of Imperial Museums. The new rule called for juries of which three-quarters of the membership had been elected by artists who had previously received awards. The most interesting new jurors for sculpture in 1864 were Barye and Cabet. There were eight jurors in all: five sculptors, two administrators, and one critic.
5. Albert Boime, "The Salon des Refusés and the Evolution of Modern Art," *The Art Quarterly* 32 (1969): 413–416.
6. T.H. Bartlett, "Auguste Rodin, Sculptor," *American Architect and Building News*, 19 January 1889, 28. Reprinted in A.E. Elsen, ed., *Auguste Rodin: Readings on His Life and Work* (Englewood Cliffs, N.J.: Prentice-Hall, 1965). Throughout this essay page numbers will refer to the original essay, which appeared in successive issues of *American Architect*.
7. George Heard Hamilton, *Manet and His Critics* (New York: Norton, 1969), 23–24.
8. In the archives of the Musée Rodin there is an official receipt from the Salon of 1865 that reads: "Reçu de M. Rodin, buste de l'homme (buste, plâtre), enregistré sous le no 9197."
9. Charles Baudelaire, "The Salon of 1846," trans. and ed. Johnathan Mayne, *The Mirror of Art* (London, 1955), 60.
10. *Gazette des Beaux-Arts* 19 (July 1865): 38.
11. Elie Roy, "Salon de 1869," *L'Artiste*, September 1869, 377–378.
12. Bartlett, 26 January 1889, 44.
13. In February 1873 Rodin signed a contract with the Belgian sculptor Van Rasbourg. They became partners and all sculpture that issued from the atelier destined for public works in Belgium would bear the name Van Rasbourg. Anything that went to France was to be signed by Rodin. The work placed in London and Vienna, shortly after the contract was signed, was shown under both their names. It was probably all Rodin's work.
14. Bernard wrote to Rodin on 8 November 1874 that he had not yet begun the "grand buste." On 15 February 1875, he wrote that the stone had been delivered and that he had begun to rough it out in the same size as the plaster. These letters are in the archives of the Musée Rodin and Professor Daniel Rosenfeld has shared this information with me.
15. Bartlett, 9 February 1889, 66.
16. Garnier wrote to Rodin on 3 February 1875: "[I have] charged M. Huguet to tell M. Trehart to pick up my bust, which I have kept at your disposition, believing that, should an accident occur, you would be able to replace it. . . ." The stationery on which the note is written describes Garnier's business: "Briquetage et Joints à l'anglaise; Cheminées d'usines et Haut-formeaux." The address is Cité Véron, Paris, 4e. Archives, Musée Rodin.
17. There were 619 sculptures in the Salon of 1875, of which 213 were portraits (including both busts and portraits in bas-relief). In

addition there were seventy-nine portrait-medallions and fifty idealized busts.

18. *La sculpture au salon de 1874* (Paris, 1875), 86.

19. *Salons*, 196–197.

20. Philippe Burty, "La Sculpture," *L'Exposition des beaux-arts* (Paris, 1882), 263–264. Burty was discussing Rodin's busts of Carrier-Belleuse and J.P. Laurens which were both shown in the Salon of 1882.

21. This has long been recognized. Judith Cladel referred to *Le Vaincu* as a "glorification de l'héroïsme malheureux qui emeut encore son coeur français." *Rodin, sa vie glorieuse et inconnue* (Paris, 1936), 115. In a paper presented at the 24th International Congress of Art History in Bologna (1979), "Nationalism, a New Seriousness, and Rodin: Some Thoughts about French Sculpture in the 1870s," I discussed the influence of the war on Rodin and on other sculptors.

22. 4 October 1873, no. 1597.

23. 9 May 1874, no. 1628.

24. 28 February 1874, no. 1618.

25. Bo Wennberg has pointed out that: "In neo-renaissance we meet drama and tragedy, heroism and patriotism. Much of this is found in effigies of Jeanne d'Arc and in sculptures seeking to find consolation even in defeat, such as Mercié's "Gloria Victis" and "Quand Même." *French and Scandinavian Sculpture in the Nineteenth Century* (Stockholm: Almqvist & Wiksell and Atlantic Highlands, N.J.: Humanities Press, 1978), 170.

26. Lafenestre, "Salon de 1872," 631.

27. Castagnary, "Salon de 1872," 1.

28. Duparc, "Le Salon de 1872," 951.

29. Duparc, "Le Salon de 1872," 952.

30. Castagnary, "Salon de 1873," 94.

31. Jouin, *La Sculpture au salon de 1873*, 9.

32. This work was designated in the salon catalogue as destined for the City of New York. It would be a gift from the government to express the gratitude of the French people for help received from America during the Franco-Prussian War.

33. Georges Lafenestre, "Salon de 1873," *Revue de France*, 30 June 1873, 626.

34. *Salons*, 97.

35. Illustration to be found in Butler, "Nationalism, a New Seriousness, and Rodin" (Bologna, 1979).

36. "Le Salon," *Le Figaro*, 19 June 1874.

37. *Salons*, 128–129.

38. Nestor Paturot, *Le Salon de 1874* (Paris, 1874), 45.

39. E. Stranham, *The Chef-d'Oeuvres d'Art of the International Exhibition* (Philadelphia, 1878), 21.

40. Marc de Montifaud, "Le Salon de 1874," *L'Artiste* 2 (1874): 23.

41. "Le Salon," *Le Figaro*, 6 May 1874.

42. Castagnary, "Salon de 1874," *Salons*, 132.

43. Montifaud, "Le Salon de 1874," 24.

44. Henri Wallon declared in his famous speech of 30 January 1875: "We must abandon this provisional situation. If monarchy is possible, show that it is acceptable; propose it. If on the contrary it is impossible, I do not say, 'Propose the Republic,' but I do say constitute the government at present established, which is the government of the Republic." The amendment was accepted by the National Assembly by a vote of 353 to 352. To many historians the Third Republic dates from this moment.

45. *Salons*, 135–140.

46. "Salon de 1875," *Revue de France*, 30 June 1875, 502.

47. Lagenevais, "Le Salon de 1875," *Revue des Deux Mondes* (1875): 935.

48. Castagnary, *Salons*, 194.

49. Th. Véron, *De l'art et des artistes de mon temps* (Paris, 1875), 87.

50. "Salon de 1875," *L'Art* 2 (1875): 79.

51. Letter from Carpeaux to Bruno Chérier, Nice, 18 April 1875. Published in Louise Clement-Carpeaux, *La Vérité sur l'oeuvre et la vie de J.-B. Carpeaux*, vol. 2 (Paris, 1935), 176.

52. Cladel, *Rodin, sa vie*, 115.

53. "La sculpture au jardin de 1876," *L'Artiste* 1 (1876): 399.

54. Beaurin, 401–413.

55. Auguste Neyt, *Gand Artistique* 4 (April 1922). Cited in Robert Descharnes and Jean-François Chabrun, *Auguste Rodin* (New York: Viking Press, 1967), 49.

56. Bartlett, 9 February 1889, 65.

57. "La leçon de l'antique," *Le Musée* 1 (1904). Quoted in Frederick Lawton, *The Life and Work of Auguste Rodin* (London: T. Fisher Unwin, 1906), 193.

58. Letter from Rodin to Bourdelle c. 1905. Quoted in Edmond Capagnac, "Rodin et Bourdelle d'après des lettres inédites," *La Grande Revue*, November 1929, 6.

59. Letter from Rodin to Bourdelle c. 1906. Quoted in Cladel, *Rodin, sa vie*, 113.

60. Anonymous, *L'Etoile belge*, 29 January 1877. Reprinted in Cladel, *Rodin, sa vie*, 115.

61. Jean Rousseau, "Revue des Arts," *Echo du Parlement* (Brussels), 11 April 1877. Reprinted in Ruth Butler, ed., *Rodin in Perspective* (Englewood Cliffs, N.J.: Prentice-Hall, 1980), 33.

62. Charles Timbal, "La Sculpture au Salon," *Gazette des Beaux-Arts*, 2nd period, 15 (1877): 544.

63. Castagnary, "Salon de 1877," *Salons*, 279.

64. Henry Jouin, *La Sculpture au salon de 1877* (Paris, 1878), 29.

65. Castagnary, "Salon de 1877," *Salons*, 282.

66. Charles Tardieu, "Le Salon de Paris—1877—La Sculpture," *L'Art* 3 (1877): 108. Reprinted in Butler, *Rodin in Perspective*, 34.

67. Charles Timbal, "La Sculpture au Salon," *Gazette des Beaux-Arts*, 2nd period, 16 (1877). Reprinted in Butler, *Rodin in Perspective*, 34.

68. Tardieu, "Le Salon de Paris—1877," 108.

69. Anatole de Montaiglon, "Exposition Universelle: La Sculpture," *Gazette des Beaux-Arts*, 2nd period, 18 (1878): 31–32.

70. Castagnary, "Salon de 1878," *Salons*, 343–347.

71. Theodore Véron, *Le Salon de 1878* (Paris, 1879), 102.

72. Véron, 813–814.

73. Bartlett, 2 March 1889, 99.

74. He did, however, do at least two drawings of "John the Baptist as a Child." One has been published in Léon Maillard, *Auguste Rodin, statuaire* (Paris, 1899) and the other in Victor Frisch and Joseph Shipley, *Auguste Rodin* (New York: Frederick A. Stokes Co., 1939). See Jacques de Caso and Patricia B. Sanders, *Rodin's Sculpture: A Critical Study of the Spreckels Collection, California Palace of the Legion of Honor* (San Francisco: San Francisco Museums of Fine Art and Rutland, Vermont: Charles E. Tuttle Co., Inc., 1977), 79.

75. Rénan, *Vie de Jésus* (Paris, 1863) and Flaubert, "Herodias," *Trois Contes* (Paris, 1877). The significance of both sources has been discussed by de Caso and Sanders, *Rodin's Sculpture*, 75.

76. Richard Bizot, unpublished paper.

77. Bartlett, 2 March 1889, 99 and 1 June 1889, 263.

78. Léonce Bénédite, *Rodin* (Paris, 1926), 26.

79. This is in the Petit Palais in Paris and Albert Elsen published

it as a study for *St. John the Baptist Preaching* in *Rodin* (New York: The Museum of Modern Art, 1963), 32. Recently he has identified a solid plaster torso in the basement of the Musée Rodin in Meudon which is almost identical to the bronze in the Petit Palais.

80. Professor Elsen recognized this plaster in the basement of Meudon in 1978 and he discussed it at the 24th International Congress of Art History in Bologna, September 1979. In my discussion I have not mentioned the famous *Walking Man*, usually dated 1877–1878 and often considered as the half-length study discussed by Bartlett. Now that we know the half-length study in Meudon, it appears that it, rather than *The Walking Man*, was the work of which Bartlett was speaking. It also seems likely that this extremely modern looking fragment, so appealing to twentieth-century eyes, is a work of around 1900, the year in which it was first exhibited. Professor Elsen has indicated to me that this is also his view of *The Walking Man*. Letter of 20 August 1980. He discusses this subject in his *In Rodin's Studio: A Photographic Record of Sculpture in the Making* (Oxford: Phaidon Press in association with the Musée Rodin, 1980), 187. See also Professor Elsen's essay, "When the Sculptures were White," figs. 6.27, 6.28.

81. This photograph is in the Rodin boxes at the Cabinet des Estampes of the Bibliothèque Nationale. The location of the head itself is unknown.

82. Eugène Véron, *Dictionnaire Véron, Le Salon de 1879* (Paris, 1879), 201.

83. Arthur Baignères, "Le Salon de 1879," *Gazette des Beaux-Arts*, 2nd period, 20 (1879): 147.

84. Eugène Véron, "La Sculpture au Salon de Paris," *L'Art*, 1879, 270.

85. J.-K. Huysmans, "Le Salon de 1879," *L'Art Moderne* (Paris, 1883). Reprinted by Gregg International, 1969, 78.

86. Huysmans, "Le Salon de 1879," 62.

87. *Petit Moniteur universelle*, 17 December 1879.

88. A fascinating, vivid, and surely biased account of Turquet's troubles is given by Chennevières, *Souvenirs d'un Directeur des Beaux-Arts*, vol. 4 (Paris, 1979), 98 ff.

89. Letter of 13 January 1880. Archives Nationales, Paris. Translated and reproduced in John L. Tancock, *The Sculpture of Auguste Rodin* (Philadelphia: Philadelphia Museum of Art, 1976), 347.

90. Professor Elsen was the first person to point out the comparison between Rustici's *St. John* and Rodin's figure. Elsen, *Rodin*, 27.

91. Bartlett, 25 May 1889, 250.

92. *Le Soir*, 2 July 1880.

93. *Le Figaro*, 5 May 1880.

94. "Salon de 1880," *L'Artiste*, 1 (1880): 364–365.

95. Archives, Musée Rodin, Paris.

96. Archives, Musée Rodin, Paris.

97. Archives Nationales, Paris. Section reprinted in Albert E. Elsen, *Rodin's Gates of Hell* (Minneapolis: University of Minnesota Press, 1960).

98. Anonymous, "Current Art," *Magazine of Art*, 6 (1883): 176. Reproduced in Butler, *Rodin in Perspective*, 44.

99. Bartlett, 11 May 1889, 223.

100. Irene de Vasconcellos, *L'Inspiration dantesque dans l'art romantique français* (Paris, 1925) and Luc-Benoist, *La Sculpture romantique* (Paris, 1928), 162.

101. "Il eut la pensée primitive de la *Porte de l'Enfer* vers 1875." Maillard, *Auguste Rodin*, 78. Rilke, too, indicated that Rodin was reading Dante's *Divine Comedy* for the first time while still in Brussels. Rainer Maria Rilke, *Auguste Rodin* (Leipzig, 1922), 19.

Rodin did numerous drawings based on the subject matter of the *Inferno* which have been dated between 1875 and 1880. See Elsen, *Rodin's Gates of Hell*, Chapter 2.

102. For a larger discussion of this point, see my essay, "Religious Sculpture in Post-Christian France," in Peter Fusco and H. W. Janson, eds., *The Romantics to Rodin: French Nineteenth-Century Sculpture from North American Collections* (Los Angeles: Los Angeles County Museum of Art and New York: George Braziller, Inc., 1980), 92–93.

103. See Albert Boime, *The Academy and French Painting in the Nineteenth Century* (London: Phaidon, 1971), 17.

2.1 The Trocadéro Palace on the opening day (from *The Illustrated Paris Universal Exhibition*, London, 1878).

2. An Infinity of Grotesque Heads: Rodin, Legrain, and a Problem in Attribution

Albert Alhadeff

For a man accustomed to adulation in his later years, Auguste Rodin's beginnings were anything but auspicious. During the 1860s and 1870s—as is well known—Rodin was employed by a host of ornament makers, jewelers, and commercial sculptors. Once, in Strasbourg, he was even in the employ of a *marchand de bons dieux*— one of "a class of men," to quote a reliable source, "not held in good repute among artists. . . ." Men whom history has cast aside—Bies, Fanières, Ginsbach—were at one time or another Rodin's employers.[1] Although scant evidence remains of his labors for these industrious *petits maîtres*, a body of work conceived for Carrier-Belleuse and other successful business sculptors has survived.[2] Skilled but—so he said—not necessarily talented, Rodin was ever willing to defer to the willful dictates of his employers: "I did not know that I had any talent, though I knew I had some skill. . . . I never signed my work, and so I was not known."[3]

Rodin's self-effacing conduct was a product of his financial difficulties. In an effort to make ends meet, he accepted jobs which under less trying circumstances he would have shunned. What is more, his employers demanded that his work remain unsigned—a condition which perpetuated their names and insured his anonymity.[4] Hence the proliferation of others' names on Rodin's early designs: the *Loos Monument* bears Pecher's name, the Beethoven medallion in Brussels carries Van Rasbourg's signature, the *Vase des Titans* is marked Carrier-Belleuse, and the *mascarons* for the Trocadéro Fountain first appeared as the work of Eugène Legrain.[5] While Rodin's collaborations with Pecher, Van Rasbourg, and Carrier-Belleuse are all well-established in the Rodin literature, his collaboration with Legrain is not.[6] Yet Rodin's tenure with the latter produced an impressive ensemble of decorative masks. Within a decade of its completion, the Trocadéro Fountain was acknowledged as one of the memorable sights of Paris. Subject to lavish praise, the *mascarons* were admired for their scale— which was grand, for their setting—which was striking,

and for their number—which, to paraphrase a contemporary account, approached "infinity." Yet, in spite of all acclaim, the fountain fell into oblivion and by 1937 it was destroyed.

As the years passed and his fame grew, Rodin came to regret his former anonymity.[7] Unhappy about his youthful collaborations and the restraint they had imposed on his reputation, he tried to set the record straight. As early as 1889, in a lengthy interview with T.H. Bartlett—surely his most reliable biographer prior to 1900—Rodin clarified not just his relations with Van Rasbourg and Pecher, but the "unpleasant experiences" he had had with a "certain decorative sculptor" as well. Bartlett comments:

Just before the great exhibition of 1878, Rodin was working with a certain decorative sculptor who was especially critical, and for whom he made a number of large heads destined for the Trocadéro Palace. . . .[8]

There can be little doubt that Rodin prized these "large heads," for, according to Bartlett, who was only relating what Rodin had said, many viewers at the *Exposition Universelle* considered them to be excellent examples, "some [said] masterpieces," of contemporary sculpture— and this in spite of the fact that "no one [knew] who really made them." Their anonymity never ceased to trouble Rodin. As late as 1906, amidst honors the world over, and certainly not in need of their bygone luster, Rodin was still distressed over their fate. Claiming as his own that which he had previously signed away, he informed his personal secretary, Frederick Lawton, of the following details. Lawton recalls:

The Trocadéro Palace had just been constructed, and some of the outside ornamentation had been entrusted to a Monsieur Legrain, who delegated a part to Rodin. He modeled a number of grotesque heads on the side facing the Champ de Mars, some on the projecting arch at the inmost post of the semi-circle, others on the waterspouts that were placed on the fountains.[9]

The *Exposition Universelle* of 1878 boasted among its

2.5

2.2

2.3

2.4

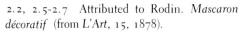

2.6 2.7

2.2, 2.5-2.7 Attributed to Rodin. *Mascaron décoratif* (from *L'Art*, 15, 1878).

2.3 *Mascaron décoratif (Le beau temps)*. Musée Rodin, Paris.

2.4 *Mascaron décoratif (Le mauvais temps)*, Musée Rodin, Paris.

many marvels a large fountain which faced the Trocadéro on the Champ de Mars. The fountain (fig. 2.1), with its many-tiered cascades and expansive basin, was a rallying point for parades and festivities. Indeed, visitors marveled at its "magnificence." Superlatives abounded:

One of the chief features of the Paris Exhibition of 1878 was the magnificent waterfall beneath the Trocadéro Palace and the grand basin at the foot of the cascade. At the four angles of this basin were gigantic groups of animals . . . while around it spouted streams of water from an infinity of grotesque heads or masks.[10]

On its upper tiers, the fountain supported six allegorical figures, and immediately below, paralleling the main cascade, were niches filled with life-size personifications of air and water. Thus, with its cascading waters, its immense scale, and its striking statuary—not the least of which were the grotesques Rodin had modeled for Legrain—the fountain was indeed "one of the chief features of the Paris Exhibition."

The masks or waterspouts lining the basin were reproduced in learned journals, cited in official reports, and honored in reviews of the *Exposition*.[11] Such publicity brought in its train official support. The result was a *médaille d'or* for Legrain and "his" *mascarons*—an award which particularly vexed Rodin in the light of his own

needs.[12] Distressed by the injustice of the events, Rodin tried to discredit Legrain during an interview with Bartlett in the late 1880s. Accusing him of duplicity, Rodin said Legrain found the *mascarons* "not wholly to his liking"—and yet chose to exhibit them in the industrial art section of the fair; furthermore, Rodin told Bartlett that since Legrain was especially critical of the *mascarons*, "they were not used for that purpose," e.g., for the Trocadéro Fountain.[13] But these statements, which ring of outrage, run contrary to the facts. Why, we may ask, would Legrain sign the *mascarons* and enter them in a competition if he disliked them? As to their placement—or lack of placement—on the Trocadéro, the evidence belies Rodin's assertion.

Attempts to untangle the controversy must cover a range of hypotheses and observations. In 1963, in the pages of *The Art Bulletin*, I published a series of *mascarons* (figs. 2.2, 2.5, 2.6, 2.7), which had first appeared in 1878 in *L'Art*, a well-known periodical of Rodin's era.[14] The *mascarons*, wood-engravings of expressive masks, were but decorative fill-ins to an article by Viollet-le-Duc, an established figure in architectural circles.[15] Of the grotesques which I published, one (fig. 2.2) matched a plaster attributed to Rodin (fig. 2.3), housed in Paris at the Musée Rodin. This observation

2.8-2.16 From left to right, top to bottom: Attributed to Rodin. *Mascaron décoratif* (from *Le Palais du Trocadéro*, figs. 31, 32, 42, 23, 1, 6, 35, 40, 39).

led to the conclusion that the other *mascarons*, which shared with our mask a certain drollery, were all fashioned by the same hand—that is Rodin's. The argument, however, does not end here. For the grotesque which is in the Musée Rodin (fig. 2.3) is but one of a pair of *mascarons*. Along with its pendant (fig. 2.4), it was acquired by Georges Grappe, director of the Musée Rodin, in 1927 from the Musée des Arts Décoratifs. This is a large and impressive plaster; Grappe knew that it and its counterpart "served as keystones" on the arcades of the Trocadéro Fountain.[16] Although aware of their provenance, however—he even knew that the stone reproductions were still *in situ* when he took possession of the *mascarons*—he failed to link them with Legrain. Could he have been unaware of this connection? This is indeed unlikely, for according to the archives of the Musée des Arts Décoratifs—archives which Grappe must have perused—it was Legrain himself who donated our *mascarons* to the Musée du Trocadéro (later, the Musée des Arts Décoratifs). What is more, the donation went beyond the Musée Rodin's *mascarons*. For as the same archives attest, Legrain supplemented his gift with eight

other "mascarons jaillissants de la cascade du Trocadéro," in sum, a gift of ten *mascarons*, eight of which Grappe left behind. In the course of time, stored in the damp attics of the Musée, they crumbled and fell apart. By 1959 they had been thrown in the trash-bin.[17]

This then is what was known in 1963: the fountain had not been reconstructed, and of the eight *mascarons* Grappe had not rescued from the Musée's vaults, only three—found in Viollet-le-Duc's article—were known. Clearly, the whole story had not been told. Our knowledge was at best fragmentary. Since then, however, the situation has changed. New findings—some as recent as 1980—permit us to fill in the gaps. Among these is a publication entitled *Le palais du Trocadéro, le nouveau palais, les dix-huit mois de travaux*, published in 1878 under the auspices of the *Exposition Universelle*. It reproduces, with Legrain as their assigned author, all but one of the *mascarons* which Grappe (figs. 2.8, 2.9) and Viollet-le-Duc (figs. 2.10, 2.11) had published. What is more, and again under Legrain's name, the other five waterspouts which lined the basin (figs. 2.12, 2.13, 2.14, 2.15, 2.16) are also reproduced. With this

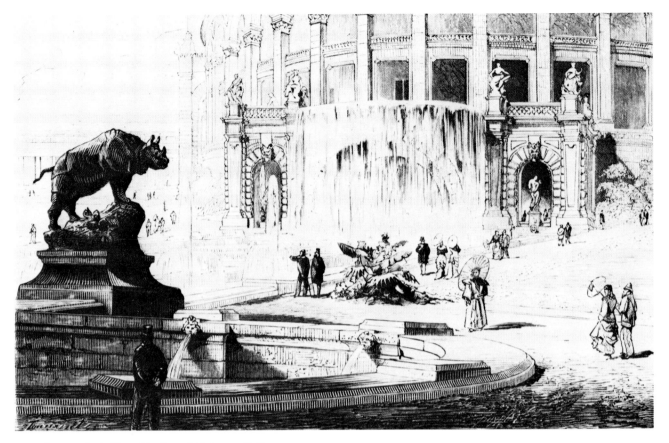

2.17 *Le cascade du Trocadéro* (from *L'Art*, 15, 1878).

publication, the *mascarons* for the Trocadéro Fountain stand revealed with Legrain, not Rodin, as their author.

Before we proceed, let us look at the *mascarons* themselves. A logical starting point would be—since they are still extant—the two keystones which Grappe secured for the Musée Rodin. Originally set in rusticated arches facing the basin below (fig. 2.17), we can see in them qualities which are difficult to perceive in the engraved reproductions—qualities which we assume the other *mascarons* shared as well. In particular, the keystones are defined by massive forms, buoyant shadows, and an overpowering sense of scale. Nothing is timid, mincing, or hesitant. On the contrary, the heads are robust and expansive. Indeed their awesome scale is but an outgrowth of their function, that of exemplar for what awaits us below in the lowermost tier.

In keeping with their monumental presence is their playful mischief. One of them (fig. 2.4), his nose wrinkled in disfavor, disconcertingly squints at us from sagging eyelids, with tangles of seaweed drooping from his lower jaws. Possibly entitled *Le mauvais temps*, as listed in the archives of the Musée des Arts Décoratifs, he is a fitting companion for the other keystone, *Le beau temps* (fig. 2.3). As opposed to his disgruntled neighbor, *Le beau*

temps is irresistibly jubilant. With his impish grin, bonhomie, and sly tongue, he is an infectious incarnation of lustful humors and, not unlike his counterpart, a ready bedfellow for Arcimboldo and his mannerist confreres.[18] To place our allegories of temperate and intemperate time in the mannerist camp is in keeping with their roguish mien. For as with so many mannerist eruptions of mischievous play, our keystones speak of unrestrained joy and abundance. Their exuberance spills into the basin below where we are beset by howling, leering, jeering, blasting, crying, glaring, and smiling emissions of life (figs. 2.5–2.7, 2.12–2.16).

Unfortunately, the waterspouts for the grand basin no longer exist. If they did, their fame would no doubt be commensurate with their bombast. Pitched on a grand scale, they are a brotherhood of vital energies, bursting with joie de vivre in the tradition of the great impromptu forces of mannerist *invenzioni*. Admittedly, their boisterous presence would be hard to appreciate if we were forced to rely solely on the reproductions from our 1878 tome, *Le palais du Trocadéro*. Fortunately, we have Viollet-le-Duc's engravings to fall back on. Then—and surely this speaks for their fame among contemporaries—they were reproduced again a few years later in *The*

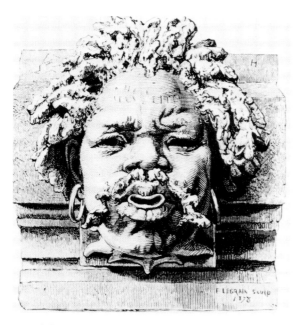

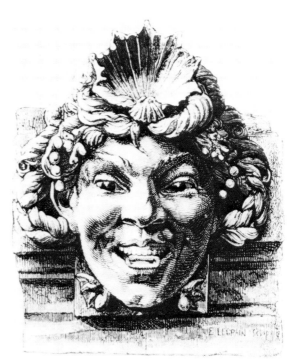

2.18, left and 2.19, right Attributed to Rodin. *Mascaron décoratif* (from *The Magazine of Art*, 4, 1881).

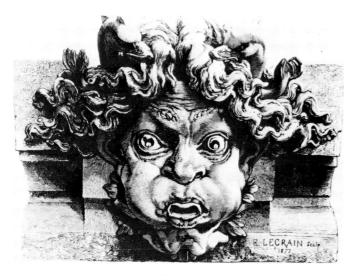

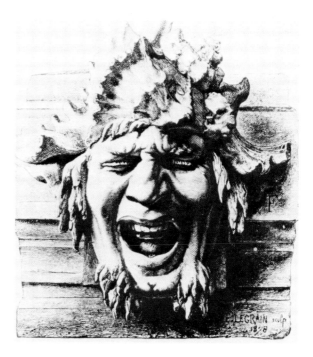

2.20, left and 2.21, right Attributed to Rodin. *Mascaron décoratif* (from *The Magazine of Art*, 4, 1881).

Magazine of Art, a London-based periodical, in an article entitled "Grotesque Heads by M. Legrain."[19] Here, engraved with great care, are two waterspouts (figs. 2.18, 2.19) which had first appeared in *Le palais du Trocadéro*. These not only bear Legrain's signature, but they are supplemented by other waterspouts (figs. 2.20, 2.21) similarly signed and known to us already from the 1878 publication of the *Exposition*. Published in 1881, these wood engravings—especially when seen against the earlier reproductions—emphasize what struck Rodin's peers most about the *mascarons*: their scale and their animated expressions—eyes popping out of their sockets, cheeks distended and about to burst, mouths agape spewing forth unwanted draughts of cold liquid, and, especially, fanciful crowns of conches and corals. Conceived as fantastic amalgams of aquatic life, their marine character is indeed droll. Hair is transformed into foam and froth (figs. 2.4, 2.18, 2.21); mouths and mustaches

are defined by grooved and serrated shells (figs. 2.13, 2.14); moss, scum, and slime wrap about necks and chins (figs. 2.7, 2.12, 2.21); conches and sponges adorn more than one forehead (figs. 2.7, 2.9, 2.21); and billed creatures from the ocean floor frolic in swells of waving hair (figs. 2.12, 2.20).

In their boisterous camaraderie our *mascarons*, we may fancy, mirror the animation which the fair generated. Passers-by captivated by the exotic sights and wares of the *Exposition*, and especially of *L'Avenue des Nations* where numerous marvels were displayed, must have seen our puckish (fig. 2.14), incredulous (fig. 2.20), and defiant (fig. 2.7) *mascarons*—one even adorned with

2.23, left The *Loos Monument* (detail), Antwerp.

2.24, right Attributed to Rodin. *Mascaron décoratif* (from *Le Palais du Trocadéro*, fig. 36).

2.22 Grotesque, the *Isolotto*. Boboli Gardens, Florence.

cicatrices on his brow (fig. 2.18)—as but more of the many wonders at the *Exposition Universelle*. Rodin himself may well have found relief from his everyday cares in the *mascarons'* joviality, and perhaps he was reminded of the joyous months he had recently spent in Italy. He had just returned from an extended stay in Florence and its environs, where he surely would have seen the inebriated forms peopling the Boboli Gardens and other mannerist enclaves. (Perhaps the grotesques which da Bologna assembled in his *Isolotto* [fig. 2.22]— with their loose whiskers, thick eyebrows, and pug noses—elicited some of the fantastic physiognomies [figs. 2.6, 2.7] found at the Trocadéro.)[20]

One pointed question must be asked before we bring our essay to a close: namely, what if the *mascarons*, which, we recall, were universally assigned to Legrain by his peers, really are by Legrain? Perhaps Grappe was mistaken in attributing the heads in figures 2.3 and 2.4 to Rodin. The problem is especially difficult to resolve because there are no publications on Legrain which might supply us with a point of comparison. Yet there are several factors in Rodin's favor which should be underscored. For one, it is difficult to see why Rodin insisted he worked on the masks for the Trocadéro if he never did. What could he gain from such an assertion? Why rob Legrain of his moment of glory if he had indeed earned it? Certainly, it is not because Rodin lacked publicity and needed to call attention to himself. In short, why should we accuse Rodin of fabrications? But then, is there any visual material which might serve our argument? Here, we must reply in the affirmative. The *Loos Monument*, a composition fashioned by Rodin in 1877, has at its base a number of grotesque heads (fig. 2.23) which bear a striking resemblance to yet another *mascaron* from the Trocadéro complex (fig. 2.24), one we have not seen before. When the two are set side by side, a number of similarities emerge: they share a severe mien; massive, boldly molded features; a heavy mustache; flaring nostrils and piercing eyes; and a rich display of sea matter woven into bands of flowing hair. These elements link the Loos grotesque not just with this particular mask, but with the Trocadéro *mascarons* in general.[21]

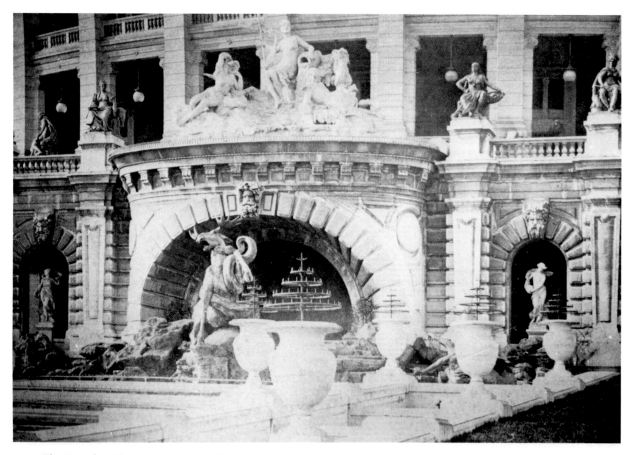

2.25 The Trocadéro Fountain, Musée Rodin Archives, Paris.

This last *mascaron* poses a further question. Identified as a keystone when it was first published in *Le Palais du Trocadéro*, its location on the fountain complex seems elusive. As the engravings of 1878 and 1881 demonstrate (figs. 2.1, 2.17), the waterspouts decorated the rim of the basin and behind them, set in rusticated arches, sat the two keystones now in Paris (figs. 2.3, 2.4). Our keystone is nowhere in sight. Its whereabouts are revealed, however—as a recently published photograph demonstrates (fig. 2.25)—when the waterfall which conceals the central arch in our engraving is arrested.[22] Then, and only then, is the central keystone exposed. Entitled *Neptune* by Legrain, the keystone is not especially fanciful or bizarre. In fact, in contrast to its confreres, *Le beau temps* and *Le mauvais temps*, it is quite severe. Some might even sense in its stern and powerful presence an allusion to an old Gaul, or an old warrior. Albert Elsen, who published the photograph before us from the Musée Rodin archives in Paris, expressed the opinion that our keystone (fig. 2.24) shared a striking resemblance with Rude's *Old Gaul* (fig. 2.26) from the *Departure of the Volunteers*.[23] Indeed, massive features, a heavily

2.26 François Rude. *Head of an Old Warrior* (the *Old Gaul*). The Metropolitan Museum of Art, Gift of Albert Gallatin, 1926.

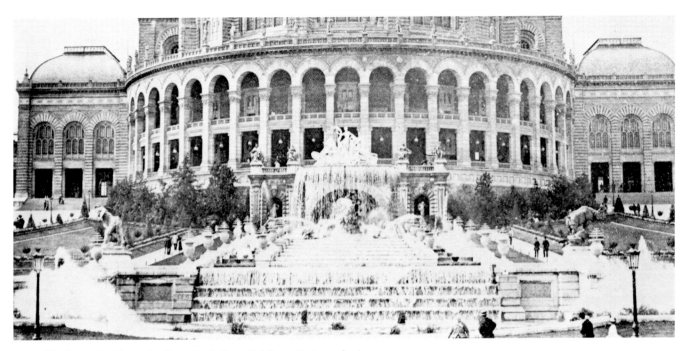

2.27 The Trocadéro Fountain (from Buel, *Beautiful Paris*, Boston, 1894).

ribbed mustache, a fierce gaze, and a clear forehead (even a careless lock of hair which falls on the cheekbone) characterize both heads. But if our keystone pays homage to the single-minded determination which Rude's *Old Gaul* personifies, we may well ask why. The answer surely lies in its function. Placed on the inmost post of the central arch, it steadfastly and unequivocally declares—as opposed to the moody expressions flanking it—the glories of France which the *Exposition Universelle* celebrated.

The photograph published by Elsen (fig. 2.25) concentrates on the upper tier. Clearly its sole purpose is to document the keystones. But what of the lower tier? After all, eight *mascarons* were involved. Does a photograph of the lower fountain not exist? Surprisingly, we may answer that question by turning to another photograph (fig. 2.27), one which only recently came to my attention.[24] Here, and the visual evidence is incontrovertible, the *mascarons* though visible on the upper arcades are, on the lower tier, nowhere in sight. The waterspouts were once there (our wood engravings testify to that), but now—and a comparison of our photograph and our engravings underlines the point—the compartments which housed *mascarons* immediately below the large bronze animal statues decorating the parterre of the basin stand empty. If Rodin did not have a photographic record of the lower basin and its waterspouts, it could be that

by the 1890s, when our photograph was taken, the waterspouts had been removed; they simply were no longer there to be recorded. Rodin, in fact, tells us as much. Discussing his work for Legrain he told Lawton that, as opposed to the grotesques on the upper tier, the waterspouts below "were removed subsequently. . . ." It is obvious that Rodin, as their author, kept track of them; he knew they were no longer *in situ* and, moreover, he knew their whereabouts. He explained to Lawton that they were "in the possession of the authorities administering the Museum of Decorative Arts. . . ."[25] With this said, there can no longer be any question that Rodin had indeed fashioned these masks, and since he was their maker, he was only too well aware of their subsequent history.

The Trocadéro Fountain was described by Rodin's peers as one of "the chief features of the Paris Exhibition of 1878." Rodin's *mascarons*, vivacious, garrulous, and mischievously spirited, were instrumental in this assessment. Their presence was inescapably vivid, leaving the impression that one had just confronted "an infinity of grotesque heads"—when in actuality, there were only eleven. Once this is realized, we can understand why Rodin never disclaimed them. On the contrary, we sympathize with his claim and rejoice, after all these years, in arguing his case and giving him his long awaited due.

NOTES

I owe special thanks to Professor Wes Blomster from the University of Colorado for his critical reading of the manuscript. Others to whom I owe thanks are Charles Roitz, Marie-Anick Wilkins, George Woodman, and Michèle Amateau.

1. For Rodin's account of these trying years see Bartlett's long interview with Rodin as reprinted in Albert E. Elsen, ed., *Auguste Rodin: Readings on His Life and Work* (Englewood Cliffs, N.J.: Prentice-Hall, 1965), 22–39. (Originally published as T.H. Bartlett, "Auguste Rodin, Sculptor," *American Architect and Building News* 25 [19 January–15 June 1889]: 682–703.) For the Strasbourg incident see Bartlett, 1889, cited in Elsen, *Rodin: Readings*, 24; for Bies and Fanières see Bartlett, 1889, cited in Elsen, *Rodin: Readings*, 22; for Ginsbach, see Judith Cladel, *Rodin* (New York: Harcourt, Brace and Co., 1937), 63.

2. Rodin's involvement with Carrier-Belleuse (1824–1887) spanned a decade or more; they worked together in Paris and in Brussels. See especially J.E. Hargrove, *The Life and Work of Albert Carrier-Belleuse* (New York and London: Garland Publishing, Inc., 1977), 160–164, 239–247. The term "business sculptor" is found in Bartlett, 1889, cited in Elsen, *Rodin: Readings*, 28.

3. Bartlett, 1889, cited in Elsen, *Rodin: Readings*, 37. According to Bartlett, Rodin's commercially-oriented employers "had made his early life little less than miserable." As Rodin expressed it: "Not one of these men treated me like a man." Bartlett, 1889, cited in Elsen, *Rodin: Readings*, 38.

4. Although, as Albert Elsen has pointed out to me (personal correspondence, 8 March 1979), "it was the practice" to accept the signatures of others, and although "in turn he did the same thing when he was master of his own atelier," Rodin never accepted the practice wholeheartedly. His own words and other contemporary testimony amply support this view: "Auguste Rodin a travaillé en Belgique près de sept ans; il existe des oeuvres signées des noms d'artistes belges et qui ont été exécutées par lui, car, pauvre, il acceptait tous les travaux qu'on lui offrait. Une étude que je publiai autrefois . . . sur ce palpitant sujet, suscita des protestations; mais Auguste Rodin s'empressa de m'écrire pour déclarer que je n'avais dit que la verité. . . ." Sander Pierron, *La Sculpture en Belgique, 1830–1930* (Brussels, 1932), 49.

5. For Pecher and the *Loos Monument* see Sander Pierron, "François Rude et Auguste Rodin à Bruxelles," *La Grande Revue* (October 1902): 138–162; also see Alhadeff, "Michelangelo and the Early Rodin," *Art Bulletin* 45 (1963): 363–367. The Beethoven medallion faces the entrance of the Brussels Royal Conservatory of Music. The work is reproduced in Robert Descharnes and Jean-François Chabrun, *Auguste Rodin* (New York: Viking Press, 1967), 45. A discussion of the *vasque* is found in H.W. Janson, "Rodin and Carrier-Belleuse: The *Vase des Titans*," *Art Bulletin* 50 (1968): 270–280. Modern scholarship has consistently confused Legrain with someone named Laouste. John L. Tancock, *The Sculpture of Auguste Rodin* (Philadelphia: Philadelphia Museum of Art, 1976), 67; Descharnes and Chabrun, *Auguste Rodin*, 50; Ionel Jianou and Cécile Goldscheider, *Rodin* (Paris: Artaud, Editions d'Art, 1967), 67; and Albert E. Elsen, *Rodin* (New York: The Museum of Modern Art, 1963), 207, follow Cladel, *Rodin*, 53, who originated this error. Cladel, however, is confused on this question since she herself names Legrain in connection with the Trocadéro earlier in the text (see p. 24).

6. Cladel, *Rodin*, 62, has Legrain working for Rodin and even calls him his "friend"—a rather topsy-turvy reading of the facts. Unfortunately, even such exemplary recent studies as Jacques de Caso and Patricia B. Sanders, *Rodin's Sculpture: A Critical Study of the Spreckels Collection, California Palace of the Legion of Honor* (San Francisco: The Fine Arts Museums of San Francisco and Rutland, Vermont: Charles E. Tuttle Co., Inc., 1977), 261, accept Cladel's recollections on this problem as correct.

7. Certainly by the mid-1880s Rodin consciously sought to assert himself in his work: his self-portrait in *The Gates of Hell*, must be seen in this light. See Alhadeff, "Rodin: A Self-Portrait in *The Gates of Hell*," *Art Bulletin* 48 (1966): 393–395.

8. Bartlett, 1889, cited in Elsen, *Rodin: Readings*, 38.

9. Frederick Lawton, *The Life and Work of Auguste Rodin* (London: T. Fisher Unwin, 1906), 50.

10. Anonymous, "Sculpture at the Paris Exhibition," *The Magazine of Art* 3 (1880): 256. Subject of universal praise, the fountain was described in numerous publications. One such passage deserves—for its enthusiasm if not for its extravagance—to be cited at length: "En dehors du Palais lui-même, le principal motif de cette décoration monumentale est une magnifique cascade qui tombe d'une hauteur de dix mètres. Le château d'eau, soutenue par une voûte . . . sous laquelle peut passer le public et qui est l'ouverture d'une grotte, verse 25,000 mètres cubes d'eau par jour, et cette masse d'eau va, par des cascatelles, se répandre dans un bassin dont la longueur est 70 mètres, c'est-à-dire égale à la hauteur des tours de Notre-Dame." (Charles Blanc, *Les Beaux Arts à L'Exposition Universelle de 1878*, [Paris, 1878], 17–18. For other descriptions see S. Vandières, *L'Exposition Universelle de 1878 illustrée* (Paris, 1879), 14, 23–24; Louis Gonse, "Exposition Universelle de 1878," *Gazette des Beaux Arts* 17 (1878): 481–492.

11. The waterspouts were reproduced in the *Gazette des Beaux Arts* (see Paul Sédille, "L'Architecture au Champ de Mars et au Trocadéro," *Gazette des Beaux Arts* 18 (1878): 912, 930. Also see below notes 15, 19; otherwise, "the new fountains and cascades at the Trocadéro, and the very fine grotesque heads by Legrain" were cited in Henry Turner, *The Society of Arts, Artisan Reports on the Paris Universal Exhibition of 1878* (London, 1879), 221.

12. Since in 1878 the scandal over the *Age of Bronze* was still unresolved, Rodin would have welcomed the favorable publicity "Legrain's *mascarons*" received. However, it was not to be. See Bartlett, 1889, cited in Elsen, *Rodin: Readings*, 38. Rodin's account is confirmed by Déroy-Férat, *Les merveilles de l'Exposition de 1878* (Paris, 1879), 770, where we learn that Legrain was granted a "médaille d'or" as a "diplôme d'honneur équivalent à une grande médaille."

13. Bartlett, 1889, cited in Elsen, *Rodin: Readings*, 38.

14. Alhadeff, "Michelangelo and the Early Rodin," 368.

15. See Viollet-le-Duc, "Les bâtiments de l'Exposition Universelle de 1878, le palais du Trocadéro," *L'Art* 15 (1878): 121–135.

16. ". . . ces deux mascarons, avec quelques autres ornements, servent de clefs aux arcades de la fontaine monumentale . . . et sont faciles à retrouver." Georges Grappe, *Catalogue du Musée Rodin, L'Hôtel Biron* (Paris, 1927), 29. The dimensions of the Musée Rodin *mascarons* are 55⅛ x 29½ x 21¼ in.

17. According to the files of the *Conservation du Musée des Arts Décoratifs* in Paris (which the Museum personnel kindly allowed me to examine in the fall of 1967), Legrain donated the *mascarons* in 1878. They are numbered consecutively from 36 to 45 with nos. 37 and 38 entitled *Le beau temps* and *Le mauvais temps*.

18. *Le palais du Trocadéro, le nouveau palais, les dix-huit mois de travaux* (Paris: A. Morel and Co., 1878). This book can be found in the city library of Paris.

19. The link with mannerist sculpture was first observed by Elsen, *Rodin*, 15. Better than our own reproductions, Elsen, *Rodin*, 15, reproduces one of our *mascarons* to its best effect.

20. Anonymous, "Grotesque Heads by M. Legrain," *The Magazine of Art* 4 (1881): 186–188.

21. For Giovanni da Bologna and the *Isolotto* see John Pope-Henessy, *An Introduction to Italian Sculpture*, vol. 3 (New York and London: Phaidon, 1970), 77ff. Naturally, in any discussion of mannerist *invenzione*, one cannot forget the gaping mouths of Federico Zuccaro's windows and doorway of the Palazzo Zuccaro on the Via Gregoriana in Rome. For a cogent discussion of Rodin's stay in Italy, see Albert E. Elsen and J. Kirk Varnedoe, *The Drawings of Rodin* (New York: Praeger, 1971), 42ff.

22. Sander Pierron, "François Rude et Auguste Rodin," 160, states that "la partie ornementale du socle" was fashioned by Jules Pecher. If this is true, then perhaps all of our *mascarons* are by Pecher, not to mention Legrain—a conclusion which is patently absurd. Moreover, Pierron himself acknowledges Pecher's mediocrity: he was an "artiste médiocre qui, ayant fait de la peinture sans aucun succès, avait abordé la statuaire sans s'imposer d'avantage." Keeping his "sèche et puérile" work in mind (the "Liberty" from the *Loos Monument* is a prime example) one must conclude that he was incapable of the caprices which our *mascarons* and the grotesques at the base of the *Loos Monument* display.

23. The photograph was kindly brought to my attention by Professor Elsen in 1979 and published by him the following year. See Albert E. Elsen, *In Rodin's Studio: A Photographic Record of Sculpture in the Making* (Oxford: Phaidon Press in association with the Musée Rodin, 1980), 45.

24. Elsen, *In Rodin's Studio*, 162.

25. See J.W. Buel, *Beautiful Paris: A Portfolio of Photographs. The Splendors, Mysteries and People of the Great City* (Boston: E. Gately and Co., 1894), pl. 79. I must kindly thank Professor John Gregoropoulos of the University of Connecticut at Storrs for sharing this photograph with me.

26. Lawton, *Life and Work*, 50.

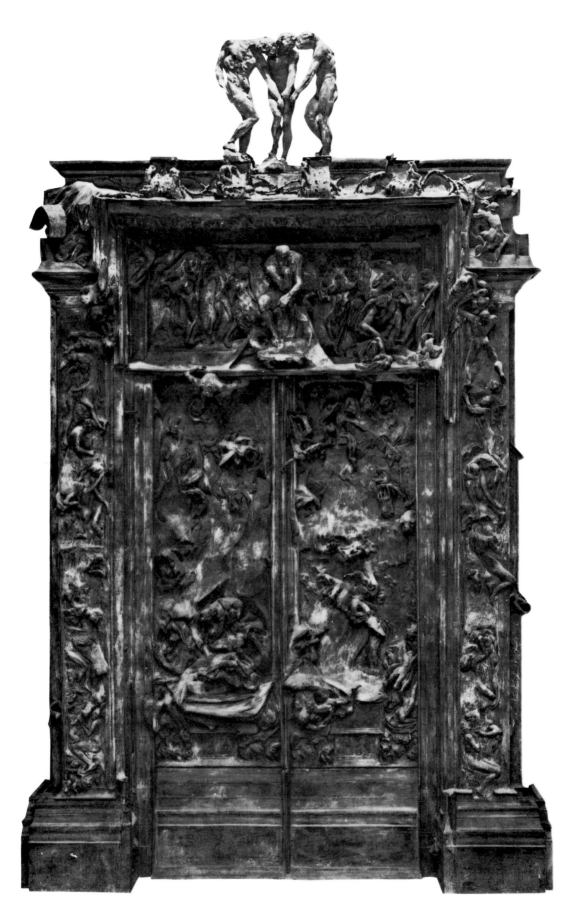

3.1 *The Gates of Hell.* Bronze. 24½ x 13 ft. Musée Rodin, Paris.

3. *The Gates of Hell: What They Are About and Something of Their History*

Albert E. Elsen

Rodin's tragic vision of modern life expressed in *The Gates of Hell* began as the interpretation of a medieval literary epic (fig. 3.1).[1] For the year that followed his commission by the French government in July 1880 for a sculptural portal to go to a new Museum of Decorative Arts, it was Rodin's idea that the *Gates* were to be about Dante's *Inferno*. We can still see this source in several sculptures and areas of the doors: *Paolo and Francesca* and *Ugolino and His Sons* in the lower left door panel (fig. 3.2); *The Three Shades* atop the portal; perhaps *The Thinker* as Dante (fig. 3.3); and less obvious motifs such as figures grappling with a serpent in the upper left door panel and those emerging from or falling into caves and sinking into soft substances (fig. 3.4). Some of the portal's topography evokes the infernal landscape of Dante.

In 1881, Rodin unsuccessfully proposed to the government that he flank the doors with life-size, free-standing statues of Adam and Eve. Even in the preliminary drawings of 1880, themes from the *Inferno* were to have joined with humanity's parents, thereby stressing the legacy of original sin. Other Biblical allusions were added at unknown dates, including plummeting and battered angels and the severed head of John the Baptist, high in the upper external right side of the gateway (fig. 3.5). Pagan mythology and Christian allegory were fused to the old epic. A centaur, for example, in the left relief pilaster dates from before 1884 (fig. 3.2), and a siren in the base below that pilaster was done before 1889. In 1899, Rodin placed the broken-winged figure of *Fortune* above the tomb at the lower left, and the two tombs in turn replaced reliefs in which at least one centaur was present. "The Dance of Death," enacted in the tympanum behind *The Thinker* (fig. 3.3) and realized by 1884, may have introduced another aspect of medieval Christian thought, unless it was a free interpretation of Dante's damned souls coming before Minos for assignment to the circles of Hell. When Rodin exhibited figures isolated from the portal, beginning in 1883, they were often baptized with such ancient references and

mythological titles as *Fallen Caryatid, Danaë, Andromeda, Psyche and Amor,* and *Fauness.* In the first years of work Rodin had begun to create a personal religion and mythology based on his awareness and understanding of the Christian and non-Christian past. Such an unorthodox admixture may have been possible because, in the words of his academically trained colleague Jules Dalou, "Rodin had the luck not to have been at the Ecole des Beaux-Arts!"[2]

Although Rodin's preliminary drawings for the portal in 1880 had stressed a series of panels containing episodes from Dante, when he actually began serious work in clay he found this traditional narrative format inhibiting.[3] He told the American sculptor Truman Bartlett before 1889, "There is no intention of classification or method of subject, no scheme of illustration. . . ."[4] The turning point in what the *Gates* are about and Rodin's decision not to illustrate but improvise came by the artist's own reckoning when he moved away from his drawings inspired by Dante and confronted life. He told a writer, "I lived a whole year with Dante, drawing the eight circles of his Hell. At the end of the year, I saw that while my drawings rendered my vision of Dante, they were not close enough to reality. And I began all over again, after nature, working with my models. I abandoned my drawings from Dante."[5]

It was almost at the project's beginning, when Rodin studied men and women, posed and unposed, that an awareness of his time and the relevance of Baudelaire's *Les Fleurs du Mal* (*Flowers of Evil*) worked their way into *The Gates of Hell.* Though probably not the literal inspiration for what Rodin did, Baudelaire's pessimistic view of the trials of the modern spirit was its poetic articulation and confirmation. The *Gates* were seen by Rodin's contemporaries as being both timeless and about modern life. In 1889 Gustave Geffroy observed their "changeless humanity." Félicien Champsaur wrote about Rodin's reading Baudelaire in the studio where the *Gates* were taking form, and James Huneker later wrote, "This

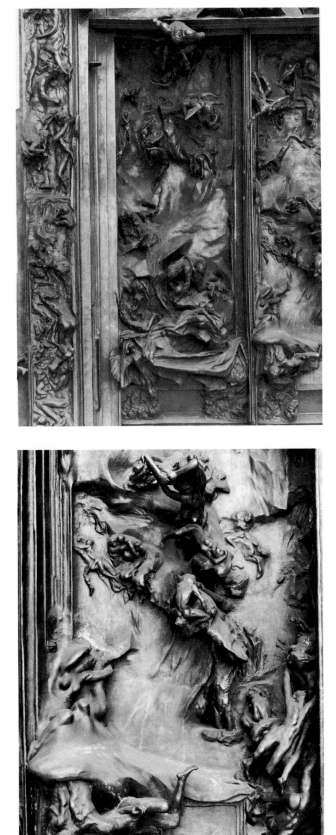

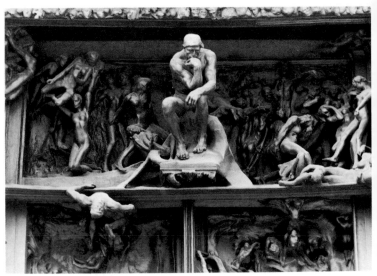

top left: 3.2 Detail of *The Gates of Hell* showing part of the right and all of the left door panels, and most of the left exterior bas-relief. Musée Rodin, Paris.

top right: 3.3 Detail showing the upper section of *The Gates of Hell*, the tympanum area, with *The Thinker.* Musée Rodin, Paris.

bottom left: 3.4 Detail of *The Gates of Hell* showing the lower half of the right door panel. Musée Rodin, Paris.

bottom right: 3.5 The upper right external portion of *The Gates of Hell.* Musée Rodin, Paris.

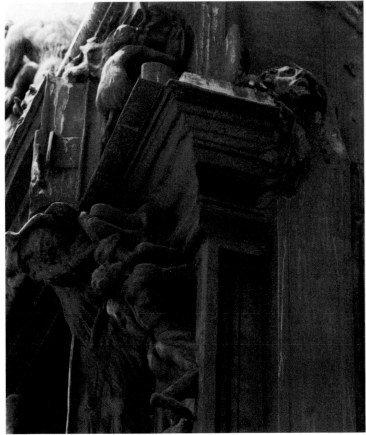

Gate is a frieze of Paris as deeply significant of modern inspiration and sorrow as the Parthenon frieze is the symbol of the great clean beauty of Hellas."[6]

The "reality" of which Rodin spoke to Bartlett meant attaining formal as well as thematic credibility. After *Adam* and *Eve* and *The Thinker*, his figures have no conscious paraphrase of previous postures in art. Like many of the routinized movements or "habitudes" of Degas's sculpture, those Rodin modeled from life, which are usually more psychologically and emotionally motivated, derive from their time and place.[7] Rodin's genius was in finding and shaping "new truths" about the body from his Parisian subjects that were both of his era and eternal. It was when Rodin was working in clay from nature and carving stone that he came to understand what he had read in great writers such as Dante and Baudelaire.

Rodin's sensibility was of his time and not outside of it. *The Gates of Hell* are unthinkable in thirteenth-century Amiens, fifteenth-century Florence, seventeenth-century Rome, or twentieth-century New York. He did not see himself apart from society or as its prophet. Although he had chosen a popular literary theme acceptable to his commissioner and well known to the public, at least by the end of the first year's work Rodin felt sufficiently confident in his own vision and skill that he could later say to Bartlett, "It has been from the beginning and will be to the end, simply and solely a matter of personal pleasure." Rodin was essentially a reactive artist who allowed himself to be acted upon by experience. The *Gates* had "no intended moral purpose" but are Rodin's compassionate commentary on the moral cost to society of the decline of orthodox religion and the addiction to materialistic values. The crucial connection he discovered between subjects from the past and present was suffering: the eternal and internal punishment inflicted by unsatisfied passions. By adding the tombs in 1899, Rodin more explicitly related his conception of life to life after death. The horror was that it would be no different: past, present, and future are a continuum, without hope of spiritual peace. The portal's fractured families, disillusioned lovers, solitary men and women groping and turning inward are of any period and every place. Rodin affirms that the past lives in us. The *Gates* are about Rodin's bridging his consciousness of the then and now. He was a modern rather than contemporary artist because he did not moralize or take sides in topical issues but preferred to strive in *The Gates of Hell* for an image of society as a whole.

Even more than Rodin's self-portrait in relief on the inside base of the right pilaster (fig. 3.6), *The Thinker*

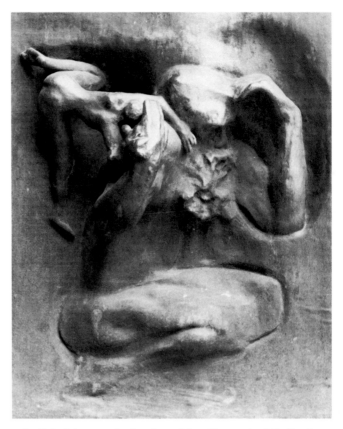

3.6 Relief showing God and possible self-portrait of Rodin, lower right section of the portal's base (not completely visible in 3.1).

reflects the artist's position in society.[8] The artist-poet has replaced Christ in the seat of Judgment, but he has the power neither to condemn nor to save souls from their personal hells. The tense solitary stillness of *The Thinker* dramatizes the effort of concentrated thought required to comprehend human tragedy and create a poetic art that expresses it truthfully. Commitment to this impossible task, like the passionate strivings of those around him, is the artist's private inferno. Above *The Thinker* and those around and below, Rodin placed a thorn vine, a crown of thorns for the artist and suffering humanity.[9]

The *Gates* move us today not primarily because they are a poignant late nineteenth-century commentary on humanity's spiritual dilemma, but because of their artistic power. As Rodin personalized his project he became less self-conscious about its having a literary base and conveying a message. His artistic instincts took command, and *The Gates of Hell* became above all a work of art in which Rodin sought unprecedented formal unities between sculpture and architecture.

3.7 Preliminary study for *The Gates of Hell*, 1880. Ink. Musée Rodin, Paris (6956).

3.8 Preliminary study for *The Gates of Hell*, 1880. Ink. Musée Rodin, Paris (6937).

3.9 Preliminary study for *The Gates of Hell*, 1880. Ink. Musée Rodin, Paris (6940).

How the Gates Came About

In the great drawing collection of the Musée Rodin are three previously unpublished sketches for the overall design of *The Gates of Hell* which must date from 1880 (figs. 3.7, 3.8, 3.9). These drawings confirm the obvious, that when he accepted such an ambitious project for which he had no previous experience, Rodin counted on Ghiberti's *Gates of Paradise* as a Renaissance proto-type.[10] That Rodin always conceived of a large figure or figures surmounting the portal connects his work with Gothic tympana and Italian sources.[11] In the early sixteenth century, Ghiberti's first baptistery doors had placed above them Jacopo Rustici's composition of *John the Baptist Preaching to a Levite and Pharisee*. The juxtaposition of these three large freestanding figures above the much smaller ones in relief must have impressed Rodin when he saw them in 1875, for by at least 1884 *The Three Shades* had been substituted figuratively for Rustici's trio and were in place atop the *Gates*.

3.10 Preliminary study for *The Gates of Hell*, 1880. Ink. Musée Rodin, Paris (6948).

Two of the three drawings (figs. 3.8, 3.9) show Rodin's cryptic but graceful notations for the life-size involuted figures of Adam and Eve that were to flank the doorway. (I read them as Adam to our left and Eve to our right.) If the government had agreed to their casting, the outsize scale of *The Three Shades* and *The Thinker*, in relation to other figures within the doors, would not be as prominent as it is today.[12] While we do not know exactly

when before 1884 Rodin decided to place the *Shades* atop the portal, a fourth, previously published drawing (fig. 3.10) suggests that in 1880 the idea of at least one large, if not life-size, figure in that position had occurred to him. The *Shades* may have come into being after the 1881 rejection by the government of the proposal for the flanking life-size statues, as they are close variants of Adam.

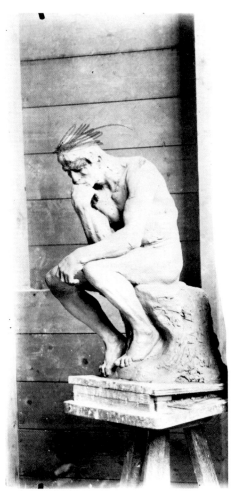

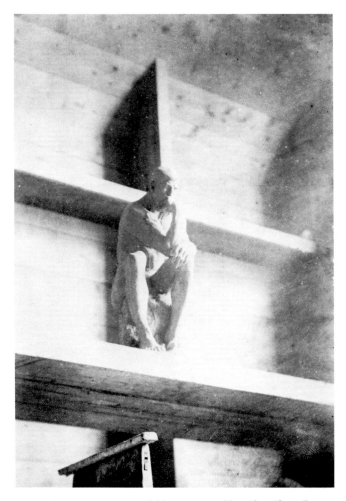

3.11 *The Thinker*, 1880-1881. Clay. Photo Pannelier or Bodmer? Albumen print with pencil notations. 9½ x 4½ in. Musée Rodin, Paris (PH 1355).

3.12 *The Thinker* (on a scaffolding), 1880-1881. Clay. Photo Pannelier or Bodmer? Gelatin silver print. 5¾ x 4 in. Musée Rodin, Paris (PH1370).

Of lesser importance to Rodin in the first three drawings is the exact number of panels for the door, and the artist may never have actually decided how many and which episodes to interpret. The drawings show the same indecision as to shape: either single panels or a triptych. In two drawings the panels are wider than they are tall. In the third they are more vertical, suggesting that they might have contained only one figure or couple each, like the last modeled architectural sketch in which the lower portions of the left and right door panels are occupied exclusively by Paolo and Francesca and Ugolino respectively. Overall, these sketchbook notations show that Rodin was not concerned with particulars, but with the general conception, the biggest elements of architecture and sculpture, and their relationship to one another.

While there are later and more developed architectural sketches, we have not as yet found working drawings (if indeed they existed) from the time in late 1880 or early 1881 when Rodin had the first actual wooden frame of the doors constructed.[13] We now have a good idea of what that original frame looked like and can understand why drawings, at least detailed drawings, may not have been required. This information comes from old photographs taken in Rodin's government-owned studio at the Dépôt des Marbres in late 1880 or in 1881, when Rodin was actually modeling *The Thinker* and his Ugolino group in clay (figs. 3.11, 3.12).[14] For the camera he posed these sculptures in front of what looks like a wall of horizontal pine planks and vertical joists; in fact, this is the first wooden armature of *The Gates of Hell*. Although we cannot see all of this framework, what is visible indicates that it was of simple design which could have been rigged by Rodin and his assistants or a professional carpenter. Within a plain rectangular frame, the two doors had recessed undivided areas above their bases and terminated at the top in a lintel. The cruciform design of the portal came with the vertical divider between the two door panels, which continued up through the

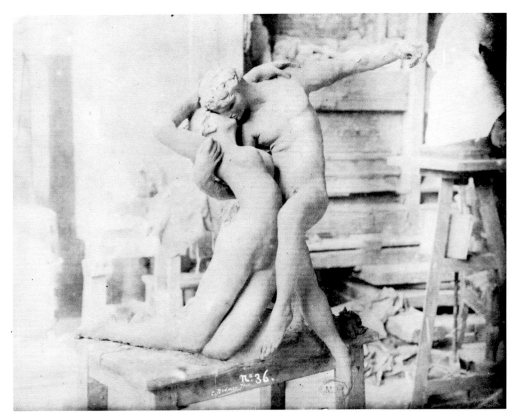

3.13 *Eternal Spring (The Gates of Hell* in wood and clay in the background), 1881? Clay. Photo Bodmer. Albumen print. 7½ x 9½ in. Musée Rodin, Paris (PH1389).

lintel area (fig. 3.12). The back wall of the lintel, or tympanum area, curved upward and came forward to meet the top cornice. The two sides of the doorway were simple vertical planks about one foot wide. The door panels seem to have been recessed only about six inches, much less than the thickness of the Ugolino group posed in front of them. The vertical center board in the tympanum left no room for *The Thinker* in that location. Old photographs show this clay sculpture raised for viewing from below on a scaffolding in front of the wooden frame, but not situated at its center. We know that in the early months of work on the *Gates*, Rodin toyed with the idea of putting *The Thinker* in front of the doors at ground level and so noted on a recently discovered old photograph of a plaster *Seated Ugolino*, the formal ancestor of *The Thinker*.[15] From photographs it is hard to judge the size of the wooden framework. In 1881 Rodin indicated to the government that the portal would be "at least 4m50 by 3m50 in size."[16]

While Rodin's lowliest *garçon d'atelier* in 1880–1881 would have known, today we are still searching for information on just how, for example, the physical background of the *Gates* was modeled. We know the figures were generally modeled separately from the doors, but not how they were mounted on them. The figures in the side reliefs were often the exception, probably modeled as reliefs on a horizontal surface before being vertically installed. Another old photograph, this one taken of *Eternal Spring* while in clay, shows in the background what is unquestionably the lower section of the portal (fig. 3.13). What we can see suggests that clay may have simply been applied directly to the rough wooden planking, after which it could have been removed and replaced by plaster casts. (On this point Truman Bartlett's 1887 notes for his Rodin articles, now located in the Manuscript Division of the Library of Congress, contain the unpublished sentence, "The whole thing was first modelled in clay and cast, in pieces, in plaster.") The portal's base shown in this photograph, while possessing more profiling and relief than what we see today (fig. 3.14), does have a section, just below the middle, that comes close. Rodin could have built up the molding of the base simply by the addition of planking. It is also possible that the first wooden framework for the door of 1880–1881 might have been used only for Rodin to work out his ideas on the architecture, in Bartlett's words as the "large first sketch," and to test the scale of his figures, and that he had to build or rebuild a larger and deeper one when he began the montage of the sculptures on the portal. When he had developed his ideas for the tympanum, which we know from its surviving plaster model was made apart from the door,

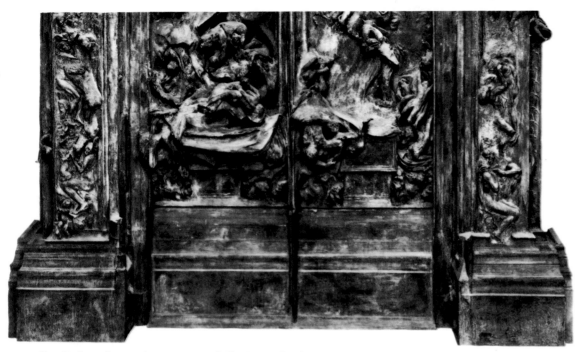

3.14 Detail of 3.1 showing lower section of *The Gates of Hell*. Musée Rodin, Paris.

Rodin would have been required to rebuild the entire upper section of the original doorway frame.

Between late 1880 and 1884, Rodin must have completed much of what we see today in *The Gates of Hell*. By June of 1884, he had progressed to the point where he could ask the founder Eugène Gonon, who had made some casts for him in 1883, to estimate the cost of reproducing the portal in bronze by the lost wax method.[17] On 15 June, Gonon replied that he had approximated the weight of the door to be "four thousand kilos" (roughly half of what the bronze *Gates* weigh today) and that the cost for the work would be 40,000 francs. In the event that the state furnished the metal, estimated at 8,000 francs, the cost would be reduced to 32,000 francs for the "good execution" by Gonod. In 1885 the Bingen Foundry gave an estimate of 35,000 francs for casting, a figure that the government accepted and set aside in Rodin's account, indicating that this foundry was to do the work.[18] From the estimated weight and Rodin's earlier approximate measurements, it would seem that by 1884 the *Gates* were about two-thirds their present height if not overall size. (As we know them today, the *Gates* measure 7.5 x 3.96 meters.) Presumably the founders' estimates were made from a substantially mounted portal. Although the *Shades* are unmentioned, Octave Mirbeau confirms this in the first detailed description of the portal published in *La France*, 18 February 1885. (The *Shades* were mentioned in 1886 by Félicien Champsaur.) It seems the size of Rodin's portal was never determined

by the architect in charge of the new Museum of Decorative Arts, which in fact was never built as planned on the site of what is today the Gare d'Orsay. In 1885, Octave Mirbeau wrote, "It is not known whether the *Gates* would be set inside or outside the new Museum."[19]

Rodin may have believed in 1884 that he was so close to completing the commission that he could compete for a major new assignment in good conscience. In October, he was successful in obtaining the commission for a monument to the Burghers of Calais (which to all intents and purposes he would complete by 1889). As a possible sign of his confidence, on 23 July 1884, Rodin entered into a contract with an architect named Nanier for a sum of 2,400 francs to work on the architecture of the doorway. The Musée Rodin files do not show Nanier's receipts for all of this amount, but in a letter of 24 February 1885, the architect complains that as of 31 December 1884, he had received only 1,000 francs out of a total of 1,424 francs incurred in expenses. Thereafter, receipts show that Nanier received only a few hundred more francs. We do not know what this architect was to receive as an hourly wage, but Rodin's most skilled assistants were getting about one franc an hour at the time. Even at four times that sum, Nanier would have put in a considerable number of hours on the architectural details. The interesting unanswered question is just how much of the architectural design we see today was devised by Nanier in consultation with Rodin and how much by the sculptor himself. Further evidence suggests that the

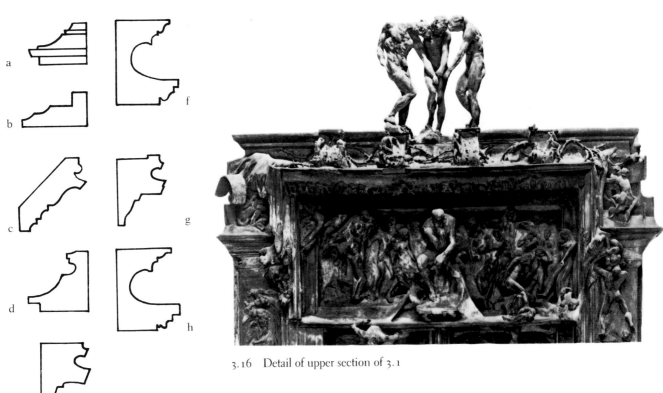

3.16 Detail of upper section of 3.1

3.15 Tracings after marginal drawings on a bill to Rodin from Guichard for carpentry work done in connection with *The Gates of Hell*, 1884.

a. "2 moulures au sapin 0.12 sur 0.13 à l'outil detaché, de 1.00"
b. "Cadres en sapin 0.65 x 0.12 à l'outil detaché"
c. "Cadres volants en sapin 00.41 sur 0.15, à l'outil detaché"
d. "2 moulures en sapin 0.12 sur 0.13 à l'outil detaché, de 1.00"
e. "Moulures en sapin 00.6 sur 0.15 à l'outil detaché"
f. "Chapiteaux ou moulures sapin 0 13 x 0 14 à l'outil detaché"
g. "Moulures en sapin 006 sur 0 15, à l'outil detaché"
h. "Chapiteaux ou moulures sapin 0 13 x 0 14 à l'outil detaché"

answer to the first question is, little if any, and to the second, most if not all.

There is a long and detailed bill in the Musée Rodin archives from an entrepreneur named Guichard, simply dated 1884, but presumably coming at the end of the year, as was the custom, for work done at the Dépôt des Marbres. In the margins of this itemized account are sketches of the moldings and capitals executed by Guichard's carpenters in pine "pour un modèle de porte" (fig. 3.15). (The terms accompanying these sketches are "Moulures à l'outil detaché," "Chapiteaux," "Cadres volants," or "montants" and "traverses.") We cannot be sure if these details were designed by Nanier in 1884.

From his letter to Rodin cited above, there is a hint not only that Rodin was slow in paying the full account, but that he may not have been pleased with the architect's interpretation of his intentions. In addition, the sketched capitals and moldings do not accord with those in the *Gates* as we see them today. It is likely that Rodin found Nanier's designs too intricate or colorful. The external framing of the central panels and that of the flanking pilasters now looks as if it was made of simple flat wooden planks set at varying depths to each other. Similarly, much of the horizontal molding at the bottom of the central panels is achieved by a stepped arrangement of flat boards. The profiles of the cornices and bases below the side pilasters do not coincide with those in Guichard's invoice, and the former are much simpler in overall design (fig. 3.14). In the final portal the most intricate moldings are those which frame the upper sides of the tympanum but which are cut off and merge into winged figures and those at the very bottom which would have been their termination (figs. 3.5, 3.16). Old photographs indicate that these deep flanking moldings did exist at one time and ran continuously from tympanum to base.[20] The meager historical evidence recommends an evolution from the elaborate to the simple. For all of Rodin's study of older architecture and drawings of moldings, much of the final portal's frame consists of flat planes and relatively simple cornices and capitals. This simplification may have resulted from Rodin's intense and prolonged reflection on modifying the interaction of

sculpture and architecture. Rodin may also have wanted fewer references to period styles in order to achieve a greater effect of timelessness. As we now see the portal, and as it was in 1900, the only areas in which there is architectural inconsistency are the side moldings of the tympanum, their truncated equivalents below at the base, and the stepped pilasters on the external sides of the doorway. Rodin's only specific comments on the *Gates* that refer to its architectural deficiencies were written on a photograph taken in 1900 of the disassembled plaster portal at the Paris Exposition: "Moins grosses de dimensions. Les moulures plus incolorés, plus fines" (Less bulky dimensions, less colorful and more fine moldings) (fig. 3.17). Rodin may have regretted the three stage pilaster added to the right side, because it made the whole too broad.

To the extent that the French government's payments to Rodin for the expense of making the plaster model of the *Gates* tell us when, and how long and extensively he worked on it, it seems that the period of greatest activity before 1899 was from the summer of 1880 to the winter of 1888. The list of payments is as follows:

14 October 1880	2,700
27 January 1883	3,000
17 November 1883	4,000
22 August 1884	2,500
14 January 1885	2,500
20 July 1885	4,000
11 October 1886	3,000
31 March 1888	4,000
TOTAL	25,700

Rodin was never again personally to request funds from the government's account of 30,000 francs that had been set up for him, and it was not until July 1917 that the curator of his museum, Léonce Bénédite, asked for the remainder of the allocation.[21] Unexplained is why in 1900 Rodin did not ask for the 4,300 francs due him. By that time he had spent far more than 30,000 francs in working on the portal. Finally, it is probable that Rodin did little or no work on the project between 1888 and June 1899.

We have always known that Rodin prepared the entire plaster form of *The Gates of Hell* for its public première at the end of May 1900. There is in the Musée Rodin archives a large chart, done in pen and ink and titled "Porte de l'Enfer—Moulage—13 Juin 1899 à 1er Juin 1900," that was undoubtedly prepared by one of Rodin's secretaries. In addition to carrying the portal's title as we know it today, this document records the names of twenty

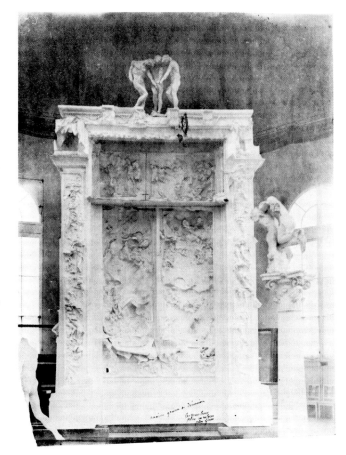

3.17 *The Gates of Hell*, 1900. Plaster. Photo Druet? Gelatin silver print. 10½ x 8 in. Musée Rodin, Paris (PH1383).

assistants, along with the exact amount each earned in two-week periods.[22] Eugène Guiochet, Jr., did the most work, a truly astonishing amount, and he must have been Rodin's most trusted assistant in making plaster molds from clay models. Four other Guiochet brothers— Gaston, Dieudonné, Auguste, and Ernest—also did work in varying amounts. Even assuming that Eugène Guiochet obtained one and one-half times or even twice the one-franc-an-hour customary wage, there were long periods when the column under his name showed bimonthly earnings of over 275 francs; and from March 1899 until the end of May, he was billing Rodin for well over 300 francs each period.[23] In one two-week stretch, 29 April–12 May, as the deadline for the show approached, Guiochet earned 410 francs. Ten-hour work days and six-day work weeks were the norm. Guiochet must have worked around the clock seven days a week. The labor cost of preparing the plasters of *The Gates of Hell* for the 1900 exhibition came to 32,438.85 francs. This expense, awesome for the time, was borne by the artist out of pocket. In addition he absorbed the even

greater costs of building his own pavilion, for example, albeit with the aid of private loans.

The obvious and important question is, on just what areas of the portal was all that work done? Rodin had repeatedly affirmed to the government and visitors, from 1884 on, that the project was near completion. We lack a photograph, not only of the fully assembled *Gates* before June 1899, but also of its frame alone without the sculptures in high relief, such as we have for June 1900 (fig. 3.17). What information we have from before 1899 comes from photographs of individual figures and couples, and drawings and lithographs made from photographs of parts of the door. There are two verbal descriptions which give us a rough sense of the former arrangement of the two door panels. We know that the architecture and much, if not all, of the sculpture were joined by 1885 when Octave Mirbeau wrote,

Each of the double doors is divided into two panels, separated by a group that seems to form a knocker. Ugolino and his sons on the right, Paolo and Francesca da Rimini on the left. . . . Above these groups Rodin has composed bas-reliefs from which figures and scenes detach themselves in varying degrees of relief. This gives his work extraordinary perspective. Each of the double doors is crowned with tragic masks, heads of furies, and the terrible or gracious allegories of sinful passions.

Below each group, there are still more reliefs. Centaurs gallop along a river of mud, carrying off women who struggle. . . . Other centaurs fire arrows upon the unfortunate who try to escape; women and prostitutes who collapse as they are carried away can be seen falling head-first into the flaming mire.[24]

Almost a year later, and as if he had read Mirbeau's article, Félicien Champsaur wrote,

Each of the doors is divided into two panels separated by a group: Ugolino on one side, Francesca da Rimini on the other. . . . Then, above them, countless furies, tragic masks, terrible and delightful allegories; and below, in a bas-relief, centaurs carrying off naked women who struggle or faint on their backs. The eternally damned try to escape from a burning river of mud into which exquisite prostitutes plunge as other centaurs rain arrows down on them.[25]

Either in 1887 or in 1899, Rodin seems to have moved the Ugolino group from the right to the left door panel and introduced in their place what we see today (fig. 3.2).[26] The two reliefs having symbolic grieving heads in their midst and flanked by rampant centaurs were removed and replaced by not only the tombs, but also the low reliefs of mothers and children that frame them. Directly above the tombs Rodin added the fallen figure of *Fortune* at the left and the couple known as *Avarice and Lust* at the right. What Mirbeau and Champsaur describe as "tragic masks" above the two groups from Dante may have been transferred to the tympanum's cornice, directly above the head of *The Thinker* (fig.

3.3).[27] In an old photograph in the Musée Rodin archives and the lithograph made from it that Bartlett reproduced in 1889, that cornice is shown devoid of sculptural decoration. (Otherwise, with a few exceptions, the central section of the tympanum and the cornice with its decoration above it and *The Three Shades* are as we see them today.) It is possible that Rodin entirely redid the upper portions of the two central door panels. Bartlett wrote that the size of the portal when he saw it was eighteen by twelve feet, two feet less than their present height, minus *The Three Shades*. His unpublished notes say that the *Gates* were in a "barnlike studio," thirty feet square and "high in proportion" and that they "reached nearly to the ceiling." It seems likely that Bartlett may have been underestimating the portal's height by a few feet and that it had reached the size we see today. It is also possible that in reworking the door panels, Rodin modified the architectural framing. Although made before 1889, two other possible additions may have been the reliefs of the *Siren* and Rodin's self-portrait on the inside panels of the bases below the side pilasters. That these additions—the tombs, the reliefs of mothers and children, the *Siren*, and the sculptor's own portrait— were made by and not after 1900, is confirmed by photographs taken in 1899–1900 of parts of the *Gates* and the full frame without high relief figures of 1900 (fig. 3.17).[28]

If indeed Rodin did not make a new cast of the entire portal (which seems likely), part of the expense incurred by Rodin's assistants in April and May of 1900 could have resulted from cleaning, if not polishing, the plasters for public presentation and from the dismounting of the figures in high relief in preparation for shipment to Rodin's pavilion. From a photograph showing just the lower half erected in the pavilion, we know that for transport, the great doorway was cut into at least two horizontal sections. The firm of Léon Autin, which also did much of Rodin's shipping, spent 509 hours between mid-May and June working on the installation of sculpture and the construction of bases and scaffolding. The wooden platform on which the portal stood and the wooden armature behind it were built in that period at a cost of 161.20 francs. Unfortunately, the exact date of the *Gates'* delivery to the pavilion does not show in Autin's accounts. Judith Cladel wrote in 1914:

The day of the opening arrived before the master had been able to have placed on the *fronton* [the tympanum] and on the panels of his monument the hundreds of great and small figures destined for their ornamentation.[29]

Rodin had been tremendously busy for weeks before June

first, having more than 150 sculptures and a large number of drawings moved and installed, and he seems to have misjudged the amount of work that had to be done.

The arrival of the *Gates* at the pavilion, presumably just before the public opening, may have meant that Rodin did not have the time for his assistants to build a scaffolding and remount the sculptures in the portal. To have done this after the opening (considering how much he had at stake) would have been disturbing to visitors and might have offered ammunition to his critics. Rodin had many other major works in the exhibition, including his plaster *Monument to Balzac*, which he was anxious for the public to see under the best conditions. Then there is another explanation, compatible with the foregoing. Judith Cladel later wrote that when the show opened, "The artist felt worn out from overwork." As for *The Gates of Hell*, Cladel was of the opinion that it was not reassembled because "he had seen it too much during the twenty years in which it had been before his eyes. He was tired of it, weary of it."[30] It is also likely that Rodin, the perfectionist, was extremely sensitive to critical comments about the denuded portal and was further disinclined to have Guiochet and the others reassemble it.[31] At the exhibition's end, he knew the *Gates* would have to be moved again, hence dismounted, either to go back to the studio or to Bingen for casting.[32]

Are the Gates Complete?

The big question that still confronts us is whether Rodin regarded the plaster model of *The Gates of Hell* in 1900 as complete or incomplete. Would he have spent so much of his own money and effort to show his work of twenty years to the government and public without its being ready for casting? The *Gates* were surely viewed by officials. It was certainly known to the sculptor in 1899 that the Museum of Decorative Arts was housed in the Marsan Pavilion of the Louvre. Rodin did, in fact, meet with one of its architects, Georges Berger, who seems to have been connected with the projected museum from 1880. On 10 January 1901, Rodin told a reporter for the *L'Echo de Paris*, named Le Nain, "A few months ago, M. Georges Berger asked me to go to the Pavilion de Marsan in order to study the place that would be suitable for my door. But I believe that the official architects show little enthusiasm for the project. And when the officials don't want it, there is nothing to do. It is a 'camorra,' (a cabal of Neopolitan malefactors) like that which killed Carpeaux."

Rodin thus did not put Berger off by pleading that his work was unfinished, but Berger may have been put off

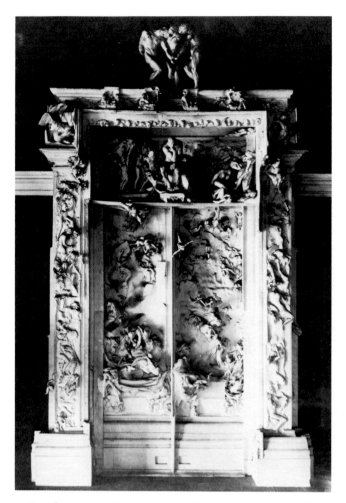

3.18 *The Gates of Hell*, as assembled by Bénédite in 1917. Plaster. Paris, Musée Rodin. Photo taken in late 1917 or early 1918.

by, among other things, the *Gates'* twenty-three foot height, which would have caused severe problems architecturally were it to have been integrated into the museum's exterior. Whether or not Rodin assembled the plaster in his pavilion did not really influence Berger's rejection. From Rodin's written note on the photograph of the portal, it would seem that he wanted modifications, but this was a reaction typical of the artist to his own work seen in photographs. He often drew possible changes on the prints themselves, but as often as not no alterations were made to the work itself. Rodin would even occasionally sell an expensive marble sculpture with some of his graphite editing marks still on it, to the annoyance of at least one client. All this is by way of saying that if casting of the *Gates* had been called for, Rodin would probably have complied, with or without modifications.

The posthumous bronze casts of *The Gates of Hell* were made from molds taken off a new fully assembled plaster of the portal that stood in the Musée Rodin chapel at least from late 1917 (fig. 3.18). (The plaster model

3.19 Detail of *The Gates* in plaster at Meudon at the time of Rodin's death. This detail shows how Rodin marked by numbers where the figures in high relief were to be reattached for final assembly.

shown in 1900 remains at Meudon.) This second, full plaster model was not personally assembled or directed by Rodin before his death in November 1917; it was done under the direction of the museum's ambitious first director, Léonce Bénédite (fig. 3.19).[33] This reassembly was begun in the spring of 1917, and in July, Bénédite wrote to the government asking for the remaining 4,300 francs in Rodin's account, adding that all of the parts of the portal had been found and assembled. The money was to cover the cost of the *montage*. We know that from some time in 1916 until his death, Rodin was physically incapable of doing even the smallest amount of work with his hands, due probably to a stroke. Although he had the legal power to do it on his own, Bénédite presumably had Rodin's permission to effect the *montage* so that the *Gates* in plaster could be featured in the new Paris Rodin Museum at the Hôtel Biron. On

the basis of what we have learned these past few years, it is my judgment that Rodin did not make a single change or modification in *The Gates of Hell* after May 1900. What we now see are the *Gates* as they looked when Rodin had them prepared for his great exhibition.[34]

This still does not answer the question of whether or not Rodin believed that he had done all he could on the portal and considered the work complete, if not finished by conventional standards. That he did not reassemble them in 1900 or when they were moved again in 1901 argues that he still had reservations about either the architecture, the sculpture, or both. A project as unprecedented, of such magnitude, undertaken over a twenty-year period by an artist for whom the idea of "finish" was anathema and who always saw other ways of extending his art, could never have been realized to Rodin's permanent and total satisfaction. ("And were the

cathedrals finished?" he would say.) In my judgment Rodin was ninety-nine percent satisfied with what he had done, and his dissatisfaction focused on the problems of modifying the architectural frame and its coordination with the sculpture. After 1900, he usually spoke in the past tense about what he had done in the *Gates*, such as showing all that could be gotten from movement in sculpture.

Even though Rodin's project was not accepted for the Marsan Pavilion, the government still owned it and made one more recorded inspection of the portal at Meudon in 1904 in order to find out when it might be ready for casting. The National Archives dossier on Rodin contains reference to a brief report by a Mr. Morand, a member of the Commission des Travaux d'Art. As there was no indication in the dossier or the report of where the bronze door was to go, it is reasonable to believe the government had no plans for it. Morand was sent on a routine inspection tour of all government sponsored projects, not just Rodin's, as part of the government's demand for an accounting of funds being held for various artists. On 9 February 1904, Morand reported that the work at Meudon was "advanced," but that its author had "manifested the intention of making diverse modifications" and he did not foresee its completion "before three or four years." In August of 1885, the government had set aside 35,000 francs for the portal's casting, but in 1904 it was decided that this sum could no longer be withheld from other projects. The Ministry of Public Instruction and Arts therefore annulled the 1885 award, while in principle maintaining the commission and Rodin's obligation to supervise the eventual casting. Another award for casting costs would be considered in future. It was this financial annulment that delayed the casting of *The Gates of Hell* in bronze after Rodin's death until Jules Mastbaum commissioned casts first for his new Rodin Museum in Philadelphia and then for the Paris Musée Rodin. There was never any question of Rodin's repaying the government, acquiring all rights to the plaster model, and then casting it for himself. [35]

Rodin had an idea of carving and casting the *Gates*. Henri Frantz wrote in 1898, "The artist's dream is to have the jambs carried out in marble and the two doors in bronze." In the Musée Rodin archives is a sketch on thin paper, as well as a cost estimate. The frame, tympanum, and *Three Shades* were to have been carved in marble at an estimated cost of 96,000 francs. The door panels were to have been bronze. There is no date on the rough sketch, which is really a tracing of a photograph made of the reassembled portal in the chapel of the Musée Rodin around the end of 1917 or early

1918. This argues that Bénédite made the request and possibly the sketch, probably after Rodin's death.

The Form of the Gates

What contributes to the conviction that to all intents and purposes *The Gates of Hell* were complete by May of 1900 is another remark Rodin made to Le Nain in the interview of 10 January 1901:

As for me, I am indifferent to whether the door is here or there. I have wanted to give a new interpretation to bas-reliefs, a work where the decorations are a part of the ensemble and give, by the play of light, a variable diversity to the sculptural motifs. I hope to have succeeded in this. And that alone interests me. The administration that commissioned and paid for the door will take it to Meudon, . . . and will place it where it desires.

Le Nain concluded, "And the master smiled again with a great deal of serenity."

By "decorations," Rodin meant the architectural frame, particularly its moldings, capitals, and bases, if not also the background for the sculpture. Their function was not only to serve as a stable container or foil for sculptural movement but also to help vary the light and shadow cast on the sculptures as the sun moved. When we understand this purpose, we can comprehend why, for example, the vertical moldings which frame the two central panels are of varying depths and are not continuous but cut back at certain points. If Rodin had kept these moldings consistently as deep as they are at their base, too much shadow would have obscured the central panels, accentuating the "holes" for which Bourdelle criticized the work. The moldings were treated somewhat like Rodin's partial figures: they were hybrid *montages*, edited or simply removed when they did not provide Rodin with the total effect he desired. The simultaneity of different styles for the moldings is comparable to the simultaneity of disparate modes in his figural sculptures, discussed in my essay "When the Sculptures Were White." Rodin loved to compare architectural moldings from past styles to the profiles of the human body, and he conceived of architecture in a sculptural as well as human sense. Close study of the two capitals atop the flanking pilaster reliefs shows that in the one on the right Rodin changed part of the neck of the capital, filling in what was curved in its counterpart to the left (fig. 3.16). He kept the unforeseen and accidental in his architecture, such as the downward sag of the top of the portal caused by the weight of *The Three Shades*, just as he did in his sculpture.

Rodin's objective for his reliefs and their relation to the decorative frame was one he had shared with Truman Bartlett in the late eighties: "My sole idea is simply one

of color and effect." This goal constitutes a daring modern vision of decorative unity—a subordination of detail and consistency in the part to the requirements of the overall aesthetic effect. Rare was the visitor to the studio who commented on the *Gates* and was *not* bewildered or overwhelmed by their complexity—the number and beauty of the disassembled components which inhibited seeing the work as an aesthetic totality. Such were the habits by which viewers "read" art that most sought stories and links to Dante or their own society rather than attempting an analysis of the overall design. Rodin's refusal to reassemble his portal after June first, 1900, may have resulted from the view that as it was, the work had a greater breadth and unity of form.

Rodin's goal may have been inspired by his study of late Gothic cathedrals and Renaissance sculpture, but as we see in the final arrangement, he had no specific precedent for the decorative unity he sought. Once he determined in 1880 to break with a traditional episodic treatment of the doors, Rodin committed himself to a heroic improvisation on an epic scale. It was to be a composition in which the architecture was neither expressively passive nor totally separate from the sculpture. As in baroque compositions, figures spill over the frames, cling to or push off from them. As in medieval art, architectural framing might terminate in human forms or the wings of an angel. As in early medieval manuscripts and Romanesque sculpture, a framing feature might be cut away to accommodate a foot or hand, as at the bottom of the bas-relief of the right pilaster.

Although not derived from impressionism, Rodin's mode of overall composition recalls certain late impressionist compositions, notably Pissarro's urban pictures of the nineties seen from above, in which unity is the result of overall spotting and averaging of densities of lights and darks, projections, and recessions. Those large uninhabited planes in the central door panels, for example, are crucial to contrasts between dense and open and allow the composition to breathe rather than strangle from congestion. It is far easier for us today, after our experience with abstraction, to read the great portal as a total arrangement.

What provides interest in the composition are the changes in scale, ranging from the largest figures, the *Shades* and *The Thinker*, down to forms only a few inches in height. These changes give vigor and surprise, variety and interest, to complement ingenious and inspired coherence. Rodin's myopia has often been cited as a cause of his failure to complete large compositions successfully. (It is forgotten that he wore glasses.) Myopia, however, would have better allowed him to study the overall balance and the effects of light and shadow on the whole portal, as it would have screened out many details. For the same reason, he welcomed fading light in the studio to study the big planes and their relationships in his figural sculptures.

As much as his interpretation of his themes of anguish, despair, and striving, the unity of *The Gates of Hell* is personal to this artist and an achievement never adequately credited. He has been categorized since his own lifetime as the master of the fragment and not the whole. The composition of *The Gates of Hell* is one of his greatest audacities. The fabric of the unity is deceptive and seemingly casual, yet in reality calculated and complex: there is the conjoining axis, at once rectangular and cruciform, made by the overall architectural frame and *The Thinker* atop the juncture of the doors and the lintel, which is played against by the figures, randomly dispersed. Elsewhere twenty years ago I argued that just the overall figural arrangement was like the counterpoise of the *Shades* atop the portal (fig. 3.1).[37] To complete the figural analogies, the portal's design has a spine running vertically through the center of the doors, *The Thinker*, and the central *Shade*. The figures were not arranged from a single viewpoint, but rather a roving perspective, as if one were free to view the work from a number of vantage points, including above the ground. Similarly, the physical background of the reliefs was made pliable to Rodin's thought and each motif attached to it. This ground could be hard or soft, rocklike or vaporous, topographical or abstract (fig. 3.4). Rodin dared to create a world free from traditional laws of joining and viewing. There was no preexisting space except in the stagelike tympanum. Rodin's figures, their relationships, and the distances between them establish these functional spaces. Thematically and formally, the *Gates* have an atomized character in large part, but in terms of form this profusion of particles is also read against the stable, continuous framing of the moldings. All are in a delicate balance that creates the impression of thematic disarray but disciplined artistic order. When Rodin spoke of driving his art further, included was the challenge to find an artistic harmony appropriate to the qualities of his thematic chaos. In the late eighties, the sculptor Truman Bartlett studied the *Gates* and wrote that "the character of the design, in comparison with that of Ghiberti . . . is more original and varied." Bartlett and a few others saw the portal in terms of its extraordinary sculptural "color"—the effect which resulted from overall light and shade. Recent critics and commentators have been blind or indifferent to these aspects which together compose the work.

The *Gates* rank as one of the greatest imaginative works of art in history. Rodin insisted that he could not make drawing or sculpture unless he had something to copy. What he told Bartlett, however, about how he formed *The Gates of Hell* shows an awareness of his greatest gift: "I followed my imagination, my own sense of arrangement, movement and composition."

NOTES

1. For a more extensive interpretation of the history and meaning of the *Gates*, see author's *Rodin's Gates of Hell* (Minneapolis: University of Minnesota Press, 1960). (This book is being revised.) See also author's *Rodin* (New York: The Museum of Modern Art, 1963); John L. Tancock, *The Sculpture of Auguste Rodin* (Philadelphia: Philadelphia Museum of Art, 1976); Jacques de Caso and Patricia B. Sanders, *Rodin's Sculpture: A Critical Study of the Spreckels Collection, California Palace of the Legion of Honor* (San Francisco: The Fine Arts Museums of San Francisco and Rutland, Vermont: Charles E. Tuttle Co., Inc., 1977).

2. Judith Cladel, *Rodin: The Man and His Art* (London: The Century Co., 1918), 36.

3. I've discussed this situation in my book, *Rodin's Gates of Hell*, chapter 3.

4. Truman H. Bartlett, "Auguste Rodin, Sculptor," a series of articles that first appeared in *The American Architect and Building News*, 25 (1889), and which were reproduced in the author's *Auguste Rodin: Readings on His Life and Work* (Englewood Cliffs, N.J.: Prentice-Hall, 1965), 69.

5. This statement was given to the writer Serge Basset, "La Porte de l'Enfer," *Le Matin*, 19 March 1900.

6. Gustave Geffroy, "Le Statuaire Rodin," *Les Lettres et les Arts*, September 1889, 295; Félicien Champsaur, "Celui qui revient de l'Enfer: Auguste Rodin," *Supplement du Figaro*, 16 January 1886; James Huneker's view is expressed in his introduction to the book by Judith Cladel, cited above, xi–xii.

7. For a recent discussion of the difference between Degas and Rodin, see Kirk Varnedoe, "The Ideology of Time: Degas and Photography," *Art in America* (Summer 1980). Varnedoe contrasts Degas's paintings—not the sculpture—with Rodin's sculpture. I believe it is more difficult to make the case for the Degas sculptures as all representing "instances of behavior that locate the figure in society," and it may be an oversimplification to say that "Rodin seeks to show gestures that lift the figure out of time into universal psycho-emotional states." As discussed in my essay on Rodin's work in plasters, it can be countered that Rodin's art was capable of both the temporal and the timeless.

8. Credit for the identification of the artist's self-portrait inside the base of the right pilaster and its dating before 1889 belongs to Albert Alhadeff, "Rodin: A Self-Portrait in *The Gates of Hell*," *Art Bulletin* 48 (1966): 393–395.

9. The identification of this motif as a thorn vine was first made by John Tancock.

10. It was suggested by Jacques de Caso in his article, "Rodin at *The Gates of Hell*," *Burlington Magazine*, 106 (February 1964), that Henri de Triqueti's earlier nineteenth-century 10m high doors for

the Church of La Madeleine in Paris, which show the Ten Commandments, was a possible influence on Rodin's early thinking about his own portal. While this is possible, their austere neoclassic framing and sculptural style and shallow space was never to Rodin's taste. None of Rodin's contemporaries who had access to both portals, nor indeed the artist himself, even mentions Triqueti's work. Varnedoe has found a far more likely source that Rodin might have seen in Paris, Charles Percier's door which held eight bronze reliefs by A. Riccio and which was in the Louvre. "Early Drawings by August Rodin," *Burlington Magazine* (April 1974): 197–202.

11. On his 1875 trip to Italy, Rodin undoubtedly saw Jacopo della Quercia's relief sculptures flanking the main doors to San Petronio. Above the doors are the free-standing and larger figures of the Virgin enthroned between saints. As Rodin contemplated placing *Eve* atop his portal, he may also have had the Bolognese example in mind.

12. A few years ago the Musée Rodin administration installed the statues of *Adam* and *Eve* on the portal's flanks. Because of the installation of the doorway on a stepped podium, the flanking statues cannot be placed sufficiently close to them, in my view, but overall one can gain a sense of what Rodin had in mind by this installation.

13. In the vast archives of the Musée Rodin, there may yet turn up a carpenter's account for this project.

14. These invaluable old photographs, taken in Rodin's lifetime and under his supervision, are in the archives of the Musée Rodin in Paris. I have published a large number of them in my *In Rodin's Studio: A Photographic Record of Sculpture in the Making* (Oxford: Phaidon Press in association with the Musée Rodin, 1980).

15. See author's *In Rodin's Studio*, 158–159 and fig. 7.

16. See author's *Rodin's Gates of Hell*, 67. Documents and correspondence pertaining to this commission can be found in the Rodin file at the National Archives in Paris.

17. Musée Rodin archives, dossier on Eugène Gonon.

18. National Archives, Paris, dossier on Rodin.

19. Judith Cladel wrote concerning the proposed museum, "The new edifice will allow a monumental portal having a highly decorative effect." *Rodin, Sa Vie Glorieuse, Sa Vie Inconnue*, Edition Définitive (Paris: Grasset, 1936), 137. We cannot be sure that Cladel actually knew that the *Gates* were to be the entrance to the museum or whether she just surmised it. Mirbeau was writing only five years after the commission in his article "Auguste Rodin," *La France*, 18 February 1885. Mirbeau's article and many others have been translated and anthologized in Ruth Butler's excellent *Rodin in Perspective* (Englewood Cliffs, N.J.: Prentice-Hall, 1980), 45–46.

20. One such photograph is reproduced in my *In Rodin's Studio*, fig. 95. In his 1885 article Mirbeau describes what are presumably the main vertical moldings: "It is framed by two exquisite moldings whose style belongs to the vague and captivating period that is no longer Gothic but not yet Renaissance. . . ."

21. On 18 May 1917, Bénédite wrote: "In 1880 M. Rodin was commissioned by the Fine Arts Administration to produce the model of *The Gates of Hell*, inspired by Dante's 'Divine Comedy,' originally intended for the Museum of Decorative Arts. The fee to be paid for this model was 30,000 francs and M. Rodin received 25,700 francs of this total. This work, while in a sense it could be said to have already been delivered to the State, in the studios of the Dépôt des Marbres, had remained unfinished, and M. Rodin had not put in a claim for the balance of the sum contracted for. Today . . . I have the honor of informing you that I have had the various parts that compose *The Gates of Hell* assembled in their entirety, in a completed form, in the choir of the chapel of the Hôtel Biron, and I therefore respectfully request, in the name of M. Rodin, the settlement of this balance, amounting to the sum of 4,300 francs." The letter is in the National Archives, and its translation is given in Robert Descharnes and Jean-François Chabrun, *Auguste Rodin* (London: Macmillan, 1967), 96. As his government-owned studio was rent-free, these payments would have covered models' fees; those of his assistants, carpenters, at least one architect; materials; tools; and other equipment. For the *Gates* Rodin never received any money for himself, which explains why, as late as 1882, he was working at an hourly wage for the Manufacture de Sèvres doing decorative art. Rodin had to rely upon the sale of his sculpture to private parties in order to support himself, his family, and the costs of several other studios he maintained from at least the mid-1880s. No sculptor could get rich as the direct result of government commissions or purchases, but the rationale was that the resulting prestige would bring clients to the artist who would want other casts or carvings of work purchased by the State. Rodin did, in fact, exhibit, cast, and sell figures from the *Gates*, starting in at least 1883.

22. The names that I have been able to decipher, in addition to those of the Guiochet family, are: Arrighi, Vimnera, Husson, Edmond, Raphael, Bandettini, Fromont, André Demont, Maguery, Tosi, J. Joseph, Pierre Detruy, Frédéric Paillet, Bongini. In the extensive dossier of Rodin's enlarger, Henri Lebossé, there are frequent references over many years to having Guiochet make plasters of the clay enlargements or reductions, and presumably this was Eugène.

23. The plaster mold makers should not have been paid as much as Rodin's skilled professional sculptor assistants who actually did modeling for him, so that the figure cited for Guiochet's hourly wage is probably a little high.

24. Butler, *Rodin in Perspective*, 47.

25. Butler, *Rodin in Perspective*, 49.

26. The indecision about the date of changing the position of Ugolino and his sons results from a contradiction between Bartlett's published articles on Rodin and his unpublished notes in the Library of Congress. In one of his articles published in 1889, Bartlett wrote, "The Ugolino group is the chief point of interest of the right-hand part of the door, and is placed on a line with the eye of the observer." (Bartlett in Elsen, *Auguste Rodin: Readings*, 74.) However, in his notes Bartlett wrote, "The lower part of the large panel on the left has for its chief part the terrible group of Ugolino and his sons. Immediately below are two figures, male and female lying horizontally. To the left of Ugolino are a crowd of figures falling, in every conceivable shape." Despite this contradiction, the reader is encouraged to read Bartlett's published account of the doors as it is the most extensive eyewitness description of the portal while it was being made. An extensive commentary on Bartlett's printed text and his notes will be presented in the forthcoming revision of my book, *Rodin's Gates of Hell*.

27. These "tragic masks" may have been depicted in a caricature of Rodin carrying *The Gates of Hell*, done in 1884 by Ch. Paillet. See de Caso and Sanders, *Rodin's Sculpture*, 126.

28. In a paper given at the 1979 International Congress on Art History, at Bologna, J.A. Schmoll argued that the portal was completed at the end of Rodin's life, based on the previously cited request of Bénédite and the view that the tombs and relief of Rodin's self-portrait were not added until long after 1900. (His paper will be published in the future as part of the proceedings of the International Congress.) Unfortunately, Schmoll did not have access to the materials on which this essay is based, nor had he seen the photographs in my

book, *In Rodin's Studio*, that appeared several months after he delivered his paper. His argument on the influence of Goethe on the reliefs of the women and children flanking the tombs, while interesting, has no basis in fact, as these reliefs were done before Rodin had read the essay in question. Further, it appears Schmoll did not read Alhadeff's article on the Rodin self-portrait, which could not have been based on Gertrude Käsebier's photo of 1908, as the relief was made before 1889.

29. Cladel, *Rodin: The Man and His Art*, 280.

30. Cladel, *Rodin: The Man and His Art*, 280.

31. I have discussed this subject in the chapter, "Why the Portal Was Not Completed," in my *Rodin's Gates of Hell*. Obviously, some of my 1960 views have been modified and changed by the information presented in this essay.

32. A vexing question is how many plaster models of the portal existed in 1900? It appears that the one shown in the 1900 pavilion went back to the Dépôt des Marbres, where it may have served Bénédite when in 1917 he had the whole reassembled in a new cast, subsequently on view in the chapel of the Musée Rodin in Paris.

33. Bénédite insisted that the montage was done under "the master's direction," but from what we know of Rodin's health, this is extremely doubtful. If the montage was done at the Dépôt des Marbres, it is even more doubtful, as Rodin was very much restricted to Meudon the last year of his life. Bénédite, *Dante: Mélanges de Critique et d'Erudition Françaises* (Paris: Librairie Française, 1921), 32. The first director of the Musée Rodin was not a paragon of truthful reporting, according to Rodin's more reliable long-time friend and biographer, Judith Cladel. In an article that appeared 16 December 1917, in *Le Courrier de la Presse*, one month after Rodin died, we read: "M. Bénédite and Mademoiselle Judith Cladel work without rest to arrange the Musée Rodin. They have begun by restoring the chapel of the Hôtel Biron where a selection of the master's works will be installed. They will set up a plaster cast of the *Porte de l'Enfer.*" In the article Bénédite makes no mention of Rodin having given the authorization for or supervising the assembly of the portal. In fact, the article states, "During Rodin's last days, M. Bénédite gathered in the studio of the rue de l'Université, all the *morceaux* of the *Porte de l'Enfer*, and he was greatly surprised to notice that the monument was complete. It was not lacking one piece. It was a question of joining together and superposing the parts of the portal in order to see it set up in its radiant ensemble." Surely, if Rodin had initiated the final assembly, his first director would have so indicated to the world in 1917 rather than in 1921. Bénédite took a large number of initiatives without Rodin's knowledge and consent, and, ethics aside, he seems to have had the legal authority to do so. Disturbing evidence of Bénédite's meddling with Rodin's arrangement of *The Gates of Hell* is given by Judith Cladel when writing with bitterness during the years 1933–1936 about the last weeks of Rodin's life and the insensitive removal of the artist's sculpture from Meudon to Paris: "Some of Rodin's scandalized assistants who cast his plasters made it known to me that charged with the reassembly of *The Gates of Hell* they received orders to place certain figures in a different arrangement than that which the artist wanted, because 'that would be better,' or because the figure of a woman representing a spring (*une source*) 'must not have the head below.' 'The sense of the cube (*la raison cubique*) is the mistress of things and not appearances,' Rodin used to say. But does a shockingly brusque functionary have the time to mediate on such an axiom?" (*Rodin, Sa Vie Glorieuse et Inconnue*, 397.) Cladel's clear accusation is that Rodin no longer had any say in what happened to his portal and that Bénédite was taking uncalled

for and insensitive liberties with its reconstruction. "La raison cubique" refers to Rodin's view that one should imagine a well-made sculpture as existing within a cube.

34. This is why it would not have been difficult for Bénédite to have Rodin's assistants reassemble the project. As further evidence, consider Rodin's statement made in 1917 to Gustave Coquiot: "Will I finish the *Gates* some day? It is improbable! Nevertheless, I would need only a few months, perhaps two or three at most to finish it. You know that all the casts are ready, labeled for the day when I am asked for the final conclusion. But will this day ever come? The government would have to pay me more money. . . . Bah! I have dispersed a little everywhere the details of my *Gates*; it is perhaps well so! Consider, to finish the *Gates*, it would have to be cast in bronze and about a hundred thousand francs would be necessary. Do you think the government would grant this to me?" Coquiot, *Rodin à l'Hôtel de Biron*, 103, quoted and translated in de Caso and Sanders, *Rodin's Sculpture*, 128. With regard to their dispersal, Rodin may have been referring to parts of the *Gates* being at the government studio, and others at Meudon.

35. Judith Cladel incorrectly reported that in 1904 Rodin returned the money received from the government, thereby making it his property, but then he willed it to the State before his death. Cladel, *Rodin, Sa Vie*, 141. Schmoll correctly pointed to this error in his Bologna paper.

36. Henri Frantz, "The Great New Doorway by Rodin," *Magazine of Art* (September 1898).

37. See the chapter "Methods and Style," in my *Rodin's Gates of Hell*, especially 83–84.

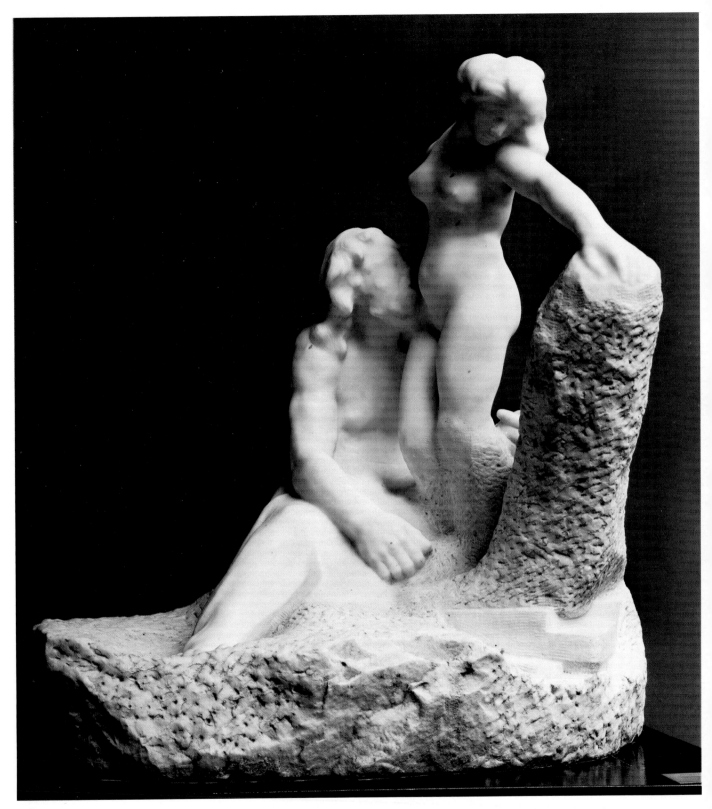

4.1 *Pygmalion and Galatea*, 1910. Marble. The Metropolitan Museum of Art, New York. Cat. no. 158.

4. Rodin's Carved Sculpture

Daniel Rosenfeld

In the twilight of his career, during his conversations on art with Paul Gsell, Rodin gave a discourse on the science of modeling that bears upon his feeling for sculpture in marble. Standing before an antique marble copy of the *Venus di Medici* that he kept in a corner of his studio for inspiration, in the darkness of late afternoon, Rodin lit a lamp and held it close to the statue, revealing the marble's subtly nuanced surface:

'Is it not marvelous?' he cried. 'Confess that you did not expect to discover so much detail. Just look at these numberless undulations of the hollow which unites the body to the thigh. Notice all the voluptuous curvings of the hip. And now, here, the adorable dimples along the loins.'
He spoke in a low voice, with the ardor of a devotee, bending before the marble as if he loved it.
'It is truly flesh!' he said.
And beaming, he added: 'You would think it moulded by kisses and caresses!' Then, suddenly laying his hands on the statue, 'You almost expect, when you touch this body, to find it warm.'[1]

This sensuous encounter recalls the myth of Pygmalion, subject of a marble sculpture carved by Rodin at this time (fig. 4.1). Like the mythical sculptor inspired by love for the statue he carved, Rodin, caressing this antique marble, could almost feel "the pulse-beat stirring where he moved his hands," as though the sculpture had just come to life.[2]

Rodin's comments before this sculpture betray his fondness for the life-evoking quality of marble. He also intended by this example to show the correctness of his own methods, which he described in his discourse to Gsell:

'Instead of imagining the different parts of a body as surfaces more or less flat, I represented them as projectures of interior volumes. I forced myself to express in each swelling of the torso or of the limbs the efflorescence of a muscle or of a bone which lay deep beneath the skin. And so the truth of my figures, instead of being merely superficial, seems to blossom from within to the outside, like life itself.'[3]

Rodin's salient contribution to sculpture in his time was to revive the sensation of "life" in an art that had grown moribund under the influence of a sterile academic ideal. Modeling was the lifeblood of Rodin's art; clay was its marrow. Rodin modeled clay, however, in view of its eventual transformation into plaster, bronze, or marble. Among the various materials of his art, it is clear that Rodin had a decided taste for marble: the catalogue of Rodin's carved sculpture includes no less than 285 individual works covering 173 distinct subjects.[4] The sculptor spent large sums of his fortune on the collection of Greek and Roman marble antiquities. It is also clear that Rodin's marble sculpture was essential to the formation of his public reputation as well as his success within the official art establishment. The marble works were not principally the product of Rodin's late years, as is sometimes maintained, but played an important role in his formative years as well as the period of his early maturity. Throughout his career, they were highly visible to the public; they were the object of major commissions; they were not limited to one aspect of his art but encompassed all genres including monuments, life-size groups, nudes, and portraits. Rodin's first successful entry in the Paris salon, the *Man with the Broken Nose* of 1875 (fig. 4.2), was a marble sculpture derived from a plaster fragment that had been rejected from the salon eleven years earlier. The lesson of this small success was not lost upon Rodin, who continued to exhibit his marble sculpture with great frequency to rather constant critical acclaim. In the official Paris salons alone he exhibited more than twenty-five marble sculptures between 1885 and 1917.[5]

The Nineteenth-Century Taste for Marble

The importance of marble sculpture in the shaping of Rodin's career is suggested by its place in his work of the late 1880s, the period of crystallization for his art and artistic reputation. In 1886, in the first major exhibition of works from *The Gates of Hell* at the Galerie Georges Petit, Rodin exhibited four marbles described by Gustave Geffroy as "esquisses réalisées en marbre" (figs. 4.12,

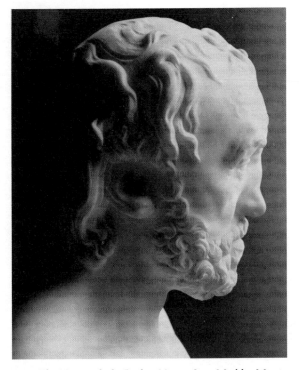

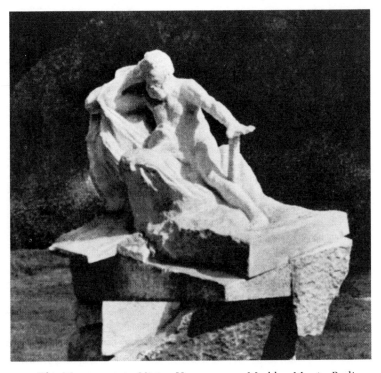

4.2 *The Man with the Broken Nose*, 1875. Marble. Musée Rodin, Paris.

4.4 *The Monument to Victor Hugo*, 1901. Marble. Musée Rodin, Meudon.

4.14).[6] The rough-cut, *non-finito*, sketchlike carving style that Geffroy suggests with this phrase became the most distinguishing characteristic of Rodin's marble sculpture, which challenged conventional norms of finish and decorum. *The Kiss* (figs. 4.9–4.11), also derived from the *Gates*, and exhibited in a small bronze with Georges Petit in 1887, was commissioned in the following year by the French government to be carved in a life-size marble, destined for the Musée du Luxembourg. This was Rodin's first official marble commission, as well as his first commission for a life-size marble group. Rodin submitted the marble bust of *Mme. Vicuña* (fig. 4.26) to the Salon of 1888, from which it was purchased by the state for the Musée du Luxembourg. In 1889, in the Monet-Rodin exhibition at the Galerie Georges Petit, Rodin exhibited five more marble works.[7] The *Danaid* (figs. 4.18, 4.19), perhaps the most exceptional of these, was also submitted by Rodin to the Salon of 1890, evidently at the last minute, for it was not listed in the catalogue, and it too was purchased for the Luxembourg. These two sculptures are visible in an old photograph of the Luxembourg, where they were displayed face to face along the central aisle amid the preponderance of academic marbles (fig. 4.3). Also in 1889 Rodin was commissioned by the Ministry of Beaux-Arts to execute a *Monument to Victor Hugo* in marble for the Panthéon (fig. 4.4). Hugo was one of France's most celebrated

heroes, and thus this was a commission of unusual importance. When his *maquette* for the monument was rejected by the beaux-arts committee, Rodin created another design for the Panthéon and negotiated a second commission for his original design to be placed in the Luxembourg Gardens.[8] In the same year Rodin won the commission for the *Monument to Claude Lorrain* offered by the city of Nancy; the sculpture included the larger than life-size marble pedestal, in high-relief, of *Apollo Bringing Light to the World* (fig. 4.5). Rodin's *maquette* was selected over examples by Barrias, Delaplanche, Marqueste, Saint-Marceaux, and Bartholdi, and he received 45,000 francs for the monument's completion.

In the nineteenth century there lingered a strong aesthetic and ideological preference for marble as a sculptural material, even while the use of plaster and bronze dramatically increased because of the relative ease and economy with which they could be reproduced. The nineteenth-century Larousse maintained in its article on sculpture: "White marble is *par excellence* the appropriate medium for the sculptor; it is better suited than any other material for the execution of flesh; it is more transparent, limpid, and brilliant."[9] Henry Jouin echoed this opinion in his *Esthétique du Sculpteur*: "It alone has the density of human modeling without hardness. Smooth to the touch like flesh, soft and transparent to the eye, it is marble that, while not being alive, will give

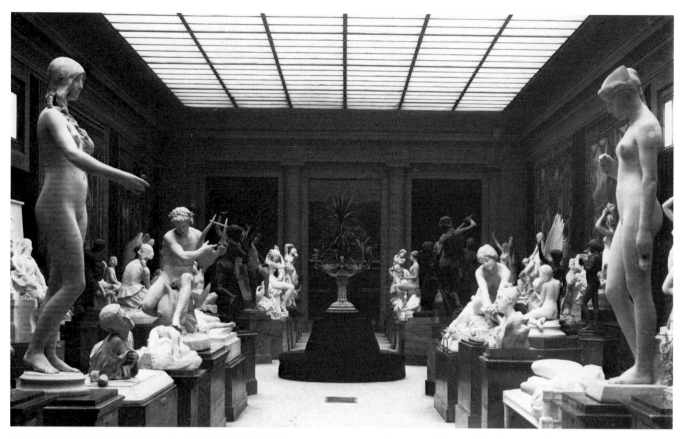

4.3 Sculpture Gallery of the Musée du Luxembourg, c. 1900.

4.5 *The Monument to Claude Lorrain*, 1892. Bronze and marble. Nancy.

in the most perfect way the illusion of life."[10] Jouin particularly admired the optical effects produced by the color and texture of marble, prompting him to ask rhetorically: "Where does the work of art begin? Where does the ray of light end?"[11] Sculptor Eugène Guillaume, director of the Ecole des Beaux-Arts, similarly praised the virtues of marble. Noting the "mysterious bonds" that link inert substance with expression, Guillaume described the monumental and stabile qualities that are the expressive effect of marble. Anticipating characteristics of Rodin's marble style, he observed that a marble figure seems inseparable from its base, whereas a bronze seems merely to rest upon it, adding: "Light and shadow harmoniously fuse along its pure white surfaces and they blend with the material that admirably reproduces the transparency and suppleness of tissue."[12]

Rodin evidently partook of these preferences at the same time that he reshaped them to his own expressive

left: 4.6 *Sleep (The Muse)* (detail), c. 1911. Marble. Private Collection.

right: 4.7 *Sleep*. Plaster. Musée Rodin, Meudon.

ends. In *Sleep* (fig. 4.6), the seeming fusion of the figure and its atmosphere and, simultaneously, the inseparability of the figure from its base, are exploited by Rodin to evoke this woman's mental drift. The composite plaster model (fig. 4.7) predetermined the subject's outward gesture of sleep. The internal sensations of withdrawal, weightlessness, and self-absorption, however, are uniquely conveyed by the marble—its transparency, limpidity, and brilliance, its cohesion and compactness, qualities lacking in the original plaster. These same qualities are apparent in works of his early maturity such as the *Danaid* (fig. 4.18) and *Mme. Vicuña* (fig. 4.26), as well as in late works like the portraits of *Mme. de Noailles* (fig. 4.28) and *Lady Sackville-West* (fig. 4.29). Indeed, Rodin need not have been swayed by conservative theory and prevailing good taste to have found in marble a substance well-suited to his original artistic concerns. The bright crystalline quality of marble, its translucence, its softness to the touch and to the eye, its ability to carry transitions between tones in soft gradations without harsh shadows suited perfectly Rodin's concern with the vital simulation of human flesh. Furthermore, as an artist

who was intensely sensitive to his place in the history of sculpture, and who envisioned himself, in opposition to the Ecole, as the true link with sculpture's past, Rodin found in marble a material that placed him squarely within the tradition of the Greeks and Michelangelo, and it is within this context that the classicizing features of the marble *Man with the Broken Nose* (fig. 4.2) may be understood.

There is no doubt that Rodin saw himself, as Leo Steinberg has observed, as a "Michelangelesque titan who imposes his will upon stone" (fig. 4.8).[13] It is also likely that the importance of Rodin's marble sculpture was augmented in his public's estimation by virtue of the material's identification with the past paragons of sculptural achievement, the majority of which survive in marble. Thus to his critics, and no doubt to himself, Rodin's links with the past were perceived as a source of his modern greatness. He was described by Gustave Geffroy as the one sculptor who could "maintain tradition and affirm the future."[14] Léonce Rosenthal, upon the death of the artist, praised him as a "revolutionary" who was at the same time "a great traditionalist."[15] Camille

4.9 Salon of the Société Nationale des Beaux-Arts, 1898, with the *Monument to Balzac* and *The Kiss*.

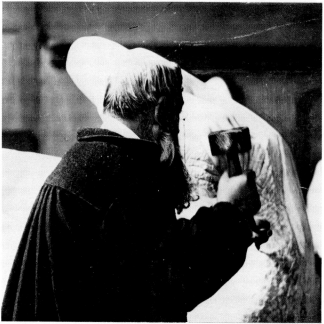

4.8 Rodin carving the marble sculpture *Ariadne*.

Mauclair similarly described him as an artist in isolation who "concludes one century and opens another, restores tradition and prejudices the future."[16]

The Salon of 1898

The mediating role between the past and the future that was served by the marble sculpture was perhaps at no moment more conspicuously and self-consciously demonstrated than at the 1898 Salon of the Société Nationale des Beaux-Arts. In the penultimate salon of the century, the plaster *Monument to Balzac,* Rodin's most audacious and challenging sculpture, was exhibited opposite *The Kiss,* certainly one of the most empathically comprehensible of the artist's mature productions (fig. 4.9). The marble dominated the center of the colonnaded circle circumscribing the axes of the exhibition space, where by its isolated situation at the hub it was designated the *clou* of the exhibition. Significantly, the *Monument to Balzac* was located on the outer circumference of the colonnaded central space, standing physically and symbolically apart from the pristine *Kiss.* Rodin, at that time president of the sculpture section of the Société Nationale, was no doubt responsible for the situation of the two works. Although he would later describe the *Balzac* as "the result of my entire life, the very pivot of my

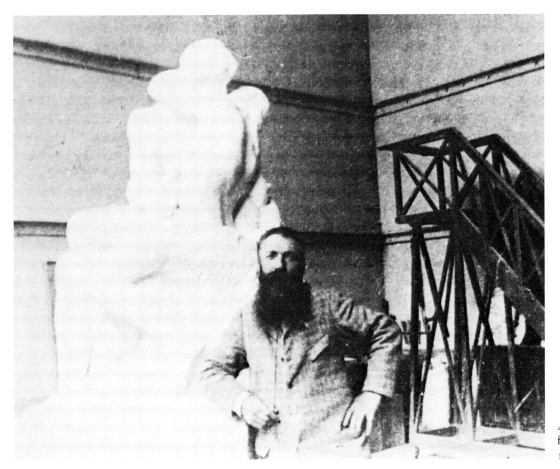

4.10 Rodin standing before the marble *Kiss*, c. 1898.

aesthetic," he chose the marble *Kiss* as the literal pivot of this salon.[17]

The placement of *The Kiss* was designed to alleviate some of the controversy that had for so long been stewing around his *Balzac*. *The Kiss*, described by Mauclair as a representation of Rodin's "ancienne manière," revealed the degree of finish and erudition in the rules of art that Rodin could exercise when he chose to.[18] It served to dispel the facile accusations that the *Balzac* was a product of artistic ignorance, and as Mauclair observed:

To give a discreet and silent lesson to the public, to colleagues and to critics, to show them the distance that has been traveled, and to assure them that, at his age, in his esteemed position, to so modify all the principles of his work, the artist has yielded to causes that are profound.[19]

By comparison to the *Balzac*, *The Kiss* is indeed a conservative work. It is a bit reductive, however, to explain *The Kiss* as little more than a counterpoint to the *Balzac* and a salve for conservative indispositions. Rodin posed proudly before the group (fig. 4.10) and no doubt took seriously a work derived from *The Gates of Hell* and destined for the Musée du Luxembourg, where it would be measured against statuary by the most eminent sculptors of the day (fig. 4.3). Indeed, the "unanimity

of praise" for this work, as it was characterized by Léonce Bénédite, suggests a degree of public acceptance that Rodin had not enjoyed in the previous decade when he first introduced his sculptures from the *Gates*. The public, Bénédite loquaciously observed,

[grew] gradually and unconsciously accustomed to innovations that it had previously condemned without pity.
 All of this trembling of flesh, all of this palpitation of life, this desire and agony, this thirst that cannot be satisfied [although] incessantly striving
 The impossible union of souls by their bodies, all of this mournful humanity . . . that seems to have escaped from the *Gates of Hell* . . . all of these creations that Mr. Rodin seems to have taken from the *Divine Comedy* in the company of Baudelaire, have only been accepted gradually and with difficulty.[20]

The positive reception of *The Kiss* in 1898, rather than demonstrating Rodin's concessions to conservative tastes of the time, may more accurately be understood to reflect the shift of those tastes to the standards of expression developed by Rodin in his work of the 1880s. "Trembling flesh" and "palpitating life," visible, for example, in the taut features of Paolo's back (fig. 4.11), are the result of the sculptor's energized modeling, which seems to blossom from within to the outside, like life itself. Vital

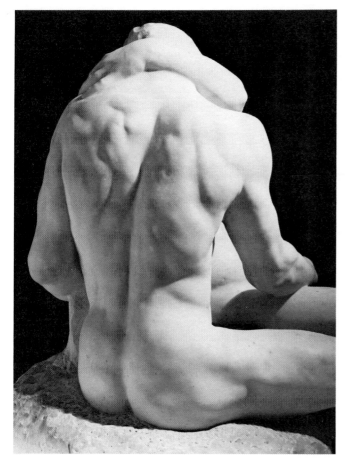

4.11 *The Kiss* (detail), 1898. Marble. Tate Gallery, London.

modeling combines with an unconventional grouping to convey a range of sentiments, inspired by Baudelaire, whose intensity, passion, and psychological honesty are far removed from the emotional languor of academic sculpture of the time.

With works such as *The Kiss*, Rodin had achieved a redefinition of sculptural beauty and expression. To one critic of the Salon of 1898 the marble *Kiss* could be described as an expression of "la vraie Beauté," and by this quality it was linked to the great sculptural tradition of the past:

Ever since the world was created, true Beauty has never provoked a 'new thrill.' There are no new thrills. From the great *Victory of Samothrace*, to Michelangelo's *Captive*, to Rodin's *Kiss*, the same rhythm gives a soul to all the masterpieces.[21]

Phrases like "la vraie Beauté" and "l'âme" are critical catchwords of nineteenth-century sculpture. Directed toward Rodin's art, however, they implied a separation from "la culte pur de la beauté," an academic tradition that included contemporary sculptors such as Dubois, Chapu, Mercié, Allar, Guillaume, and Barrias.[22] This "cult" was described by Léonce Bénédite, with no malice

intended (for he was the director of the Musée du Luxembourg, and thus the patron of their works), as a "disinterested art, detached from all contingencies of life," and evidence of this can be discerned among the marbles of the Luxembourg (fig. 4.3).[23] For Rodin, as for his advocates, it was not merely detached but rather comatose, an art of "practitioners and clever mongers," which was limited to "a few borrowed gestures that are repeated and hackneyed by everybody."[24] *The Kiss* revealed that beauty and soul need not preclude the expression of life, and this combination and reorientation of critical values provided the basis and substance for Rodin's artistic appeal. This resulted in what was described by Adrien Farge as "a new artistic formula" in which beauty is not simply the perfection of lines and forms, "but the expression of life caught by surprise in the eloquent manifestation of human passions in their violence and in their serenity."[25] Bénédite found the same quality in the marble *Kiss*, which "restored life to art by expressing new aspects of the human spirit."[26]

The 1880s and The Gates of Hell

Rodin's critics viewed his art as a whole. The restoration of "life" that was the core of his contemporary relevance was not distinguishable in their minds according to the medium in which he worked. They praised the same qualities in his plasters, bronzes, and marbles, in his most rudimentary sketches as well as his most polished and refined works of art. Essential to this perception was the interrelatedness that was the result of sculpture's capacity to be reproduced and transformed from one material state into another. Antoine Bourdelle, for example, who worked as an assistant carving for Rodin, made no distinction between media when assessing the talents of his master: "There has never been, there will never be a *maître* able to impose upon clay, upon bronze, upon marble the forms of tangible things with more profundity and intensity than Rodin."[27] Gustave Geffroy similarly emphasized the unity of Rodin's art, observing that his works "impose life upon plaster, upon marble, and upon bronze." Geffroy continued: "There is throughout the same fullness, the same passage of light, the same [treatment of] sculpture enveloped by its atmosphere."[28]

The modernity of the marbles was nonetheless apparent to Rodin's critics. Their perception of his role as the regenerator of modern sculpture can be seen in their responses to the carved work he exhibited in the 1880s. Octave Mirbeau, one of Rodin's earliest and most insightful defenders, reflected the tenor of praise for the

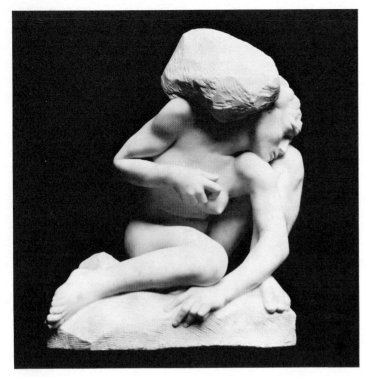

4.12 *Crouching Woman / Caryatid*, 1886. Marble. Museum of Fine Arts, Boston, Gift of the Estate of Samuel Isham. Cat. no. 155.

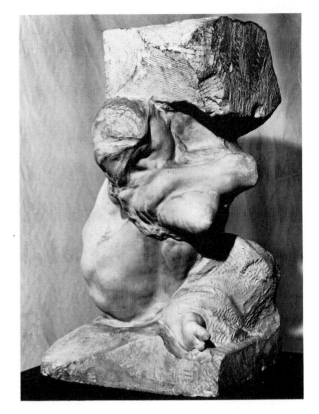

4.13 *The Fallen Caryatid Carrying Her Stone*, 1894. French limestone. The Andrew H. and Walter R. Beardsley Foundation, Ruthmere, Elkhart, Indiana. Cat. no. 153.

marbles when he wrote in 1889 of the artist and his sculpture exhibited that year at the Galerie Georges Petit:

Also the admirer of the beauty of the eternal antique form, the inventor of thousands of corporeal attitudes, the regenerator of the plastic tradition, he has been able, without violating the equilibrium of anatomy, in imposing new beauties upon art . . . not only to force marble to writhe with sadness and voluptuousness, he has also been able to force it to cry the supreme suffering of modern negation. . . .[29]

Mirbeau's reference to marble would be more idiomatic than specific, were it not that Rodin exhibited five marbles with Petit. His prose suggests the identification of Rodin's writhing marble sculpture with the moral malaise, pessimism, and anxiety associated with the progeny of *The Gates of Hell* and symptomatic of the *mal du siècle* endemic in these years. By emphasizing the correspondence between Rodin's art and the eternal beauty of the antique, Mirbeau stressed that Rodin had regenerated sculpture not by imitating the Greeks, but by providing a new notion of beauty and expression derived from modern experience. Emile Michelet, reviewing Rodin's works in 1886, commented upon the modernity of Rodin's marbles in terms that may have inspired Mirbeau, calling him the "ruler of stone" who "makes marble writhe beneath the impulse of the modern spirit."[30] In a review of 1888, symbolist critic Rodolphe Darzens, upon visiting the artist's studio, observed marble sculpture that had barely been carved ("ébauchés à

peine") which "only [gave] an impression, but how true and persistent, of life"[31] Reviewing the Monet-Rodin exhibition of 1889, Edmond Jacques praised Rodin's ability to express "passion, force, and life." Rodin, he observed, "is not afraid to push sculpture to the point of reality . . . following the interior sentiments or the inclinations of the spirit, and he has dared to deliver marble from its classic immobility. That is his crime; it is what the inveterate partisans of immobility will never forgive him."[32]

The expression of modern sentiments through the mobility of modeling and energized posture is apparent in carved versions of the *Fallen Caryatid Carrying Her Stone* (figs. 4.12, 4.13). The first example of this work, now lost, was shown in marble at the exhibition of the Cercle de la rue Vivienne in the winter of 1882–1883, and thus it is the first subject from *The Gates of Hell* to have been reworked into a freestanding marble and exhibited.[33] The sculpture bears little relation to the architectural caryatids that Rodin created in Brussels a decade before. Neither decorative nor functional, the *Fallen Caryatid* was conceived rather as an independent, psychologically expressive sculpture in the tradition of the freestanding nude. She is one among the damned

whose inner torment is reflected by her twisted posture and by the burden that she bears, which suggest a moral more than a physical oppression. Rodin has achieved this effect through the torsion of the figure's volumes which seem simultaneously energized and equilibrated. The figure is composed in opposing planes that move from side to side and front to back, as in the counterbalance of the knees, hips, and shoulders, or of the head and stony mass that the figure supports. This torsion conveys the *Caryatid*'s physical oppression, and at the same time evokes her struggle against it; the sculpture's drama and vitality emerge from this conflict. There is a dramatic effect also in the surface treatment of the various carved versions in which smooth yet tautly modeled flesh is set against the rough, pitted stone. This textural contrast further emphasizes the figure's muscular tension. When Gustave Geffroy observed the marble version of this sculpture exhibited with Georges Petit in 1886, he described the large stone that the woman carries as "rounded, worn, immovable, and heavy like Unhappiness."[34] Rilke similarly remarked that this figure "bears its burden as we bear the impossible dreams from which we can find no escape."[35] Both authors equate a physical condition with a modern state of mind that is essentially tragic. An open-ended subjective appeal and emotional directness are the qualities that defined, and continue to define, the relevance of such works.

Rodin's statue of *Eve* (fig. 4.14), like the *Caryatid*, is another fallen woman from *The Gates of Hell* developed by Rodin into a freestanding marble sculpture. The first marble version was carved between 1883–1886, and subsequently Rodin carved at least eleven additional examples, making it his most frequently reproduced marble sculpture. Like the *Caryatid*, *Eve* turns in on herself in a gesture of anguish. She seems to withdraw and push forward at the same time, creating a tension between backward and forward movement, as between the subject's past and future. In a state of perpetual development, like the *Caryatid*, she is animated through the appearance of her simultaneous submission and resistance to the laws of gravity. This tension between will and submission creates the tragic expression of "life" so frequently admired in Rodin's sculpture. Recalling the praise of Edmond Jacques of 1889, Rodin has here, as in the *Caryatid*, delivered marble from its classic immobility. No longer detached from the contingencies of life, its movement and emotional effect change with the viewer's physical relation to it in the round. Content is more a function of one's response to the physical properties of the sculpture, experienced in time, than to the subject as an end in itself.

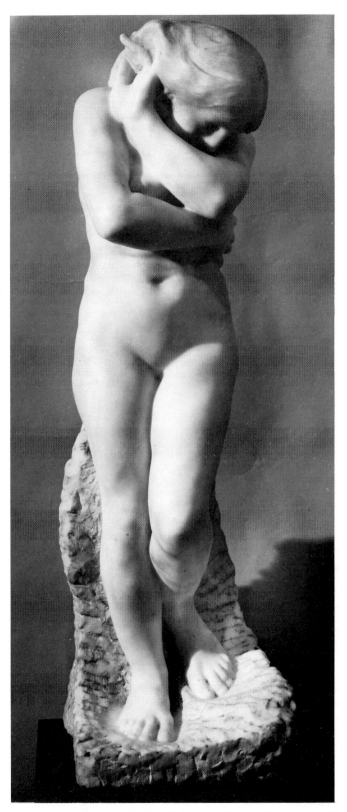

4.14 *Eve*, after 1900. Marble. Collection of Mr. and Mrs. James W. Alsdorf, Chicago. Cat. no. 149.

Rodin's Atelier

The multiple marble examples of *Eve* raise the question of originality and authenticity in Rodin's carved sculpture. The critical appreciation of the marbles in Rodin's time was not compromised by the well-known fact that he, for the most part, did not carve them. The many descriptions of the *maître* at work, surrounded by his corps of *mouleurs*, *metteurs au point*, and *praticiens* consistently emphasized the size of Rodin's atelier as an index of his artistic stature. Judith Cladel describes the atmosphere of work surrounding Rodin in his atelier, where one could hear the reverberations of the "dry blows of the practitioners' chisels carving the marble, smoothing the stone, beneath the downfall of white dust that made the room seem like a large hour-glass."[36] Such accounts of fervid industry in the production of an artist's work stand in sharp contrast to the image of the artist as an isolated genius whose work is created in a moment's heat of inspiration. Indeed, descriptions like Cladel's replace the solitary sculptor with one who was required to control the hands of many in the management of his atelier.

Rodin's atelier grew in proportion to his renown and the expanding demand for his work. Documentation in the Musée Rodin reveals the names of only three or four assistants who occasionally carved for Rodin before 1880; between 1880 and 1884 there were at least eight; over the next four years the number increased to at least twelve; in the 1890s more than twenty worked in his atelier; and between 1900 and 1910 nearly fifty individuals were involved with the execution of Rodin's marble sculptures. Some of these assistants were *metteurs au point*, employed for the initial measurement and roughing-out of the marble. Others were *praticiens* who executed the more advanced stages of carving. Most worked part time, when Rodin had a specific marble to be carved. Some, such as Jean Escoula, Victor Peter, Antoine Bourdelle, and Georges Mathet worked for Rodin over a long period of time, and were his most trusted assistants. Some, such as Escoula, Peter, Bourdelle, Despiau, Desbois, and Pompon, enjoyed considerable success in their own artistic careers at the same time that they carved for Rodin. Most were virtually unknown, earning their livings as artisans. Almost all were French; almost none were Italian stonecutters, contrary to popular myth.

The participation of numerous individuals other than the artist in the execution of his work is fairly typical in the history of art, and in the history of sculpture, even in the present, it is more often the rule than the exception. Sculpture is an art of weighty, intractable materials which lends itself, by virtue of this fact, to the participation of assistants. Because so much of this work is more mechanical than conceptual, it was desirable to divide the labor among hired hands, thus freeing the artist for creative work. Rodin's extraordinary productivity was made possible by the division of labor in his studio. Moreover, this division of labor applies to the execution of all his sculpture, save for his original clay models. The marbles are perhaps unique in Rodin's work in that he finished them himself, unlike the bronzes which he seems rarely to have touched. Eugène Guillaume rhetorically addressed the issue of artistic responsibility in the use of assistants when he asked: "Is the artist one man or a collection of people?"[37] The answer was emphatically the latter. The *Dictionnaire de l'Académie des Beaux-Arts*, stating the official moral guidelines for the use of assistants in the creation of an artist's work, warned that it was a matter of conscience for an artist to abandon his work to strangers without the active surveillance of their efforts.[38] This would apply to the carving of a marble as it would to the casting of bronze, yet bronze casting made supervision more difficult since it was done outside of the artist's studio.

Abundant documentation indicates Rodin's participation in the carving of his marble works. He never used commercial ateliers such as Maison Müller or Barbedienne for the carving of his sculpture (although Barbedienne would be contracted for a number of bronze editions, including *The Kiss* and *Eternal Spring*), no doubt because he did not wish to relinquish his active control. Voluminous correspondence between Rodin and his assistants documents his direction of their activities, and this is no doubt only a faint reflection of the guidance that he would have been more likely to communicate by word of mouth in the daily operation of his atelier. Anthony Ludovici, Rodin's personal secretary in 1906, recalled hearing the artist "a dozen times criticize the work of an assistant, imploring him to 'go and study more closely!' . . . Rodin spoke as a workman who knew what arduous tasks he had once imposed upon himself, and [he] was not prepared to pass slipshod or unconscientious work produced by others."[39] Judith Cladel remarked that although Rodin was too engrossed in the more creative aspects of his art to lend himself for very long to the patient art of carving, "the master had recourse to assistants whose work he did not cease to control, to supervise and watch over with continual observations, made with jealous tenacity for exactitude and perfection."[40] Elsewhere Cladel commented on Rodin's daily participation in the execution of the marble

Monument to Victor Hugo (fig. 4.4), upon which he indicated, "almost hour by hour, with strokes of an imperious pencil, the contours to maintain, the hollows to deepen, the passages to learnedly model in the light."[41] Another observer similarly described the marbles in Rodin's studio, streaked with pencil marks, which revealed the "conscientious artist going from one marble to the next, making continual retouches daily."[42]

There is evidence to suggest that Rodin wanted his editing of the marbles to be visible among the works displayed in the Musée Rodin. Thus, to encourage the establishment of the museum by the French senate, Eugène Lintilhac noted upon addressing that body that the visitor would be able to see there, according to Rodin's intentions,

the authoritative marks made by the *statuaire* for the *praticiens*, the vigilant network of hatchings of his black pencil upon the whiteness of the block of the *ébauche*, his imperious blows of the chisel, like wounds on the flanks of the marble, indicating that the execution of a form has betrayed a conception, and everywhere a conscience— 'this plumb-line of the artist,' he said—evidenced by dozens of *maquettes* for the same mask, or for a single gesture.[43]

The number of unfinished works on view in the Musée Rodin, some of which appear to have been deliberately marred by the artist's hatch marks, were in fact designed to exhibit his control of his marble production. Ironically, these works may have done much to compromise the perception of quality in Rodin's more successful marble sculpture.

Other contemporaries described Rodin not merely supervising the work of his assistants, but actually doing some carving himself, as in this memoir by Malvina Hoffman, who worked briefly for Rodin:

I have watched Rodin carving his own marbles at his studio in the rue de l'Université, and have marveled at the way he could suggest soft feathers of a broken wing, carving them directly in the block, without referring to the small plaster model. The pressure of an arm against another arm or the weight of a foot on the ground were certain problems which Rodin solved himself, explaining to me just how the desired result was obtained in marble. He avoided any sharp edges, and used the light reflections almost as a painter would, to envelop his forms. He had a horror of deep holes or sharp outlines. He had a perfectly definite technique which is easily recognized, and he told me he spent many hours identifying the strokes of certain tools, and just what effects they were capable of giving, in the collection of Michelangelo's sculptures in Florence.[44]

Hoffman's account emphasizes the knowledge and decisiveness that Rodin was able to bring to carving, much as he would when working in clay. He knew the effects in marble that he wished to achieve, and he knew how to use his chisel to achieve them. He appears to have studied not only Michelangelo's composition, but also

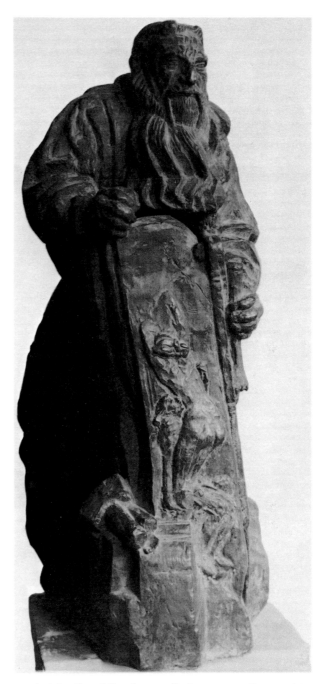

4.15 Antoine Bourdelle. *Auguste Rodin*, c. 1910. Bronze. Musée Rodin, Paris.

his carving technique. Reminiscent of Michelangelo, Rodin may have occasionally carved passages directly, leaving his model aside while improvising in the stone. This is suggested by his deliberate pose before the unfinished *Ariadne*, upon which he chisels in the absence of a model or measuring instruments (fig. 4.8). Rodin's control of his marble production is also suggested in Bourdelle's portrait of him (fig. 4.15). Bourdelle shows the *maître* standing behind his work with a firm grip on his chisel, while the handles of three mallets at his feet

point outward for others to grasp. Bourdelle's portrait speaks from the experience of an assistant who carved for Rodin, and it pointedly focuses upon his authority as a *maître* actively controlling the chisel that he has hired other hands to propel.

As Hoffman's account very clearly reveals, it was not for lack of skill that Rodin hired assistants to carve for him. Rodin's earliest experiences as a sculptor had provided him with an intimate knowledge of his craft. When Rodin failed to gain admission to the Ecole des Beaux-Arts, it became necessary to live and learn as an artisan working for other artists. Spared the privilege of a theoretical academic education, he developed rather as "a laborer-become-artist by the willfulness of his nature and the power of work."[45] He worked in the ateliers of decorative sculptors during the Second Empire and as a stonecutter in Strasbourg and the south of France.[46] As an assistant for Carrier-Belleuse between 1864 and 1871, he learned the inner workings of one of the most productive ateliers of the Second Empire, which employed dozens of assistants for the production of work that ranged from large-scale architectural decoration to salon sculpture to portraiture and *bibelots*. This no doubt provided the model for Rodin's subsequent enterprise. As late as 1877 Rodin worked for a sculptor named Legrain, who employed him to carve stone *mascarons* for the Palais du Trocadéro.[47] This project epitomizes Rodin's unglamorous career as an artisan. The *mascarons* were not attributed to him but to his employer, although Rodin is believed to have been responsible for their design. They were situated facing the Champ de Mars, the location of the annual salon where in the same year *The Age of Bronze* was submitted amid accusations that it was cast from life. Rodin's anonymously executed *mascarons* were situated beneath monumental figural commissions by Falguière, Delaplanche, Hiolle, and Mercié, all of whom were born within a decade of Rodin, all of whom were winners of the Prix de Rome, and all of whom enjoyed an early success that Rodin had been denied.

Late in his life Rodin spoke candidly of the time spent working for others: "The necessity of earning a living made it necessary for me to learn all aspects of my craft. I executed the *mise au point*, hewed marbles, stones, ornaments . . . certainly for too long. I regret having wasted so much time."[48] The benefit of this experience was to have provided Rodin a "hands on" knowledge of the craft of carving, enabling him to develop a sensibility for working in stone. His authority as the master of a large atelier was predicated upon his technical expertise, which allowed him to control all stages of his work's

production. Rodin, unique among successful sculptors of his generation, was described by sympathetic critics as an "artist-worker," a man of métier as well as an artist, and because of this virtue he stood apart from the sculptors of the Ecole. Félicien Fagus, with full praise intended, thus observed: "He began by learning his métier, by becoming what he will remain all his life: an artisan."[49]

Indirect Carving

The virtues identified with Rodin's craftsmanly skills, however, were ancillary to his skills as an artist. For as long as sculpture has been a part of the liberal arts, the importance of the sculptor's work has been measured by his capacity for invention rather than for physical toil. The assignment of carving to assistants reflected the hard-won elevation of the sculptor's profession from the mechanical arts to the liberal arts and was justified by technical advancements in carving that increased the precision with which a sculptor's model could be translated into stone. Called "indirect carving," the technique practiced since the sixteenth century and practiced by Rodin involved the meticulous translation of measurements from a model, which could be endlessly reworked, to a block of stone, which could not.[50] The process by which this is accomplished, known as the *mise au point* (or "pointing"), involves the measurement of points in depth on the model, which are then transposed to the marble to be carved.

A photograph of the caryatid figure from the marble group *Illusions Received by the Earth*, taken while the sculpture was being carved, shows the *mise au point* in its various stages of completion (fig. 4.16). In areas where the surfaces have only been generally shaped, as in the blocky contours of the caryatid's hair, the points of measurement that have been drilled into the surface are dispersed at a relative distance. The carver, using a broad-toothed chisel, has blocked out broad planes with relatively few measurements taken. In the more advanced carving of the figure's body, by contrast, the measurements are closer together and more regularly applied. The sculptor has here used a flat chisel, which shaves the surface smoothly, without the ridges caused by the toothed chisel. One can observe how the measurements have been evenly rendered along each square centimeter, running in regular arcs along the figure's thigh. Rodin's participation in the carving of this figure is suggested by the hatch marks that can be seen on the figure's hand, probably made to indicate to his assistant how he wanted that passage to be developed. These editing marks and

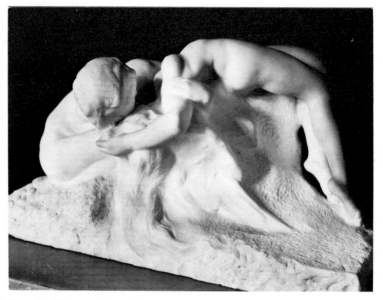

left: 4.16 *Illusions Received by the Earth*, 1903. Marble. Musée des Beaux-Arts, Lille. Atelier photograph of the sculpture in progress.
right: 4.17 *Illusions Received by the Earth*, 1903. Marble. Musée des Beaux-Arts, Lille.

the measuring holes (called *détail*) would gradually be removed as the surface was progressively carved to its final depth (fig. 4.17). It was not uncommon for Rodin to preserve the vestiges of the *mise au point* in his finished sculpture, thus calling deliberate attention to the process by which it was made. The bust of *Mme. de Noailles* in this exhibition (fig. 4.28) displays a guiding mark (called a *point de repère*) on top of the sculpture's head that served as the fixed point of reference from which the measurements could be rendered.

The *mise au point* is the logical consequence of the difficulties confronted when working in stone. As T. B. Eméric-David explained in his treatise on sculpture: ". . . the most talented artist would not be able to discover from the very first, in a complete figure, its proportions, movement, beauty, truth. It is impossible when working in this manner to express the interior before the exterior: an error is irreparable."[51] Sculpture in marble, therefore, like sculpture in bronze, was preceded by a model that permitted the trial and error not possible when carving or casting. This is apparent in *Illusions Received by the Earth*, which is a composite of the *Caryatid* (fig. 4.12) and a figure derived from the *Torso of Adèle*. Rodin reworked previously conceived sculptures like pieces of a puzzle to create new groupings—a form of improvisation that would not have been possible had he carved this marble directly.

The *mise au point*, in direct proportion to its mechanical precision, is not a creatively demanding task,

and it is not surprising that Rodin considered his prolonged employment at this work to have been time wasted. One technical manual described the technique as "nothing other than a succession of geometric problems that are solved in the process of execution."[52] The nineteenth-century Larousse similarly observed:

There is in this work a succession of operations that demand neither genius nor a special taste, but simply patience, care, and a certain amount of manual facility. It is a part of the métier which, while being important, nonetheless presents little attraction for the artist.[53]

It was both necessary and customary that the artist finish his sculpture, refining and individualizing its surfaces. The substantial differences in the treatment of the versions of the *Fallen Caryatid* or *Eve*, for example, must be understood as the result of Rodin's active control of their execution. The practitioners would never have ventured to change the artist's conception on their own, nor would it have been tolerated.

Because of its mechanical reliability, the *mise au point* served to widen the gap between the invention and execution of a sculptor's work, and thus to demarcate the virtues of "art" from the exigencies of "craft." This distinction in turn conditioned the artist's and practitioner's attitudes toward their work. Bourdelle very deliberately affirmed that he was never Rodin's "collaborator," and elsewhere he defined his role as that of an "artisan" when working for Rodin.[54] The Larousse encyclopedia, which described the *mise au point* as "almost exclusively handicraft," went on to explain: "This is not

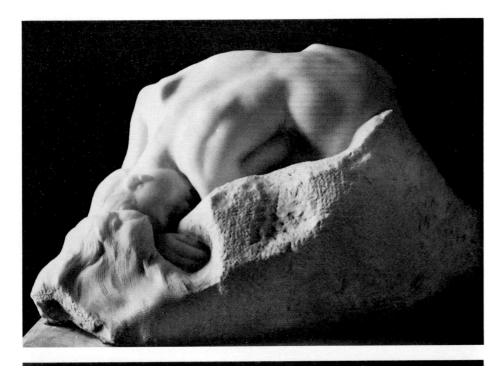

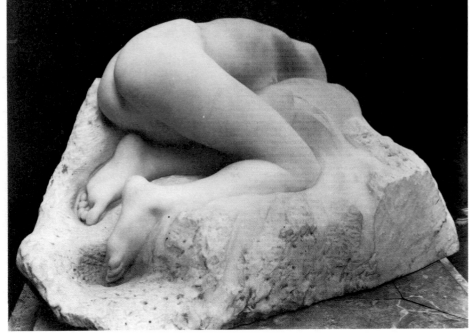

4.18 *Danaid*, 1888. Marble. Musée
d'Orsay, Paris. Cat. no. 151, different
version.

4.19 *Danaid*, second view of 4.18.

to say that the practitioner might not himself be an
artist. . . . As a practitioner he is an artisan."[55] The same
sentiments were echoed by Henry Jouin: "It is not [the
practitioner] who sings; he transcribes. The poem is the
work of the artist, the practitioner only apprehends its
syntax. An artist with clipped wings, sometimes he
manages to touch upon beauty; he knows neither how
to embrace it nor how to name it."[56]

The Quality of the Marbles

While there are evident technical and theoretical bases
for his use of assistants, the overriding issue remains the
effect of this marriage of artist and artisan upon the
quality of Rodin's carved sculpture. The harshest modern
assessment of these works has maintained that they
should be disregarded because "he did not make them."[57]

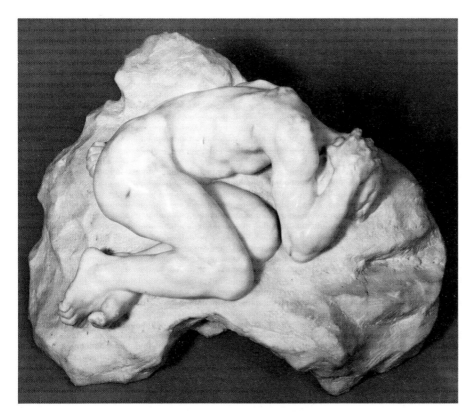

4.20 *Despair*, c. 1889-1893. Marble. The St. Louis Art Museum. Cat. no. 148.

There is no doubt that Rodin produced some inferior marble sculpture, and that the demands made upon him for production, particularly after 1900, may have exceeded his ability fully to control quality. Yet it is no less true that some of his finest and most innovative works were carved in these years. Moreover, it is arguable that Rodin's best marble sculpture is equal to his work in any other medium, measured by any criterion of quality. The modeling, innovativeness in style and subject, beauty, and expression compare favorably to that in his other work and betray its unity. It is also significant that the issue of their authenticity as products of the artist's hand, so disquieting to some modern critics, seems not to have concerned Rodin's contemporaries, who were familiar with the facts of their execution and no less sensitive to their beauty and originality. In a memoir first published in 1912 and republished upon Rodin's death, George Bernard Shaw discussed the quality of Rodin's carved sculpture relative to his other work. Observing the artist's appreciation for antique marble fragments, Shaw observed, "There never was such an eye for carved stone as Rodin's," and he continued:

In his own work he shows a strong feeling for the beauty of marble. He gave me three busts of myself: one in bronze, one in plaster, one in marble. The bronze is me. . . . The plaster is me. But the marble has quite another sort of life: it glows; and light flows over it. It does not look solid: it looks luminous; and this curious glowing and flowing keeps people's fingers off it; for you feel as if you could not catch hold

of it. People say that all modern sculpture is done by Italian artisans who mechanically reproduce the sculptor's plaster model in the stone. Rodin himself says so. But the particular qualities that Rodin gets in his marbles are not in the clay models. What is more, other sculptors can hire artisans, including those who have worked for Rodin. Yet no other sculptor produces marbles such as Rodin. One day Rodin told me that all modern sculpture is imposture; that neither he nor any of the others can use a chisel. A few days later he let slip the remark: 'Handling a chisel is very interesting.'[58]

Rodin's feeling for the beauty of marble, whose modeled passages seem to display "another sort of life," is epitomized by the marble *Danaid* (fig. 4.18, 4.19), exhibited in 1889, of which a later version can be seen in this exhibition. The *Danaid*, like the *Fallen Caryatid Carrying Her Stone*, is one of the numerous fallen figures derived from *The Gates of Hell*. Its masculine counterpart, the stone figure known as *Despair* (fig. 4.20), crouching twisted upon its base, suggests the artist's range in the treatment of this motif. The subject of the Danaides is taken from Greek mythology and recounted by Apollodorus and by Horace in his *Odes*. It concerns the fifty daughters of Danaus who, having murdered their husbands on the night they were wed, were condemned perpetually to draw water in the underworld with perforated vessels. Rodin's *Danaid* collapses upon a large vase out of which water spills, its currents echoed by the flow of her long hair over the side of the base. Like other fallen figures from the *Gates* such as the *Caryatid*, the

Danaid, although fallen, is not passive. She concurrently struggles and succumbs in a complex gesture evoking a profound psychological despair. The subject is literary but nonrhetorical in content. Expression is the consequence of modeling and compositional torsion. Identification of the literary motif is not essential to its effect.

The absorption of the intricately carved *Danaid* into the contours of its rough-cut base, most apparent in the 1889 version, displays the *non-finito* carving style which Rodin developed in these years, and which became the hallmark of his marble sculpture. The base is not treated as a flat surface designed merely to support the figure, but rather as an essential element in the figure's formal design and expressive content. The base, when viewed from the figure's left, is raised in rocky peaks coordinated with the contours of her curving back and hips. Her lower torso is obscured behind it, becoming visible only as one walks around the sculpture. The base has no fixed sides in the original version of this sculpture, but rather curves around the figure, offering no single point of view that can be uniquely called its front. There is similarly no point of view from which this nude can be viewed in its entirety. From her right (fig. 4.19), the *Danaid* is absorbed in the concavities of the stony base, her head obscured in her arms. Viewed from the rear, one looks at her raised buttocks, which conceal her upper torso and head. The sculpture thus exhibits a succession of fragmented views that encourages an active, mobile viewing in the round, during which the full drama of the figure unfolds. She appears to sink or rise as the viewer circles the sculpture, succumbing to her exhaustion or willfully struggling to overcome it as one views the shifting movements of her fall. The design of this sculpture so that it must be viewed in time, in the round, encouraging the active participation of the viewer, is a concern that Rodin was developing at this same moment in *The Burghers of Calais*, and it betrays the consistency and aesthetic unity of Rodin's work, even among subjects that substantially differed.

The integration of seemingly unfinished elements into a sculpture that is complete and refined is one of the most important innovations of the *Danaid*, and one of Rodin's most important challenges to the conventions of academic taste. This is apparent in the *non-finito* carving of the stony base as well as in the figure's fragmentation as one views it in the round. Evoking the correspondence between this formal treatment and the subject's mythical identity, Felix Jeantet, observing the marble *Danaid* in 1889, described "the despair of the human soul in front of the human work that will never be finished, the inconsolable regret of the unrealizable dream, the im-

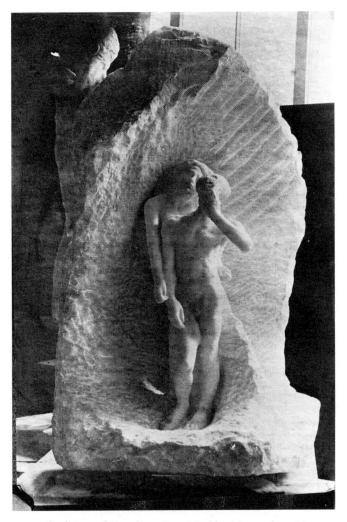

4.21 *Orpheus and Eurydice*, 1894. Marble. Metropolitan Museum of Art, Gift of Thomas F. Ryan, 1910. Cat. no. 152. Photo taken in Rodin's studio, c. 1894.

potence of the finite before the infinite."[59] Rilke, also moved by the *non-finito* carving and its effect upon the work, described the expressive beauty of the figure's hand, "which like a broken flower speaks softly once more of life that lies deep underneath the eternal ice of the block."[60]

Rodin's use of unfinished elements in a finished sculpture was clearly influenced by Michelangelo, yet it differed in its essential conception and meaning. Whereas Michelangelo approached his sculpture from the outer extremities of the block, carving to release his figure from the "prison" of stone, Rodin approached his conception as an indirect carver whose essential working medium is clay. Michelangelo considered sculpture to be "that which is done by subtracting."[61] Rodin, by contrast, thought of sculpture as an additive process. This is apparent in the marble *Orpheus and Eurydice* (figs. 4.21, 4.22), a unique sculpture dating from 1893, which along

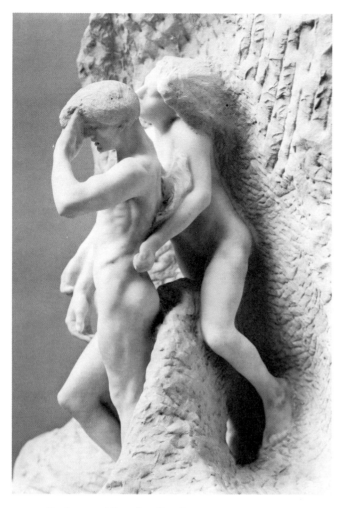

with *The Kiss* and the marble *Romeo and Juliette* reveals the artist's preoccupation with the theme of tragic love. In this story taken from Ovid, Rodin uses the rough-cut stone surrounding the figures to evoke the consequences of Orpheus's ill-timed glance, which sent his beloved Eurydice sinking back into the underworld. Each of the figures in this group had a previous life in Rodin's work: Orpheus is a reworking of the figure of *Adam*; Eurydice is derived from the *Martyr* which can be seen in this exhibition in bronze. This female figure was adjusted and reoriented by Rodin to create the androgynous marble, *Fall of Icarus* (fig. 4.23). It was used again to convey resurrection in *The Broken Lily* (fig. 4.24), a work commissioned by a young, dying artist named Sourisseau for his tomb. In *Orpheus and Eurydice,* Rodin combines the two figures to create a new subject and meaning. In a manner opposite that of Michelangelo, Eurydice, like the *Danaid*, appears to be absorbed by the block rather than bursting from it. Moreover, the issue of finish must be distinguished in relation to the two artists' *non-finito* styles. Michelangelo's *Captives*, for example, are said to be unfinished for lack of time or carving error, which forced them to be abandoned.[62] Conversely, by virtue of

4.22 *Orpheus and Eurydice* (detail).

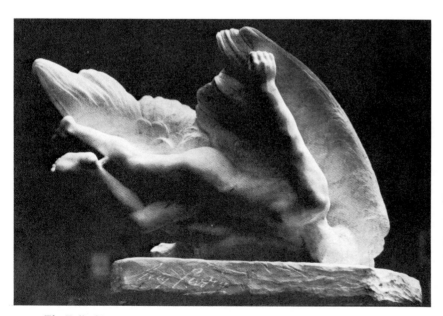

4.23 *The Fall of Icarus*, 1897. Marble. Present location unknown.

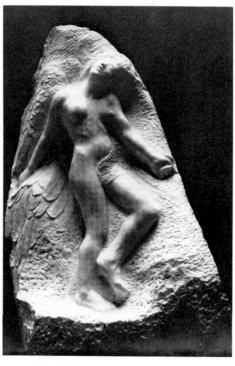

4.24 *The Broken Lily*, 1911. Marble. Cemetery St.-Acheul, Amiens.

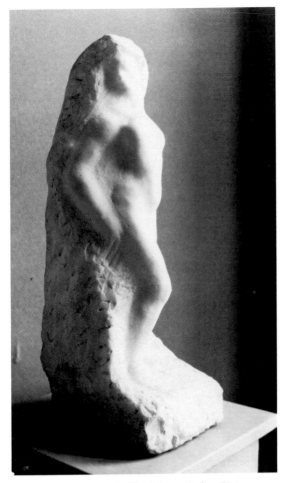

4.25 *Psyche*, 1906. Marble. Musée Rodin, Paris.

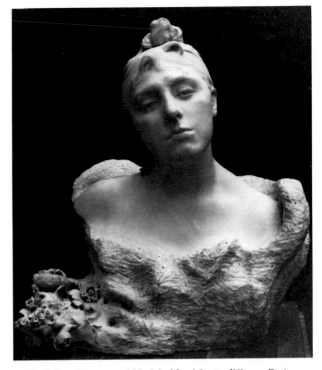

4.26 *Mme. Vicuña*, 1888. Marble. Musée d'Orsay, Paris.

the indirect carving technique, which presumes the calculated development of a marble from a sketch, to a refined *maquette*, to a carefully measured marble, Rodin's carved works are among the most finished and refined of his work in any medium. The *non-finito* elements in *Orpheus and Eurydice* are calculated with regard to composition and content; the rough-cut stone is not leftover material, but an integral component of the work. The photograph taken in Rodin's studio (fig. 4.21) shows that he intended the group to be seen in natural light, where the effect of the stony mass upon the play of shadow would be most pronounced. In this light the modeling of Eurydice seems amorphous by comparison to Orpheus's taut, muscular features, and whereas Eurydice seems to dissolve within the recesses of the stone like an incorporeal vision, Orpheus seems inextricably bound by the laws of gravity.

Rodin's marbles are married to light (fig. 4.25). Their fluid, bright, translucent surfaces blend with the surrounding atmosphere, dematerializing their subjects, and

enveloping them in a luminous haze. Commenting upon the specific effects of modeling in Rodin's marbles, Rilke observed: "When Rodin seeks to condense the atmosphere about the surfaces of his works, the stone appears almost to dissolve in the air, the marble is the compact, fruitful kernel, and its last, softest contour the vibrating air. The light touching the marble loses its will, it does not penetrate into the stone, but nestles close, lingers, dwells in the stone."[63] Rodin once described his modeling as "a fluid mass agitated by a strong wind."[64] More appropriately, as it pertains to the marriage of his marbles with the light, his modeling seems agitated by a gentle breeze. The surface treatment of the marble sculpture, and its resulting effect, is less dramatic than that of his vigorous bronzes. The vitality of these works is not, however, diminished by this fact.

The subtle fusion of material and light is nowhere more apparent than in Rodin's marble portraits, especially those of women. Rodin characteristically enhances this effect through the counterpoint of rough-cut stone and softly modeled features. One of the most striking examples of Rodin's marble portraits is the bust of *Mme. Vicuña*, wife of the Chilean ambassador to Paris, carved in 1888 (fig. 4.26). The modernity and nervous vitality of this portrait prompted Gustave Geffroy to coin it "la femme d'aujourd'hui."[65] Academic critic Charles Blanc maintained that in portraiture, "attention is the most striking

4.27 *Bellona*, 1889. Marble. Dr. and Mrs. Jules Lane. Cat. no. 147.

4.28 *Madame X (The Countess of Noailles)* (detail), 1906. Marble. Metropolitan Museum of Art, Gift of Thomas F. Ryan, 1910. Cat. no. 161.

4.29 *Lady Sackville-West*, 1917. Marble. Musée Rodin, Paris. Cat. no. 162.

mark of the spirit."[66] As depicted by Rodin, Mme. Vicuña is not merely attentive; she seems responsive, sharing characteristics of the more theatrical *Bellona* (fig. 4.27), carved at the same time but conceived a decade earlier. The asymmetry of these compositions, the outward turn of their heads, and the emergence of each from the rough-cut stone "like a flower from its verdant envelope" all enhance the expression of vital character that make these busts so engaging.[67]

No two portraits by Rodin are composed identically. In each, verisimilitude as an end in itself yields to the expression of an individualized character. In contrast to the alert and engaging bust of *Mme. Vicuña*, Rodin's later portraits like the *Countess of Noailles* of 1908 (fig. 4.28) or *Lady Sackville-West* of 1917, the last marble sculpture completed in Rodin's lifetime (fig. 4.29), are remote and introspective. Rodin believed that no artistic work required as much penetration as the portrait. He approached the external features of his subjects by working from profiles, looking at them from 360 degrees rather than from a fixed point of view. More significant than its aid to Rodin in the accurate rendering of features, this inclusive external approach served his effort to convey a penetrating psychological reading. Rodin observed: "The resemblance which [the artist] ought to obtain is that of the soul; that alone matters; it is that which the sculptor . . . should seek beneath the mask of the

features."[68] The busts of the *Countess of Noailles* and *Lady Sackville-West* are two exceptional examples of the "soul portraits" that Rodin created in his later years, and in each, one can see the effect of modeling upon the dreamlike expression of his sitter. Rodin's subjects seem as though they are enveloped by a mist; their modeling denies their materiality. Possibly to prevent the appearance of complete evaporation, the bust of the *Countess of Noailles* is etched with bold lines to suggest the texture of her hair. Their staccato effect against the smooth, white surface reaffirms the marble's tangibility. In the portrait of *Lady Sackville-West*, Rodin shows his subject in an attitude of sleep, her head turned to the side, floating on a mass of rough-cut stone that has been very deliberately shaped. The viewer becomes aware of her dreamlike state through the contrast of softly modeled features with the swirling, fluid contours of the base (which includes her scarf) and her hair, which have been energized by the directional patterns of the chisel. As rough as these surfaces appear, one notices how intricately, and with what calculation, they have been carved. By this contrast of textures Rodin has managed to evoke the sensation of weightlessness that one experiences when sinking into a dream, as one imagines this hazy head sinking back into the stone. At the same time, the viewer is aware of the massiveness of this sculpture, of its weight and material identity. The suggested contrast between mind and matter, like the contrast between the vaporous modeling of the features and the tangibility of the pitted stone, evokes the drama of this quiet sculpture, which even in sleep seems vital and alive.

This essay began by observing that Rodin's outstanding contribution to sculpture in his time was to renew the sensation of "life" in an art that had been paralyzed by a false academic ideal. Looking again at *Pygmalion and Galatea* (fig. 4.1), one can see in Rodin's mythical alter ego his own affection for marble and its ability to rival life, even as this fleshy Galatea, buried knee-deep in the material of her origin, suggests the limits on that dream of becoming a reality. The marbles are derived from the same clay models that produced his plasters and bronzes. They share with all of Rodin's art the same expressive concerns, the same inventiveness, originality, and audacity. In their modeling, composition, style, subjects, and meaning, Rodin's marbles, like his plasters and bronzes, contributed in essential ways to the revitalization of nineteenth-century sculpture, pointing the way for the pioneers of sculpture in the twentieth century. If the marble sculpture differs from Rodin's work in other materials, it is by virtue of its relative finish, and by the material's identification with the Hellenic origins of Western sculpture. Because of this it could challenge academic norms at the very heart of their pretense. The marbles presented a new definition of beauty and life in sculpture, making Rodin the heir to a classical tradition without undermining his modern relevance. Finally, the issue of the marbles' authenticity relative to the facts of their execution, which is disconcerting to some modern critics as it never was to Rodin's contemporaries, should finally be laid to rest. The overall quality of these works, their unity of style and expression, and their superiority and clear distinctness from the work of his contemporaries belie the myth that Rodin did not make them. It is required only that one view these sculptures with a discerning eye and an unprejudiced mind to be aware, as one critic observed, that "Rodin's marbles are alive. It matters little that we see them sitting motionless on their socles; they walk, they advance, they will survive us, they will pass before generations yet to be born in order to speak of us, to inform of our soul, our grief, our energies."[69] Today, as in Rodin's time, the marbles achieve these effects supremely.

NOTES

1. Paul Gsell, *Rodin on Art*, trans. Mrs. Romilly Fedden (New York: Horizon Press, 1971), 55.

2. "Pygmalion, half-dazed, lost in his raptures,/And half in doubt, afraid his senses failed him,/Touched her again and felt his hopes come true,/The pulse-beat stirring where he moved his hands." Ovid, *Metamorphoses*, trans. Horace Gregory (New York: Viking, 1958), 282.

3. Gsell, *Rodin on Art*, 59.

4. Excluded from this catalogue in preparation by this author are the considerable number of sculptures that remained unfinished at the time of the artist's death in 1917.

5. The following is a list of the marble sculpture exhibited by Rodin between 1885–1917, first in the Salon de la Société des Artistes Français, and after 1889 in the Salon de la Société Nationale des Beaux-Arts. 1888: *Mme. Vicuña*; 1889: *Victor Hugo*, bust; 1890: *Danaid*; 1892: *Puvis de Chavannes*, bust; 1895: *Octave Mirbeau*, relief; *Thought*; 1896: *Illusion, Daughter of Icarus*; *Supremacy (Eternal Idol)*; 1897: *The Thought of Life*; *Cupid and Psyche (Eternal Spring)*; *Caryatid*; 1898: *The Kiss*; 1899: marble group (*The Phantom's Kiss?*); 1900: *The Kiss* (Decennial Exhibition); 1901: *Monument to Victor Hugo*; 1904: *Mrs. Simpson*; 1905: *Anguish (La Douleur)*; *Prodigal Son* (Salon d'Automne); 1907: *Mrs. Hunter*; *Eve Fairfax*; *Mrs. Gouloubeff*; 1908: *Triton and Nereid*; 1909: *Mrs. Elisseieff*; 1911: *Duc de Rohan*; *The Broken Lily*; *Mozart*; 1912: unspecified marble in garden statuary section; 1913: *Puvis de Chavannes*.

6. Literally, "sketches realized in marble." Gustave Geffroy, "Chronique Rodin," *La Justice*, 11 July 1886, 1. The marble sculptures exhibited by Rodin included: *Eve, Psyche, Caryatid, Crouching Woman*.

7. Marbles exhibited by Rodin included: *Head of St. John the Baptist on a Platter, Bellona, Danaid, Galatea (La Jeunesse), Satyresses*.

8. The marble was exhibited in the Salon of 1901 and was not inaugurated until 1909 when it was installed in the gardens of the Palais Royal. The Panthéon monument was never erected.

9. Pierre Larousse, "Sculpture," *Grand Dictionnaire Universel du XIXe Siècle*, vol. 14 (Paris, 1875), 431.

10. Henry Jouin, *Esthétique du Sculpteur* (Paris: Henri Laurens, 1888), 105.

11. Jouin, *Esthétique du Sculpteur*, 108.

12. Eugène Guillaume, *La Sculpture en Bronze* (Paris: A. Morel, 1868), 21–23. A preference for marble is further suggested by the acquisition policies of the French state in Rodin's time. Of the 242 sculptures listed in the catalogue of the Musée du Luxembourg, 105 were in marble, 112 were in bronze, and the remainder were in an assortment of other materials. Although just less than half of the sculptures in this collection were in marble, by a ratio of roughly 2:1 it provided the material for monumental groups, figures, and half-life-size figures. Thus, there were twenty-four large scale marble groups, and only nine in bronze; there were forty-five life-size or half-life-size marble figures, and only twenty-six in bronze. By contrast, there were thirty-one bronze figurines and only eleven in marble; and there were forty-five bronze busts, and only twenty-five in marble. Many of these busts were presumably works that had been commissioned elsewhere. Thus, among Rodin's busts in the Luxembourg, the following existed in marble examples belonging to other collections: *Puvis de Chavannes, Falquière, Henri Rochefort, Victor Hugo, George Wyndham, Mrs. Hunter, Duc de Rohan, Mahler, Thomas Ryan*. See: Léonce Bénédite, *Catalogue Sommaire des Peintures et Sculptures de l'Ecole Contemporaine Exposées dans les Galeries du Musée National du Luxembourg* (Paris: Gaston Braun, n.d.).

13. Leo Steinberg, "Rodin," *Other Criteria* (New York: Oxford University Press, 1972), 329.

14. Gustave Geffroy, "Salon de 1896: 'La Sculpture,'" *La Vie Artistique*, vol. 5 (Paris: H. Floury, 1897), 195.

15. Léonce Rosenthal, "Auguste Rodin," *Humanité*, 18 November 1917.

16. Camille Mauclair, "Auguste Rodin, son Oeuvre, son Milieu, son Influence," *Revue Universelle*, August 1901, 775.

17. Judith Cladel, *Rodin, Sa Vie Glorieuse, Sa Vie Inconnue* (Paris: Grasset, 1950), 223.

18. Camille Mauclair, "L'Art de M. Auguste Rodin," *Revue des Revues*, 15 June 1898, 604.

19. Mauclair, "L'Art de M. Auguste Rodin," 604.

20. Léonce Bénédite, "Les Salons de 1898: 'La Sculpture,'" *Gazette des Beaux-Arts*, 1 August 1898, 140.

21. Claude Bienne, "Exposition des Beaux-Arts, La Sculpture à la Société Nationale des Beaux-Arts," *Revue Hebdomadaire*, 14 May 1898, 267.

22. The "cult" was so described by Ernest Chesneau. The author, guided by the positivist spirit of his epoch, proceeded to define the aims of art in terms that bear upon Rodin's development in the decade that this book was published: "The goal of art is to express the human spirit, all of its emotions, all of its sentiments, its troubles, its joys, its doubts, its passions and its adorations, its loves and its hates, its failures and its hopes, its knowledge of the real and its aspirations towards the hereafter—the entire spirit, as completely as the possibilities of expression appropriate to each art will permit, with no other limit beyond these." Ernest Chesneau, *L'Education de l'Artiste* (Paris: Charavay, 1880), 29.

23. Léonce Bénédite, *Les Sculpteurs Français Contemporains* (Paris: H. Laurens, 1901), 7–8.

24. Mauclair, "L'Art de M. Auguste Rodin," 608; Gustave Geffroy, "L'Incertitude des Sculpteurs," *La Vie Artistique*, vol. 2 (Paris: E. Dentu, 1893), 290.

25. Adrien Farge, "Rodin," *Art et Littérature*, 5 February 1901, 2.

26. Léonce Bénédite, "Les Salons de 1898," 142.

27. Antoine Bourdelle, "L'Art et Rodin," *La Vie*, 1919, 98; cf. Edmond Campagnac, "Rodin et Bourdelle d'Après des Lettres Inédites," *La Grande Revue*, 1 November 1929, 4.

28. Gustave Geffroy, "Salon de 1895: Un Bourgeois de Calais," *La Vie Artistique*, vol. 4 (Paris: E. Dentu, 1895), 213.

29. Octave Mirbeau, "Auguste Rodin," *L'Echo de Paris*, 25 May 1889.

30. Emile Michelet, "Le Salon de 1886," *Jeune France*, July 1886,

771–772.

31. Rodolphe Darzens, "Auguste Rodin," *Jeune France*, January 1888, 302.

32. Edmond Jacques, "Rodin et Monet," *L'Intransigéant*, 7 July 1889.

33. Charles Frémine, "Salon de 1883," *Le Rappel*, 28 November 1883; see Ruth Butler, *Rodin in Perspective* (Englewood Cliffs, N.J.: Prentice-Hall, 1980), 42.

34. Gustave Geffroy, "Chronique Rodin," *La Justice*, 11 July 1886, 1.

35. Rainer Maria Rilke, "Auguste Rodin," quoted in Albert Elsen, ed., *Auguste Rodin: Readings on His Life and Art* (Englewood Cliffs, N.J.: Prentice-Hall, 1965), 129–130.

36. Judith Cladel, *Auguste Rodin, l'Oeuvre et l'Homme* (Brussels: Libraire Nationale d'Art et d'Histoire, 1908), 14.

37. Guillaume, *La Sculpture en Bronze*, 29.

38. Académie des Beaux-Arts, *Dictionnaire de l'Académie des Beaux-Arts*, vol. 1 (Paris: Firmin Didio, 1858), 156.

39. Anthony M. Ludovici, *Personal Reminiscences of Auguste Rodin* (London: John Murray, 1926), 68.

40. Judith Cladel, "L'Affaire des Faux-Rodins," *Bonsoir*, 27 January 1919.

41. Cladel, *Rodin, Sa Vie Glorieuse*, 176; cf. Cladel, *Rodin, l'Oeuvre et l'Homme*, 22.

42. Irénée Mauget, "Souvenirs sur Rodin et l'Hôtel Biron," *Comoedia*, 10 August 1920; cf. Maurice Guillemot, "Le Scandale Rodin," *La Petite République*, 31 January 1919.

43. Eugène Lintilhac, *Rapport Fait au Nom de la Commission Chargée d'Examiner le Projet de Loi, Adopté par la Chambre des Deputés, Portant Acceptation définitive de la Donation Consentie à l'Etat par M. Auguste Rodin*, 387 (Paris: Sénat de la République Française, 26 October 1916); cf. Judith Cladel, *Rodin, l'Oeuvre et l'Homme*, 105.

44. Malvina Hoffmann, *Heads and Tales* (New York: Scribner, 1936), 97.

45. Gustave Larroumet, "Rodin," *Figaro*, 12 January 1895.

46. Frederick Lawton, *The Life and Work of Auguste Rodin* (London: T. Fisher Unwin, 1906), 24; Ruth Butler Mirolli, "The Early Work of Auguste Rodin and Its Background," (Ph.D. diss., New York University, 1966), 101; T. H. Bartlett, "Auguste Rodin, Sculptor," *American Architect and Building News*, January–June 1889; reprinted in Elsen, *Auguste Rodin: Readings*, 22–23.

47. Musée Rodin Archives: correspondence, Bulard to Georges Grappe, 9 September 1935.

48. H.C.E. Dujardin-Beaumetz, *Entretiens avec Rodin* (Paris, 1913), 81.

49. Félicien Fagus, "Discours sur la Mission de Rodin," *Revue Blanche*, 15 June 1900, 246.

50. Direct carving, by contrast, entails the direct execution of the marble block in the absence of an elaborate model. It presumes that a sculpture is conceived and developed in the actual process of carving, rather than by modeling in advance.

51. T.-B. Eméric-David, *Récherches sur l'Art Statuaire Considéré chez les Anciens et chez les Modernes* (Paris: Jules Renouard, 1863), 274–275. In this context, the author attributes Michelangelo's unfinished sculpture to his failure to work from a fully developed model. This was a common assumption in Rodin's time; cf. Eugène Guillaume, *Etudes d'Art Antique et Moderne* (Paris: Perrin, 1888), 90–93.

52. Karl Robert, *Traité pratique du Modelage et de la Sculpture* (Paris: Henri Laurens, 1889), 15.

53. Larousse, "Mise au Point," *Grand Dictionnaire*, vol. 11, 30.

54. Paul Bringuier, "Ce que Rodin doit à Bourdelle et ce que Bourdelle doit à Rodin," *Le Journal*, 18 March 1928.

55. Larousse, "Praticien," *Grand Dictionnaire*, vol. 13, 36.

56. Jouin, *Esthétique du Sculpteur*, 126.

57. Steinberg, "Rodin," *Other Criteria*, 330; cf. William Tucker, "Rodin," *The Language of Sculpture* (London: Thames and Hudson, 1974), 30–31.

58. George Bernard Shaw, "A Memory of Rodin," *The Lantern*, January 1918, 295; cf. George Bernard Shaw, "Sur Rodin," *Gil Blas*, 24 November 1912.

59. Félix Jeantet, "Exposition des Oeuvres de Rodin," *Le Blanc et Noir*, June 1889.

60. Rainer Maria Rilke, "Auguste Rodin," quoted in Elsen, *Rodin: Readings*, 129.

61. Rudolf Wittkower, *Sculpture, Processes and Principles* (New York: Harper and Row, 1977), 116–122, 127.

62. Eméric-David, *Récherches sur l'Art Statuaire*, 275; Guillaume, *Etudes d'Art Antique et Moderne*, 90–93; Ludwig Goldscheider, *Michelangelo's Bozzetti for Statues in the Medici Chapel* (London, 1957), 8.

63. Rainer Maria Rilke, "Auguste Rodin," quoted in Elsen, *Rodin: Readings*, 142–143; Geffroy similarly wrote: "Rodin . . . does not separate the beings that he represents from the atmosphere in which they live, because he invests them with the light and shadow that unifies them." Gustave Geffroy, "Deux Figures de Rodin," *La Vie Artistique*, vol. 5 (Paris: H. Floury, 1897), 169.

64. Judith Cladel, *Auguste Rodin, Pris Sur la Vie* (Paris: Editions de la Plume, 1903), 40.

65. Gustave Geffroy, "Salon de 1888, Un Buste de Femme," *La Justice*, 23 May 1888.

66. Charles Blanc, "Salon de 1886," *Gazette des Beaux-Arts*, July 1886, 64.

67. Bartlett, "Auguste Rodin, Sculptor," quoted in Elsen, *Rodin: Readings*, 83–84.

68. Gsell, *Rodin on Art*, 124–125.

69. André Flament, "Salon de la Société Nationale des Beaux-Arts," *L'Intransigéant*, 13 April 1907.

5.1a Paul Gasq. *Sculpture, or Art and Nature*, c. 1900. Grand Palais, Paris.

5.1b Alfred Boucher. *Painting, or Inspiration*, c. 1900. Grand Palais, Paris.

5. *Rodin's Humanization of the Muse*

Rosalyn Frankel Jamison

The Greek mythological concept of the Muses—nine sister goddesses who presided over the sciences, poetry, and music—served into the late nineteenth century as a vehicle for expressing contemporary notions about creativity. The original muse, as depicted in ancient art, was a serene, pensive, robed woman holding an attribute of one of the arts.[1] A welcome celestial messenger, she was commonly shown at the poet or philosopher's side, heeding her own quiet thoughts or actively conversing and communing with him. With grace and assurance, she embodied the lyrical ease of divine inspiration. When, beginning with Christian art, the symbol of the muse evolved into an angel, the guarantee of inspiration was still implied. This guarantee remained constant as both muse and inspiring angel were humanized in the course of Renaissance and baroque art. Even in the presence of a melancholy creator, the muse remained imperturbable and confident. In eighteenth-century depictions of the muse, inspiration was shown passing effortlessly from a wife, mistress, or daughter to the artist or writer; a glance, a touch, or a light guiding of the quill brought inspiration to a seemingly passive recipient. This traditional muse—a divine or external source of inspiration—lingered in the positivist, rational atmosphere of the late nineteenth century and was especially apparent in academic and official art. This is well exemplified in the sculpture created for the façade of the Grand Palais in Paris to allegorize inspiration in the arts (figs. 5.1a, 5.1b). At the end of the century, symbolist poets and artists, in keeping with their idealist and spiritualist views, continued to view inspiration as derived from the muse or supernatural source. It was from this long tradition that Rodin significantly departed.[2]

Rodin's contemporaries had already begun to deviate from this tradition in their humanization of the muse. They updated her appearance and function.[3] They also admitted sensual, melancholy *fin de siècle* types into the province of muse, implying that inspiration could be an unpredictable and even dangerous force. Even in public

sculpture, where a more idealized conception of the muse tended to persist, changes appeared. While the muse in Denis Puech's *Monument to Leconte de Lisle* (1898) (fig. 5.2) is otherwise a conventional figure paying tribute to the poet, she exhibits a new realism in facial and body type and reflects the contemporary tendency to conflate traditional symbols, blending the meanings

5.2 Denis Puech. *Monument to Charles Marie Leconte de Lisle*, 1898. Marble. Luxembourg Gardens, Paris.

of muse, victory, and glory. Rodin, however, went beyond all of these modernized muses to dramatize the more elusive characteristics of the creative process. The muse became a major theme in his work, the symbolic vehicle through which he continually explored the nature of creativity.[4] While he retained some of her traditional features, he transformed them to serve his own personal view. Rather than divine guidance or a sudden flash of inspiration, invoked by the romanticist and symbolist artists of his century, Rodin's muses were reflection, hard work, and chance. He recognized the role of passion in stimulating the artistic imagination, but it was primarily the prolonged and disciplined study of nature and antique art that instructed his creativity.

That Rodin was at heart a nineteenth-century positivist is indicated by his elucidation of the process by which revelation came to him. He improvised his own working method; images flowed into his imagination from past study of nature and art, and he allowed them to fuse freely with the visual reality before him.[5] This way of working constituted a rational, self-generated inspiration. In addition, Rodin conceded, however, one incalculable influence: the creative force unleashed by chance. As he worked, he surrounded himself with a well-stocked repertoire of sculpture fragments—the scattered torsos, heads, feet, and hands seen in old photographs of his studio, frequently the result of accident or deliberate breakage. He then cultivated inspiration with exhaustive testing of each form in new contexts, seeking the infinite suggestive potential of unexpected, ever-changing juxtapositions. For Rodin, arranging new compositional possibilities—slow, hard work—replaced the ease and spontaneity traditionally associated with inspiration and the muse.

Even though Rodin disavowed the notion of inspiration, his art, ironically, expressed the reverse.[6] A wide assortment of mythical or inspirational figures populates his works: muses, sirens, caryatids, and other symbols which he deemed appropriate to convey the modern connotations of a muse. These allegorical figures are prominent not only in the monuments to genius, where their presence can be explained as conventional, but also in his private works.[7]

The Genius of Sculpture, a pen and wash drawing from the early 1880s (fig. 5.3), recalls elements from traditional representations of inspiration.[8] The drawing shows a nude sculptor before a small sculpture on a modeling stand. He reaches out his left arm to the sculpture but is not working on it; his other arm is raised to his forehead. Overhead hovers a small figure, a wingless nude devoid of attributes. The figure encircles

5.3 *The Genius of Sculpture*, c. 1880-1882. Brown ink and wash on brown transparent paper. 10⅜ x 7½ in. Inscribed: *La Genie de la Sculpture/A. Rodin* (in graphite on verso of old mount). Mrs. Noah Butkin, Cleveland.

the sculptor with its arms in a gesture of support or embrace, and their heads seem to touch—a pose often seen in traditional depictions of inspiration. Aspects of the sculptor's pose also recall prototypes from the tradition of those who receive divine inspiration.[9] Thus, though not a traditional muse or angel, the floating figure seems to represent an inspiring agent.

Closer scrutiny of the drawing, however, reveals that Rodin's conception symbolized entirely his own view. He chose an airborne "genius" over a traditional winged inspirer—one that, in fact, seems to rise away from the sculptor. And instead of pointing heavenward as was customary for a passive recipient of divine guidance, the sculptor here, by putting his hand to his forehead, expresses active thought. The hovering genius is thus the symbol of creative energy emanating from within.[10]

The statuette on the workstand in Rodin's drawing augments the personal meaning of the allegory. A crouching female whose arms are tightly drawn around her chest, this figure shows the self-enclosed gesture of Rodin's *Eve* from the same period. She represents an unorthodox variation on traditional sculptor-statue pairs; typical representations of Galatea, for instance, show the statue, once awakened to life in answer to Pygmalion's prayer, openly submissive before her maker. Another prototype of relevance to Rodin's drawing is the allegorical image of *Art* in Cesare Ripa's famous baroque dictionary of pictorial imagery. Here the statue beside a seated

woman personifying Art points to an exposed breast to reveal nature as inspiration of all of the arts. Rodin, in his self-enclosed statuette, likewise seems to depict, not the completed act of creation, but a symbol of inspiration. Significantly, however, he conceives of the figure as recalcitrant and unyielding.[11]

The elusiveness of inspiration became an important theme in Rodin's work. He continued, through other motifs, to depart from the idealized muse and to hu-

5.4 *The Fallen Caryatid Carrying Her Stone*, c.1881. Bronze, 51¼ in. Musée Rodin, Paris.

manize the abstraction in ways that corresponded to his personal experience. *The Fallen Caryatid Carrying Her Stone* (c. 1881) (fig. 5.4) is indeed an unconventional caryatid and may in fact be one of Rodin's earliest sculptures of a personalized muse. He depicted the caryatid as a crouching nude, falling beneath the weight of a stone on her shoulder. Rather than the traditional draped woman supporting an entablature, Rodin's caryatid is a moving symbol of physical and mental anguish, suggesting perhaps the difficulty of inspiration or the plight of the creator. That Rodin's caryatid represents a personalized muse is ultimately speculative, but it is

hoped this aspect of her identity will gain credence in the context of the rest of this essay. Indeed, Rodin's figure brings to mind several other personalized caryatids from nineteenth-century literature. Victor Hugo, in one of his poems from the collection *The Interior Voices* (1837), described an embittered, defiant caryatid no longer willing to support her weight: "May the caryatid, in her slow revolt, / At last weary, refuse to hold up the archivolt / And say: it is enough!" Inspired by this compelling symbol, Théodore de Banville, in 1841, composed his poem "The Imprecations of a Caryatid"— later included in his first book of verse *The Caryatids* (1842)—which closes with the wish of an accursed and vengeful caryatid to transfer her burden to the shoulders of men and let them carry the interior weight of their own iniquities.[12] From these poets, Rodin may have adapted the symbol of the caryatid, weary of her burden, to serve his own personal allegory of the burdened creator.

In *I Am Beautiful* (1882) (fig. 5.5), Rodin delivered a more radical statement of this theme. The poet's muse, a withdrawn and self-compressed nude representing Beauty, withholds herself from his grasp, unyielding despite his passion. The work represents an elusive and

5.5 *I Am Beautiful*, 1880. Plaster. 29½ in. Musée Rodin, Paris.

agonized inspiration and again suggests Rodin's own futile striving before an unyielding muse.[13] In 1885, however, he returned to the caryatid for the broader muse symbol he sought. He adapted the motif of the stone for his sculpture *Meditation*. Here he expressed prolonged mental suffering in a leaning figure with strained neck and bowed head, who supports a large stone between her forehead and oversized right arm.[14]

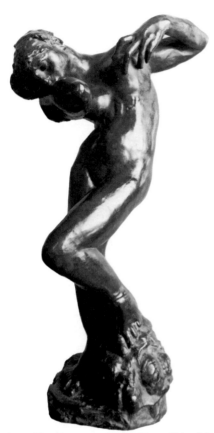

5.6 *Meditation*, 1885. Bronze. 30¾ x 13⅜ x 11⅜ in. Musée Rodin, Paris.

In another version of *Meditation* from the same year (fig. 5.6), Rodin showed the figure with her head and neck still expressively inclined to one side under the pressure of an invisible weight. He also introduced a new symbolic gesture—the fingers of the left hand pressing the breast. The gesture recalls one traditionally associated with inspiration (the muse squeezing milk onto books or musical instruments seen in Renaissance and baroque paintings); Rodin, however, was probably attracted to it as a natural and intuitive symbol for uncertain fertility.[15] The deeper meaning that Rodin intended for the figure becomes more apparent in light of the similarity between its pose and that of his earlier figure *Adam* (1880), whose alternate title was *Creation*.[16] Through *Meditation*, then,

Rodin expanded the meaning of the muse by fusing traditional motifs with his own personal experiences. As he continued to humanize the abstraction, he blurred the distinction between a thoughtful woman and the traditional muse.

The Tragic Muse of the same year, 1885, more openly expressed the personalized meanings of Rodin's previous muses. In this work, he relinquished object attributes and recognizable gestures from tradition that were seen in the earlier figures (*Meditation* without her stone foreshadowed his move in this direction) and intensified his effort to embody the creative process. The full-figure version of this muse, unfinished according to Grappe, is an ungainly nude in a crouched and twisted pose. Her distinctly graceless, oversized left arm is raised in what seems a hesitant gesture of benediction.[17] It suggests both an aggressive inspiring force and ineffectual motion; Rodin experimented, in fact, with the idea of omitting the arm altogether. The figure's ambiguous meaning is reflected in the other titles associated with the work: *Enthusiasm* as well as *The Crouching Woman Who*

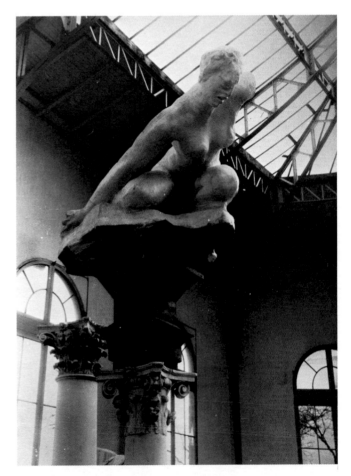

5.7 *The Tragic Muse*, before 1885. Plaster. 35⅜ x 62¼ x 37⅜ in. Photo Bulloz. Musée Rodin Archives, 1436.

Invites Confusion.[18] One old photograph (fig. 5.7) shows the same muse, without its left arm, placed on an ancient Corinthian column to preside over Rodin's entire studio. This image best suggests the central importance of the tragic muse for Rodin.[19] When in the same year he gave *The Head of the Tragic Muse* a separate existence (fig. 5.8), he created a grotesque emblem of mental and emotional agony. The drooping mouth, hollowed eye socket, and deformed skull were without counterpart in the art of any century. Rodin invested the muse with her creator's private agony of inspiration.

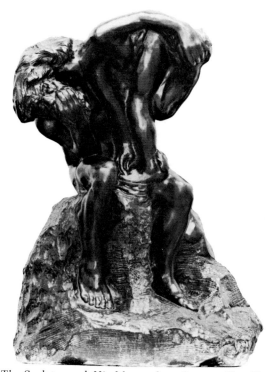

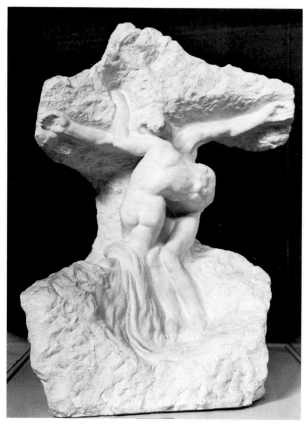

5.9 *The Sculptor and His Muse*, 1890. Bronze. The Fine Arts Museums of San Francisco, Gift of Mrs. Alma deBretteville Spreckels. Cat. no. 132.

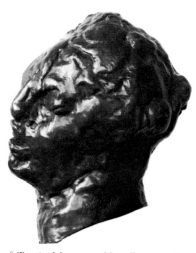

5.8 *Head of Tragic Muse*, c.1885. Bronze. Stanford University Museum of Art, Gift of the B. G. Cantor Art Foundation. Cat. no. 130.

Rodin also fashioned his muses to represent another aspect of creativity. Although he was not the first to show sexuality in the muse, he was the most audacious of his century in showing the erotic energy that, for him, functioned as inspiration. In *The Sculptor and His Muse* (1890) (fig. 5.9), the physical passion that was implicit in some of his previous works became more overt.[20] Rodin merged sexual stimulation with the traditional notion of sacred communion between artist and muse. The young muse not only whispers into the old sculptor's ear but also sexually caresses him, as his face, distorted by pleasure and pain, reflects the mutiple effects of her inspiration. Ironically, while the symbolists were negating the role of earthly sensibilities in creativity and in the achievement of immortality, Rodin was emphasizing the role of sexuality in the creative process.[21]

Rodin's muses also served to console the martyred creator. In *Christ and the Magdalene* (plaster, 1894) (fig. 5.10)—alternately titled *Prometheus and the Oceanid* and *The Genius and Pity*—Rodin most clearly stated the intrinsically tragic nature of creation, a view that permeated his images of creators and informed his notion

5.10 *Christ and Mary Magdalene*, after 1894. Plaster. The Fine Arts Museums of San Francisco, Gift of Mrs. Alma deBretteville Spreckels. Cat. no. 133.

of the muse.[22] While Christ, Prometheus, and the artist were commonly identified with one another during the nineteenth century, Rodin added the element of the self-portrait.[23] The merging of all of these levels of meaning along with the theme of creation was new. In this, one of Rodin's rare religious works, he did not reduce mythic and modern symbols to a Christian absolute, as did his contemporaries.[24] Instead, by syncretizing the religious, mythic, and modern creative genius, Rodin brought to light some basic truths about his own experience of the creative role: it led not only to enlightenment but to tragic suffering and martyrdom as well. In Rodin's view of creation, then, the Magdalene, the Oceanid, and Pity were fused into one to play the role of consoling muse.

When Rodin worked with the poet and muse theme in his public monuments to genius, he was no doubt aware of his conservative precursors in this field, for such monuments flourished during the Third Republic. Sculptors for public memorials to genius adhered to a fixed repertoire of muse types traditional in academic classicism. More frequently tribute-paying than inspiring, these muses had characteristics and symbolic meanings dictated by pragmatic and didactic aims.[25] Yet even in his monuments to the most revered geniuses of the past and present, Rodin did not abandon his humanized conception of the muse for a conventional one. In his monuments, he drew on the same unheroic and ambiguously inspiring figures that populated his private works. In the first of his monuments to use the motif of muses, the projects for a Victor Hugo memorial commissioned for the Pantheon in 1889, they became the focus of his experimentation, sensitively registering each change in intention.

In the first study for the monument (fig. 5.11), Rodin arranged the muses in an expressive arc around the poet's head. Dramatic and conspicuous in their proximity to the poet, they defied the customary format wherein the portrait and allegorical figures remained in separate tiers or realms.[26] While they gave the general impression of a unified trio, in their varied poses they formed an entirely unclassical group.[27] In fact, the rightmost muse is turned away from the poet, embraced or entrapped by the muse to her left, disturbing the harmony of their arrangement and, by extension, of inspiration. Correspondingly, the poet is a limp, distracted, naked figure, seated in an awkward sliding pose. The head droops to one side, eyes narrowed in concentration, right index finger raised hesitantly to the lips.[28] Thus, in Rodin's spontaneous first study, the muses were a poignant accompaniment to an unheroic poet, an unorthodox conception for a monument to the most prolific and

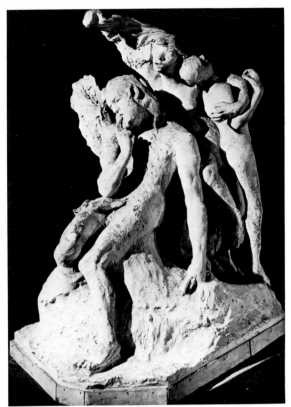

5.11 First project for *Victor Hugo Monument*, 1889-1890. Plaster. 39 in. Musée Rodin, Meudon. Photo, Musée Rodin Archives.

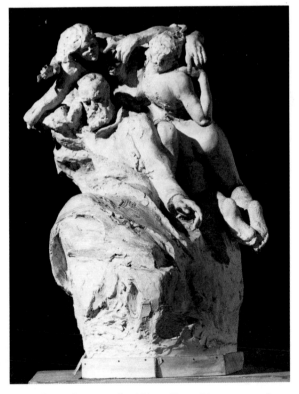

5.12 Second project for *Victor Hugo Monument*, 1890. Plaster. 33 in. Musée Rodin, Meudon. Photo, Musée Rodin Archives.

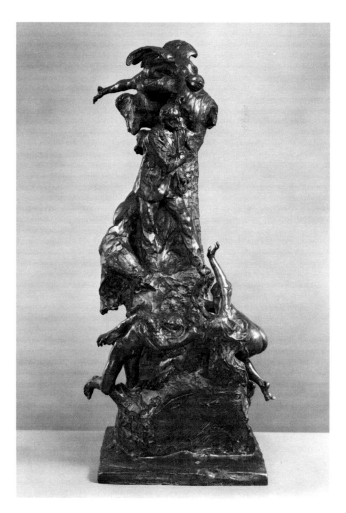

5.13 *Iris, Messenger of the Gods*, 1890-1891. Bronze. 37⅜ x 34¼ x 15¾ in. Musée Rodin, Paris.

5.14 Maquette for the second *Victor Hugo Monument (The Apotheosis of Victor Hugo)*, 1890-1891. Bronze. Philadelphia Museum of Art, Gift of Jules Mastbaum. Cat. no. 131.

fertile of French romantic writers. While they may have embodied, still, the customary personifications of a poet's major works or literary modes, already at this early stage Rodin's muses were, as the poet Rilke observed, "like the thoughts of [the poet's] solitude become visible."[29]

As the Hugo monument evolved, Rodin moved away from the unheroic conception of the poet to that of a more conventional thinker in contemporary dress. The figure of Hugo in the second project (fig. 5.12) represented the heroic exiled poet silencing the sea in order to hear his interior voices. The muses, however, remained an enigmatic trio. A sweeter-faced muse was inserted at the left, and the rightmost muse, still turned from the poet, was given a more graceful pose, but the overall tone of the group remained ambiguous. According to Grappe, at this stage of the project, Rodin had planned to include a personification of *Glory*, a large, winged version of *Iris, Messenger of the Gods* (1890–1891) (fig. 5.13) who, in her bluntly erotic, dancelike pose, would crown the seated poet and the muses. Had this idea been realized, it would have further invigorated this conventional maquette, heightening Rodin's exposure of the role of passion in creation.[30] Even without the figure of *Glory*, the maquette was rejected, but Rodin did preserve this idea when, at the end of 1890, he began a second monument for the Pantheon, one otherwise more conventional and decorative (fig. 5.14, illustrating a bronze maquette for the new monument).[31]

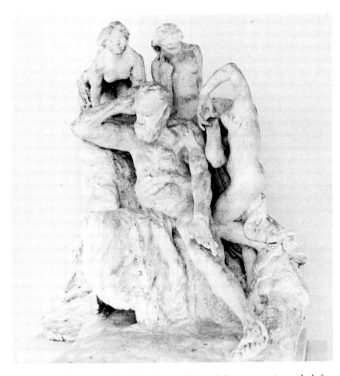

5.15 Third project for the *Victor Hugo Monument* intended for Luxembourg Gardens, 1891-1897. Plaster. 44⅛ in. Musée Rodin, Meudon. Photo, Musée Rodin Archives.

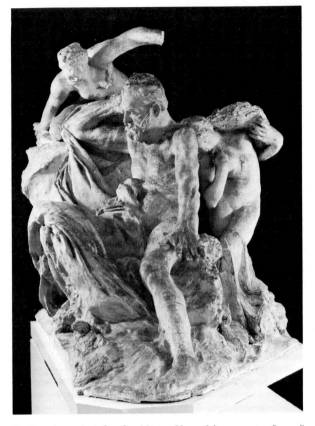

5.16 Fourth project for the *Victor Hugo Monument*, 1891-1897. Plaster. 36¼ in. Musée Rodin, Meudon. Photo, Musée Rodin Archives.

Shortly afterwards, in 1891, having been given the opportunity to resume work on the first monument for an outdoor site, Rodin again revised his conception of the poet, now introducing partial nudity (fig. 5.15).[32] Even though he assigned Hugo a realistic, middle-aged anatomy, which imparted to the otherwise heroic figure a distinctly unclassical and controversial note, he retained the dignified gestures and pose from the previous version. His muses, however, became more unheroic, more sharply differentiated, and more unorthodox in their suggestive meanings. Rodin even introduced a new muse, his personal symbol *Meditation* now retitled *The Interior Voice*, standing apart from the group. Her raised arm reaching down to touch her breast echoes the poet's arm cupped to his ear, thereby suggesting a link between the poet's intense effort to hear an interior voice and the muse's quest for fertility.[33] Clearly, Rodin relished the contrast between the heroic façade of contemplation and the ignoble struggles underlying the creative life. From this third stage of the project onward, Rodin made it primarily the burden of the muses to reveal without idealization the inner struggles of the modern creative mind.

In the fourth stage Rodin simplified the composition, crystallizing its symbolic content (fig. 5.16). He reduced the muses to two expressively contrasting types, possibly alluding to the inner voice of the poet and the external voice of nature and humanity as described by Hugo himself.[34] Drawing on his personal vocabulary of inspiration, Rodin gave *The Interior Voice* a stone to bear, possibly noting the special adaptability of that motif in the context of this monument. As Hugo himself had defined the poet-thinker, his mission was to "reconstruct stone by stone" the values of a society in spiritual decay.[35] More significantly, the opposing muse of the pair was Rodin's earlier *Tragic Muse* (1885), placed high on a rocky ledge above Hugo's right shoulder, so that now the most deified poet of the century was depicted as the recipient of her ambiguous and complex inspiration.

In the 1897 variant of this maquette (fig. 5.17), exhibited in the salon, Rodin conveyed the tortuous process of creation still more graphically, not only in the form and iconography of the muses, but also in the sculpture's actual physical state. *The Interior Voice*, presented as armless, expressively communicated indecision and inertia.[36] Curiously analogous to the crude raised arm of *The Tragic Muse*, the poet's left arm was propped up by a bar and incompletely joined to the torso. Through gestures, poses, and suggestive parallelism—

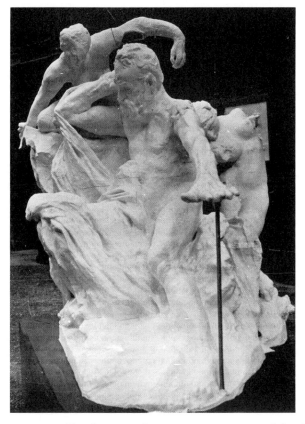

5.17 Variant of fourth project of *Victor Hugo Monument* exhibited at the Salon of 1897. Plaster. 36¼ in. Photo, Musée Rodin Archives.

as well as to his belief in their public appropriateness. The bold and unprecedented *Tragic Muse*, discordantly paired with the heroic figure of Victor Hugo, most clearly expresses Rodin's strivings for an original monument not merely to a creator, but to the creative process as well.

It was in the *Monument to Balzac* (commissioned in 1891 and completed in 1898) (fig. 5.18) that Rodin conveyed his most audacious and personal concepts about genius and inspiration. What he had previously reserved for the allegorical context of the muse, he now subsumed in the portrait of the creator himself.[38] He depicted Balzac not as a conventionally dignified writer in either antique garb or modern dress, but rather alone at night dressed in the "monk's robe" in which he typically worked.[39] While informal dress and nightwear

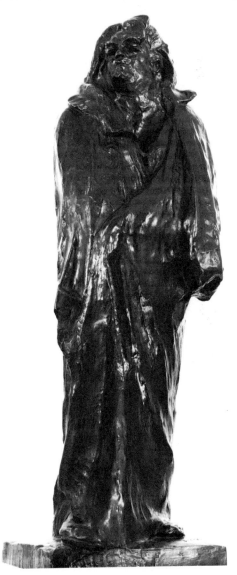

and now the publication of a "work state" of the study—Rodin exposed the painstaking physical process of creation.

In the unfolding of his ideas, Rodin came to focus on *The Tragic Muse*, the most radical symbol of his personal invention which had become the monument's expressive core. The Hugo monument had indeed become a vehicle of personal reflection—the profound synthesis of Rodin's view of Hugo's creativity and the multiple notions of his own. Rodin, no doubt, strongly identified with Hugo's strict reliance on nature for inspiration, his immense regard for the thinkers of his age, and his messianic dedication to art.[37] In *The Tragic Muse* at the side of a masterful poet, Rodin strove to convey the poet's communion with the voices of nature, humanity, and God, as well as the poignancy of Hugo's tragic exile and of the creative role itself. To evoke these multiple meanings was a difficult formal and iconographic challenge which did not readily lend itself to traditional compositions or symbols—hence, the complex history of the project. Although the final version of the monument featured Hugo alone, the tenacity with which Rodin clung to the motif of the muses attests to their personal significance

5.18 Final half-life-size version of *The Monument to Balzac*, 1897-1898. Bronze. B. G. Cantor Collections. Cat. no. 145.

had previously been associated with the iconography of inspiration, Rodin took this intimate realism to an extreme.[40] He expressed not just a private but an unbecoming moment of nocturnal inspiration with a realism unprecedented in the entire tradition of painted and sculpted monuments to genius. He showed a Balzac whose creative fervor left a tragic imprint on the face, a Balzac leaning back dramatically, gathering his robe around him, a metaphor for the increasing energy within.

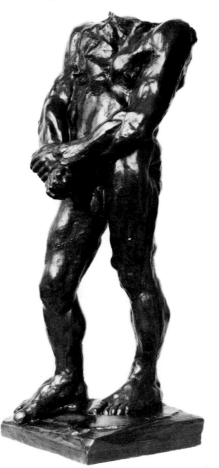

5.19 *Naked Headless Figure Study for the Final Balzac*, study "F," 1896. Bronze. Stanford University Museum of Art, Gift of the B. G. Cantor Art Foundation. Cat. no. 144, another cast.

One study, in fact, explored the idea of a headless male figure holding an erect penis, suggesting the sexual energy inherent in creative tension (fig. 5.19). This theme, which he had previously explored in the allegorical context of a muse, he finally included in the Balzac monument as an implied and covert gesture. Rodin's images of creators gradually assumed the form of his personalized muses, openly reflecting the inner dynamics of the creative mind.

Rodin depicted the creator with a new realism that did not preclude further experiments in personalizing the

5.20 *The Shade with the Fallen Caryatid*, after 1898. Plaster. Photo Bodmer. Musée Rodin Archives, 1354.

muse; in fact, novel combinations of the muse types he first conceived in the eighties continued to enrich his iconography. As late as 1898, the motif of the stone-bearing caryatid reappeared in his work. He combined this figure with his earlier *Shade*, whose right knee was made to rest on the *Caryatid*'s shoulder (fig. 5.20). In light of the *Shade*'s pose (which Rodin derived from his figure *Adam*, alternately called *Creation*), the rejoining of old parts created a new symbol: the muse's literal assumption of the creator's burdens. In another study, Rodin combined the *Shade* with the armless version of *Meditation*.[41] Similarly, countless experimental plasters showing curiously intertwined figures—some embracing, others seeming to grow one from the other—may also be seen as stages in the evolution of Rodin's personalized poet and muse. One of the most mysterious figures in the Meudon Reserve is the study of a *Man Growing from the Shoulder of a Seated Woman* (fig. 5.21), which harks back to Rodin's earlier visual formula for showing the muses, sirens, or Eurydice held or suspended above a poet's head.[42] Here, however, Rodin produced a curious inversion of the formula. Through the conjunction of two partial figures, an armless male figure seems to

5.21 *Man Growing from the Shoulder of a Seated Woman*, date unknown. Plaster. Musée Rodin, Meudon Reserve, Paris.

emerge from a seated woman below. That Rodin derived the figure of the youthful male from his earlier work, *The Death of the Poet* (c. 1888)—where the same figure with eyes closed and head bowed was shown lying on the ground beneath a trio of sirens or muses—reveals how his most elusive symbols become more intelligible when approached from the context of his work. Though unorthodox in pose and gesture, their basis in intuition allowed Rodin to believe in their fundamental clarity.[43]

After the rejection of the Balzac monument, Rodin retreated from his daring approach. In the three major monument commissions which occupied him from 1899 to the end of his life, he showed a new conservative spirit. He turned to the customary memorial themes—fame and glory—as opposed to inspiration. He was no longer as concerned with probing the physiognomy or psychology of the actively inspired creator; he tended toward abstract, heroic themes that were simpler and more legible. Rodin's concession to familiar and acceptable symbolism, coupled with his chronic pattern of unfinished monuments, might be regarded as a slackening of his creative force and of his commitment to modernizing the public monument. Yet, even within this framework of conservatism, he endeavored to go beyond the stereotypes of academic classicism in order to revitalize traditional allegorical formulas. As before, his intentions are most evident in the intermediate stages of his projects, where plural and nonstereotypical meanings continued to surface.

When a memorial to his friend, the symbolist painter Eugène Carrière, was proposed in 1912, Rodin conceived a traditional apotheosis scheme: the youthful, idealized artist shown crowned by a descending victory. In an inscribed plaster maquette (fig. 5.22), the victory, winged and laurel-bearing, is posed in the traditional diagonal arrangement in relation to the artist. Carrière or his surrogate is depicted standing, with one leg raised, in the pose associated since antiquity with poetic victory. By

5.22 Project for the proposed *Monument to Eugène Carrière*, 1912. Plaster. 16 x 7 x 6 in. Inscribed: *Carrière*. Philadelphia Museum of Art.

virtue of this pose, the maquette recalls several studies from the mid-1890s which represent Rodin's most experimental ideas. Despite the maquette's prosaic form, the earlier studies from which it was derived offer a host of unorthodox associations.

One of these studies, *The Poet and Love* (c. 1896) (fig. 5.23), shows a headless, winged figure with a poet, an idealized torso now with a martyr's head (that of *St. John the Baptist*). The left leg of the poet, which Rodin raised unusually high, was as much an embellishment of pathos as of victory. It alluded to the raised, chained leg of

5.23 *The Poet and Love*, c.1896. Plaster relief.
16¾ x 11 x 6 in. Philadelphia Museum of Art.

5.24 *Group of Three Figures*, mid-1890s. Plaster. 11⅝ x 9¾ x 7½ in. Philadelphia Museum of Art.

5.25 *Study for the Monument to Eugène Carrière, "The Hero."* Bronze. The Fine Arts Museums of San Francisco, Gift of Mrs. Alma deBretteville Spreckels. Cat. no. 136.

Prometheus, a popular emblem in nineteenth-century art of the legendary sculptor's martyrdom and captivity.[44] By choosing the figures of poet and love, Rodin stressed also the creator's need for passion and consolation, a theme especially appropriate to his own difficult decade of the nineties. Although the dominant note of this study was tragic, other nuances can be seen as well. The poet's agitated expression and the energy of the outstretched arms of both figures suggest Rodin's preferred theme of inspiration—the pain and ecstasy of creation.

In another study related to the Carrière monument, the *Group of Three Figures* (mid-1890s) (fig. 5.24), Rodin placed a poet between two solemn muses. Again, the poet's leg is raised, and his left hand extends over a scroll the muses unroll before him. These muses are impassive and statuesque, in contrast to the poet's lifelike concentration and active pose, recalling the poet-muse compositions of antique sarcophagi.[45] In this, his most classical plaster, Rodin presented inspiration in its most lyrical and serene form, translating the mystery and gravity of the ancient communion in modern terms.

The study closest to the final Carrière maquette reveals at once that Rodin was not conferring a conventional apotheosis upon the painter. In this version, a group

known as *The Hero* (c.1896) (fig. 5.25), Rodin omitted the adoring head of the victory, sliced off one of her wings, and eliminated the laurel wreath and her arms as well. He sacrificed the explicit attributes and gestures of laureation, preserving only the victory's customary diagonal placement with respect to the deceased. Rodin seems to have searched out the core of the image of apotheosis and arrived at what was essential to evoke the time-honored theme. When stripped of her prosaic identifying features, Rodin's victory becomes suggestive of the muse or thought taking flight, presenting a distinct contrast to the lifeless conflations—at the level of attributes only—of muse and victory in the monuments of his contemporaries.[46] Thus, the works preliminary to the final Carrière maquette join the creator's glorification with the idea which continued to preoccupy Rodin—the creator's inspiration.

In the monument proposed in 1899 to Puvis de Chavannes, the artist he most admired, Rodin pursued this approach. Again, his conception was apparently conservative: a dignified bust of the painter guarded by the traditional funerary figure, *The Spirit of Eternal Repose* (c.1898) (fig. 5.26). The spirit, later rechristened *Muse*, is displayed in the cross-legged position connoting

5.26 *The Spirit of Eternal Repose*, c. 1898. Plaster. Armless version exhibited at the Rodin Exhibition in 1900. 76¾ x 37¾ x 34¼ in. Photo, Musée Rodin Archives.

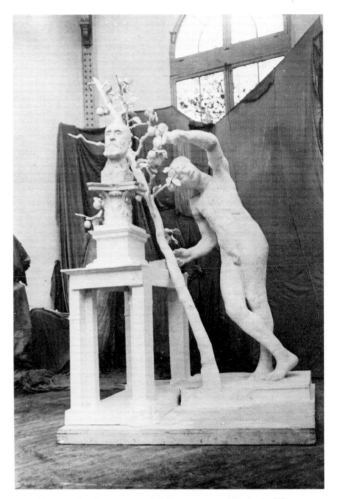

5.27 Project for the proposed *Monument to Puvis de Chavannes*, 1899-c. 1907. Plaster. Photo, Musée Rodin Archives, 1473.

sleep and death. Its off-balance pose, however, contrasts with the traditional prototype shown leaning on the door to Hades. Although the figure was alternatively known as the *Funerary Spirit*, it was not particularly funereal, but instead solemn and even sensuous; Rodin created a separate *Head of a Funerary Spirit* (c. 1898) which conformed more closely to the funereal tone expected in memorial sculpture.[47] The *Funerary Spirit*'s full identity becomes clearer in another, more detailed study known through an old photograph (fig. 5.27): a bust of Puvis stands upon a plain table, against which a branch from an apple tree leans, and behind it *The Spirit of Eternal Repose* raises his arms in homage. This idea, reminiscent of ancient Greek domestic altars, derived from the classical tradition of apotheosis images.

In keeping with his stated aim to "treat his subject largely and seriously, in the style of Puvis de Chavannes's own work," Rodin seems to have drawn on prototypes in which a bust or a full figure was shown on Mount Parnassus, adored by histories, fames, the muses, or

Apollo.[48] The allegorical figure paying tribute to Puvis, then, becomes Apollo, whose idealized form and sensuous grace embodied the classicism which Rodin admired in Puvis's work. Again, Rodin altered the customary iconography by subordinating the rhetorical gestures—the offering of laurel or lyre—to his own idea of expression: the *Spirit* figuratively crowns the bust with the entire branch of the tree, an original gesture contrary to convention.[49] The mysterious relationship between spirit and bust is more compelling than any of its prototypes. Remembering the god who inspires the poet in life and crowns him after death, Rodin revitalized the funerary spirit to embody not only an eternal life force but an eternal creative force as well.

The projects begun in 1905 for a London monument to the painter James McNeill Whistler epitomize Rodin's inventive approach to traditional symbols. The final maquette, known only through a plaster sketch model completed after Rodin's death, was based on a common neoclassical formula preserved in nineteenth-century

5.28 Study for a *Monument to Whistler*, c. 1905. Pencil. 7½ x 5⅛ in. Pencil inscription on recto. Musée Rodin, Paris (D 6030).

examples—the medallion or bust of the glorified individual contemplated for eternity by a female personification of victory.[50] This theme is reflected in several of Rodin's early drawings of victory, winged and draped as was customary, holding a medallion at her side. One drawing (fig. 5.28) shows the victory wingless and in a more dynamic pose, the medallion now supported on her raised knee. The plaster exhibited by Rodin at the Salon of 1908 (fig. 5.29), which displayed the portrait likeness of his mistress of the period, sculptor Gwen John, reverted to this raised leg pose. It was a partially draped, armless nude, leaning forward over her left leg, which was raised on a tall mound in front of her. The new title of the figure, *Muse* (albeit with the curious epithet "climbing the mountain of fame"), reveals that he was steering the original meaning of victory toward that of meditative muse. Bypassing his own repertoire of symbols, Rodin mined antique art for the most expressive of ancient thinking poses—that of Melpomene on the far right of the Louvre *Muse Sarcophagus* (fig. 5.30).[51] Melpomene stands meditating with chin supported in hand, elbows resting directly on her right knee, her foot placed on a rocky ledge. Unlike her sisters on this and other sarcophagi, her entire torso participates in the gesture of thought; one of Rodin's sketches for the project,

5.29 *Whistler's Muse*, c. 1903-1908. Bronze version. Stanford University Museum of Art, Gift of the B. G. Cantor Art Foundation. Cat. no. 137.

Gwen John in the Act of Drawing (fig. 5.31), presents a close parallel to the pose of Melpomene.[52] Thus, while preserving his model's identity as an artist, Rodin also depicted her as a genuine synthesis of the past and present.

Whistler's Muse confirms that a fundamental repertoire of classical gestures and poses was the mainstay of Rodin's symbolic vocabulary to the end of his life. Yet, while Rodin had never been closer to his beloved classical sources, the figure departed radically from the ideal. Admittedly more orthodox than the Hugo monument muses, Gwen John with her non-Grecian features and withdrawn expression communicated a solemnity tinged with uncertainty, a contrast to the grave optimism of the ancient ideal. Hence, this muse was not merely a picturesque convention borrowed from the past; she embodied instead "the very soul of meditation," as Rodin

top: 5.30 *Melpomene*, on *Louvre Muse Sarcophagus*, mid-2nd century A.D. Marble. 80¾ x 36¼ in. (entire sarcophagus). Musée du Louvre, Paris.

bottom: 5.31 *Gwen John in the Act of Drawing*, c. 1903-1908. Pencil and watercolor on paper. 12⅞ x 9⅞ in. Signed: *Aug. Rodin* and inscribed on verso: *Etude pour le monument de Whistler*. Musée Rodin, Paris (D 4259).

once described the muse who dwelled in his own garden.[53] Even within a more conventional framework, Rodin was still personalizing the muse.

Rodin discovered in traditional motifs the unlimited potential to convey personal meanings genuinely relevant to the present. He thereby invigorated the modern monument through tradition without rejecting the past. He was able to transform the traditional attributes of an allegorical theme by striving not merely for equivalent but for more fundamental and evocative symbolism. In this blending of the past with his own time, Rodin shared late nineteenth-century symbolist thought, which fused forms and ideas to produce new symbols based on convergent meanings. In this regard, his approach ties him to symbolists like the painters Gustave Moreau and Puvis de Chavannes and the leading poet of the movement, Stéphane Mallarmé. The latter wrote of the enduring relevance of pagan myth and of the artist's duty to preserve but revitalize the ancient symbols—to fill them with modern significance. He advocated, not an empty revivalism, but a true restoration of myth, drawing vitality from tradition at its source.[54] Thus Mallarmé, and Rodin like him, went beyond the conservative strain of mythic themes of nineteenth-century literature and art. Whereas the academic tradition used myth to dignify and idealize subjects, both Mallarmé and Rodin were fascinated by myth's enduring ability to inspire the artist's emotions and evoke an imaginative response.

In the projects following the Hugo and Balzac monuments, then, Rodin steered the themes of fame and glory subtly toward meditation. He rejected the trite formulas of his contemporaries—history or the muses inscribing the name of the deceased for posterity and fame trumpeting his glory and decking him with fronds of palm. An allusive symbolism replaced the usual clarity associated with classicizing style and allegory even in what seem Rodin's most conservative monuments. The motifs taken from tradition were permeated with personal meaning, fused at the level of intuition and suggestion.

In turning repeatedly, then, to the concrete mythical muse, Rodin found a symbol which inspired him personally. He extended the traditional symbol to include sirens, caryatids, and meditations, all of which embodied his multiple notions of the labor of the creative mind. They exposed, for the first time publicly, the less heroic and more elusive aspects of the inner workings of the artistic mind. Rodin's muses also became a personal symbol for the spiritual function of art, a function which he viewed as imperative in an age of disbelief. In this respect, they were like the angels of the German poet Rilke, who was profoundly influenced by his contact with Rodin.[55] Constantin Brancusi, an important modern sculptor, also struggled to sustain the muse into the twentieth century, albeit as a symbol of serenity and joy.[56] Thus, the legacy of Rodin can be observed in the younger artists of his time, who found traditional motifs, such as the muse, crucial to the development of their art, not just in form but in theme as well. They seem to have learned from Rodin that these were fertile symbols—age-old motifs that could be made new again to represent the creative imagination.

NOTES

This essay is based on a doctoral thesis, currently in progress, investigating the broader subject of Rodin's monuments to genius. The thesis will examine the relation of their iconography to his independent works and to the monuments produced by his contemporaries.

I would like to thank in particular Dr. Albert Elsen, who has offered his insights generously and has guided my research in an invaluable way. I am also thankful to the Musée Rodin in Paris for the cooperation of curators and staff in making archive materials available to me. And last, I would like to express gratitude for the B. G. Cantor Foundation grant which facilitated the necessary research abroad.

1. The range of function of the original muses excluded painting and sculpture. It was not until the sixteenth century that these branches of art were even understood to require intellectual effort and therefore inspiration. The development of muses and allegorical personifications for these arts was closely tied to the social and cultural history of the artist. By the eighteenth century, muses of painting and sculpture were not uncommon. See, for example, François Boucher's oil *The Muse of Painting* (illustrated in Haldane MacFall, *François Boucher* [London: The Connoisseur, 1908], 96) and Giuseppe Ceracchi's marble portrait *Anne Seymour Damer as the Muse of Sculpture* (illustrated in Gérard Hubert, *Les Sculpteurs Italiens en France sous la Révolution, l'Empire et la Restauration, 1790–1830* [Paris: Editions E. de Boccard, 1964], pl. 7).

2. Muse images up through the eighteenth century can be conveniently reviewed in Joachim Gaus, "Ingenium und Ars—Das Ehepaarbildnis Lavoisier von David und die Ikonographie der Museninspiration," *Wallraf-Richarts Jahrbuch*, 36 (1974): 199–228. In the nineteenth century, the muse appeared often in the work of symbolist artists. One of the best known of these works is Puvis de Chavannes's *Sacred Grove to the Arts and Muses*, c. 1884, decorating the staircase of the Musée de Lyon. Others of his decorative programs incorporating the muse include those for the Hôtel de Ville in Paris and for the Boston Public Library.

3. The variety of approaches of nineteenth-century artists to modernizing the muse can be seen in the paintings and prints of Gustave Moreau, Puvis de Chavannes, Félicien Rops, Henri Fantin-Latour, Fernand Khnopff, and Maurice Denis, among others. This is discussed also in Jacques de Caso and Patricia Sanders, *Rodin's Sculpture: A Critical Study of the Spreckels Collection, California Palace of the Legion of Honor* (San Francisco: The Fine Arts Museums of San Francisco and Rutland, Vermont: Charles E. Tuttle Co., Inc., 1977), 49–50.

For a more detailed discussion of Puech's monument, see Mechtild Schneider, "Denkmäler für Künstler in Frankreich: Ein Thema der Auftragsplastik im 19. Jahrhundert" (inaugural dissertation, Johann-Wolfgang-Goethe Universität, Frankfurt-am-Main, 1977), 185–188.

4. The muses are part of a broader creation iconography pervading Rodin's work. He depicted geniuses of his own era as well as several from legend and myth, in countless portraits, monuments, and independent sculptures. He also made images personifying the artist, poet, and thinker. Creation subjects were not exclusive to Rodin. A self-conscious concern with creativity was part of the intellectual environment of the nineteenth century; it preoccupied many artists and writers, from the romanticists to the symbolists. The poet-muse dialogue found in the poems of Alfred de Musset and Victor Hugo had its visual counterpart in painted and sculpted images of the artist inspired by an angel or muse. In sculpture, monuments to genius thrived, reflecting the past century's rich tradition and the congenial democratic atmosphere of the Third Republic in particular. In this context, the poet-muse motif became an important convention, as observed in monuments by Emanuel Frémiet, Denis Puech, Ernest Barrias, Antonin Mercié and Jules Dalou, to name a few.

5. Rodin's own description of his working method is quoted in Frederick Lawton, *The Life and Work of Auguste Rodin* (London: T. Fisher Unwin, 1906), 162–163. Albert Elsen, *Rodin* (New York: The Museum of Modern Art, 1963), 141–145, also discusses the importance of improvisation for Rodin's work.

6. Rodin frequently spoke of his mistrust of inspiration; his advice to young artists, quoted in de Caso and Sanders, *Rodin's Sculpture*, 53, n.11, was: "De la patience! Ne comptez pas sur l'inspiration. Elle n'existe pas." Counterbalancing this mistrust of inspiration was a faith in hard work, revealed through statements, old photographs deglamorizing his work and studio, and the preservation in his sculpture of toolmarks and accidental effects. Albert Elsen has written extensively about this subject, most recently in *In Rodin's Studio: A Photographic Record of Sculpture in the Making* (Oxford: Phaidon Press in association with the Musée Rodin, 1980). The most telling example of Rodin's wish to present the activity of the artist as work was his project for a *Monument to Labor* (1894) wherein he planned to arrange artists, poets, and philosophers at the summit of a spiral beginning with manual workers, thereby including the creative artist within a comprehensive brotherhood of workers.

7. The allegorical conventions for monuments included a range of formulas. Sculptors might typically represent literary artists meditating, writing, or addressing the public, their work identified by the tangible signs of manuscripts, books, and quills. They also frequently turned to more abstract statements through the use of allegorical figures accompanying the portrait statue. These were figures which personified an author's writings, inspired him, or paid him tribute. For monuments to visual artists, tangible professional emblems, rather than abstract allegories, predominated; palettes, brushes, mallets, replicas of statues, or motifs from paintings were easily depicted. However, here too, sculptors would occasionally employ the commemorative allegories of fame and glory and less frequently, inspiration.

These formulas underwent some change with the popularization of the monument to genius during the Third Republic. Some sculptors, in rethinking the allegorical method, simply introduced more realism into the rendering of their symbolic figures—this was frequently taken to banal extremes—while others merged the age-old symbols in monotonous ways. Occasionally a novel motif was introduced, such as an author's modern reader, shown in contem-

porary dress and holding an open book, as seen in Raoul-Charles Verlet's *Monument to Guy de Maupassant* (1897; illustrated and discussed in Schneider, *Denkmäler*, fig. 58 and 182–184).

8. In the sculpture *A Night in May* (plaster?, date unknown, preserved in an old photograph and illustrated in Elsen, *In Rodin's Studio*, pl. 80), Rodin portrayed a haloed muse or angel, a surprising allusion to divine inspiration in light of his disbelief in this source. The sculpture probably depicts the muse of the romantic poet Alfred de Musset, after whose poem Rodin titled the work. In the poem's dialogue between poet and muse, the muse is the optimistic consoler of a dejected poet.

9. Compare Rodin's drawing to the mannerist prototype, Giulio Bonasone's print *Socrates as Artist* (1555), which depicts the philosopher seated before an easel, receiving guidance from behind by a winged female inspirer. She leans her head close to that of the philosopher and her profile echoes his. This is similar to the intimate closeness of the heads of the sculptor and genius in Rodin's drawing. The arrangement of the philosopher's arms also seems a prototype for Rodin's drawing. In one arm, Socrates holds up a compass, and with the other, he reaches out toward the easel. In the print, these gestures signify the heavens as the divine source of inspiration (illustrated in Gaus, "Ingenium und Ars," 215, fig. 14).

For the sculptor's unusual pose, with his leg propped behind him, and for the very idea of an airborne inspiring figure, Rodin seems to have recalled Caravaggio's memorable depiction of divine inspiration in *Saint Matthew and the Angel* (second version, 1602). In Caravaggio's painting, the bench appears to be a useful support for the saint as he leans forward to record the dictation of the angel; Rodin's use of the motif, by contrast, seems entirely symbolic.

10. The thinker and personification of his thought was a restatement of a motif on one of the lower reliefs of *The Gates of Hell*, begun in 1880 (the relief is illustrated in Albert Elsen's essay "The Gates of Hell," fig. 3.6). Here Rodin depicted solely a thinker and floating figure of thought. Albert Alhadeff has discussed this relief and its history of interpretation by Rodin and other writers and argues for the interpretation of the thinker as Rodin's self-portrait. See his article "Rodin: A Self-Portrait in *The Gates of Hell*," *Art Bulletin* 48 (1966): 393–395.

Rodin's specific focus in this drawing on the art of sculpture suggests that he may have sought to confirm the cerebral nature of the art of sculpture and also supply a modern allegory for that "lowly" art which, he no doubt was aware, lacked a canonical symbol. The image of a thinker-sculptor appeared several times in nineteenth-century sculpture, but typically the sculptor was shown in one of a variety of rhetorical thinking poses. See, for example, James Pradier's *Phidias* (1835; illustrated in Schneider, *Denkmäler*, fig. 32) and Aimé Millet's *Phidias* (1889; illustrated in Bo Wennberg, *French and Scandinavian Sculpture in the Nineteenth Century* [Atlantic Highlands, N.J.: Humanities Press, 1978], 28). Pradier's figure is shown engrossed in thought; the right hand holding the mallet is at rest, while the left hand is raised to the sculptor's chin. Millet's *Phidias* is shown standing pensively beside his sculpture.

11. Rodin's treatment of *Pygmalion and Galatea* (1889) would seem to confirm the unorthodox meaning of the statuette in the drawing, for Rodin showed Galatea withholding herself from the sculptor. Since it was Venus who pitied Pygmalion and brought his beloved statue to life, Galatea is often described in the *Venus pudica* pose. Rodin's figure may derive from this conventional pose of modesty as well.

12. De Banville's poem "The Imprecations of a Caryatid" is reproduced in Théodore de Banville, *Poésies Complètes*, vol. 3, *Les Cariatides* (Paris: Bibliothèque-Charpentier, 1891), 160–161. It is prefaced by the lines from Hugo's *The Interior Voices* quoted in the essay (from the poem "To the Arc of Triumph" where the caryatid symbol is used in a somewhat different political and historical context) and by another verse about the caryatid from Hugo's *The Rhine* (letter 24). De Banville's poem closes a section including other poems that directly describe the mystery and difficulty of a poet's existence, for example, "The Dead Lyre." Among its multiple meanings, then, the caryatid symbol presumably encompassed for De Banville a metaphor of the poet. I would like to thank Dr. Lucile Golson (University of Southern California, retired) for suggestions in translating and helpful discussion of De Banville's poem.

For further discussion of the caryatid symbol, see Elsen, *In Rodin's Studio*, 168, and de Caso and Sanders, *Rodin's Sculpture*, 155–157. The latter source points to the Dantesque implications of the symbol of the stone; Dante, in *Purgatorio* (cantos 10 and 11), likened the atoning, stone-bearing souls in purgatory to caryatids succumbing under their burdens.

13. A great deal has been written about this work by Elsen, in *Rodin*, 61ff., and in *In Rodin's Studio*, 167. The former reproduces a translation of Baudelaire's verse from the poem *La Beauté* which was inscribed on the sculpture's base (in a later cast):

I am beautiful, oh mortals, as a dream of stone,
And my breast, whereon each dies in his turn,
Is made to inspire in the poet a love
As eternal and silent as the substance itself.

Elsen's interpretation of the group is most convincing within the context of Rodin's work. He points out also that this elusive muse appeared twice on *The Gates of Hell*, first paired with the poet from *I Am Beautiful* at the upper right and then, alone, in the lintel behind *Dante* or *The Thinker*. A further indication of how important the theme of elusive inspiration was for Rodin is his subsequent work *Man and His Thought*, also known as *The Poet and the Muse* (1889). Here, the poet is shown as a solemn, kneeling supplicant at the breast of the muse, a small and youthful woman who looks away from him. That the inscription on the base of *I Am Beautiful* might be as appropriately inscribed here reveals how Rodin created numerous variations on his basic themes.

14. Illustrated in Georges Grappe, *Catalogue du Musée Rodin*, vol. 1, *Essai de classement chronologiques des oeuvres d'Auguste Rodin*, 5th ed. (Paris, 1944), cat. no. 128; referred to as *The Large Meditation*. This edition of Grappe's catalogue will be the one subsequently referred to unless otherwise noted.

15. The muse's gesture of pressing the breast can be understood in the general context of Rodin's emphasis on sexual gestures. More specifically, however, it has a history of association with inspiration. Giovanni Serodine's *Feminine Allegorical Figure*, a baroque painting, shows what is presumably a sad muse mourning the death of her poet. A lyre and open books are spread before her on a table. Rather than squeezing milk onto them, she lowers her head, closes her eyes, and presses one of her breasts. This work has been discussed in connection with Rodin's Hugo monument in Schneider, *Denkmäler*, 252–253, where primary sources for the interpretaion of Serodine's melancholic muse-bacchante are given. Elsen, *In Rodin's Studio*, 167, also suggests the associations of this hand-to-breast gesture with birth, desire for a child, or grieving over the loss of one. He makes these observations in connection with another figure exhibiting the gesture, *The Crouching Woman* (1880–1881), a figure which in fact is very close in overall pose to the one in Serodine's painting. (The

former is discussed and illustrated in Elsen, *In Rodin's Studio*, 167 and pl. 31; the latter is illustrated in Roberto Longhi, *Giovanni Serodine* [Firenze: Sansone, (1950)], pl. 26.)

16. Grappe, *Catalogue*, cat. no. 47, gives the alternate titles for *Adam* as *Creation* or *The Creation of Man*.

17. *The Tragic Muse* shown with her raised left arm is illustrated in Grappe, *Catalogue*, cat. no. 129.

18. Grappe, *Catalogue*, cat. no. 129. Its other alternate title, *The Celestial Muse*, seems to be most ironic.

19. See also the illustration in Robert Descharnes and Jean-François Chabrun, *Auguste Rodin* (London: Macmillan and Co., 1967), 153. The photograph includes the model for *The Tower of Labor* and, hence, dates at least after 1894.

20. For further discussion, particularly of Rodin's views about the role of woman as muse, see de Caso and Sanders, *Rodin's Sculpture*, 49–53.

21. Gustave Moreau's personal notebooks typify the spiritual idealism that evolved in the symbolist environment. His writings about the need to negate the senses present a stark contrast to Rodin's robust, sensual view of creation. See, for example, Moreau's notes about his late painting *Dead Lyres*, reproduced and discussed in Julius Kaplan, *Gustave Moreau* (Los Angeles: Los Angeles County Museum of Art, 1974), 50, 141. What Rodin and Moreau shared was a belief in the profound sacrifice required for creation.

22. Rodin repeatedly referred to the suffering and tragedy connected with the creative role. While he described "the martyrdom of the creature tormented by unrealizable aspirations," he also observed "the sanctity of effort and suffering"; quoted in Auguste Rodin, *On Art and Artists*, Alfred Werner (ed.), (New York: Philosophical Library, 1957), 210, 230. He asserted that tragedy could be transformed constructively by the creative individual (*On Art and Artists*, 66–67). It is not surprising, then, that Rodin was fascinated with the legends of Prometheus and Orpheus in which suffering and creation were prototypically joined. The prominence of these myths in his works and statements ties him to romanticist and symbolist thought. For further discussions of the symbolic importance of these myths for nineteenth-century artists and writers, see Maurice Schroder, *Icarus: The Image of the Artist in French Romanticism* (Cambridge, Mass.: Harvard University Press, 1961) and Léon Cellier, "Le Romanticisme et la mythe d'Orphée," *Cahiers de l'Association internationale des études françaises* 10 (1958): 138–157.

23. This work as a self-portrait is discussed by Elsen, *In Rodin's Studio*, 180. De Caso and Sanders, *Rodin's Sculpture*, 93–97, also discuss the work in the context of the growing indentification of other nineteenth-century artists with the figure of Christ.

24. Compare the series of ten oil panels by Gustave Moreau, *The Ages of Man* (1886), where each of three rows of panels treats, respectively, the life stages of the individual, of the artist, and of civilization as a whole. While Moreau syncretized themes from the Bible and classical mythology, the crucifixion scene in the uppermost panel points to the overriding Christian absolute. This series is discussed in Kaplan, *Gustave Moreau*, 44–45 and illustrated in *Musée Gustave Moreau: Catalogue des Peintures, Dessins, Cartons, Aquarelles* (Paris: Editions des musées nationaux, 1974), cat. no. 216. For Rodin, by contrast, the overriding absolute was a poetic one; that is, he extolled Jesus and Orpheus alike for their ability to create the poetic symbols necessary for humanity's spiritual sustenance. Both Christianity and paganism held out for Rodin an ideal of higher poetry and the potential for spiritual renewal. His views about the equivalent spiritual roles of Jesus and Orpheus are recorded in Judith

Cladel, *Auguste Rodin, Pris sur la Vie* (Paris: Editions de la Plume, 1903), 100–101.

25. Compare, for example, Jules Dalou's relief of 1886, *The Apotheosis of Victor Hugo*, which depicts an ecstatic muse crowning the deified poet with a lyre. The laurel-wreathed poet is seen in antique dress seated in a stylized posture of thought, and the entire scene is set within an aureole of light surrounded by winged putti bearing the author's major literary works. A tamer, still more conventionally academic muse is seen in Ernest Barrias's *Monument to Victor Hugo* (1902, formerly Place Victor Hugo, destroyed). Both works are illustrated in Schneider, *Denkmäler*, figs. 87 and 95.

26. Rodin had observed the customary separation between the realistic and allegorical realms in his major monument preceding the Victor Hugo memorial, the *Monument to Claude Lorrain*, commissioned in 1887 and inaugurated in 1892, hence overlapping the early Hugo projects. His more routine memorial to the Chilean statesman and historian, the *Monument to Benjamin Vicuña-McKenna*, commissioned in 1886, predictably followed the traditional format. Both are illustrated in Elsen, *In Rodin's Studio*, pls. 72 and 73.

27. The first study with all three muses intact is illustrated in Cécile Goldscheider, "Rodin et le monument de Victor Hugo," *La Revue des Arts*, no. 3 (October 1956): 180, fig. 3. In terms of a source for the flying muses, Schneider, *Denkmäler*, 259, fig. 91, suggests Jean-Baptiste Carpeaux's plaster *Tragedy and Comedy* (1876, Louvre). The book offers useful suggestions also regarding sources in popular iconography for the Hugo monument; the section on Rodin, however, terminates with the Balzac monument.

28. The unheroic conception of the poet in this first Hugo study is entirely devoid of the active mental tension of Rodin's earlier poet-thinker at the center of *The Gates of Hell*. The overall pose of the poet—the positioning of the legs, the tilted head, the limp body—is reminiscent of the drooping torso of depictions of the *Deposition of Christ*, particularly the sculpture by Michelangelo in Florence Cathedral (1547–1555); Schneider has previously pointed out this connection (*Denkmäler*, 244). The extremely relaxed pose also recalls the magical slumber of Endymion, the young shepherd kept eternally warm and living through the passion-filled scheming of the moon, Selene. There is apparently a precedent for a poet-muse composition with the poet depicted in this pose: Gustave Moreau's Roman drawing *Hesiod and the Muse* (1857), which itself was probably inspired by the *Endymion* relief at the Capitoline Museum in Rome. The drawing is discussed and illustrated in Kaplan, *Gustave Moreau*, 20–21, 73. While it was never exhibited, perhaps Puvis de Chavannes made Rodin aware of the drawing or its expressive idea. I would like to thank Dr. Antony Raubitschek (Professor Emeritus, Stanford University) for confirming the reading of the pose as Endymion.

With regard to the curious gesture of the poet's finger raised to the mouth, it is a common gesture of thought in antique prototypes showing poets, philosophers, or muses in the act of meditating. Admittedly, the gesture is also an emblem of silence, derived from the ancient Greek iconography for Harpocrates, the god of silence, and preserved in nineteenth-century funeral sculpture. However, the absence in this initial Hugo study of the motif of the veils which typically accompany the gesture, and the subsequent addition, in the third Hugo project, of a muse called *Meditation* or *The Interior Voice*, suggest that Rodin saw the gesture in terms of its meditative rather than funereal meaning. Hugo's gesture of silence would seem to convey more about his silencing the sea in order to hear his interior voices than about the eternal silence of death.

29. Rainer Maria Rilke, *Rodin*, trans. Jessie Lemont and Hans

Trausil (London: Grey Walls Press, 1946), 47. The muses of the Hugo monument, including those of the subsequent projects, have been variously interpreted as muses of the *Oriental* poems, *The Interior Voices*, *The Chastisements*, *The Legend of Centuries*, of "history," "the idyll," and so forth. Rodin's own titles, as cited to the commissioners in 1889—*Youth, Maturity,* and *Old Age*—seem too literal for his way of thinking and most likely represent a patronizing concession to the contemporary taste for monuments both legible and banal.

Rodin's personal meanings for the initial Hugo study can be gauged from sources within his own and the poet's work. For the muses, he drew on the same ambiguously inspiring sirens as had appeared in *The Death of the Poet* (c. 1888) and may have preserved their connotation of the tragic effects of inspiration and the creative role (illustrated in John Tancock, *The Sculpture of Auguste Rodin* [Philadelphia: Philadelphia Museum of Art, 1976], fig. 24-2). From Hugo's writings, Rodin may have recalled the voices of "man, nature, and the events of the time," whose lessons addressed themselves to the "heart, soul, and spirit," respectively, and whose triple voice it was the "poet's mission to unite"; see Victor Hugo, *Les Voix Interieures. Les Rayons et Les Ombres* (Paris: Librairie de L. Hachette, 1863), 5–6.

30. Rodin's plan to use *Iris, Messenger of the Gods* as the symbol of Glory is indicated in Grappe, *Catalogue*, cat. no. 248. One may wonder which of Iris's numerous mythic meanings Rodin wished to bring to bear on the figure Glory: rainbow messenger of the gods, agent of fate releasing souls from their bodies, or more interesting, Iris as the eternal arbiter of truth, who brought water in an urn from the River Styx to serve as a truth potion for the gods themselves. Indeed, *The Enlarged Head of Iris* (1890–1891) is one of Rodin's most mysteriously impassive figures.

31. The second stage of the Hugo project was rejected in July of 1890, not owing to dissatisfaction with the thematic conception of poet or muses but, apparently, because of the committee's preference for a figure to harmonize with the site and with the standing figure of *Mirabeau* by Jean-Antoine Injalbert in the opposite arm of the Pantheon crossing. For a detailed discussion of the Hugo projects, see Tancock, *Sculpture of Auguste Rodin*, 412–423.

Rodin's second monument begun for the Pantheon, which ultimately was never delivered, was based on an apotheosis. The text illustrates the maquette which shows the poet in contemporary dress, meditating while striding on a tall mountain cliff. It can be compared to another project for the second Hugo monument which was based, by contrast, on the poet depicted as a nude. Most authors have held the nude version to be the definitive one (illustrated in Tancock, *Sculpture of Auguste Rodin*, fig. 71-9). At this writing, Jane Mayo Roos of Columbia University is completing a dissertation on the Pantheon sculptural program and she also is of this opinion, based on documents that she has investigated.

Revealing Rodin's greater efforts to conform to convention, both projects for the second monument invite comparison with a traditional prototype also conceived in a decorative form. Rodin's winged crowning motif, three-tiered composition, mountain setting, allegorical figures embroidered around the base, and plan for possible execution of the monument in colossal form recall Titon de Tillet's *French Parnassus*, proposed in 1708 for Paris or Versailles, to honor the poets and musicians of France's Golden Age (illustrated in Judith Colton, The *Parnasse François* [New Haven and London: Yale University Press, 1979], pls. 5–8, 26). Rodin could have seen the bronze model at Versailles or a painted copy after the model.

32. The site proposed for the first Hugo monument was the Luxembourg Gardens in Paris. It was, however, changed in 1909 to the gardens of the Palais Royal, where the monument was inaugurated in 1909 and remained until 1935 when it was delivered to the Rodin Museum.

33. *Meditation* originated in *The Gates of Hell*; there she was not shown touching her breast. The full and complex history of this figure is traced by Leo Steinberg in his introduction to *Rodin: Sculptures and Drawings* (New York: Charles E. Slatkin Galleries, 1963), 21. See also note 15.

34. See the opening lines of the introduction in Hugo, *Les Voix*, 5.

35. See Hugo's poem "This century is wonderful and strong" (1837), which opens *The Interior Voices* and from which the following verses are reproduced:

Des poëtes puissants, têtes par Dieu touchées,
Nous jettent les rayons de leurs fronts inspirés,
L'art a de frais vallons où les âmes penchées
Boivent la poésie à des ruisseaux sacrés.
Pierre à pierre, en songeant aux veilles moeurs éteintes
Sous la société qui chancelle à tous vents
Le penseur reconstruit ces deux colonnes saintes,
Le respect des veillards et l'amour des enfants.

Other lines from the same poem reveal how similar were the sentiments of Rodin and Hugo on the subject of the poet-thinker. Hugo, *Les Voix*, 9–11.

36. Rodin described the armless state of a later, similarly fragmented torso, *Meditation, Half-Length Figure of a Woman* (1909), using the same terms; Rodin, *On Art and Artists*, 164. An armless torso occurs as a motif in several of the intermediate studies for the monument intended for Whistler, which dates from 1905 through 1913, overlapping the date of the armless *Meditation* of 1909.

37. Rodin, in fact, had himself photographed on the island of Guernsey in the pose of a reclining Hugo; the photograph is reproduced in Descharnes and Chabrun, *Auguste Rodin*, 183. Rodin's indentification with Hugo is also suggested by Lawton, *The Life and Work*, 162–163, and, of course, by Edward Steichen in his photograph *Rodin-Thinker* (1902; reproduced in Elsen, *Rodin*, 190). There were, however, strong differences in the religious beliefs of Rodin and Hugo. Hugo's view of art as a messianic mission, especially heightened during the period of his exile, bordered on a mystic occultism quite foreign to Rodin's way of thinking.

38. Compare the same expressive idiom in *The Tragic Muse* (c. 1885), *The Enlarged Head of Iris* (1890–1891), and earlier, in the head of the wounded warrior in *La Défense* (plaster, 1879, in the Meudon Reserve, illustrated in Elsen, *In Rodin's Studio*, 161.)

Rodin planned, as late as 1898, a socle relief for the Balzac monument: a personification of *The Human Comedy*, grimacing while removing her mask. Since the monument was rejected, it can only be presumed that he would not have incorporated this symbolic figure.

39. Rodin considered some of these more conventional alternatives in his first campaign of studies; see Albert Elsen, Stephen McGough and Steven Wander, *Rodin & Balzac: Rodin's Sculptural Studies for the Monument to Balzac from the Cantor, Fitzgerald Collection* (Stanford: Stanford University Museum of Art, 1973), pls. 8, 16, and 17, which include a range of types from antique victor to modern orator.

40. For example, as early as 1738, Louis-François Roubiliac's *Handel* monument showed the composer in dressing gown and

nightcap, with one bedroom slipper comfortably removed, strumming on a harp while a cupid recorded the melody (illustrated in Margaret Whinney, *Sculpture in Britain: 1530–1880* [Baltimore: Penguin Books, 1964], pl. 74). Closer to Rodin's time, Albert Carrier-Belleuse in his *Monument to Alexandre Dumas the Elder* (1886) portrayed the author in a disheveled robe, informally viewed in the grips of thought. While the sculptor still had recourse to a graceful eighteenth-century realism—seen in the motif of the quill posed in midair—the intense and narrowed gaze of the author reveals a concentration beyond that of his predecessors (discussed and illustrated in June Hargrove, *The Life and Work of Albert Carrier-Belleuse* [New York and London: Garland Publishing, Inc., 1977], 95–96 and pl. 42).

41. Another recurring motif in Rodin's work was the gesture of the outstretched arm, which he employed to express creation or inspiration in: *Vulcan Creating Pandora* (1889), *The Creation* (1889), *A Night in May* (see note 8), and the full figure of *The Tragic Muse* (1885), an expressive variant of the gesture. The gesture was used also for a figure in *The Gates of Hell*, mid-1880; illustrated in Tancock, *Sculpture of Auguste Rodin*, fig. 67-69-15.

For further discussion of the two *Shade* compositions of 1898, see Elsen, *In Rodin's Studio*, cat. nos. 37 and 39.

42. Compare the Meudon study to Rodin's *Orpheus and the Maenads*, also called *Orpheus and the Muses* (pre-1889), *Orpheus and Eurydice* (1892), and the studies for the first Hugo monument (1889–1897).

43. Rodin's belief in the comprehensibility of natural symbols independent of any literary meaning ties his approach to that of the symbolist poets and artists. His own frequent use of literary titles does not contradict this approach to symbols. He characteristically assigned a title after the completion of a work. For a useful discussion of the extension of traditional literary symbols under the impetus of symbolism, see Robert Goldwater, *Symbolism* (New York: Harper and Row, 1979).

44. Rodin's enlarged plaster of *The Poet and Love*, with its wider expanse of rock behind the figures, offers an interesting visual parallel to an antique source: the Roman wall painting of *Prometheus Delivered by Hercules and Athena* from the Villa Pamfili in Rome. The unified curved line of the poet's torso and free leg and the gesture of the outstretched arms (for the poet, one arm, not both as in the ancient prototype) are the salient features relating the two compositions. See Salomon Reinach, *Répertoire de Peintures Grecques et Romaines* (Paris: Editions Ernest Leroux, 1922), 212, fig. 1.

45. Compare Rodin's *Group of Three Figures* with the composition of poet and two muses on the so-called *Plotinus Sarcophagus* at the Lateran in Rome. Many late antique sarcophagi depict a portrait group of the deceased individual and family arranged in a composition from the poet-muse tradition. Rodin could have seen this sarcophagus or others like it during his trip to Rome in late 1874–1875. This work is illustrated in Max Wegner, *Die Musensarkophage* (Berlin: Berlag Gehr. Mann, 1966), 71, cat. no. 116.

46. The visual motif of a winged female figure escaping a male figure's grasp is discussed by Tancock, *Sculpture of Auguste Rodin*, 303–305, in the context of Rodin's other works and biography.

47. *The Spirit of Eternal Repose* (plaster, c. 1898) is illustrated in Grappe, *Catalogue*, cat. no. 293, where it is dated one year earlier than the actual commission for the monument. The *Head of a Funerary Spirit* (1890–1891) is illustrated in Tancock, *Sculpture of Auguste Rodin*, cat. no. 118.

48. Rodin's aims for the Puvis monument are quoted in Tancock, *Sculpture of Auguste Rodin*, 613. Lawton, *Life and Work*, 270;

Camille Mauclair, *Auguste Rodin: The Man, His Ideas, His Works* (London: Duckworth, 1905), 89–90; and Rilke in his European lectures published in 1907 (Rainer Maria Rilke, *Selected Works*, vol. 1, *Prose*, trans. G. Craig Houston [London: Hogarth Press, 1954], 157) all describe this photographed study. The first two authors report that Rodin's idea came from the image of ancient domestic altars. This iconography persisted in seventeenth-century frontispieces to the literary or philosophical writings of great men; these offer a close prototype for Rodin's study. See, for example, Schneider, *Denkmäler*, fig. 7. It should be noted also that Rodin's montages were at times arranged just for the purpose of being photographed. Since the motifs in this photographed project for a Puvis monument survive in close versions, it would seem that this was an actual working idea.

Mauclair describes a variant of the study seen in the old photograph which includes a seated, nude youth dreaming, leaning on the table, behind the bust. A plaster at Meudon (illustrated in Tancock, *Sculpture of Auguste Rodin*, 44, pl. 16) shows a pair of female figures, one seated in a relaxed pose, the other (*The Eternal Idol*) shown kneeling above, with a laurel branch to the right of them. This study may relate to that described by Mauclair. In general, the Puvis project still needs further investigation.

49. Rodin seems to have remembered Carrier-Belleuse's enrapt *Bacchante* from the Salons of 1861 and 1863, reaching up to display her sensuous body and to anoint the herm of Bacchus (illustrated in Hargrove, *Life and Work*, 45, fig. 7). Albert Elsen has suggested to me another possible source for Rodin's figure of "Apollo": *The Apollo Sauroktonos* (or *Apollo with a Lizard*) by Praxiteles, the original dating from the fourth century B.C. All of these sources may have contributed to Rodin's final idea.

50. The final plaster sketch is illustrated in Joy Newton and Margaret MacDonald, "Rodin: The Whistler Monument," *Gazette des Beaux-Arts*, VIe, 92 (December 1978), 221–232, fig. 6. This article gives a full account of the history of the project. Rodin was probably familiar with the numerous examples of the neoclassical apotheosis formula preserved among the monuments in St. Paul's Cathedral in London; see, for example, Whinney, *Sculpture in Britain*, pl. 159.

51. Rodin undoubtedly knew the *Muse Sarcophagus* (illustrated in Wegner, *Die Musensarkophage*, pls. 3 and 6) which was in the Louvre's collection in the early nineteenth century and was reproduced, as early as 1804, in publications of the museum's collection. J.-D. Ingres also turned to this particular pose of Melpomene in one of his series of drawings of 1856 for the watercolor *The Birth of the Muses*, although he did not retain it for the final watercolor (the drawing is illustrated in L. Fröhlich-Burne, *Ingres: His Life and Art*, trans. M. White [London: W. Heinemann, 1926], pl. 65.) Finally, in the twentieth century, Emile-Antoine Bourdelle used the pose for one of his muse reliefs decorating the façade of the Champs-Elysées Theatre (illustrated in D'Emile-François Julia, *Antoine Bourdelle* [Paris: Librairie de France, 1930], pl. 15.) One final note about the distinctive pose of Melpomene: it originally also served a non-meditative function. It made visible the tall laced boot—the buskin—worn in ancient times by actors in a tragedy.

52. See Victoria Thorson's essay "Symbolism and Conservatism in Rodin's Late Drawings," in Albert Elsen and Kirk Varnedoe, *The Drawings of Rodin* (New York: Praeger Publishers, 1972), 121–139, for a discussion of Rodin's drawings of classical subjects. While Rodin generally avoided the standard academic poses derived from classical art and preferred to work with untrained models, Thorson suggests that he occasionally turned to the academic method of posing the model after a classical prototype. She cites examples among the late

drawings where Rodin borrows closely from identifiable antique prototypes, rather than the natural posture recalling to him, after the fact, a source in tradition.

53. Quoted in Judith Cladel, *Rodin: The Man and His Art*, trans. S. K. Star (New York: The Century Co., 1917), 171.

54. Mallarmé championed the inspiring power of myth "at the source":

> . . . free from everything, imputed place, known time and person. . . . borrowed from the meaning latent in them all. . . . The Theatre calls them forth, not fixed, nor venerable, nor notorious, but one, disengaged from personality, for it composes our multiple aspect. . . . Type without previous denomination, so that surprise may emanate. . . . Man, and then his terrestrial dwelling place exchange a reciprocity of proofs. Thus, the mystery. (from *The Divagations*, 1897, translated in Grange Woolley, *Stéphane Mallarmé* [Madison, N.J.: Drew University, 1942], 98.)

To this end, Mallarmé adapted George W. Cox's *The Mythology of the Aryan Nations* (1878) which represented the nineteenth century's increasingly scientific and inductive approach to myth as opposed to a symbolic one which saw myth only in terms of distorted Christian absolutes. In the appendix to the adapted book, *Les Dieux antiques: nouvelle mythologie illustré d'après George W. Cox et les travaux de science moderne à l'usage des lycées, pensionnats, écoles et des gens du monde* (Paris: J. Rothschild, 1880), Mallarmé explained the new approach to myth and included excerpts from the poetry of the Parnassians. Mallarmé's place in the larger context of the nineteenth-century taste for Hellenism is elucidated in Robert Cohen's article, "Mallarmé and the Greeks," in Walter Langlois (ed.), *The Persistent Voice: Hellenism in French Literature Since the Eighteenth Century* (New York: New York University Press, 1971).

55. The close contact between the two men began in 1902, when the poet came to Paris to write a monograph about the sculptor, and lasted until about 1914. In 1906, Rilke served for six months as Rodin's secretary.

Among the most perceptive writings on the subject of Rilke are those by Stephen Spender, in both *The Creative Element* (London: Hamish Hamilton, 1953) and in *The Struggle of the Modern* (Berkeley and Los Angeles: University of California Press, 1963). Indeed, the subject matter of Rilke extends many of Rodin's romantic and symbolist themes into the twentieth century. Like Rodin, Rilke was particularly interested in the myth of the tragic poet Orpheus and in the general theme of the spiritual struggles of the artist; these themes were treated in *Duino Elegies* (1923) and *Sonnets to Orpheus* (1923).

56. For Brancusi, the theme of *The Sleeping Muse* became one which preoccupied him beginning with his head of a *Sleeping Muse* of 1906, closely inspired by Rodin's *Muse* (marble) of 1900.

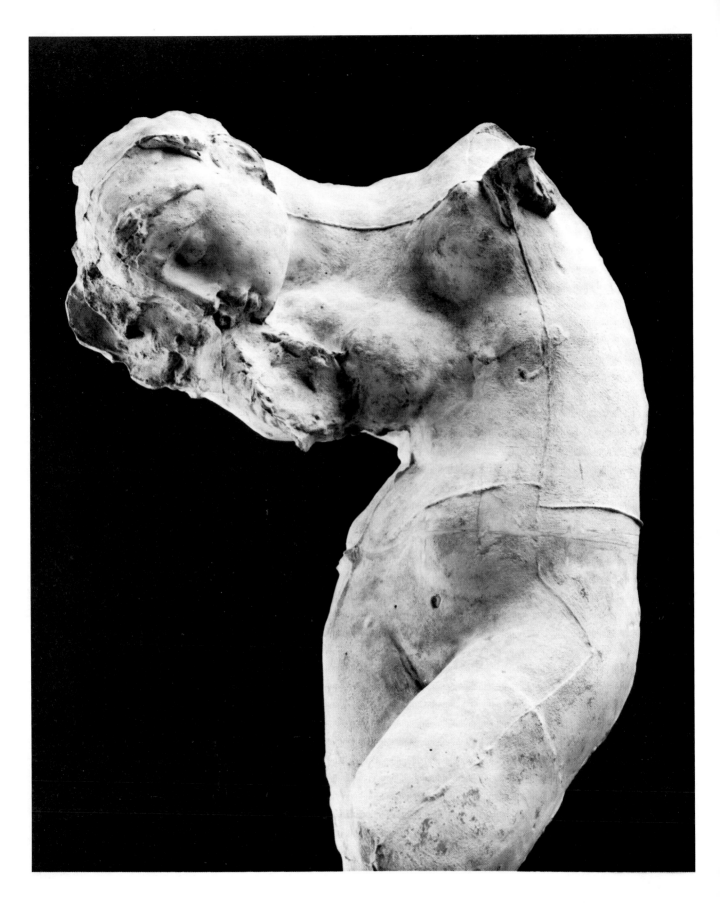

6.41 *Meditation* without arms, 1883-1884(?). Detail. Plaster. Musée Rodin (S680). Cat. no. 48.

6. When the Sculptures Were White: Rodin's Work in Plaster

Albert E. Elsen

In the reserve of the Rodin Museum at Meudon are many Rodin sculptures without dates and titles. They lack histories of enlargement or reduction, bronze casting or carving, exhibition or photographic reproduction.[1] Few were commented on by the sculptor's friends and critics who wrote about their visits to his studios. These are the works of the Rodin we never knew. The literature and old photographs prepare us for their large number, if not their quality.[2] Beginning in the early 1880s, visitors reported the sculptural abundance in the studios, and to Rilke, these countless plasters seemed like sculpture in waiting. Repeatedly, Rodin told others that he did not wait for inspiration but that as he worked ideas came. "It is odious for me when I don't produce. . . . It's work and determination which have given the vigor, made the strength of my art."[3] More than the bronzes and marbles, these plasters bring us close to Rodin the prodigious worker. They are sometimes the result of improvisations that transformed the sculptural process, especially when he sought greater economy or fluency of expression. Many are discoveries about unifying the human form within itself and with others. What moves us today is that, unlike Rodin's public statuary, many of these small plasters are free of self-conscious striving and the will to heroic form.

Only at the Rodin Museum in Meudon can one begin to gain a sense of that world of white sculptures whose origins and destinies were in the hands of the man who daily labored in their midst, drawing inspiration from and adding to them for so many years. The present exhibition of Rodin's works in plaster may dismay some people who think of this material as a temporary medium, a way station on a sculpture's trip to a nobler destination in bronze or marble. There is no question that plaster was essential to preserving what Rodin had begun in clay and that many sculptures were then bronze cast and carved. What the Meudon Reserve tells us is that plaster was not a sculpture's limbo. It was susceptible to etching, filing, carving, and modeling in clay and dipping in wet plaster. Whether hard or soft, plaster was variously reworked by addition and subtraction and was even highly polished, as when Rodin had to make a formal presentation of the model for *The Burghers of Calais* to a jury. The generally matte surface of plaster allowed critical study of body planes without the distracting light reflections that could come off of bronze. Plaster's color and soft luminosity were ideal for the artist's contemplation of a work's potential for carving in marble. Rodin knew *The Gates of Hell* only in white and even contemplated carving part of them in marble. Figuratively and literally, the portal was the *eminence blanche* behind much of his life's work. Not only did Rodin exhibit his new figures in plaster, according to salon custom, but he must have given away to friends nearly as many plasters as bronzes that he sold.[4] From 1900 until his death, Rodin's museum at Meudon, visited by people from all over the world, was almost entirely tenanted by plasters, as it is today.[5] Rodin's own precedent is thus the incentive for this part of the exhibition. Shown here and discussed, like some core sample from an archaeological site, are plasters done at different times, with differing motives and in varying modes.

Studies For and Unfamiliar Parts of Public Projects, an Imaginative Head, and Lesser Known Portraits

The story of the problems Rodin had with his statue of *Eve*, notably the pregnancy of the model, is well known, as are the figure's affinities with Michelangelo's painting of this subject. What we have never before seen is a roughly ten-inch-high plaster study for the upper portion of humanity's sinful mother (figs. 6.1, 6.2). Until recently, in fact, we did not know of small-scale studies for the early public statues, such as *The Age of Bronze*, nor did we realize specifically how Rodin felt compelled to work out gestures and attitudes by segmenting the figure.[6] Made in 1880, the study of *Eve* lacks her left arm from just below the shoulder to the wrist. Unlike the final

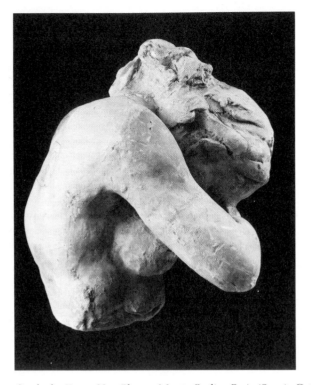

6.1 *Study for Eve*, 1881. Plaster. Musée Rodin, Paris (S707). Cat. no. 67.

6.2 *Study for Eve.*

Eve, this precursor does not claw at her torso with her right hand, and her left is addressed to the back of her head on the left side. The head rests on the left forearm, and when intact, the two arms would have all but concealed the woman's face, which Rodin did not take the pains to define. That this concealment bothered Rodin is suggested by the removal of most of the left arm. This study reminds us that with statues intended for the salon, Rodin worried over the exact placement of limbs, and if the final *Eve* was generally influenced by Michelangelo (in the crossing of the arms), the final pose came by trial and error. This plaster fragment, which is not self-supporting, was daring for the time in its concealment of the face and sense of formal and mental self-enclosure. When Rodin considered the fragment, however, as the climax of a full figure, he apparently felt the need to elevate the head slightly and drop the arms, thereby opening up the form while tightening the drama of the gestures.

Coming upon a vertically segmented, battered male head in the Meudon Reserve was a shock because it seemed to have no history in Rodin's cast work (fig. 6.3). Its almost caricatural brutality seemed out of keeping with his style. Yet, it is a head that has been before the public since 1879, when Rodin first exhibited his project for a monument to the defense of Paris. The head

belongs to the wounded warrior being roused back to battle from his descent into death by the screaming Spirit of War (fig. 6.4). We have never looked on the man's face because it is upturned toward the winged woman. The two figures were made separately (the woman first), and when it came time to join them, Rodin cut away the unmodeled right side of the male head in order to achieve a tighter unity. The mouth is a gash, the area around the left nostril and eye deeply scored, so that when upright, seen in profile and from slightly below, the injected shadows add to the pathos of the subject and throw the nose into still greater prominence. While Rose Beuret presumably posed for the head of the Spirit of War, the warrior's head is possibly an invention. In Rodin's opinion, his entry was rejected by the jury because it was too active and dramatic. If the jurors had looked at the face of the figure who symbolized the armies of France, they might have found other grounds for their decision.

A second plaster that had but one public manifestation in Rodin's art comes from work for *The Gates of Hell*. This portal spawned many of his most famous sculptures, and so numerous are its figures, many little known outside of the door, that small works are often automatically attributed to the *Gates*. The small plaster *Torso of a Woman*, on whose abdomen rests the hand of a

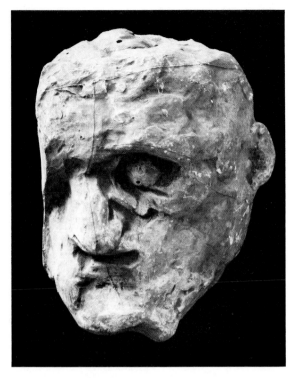

6.3 *Head of the Warrior from La Défense* (also known as *The Call to Arms*), 1879. Plaster. Musée Rodin, Paris (S702). Cat. no. 64.

6.5 *Woman's Torso with the Hand of a Skeleton on her Stomach,* c. 1883-1884. Plaster. Musée Rodin, Paris (S678). Cat. no. 73.

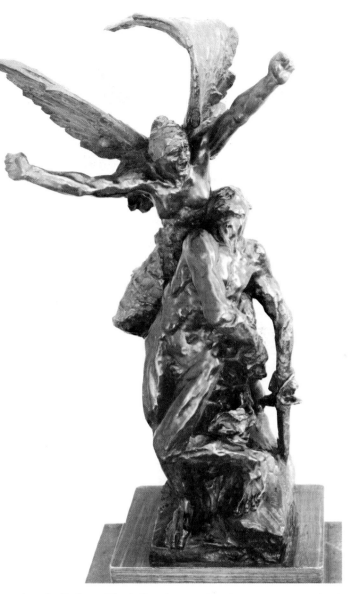

6.4 *La Défense (The Call to Arms)*, 1879. Bronze. 45 in. Portland Museum of Art.

skeleton, was probably destined for the tympanum group, just behind *The Thinker* and to his left (figs. 6.5 and 3.3). The fragment is part of the portal's "Dance Macabre," the meeting of the living and the dead. As was so often the case with Rodin—a distinguishing mark of his way of working—a detail is as eloquent as a totality. The squared-off torso reflects a frequent editorial decision by the artist, who may have enjoyed the cubic compacting of the form within which is framed the shocking juxtaposition of bone and flesh.

According to Georges Grappe, who reproduced the *Dernière Vision* in his 1944 catalogue of the Musée Rodin, this small relief was done before 1902 and was exhibited that year in Prague over the title *Morning Star*

6.6 *The Last Vision*, 1901-1902. Plaster. Musée Rodin, Paris (S694). Cat. no. 68.

6.7 *Severed Head of St. John the Baptist*, 1887(?). Plaster. National Gallery of Art, Gift of Mrs. John W. Simpson, 1942. Cat. no. 80.

(fig. 6.6).[7] In 1904, it was exhibited in Düsseldorf as *The Last Vision*, but it was also known as *Before the Shipwreck*. Helen von Nostitz records that it represented a ship-wrecked man having a vision of his past life.[8] In 1906, Rodin finished a marble relief carved from a plaster such as this as a monument to his friend, the poet Maurice Rollinat, who had committed suicide in 1903.[9] Despite the artist's offer, Rollinat had never sat for his portrait. Approached by a distinguished memorial committee that included Sarah Bernhardt, Rodin told its representative that on his own he had worked on this relief as a tribute to his dead friend. (The problem with this statement is that Rodin had finished the relief before Rollinat's death.) The small plaster composition is a montage, like the several titles attached to it. The man's head is the tiny version of Rodin's decapitated head of *St. John the Baptist* (fig. 6.7). The youthful head, according to Grappe, derives from a woman Rodin admired, and it is one the artist repeatedly used in such works as the small *Seated Woman in a Greek Urn* (fig. 6.32). From his inventory of hands Rodin selected two as a support for the woman's head and as the anguished gesture of the man. The hands are overlarge in proportion to the heads. To some of the poet's friends, Rodin's plaster head bore a resemblance to Rollinat. The dead poet's family, however, refused the proposal to place the marble relief on the grave, and instead it was set in the outer wall of the village church at Fresselines, where the *curé* had been a close friend of the poet. With its visionary theme,

graduated focus on the heads and hands, and nebulous background, the relief satisfies those who would see Rodin as a symbolist. The artist willingly acknowledged his admiration for the art of Carrière, whose painting style comes closest to Rodin's mode in this relief.

One of the rewards of this small work is its revelation of Rodin's insouciant way of constructing a relief—without regard for trued edges or for rear or frontal planes, even eradicating other images that might have been in the relief, such as the fragment of a limb at the lower right.

Heads and Portraits

When we think of Rodin and the head in sculpture, we automatically make the association with portraits. Some of his most eloquent writing was on how he fashioned the portraits of his sitters, slowly working toward an interpretation of their personality and character. From the Meudon Reserve comes evidence of Rodin's imagined heads, hybrids from memory, impromptu inventions. One such is the *Head of An Old Man* (fig. 6.8), perhaps destined to surmount the body of an aged satyr. A characteristic of these fictions is the mergence of the features, a more synoptic treatment of facial hair, and the flow of cheeks into eye and nose area in a more molten fashion than when Rodin was carefully contouring the profiles of a live sitter. In this particular head there is no evidence of a labor of improvement toward

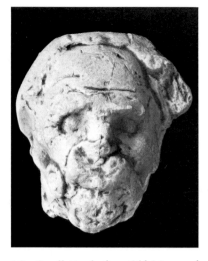

6.8 *Small Head of an Old Man*, n.d. Plaster. Musée Rodin, Paris (S674). Cat. no. 70.

6.9 *Large Head of an Old Man*, n.d. Plaster. Musée Rodin, Paris (S676). Cat. no. 71.

6.9

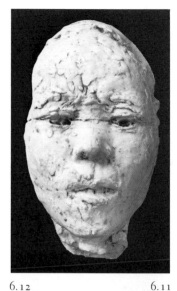

6.12 6.11

6.12 *Mask of Hanako*, 1907-1911. Plaster. Musée Rodin, Paris (S541). Cat. nos. 52-54.

6.11 *Mask of Hanako in the Pose of "Anguish of Death,"* 1907-1911. Plaster. Musée Rodin, Paris (S553). Cat. nos. 52-54.

6.10 *Mask of Hanako with a Supporting Plaque*, 1907-1911. Plaster. Musée Rodin, Paris (S544). Cat. nos. 52-54.

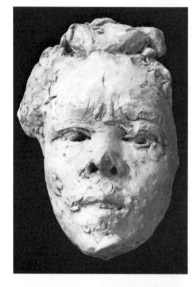

6.10

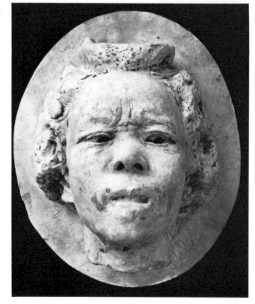

definition and expression. The eyes are unrelieved, flattened orbs which gain expression only from the shadows cast by their sockets. Given any segment of this face in isolation, one would be hard pressed to recognize its anatomical origin. Rodin's most spectacular achievement in this mode is the great *Head of Iris*. As with that sculpture's majestic challenge to form, the artist here chose to have the original half-life-size head of the old man enlarged in plaster (fig. 6.9), perhaps so that he could study the amplified effects of his intuitions formed by years of studying the face.

Rodin had many subjects who inspired brilliant portraits, notably his lifelong companion Rose; his mistress, the sculptor Camille Claudel; and Georges Clemenceau, who patiently sat through from thirteen to twenty-three versions or preliminary studies. None of the aforementioned inspired as startling a series of facial studies as did the Japanese actress Hanako. In an exemplary exhibition and catalogue on *Rodin et l'Extreme Orient*, Madame Monique Laurent reproduced twenty-three busts, heads, and masks of this gifted woman, which were modeled between 1907 and about 1911. Chosen for this exhibition are three plasters, two of which were previously known to the world before 1979 only in Edward Steichen's 1908 photographs, and the third, neither seen nor reproduced until the 1979 exhibition mounted by the Musée Rodin in Japan and Paris (figs. 6.10, 6.11, 6.12). They permit a survey of Rodin's inspired reworking of his surfaces, which intensify Hanako's dramatic expressions, not un-

self-consciously and momentarily made, but tenaciously held during twenty-minute poses. One such pose (fig. 6.11), favored by Hanako, reportedly shows the expression "anguish of death," enacted by her in a play Rodin saw in 1906. Judith Cladel, who watched Rodin at work on some of these heads, confirms what we can now see: that with a penknife the sculptor etched into the areas about the eyes (both in clay and plaster), a technique that seems uncharacteristic in terms of his previous heads. The system of estampage, by which Rodin caused several clay casts to be made from a prototype, explains the basic structural resemblance between different series of Hanako heads. This technique is not apparent because of surface changes, modification of the silhouette, and in certain cases the submersion of a plaster into wet plaster. Surprising are the corrections that include those which give precision to an eyelid, the rude denting of nostril and chin, and the spottings of tiny balls of clay that may land on a cheek, below an eye, or above a lip. All are matched with his awareness of how the contouring of the head can amplify or focus down on facial expression. This impressive repertoire of technical devices sharpens the psychological and formal focus of a head to keep its changeful character under light, and all came to bear in Rodin's final work of art, which only illness interrupted.

In the last years of his life, Rodin seems to have suffered from a series of strokes. In 1916, he began a bust of Etienne Clémentel, an amateur painter and politician, who as a minister had been of assistance in the establishment of the Musée Rodin and who became one of the executors of Rodin's estate (figs. 6.13, 6.14, 6.15, 6.16). According to the account of someone who knew Rodin, the artist may have been stricken by one of these strokes while at work on the fourth version of the statesman's bust and the clay or tool supposedly dropped from his hand. While the fourth study was cast in bronze to satisfy the subject, until now we have not had the occasion to see publicly all of the studies together. Although less numerous than the great Clemenceau series (too fragile to exhibit because many have actual clay attached to the plaster), the Clémentel group gives us a dramatic demonstration of how Rodin evolved a portrait.

From the subject himself, we have an account of how the artist worked. Testifying on 22 May 1919, in a trial involving the government and the Musée Rodin versus the Montagutelli Foundry and others accused of making false Rodins, Clémentel recalled his sittings three years earlier:

He had indicated to me at the beginning of our sessions how he wanted to work. He said to me: "I will make four successive busts. The first I am going to bring out in relief the slight impressions in the clay." It's true. In four or five sittings he took his measurements, without any sort of preliminary studies, constantly delineating as he progressed. He studied the foreshortening, but in constantly following the lines for his plan. He had fashioned in a few sessions, maybe seven at the most, a first bust which is splendid. It's not a portrait, but all the same it's admirably lifelike: it has life; it has an intense presence of its subject. He said to me: "When I have this . . . I would make a mould of the first bust. I'll make a cast in clay from this mould, and then your suffering will begin.

"I would like to work as a certain number of my colleagues do, whose names I'd prefer not to mention. It also takes a great artist to be . . . very finicky. I shall work like them. I must forewarn you that it will be necessary to assume many attitudes. Notably, I hope that you might allow me to work from above. . . ." He began manipulating the clay, and began working on the bust.

He worked upon the bust during long sessions, during which he would say to me: "Don't worry about the [impression of] life [in your bust]—it will return." He worked in these sessions by building up the clay. . . . at one point [he severed the head of the bust from the neck]. He then resuscitated the head in order to work on it from a horizontal rather than a vertical plane. Naturally, there had been some compression of the clay [as a result], and it was not well recovered. Rodin resumed working on the bust, examined it, continued working and made a second mould. [From this mould] he made a clay impression and said: "Now I am going to give you life. This is the third stage."

He said to me: "In the fourth stage I will work upon the planes. I have not yet begun this. [The bust is not yet beyond] the third stage."[11]

Rodin was never to finish his projected fourth stage, and the four surviving plaster busts presented here represent only the first three. (In the sequence as I have arranged it, the third version is a dipped cast of the second and is not discussed by Clémentel, who was probably not an eyewitness to its making.)

As indicated by Clémentel, Rodin's first step was to do a thorough reconnaissance of the subject's head to establish its basic dimensions and physical "caractère" (fig. 6.13). The clay report then served as the basis for other clay and/or plaster casts, so that Rodin would always retain his original version should he in the subsequent studies "overwork the material" or lose fidelity to the original impression. The mapping phase was one in which Rodin worked for verifiable exactitude of distances and shapes. Thereafter came more exacting and endless probings for expressiveness, being "finicky," during which he had to call upon a lifetime of such work while trying to establish an open state of mind to confront his subject freshly.

The second plaster (fig. 6.14) differs from the first in having been mounted on full neck, shoulders, and chest, the traditional bust form of portraiture. Rodin had determined to use the chin up, frontal pose seen in his earliest work, a convention for heroes since antiquity.

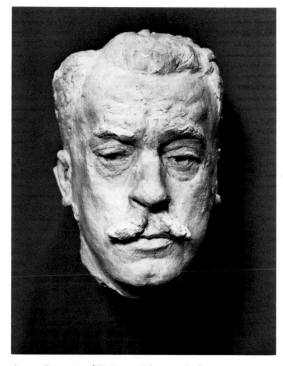

6.13 *Portrait of Etienne Clémentel*, first state, 1916. Terra cotta. Musée Rodin, Paris. Cat. nos. 59-62.

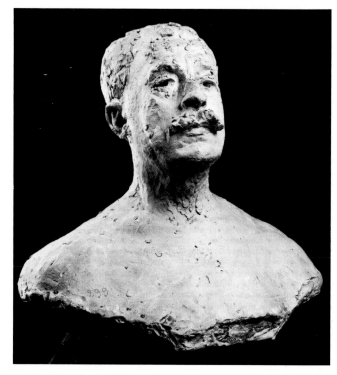

6.14 *Study for Portrait of Etienne Clémentel*, second state, 1916. Plaster. Musée Rodin, Paris. Cat. nos. 59-62.

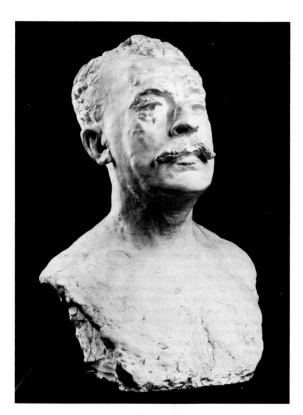

6.15 *Study for Portrait of Etienne Clémentel*, third state, 1916. Dipped plaster. Musée Rodin, Paris. Cat. nos. 59-62.

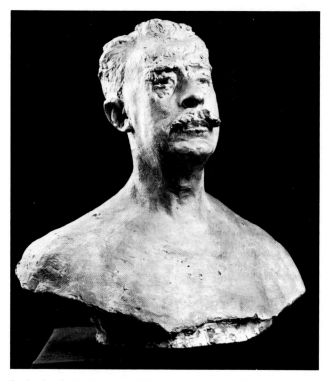

6.16 *Study for Portrait of Etienne Clémentel*, fourth state, 1916. Plaster. Musée Rodin, Paris. Cat. nos. 59-62.

Within this format, he further searched out individuality.

The area that came to assume the greatest burden of expressiveness in the three remaining studies is that of the eyes and the brow. While Rodin reworked Clémentel's lower lip, slightly altered the mustache, and thinned and thickened the cheeks and jowls, it is the small area around the eyes, particularly the upper eyelids, that astonishes. Just how he rebuilt these surfaces can be seen in the second plaster, which had also assumed the full bust format. With small balls of clay that had been rolled between the fingers, Rodin worked all over the upper part of the head so that it took on the appearance of that of a man afflicted by warts. We can never know what he saw in his living subject that would account for these touches, but from his own descriptions of working on portraits, this was the phase when he was pushing his sculpture beyond physical resemblance. These otherwise anatomically unaccountable touches may have been prompted by Rodin's unique method of focusing points of light and shadow in certain areas, notably the eye sockets, that would often otherwise be filled with shadow. The upper eyelids took on such an accumulation of clay patches that the distinction between brow and eye began to break down. Here one can see what Rodin meant by sculpture being reduced to the hole and the lump. What he achieved in the area of the eyes evokes comparison not with other sculptors so much as with Rembrandt, who in his later portraits let the light fall below the eyes and worked more by intuition than description.

The third plaster (fig. 6.15), as I have arranged them, explains why Rodin did not temper by further modeling the rudely applied balls of clay in the second head. Rodin used the technique of dipping the second plaster into liquid plaster, thus overlaying what he had previously done with a new skin, one which makes the subject look younger (as if the skin had more youthful elasticity), and which also effects smoother transitions between the added patches and the original surface. (The hair, however, is that found at the top of the first study, not the second, and is not dip cast.) The fourth and last plaster seems a fresh reworking of the very first, mounted on the bust of the second (fig. 6.16).

In this last study, he has completely redone the touches around the eyes, reshaped the eyebrows—further obliterating distinction between hair, flesh, and bone—and given a new characterization to the brow and the lower lip. (The first mustache is pretty much intact.) Presumably, it was while working on this head that the clay dropped from his fingers and, it would appear, he stopped. By the accounts of Judith Cladel and Marcelle Tirel, Clémentel was so eager to have his portrait finished that he asked one of Rodin's most trusted assistants, the sculptor Jules Desbois, to do the job. Marcelle Tirel wrote, "One corner of the mouth is unfinished and the top of the head has not been filled. Rodin worked at it now and again when his brain was clear. But his wife, rightly enough, would not let him touch the clay: he would certainly have spoilt the whole study. . . ."[12]

Judith Cladel, who was actually present when Desbois came to inspect the last work, gives us an incredible account of the stricken Rodin, mute and motionless, watching the whole episode:

Madame Rose [Rose Beuret] unfolded the humid cloths which covered the clay she had carefully maintained. It was a painful consultation: Auguste Rodin was there, before his work, his last work, happily equal in quality to its precedents. Immobile, his mind veiled, powerless as ever, he looked at the bust, then at Desbois and Clémentel, without saying a word, and seemed to me to be without regrets, "It is very handsome, this bust," declared the author of the great Leda; "It must not be touched. The back of the skull is slightly unfinished, but this is not an essential part. The only thing to do is to consign it to a good mould maker, and I accept the task of supervising the mould making."[13]

Tirel records that Desbois told Clémentel, "If I succeed people will say it was Rodin. If I fail, they will say I've spoilt the bust." If Rodin's health had not failed, it is certain, considering Clémentel's testimony concerning the aborted fourth stage, that Rodin would have continued to make more studies, as with Clemenceau, for his art had arrived at the point where it was like a diary of his daily life.

Couples and Coupling

The Kiss may be Rodin's sculpture most popular with the public and least liked by artists. Perhaps this is so for the same reasons: by means of beautiful bodies realistically carved in stone by skilled assistants, Rodin engaged in story telling and the expression of tender sentiments. Literary inspiration and its narration, the depiction of feeling, illusionism, and indirect carving have been the strongest taboos in modern art. Much preferred today by artists and critics are such works as the *Flying Figure Embracing a Woman* (fig. 6.17). In the absence of fully defined heads, their bodies become pure gesture, an intriguing combination of open and closed movement floating in space. This sculpture does, in fact, exemplify Rodin's later views that a fortuitous coupling could be justified as long as the modeling of both was good and the overall decorative effect successful.

During his early career, until at least the early 1880s, Rodin taught himself how to intermingle the limbs of couples in the great tradition of mutuality found in

6.18 A *Couple Intertwined*, 1870s(?). Plaster. Musée Rodin, Paris (S693). Cat. no. 38.

6.19 A *Couple Intertwined*, 1870s(?). Plaster. Musée Rodin, Paris (S694). Cat. no. 37.

6.20 A *Couple Intertwined*, 1870s(?). Plaster. Musée Rodin, Paris (S691). Cat. no. 36.

6.17 *Flying Figure Embracing a Woman (A Couple Intertwined, The Man's Outstretched Arm Entwined around a Seated Woman)*, n.d. Plaster. Musé Rodin, Paris (S698). Cat. no. 42.

6.21 A *Couple Intertwined*, 1870s(?). Plaster. Musée Rodin, Paris (S692). Cat. no. 39.

Western sculpture that commences toward the end of the Middle Ages. Surviving in terra cotta and plaster are many small early studies, perhaps related to *The Kiss*, fashioned largely with rolls of clay, showing Rodin's industry and ingenuity in exploring conventionally entwined figures to express such mutual awareness as love and consolation (figs. 6.18, 6.19, 6.20, 6.21). This technique, which he could have learned from such older artists as Carpeaux, permitted rapid establishment of imagined or observed couplings. (Academic teachers encouraged this form of notation.) Around 1910, Rodin, who never let a good idea go to waste, used this technique

of rolled clay to make his "snakes," the marvelous series of "Dance Movements" modeled instantaneously from naked cancan dancers cavorting in his studio (figs. 6.22, 6.23, 6.24). He then offered these improvisations as complete sculptures, unlike the earlier studies intended for more elaborated compositions. By the time of the "Dance Movements," his ideas on coupling figures had radically changed, and there was no need for intertwining, only juxtaposition, sometimes using casts of the same figure.

For the public and clients who would commission them in marble, Rodin successfully exhibited his most

decorous lovers: *The Eternal Idyll, Eternal Spring,* and *The Kiss.* Since the artist's death, the reticent males in these works have incurred the incredulity of more than one critic who was otherwise sympathetic to Rodin's art but disdained or disregarded the imaginative tact Rodin showed his contemporaries. There has long been a rumor that Rodin's reserve of unexhibited sculpture was like the once secret museum in Pompeii, filled with erotic subjects. If they existed, they have been destroyed, for very few explicitly erotic works are to be found. One such is that of lesbian love, for which he did a montage from his repertory of figural parts (fig. 6.25). With all of its abandon, the work was a chance encounter, a reminder of how active Rodin was when the models had left.

Perhaps more credible to Rodin's critics today than the delicacy shown by the male partners in the most famous sculptures of loving couples will be the lusty, complex mutual envelopment of a plaster pair shown for the first time (fig. 6.26). In his enthusiasm for the subject, Rodin defied gravity, anatomy, and conventional composition. Not mounted on a base, his figures are not merely joined, but fused. Under cursory inspection the couple seem to have too few or too many limbs, depending upon the point of view. The male figure came into existence in the *Gates,* head bowed, body stretching with one leg on the ground and the other poised on a rock. (Apart from the *Gates,* the figure was called *Polyphemus.*) Rodin jammed into the extended male

6.25 *Lesbian Couple,* n.d. Plaster. Musée Rodin, Paris (S705). Cat. no. 43.

body the contorted figure of a woman, who wraps her left leg around the man's waist. Even in the earlier and relatively more sedate couples, men and women sling their legs over one another; Rodin was obsessed with the drive for total mergence of two human beings. This more athletic pair, which must date well after 1880, is fused not only by bodily movement but also by a common

6.26 *The Embrace*, 1870s(?). Plaster. Musée Rodin, Paris (S696). Cat. no. 40.

surface. Its roughness Rodin accepted, because it seemed to augment the figures' physical movement. The continuous surface from the woman's shoulder to the man's head and the frequent fluid passages may have been achieved as follows: they first existed separately in plaster, and Rodin added parts in clay or wet plaster, such as an arm or leg, and then joined them together, possibly with wax. He then seems to have dipped the couple into liquid plaster. Liking the result, he made a piece mold and cast a new plaster, which would account for the casting seams atop the more liquefied surfaces.

While working on *The Gates of Hell* in the early 1880s, Rodin extended his options as a composer by challenging conventions of credibility and consistency. When manipulating his plasters, he came to ignore traditional assumptions: that there is a need for psychological reciprocation through facial expressions and gestures; that figures conjoined must each be different; that couples should constitute a compact if not closed silhouette or one conceivable within an imagined pyramid or cube; that once a figure was fashioned in a given relation to gravity that orientation must be sustained; that anatomical credibility if not exactness must be maintained; and that a sculpture should have a clearly discernible front by which the action could be clearly read. The frequent physical proximity but mental es-

trangement of his coupled figures was as much a peculiarity of his time as were the distracted couples depicted by Degas. So was Rodin's repetition of the same form, an effect accomplished in painting by a mirror reflection or occasionally in Degas's case by repeating the same model seen from different viewpoints. The doubling of a joint or drastically extending the length of a limb were compositional exigencies that preempted anatomical rules. Inverting a figure modeled upright without adjusting disposal of body weight did not deter Rodin if the result looked aesthetically and dramatically right.

Dip Casting

Genius loves frugality. Rodin still surprises by the inventive economy that allowed him with the simplest means to extract the most from what he had previously done. We now know for certain that Rodin augmented his considerable productivity by occasionally dipping plaster casts of heads and small figures into liquid plaster, thereby winning for them a new expressiveness and for himself a fresh surface on which to carry out different possibilities.[14] (Since he had several plasters made of the same work, he thus retained casts that were not dipped.) We know that he sometimes dipped plasters that were given as gifts, perhaps because they gave a cleaner as well as softer impression, after having been exposed to the dust and hazards of life in the studio.[15] Rodin used this technique intermittently between at least 1878 and the next to the last work he did in 1916. Whether or not he derived this process from another artist is unknown, but it seems without precedent. (Medardo Rosso employed it with his wax sculptures in the 1890s, often dipping a plaster into liquid wax.) Within his own art, Rodin may have developed the idea after encountering the practice of his mold makers, who might line a mold with liquid plaster to provide the outer skin of a work that was to be a solid cast.[16] This technique was used in 1878 with the great plaster *Torso* for *St. John the Baptist* (and later *The Walking Man*). Rodin's earliest dipped cast that I have found is a study for the head of *St. John the Baptist,* made in 1878 (fig. 6.27).

Juxtaposed, the dipped and undipped studies of the head of *St. John* make a striking contrast (figs. 6.27, 6.28). The former appears younger, the planes broader, and the surface as a whole less variegated, and the untempered touches and gouges of the original cast have been smoothed out. With a knife, Rodin etched lines for the beard, mustache, eyebrows, and eyes into the coated version. The opening of the mouth has been deepened, and graphite notations on the right side of the face add

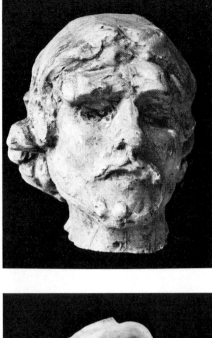

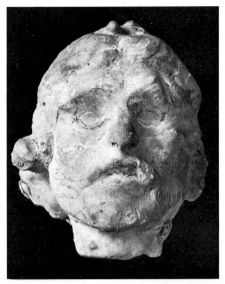

left: 6.27 *Study for the Head of St. John the Baptist*, 1877-1878. Plaster. Musée Rodin, Paris (S679). Cat. nos. 65-66.

right: 6.28 *Study for the Head of St. John the Baptist*, 1877-1878. Dipped plaster version of 6.27. Musée Rodin, Paris (S304). Cat. nos. 65-66.

6.29 *Bust of Helen von Nostitz*, 1902(?). Dipped plaster with carving and filing. Musée Rodin, Paris (S688). Cat. nos. 116-118.

right: 6.30 *Bust of Helen von Nostitz*, 1902(?). Dipped plaster with graphite notations and some chiseling. Musée Rodin, Paris (S689). Cat. nos. 116-118.

to the evidence that Rodin wanted more animation to relieve the greater blondness of the cast. Over the surface are small pits, left by air bubbles in the wet plaster, and atop the head are small conical mounds caused by the liquid plaster running downward as the head was probably immersed upside down with Rodin holding it by the hollow in the neck. He made no attempt to disguise or remove these and other procedural accidents. They were accommodated by his style, vision, and attitude toward truthfulness. If the accidental accentuated or was consistent with the character of the subject and enhanced the overall movement and animation of the sculpture, then it was accepted as artistically right.

The dipped cast method offered Rodin the opportunity to see how his portraits of women, notably that of Helen von Nostitz, might look in marble, and quite logically he used the process in one version to effect a veil over most of her features (figs. 6.29, 6.30). The graphite notations in the hair of the veiled version recall his method of editing stone sculptures in the process of being carved by his assistants. In addition, both portraits show that plaster editing included work with files and chisels. Cosmetically appealing, the liquid coating also serves to heighten the woman's mood of withdrawal. (The von Nostitz dipped heads make us think of Brancusi's process of slowly erasing the features of his *Sleeping Muse*.) By varying the consistency of the liquid medium, Rodin could control how much nuance of his original modeling would be preserved. In the instance of the veiled portrait, he may have dipped the plaster more than once to obtain

6.31

6.32

6.33

6.31 *Seated Woman with Arms and Legs Crossed*, n.d. Plaster. Musée Rodin, Paris (S708). Cat. no. 72.

6.32 *Standing Faun with Seated Woman*, n.d. Plaster. Musée Rodin, Paris (S700). Cat. no. 44.

6.33 *Nude Seated Woman with Her Left Thigh Raised*, n.d. Plaster. Musée Rodin, Paris (S682). Cat. no. 46.

6.34 *Standing Faun*, n.d. Plaster. Musée Rodin, Paris (S687). Cat. no. 45.

the layered effect across the lower face. So strong and distinctive was his touch that even after several *surmoulages* in bronze, Rodin's modeling is not totally lost. So, too, in these plasters the second skin, like his most cursory contour drawing, betrays the artistic knowledge that lies beneath.

When Rodin applied his fluid medium to an entire figure sculpture that may have been synthesized from different parts and unfinished at the extremities, he won an overall cohesiveness and consistency, in sum, a new plausibility. Discrepancies of proportion, identity of sexual parts, and length of paired limbs are all masked by this fluency of surface. Surprisingly, a technique that seems so natural for the enhancement of strenuous movement is also applied to a self-immobilized, seated figure (fig. 6.31). Liquefaction is thus not reserved for

transmission of energy, as one might expect with Rodin, but was also used in more unexpected, poetic, or mysterious ways. The seated woman's postural criss-crossing of paired limbs evokes psychological self-imprisonment or strife and is subtly seconded by this unnatural uniform integument. The aesthetic unity of the dipped cast is here at the service of evoking the divided, imprisoned self.

One of the most eloquent examples of raw, unfinished work among Rodin's plasters is the couple titled by the Musée Rodin *Faun and Seated Woman* (fig. 6.32). After their wedding by wax and liquid plaster, the figures have undergone additions and subtractions. When we look at the separated figures of the couple (figs. 6.33, 6.34), it is easier to see how this double process was carried out. While they had been stripped of limbs that to the artist

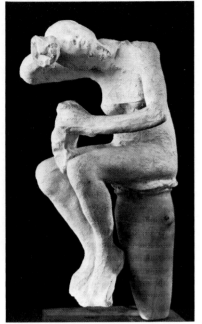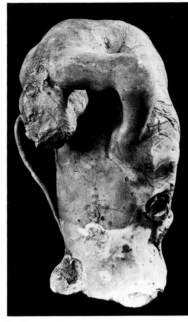

6.35 6.36

seemed unessential when they were isolated, in conjoining them Rodin felt compelled to extend and complete the gestures of their respective right arms. Points of physical contact between two freshly joined figures always received Rodin's most concentrated scrutiny, and dissatisfied with this juncture at some later date than their union, he cut through the surface of the faun's torso to clarify or adjust its planes in relation to the woman's shoulders. Rodin always wanted strong emphasis on the direction of a body part and emphatic contrasts between sections of a figure or couple. Thus, we see that dip casting was not always a final state, but often only an intermediate stage in the ongoing sculptural process.

Never cast in bronze and probably not exhibited publicly by the artist are a number of small sculptures conjoined with ancient urns and dishes. (Only recently have they been photographically reproduced.) One of the most striking in the authority of its observation of a habitual life-gesture is that of a woman wiping her head while seated on an urn (fig. 6.35). (Her head is from another source and roughly added to the torso.) The urn, taken from Rodin's large collection of antiques, served as a convenient support, although its height did not permit the woman's feet to touch the ground. Rodin must have found such conjunctions as this amusing, and it is fair to say that they represent both the practical solution to mounting sculpture and creative play on his part. In one instance, however, Rodin dip cast a figure presumably standing in and curled over an actual small cup with a handle (fig. 6.36). It may not have been lost on him that the pitted ancient pot thus looked like those

retrieved from the sea after long submersion. With knife and graphite Rodin worried the surface at several points, discontent with a less inflected, sensuous smoothness such as that for which younger modern sculptors in the twentieth century were searching. Rodin knew that for centuries artists had compared ancient Greek vases with women's torsos. By using his own ready-made sculptures and collected objects and the dip cast, which muted their differences, he was able to enact that comparison.

"Parcels of Truth:" The Partial Figures[17]

Despite recent attempts to find antecedents in nineteenth-century sculpture for Rodin's use of the partial figure, it was he who first willed their status as complete works of art. In effect, Rodin posed a question crucial to modern sculpture: what can sculpture do without? Considering that his art was in the long tradition of Western figural sculpture, the answer was stunning: heads, arms, legs, hands, and feet. A number of partial figures in plaster have been introduced into this exhibition so that we may see the work by Rodin most influential for such younger modern contemporaries as Maillol, Matisse, Brancusi, Lehmbruck, Archipenko, Duchamp-Villon, Gaudier Brzeska, and Lipchitz. Rodin could not have foreseen the results of the creative tensions his partial figures would awaken in others, but from at least 1900 he was aware that they had the most to offer serious younger artists concerned with sculpture's future.

As with *The Gates of Hell*, the partial figures were part of Rodin's intent to harmonize the outer world with his

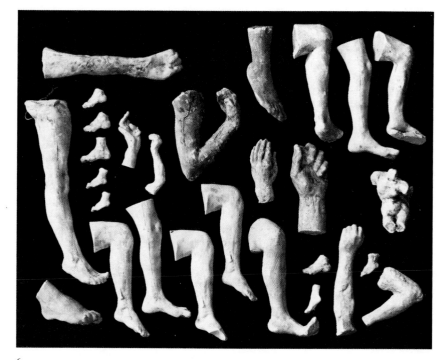

6.37

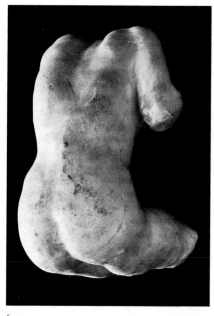

6.40

inner life and also to connect past with present. It is his plaster partial figures that come closest to fragmented ancient sculpture; they confirmed for him that his work in this mode had genuine beauty and artistic self-sufficiency. The study of ancient torsos persuaded Rodin that his Greek predecessors had also worked from the living model. His partial figures were a way of showing between his work and that of the ancients a shared basis in life, in pure modeling, and in the study of planes. Furthering this association are the many quiescent partial figures which simply sit or stand. Beauty and drama come from their firm fullness of life, a healthful state of just being rather than doing. The same is true of many extremities Rodin kept in reserve or enjoyed in themselves (fig. 6.37).

Ancient fragments rarely can be fully enjoyed for the fortuitous silhouette made by accidental amputation. The fragmented figure was intolerable to the Greek notion of beauty and wholeness. Some of Rodin's *études*, such as the series of the back of a *Seated Woman* (figs. 6.38, 6.39, 6.40), were never intended as full figures. In Rodin's art the terminations of the torsos are usually calculated, and if the result of accident, they were sometimes reworked. When enlarged, the stumps were usually trued or squared off. It is difficult to establish a consistent principle by which Rodin "completed" his partial figures, particularly the torsos. Usually he either fashioned part of the upper arm or cut off most of a leg, leaving some fragment to indicate the direction of the

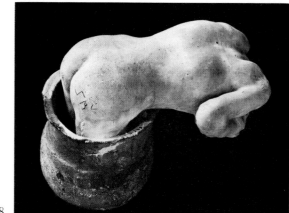

6.38

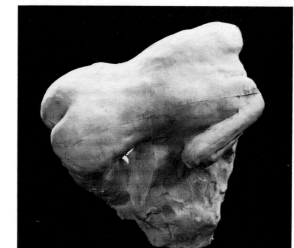

6.39

6.42 *Prayer* (without the right leg), 1883-1884(?). Plaster. Musée Rodin (S684). Cat. no. 34.

6.43 *Prayer* (small version), 1883-1884(?). Plaster. Musée Rodin, Paris (S685). Cat. no. 33.

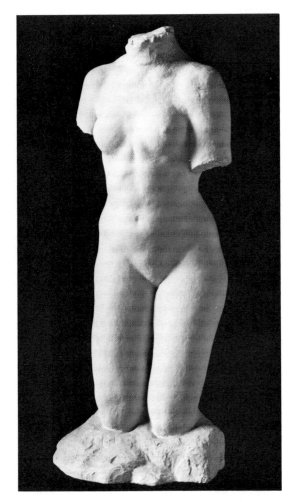

6.44 *Prayer* (life-sized), 1883-1884(?). Plaster. Musée Rodin, Paris (S709) Cat. no. 35.

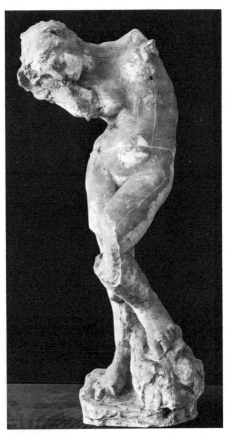

6.41 *Meditation* without arms, 1883-1884(?). Plaster. Musée Rodin, Paris (S680). Cat. no. 48.

limb's original gesture. There are, however, sculptures such as *Meditation* (fig. 6.41), in which the break comes right at the joint of the arm. In a version of *Prayer* (fig. 6.42), the woman's right leg has been entirely removed at the pelvis. In all cases, Rodin intended the broken joint to be read as part of the sculpture's overall silhouette and judged for its aesthetic rightness. The terminal edges of the upper arms of *Prayer* (figs. 6.43, 6.44) seem a natural formal continuation of the torso's contours. Looking at the *Woman's Back* group for other examples, it is impossible to imagine placing a neck and head atop the shoulders, whose undulant lines prophesy their counterparts in Jean Arp's ebullient torsos of the 1930s.

As much as the full figures, some of Rodin's partial figures attest to his fascination with the figural arabesque in depth. *The Kneeling Nude* without head and arms is a paradigmatic expression of the torsion he sought, what he termed *désinvolture* (fig. 6.45). The truncated *Meditation* astonishes from every viewpoint which close tracking of the form requires us to take. Rodin loved

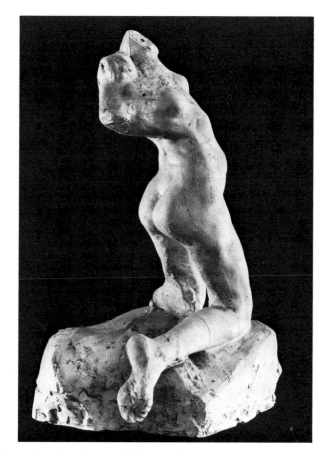

6.45 *Kneeling Nude*, n.d. Plaster. Musée Rodin, Paris (S677). Cat. no. 31.

right: 6.46 *Nijinsky*, 1912. Bronze. Musée Rodin, Paris. Cat. no. 334.

composing the figure in depth and passionately pursued the contour that was unconfined to any vertical plane. If an arm or leg blocked the tracking, Rodin removed it the way a pathfinder might break limbs from trees blocking his route.

The rhythm of Rodin's sculpture includes alternation of open and closed forms, and sometimes the same figure is shown with its limbs intact in maximal extension and then in a highly contracted form. (The former satisfies those who want to see Rodin as the last of the baroque artists, but the latter confounds such classification.) One can ponder what constituted the motives for the contraction of the body that Rodin often sought. Was it the purest expression of a single idea or state of being or movement? Was it the most expressive core of a figural composition and one to which he felt he could add a variety of gestures rather than just one? Was it the quest for the minimal means to achieve a credible sculpture? Was it simply a matter of a given model inspiring only a torso, a hand, or a foot? Perhaps none, but probably

all of these applied in one way or another. Can we really be sure Rodin was purely an inductive thinker, an artist who had to build from parts to the whole, as Matisse saw him? (Was Matisse misreading Rodin in what Harold Bloom calls "the anxiety of influence"?[18]) Can we be sure, for example, that the partial figure of *Meditation* came before and not after the original half life-size full figure? What do we call an artist who establishes the modern premise that a complete work of art need not presuppose the whole human form and whose guidance in completing partial figures and hybrid montages was the *total effect?* Rodin's greatness, like Picasso's, beggars typification.

Symmetry was taboo for nineteenth-century sculptors and so, it would seem, for Rodin. Yet, this sculptor, who once said that rules were for mediocre artists, could not resist modeling upright, motionless, and frontal figures whose weight was equally distributed on their legs. It is in works such as *Prayer* that Rodin's touch, the

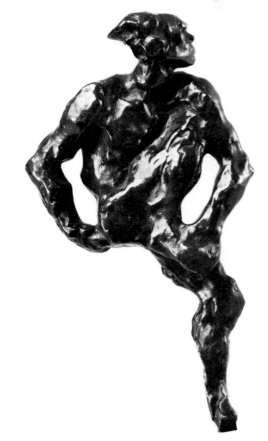

nuance of his modeling, carries the burden of animation (fig. 6.43). His modernity is often cited in his ability to capture fluid energy, the mobilization of the body which destroys distinction between its parts, and the defiance of gravity, as in his sculpture of Nijinsky (fig. 6.46). Yet Rodin recognized, as did Maillol, whom he admired,

6.48 *Iris, Messenger of the Gods*, small version, 1890(?). Plaster. Musée Rodin, Paris (S695). Cat. no. 56.

6.47 *Iris, Messenger of the Gods* without a head, 1890(?). Plaster. Musée Rodin, Paris (S699). Cat. no. 57.

6.49 *Iris, Messenger of the Gods* with a head, 1890(?). Plaster. Musée Rodin, Paris (S706). Cat. no. 58.

that modern life also valued the tranquil. Unlike Maillol's placid figures, however, those of Rodin still have nerves, and immobility is not their permanent or habitual state; the energy of his figures is only temporarily banked.

Rodin's nineteenth-century fame was founded in large part on his original studies of human movement. It was not only that he introduced new figural action and ignored academic rules about a work's being plumb (having an upright, vertical axis with the supporting foot below the head) but also that his images of active, naked women butted against social codes of propriety. At least since the *Crouching Woman*, made for the *Gates* around 1881, Rodin had been fascinated with a woman's thigh compressed against the side of her torso, resulting in a sculpturally daring revelation of the subject's crotch. Rodin's tact was in showing the subject's total self-absorption and unawareness of the viewer and in not displaying such work to certain studio visitors. The Meudon Reserve discloses a powerful series of variations and enlargements of the motif of a cancan dancer that was perhaps a reworking of the piece done in the early nineties and called *Iris, Messenger of the Gods* (figs. 6.47, 6.48, 6.49). The enlargement shows how Rodin had finally pared the complex form down to its most compressed statement of diverging axes and energy. This series brings to mind Rodin's enthusiasm for what "nature" afforded him:

For every one of her beauties that she shows us, and that we express, there are a hundred, a thousand that escape us, that exceed us. We know only parcels of truth. There are unknown forces within nature; when we give ourselves wholly to her, without reserve, she lends them to us; she shows us these forms which our watching eyes do not see, which our intelligence does not understand or suspect. In art, to admit only what one understands leads to impotence.[19]

It has become the vogue to contrast Degas and Rodin in such a way to make the former a realist and the latter a symbolist. The sculpture of Degas is seen as embodying specifically modern gestures, movements enacted by anonymous models conditioned by contemporary Parisian culture or lifestyle. Further, Degas's sculpture is seen as existing in "real" or universal space (i.e. a space continuous with that of the viewer), while Rodin's thrives in a "symbolist" space. One writer, ignorant of Rodin's history and work as a whole, has even gone so far as to proclaim mistakenly that Rodin's small sculptures were inspired late in life by those of Degas. Setting aside the considerable qualitative merits of both sculptors, such polarizations are simplistic at best, proceeding from lack of awareness of the range of Rodin's art. Degas's ballet dancers certainly belong to Paris of the nineteenth century, but so do Rodin's many *études* of the cancan dancers who modeled for him. At times he would simply title the forms they inspired "Flying Figures," which should satisfy a realist partisan. On other occasions he

would title a figure, "Iris, Messenger of the Gods," which would please a symbolist adherent. When Degas situated a recumbent bather in a contemporary basin, he was a realist. When Rodin put a figure in a small, unadorned Greek pot, he was supposedly not a realist. That Rodin did not cast the pot, but used it as a ready-made base or receptacle for his figure, is not taken into account by those who like tidy classifications. Degas's figures were always mounted on bases, and because these bases were not modeled to suggest earth or rocks, they seem to some more "modern" or realistic than those illusionistic mounts often used by Rodin to stage his figures. Rodin, however, produced dozens of small sculptures which have *no* bases, whose home is the hand or whatever surface they are set down on. Are these small sculptures to be viewed as existing in a symbolist space any more than Degas's less than life-size figures? If the latter are supposed to exist in our space, then in a sense they are freaks. Degas's small sculptures belong to a tradition of miniaturizing the human figure and its space.

If we take one small partial figure by Rodin, the *Woman Removing Her Dress* (fig. 6.50), we can see how close in theme he could come to Degas. The absence,

6.50 *Woman Removing Her Dress*, n.d. Plaster. Musée Rodin, Paris (S683). Cat. no. 69.

however, of an illusionistic setting, coupled with the simplicity of the costume, removes the coordinates of time and physical place, just as the absence of a base removes fixity of the figure's orientation. Or, if we take the series of the woman's back (*Petit torse feminin assis*), we have the gamut of Rodin's options: juncture of sculpture and ancient pot, which can evoke ambiguous classical association; juncture of the body with a simulation of earth or a rock to inspire references to a nude in nature, creating a *poésie*; and finally the torso by itself, which makes it conceivably of the moment and the viewer's place. A lesson of the plasters is that Rodin resists classification as a realist or a symbolist. He is all and exclusively none of these typifications. He is Janus-headed, synthesizing the past and the present, and he has also a clear focus on the future in terms of the fruitfulness of the partial figure for sculptural invention. Rodin had fewer self-imposed taboos than Degas, but this fact made him no less modern.

Simultaneity of Modes in Single and Paired Figures

With few exceptions, until Rodin western European sculptors practiced consistency of mode in their work. Thus the style, technique, proportion, and size of figural parts would be broadly consistent from one work to another, particularly within a single sculpture of an individual or paired figures. Modal variations in an artist's sculptures might be dictated by a theme, as in Donatello. In older art, such as that of medieval tympana, scale and proportional discrepancies between two or more figures usually symbolized the world of rank, and the sculptor was illustrating his society's religious and political hierarchy. He was also enhancing the visibility of the most prominent personage. Inconsistency of style was at times found in individual medieval sculptures, as at Rheims Cathedral, when ancient sculptured heads were grafted on to modern bodies. The hermaphrodite allowed Greek and baroque sculptors to combine male and female sexual features in one figure. It was not in a revival of the foregoing exceptions to the rule of consistency that Rodin was innovative.

In Rodin's partial figures there frequently coexist imitative modeling of the body and explicit reference to the sculptural process, such as editing and casting marks, accidents and chance effects. Illusion was wedded to anti-illusion in such major sculptures as *The Walking Man*, where along with the violent editing of the torso and the rough bonding of the legs to the body, the strap of the armature is visible by the right ankle. All of these

6.51

deviations from consistency were preserved in the enlargement and bronze casting.

Since the ancients, sculptors have made interchangeable parts for sculptures, as with Egyptian portrait heads and Greek Tanagra figures, but these parts were so made and joined as to maintain the illusion of consistent depiction of an individual. Rodin never conceived of any sculpture he made, including his earliest exhibited statues, as being completely restricted by fidelity to one model. (By his own account he once tried the head of *The Man With a Broken Nose* on the body of *The Age of Bronze*.) One of his most intriguing grafts was that of the body of *The Earth* with the later plaster version of *The Man With a Broken Nose* (fig. 6.51). The neck was first roughly shaped by a heavy wet plaster collar, which when dry Rodin chiseled to reduce its thickness. The body itself is like a landing field for accidents caused by the dripping of the wet plaster, probably when the neck was being fashioned. The sex of the original figure *The Earth* is female, and the modes of modeling head and body were different. Proportionately, the head is overlarge. By itself, *The Earth* is one of Rodin's most mysterious sculptures. Its reincarnation was an even more powerful challenge to finesse and finish, while the head, which by itself evokes passive resignation, became the determined image of a thrusting force. On those occasions when Rodin joined two plaster figures together and saw the need for adding to a partial figure, he might roughly model a head in plaster, as in the *Flying Figure*

Embracing a Woman (fig. 17). Modeled plaster never was carried to the definition of work in clay.

Two of the more dramatic modal discrepancies in Rodin's art involved size and sex. With two life-size plaster figures of *The Shade*, for example, Rodin respectively conjoined the half life-size figures of *The Fallen Caryatid* and *Meditation*. That the plaster *Shade with Meditation* is in the Ny Carlsberg Collection testifies to Rodin's determination to make public his audacities. One can encounter disparity in the size of the head relative to that of the body in *The Naked Balzac With Folded Arms* or the torso and legs of *The Walking Man*, single figures he exhibited and bronze cast. Not exhibited because of its size and extreme fragility is one of Rodin's last montages, *Absolution*, in which he conjoined the life-size masculine body and legs of his earliest *Ugolino* with a woman's head and then attached to this sexual and formal hybrid the upright form of the half life-size plaster of *The Earth*.[20] Presumably to effect this unusual union both compositionally and dramatically, Rodin employed a large tarpaulin dipped in plaster to shroud the couple on one side. Another of his bisexual figures whose discrepancies include those of modeling is the upper half of the imploring woman that he used in the *Centauresse* (fig. 6.52). *The Head of Sorrow*, which was modeled from a woman, was used on such male figures as *The Prodigal Son* and one of the sons of *Ugolino*.

One of the most provocative dualities in Rodin's art is that of the lyrical and the grotesque found within a

6.52

6.53

single figure. Among works bronze cast in Rodin's lifetime, *The Kneeling Fauness* is one of the best examples.[21] Her beautiful body is surmounted by a battered head. Analagous to this work are the plaster partial figure versions of *The Tragic Muse* and *Crouching Nude* (figs. 6.53, 6.54). Attached to the bottom of the first is a large phallic tenon used to join the figure to the plaster *Victor Hugo Monument*. The head of *The Tragic Muse* was originally modeled to express a being whose features were warped by despair or anxiety, and subsequent rude additions to the forehead and nose seem plausible exaggerations of those states. Rodin also modified the cosmetic perfection of the body by editing with a knife and adding coarse clay or plaster excrescences to the surface. (The ragged ridge running from left armpit to left breast may have been a structural addition to help support the plaster arm.) *The Crouching Nude* is one of the most astonishing previously unknown works in Rodin's art. If it were exhibited alone, without identification, probably few would recognize this sculpture as a Rodin. It was built up at a date unknown from a smaller headless, crouching body that still exists at Meudon as a terra cotta. Rodin had this headless figure enlarged, and he added to it the arms framing a truly amazing head. The roughly fashioned arms do not end in hands but simply fuse with one another. Rodin did not add feet to the enlargement, and his assistant, probably Lebossé, faith-

6.54 *Crouching Nude with a Grotesque Head*, 1900–1912(?). Plaster. Musée Rodin, Paris (S704). Cat. no. 30.

6.55 Head of the *Crouching Nude*, detail of 6.54.

6.56 Head of *The Thinker* with panel attached, enlarged version, c. 1904. Plaster. Musée Rodin, Paris.

fully reproduced on a larger scale the lumps of clay originally applied to the lower legs. Although the torso is sensuously formed, Rodin did not insist upon the complete sexual identity of this curious compacted, caryatidlike form. Just the tight juxtaposition of rough and smooth surface treatment of the legs and body, the squared off contouring of limbs that balance on a rounded figural base, and the continuous, diagonal, surfboard plane of the back should be enough to intrigue the most inquisitive figural sculptor today. It is the head (fig. 6.55), however, that is the climax and cause of the greatest consternation. It seems patched together with twin rolls of clay for the nose, an oval mound for the forehead, and undefined hollows for the eyes—what one would expect Rodin to have done at the start of modeling the head, before he had begun working from the model in order to refine contours and features. The flattened oval slab where we expect the mouth and chin recalls a comparable passage in a plaster head of *The Thinker* (fig. 6.56), also in the Meudon Reserve. A slab replaces the lower features at the point where the back of the man's right hand was in contact with his face. Rodin liked this incongruity so much that he attached a board to one side of the head to make it like a relief.

What were Rodin's motives in withholding his manual skill by arresting his improvisation of the woman's head and arms and then causing them to be fixed in plaster? Unquestionably, the result is the antithesis of beautiful form as it was known in Rodin's day and of which he was capable. To claim that Rodin sought to depict ugliness is to forget that he denied its existence in nature, saying that all natural forms had character. Rodin strove most of his life to push sculpture further than it had gone before. It may have been that in this work Rodin was testing art's power and mystery.

How did these modal inconsistencies come about? Historically, they first occurred in the privacy of the studio with, presumably, no public destination. Before *The Age of Bronze*, Rodin made a living for twenty years by working in different historical styles to satisfy the commercial tastes of his employers and the public, while privately developing his own "styleless art." As best he could, while establishing his public reputation in the decade after 1877, Rodin produced many works that met salon standards of finish and theme. Privately working on the *Gates*, he was improvising and inventing ways to make his sculpture more responsive to thought and feeling during the moments when inspiration came upon

him as he worked. Impatience and convenience may have initiated the rough ligatures connecting disparately made parts, for example. They were not shown to the public immediately, as Rodin had to pay his professional dues and establish himself as an uncommon, but still traditional statue maker. He had to build his own confidence in his judgment. Slowly, over time, he exhibited his *études*—along with more acceptable work. He also needed time to accustom himself to his own daring, to understand its implications, as with the partial figures, before affirming in public that his audacities had artistic validity. He had this conviction certainly by 1900. Rodin was the first among modern sculptors to disappoint the public by giving it less than was expected: less finish, less modeling, less style, less consistency, less than the whole figure, less discretion, and less idealism. Before modern architects took it as their credo, Rodin showed that artistically, less could be more.

The Lessons of the Plasters

To those who may still be skeptical about whether these plasters are works of art and whether Rodin would have wished them to be shown, consider that during his life he had many photographers record such works not only for his own benefit, but for writers and the world press as well. At his own expense he caused to be bronze cast the life-size enlargement of the *Petit torse feminin assis* and one of his most daring hybrids, *Crouching Woman*, which he gave as part of the donation to the British nation in 1914.[22] If World War I had not intervened, he might have cast in bronze more of these small works, possibly for his own museum. That more of these plasters were not cast in metal is explained by the staggering demand for Rodin's better known, more public art. Clients who traveled from afar to his studio wanted to commission casts of those works with which they were already familiar—*The Age of Bronze, Eve, The Kiss*, and *The Thinker*. That so many of these previously unknown small plasters were enlarged tells us of Rodin's satisfaction with them. After the great 1900 exhibition, along with portraits, the works he exhibited in the salons until 1914 were almost all partial figures. Many studio visitors mention Rodin's showing them with pleasure his small *études* taken from glass cabinets. Rodin was also a great teacher who wanted to demystify the studio. In his zeal to share all the stages of the sculptural process, he was a missionary to the world.[23]

Perhaps the most dramatic lesson of the plasters is the considerable amount of work that Rodin did after the model had left, when nature was no longer before his eyes, though still in his mind. How often the artist told writers that he was helpless without something to imitate and that nature was his only guide. It was also Rodin, however, who said that he sought to "express life" as well as "render nature" and that "the artist makes tangible that which was invisible."[24] We have to imagine Rodin in the privacy of the studios, surrounded by all those figures and fragments, like hundreds of particles of energy waiting to be magnetized to some new nucleus. His imagination was fired not only by the sight of warm, living flesh, but also by his own art. There was a decided discipline to Rodin's daring with the plasters. He could have been describing himself when he spoke to Dujardin-Beaumetz about the knowledge and skill a sculptor should have:

A man who has studied nature a lot, who has seen rightly, has gained quick intelligence can make, undo, rebuild his work, analyze it, add to it, recompose it. . . . He who cannot set up a figure exactly doesn't have the possibility of variations.[25]

Having met these requirements, Rodin had few inhibitions with respect to the manipulation and montage of the plasters when it came to the joining of incongruities in improbable weddings; but these inhibitions are telling of what he considered the ultimate limits of sculpture. All through his life, artistic credibility was tied to his view of nature and the imperative of expressing life. As he matured, he grew alert to nature's variety, surprises and mysteries. This realization brought him to the view that "In art, to admit only what one understands leads to impotence." Rodin could look at his sculpture abstractly in terms of line and plane, but he could not bring himself to make either abstract sculpture or sculpture about objects. To Marcelle Tirel, Rodin said, "They turn out that Cubist stuff, that filth that sickens me. The whole of art lies in the human body."[26]

Unquestionably, the manipulation of his plasters refreshed Rodin's thought, shook him up, and constantly was a reminder of the impossible goal of capturing both the abundance of nature and sculpture. To some, Rodin's simultaneous work in public and private modes, fashioning a commissioned bust of a beautiful client while also concocting a grotesque crouching caryatid, may smack of insincerity. From its beginnings, Rodin's art knew multiple modes. Just as Picasso was to do, Rodin always kept open his options so that art could respond to as much of experience as possible. Rarely do we find an artist, especially a sculptor, whose work has been accessible throughout a lifetime to a full range of observations, thoughts, and emotions—things the artist loved. Along with an already astonishing known production, these plasters promote Rodin as such a rarity.

NOTES

1. The Meudon Reserve is located in the basement of the pavilion of the Rodin Museum in Meudon, just outside of Paris. The building of this pavilion in the late 1920s was made possible by funds given by Jules Mastbaum, who also established the Rodin Museum in Philadelphia. The reserve is not accessible to members of the public, who nevertheless can enjoy an abundance of Rodin's plasters in the main hall of the pavilion.

2. The great collection of these old photographs, taken in Rodin's studios under his supervision, are housed in the Rodin Museum in Paris. A large selection of these pictures appears in the author's *In Rodin's Studio: A Photographic Record of Sculpture in the Making* (Oxford: Phaidon Press in association with the Musée Rodin, 1980).

3. H.C.E. Dujardin-Beaumetz, "Rodin's Reflections on Art," in Albert Elsen, *Auguste Rodin: Readings on His Life and Work* (Englewood Cliffs, N.J.: Prentice-Hall, 1965), 179.

4. This information comes from the archives of the Rodin Museum in Paris. There are many letters of thanks to Rodin from artists, writers, critics, and government officials, who received plaster sculpture, often without warning, but usually after a friendly article or service performed for the sculptor.

5. From 1901 until the late 1920s, the Rodin Museum at Meudon consisted of the artist's 1900 pavilion which had been transported from its original site near the Pont de l'Alma. As it was not built to be a permanent structure, it disintegrated and was replaced by that donated by Jules Mastbaum.

6. For a photograph of the surviving study for *The Age of Bronze*, see author's *In Rodin's Studio*, 157.

7. Georges Grappe, *Catalogue du Musée Rodin* (Paris, 1944), 109.

8. Grappe, *Catalogue*, 109.

9. Accounts of the commission can be found in *L'Abeille de la Creuse*, 6 August 1905; *Le Figaro*, 23 August 1905; *La Grande Revue*, 1 April 1906; *Le Radical*, 30 October 1906; and *Le Gil Blas*, 3 November 1906. (These articles are on file in the Rollinat dossier in the Paris Rodin Museum.)

10. Judith Cladel, *Rodin the Man and His Art* (New York, 1918), 161–165.

11. This material, including the translation, comes from an unpublished paper in the author's file written for a course on Art and the Law by Daniel Rosenfeld and it in turn is drawn from the Tribunal de Police Correctionnelle de la Seine—8ᵉ Chambre. Presidence de Monsieur Larcher. *Affair Le Ministre de l'Instruction Publique des Beaux-Arts et M. Bénédite, Conservateur du Musée Rodin, Parties Civiles. Contre: MM. Montagutelli et Autres.* No. 5.044—1 à 9. 8–23 May 1919. I wish to thank Mr. Rosenfeld for allowing me to publish this excerpt.

12. Marcelle Tirel, *The Last Years of Rodin* (New York, 1925), 83.

13. Judith Cladel, *Rodin, Sa Vie Glorieuse, Sa Vie Inconnue* (Paris: Grasset, 1936), 368–370. Cladel and Tirel's accounts differ radically from that of Clémentel, who in his testimony on 22 May 1919, gave the following recollection:

> One day he told me that he was physically exhausted. Those of you who are familiar with the labor of sculpture might be able to understand how, for an old man of seventy-eight years, working . . . for durations of fifteen minutes, half-hours and hours, might show tremendous physical fatigue as a result. He said to me: 'I have not yet achieved what I want, [but] I feel tired. I'll begin the fourth stage later, but I do want to finish [the bust] and I will be happy to try and finish the bust today if you think it necessary.' I said to him . . . that it would not be necessary. Meanwhile, it [would have been] possible, without touching the bust, to add—it's very simple—that which had been eradicated in the second stage. And when he made a clay impression from the third mould, he called in Mr. Desbois, and informed him that it should not be touched. He wanted to continue the fourth stage. Unhappily time did not permit.

Although a friend of the artist and one of the executors of his estate, Clémentel's version seems self-serving. It was not time, but Rodin's poor health that prevented the work's completion. Several bronze casts were made of the fourth bust, and one of several plaster casts of the final unfinished version was given to Judith Cladel and is now in the collection of Mr. Ben Deane.

14. I would like to thank my colleague the sculptor Richard Randell for his help on this subject.

15. Jacques de Caso and Patricia B. Sanders, *Rodin's Sculpture: A Critical Study of the Spreckels Collection, California Palace of the Legion of Honor* (San Francisco: The Fine Arts Museums of San Francisco and Rutland, Vermont: Charles E. Tuttle Co., 1977), 212–213. This museum has a *Head of Pierre de Wissant* that shows every evidence of having been a dipped cast.

16. This technique was explained to me by Richard Randell, who had occasion to inspect the Rodin plaster *Torso* for *St. John the Baptist*, which is a solid plaster cast.

17. On this subject, see author's *The Partial Figure in Modern Sculpture: From Rodin to 1969* (Baltimore: The Baltimore Museum of Art, 1969), 13–28.

18. Harold Bloom, *The Anxiety of Influence: A Theory of Poetry* (New York: Oxford University Press, 1973).

19. Dujardin-Beaumetz, "Rodin's Reflections," 161.

20. This work will be reproduced in my essay, "Recent Rodin Discoveries," to be published in *The Proceedings of the XXIV International Congress of Art History*, held in Bologna, 1979.

21. See author's *In Rodin's Studio*, fig. 97.

22. For a reproduction of the latter sculpture, see author's *In Rodin's Studio*, fig. 96.

23. This was dramatically shown in Rodin's use of photography and is discussed in my book cited above.

24. Dujardin-Beaumetz, "Rodin's Reflections," 161, 177.

25. Dujardin-Beaumetz, "Rodin's Reflections," 176.

26. Tirel, *The Last Years*, 99–100.

7.70 *Assemblage of Two Female Nude Figures*, c. 1900-1905. Pencil and watercolor wash with collage. Musée Rodin, Paris (D5188). Cat. no. 350.

7. Rodin's Drawings

Kirk Varnedoe

The Continuous Line: Modes and Meanings of Rodin's Draftsmanship

Rodin's drawings form a massive (close to eight thousand extant) corpus whose paradoxes are at the measure of its scale. In an essay published in 1971, I examined some of the problems involved—the apparent absence of relation between drawings and sculpture, the peculiar complexities of stylistic development, etc.—and proposed a chronological schema by which the drawings might be understood in relation to Rodin's larger *oeuvre*.[1] That schema still seems sound, and the notes to the present exhibition offer refinements more than revisions.

Certain aspects of Rodin's draftmanship, however, become clear only when one considers the work as a totality, or more particularly when one reviews in its entirety the group of more than seven thousand drawings he kept. In 1977–1978, through the graciousness of the new administration of the Musée Rodin, I was able to accomplish such a study. The selection of this exhibition draws on that research, and on the unparalleled resources of Rodin's own collection, to demonstrate the procedures and the interrelatedness of his drawings in a fashion heretofore impossible. As a general introduction to these works, I offer some reflections on the experience of seeing the collection as a whole, symphonically, as a life's work.

Rodin drew constantly in almost every phase of his career, and in a bewildering panoply of styles. Finally, however, the central concerns of his draftsmanship, and the vast majority of all the drawings, can be seen to lie in two basic modes: the imaginative drawings that preoccupied him from his earliest years through the 1880s and the life drawings to which he devoted himself from the mid-1890s until his death. Although they may seem totally disparate, it is clear that we can approach a coherent understanding of the artist only by studying these bodies of work together, as complementary expressions of a single mind.

There are telling procedural similarities. When each mode of drawing is seen *in extenso*, what become striking are the constant operations of reconsideration, the massive repetitiveness, and the dogged attention to sets of gestures, themes, and ideas. In both the imaginative and the life drawings, an initial execution marked by quick impulse was offset by an extraordinary ongoing patience, a determination to exhaust the possibilities of each form. The two seemingly opposed paces of production form a rhythmic interlock between two psychological poles of creation: first scattering and diversity, and then regrouping, analysis, and narrow shaping.[2] In both major modes of drawing, too, Rodin was first led to the expressiveness of a particular gesture by intuitive attraction; his choice of motif preceded any conscious consideration of literary meaning. Then, the selected gesture was adapted and readapted to multiple literary/mythological/symbolic associations. This order of procedure acted as certainly on a huddled mourner from an early entombment scene as it did on a model seized later in the passing rush of a dance.

The most important bond joining Rodin's early and late draftsmanship, though, has less to do with procedure than with basic meanings of style, and will require a more lengthy elucidation. Unlike other fashions of drawing Rodin used from time to time, these two major modes were not just inflections of rendering, but manners of conceptualization that held personal expressive values. These ways of drawing, in inseparable conjunction with what was drawn, made statements about what sculpture should be, not only visually but morally and spiritually as well. If we examine the visual differences, we will be led steadily into the other realm of ideas.

Joining the two modes in one history, we can find at work a pendulum process with regard to line and value, each mode beginning with the linear and progressing toward a concern for tone and light. The imaginative drawings begin as airless, shadowless delineations. As they are reworked, their contours become heavier and join with added backgrounds. Eventually the "black" drawings seem like grottoes, their figures illuminated selectively in dark enfolding caves of space (analogous to the draperylike "caves" with which Rodin surrounded

153

his sculptures when he drew them in the 1880s). The internal articulation of the figure is first seen as a schematic map of muscles; but the volumes are subsequently bound together by ink shadows and then by more generalizing masses of white gouache highlights. These processes need not have happened over years; in the maturity of the style, a single day's elaboration of a pencil work might have recapitulated the history of the mode. It was also a process Rodin could and did reverse, by taking from a gouached image a linear tracing, thus returning the form to its simplest state.

The later drawings, instead of growing out of the painterly vision of the fully developed "blacks," radically overthrew it. Linearity again dominated, but in a wholly different framework. The body was not schematically divided, but sweepingly unified, both by an initial lack of internal definition and by the subsequent application of a watercolor wash. The tonal pattern of the early drawings was thus reversed—to dark figure on light ground—and with it the relation of the figure to atmosphere.

The basic change was from a conceptual to a visual mode, and not just in the banal sense that this is circumstantially the way the respective drawings were made. Though the imaginative drawings were often actually based on visible models (see fig. 7.3) their basic *écorché* (flayed) treatment of the body was explicitly antivisual, analytic in the fashion of an x-ray. The later figure drawings by contrast, more than simply done from life, were meant to be true to an experiential model of vision. Rodin described the final watercolors as embodying the look of a figure seen at a distance against a twilight sky;[3] they refer to the physical limitations of sight (not the powers of the mind) as the determinants of style. Moreover, the original rapid life drawings on which they were based were (in opposition to the clarifying "far" vision of the watercolors) explicitly about the deformations of near vision, in a very special way, having to do with figure's interaction with space.

The early drawings characteristically employed a very restricted depth, as if the personae were lined up before a wall, and pressed back by a transparent picture plane. Some of their archaic, frustrated power derives from that compression. In the later life drawings, the sheet is felt more as a permeable block of space. The models push their limbs into its depth, out to its face, and against or through its lateral and vertical boundaries. The negative spaces between the figure and the boundaries of the imagined volume—the interactions of contours with the edge of the page—play a central role both in evoking the power of movement and in signifying the artist's pres-

ence. In their cropping, perspective, and placement on the page, these figures aggressively refer to the artist's choice of proximate vantage (figs. 7.46, 7.47, 7.48). This spatial feature is worth pursuing, for its basis is more extraordinary than may at first be evident.

On the one hand, the contours of these figures were drawn with the experience of a lifetime's modeling. As it flows, the line springs and swells in constant kinesthetic sympathy with the play of muscles and gravity in the pose—a response possible only because of haptic knowledge so decisively set in the artist's spirit that it can command his fingertips without recourse to the conscious mind. Simultaneously, however, the model is also seized as an overall volume, by an eye of watchful innocence rather than experience, constantly attentive to the unpredictable, aberrant shapes formed in momentary congruences of pose and viewpoint. The latter shapes, their overlaps and foreshortenings synthesized into unitary silhouettes, later find their ultimate expression in cutouts (see figs. 7.64, 7.68). Drawing in this fashion demonstrates enormous confidence: first in letting the instinct of the hand have its way; and second in defeating the (normally involuntary and tyrannical) perceptual censorship of ideas of "correct" proportions, scale constancy, and basic intelligibility. The figures are drawn at once knowledgeably/sculpturally, in the absorbed elaboration of the line itself, and "naively"/optically, in the receptiveness to unexpected, perspectively deformed configurations.

With these considerations in mind we can reexamine more meaningfully the basic distinction between conceptual and visual in the early and late modes of drawing. The early drawings were done from memory and are about what memory does; they are at base static, analytic schemata of the figure produced by mental condensation and reformulation over time. The later drawings, by contrast, are about defeating memory by immersion in the lived instant and thus opening the way to a counteranalytic (more Bergsonian)[4] perception of form in transition, taken in its optical, experiential reality rather than its ideated form.

On the level of larger meanings which we thus approach, we would do well also to reexamine in more specific terms the apparent truism that the imaginative/ "black" drawings are by and large serious, and the life drawings light and playfully exuberant. The early drawings extrapolated their basic poses of conflicted counterrotation and their constricted spaces from the inherited codes of the Western artistic tradition. The poses that then intuitively attracted Rodin seem most frequently to have been associated with (and subsequently readapted

to) themes of anguish and struggle, and tragedies of limits, ends, and constraints. Rituals of death had a privileged place; and gestures of aggrieved consciousness, even more than contortions of physical suffering, seem to have moved the artist. There are for example no crucifixions in the imaginative works, but the entombment is a constantly repeated motif;[5] and the tendency in such images is to focus on and increase the number of attendant spectators. *The Thinker*, Rodin's earliest conception of the creator/poet, is far more than coincidentally derived from the lineage of these mournful watchers at the tomb. The repeated appearance of a two-figure group comprising a massive parent and helpless child is also characteristic. By the multiple manipulations of the drawings themselves, this motif becomes an ambivalent emblem of civilization; the protective role of paternal authority and/or maternal love (figs. 7.29, 7.37); the conflict between man's natural/animal condition and the constraints of his humanity/morality (*Ugolino*, see figs. 7.26–7.29); and the symbolic drama of infanticide (*Ugolino* and *Medea*[6]) which may stand for the relentless process of time consuming its own creations.

In the life drawings, there seems no question of such issues. Instead of being drawn from tradition, poses originate in random movement, in patterns of instinct and spontaneity rather than ritual. Yet such works do not simply bespeak a frivolous escape from concern for human meaning. They constitute instead a declaration of belief, highly consistent with the time of their creation, that the basic significance of life is latent in its ephemeral, seemingly random, and unguarded manifestations. As early as the later 1870s, when he rejected Michelangelo's poses in favor of studying without prejudice his models' natural movements, Rodin implicitly affirmed that one does not equal the past by imitating it, and that the secrets of great creations must be rediscovered at their source rather than in venerated representations. The idea of the later drawings originated in that decision (as Rodin himself later explained to Bourdelle[7]), though it took two more decades to find its form. Freud's contemporaneous understanding of the significance of the apparently arbitrary, and his belief that the inherited representations of myth and religion are only reflections of basic human experiences recoverable from our own unconscious lives, should be cited in juxtaposition.

Both major phases of Rodin's draftsmanship were thus motivated by a concern for significant gesture; but the worlds of meaning to which the two modes addressed themselves were opposed. The earlier drawings returned again and again to the dilemma of civilization, expressed in the interlock between the power of the heroic and noble and the agony of consciousness of contradictions, guilt, and mortality. The later drawings dealt instead with the natural energy of movements determined in subjective centers beyond the reach of social discipline, historical memory, or constraining doubt. The difference in emotional tone and underlying idea corresponds in many respects to the different ideas of creation manifest in *The Thinker* and the *Balzac* respectively.

The flayed nudity in the early drawings is a traditional attribute of knowledge (the *écorché* as sign of science and medicine) and mortality (the *écorché* as *vanitas* motif). The nudity of the later figures, purified to extreme simplicity, is an invented correlative of the freedom of uncensored instinctual life, not just in the models but also in the artist. The reduction of means and the renunciation of analysis in favor of dynamic summary, permit the unconstrained flow of the artist's hand and the participation of his own instinctive gesture in response to the model's. If the heavily masculine early drawings are romantic meditations on the epic suffering of civilized man, the later drawings provide the obverse: a feminine, labile world of unrestrained feeling and liberated, omnidirectional movement. In the earlier work, recurrent poses of self-address (*The Age of Bronze* and *The Thinker* reflect them) give expression to internal conflicts and blockages; but the later poses return to forms of self-caress that (like the *Balzac*, as he grasps himself under his cloak) manifest narcissism and the unchecked flow of erotic energy.

The earlier imaginative world is that of man after the Fall (the sculptures of *Adam* and *Eve* belong to it), while the latter is, more than pagan, pseudo-Edenic in its celebration of unashamed sexuality. The realm of the mind, of the museum, of inherited culture is replaced by the false garden of the artist's studio, the privileged space in which the cloaks of society can be removed and fundamental truths enacted. The artifice of this later naturalness is constantly written between its lines, nudity and gesture now deriving from the context of performance, the artist's presence, and the figures' unconcealed roles as models.

In these late drawings as in the earlier ones, the movement of the body and the manner of its presentation refer together, in league, to a belief structure regarding the appropriate concerns and purposes of art and the role of the artist's mind in creating it. In their progression from tragic history to a celebration of unconscious immediate experience, Rodin's two stages of draftsmanship not only illuminate his own development but also parallel a fundamental pattern of intellectual evolution in early modern culture. The early drawings wear the

weight of their part of these meditations more openly, in individual images. The later drawings, seemingly casual and licentiously playful, only assume their full valence when taken in the multiplicity of their production, with the principles of their conception understood.

Taken individually, an erotic drawing such as fig. 7.51 may seem the titillating self-indulgence of a voyeur. When the later drawings are seen in great number, though, the frequency of such investigations acts to change their meaning, and it becomes clear that these are only more pointed instances of the consuming erotic curiosity that is a mainspring of the entire mode. The nude women in the later drawings wheel, dance, and stretch in a dizzying kaleidoscope of poses, with a seemingly inexhaustible inventiveness of movement; but again and again, this freedom of motion pivots around, and refers to, the fixed axial center of their sex. In a sequence of drawings, this centering phenomenon can be surprising, or amusing. In several hundred, it becomes impressive. In several hundred more, and several hundred more beyond that, it can become by turns astonishing, tedious, numbing. Finally, passing from sheet to sheet through these later watercolors and drawings, in day after day of research, over hundreds of drawings after hundreds of drawings after hundreds of drawings drumming with unrelenting insistence on this same note of sexualized vision, I find all my skepticisms defeated, inadequate; and I am moved. These are not documents of idle self-indulgence, but of heated, driving fascination, the displaced locus of the same intense seriousness that motivated Rodin's draftsmanship from its beginnings. The recurrent themes of death and the conflicts of consciousness that compelled the young man's work have here been supplanted, in the spirit of the aging artist, by an ecstatic obsession with the mystery of creation taken at its primal source.

NOTES

1. See "Rodin as a Draftsman—A Chronological Perspective," in Albert Elsen and J. Kirk T. Varnedoe, *The Drawings of Rodin* (New York: Praeger, 1971).
2. See Anton Ehrenzweig, *The Hidden Order of Art* (Berkeley: University of California Press, 1967).
3. See the discussion of Rodin's ideas on this matter, in the specific notes to "Life Drawings and Watercolors," below.
4. Henri Bergson's *Essais sur les données immediates de la conscience* first expounded his idea, widely popular in the early twentieth century, that one could only grasp reality as a flow, outside of standard analytic reflection. This essay was published in 1888.
5. Rodin did draw two very peculiar crucifixions, one with a live lion roaring from the cross to which it is nailed; and the other showing lion skeletons on crosses. Neither of these seems connected to the main body of the imaginative and/or "black" drawings.
6. For a Rodin drawing of Medea, see Elsen and Varnedoe, *The Drawings of Rodin*, fig. 18, p. 44.
7. See the quote from Rodin at the end of the specific notes to "The Trip to Italy, 1875."

Early Drawings

After a brief and desultory encounter with general education, Rodin entered the Special Imperial School of Drawing and Mathematics at the age of fourteen, in 1854. This government-sponsored school, open to all without entrance examination or tuition, was familiarly known as the Petite Ecole (Little School) in acknowledgment of its subordinate position with regard to the prestigious, competitive Ecole des Beaux-Arts. Although the Petite Ecole was primarily intended as a training ground for artisans and those in industrial arts, many aspiring painters and sculptors—including Rodin—tried to use it as a springboard to the larger school.

The faculty of the Petite Ecole was esteemed in its own right and included an exceptional teacher, Horace Lecoq de Boisbaudran, whose innovative and broadly tolerant instruction Rodin later acknowledged with gratitude. Lecoq's techniques for training visual memory, his disaffection for the artificiality of studio poses, and his insistence on the individual study of nature were all important to Rodin's formation.[1] There is no indication, though, that Rodin was in any way an exceptional student. He seems to have progressed dutifully and without particular distinction through graduated steps of copy drawings: after engravings, after ornament, after plaster casts of sculpture, and finally from life. Knowing the sculptor's later explorations of physical and emotional distress, we may find the evidence of his early attention to a fragment cast of Puget's agonized *Milo* (fig. 7.1) to be intriguing. Little in such copies (see also fig. 7.2) or in any of his other student exercises, however, foreshadows his power as an artist.

Rodin's training at the Petite Ecole allowed him to pass the drawing examinations for admission to the Ecole des Beaux-Arts, but on three attempts (1857–1859), he failed the sculptural tests (he later felt that his modeling had been too marked by an eighteenth-century character to suit the neoclassical tastes of the Ecole's examiners). This rejection from the standard route of advanced training set Rodin off on a long period of apprenticeship to restorers, jewelry-makers, and fabricators of ornamental sculpture—a period of hardship and near-anonymity that lasted until the salons of the later 1870s and the commissions of the early 1880s. During all this time, Rodin continued to work on his own, producing countless sculptural studies now lost and doubtless pursuing much of his private research through the cheaper and less restrictive practice of drawing. Here again, however, we find that the main piece of evidence seemingly attrib-

7.1 Study of a fragment cast of Puget's *Milo of Crotona*, c. 1857. Pencil. Musée Rodin, Paris (D2067). Cat. No. 225.

7.2 Study of the *Borghese Gladiator*, c. 1856. Pencil, pen and ink. Musée Rodin, Paris (D2028). Cat. no. 224.

7.3 The Mastbaum Sketchbook, n.d. Pencil, pen and ink, sepia wash. Private Collection. Cat. no. 227.

utable to the period, a sketchbook once owned by the artist's cousin (fig. 7.3), is frustratingly unrevealing. These sketches, from animals, from life, and from unidentified artistic sources, are all suave but impersonally bland, marked only intermittently by stylistic idiosyncracies. Absolutely consistent with certain veins of Second Empire taste, they have little if anything to do with the art Rodin would later produce.[2]

Must we then assume a near-total revolution in Rodin's artistic consciousness in the late 1870s and suppose that the fertility of his subsequent production had no tangible connection with twenty years of study and development? Specifically in regard to draftsmanship, are we to see the personal, expressive drawings associated with *The Gates of Hell* in the early 1880s (figs. 7.18–7.20, 7.23–7.35) as sudden, unprepared inventions? If we reexamine the evidence, we can discern an alternative explanation—one that involves redating large numbers of drawings and reconsidering the pattern of Rodin's development.

In part because of their specific themes and/or annotated titles, and also because of the general spiritual affinities between their black violence and the dark

emotional tenor of the *Gates*, Rodin's numerous gouache-and-ink drawings from imagination (figs. 7.20, 7.27–7.34) were long held to be attempts to visualize Dante's *Inferno* during the conception of the *Gates*. These imaginative drawings—some partially in pencil, others reworked in pen, others wholly covered with multiple washes—seemed to form a unified body of work, not only by their content but also by their consistent size and paper type. Closer investigation, however, indicates that these images were produced over a broad span of time. Many of them, far from being prompted by the *Gates* commission, seem to predate it by decades. Such a conclusion is based in part on the wide range of competence in the basic rendering of forms. In many of the drawings where original pencil work is visible (as in fig. 7.4) the fumbling, hesitant stroke and naive anatomical construction appear not those of a mature artist, but of a rank beginner. Such pencil compositions have also frequently been found not to be imaginative inventions, but paraphrases or copies of sculptures in the Musée du Louvre (compare fig. 7.4 with fig. 7.5).

The character of these drawings suggests the following

7.4 Study of an *Entombment* by Germain Pilon, c. 1855 (partially reworked at a later date). Pencil, pen and ink, ink wash. Musée Rodin, Paris (D2036). Cat. no. 226.

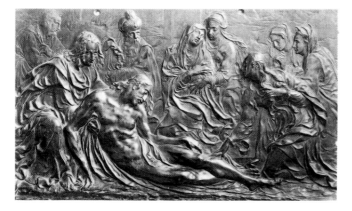

7.5 Germain Pilon. *Entombment*, c. 1580-1585. Bronze bas-relief. 19 x 32 in. Musée du Louvre, Paris.

7.6 Reworking of the *Borghese Gladiator* study. Musée Rodin, Paris (D5378).

history.[3] In Rodin's earliest years as an art student, contemporaneous with or prior to his Petite Ecole exercises, he began a separate, private investigation of figure composition. These personal notations were perfunctorily blunt and summary, and very likely done from memory (accounting for the discrepancies in a copy such as fig. 7.4). When we compare a careful schoolboy exercise (fig. 7.2) with another image of the same figure in this alternative mode (fig. 7.6), the difference in accuracy and finish is clear. Such private drawings are marked by more than simple inattention or clumsiness. Even in their raw beginnings they have a manner of their own that subsumes their diverse models within a distinctive vision, devoid of decoration and peopled with over-muscled, stiffly articulated schematic figures. Without Rodin's annotation to guide us, for example, we would be hard pressed to recognize Germain Pilon's fluidly graceful *Entombment* (fig. 7.5) as it was reconceived in this personal fashion, constricted and denuded (fig. 7.4).

7.7 *Three Nude Male Figures with a Tambourine*, c. 1882. Pencil and watercolor wash. 5 x 3¾ in. Philadelphia Museum of Art.

7.8 *Three Figures with a Book*, c. 1882. Verso of 7.7.

Whatever facility or stylistic self-awareness Rodin acquired in school and as an apprentice, and regardless of the other styles he practiced for other purposes, this genre of imaginative exercise pursued its own internal course of development over more than twenty years. The characteristic *écorché* (flayed) figural mode is essentially consistent between the awkward initial essays and the fluid confidence of later drawings such as figs. 7.24 and 7.25. In numerous instances, the images retained over decades are nearly the same (compare fig. 7.7 with its much earlier *verso*, fig. 7.8); often a continuous progression of the style is found in successive overlays on a single image.

Rodin carefully preserved scraps of these seemingly humble, halting notations from his student years and returned to the same sheets again and again over long periods of time. He repeatedly reworked particular figures, added others, and adjusted the images iconographically and stylistically to bring them into line with his current ideas. Thus, in fig. 7.4 for example, the more cursive ink lines and unifying washes of the figures on the right date from a period long after the original rendering of the scene. Often in such cases, all of the original pencil lines became buried under subsequent reworkings that wholly remade the image. A great many of the boldly washed ink-and-gouache images of post-1880 (such as figs. 7.32–7.40) are undoubtedly built in this fashion directly on Rodin's earliest drawings.

By juxtaposing pencil studies such as fig. 7.4 and fig. 7.24 to gouached images such as fig. 7.32 and fig. 7.34 in an interlocked chain of investigation that begins in the 1850s, we avoid the anomaly of a hypothetical explosion of talent in the late 1870s and stress the ways in which his mature work is built—often quite literally—upon years of patient and focused study. The other early evidences of commonplace competence and eclecticism also fade before the picture of a young Rodin, not precociously talented, but determined in his pursuit of a highly personal vision. He quickly found the masterpieces of the past that moved him—particularly scenes of grief and suffering—and made them a part of his consciousness by translating them into a private idiom. As he noted the compositions, he eliminated any stylistic grace or narrative smoothness in favor of a severe, shadowless delineation of forms, disjunctively and tensely articulated within radically compressed space. From the very beginning of his self-training, before he had the skill fully to define it, he thus aimed for an art of power more than subtlety, monumental seriousness before harmony, and willful expressive distortion over faithful

naturalism. More than on any lesson he was given or any skill he learned, Rodin persistently, patiently built on this initial personal impulse, returning to these crude drawings year after year, not merely to "correct" or "improve" them, but to amplify and channel the power he found in them.

The artist who came to such rapid maturity in the late 1870s and early 1880s was the product of this long private process of study and in very significant ways the direct descendant of the willful, struggling draftsman of the 1850s. Compositions such as fig. 7.3, reworked over more than twenty years, came to feed directly into Rodin's early projects for *The Gates of Hell* (see fig. 7.19); and the figure study they reflect informed his sculptural production even up into the 1890s.

NOTES

1. This period of Rodin's work is discussed in detail, and more examples illustrated, in my chronological essay in Elsen and Varnedoe, *The Drawings of Rodin*, 26–36.
2. For a fuller discussion of the sketchbook, see *The Drawings of Rodin*, 30–36; and Jacques de Caso, "Rodin's Mastbaum Album," in *Master Drawings* (Summer 1972): 155–161.
3. I first advanced the schema for redating Rodin's imaginative drawings in *The Drawings of Rodin*, 37–42, and developed these ideas more fully in "Early Drawings by Auguste Rodin," *Burlington Magazine* (April 1974): 197–202.

The Trip to Italy, 1875

Rodin's trip to Italy at the end of the winter of 1875 seems an extremely important, even decisive, moment in his life. When he left Brussels (where he had been working since 1871) he was an obscure thirty-five-year-old journeyman sculptor. When he returned, his career rapidly accelerated and his artistic personality began clearly to announce itself. By Rodin's own testimony, Michelangelo was a prime cause of this change. He told T.H. Bartlett that "in looking at the Medici tombs I was more profoundly impressed than with anything I have ever seen."[1] He later specified to the sculptor Bourdelle that "My liberation from academicism was via Michelangelo. . . . He is the bridge by which I passed from one circle to another. He is the powerful Geryon that carried me."[2]

Scholars' views of the Italian trip have traditionally centered on such recollections and on one letter Rodin wrote from Italy to his mistress Rose.[3] However, Rodin's later memories were highly selective, and the letter to Rose, written halfway through the trip, dwells only on the experience of Florence. Hence we have had a misleadingly narrow picture of an itinerary that went on to include Rome, Naples, Siena, Padua, and Venice. Fuller documentation of the journey can be found in the drawings Rodin preserved from it and personally assembled in montage sheets such as fig. 7.9 and fig. 7.10.

Among the drawings in these montages, the three images most readily identifiable are those of the monument that moved Rodin most deeply: the Medici tombs (MR 268, MR 269, and MR 270 on fig. 7.10). Rodin insisted in a contemporary letter and later recollections that his primary study of the tombs had been in the form of sketches done in his hotel room, not of the figures themselves, but of systems of "scaffoldings" that he invented in order to understand their composition.[4] Such testimony and the present lack of any such "scaffolding" drawings notwithstanding, the three preserved images were undoubtedly drawn on the spot, from the right side of the tomb of Lorenzo de' Medici, studying the compositional linkages between the seated *Lorenzo* and the figure of *Night* below. Two other figures by Michelangelo, the *David/Apollo* and the *Victory*, are the sources of MR 218 and MR 219 respectively, on fig. 7.9 (although these faint sketches seem to be from memory, and an imagined female figure has been added in each case). There are as well, on other montage sheets not exhibited here, studies from Michelangelo's *Moses* in Rome.[5]

7.10 *Montage Sheet of 10 Studies*, c. 1875-1878. Pencil, pen and ink. Musée Rodin, Paris (D264-273). Cat. no. 229.

7.9 *Montage Sheet of 17 Studies*, 1875-1878. Pencil, pen and ink. Musée Rodin, Paris (D205-221). Cat. no. 228.

7.11 *Montage Sheet of 6 Studies*, c. 1875-1878. Pencil, pen and ink. *Verso* of 7.10. Musée Rodin, Paris (D274-279).
Cat. no. 229.

However, many images we might expect to find are notably missing from the preserved drawings. There is no study after the Sistine Ceiling, for example, even though we know Rodin visited the Vatican; no image of either the Duomo *Pietà* or the *David*, which must have been central points of study in Florence; and no full drawing of either of the seated dukes from the Medici tombs, despite the *Lorenzo de' Medici*'s seemingly indispensable relation to Rodin's later *Thinker*. Since the evidence of the mount sheets suggests both a steady campaign of drawing and a scrupulous practice of conservation, these extensive omissions are hard to credit to simple loss. The lacunae, in combination with the numerous copies after other works that Rodin did preserve, suggest that the trip to Italy was not at all a single-minded pilgrimage to Michelangelo.

While in Italy, Rodin was attentive to great and minor works of various kinds. The most consistent record of these interests lies in thirty-eight pages and page fragments, now dispersed among several montages, from what was apparently a palm-sized bound sketchbook. Part of the book is now invisible, as Rodin, in selecting pages to mount, inevitably made any *verso* drawings inaccessible. The sketchbook seems to have first been used in Rome (the *Moses* was drawn in it, but not the Medici tombs) and to have continued in use through the last stop on Rodin's journey, Venice. The single most heavily documented work is Donatello's equestrian *Gattemelata* in Padua, which Rodin studied from numerous points of view (see MR 207 on fig. 7.9 and MR 271 on fig. 7.10). He also paid special attention to the Cesi tombs in Sta. Maria della Pace in Rome, sketching Vicenzo di Rossi's companion tomb figures of Angelo Cesi (MR 272 and MR 273 on fig. 7.10) and Cesi's mother in several full-length and detail drawings. Other copied motifs not exhibited here include Roman sarcophagi, antique erotica, and Verrocchio's *Colleone* equestrian in Venice.[6]

Further identifications of sources may eventually round out our inventory of Rodin's studies during this brief journey. Whatever specific information the montage sheets may give us, though, they are perhaps even more valuable general evidence of his drawing procedures. A small sketchbook page such as MR 217 (fig. 7.12), for

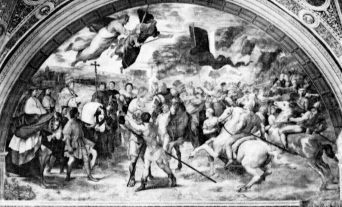

7.12 Sketchbook page. Musée Rodin, Paris (D217).

7.13 Roman Double Portrait Bust. Vatican, Rome.

7.14 Raphael. *The Repulse of Attila*, c. 1511. Stanza della Segnatura, Vatican, Rome.

example, presents a challenge not just to source recognition but to simple legibility. When we are finally able to identify the motifs—a double Roman portrait bust from the Vatican museum (fig. 7.13) for the inverted pencil sketch at lower right and Raphael's fresco of Atilla and Leo I (fig. 7.14) for the main pen sketch—we are left to ponder Rodin's interest in making and preserving such abstracted representations of these works. These radically summary notations remind us that for Rodin the process of drawing, whether from memory or from the original, was a way of testing his understanding of what he was seeing. He then required, not a faithful copy, but only a memory aid to key his recollection of the salient points he had found in the composition or gesture. A tiny sheet like this was saved to remind him of what he had learned from the experience, rather than

to re-present the works themselves. Even in the process of copying, he transformed what he saw; hence the change of Raphael's fresco to a rectangular format and the annotation "atilla bas relief de raphaelle [*sic*]," which annex it immediately to Rodin's sphere of interests.

Rodin's rapid, summary execution was then matched by paradoxically patient conservation and reconsideration. With the notations he brought back from Italy, even these schematic ones, Rodin built a collaged dossier for continued study. It is not just the drawings themselves, but this manner of preservation and subsequent elaboration, that is revealing. Rodin's construction of the montage sheets after his return from Italy was a significant process of self-examination and self-editing. Once the drawings were mounted, they were still not static, but always open to reworking by an overlaid or adjoining

7.15 *Life Studies of Michelangelo's Poses*, n.d. Pencil. Musée Rodin, Paris (D285-288). Cat. no. 230.

7.16 *Life Studies of Michelangelo's Poses*, n.d. Pencil. *Verso* of 7.15. Musée Rodin, Paris (D280-284). Cat. no. 230.

sketch, which might add an attribute, change the position of a limb, or suggest an adjunct figure that would affect the meaning of the original image. From the original drawings, Rodin also made tracings, in order to try multiple variants and hybrids of figures, in new orientations and combinations (see for example the multiple tracings of the same figure across the top of fig. 7.9). The particular practice of tracing (especially when used in connection with life drawings such as those in fig. 7.15) prefigures Rodin's later, watercolor manner of drawing; and the strategies of study first demonstrated on these montages—editing, multiplying, readapting and recombining figures—were later to become distinctive marks of his originality in much of his sculptural composition.

In regard to Rodin's experience of Michelangelo as well, it would seem that the period of reassessment following the trip was as crucial as any direct study in Italy. Rodin later described how, back in Brussels, he undertook a focused study of Michelangelo's poses, enacted by live models.[7] The results of such a session are shown in fig. 7.15. The semi-kneeling rotated pose studied in the lower left quadrant of the page is roughly that of the *Victory*, and the two reclining postures (upper center and lower left) derive from the recumbent figures of the Medici tombs.[8] It was this life study and reflection on Michelangelo rather than an immediate "conversion experience" or any direct copy drawings in Italy that gave rise to Rodin's few explicitly Michelangelesque works, such as the *Adam*.[9] Other sculptures often seen as influenced by Michelangelo, notably *The Age of Bronze* and *The Thinker*, have no forebears among the drawings associated with the Italian trip and are more tellingly considered as having originated under other influences. *The Thinker* descends from a long line of mourning figures that appear in Rodin's drawings from earlier years; and *The Age of Bronze*, more Donatello-like in modeling, can be understood as related to a broader wave of "Florentine" bronze figures in the salons of the 1860s and 1870s.

Rodin's eventual dissatisfaction with the results obtained in trying to copy Michelangelo's gestures pushed him—as did his subsequent dissatisfaction with the imaginative drawings as sources for *The Gates of Hell*—

toward an exploration of the unposed movements of his models.[10] He felt that by observing these unposed actions, he could find afresh the gestural principles Michelangelo's work embodied. After 1900, describing to Bourdelle the origins of his later manner of drawing simplified line studies of nude models in motion, Rodin explained:

Michelangelo gave me some invaluable perceptions, and I copied him in my spirit, in certain of my works, before understanding him. Once I understood, I saw that this movement existed in nature, and that I had only to avoid losing that in my models. . . . that this movement was something natural, not something I could impose artificially; from that point originated my drawings, which came a long time afterwards, however, and in which one will find Michelangelo again, in such a natural form that one will not suspect it.[11]

NOTES

1. See Albert Elsen, ed., *Auguste Rodin: Readings on His Life and Work* (Englewood Cliffs, N.J.: Prentice-Hall, 1965), 31. Rodin's reactions to Michelangelo were discussed in my chronological study in *The Drawings of Rodin*, 42–50.

2. See the discussion of Rodin's correspondence with Bourdelle in Elisabeth Chase Geissbuhler, *Rodin: Later Drawings* (Boston, 1963), 20.

3. This undated letter from Rodin to Rose Beuret is quoted at length in Judith Cladel, *Rodin, sa vie glorieuse, sa vie inconnue* (Paris, 1948), 111–112.

4. See the letter cited above, note 4; and Rodin's recollections conveyed to Bartlett, in Elsen, ed., *Auguste Rodin: Readings on His Life and Work*, 31.

5. See fig. 22, p. 46, in *The Drawings of Rodin*.

6. These additional sources were shown, and the sketchbook discussed in greater depth, in my talk, "Rodin's Italian Sketchbook," given at the meeting of the College Art Association of America, in Los Angeles, in 1976. This talk will be the basis of a future article.

7. Judith Cladel reported Rodin's discussion of these life studies in *Auguste Rodin pris sur la vie* (Paris, 1902), 76.

8. See also another sheet from the same period and practice, fig. 23, p. 47, in *The Drawings of Rodin*. In the context of that earlier discussion, p. 43, I considered the question, here left unaddressed, of the large chalk studies after Medici tomb figures (see figs. 19 and 20 in *The Drawings of Rodin*). Subsequent research more fully confirms that these drawings were not done in Italy (another image in exactly the same format and style is of a pseudo-Michelangelo *Cupid* in the Victoria and Albert Museum); and recent inspection of the drawings shows that disastrous restoration attempts, not the fault of the present more scrupulous administration of the Musée Rodin, have totally altered the look of the chalk drawings, to such a degree that all questions regarding their style must henceforth refer to older photographs.

9. An unpublished letter from Rodin (in Paris) to Rose (in Brussels) of 1877 includes a sketch of Rodin's maquette for the competition for a monument to Byron. This sketch makes clear that the original conception of the *Adam* (which has been known to have been preceded by a similar *Creation of Man*), must be dated back at least as far as the conception of the central figure of the *Byron* maquette, and thus to a period quite close to Rodin's return from Italy. (Musée Rodin archives.)

10. See Cladel, *Auguste Rodin pris sur la vie*, 76.

11. See Geissbuhler, *Rodin: Later Drawings*, 20.

Unrealized Projects of the Early Years

The Metropolitan Museum's *The Golden Age (L'Age d'Or)* (fig. 7.17) is one of the most beautiful of a series of chalk drawings that seem to have been imaginations of possible sculptural groups, conceived in a decorative, eighteenth-century revival taste.[1] These drawings were rendered in an uncharacteristically finished, elegant fashion, perhaps to be used as enticements for commissions. The subjects and styles of the proposed sculptures correspond closely to the aesthetic of Albert-Ernest Carrier-Belleuse, a popular and prolific sculptor for whom Rodin worked as an apprentice;[2] and to such early Rodin works as the *Young Mother and Child* of c.1865–1870 in the Musée Rodin.[3]

7.17 *The Golden Age (L'Age d'Or)* c. 1875-1880. Black chalk heightened with white. Metropolitan Museum of Art, New York. Cat. no. 231.

NOTES

1. For other examples of this work, see *The Drawings of Rodin*, 54–55.
2. For Carrier-Belleuse, see Peter Fusco and H.W. Janson, eds., *The Romantics to Rodin* (Los Angeles: Los Angeles County Museum of Art and New York: George Braziller, Inc., 1980), 160–172.
3. See Georges Grappe, *Catalogue du Musée Rodin* (Paris, 1931), no. 11 *bis*; see also nos. 22, 23, and 24 for other related examples.

The "Black" Drawings and The Gates of Hell

In drawings as in sculpture, Rodin was rarely an illustrator, in the sense of inventing compositions specifically to embody a given text. When called on to visualize a story—as he was in the 1880 commission for a bronze portal with scenes from Dante's *Inferno*—he characteristically returned to a collection of images already formed, to find those he thought appropriate and adaptable. We have already seen how years of drawing provided Rodin with just such a collection for exploitation in 1880. Sifting through drawings cut out and saved from earlier study sheets, he would select one such as fig. 7.18, note its fitness for use ("bas relief to execute" is inscribed on the mount) and at the same time use the remaining open paper to elaborate his current thinking regarding the overall scheme of the portal.

Drawings were especially important to Rodin in the first year of his work on the *Gates*; after that he depended on them less, if at all. In the beginning, as fig. 7.18 demonstrates, he alternated between a search for separate elements and a concern for defining the general plan. The initial architectural schemes (fig. 7.19) have often been identified with Ghiberti's Renaissance masterpiece, the *Gates of Paradise* on the Baptistery in Florence: rectangular bas-relief scenes evenly distributed on each door panel. The number of panels in Rodin's conception, however, do not correspond, and the individual compositions apparently envisioned are remote in character from Ghiberti's. The scene of Ugolino chewing on the head of the Pisan archbishop (witnessed by Dante and Vergil in the *Inferno*) in fig. 7.26 is typical of the early compositional thoughts. Evolved from entombment scenes such as fig. 7.4, it shows a constricted composition in a shallow relief space, packed with powerfully muscled figures—quite the opposite of Ghiberti's more graceful openness.[1]

Adjoining such narrative panels but in compositional disjunction from them, a series of large individual figures was also envisioned. Some appeared in the fashion of the sibyls and prophets on the Sistine Ceiling; but then an even larger and more separate figure (Eve?) was conceived for the center of the door, in the manner of a Christ or Virgin figure on the trumeau of a Gothic portal (see fig. 7.19). Finally, in sketches like that in fig. 7.18, two separate systems began to declare themselves: a recessive, increasingly overshadowed series of low-relief narrative scenes on the door panels; and a perimeter of monumental one- or two-figure groups, fully in the

7.18 *Reclining Figure with Child, with Architectural Study for The Gates of Hell*, c. 1880-1881. Pencil, pen and ink, ink wash. Musée Rodin, Paris (D1966). Cat. no. 234.

7.19 *Architectural Study for The Gates of Hell*, 1880. Pencil, pen and ink. Musée Rodin, Paris (D1963). Cat. no. 233.

round, in the jambs, in the tympanum, and eventually within the lower doors as well.

For these latter figures, Rodin turned to early imaginative drawings, isolating and reworking individual figures and pairs. On these as on the scenes corresponding to the narrative, he added thick washes of ink and gouache to assert a powerful drama of volume. In all likelihood, the ink reworking of such drawings had begun years before, as Rodin started to conceive a more assertive approach to modeling. The requirements of the *Gates* led him to an especially thorough reconsideration of his drawings, and the definitive form of the so-called "black" style of tenebrous wash treatment should be dated to the period 1880–1882.[2]

Although some of these "black" drawings can plausibly be connected to forms in the early sculptural studies for the *Gates*, very few can claim direct descendants in the final population of the portal. As Albert Elsen pointed out in the first scholarly discussion of the question, many of the "blacks" evoke effects that would have defied strict translation into sculpture.[3] Rodin once told an interviewer regarding the *Gates* that "at the end of a year, I saw that my drawings, if they rendered my vision of Dante, were not close enough to reality. And I started all over, after Nature, working with my models I had abandoned my drawings after Dante."[4] Nonetheless, the study represented by these imaginative drawings does still reverberate throughout the *Gates* as finally constituted. The impact is perhaps most evident in the two low-relief side

panels, but it is present in *The Thinker* as well, and in the gestural life—albeit studied in live models—of numerous smaller figures in the two central doors.[5]

Their eventual dissociation from Rodin's process of sculpting denied the imaginative drawings any final function as preparatory studies. Yet, as they were often initially based on sculptures, long reworked as hopeful projects for future modeling, and then pointedly taken up for potential realization in the early *Gates*, these drawings can hardly be seen as an activity separate from the mainstream of Rodin's art. They do not seem to have been conceived as practical previsualizations of stone or bronze, but rather (even when drawn from sculpted sources) as imaginations of superhuman living form disposed as sculpture. Their role in the development of Rodin's sense of gesture, composition, and the modeling of form by light should not be underestimated. Especially important in this regard is the intensely pictorial nature of the ultimate, gouache-and-ink realizations. In contradiction to his insistence on clear silhouette in the modeling of the 1877 *Age of Bronze*, these "black" images attest to the artist's early attraction to salient modeling highlighted amidst heavily obscuring shadow. The vision of these drawings might in this respect instructively be compared to the aesthetic Rodin approved much later in photographs of his work by Haweis and Coles and Steichen (see figs. 9.48–9.67).

7.22 *The Sculptor's Vision*. Location unknown.

left: 7.20 *Michelangelo Modeling the Slave*, c. 1882. Pen and ink, ink wash, gouache. Musée Rodin, Paris (D5618). Cat. no. 247.

The "black" drawings belong to the romantic tradition, not only in their themes of suffering and struggle, but also in the imagination of classical form isolated and spotlighted in deep, turbulent darkness. They are not, however, in the nineteenth-century visionary tradition of Blake, Goya, Victor Hugo, and Redon. If they occasionally refer to mythical creatures such as centaurs, they are still insistently concrete and earthbound in their visualization. Avoiding anything fantastic in figural scale and proportions, and rarely abandoning the laws of gravity, they are austere in their reduction to a limited, wholly unspecific space. The facture of the drawings is aggressively loose and their manner often violently expressive, but the ideal honored is that of a noble, deeply serious art in the grand tradition.

Of special interest in the group of "black" drawings here exhibited is the image of a sculptor, fig. 7.20, which was entitled "Michelangelo Modeling the Slave" when it was published in 1897.[6] Among Rodin's imaginative drawings there are a few that constitute, as this one does, symbolic self-portraiture (see also fig. 7.21). Rodin's attention to the image of the sculptor at work, here and in his sculpture (in *Pygmalion and Galatea* and *The Sculptor and His Muse*), signals not simple *amour-propre* but fascination with the creative act. (See Rosalyn Jamison, "Rodin's Humanization of the Muse," elsewhere in this catalogue.) Commensurate with the nine-

7.21 *The Sculptor.*

teenth-century archetype of the profession, Rodin represents the sculptor as part brute, part dreamer. In this fantasized image obviously inconsistent with Michelangelo's actual slaves (which are carved, and approximately life-size), the modeler is shown as a hulking physical force, far more imposing himself than the modest form he stoops intently to shape. This image bears connection to another, now lost (fig. 7.22), that was more specifically personal. In the latter, the muscular concentration of the sculptor is set against a shadowy host of figures, presumably creatures of his imagination. Rodin called this scene "The Sculptor's Vision." An interviewer reported that it "indicates Rodin's entire life, and illustrates his whole character," and that Rodin "proposes to execute this design for his own tomb."[7]

NOTES

1. I have argued elsewhere that both architectural plan and narrative-scene format may owe something to a door in the Salle des Caryatides in the Musée du Louvre (now stripped of its sculpture), which held reliefs by Andrea Riccio. See "Early Drawings by Auguste Rodin." (There I also demonstrate the ancestry of fig. 7.26 in a copy after an entombment relief in the Musée du Louvre.)

2. See the discussion of this issue in Elsen and Varnedoe, *The Drawings of Rodin*, 61–62.

3. See Albert Elsen, *Rodin's Gates of Hell* (Minneapolis: University of Minnesota Press, 1963).

4. Originally cited by Elsen in "Rodin's 'La Ronde'," *Burlington Magazine* (June 1965), from an interview published in *Le Matin*, 19 March 1900.

5. See the partial listing of connections between drawings and sculpture in my article, "Early Drawings by Auguste Rodin," note 19, p. 202.

6. It was one of the drawings reproduced in facsimile in the limited-edition *Les Dessins de Auguste Rodin*, produced by Maison Goupil.

7. See T. H. Bartlett in Elsen, ed., *Auguste Rodin: Readings on His Life and Work*, 86. The drawing was published in *L'Art*, 1883.

7.23 *Nude Male Figure*, c. 1881. Pencil, pen and ink, ink wash. Musée Rodin, Paris (D5584). Cat. no. 235.

7.24 *Two Nude Men Struggling*, c. 1882. Pencil, pen and ink. Musée Rodin, Paris (D1946). Cat. no. 236.

7.26 *Ugolino*, c. 1870-1880. Pencil, pen and ink. Philadelphia Museum of Art. Cat. no. 238.

left: 7.25 *Seated Figure with Child*, with added sketch of face, c. 1880. Ink and ink wash. Mrs. Katharine Graham. Cat. no. 237.

7.27 *Ugolino/Icarus*, c. 1880-1882. Pencil, pen and ink, ink wash. Musée Rodin, Paris (D1993). Cat. no. 239.

7.28 *Ugolino*, c. 1882. Pen and ink, ink wash, gouache. Musée Rodin, Paris (D5624). Cat. no. 240.

7.29 *Ugolino*, c. 1875-1882. Pencil, pen and ink, ink wash, gouache. Musée Rodin, Paris (D7208). Cat. no. 241.

7.31 *Seated Male Nude*, c. 1880-1882. Ink. Mrs. Katharine Graham. Cat. no. 243.

7.30 *Two Nude Male Figures Struggling*, c. 1882. Pen and ink, ink wash. Musée Rodin, Paris (D6895). Cat. no. 242.

7.32 *Le Sabbat*, c. 1882. Pen and ink, gouache. The Art Institute of Chicago, Gift of Rodert Allerton, 1923.

7.33 *Chevalier (Horseman)*, 1889. Pen and ink, gouache. The Art Institute of Chicago, The Alfred Stieglitz Collection 1949. Cat. no. 245.

7.36 *Seated, Twisting Male Figure*, c. 1878-1882. Ink, ink wash, and gouache over pencil. Mrs. Katharine Graham. Cat. no. 249.

7.35 *Two Male Figures as Architectural Caryatids*, c. 1885. Ink heightened with white gouache. Mrs. Katharine Graham. Cat. no. 248.

7.39 *Centaur and Woman (Centaur and Satyr)*, c. 1880. Ink, ink wash, and gouache over pencil. Mrs. Katharine Graham. Cat. no. 252.

7.37 *Mother and Child (Seated Figure with Child)*, c. 1880. Ink, ink wash, and gouache over pencil. Mrs. Katharine Graham. Cat. no. 250.

7.40 *La Ronde*, c. 1880. Private Collection, Paris. Cat. no. 253.

bottom: 7.38 *Reclining Couple (Reclining Figure Embracing a Child)*, c. 1880. Ink, ink wash, and gouache over pencil. Mrs. Katharine Graham. Cat. no. 251.

Transitional Drawings of the 1890s

The two most familiar modes of Rodin's draftsmanship—
his gouached imaginative drawings and his later pencil-
and-watercolor studies of nude models—are diametrically
opposed to each other in virtually all apparent respects.
Although it has its foundation in ideas Rodin began to
formulate in the late 1870s, the later mode does not
grow out of the earlier, but represents a radically new
departure in the later 1890s.

There are numerous small drawings of nudes, however,
that do seem to offer an intermediary step between the
imaginative and life drawings. An image such as fig.
7.41, for example, approaches the "black" style in its
vivid color, aggressive pen stroke, freely applied wash
background, and small format. Yet at the same time the
body type does not seem consistent with the earlier
drawings, and the pose seems taken from life study.
Within the number of such transitional drawings, prob-
ably from the years 1891–1896, we can find a range of
nuances running from this latter image, closer to the
"blacks," through the refined line and scant color of fig.
7.44 and fig. 7.45, to the more continuous, sculptural
contours and active pose of fig. 7.43, prefiguring the
full-blown later mode.

Seemingly the least complex or ambitious drawings
Rodin ever executed, these transitional works are also
(perhaps for that reason) among his lightest and most
charming. The fearful brooding melancholy of the earlier
drawings is replaced by postures of casual idleness,
toilette, and lively eroticism. Nudity is no longer heroic
or symbolic, but offered for pleasure as its own excuse.
Yet for all the seeming modesty of their aims, these small
drawings are highly significant as the initiators of Rodin's
innovative and influential later manner. The reduction
of figure drawing to such a simplicity of means was no
offhand gesture, but a bold one no doubt considered in
careful relation to such contemporary forces as renascent
Japanism and in relation to a revision of Rodin's sculptural
thinking as well.

top: 7.41 *Kneeling Female Nude*, c. 1890-1893. Pencil, pen and ink,
watercolor wash. Musée Rodin, Paris (D4312). Cat. no. 306.

bottom: 7.42 *Standing Female Nude*, c. 1894-1895. Pencil, water-
color wash. Musée Rodin, Paris (D4315). Cat. no. 307.

7.43 *Two Studies of Female Nude with One Leg Raised*, n.d. Pencil, watercolor wash.
Musée Rodin, Paris (D4271, 4272). Cat. no. 308.

7.45 *Seated Nude*, n.d. Pencil and watercolor.
Leon and Molly Lyon. Cat. no. 310.

7.44 *Two Nude Figures*, n.d. Pencil and watercolor. Leon and Molly Lyon. Cat. no. 309.

top left: 7.46 *Male Nude Foreshortened*, c. 1898. Pencil. Musée Rodin, Paris (D474). Cat. no. 311.

bottom left: 7.47 *Two Female Nudes Reclining*, c. 1898. Pencil. Musée Rodin, Paris (D891). Cat. no. 312.

7.48 *Female Nude Reclining*, c. 1898. Pencil. Musée Rodin, Paris (D736). Cat. no. 313.

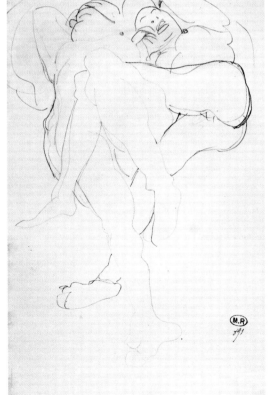

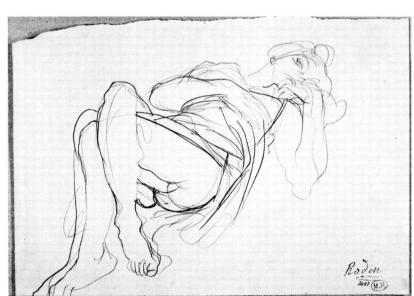

7.49 *Female Model Reclining, in Chemise*, c. 1898. Pencil. Musée Rodin, Paris (D2483). Cat. no. 314.

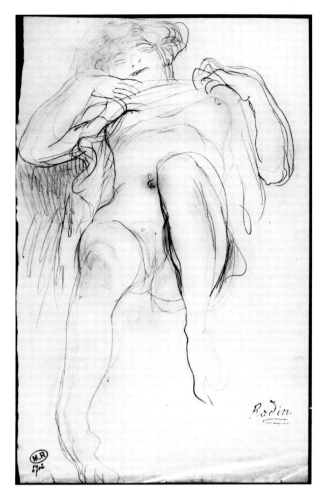 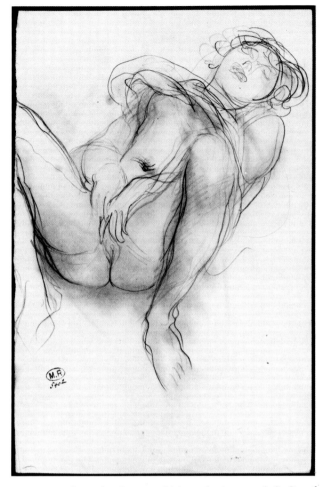

7.50 *Female Model Reclining, Lifting Chemise*, c. 1898. Pencil. Musée Rodin, Paris (D2702). Cat. no. 315.

7.51 *Female Nude, Gesture of Masturbation*, c. 1898. Pencil. Musée Rodin, Paris (D5402). Cat. no. 316.

Life Drawings and Watercolors

It is impossible to date with certainty the beginnings of Rodin's later mode of line drawings and watercolors of the nude model. The earliest reproduction of a work in this style dates from 1897. I have argued elsewhere that these drawings begin in their definitive form around 1895–1896 and that the style's conception is directly tied to Rodin's rethinking of sculptural principles in the context of his work on the *Balzac* (1892–1898).[1]

The late manner involved from the outset two separate but related procedures: pencil drawings from life and watercolors based on tracings. First Rodin drew from models, not posed but moving more or less spontaneously before him. As they gymnastically stretched, bent, danced, or reclined (see figs. 7.52–7.58) he drew constantly, rapidly moving from one sheet of paper to the next, without taking his eyes off the model to look at the drawings. By reflex, semi-automatically, he inscribed continuous contours that leaped, swelled, and twisted in simultaneous response to the play of muscle and bone he observed. He later explained his motivation in such unreflective, "eyes-off" renderings:

Don't you see that, for my work of modeling, I have not only to possess a complete *knowledge* of the human form, but also a deep *feeling* for every aspect of it? I have, as it were, to *incorporate* the lines of the human body, and they must become part of myself, deeply seated in my instincts. I must feel them at the end of my fingers. All this must flow naturally from my eye to my hand. Only then can I be certain that I understand. Now look! What is this drawing? Not once in describing the shape of that mass did I shift my eyes from the model. Why? Because I wanted to make sure that nothing evaded my grasp of it. Not a thought about the technical problem of representing it on paper could be allowed to arrest the flow of my feelings about it, from my eye to my hand. The moment I drop my eyes that flow stops.[2]

Rodin then gathered these rapid life studies together, and returned to them after the model's departure, or on a later day. Occasionally he reworked them directly, adjusting a line gone awry or restating a contour obscured by pentimenti. His main endeavor at this time was, however, to produce second-generation images that would clarify and refine selected figures from the life drawings. He did this primarily by tracing. Selecting a drawing such as fig. 7.60, he would, by tracing its main contours onto another sheet of paper, produce a version free from redundant lines and unwanted proportional distortions (fig. 7.61). Onto this new drawing he applied a sienna or terra-cotta watercolor wash, to unify the figure's overall form and to amplify its volumes (figs. 7.59, 7.63, 7.69). From a score of life studies such as figs. 7.52–7.58, he would distill a few such watercolors (fig. 7.59) that synthesized the beauty of the movement.

The appearance of the watercolors—a fine, wiry contour and a single tone of wash—was an expression of Rodin's most advanced thinking about sculpture. It corresponded to his attempt to achieve what he described to Camille Mauclair in 1898 as "a drawing of movement in the air." This kind of sculpture

was to obey the natural principles of sculpture made to be seen in the open air, that is, the search for contour and for what the painters call *value*. In order to understand this notion exactly, one should think about what one sees of a person stood up against the light of the twilight sky: a very precise silhouette, filled by a dark coloration, with indistinct details. The rapport between this dark coloration and the tone of the sky is the value, that is to say, that which gives the notion of material substance to the body. . . . All we see essentially of a statue standing high in place, and all that carries, is its movement, its contour, and its value.

Furthermore, the two-step process of wholly absorbed drawings from life leading to condensed, simplified second-generation figures is one that reflects the bipartite strategy of creation Rodin explained in the same interview:

In sacrificing everything to the *drawing of movement*, Rodin held to a preoccupation with pure realism, for he first studied the instinctive thrust of the personage, without thinking in advance of stylizing it.

This double tendency, synthesization of the figure in reducing it to its silhouette and to its value, with a rapid and simultaneous study of movement in all its aspects, Rodin has felt growing in him over the years. . . .

The artist, in order to stress what he had said, showed me [along with several sculptures] some drawings with a single line, washed with a light watercolor, and synthesizing rapid movements.[3]

The process of Rodin's later drawings as outlined thus far constitutes a model that may have varied considerably in particular applications. Many of his life studies were obviously drawn with at least some visual verification of the work in process, and many of the multiple duplicate watercolors of a given figure may have been reproduced without direct tracing. Nonetheless, the *ideal* of the two-step methodology—intense concentration on dynamic life leading to simplified synthesis—is a significant one, not only in relation to Rodin's own sculpture, but in connection with broader trends in later nineteenth-century art. Parallels might be examined for example in the work of Rodin's contemporary Claude Monet. The latter's series paintings, involving initial moves from canvas to canvas in pursuit of changing light effects on a motif (and then subsequent reworking in the studio), progress through an obsessive concern with naturalist transcription toward a high degree of synthetic, self-evident decorative artifice in color and design. A major difference is that in Rodin's case contingent conditions such as light are

seen as stable, and ignored, while the motif itself is in constant change.

The conception of the modern nude found in these later drawings is also very much of its time and might usefully be compared to that of Edgar Degas's pastels and drawings of the 1880s and 1890s. In both cases the nude figure was de-idealized, removed from academic conventions of beauty and decorum in order to be a vehicle for the study of more natural, truthful movement. For Degas, though, this new truth was revealed in the ritualized, habitual gestures of the *toilette*, whereas Rodin's goal was precisely non-habitual, eccentric movement, extracted from the free-wheeling gymnastics he encouraged his models to perform. Degas's nude bathers are furthermore totally self-absorbed; the artist's presence is implied by close-in framing and unusual viewpoints, but ignored by the model. In Rodin's images, the element of performance is often unmistakable, and the psychological interaction between artist and model is frequently explicit in a gaze. Nowhere is this more an issue than in the erotic postures that constitute a leitmotif of the later drawings (figs. 7.49–7.51).

In these erotic poses we are not dealing with simple examinations of anatomy (though in this regard they are often extremely precise) but with records of the artist's emotional experience. However economical the means of these drawings, the facial expressions of the models are usually faithfully indicated: equal tokens, with the self-manipulations Rodin doubtless encouraged (or that models came to offer "spontaneously" to please him), of the mimed fantasies of sexual dominance he hired by the hour. Degas shows the modern nude disabused of conventions of sexual titillation; even (or especially) in the purportedly erotic context of the bordello, his depictions tend in the direction of the domestic, the clinically banal, or the grotesque. Rodin's figures break convention in the opposite sense, self-consciously playing with devices of concealment and display, and tending toward heated pornography. Although there are no known instances of heterosexual activity in these works, lesbian play of varying degrees of intensity (fig. 7.47) is common, and the overtones of acknowledged voyeurism are pervasive.

No doubt their erotic electricity helped make these drawings so widely influential in the pre-World War I period. Rodin has rarely been sufficiently credited for the impact he made, via the combination of purified line and frank sexuality in his watercolors, on the nudes of artists such as Klimt, Schiele, and Matisse.[4] In general, inadequate knowledge of the quantities of drawings in the Musée Rodin reserves, and the corruption of public judgment by an epidemic number of forgeries, have hampered recognition of his seminal position in modern draftsmanship. Rapid contour drawing without looking away from the model has, for example, become a standard part of modern artistic pedagogy, while its roots in Rodin's practice are virtually forgotten.

Innovative in their original conception, the later drawings are equally noteworthy—and modern—in the way Rodin subsequently acted on them. Returning to fig. 7.60, the artist immediately felt it offered new possibilities seen upside down and noted "bas" ("low," or in this context, "this end down") on the original upper edge. When he reworked the figure as a watercolor (fig. 7.61) he retained the inversion (as witnessed by the placement of his signature). The figure standing on one leg and both hands in fig. 7.65 was likewise inverted (fig. 7.66); then reconceived horizontally (fig. 7.67); and eventually liberated from any reference to the rectangle of the page by being cut out (fig. 7.68). In the whole process of reorientation, but especially in the free-floating cut-out forms (see also fig. 7.64), these drawings relate to sculptures (such as *Iris, Messenger of the Gods*) that have no fixed relation to a base; and especially to the small late *Dancers*, which seem conceived for the hand and offer an infinity of possible orientations.

Though originally drawn from randomly generated gestures outside traditional codes of symbolic meaning, these figures were frequently titled and/or reformulated by Rodin—sometimes via massive pencil reworkings in which the original watercolor is largely buried—as mythical figures or forms of nature. Each new repetition of the drawing and each new orientation might suggest a different meaning. He designated the original position of fig. 7.65 a tripod, the inverted form a tree, and the horizontal version a rainbow. As Rodin detached the figure from its original life referent and pushed it toward abstraction by simplifying its form and subverting its orientation, he also liberated an expanded field of possible new meanings. The spirit of his formal experiment is inseparable from this continual attentiveness to suggested meaning; and the juncture of the two locates Rodin's complex position simultaneously within modernism and traditional associative patterns of symbolism.[5]

Even in the semi-automatic, wholly absorbed pencil studies from life, Rodin's belief in the larger meaning of the human form, its viability as the touchstone not just of symbolic expression but of all human creation, was never very distant. In a remarkable demonstration of his ideas of intimate interrelation between the body and even the most abstract cultural forms, he generated the design of architectural moldings from the volumes and rhythms

of the female silhouette (fig. 7.78; compare this to one of his numerous exacting studies of the profiles and light patterns of actual moldings, fig. 7.79). Such faith in the ubiquity of meaning and beauty in the language of the body—rather than mere disregard for these qualities—fueled the liberties Rodin took in exploring the larger possibilities of uninhibited movement and unexpected recombinations of figures, in drawings as in sculpture. In traced assemblages (fig. 7.71) and collages (figs 7.70, 7.72) he evinced a proto-surrealist keenness to the revelatory potentials of unexpected encounters.

Until a detailed inventory and dating of all Rodin's early sculpture is made, we can only speculate whether such procedures in drawing (which can be dated back to the practices of montage sheets c. 1877—see figs. 7.9, 7.10) derive from or prefigure similar practices in sculpture. Rodin told Bourdelle after 1900 that "My drawings are the result of my sculpture"—the succinct exposition of the principles on which his life's work had been based.[6] In practice as well as in this conceptual sense, the later drawings were certainly not conceived as direct preparatory studies for sculpture. Drawing in Rodin's later years was both recreation and discipline, a means of constant investigation and testing, providing important but nonspecific preparation for his work of modeling. As a part of his general desire to make the full workings of his artistry evident, he thought it important that such drawings be exhibited and understood. "As my drawings are more free," he explained to Bourdelle, "they will give more liberty to artists who study them, not in telling them to do likewise, but in showing them their own genius and giving wings to their own impulse, in showing them the enormous space in which they can develop."[7]

Rodin continued to draw abundantly well into his final years, and there is no evidence that his hand weakened. The essential innovative power of the later mode of drawing seems to have been wholly realized by 1900 (the development of the cut-outs may have come slightly later). After 1906, Rodin apparently ceased to use watercolor and began to practice a softer, more atmospheric pencil style, dependent on extensive smudging of the contours.[8] Two of his rare dated drawings, from 1908 (figs. 7.73, 7.74), show him still vigorous and rapid in the delineation of the figure, but more concerned than before with the pictorial modeling of internal forms. This taste, particularly in ethereal, silvery images such as figs. 7.76 and 7.77, is consistent with the aging artist's interests in muted effects of light and in the reintegration of sculpture with atmopshere—interests we see expressed in his later marble sculpture and reflected in the photographs he had taken of his work by Haweis and Coles and Steichen (figs. 9.48–9.67).

NOTES

1. Elsen and Varnedoe, *The Drawings of Rodin*, 69–87.
2. Anthony Ludovici, *Personal Reminiscences of Auguste Rodin* (Philadelphia, 1926), 138–139.
3. Camille Mauclair, "L'Art de M. Auguste Rodin," *Revue des revues* (15 June 1898): 597–599, 607.
4. Elsen considers these connections in his introduction to *The Drawings of Rodin* and in his *The Sculpture of Henri Matisse* (New York: Abrams, 1972), 93. See also Elsen's "Drawing and the True Rodin," *Artforum* (February 1972):64–69.
5. See Victoria Thorson, "Symbolism and Conservatism in Rodin's Late Drawings," in Elsen and Varnedoe, *The Drawings of Rodin*, 121–139.
6. Cited in Geissbuhler, *Rodin: Later Drawings*, 2. Charles Quentin, in the *Art Journal* (July 1898):194, reported that Rodin considered these late drawings "the synthesis of his life's work, the outcome of all his labor and knowledge."
7. Cited in Geissbuhler, *Rodin: Later Drawings*, 20.
8. See the discussion of this late pencil manner in Elsen and Varnedoe, *The Drawings of Rodin*, 92–93. Although the occasion does not permit a full discussion, I should note here that I partially erred in the three-part classification of Rodin's later drawings that I outlined in this latter section of *The Drawings of Rodin*. There are "Type III" pencil drawings, but no "Type III" watercolors, and the two-step watercolor mode of Types I and II should be seen as something separate from Type III altogether. The *Seated Nude*, fig. 81 of that book, that was advanced as a "Type III" watercolor, is in fact a forgery. In my opinion it is a forgery executed by Odilon Roche, and this in turn points out that the section of *The Drawings of Rodin* devoted to analysis of forgeries must be revised in relation to the putative "pseudo-Roche" (182–184). Research in the archives of the Institut Neerlandais in Paris makes it clear that the Roche collector's mark reproduced as no. 2007e in the *Supplément* (1956) to Frits Lugt's invaluable *Marques des Collections des Dessins et des Estampes* is a faulty approximation of Roche's real mark. His real *cachet* is in fact the one I attacked as a forgery (fig. 148 of *The Drawings of Rodin*), and the forger connected with the drawings bearing this mark is in my opinion Roche himself. This revision will however have to await full elaboration in future writings.

left: 7.52 *Female Nude Dancing*, c. 1900. Pencil. Musée Rodin, Paris (D518). Cat. no. 341.

right: 7.53 *Female Nude Dancing*, c. 1900. Pencil. Musée Rodin, Paris (D1014). Cat. no. 342.

left: 7.54 *Female Nude Dancing*, c. 1900. Pencil. Musée Rodin, Paris (D2362). Cat. no. 343.

right: 7.55 *Female Nude Dancing*, c. 1900. Pencil. Musée Rodin, Paris (D2943). Cat. no. 344.

left: 7.56 *Female Nude Dancing*, c. 1900. Pencil. Musée Rodin, Paris (D5612). Cat. no. 345.

right: 7.57 *Female Nude Dancing*, c. 1900. Pencil. Musée Rodin, Paris (D2391). Cat. no. 346.

left: 7.58 *Female Nude Dancing*, c. 1900. Pencil. Musée Rodin, Paris (D2951). Cat. no. 347.

right: 7.59 *Nude with Draperies*, c. 1900-1902. Pencil, watercolor wash. The Art Institute of Chicago, The Alfred Stieglitz Collection. Cat. no. 348.

7.62 *Female Nude Kneeling*, c. 1900. Pencil. Musée Rodin, Paris (D2349). Cat. no. 319.

7.63 *Female Nude Kneeling*, c. 1900. Pencil, water-color wash. Musée Rodin, Paris (D4248). Cat. no. 320.

left: 7.60 *Male Nude in Bridge Position*, c. 1898. Pencil. Musée Rodin, Paris (D478). Cat. no. 317.

right: 7.61 *Male Nude in Bridge Position*, inverted, n.d. Pencil, watercolor wash. Musée Rodin, Paris (D5124). Cat. no. 318.

7.67 *Female Nude, Hands on Floor, Left Leg Raised*, reoriented horizontally, c. 1900. Pencil, watercolor wash. Musée Rodin, Paris (D4403). Cat. no. 324.

bottom left: 7.65 *Female Nude, Hands on Floor, Left Leg Raised*, c. 1900. Pencil, watercolor wash. Musée Rodin, Paris (D4404). Cat. no. 322.

7.64 *Female Nude Kneeling*, c. 1900. Pencil, watercolor wash, cut-out. Musée Rodin, Paris (D5212). Cat. no. 321.

bottom right: 7.66 *Female Nude, Hands on Floor, Left Leg Raised*, inverted, c. 1900. Pencil, watercolor wash. Musée Rodin, Paris (D4419). Cat. no. 323.

7.68 *Female Nude, Hands on Floor, Left Leg Raised,* c. 1900. Pencil, watercolor wash, cut-out. Musée Rodin, Paris (D5202). Cat. no. 325.

right: 7.71 *Two Female Nude Figures,* c. 1900-1905. Pencil and water-color wash. Musée Rodin, Paris (D4692). Cat. no. 326.

7.69 *Dancing Figure,* c. 1900-1905. Pencil, watercolor wash. National Gallery of Art, Gift of Mrs. John W. Simpson, 1942. Cat. no. 349.

7.70 *Assemblage of Two Female Nude Figures,* c. 1900-1905. Pencil and watercolor wash with collage. Musée Rodin, Paris (D5188). Cat. no. 350.

7.72 *Montage Sheet with 3 Cut-Out Figures*, c. 1900-1905. Cut-outs in pencil and watercolor wash glued down. Princeton University. Cat. no. 351.

left: 7.73 *Seated Nude*, 1908. Pencil. National Gallery of Art, Gift of Mrs. John W. Simpson, 1942. Cat. no. 327.

right: 7.74 *Seated Nude*, 1908. Pencil. National Gallery of Art, Gift of Mrs. John W. Simpson, 1942. Cat. no. 328.

7.75 *Female Nude with Legs Behind Head*, c. 1905. Pencil. Musée Rodin, Paris (D2824). Cat. no. 329.

7.76 *Reclining Female Nude*, c. 1906-1910. Pencil. Musée Rodin, Paris (D2774). Cat. no. 330.

left: 7.77 *Female Model Opening Robe*, c. 1908. Pencil. Musée Rodin, Paris (D2963). Cat. no. 331.

right: 7.78 *Female Model's Silhouette Transformed into Architectural Molding/Cornice*, c. 1900-1910. Pencil. Musée Rodin, Paris (D3482). Cat. no. 332.

bottom: 7.79 *Architectural Sketch*. From *Sketches and Notes, The Cathedrals of France*. Philadelphia Museum of Art.

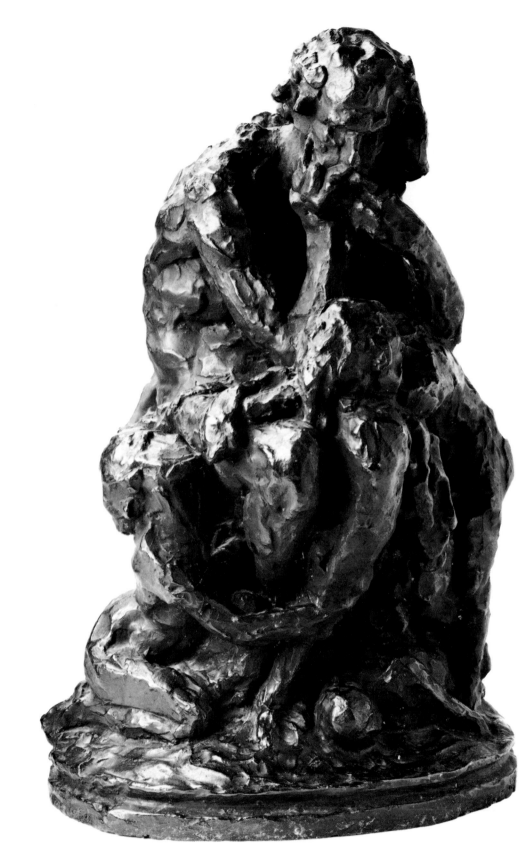

8.1 Jean-Baptiste Carpeaux. *Ugolin*. Bronze.

8. Rodin's Drawings of Ugolino

Claudie Judrin

Ugolino della Gherardesca, count of Donoratico, lived in the thirteenth century. The Italian cities of that time were divided into two factions, the Ghibellines, who supported the Germano-Roman emperor, and the Guelphs, who backed the pope and the independence of the papal state. Although Ugolino was from a family of Ghibelline partisans, he joined the Guelphs when circumstances favored them. Because of this, he was imprisoned and later sent into exile. He must have managed to erase his disfavor rather quickly, however, for by the time of the Genoan War, he was named admiral of the Pisan fleet. He held few scruples about criticizing the Ghibellines, who supported the Archbishop of Pisa, Ruggiero deglí Ubaldini. Hence, when he unthinkingly reconciled himself with the Ghibellines, the Archbishop of Pisa had him accused of treason. Again, Ugolino was imprisoned, along with his sons, Gaddo and Uguiccione, and his two granddaughters, Brigata and Anselmuccio. The keys to their cell were thrown into the Arno River, and they were left to die of starvation in February 1289, in a tower not far from Pisa—which came to be called the "Tower of Hunger." Ironically, one of Dante's friends and comrades in arms, Nino, was a grandson of Ugolino.

The immediate precursor of Rodin's Ugolino was that of Carpeaux, which went on exhibition at the Ecole des Beaux-Arts in 1862. The theme of a father seated with his children in an attitude intended to show pain had already been treated by the painter Fortuné Dufau in the Salon of 1800. The *Ugolin* of Carpeaux is more defined, more gripping, and more contemporary than this predecessor. A preliminary drawing by Carpeaux, conceived in low-relief, showed Ugolino crawling among his dead children (Paris, Musée du Louvre, Cabinet des dessins). Had Rodin, who later chose to illustrate the same passage from Dante's *Inferno*, any knowledge of this previous work? It would be interesting to find out, for Rodin included what Carpeaux omitted. Carpeaux also did a rough outline in terra cotta which represents Ugolino devouring the skull of the Archbishop Ruggiero (Paris, Musée du Louvre). In the end, Carpeaux chose the following episode:

I gnawed at both my hands for misery;
 And they, who thought it was for hunger plain
 And simple, rose at once and said to me:
"O Father, it will give us much less pain
 If thou wilt feed on us. . . ." [33, 58–62][1]

Among these three possibilities, Rodin opted for the most moving, beastly, and modern—the one which captured both his imagination and the spirit of the nineteenth century. Nevertheless, it is generally agreed that Carpeaux, and through him Michelangelo, was the true model for Rodin, who possessed a preliminary bronze model of Carpeaux's *Ugolin*—an indication of the admiration which Rodin held for the artist (fig. 8.1). This draft of the *Ugolin de la Villa Medici* had been uncovered in Rome by a friend of Achille Segard, journalist and critic, who offered it to Rodin on 5 November 1910 in exchange for a bust of Alphonse Legros. In July 1912, Rodin also acquired an album of fifteen sketches by Carpeaux, a purchase from a Mr. Lapayre. Only twenty years after Carpeaux, Rodin, with no less daring, took up the same theme to make of it something new.

Now why do we attach so much importance to the theme of Ugolino in the drawings of Rodin? Although comparing sculpture to drawings is often fruitless, when it comes to Rodin, the juxtaposition can be revealing. The Musée Rodin in Paris possesses six of the seven drawings published within the artist's lifetime under the title *Ugolin* as part of an album devoted to the graphic works for *The Gates of Hell*. Consulting them is thus an easy matter. Ugolino's name occurs frequently in titles of Rodin's drawings inspired by Dante. Here, we will deal with only those which Rodin titled himself; too often since his death others have assigned incorrect titles to drawings, assuming mistakenly that the inspiration for a sculpture and a drawing which it resembles was the same.

It is often difficult to know which canto of the *Inferno* relates to which drawing, but here again, comments by Rodin himself give us reason to say that few cantos fascinated him or were as extensively illustrated by him as that about the death of Ugolino, canto 33.

Rodin regarded Dante not only as a poet, but also as a visionary and sculptor in that he described his characters' attitudes and gestures. Rodin's own powerful imagination enabled him to enter into the soul of Dante without any difficulty. Though ostensibly deriving his inspiration from Dante, however, Rodin often followed his own bent, inventing images rather than adhering strictly to nature. In fact he later confessed to having strayed so far from reality in his drawings that he felt compelled to return to working from models. In any event, his depiction of themes from Dante's *Inferno*, whose first translation into French (the same version known to Rodin) appeared in Rivarol's work, *Belle Infidèle* in 1785, is one of a perfect association between writer and illustrator.

Led by Rodin's imagination, the spectator follows step by step through the text of Rivarol. Albert Elsen, who reports about T. H. Bartlett's visit to the sculptor in 1887, states that this volume never left Rodin's pocket.[2] Even though his sculpture only translates two scenes, the death of Gaddo and Ugolino about to devour his sons, one might say that the drawings are literally married to the drama—pausing before each new event and giving several interpretations of the same episode. Rodin read the *Inferno* with pencil in hand, even jotting notes in the margins. In 1900, the artist declared to Serge Basset how he felt he had spent an entire year with Dante—living only from him and with him and drawing the circles of his hell.[3] His way of taking notes on his reading led Octave Mirbeau[4] and later Georges Grappe[5] to say that Rodin did not draw these sketches for the general public. The fact is that the artist agreed to have published in *L'Art* in 1883 several sketches intended for the monumental gateway to the Musée des Arts Décoratifs and for the Sèvres Porcelain Factory and to have three others, dedicated to the painter Alfred Roll, put on exhibition at the Cercle des Arts Libéraux in February and March of the same year. One of them, entitled *St. Francis*, is beyond doubt related to the Count Guido in canto 27, verse 112, of the *Inferno*. Another drawing, representing a profile of St. John the Baptist, was used to illustrate the catalogue for the Salon of 1880.

There is difficulty in dating the drawings for the *Gates*. The conservator of the Ny Carlsberg Sculpture Museum in Copenhagen, Haavard Rostrup, thinks, as does Grappe, that a number of these works were executed between 1860 and 1875.[6] It would even seem, according to Judith Cladel, that Rodin discovered Dante while in the Petite Ecole.[7] Writing in 1899, Léon Maillard tells how upon Rodin's return from Italy Dante became one of his bedside books.[8] The influence of Carpeaux's *Ugolin*, starting with its presentation in 1862, has already been mentioned. One is more inclined, however, to place Rodin's Ugolino drawings somewhere between 1875 and 1880, when, after his trip to Italy, he worked in the Sèvres Porcelain Factory and made a preliminary Ugolino, sculpted in 1876 but later destroyed. It might also be argued that Rodin took these works up again a few years later. This would have been consistent with his way of working, which was to make multiple uses of the same sculpture. One work often gave birth to others. What may seem to our eyes a completed work, to Rodin was merely one state. The Ugolino drawings are telling evidence of this. In a list of titles, quite accurate for the period, ten out of the forty-one drawings have reference to Ugolino. The list is a sort of receipt for the works entrusted to Léon Maillard as of 1895 for the publication of his study of the sculptor, which did not appear until 1899. Several are not included in the Floury edition; many others are poorly identified. The variety of the titles related to Ugolino is surprising. The grouping together of all or part of the many Ugolinos—about thirty drawings in all found in the course of examining the documentation, publications, and museum originals—composes a kind of drama in four acts, which unfolds in the span of one week and hence obeys the classical rules of theater concerning unity of time and place. Each day refers to one act, and each event to one scene.

PROLOGUE
The Feast of Ugolino

As the drama opens, Dante relates his encounter with Count Ugolino, whereupon the reader is immediately thrown into the grips of horror.

I saw two frozen together in one hole
 So that the one head capped the other head;
And as starved men tear bread, this tore the poll
 Of the one beneath, chewing with ravenous jaw,
 Where brain meets marrow, just beneath the skull. [32, 125–129]

The two unhappy souls are Ugolino and the Archbishop Ruggiero. Ugolino has been condemned never to appease his hunger for vengeance but to devour his executioner. The poet begins canto 33:

Lifting his mouth up from the horrid feast,
 The sinner wiped it on the hair that grew
 Atop the head whose rear he had laid waste. . . . [33, 1–3]

8.3 Drawing D1916. Musée Rodin, Paris.

8.4 Drawing D6895. *Two Nude Male Figures Struggling*, c. 1882. Pen and ink, ink wash. Musée Rodin, Paris. Cat. no. 242.

8.2 Drawing D3755. Musée Rodin, Paris.

right:

8.6 *Ugolino*, c. 1870-1880. Pencil, pen and ink. Philadelphia Museum of Art. Cat. no. 238.

8.5 Drawing D5589. Musée Rodin, Paris.

Drawing D3755 (fig. 8.2) carries a legend, handwritten by Rodin, which reads, "Ugolin dévorant qui interrompt son cruel repas" ("Ravenous Ugolino interrupts his cruel feast"). His attitude is that of a man who has brought down his opponent. The line of the mouth stands out, for Rodin wants to remain true to the intention of Dante, who begins the canto with the word *bocca* ("mouth") in order to increase the horror and emphasize the fact that Ugolino is nothing but a mouth. Splashes of ink wash obscure the profile of Ugolino and pen strokes accentuate the musculature of the adversaries. Drawing D1916 (fig. 8.3) represents the same scene but in a side view; emphasis is more heavily placed on the hand-to-hand struggle than on the character of Ugolino himself. The entire drawing is drowned in cascades of ink and gouache, which hide in places the inscription: "Ugolin faisant son cruel repas l'interrompt pour répondre à Dante et du sang que nous perdons croît et se fortifie" ("In the midst of his cruel dinner Ugolino pauses to answer Dante, and from the blood that we lose he grows and is strengthened"). Drawing D6895 (fig. 8.4) stresses the contrast between light and shadow which plunges the spectator into the darkness. Drawing D5589 (fig. 8.5), executed in graphite, shows Ugolino triumphant yet unquiet. Rodin chose it to illustrate the program for a five-act play by François de Curel, *Le repas de lion*, which played at the Théâtre Antoine for the second evening of *avant garde* on 26 November 1897. A completely different inspiration gave rise to the drawing from the Philadelphia Museum of Art (fig. 8.6) which Rodin annotated not only as "Ugolin," but also as "Guidon," "Victor Hugo,"

"Dante and Vergil." Conceived in low-relief, like an entombment, the play unfolds before the shadows and in front of Dante and Vergil. References to the Count Guido da Montefeltro, whose adventures are related in canto 27 of the *Inferno*, and to Victor Hugo, whose tomb Rodin was designing, come as no surprise. This is again along the line of the artist's way of doing things. The same drawing gives rise to several themes in his imagination. This design with its multiple personages seems to have been planned for the panels of *The Gates of Hell* in the manner of Pisano or Ghiberti. Sketches of the overall layout of the portal, found in the Musée Rodin collection, confirm this supposition.

FIRST DAY
ACT I, SCENE 1

From among the drawings included on Léon Maillard's list, the following titles hold our attention: (twice) "Ugolino listening to the bolting of the door"; (twice) "the feast of Ugolino"; (twice) "Ugolino standing"; and (once) "Ugolino the first day"; (once) "Ugolino the fourth day"; (once) "Ugolino." These titles are confirmation of a literal illustration. Were it not for page thirty-one in Maillard's book, where the drawing is annotated "Ugolino the first day," (fig. 8.7) identification of this scene would be risky indeed. There is nothing tragic about the attitude yet—we see a father surrounded by his children. The artist has purposely depicted this serene configuration. It is important to bear in mind that during this period, Rodin did numerous "motherhoods" whose characters' genders are often ill-defined. With the exception of the final drawing, which is related to the sculpture, Rodin usually has two out of the four children pictured at a time, as if a sheet of paper would not serve to group together five actors without loss of focus.

Ugolino tells Dante how, after a sad dream wherein he sees his enemies as wild dogs, he hears his children cry out in their sleep for bread.

By now they'd waked; the hour at which our mess
 Was daily brought drew near; ill dreams had stirred
 Our hearts and filled us with unquietness. [33,43–45]

This said, he holds his children fast to him, covering their eyes, as in number 52 of the Goupil album, entitled "Ugolino in his prison" (fig. 8.8). This peculiar drawing was cut out by the artist in a way reminiscent of a tree and its boughs. Likewise Rodin added on the backing the name *chêne* ("oak"). Drawing D1964 (fig. 8.9) shows three nude women, originally in a drypoint of the *Ames du Purgatoire*, which adorned the frontispiece of *La Vie*

Artistique by Gustave Geffroy in 1893. Rodin christened these entwined silhouettes with various names: "drapeau," "limbes," "liberté," "égalité," "fraternité," "trois grâces," "la guerre," and finally "Ugolin." Drawing D6899 (fig. 8.10), which he dedicated to his friend, the master mariner Bigand-Kaire, is of a similar inspiration. Time and again, Rodin restricted the episode to two characters, a father seated with his son by his side. Had Rodin not written *Ugolin* on drawing D3777 (fig. 8.11), it would have been impossible to assert that it is indeed an Ugolino. The characters here are seen in profile, as opposed to drawing 112 in the Goupil album (fig. 8.12). The color is dark, done with a brush, heavy with ink wash and gouache, on paper, which is pasted and counter-pasted, showing Rodin's diverse alterations and concern for relief. We see a father whose eyes are turned away from his son to avoid reading in them his own distress. The very impotence of Ugolino is a source of despair. Entitled *Homme et enfant* ("Man and child"), it was given the name "Etude pour l'Ugolin" in an article by Francis de Miomandre, published in 1914 in *L'Art et les Artistes*.[9] A drawing in the collection of Madame Léonce Bénédite (fig. 8.13), which was put up for sale at the Drouot auction, 31 May 1928, carries the heading, "Ugolin" in the legend. Here a parent tenderly holds his child in his lap. Undoubtedly, there are many other similar drawings whose relationship to Ugolino still remains ambiguous.

ACT I, SCENE 2

The already tragic situation becomes terrifying: the prisoners are suddenly condemned to death under atrocious conditions.

Then at the foot of that grim tower I heard
 Men nailing up the gate, far down below;
 I gazed in my sons' eyes without a word;
I wept not; I seemed turned to stone all through. [33, 46–49]

Rodin chose to illustrate the moment where Ugolino and his sons hear them "nailing up the gate"—where this sound rips the silence and freezes their blood. In drawing D3783 (fig. 8.14) the eyes of the three condemned people are turned towards the never-to-be-opened door. The inscriptions were placed in the margins by Rodin before setting off the lines with white gouache, which leads us to suppose that the artist retouched his drawings several different times. The interval between the ink sketch and the addition remains unknown. The backing paper is one that most likely came from the fabric shop which supplied Rose Beuret. Whether they date from the reference to Ugolino or not, we also read the words:

8.7

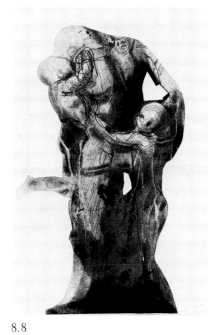

8.8

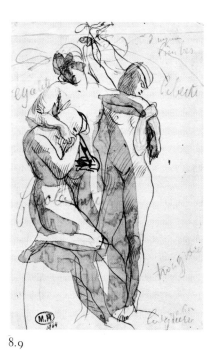

8.9

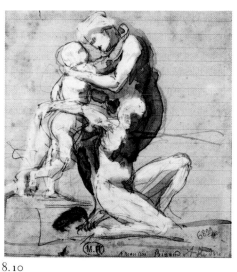

8.10

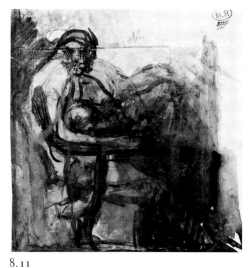

8.11

8.13

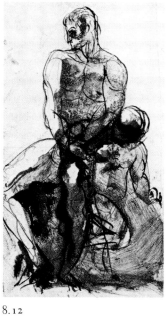

8.12

8.14

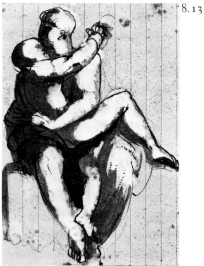

8.7 *Ugolino the First Day*. Published in 1899 in Léon Maillard's *Auguste Rodin Statuaire*. Musée Rodin, Paris.

8.8. *Ugolino in His Prison*. Goupil album, number 52. Musée Rodin, Paris.

8.9 Drawing D1964. Musée Rodin, Paris.

8.10 Drawing D6899. Musée Rodin, Paris.

8.11 Drawing D3777. Musée Rodin, Paris.

8.12 *Man and Child*. Goupil album, number 112. Musée Rodin, Paris.

8.13 *Ugolino*. Musée Rodin, Paris.

8.14 Drawing D3783. Musée Rodin, Paris.

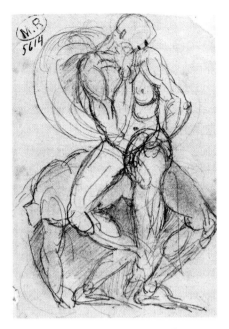

8.15 Drawing D5614. Musée Rodin, Paris.

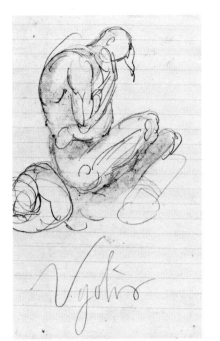

8.16 Drawing D5589 *verso.* Musée Rodin, Paris.

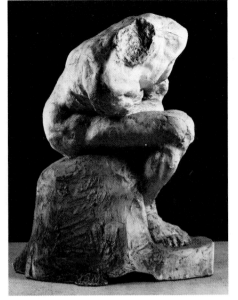

8.17 *Ugolino,* 1876-1877(?). Plaster. Musée Rodin, Meudon.

"pédagogue," "Niobé," "Niobide," "rocher." The gesture of Ugolino may be considered declamatory, which would justify the word *pédagogue.* The connection to the legend of Niobe, overcome by the death of her fourteen children and turned to stone for having mocked the modest progeniture of Leto, may be related to Ugolino, who embodies paternal dread.[10]

SECOND DAY
ACT II, SCENE 1

Dante sets the rhythm of his tale to the unrelenting march of time which hastens to the fatal moment. Even without knowing precisely how long it has been since they were walled in, the narrator reminds us that an inexorable countdown has begun.

. . . . And when the first faint ray
Stole through into that dismal cell of stone,
 And eyeing those four faces I could see
 In every one the image of my own,
I gnawed at both my hands for misery. . . . [33, 55–58]

Rodin took up these last few words and the attitude of these characters, huddled tightly together better to express physical and moral anguish. The father seated beside his starving son heralds the pose of *The Thinker.* Drawing D5614 (fig. 8.15) prefigures the gesture of the right elbow on the left thigh. A front view of this Ugolino evokes the drawing of *The Thinker* done in 1887–1888, which is related to one of Baudelaire's poems from *Les Fleurs du Mal,* "Les Bijoux." Graphite lines bring out the prominent musculature, which, seen from profile this time (D5589 verso, fig. 8.16), comes close to a plaster cast for Ugolino that was never executed in bronze (fig. 8.17). It was exhibited in 1900 in the Pavillon de l'Alma. The plaster casts in the Meudon collection probably date from 1876 or early 1877, for Rodin dealt with the matter in several letters he wrote from 3, rue Bretonvilliers, which were addressed to Rose, who had remained behind in Belgium. He asked Rose to send him his Ugolino so that he could work on it. He even commented that the leg lying on the table had never been cast—which is easily verified.

This powerful torso, down to its very socle, prefigures *The Thinker* and is reminiscent of the Belvedere torso, transposed onto the balustrade of the Palais des Académies in Brussels. In a drawing at the Fine Arts Museum in Lyons (fig. 8.18), bought in November 1910, Ugolino is seated in quite as contorted a pose as *The Thinker,* though less doubled up. One of his sons seems to be speaking to him, leading us into what can be called the second scene of Act II.

ACT II, SCENE 2

The second day of fasting continues:

And they, who thought it was for hunger plain
And simple, rose at once and said to me:
"O Father, it will give us much less pain

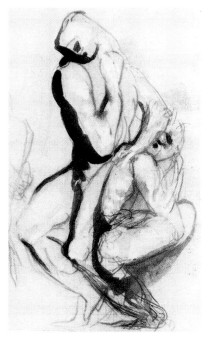

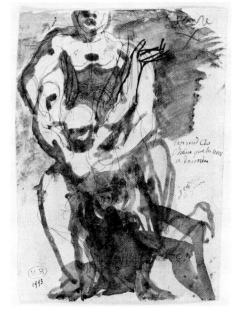

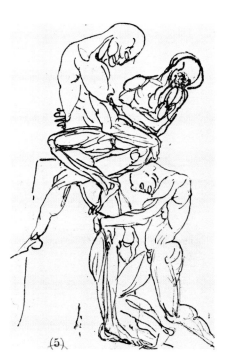

8.18 *Ugolino*. Musée des Beaux-Arts, Lyon.

8.19 Drawing D1993. *Ugolino/Icarus*, c. 1880-1882. Pencil, pen and ink, ink wash. Musée Rodin, Paris. Cat. no. 239.

8.20 Drawing published in 1899 in *Archives de Thérapeutique*.

If thou wilt feed on us; thy gift at birth
Was this sad flesh, strip thou it off again." [33, 59–63]

The movements become more tense and desperate. His son, half-faint with hunger, grabs onto the arms of Ugolino, who holds him up painfully. This scene is translated by Rodin in drawing D1993 (fig. 8.19) and commented on by the artist again in the margin: "reprend ces chairs que tu nous as donnée" ("take back this flesh which you have given us"). Brush strokes in brown ink, which in places miss the square sheet of paper, further increase the pathos. Another connection took place in the imagination of Rodin—that of Icarus whom Dante encounters in canto 17, verse 109, where Daedalus holds him up as he dies. In 1895, Rodin sculpted *Chute d'Icare* ("Fall of Icarus"). Another drawing (fig. 8.20) reproduced in December 1899 by André Mycho for the magazine *Archives de Thérapeutique*, shows just how much Rodin knew and cared about anatomy and the study of muscles. Its writer was sensitive to the forced attitudes which Rodin drew, as were doctors, who often showed an interest in the artist's muscular play.[11] In the 1882 sculpture, the arm movement of the dying son, by Leo Steinberg's account, indicated paralysis and death.[12] Mycho notes that Rodin's anatomical science is more revealing in his hasty, rough outlines than in his more finished drawings. Furthermore, let us point out that, from his early youth, Rodin drew unclothed figures and

that throughout his life, he never ceased making nude studies of his figures before he dressed them.

FOURTH DAY
ACT III

The third day is one of silence. On the fourth, Gaddo dies. The first of Ugolino's sons to succumb, he cries out as in reproach, "Father, help me." Rodin chose to place Gaddo's body in Ugolino's lap, like a Christ cradled in his mother's arms. Ugolino's pose is, then, one we associate with the compassionate Virgin. In the powerful and tragic drawing D7208 (fig. 8.21), gouache on a background of brown wash lends the bodies a ghastly aspect. It was unnecessary for Rodin to design a prison scene in order to suggest the foulness of the tableau. No anecdote distracts our attention. This drawing is all the more telling when looked at in relation to the lower right panel in the plaster of the third architectural sketch for the *Gates* (fig. 8.22). Here the interaction of the figures is clear. The drawing seems to have been done in 1880 in preparation for the sculpture. The inclination of the face communicates a touching compassion, while, in a sketch (fig. 8.23) published in *The French Magazine* of April 1899, Ugolino turns away, averting his glance from his son's desperate face. In another drawing at the Musée Rodin (D5628, fig. 8.24), the sculptor is careful to mute the impact of the subject; the figures are seen in profile,

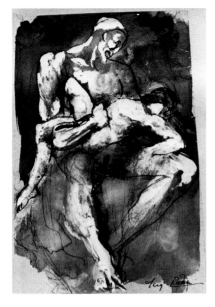

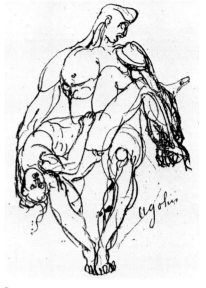

8.23

8.22

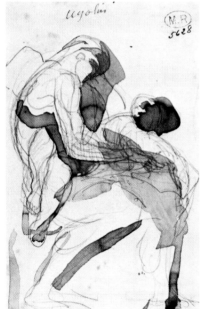

8.21

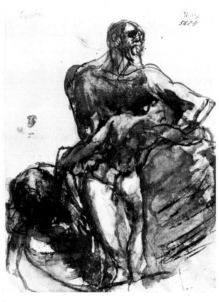

8.25

8.24

8.21 Drawing D7208. Musée Rodin, Paris.

8.22 *Third Architectural Sketch for The Gates of Hell*, 1880-1881. Detail, lower right panel. Plaster. Hirshhorn Museum and Sculpture Garden, Smithsonian Institution. Cat. no. 232.

8.23 Sketch published in 1899 in *The French Magazine*.

8.24 Drawing D5628. Musée Rodin, Paris.

8.25 Drawing D5624. *Ugolino*, c. 1875-1882. Pencil, pen and ink, ink wash, gouache. Musée Rodin, Paris. Cat. no. 240.

and the overwhelming pressure on the father is all the more marked. Drawing D5624 (fig. 8.25) brings into view a scene that is quite difficult to describe. Is Gaddo stretched out on his father's lap or half-leaning between his legs? What strikes us is Ugolino's animallike expression. The mouth hangs open; the eyes are sunk in. It is the face of Death.

SEVENTH DAY
ACT IV

At last the flesh weakens, and Ugolino begins to collapse in a posture chosen by Rodin for his sculpture. Dante writes:

As thou dost see me here, I saw him die,

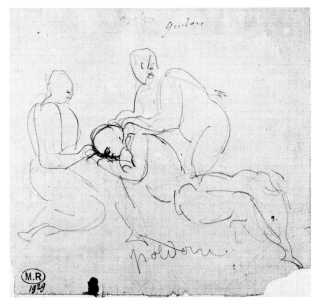

8.26 Drawing D1929. Musée Rodin, Paris.

8.27 Study sheet D153-159. Musée Rodin, Paris.

And one by one the other three die too,
From the fifth day to the sixth. Already I
Was blind; I took to fumbling them over; two
Long days I groped there, calling on the dead;
Then famine did what sorrow could not do. [33, 70–75]

For decency's sake, neither Dante nor Rodin depicts the father devouring his sons, as Goya does with Saturn. Dante does not describe the horror, aside from the scene in which Ugolino gnaws at his enemy's skull, which Rodin merely translates in drawing. In drawing D1929 (fig. 8.26), have we reached this episode or are we still confronted with Ugolino, looking for some sign of life from his children? It would be unwise to settle the question, especially since Rodin gives the children adult bodies. Rodin also wrote on the drawing "Polidore" [sic] in reference to canto 30, verse 19 of the Inferno, where Hecuba loses her mind at the sight of her son's corpse on the banks of the Thrace, and "Guidon" in allusion to the captain of Montefeltro whose hide was argued over by St. Francis and a black cherub of hell (canto 27, verses 112–115). There remains to be mentioned one sheet of sketches (D153–159, fig. 8.27) where some figures seem to be cutting one another's throats, while others look on beseechingly. One sketch, set off in ink, shows Ugolino on all fours, searching for life in three or four of his children. To our knowledge, this is the only Ugolino which recalls the definitive sculpture of 1882 (fig. 8.28). Unlike the sculpture, here Ugolino's bust is erect, with one leg flung backwards and the left arm stretched out in a blind movement. Rodin commented at the bottom: "Ugolin Médée Médaillon M. Van Berkelear." Even though the relationship of the three

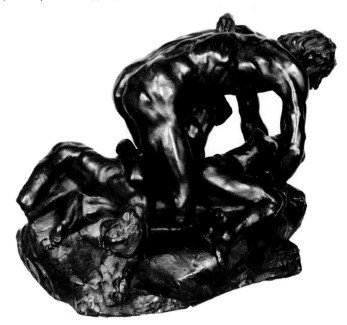

8.28 Ugolino, 1882. Bronze.

inscriptions is uncertain, there are similarities between the Medea theme and that of Ugolino. Rodin must have been familiar with Delacroix's Medea. In his catalogue for the Rodin Museum in Philadelphia, Tancock identifies one Medea which he dates between 1865 and 1870. At the Rodin Museum in Paris, a very distinct drawing (D2056) of a mother and children clinging to each other with agitated gestures carries the title Médée. In letters of 1877, which Rodin sent to Rose Beuret in Brussels, the names of Ugolino and Van Berkelear, a pharmacist friend who often advanced Rodin money, are linked. Hence it is evident that these different sketches date from

1877 and prefigure the sculpture, which Pignatelli, model for the Ugolino, later gave exact form. Rodin, both more daring and more contemporary than Carpeaux, emphasized the animal nature of the hero, whom he occasionally called "Bête humaine" ("human beast") or else, without children, "Nabuchodonosor," after the Babylonian king in the Bible who is condemned to graze on the land for having massacred the Jews. The visionary, Blake, also took inspiration from this source. Rodin had even planned his Ugolino to be seen from overhead, like Daniel in the lion's den.

It is out of the question to try and gather here all of the drawings by Rodin which deal with Ugolino. Although we shall probably never know, if we were to bring together all those which were given away or sold, to be found in museums and private collections, they would number well over thirty. The quality and variety of the drawings here, however, illustrate the particular interest which Rodin showed in this theme, even before planning it in sculpture. Yet it is as a sculptor that he drew, ever watchful for the play of light which made volumes stand out. He went so far as to endow Ugolino with an athlete's body, in order to accentuate the contrast between the father and his children—the Ogre and Tom Thumb—who are nonetheless united in starvation and an equally atrocious end. Not unrelated to the sinister ink washes by Victor Hugo, these drawings express the romantic subject of man as a prey to destiny.

NOTES

1. All passages from Dante's *Inferno* are taken from the Penguin Books edition of *The Divine Comedy*, Dorothy L. Sayers, trans. (1949).
2. Albert Elsen, *Rodin's Gates of Hell* (Minneapolis: University of Minnesota Press, 1960), chapter 2.
3. In *Le Matin*, 19 March 1900, Rodin is quoted: "un an entier avec Dante, ne vivant que de lui et qu'avec lui, dessinant les cercles de son Enfer."
4. *Les dessins d'Auguste Rodin*, preface by Octave Mirbeau (Paris: Boussod, Manzi, Joyant et Cie, 1897).
5. "Les dessins de Rodin pour la Porte de l'Enfer," *Formes* 30 (1932): 320.
6. "Dessins de Rodin de la Ny Carlsberg Glyptothèque de Copenhague" (1938).
7. *Rodin, sa vie glorieuse, sa vie inconnue* (Paris, 1936), 79.
8. *Auguste Rodin Statuaire* (Paris, 1899), 80.
9. "Rodin, sa vie, son oeuvre" in *L'Art et les Artistes* (Paris, 1914).
10. The theme of Niobe, taken up by Dante in canto 12, verse 37, of *Purgatory*, was made into a marble statue by Rodin. John Tancock, *The Sculpture of Auguste Rodin* (Philadelphia: Philadelphia Museum of Art, 1976), gives an illustration of a Niobide from the Toledo Art Museum, dated around 1870 or the turn of the century.
11. Dr. Sauvé, "L'anatomie dans la sculpture de Rodin" (Paris, 1941).
12. Leo Steinberg, *Other Criteria, Confrontations with Twentieth Century Art* (New York: Oxford University Press, 1972).

9.58 Steichen. *Balzac* ("The Open Sky"), 1908. Cat. no. 205.

9. *Rodin and Photography*

Kirk Varnedoe

To our knowledge, Rodin never made a photograph himself. Yet he was one of the first artists for whom photography was a familiar part of virtually every aspect of his work, from studio labors to final public dissemination. In collaboration with many different photographers, he brought into being an enormous body of work that demonstrates—his later pronouncements against photography's base nature notwithstanding[1]—a highly original awareness of the camera's potential.

This awareness took hold at the time of his maturation as a sculptor. Despite his early friendship with the photographer Charles Aubry, he does not seem to have profited from the increased efficiency and inexpensive availability of photographic services in the 1850s and 1860s.[2] In Rodin's apprentice years, photography could have provided a natural aid in building a study dossier of traditional poses and compositions; yet he relied on drawings alone.[3] It would have helped him, too, to record his private sculptural studies, destroyed in order to regain materials or lost to accident; but no image of these is preserved. It seems he only began to exploit the possibilities of the medium in the late 1870s, when he came into the public eye.

From his trip to Italy in 1875 Rodin apparently brought back photographs of Italian art purchased along the way.[4] In this period as well, he may have begun to collect the numerous photographs of French medieval and Renaissance sculpture now in the Musée Rodin archives.[5] His first documented use of photography in connection with his own work dates from 1877, when (as Albert Elsen has illustrated elsewhere[6]) he ordered for the Paris salon jury photographs of his model for *The Age of Bronze* and of the sculpture itself, in an effort to disprove allegations that he had cast the sculpture from the model's body. The same photographs of the sculpture (fig. 9.1) were the source, via tracing, for Rodin's earliest drawings of *The Age of Bronze* (fig. 9.2). In these instances, the photograph served simply as an after-the-fact document of mechanical accuracy: objective evidence of comparative anatomy and a shortcut to accurate rendering of contours. As Rodin's sculptural production subsequently expanded, however, photography became a more integral part of his working procedure and a more telling reflection of his aesthetic.

The Age of Bronze had been a laboriously conceived, tightly modeled figure built up over long months of cautious study of silhouetted contours.[7] The contemporary photographs Rodin ordered taken of the finished work were in turn dry, evenly lighted, and impersonal. Thereafter, however, Rodin was a different sculptor, more aggressive, more self-aware, and ever more pressed by the demands of exhibitions and commissions. The increasing frequency with which he called photographers to his studio after 1880 reflects the new pace, and the images they made embody the stylistic changes, as well as the intense self-investigation, that shaped the production of the 1880s.

The photographs taken in Rodin's studio from the time of the *St. John the Baptist* (see fig. 9.3) onward, regardless of photographer, clearly bear the impress of the artist's active participation as the "director" of lighting and point of view; and thus allow us to see the sculpture mediated by his own vision. These were not (as opposed to the Marconi photo of *The Age of Bronze*, fig. 9.1) images made with the neutral intention of conveying maximum surface information. Rodin ordered the photos of the 1880s less as evidence than as trials, means to test the sculpture from multiple points of view and in different conditions of light. This testing procedure put pressure on the works to hold their own against changing situations, and on Rodin to guarantee their stable integrity from multiple vantages. It also allowed the sculptor to gather a record of his work fixed in the conditions he found most favorable. Thus the photographs he kept from the 1880s return consistently to a common aesthetic that favors raking light or backlighting, with the figures frequently cloaked in transparent shadows and their salient surfaces brought up, especially at the edges of the

left: 9.1 Marconi. *Age of Bronze*, 1877.
Albumen print.

right: 9.2 *Age of Bronze*. Pen and ink.
Musée du Louvre, Paris.

forms, in strong highlight.[8] The drawings that Rodin did from these images (see fig. 9.4) are accordingly not simply expedient tracings from the contours, but evocations or intensifications of the pictorial chiaroscuro captured in the photographs.[9]

Although this evidence of Rodin's ideal vision of his work is incalculably valuable to us, photography was perhaps even more important to the artist in that it challenged, or at the least dissociated itself from, his preconceived image of his own sculpture. Absorbed in the physical reality of modeling, and preoccupied by the conceptual ideal he sought to realize, he could use a photograph to provide detachment. The camera, confronting the still wet and malleable clay, stopped the modeling process cold, miniaturized and flattened the form it faced, and presented the artist with a small paper surrogate far more "manipulable" than the sculpture itself. Some of the spiritual distance Rodin might have gained by leaving the work aside for a week or a month

was thus more readily obtained, and the lessons of that experience made more immediately available to the ongoing development of the figure—a development he could previsualize by drawing on the photograph.[10]

Rodin was always exceptionally attentive to the possibilities he might discover in a work's change of state—as it was enlarged, rendered in a new material, or simply prey to accident. The transformation of the sculpture's image wrought by photography constituted a radical change of state and held the potential of revealing surprise conjunctions of forms or inflections of light that might be seized by Rodin as material for further elaboration. Rodin's ability thus to reconsider and redirect works already created was a determining part of his artistic personality, and of his modernity. The boldness of his initial conception and execution—in choosing evocative poses, or in the power of his modeling—is of course evident and important. But perhaps even more crucial for the development of modern sculpture was his constantly attentive self-examination, a faculty that led him to stop where others might have continued and to continue with what others might have thought finished. Photography, not only by affording him a quick method of objectifying his work, but also by providing him cheap and dispensable miniature surrogates, facilitated the roles of reflection, experiment, and play (in the most serious sense) in his process of creation. By assigning to photog-

raphy a task normally given to more laborious plaster casting, of preserving the various stages in the elaboration of his works, Rodin further satisfied his urge to economy of effort, his desire not to let any potentially useful or informative aspect of his work pass unrecorded or escape availability for future exploitation. Fixing diverse orientations and transitional combinations of sculptures, photography helped him to enact more directly with his own work the practices of duplication and montage he had previously pursued, via tracing, in his study drawings of the sculpture of others (see figs. 7.9, 7.10).

The paper image could thus become a viable extension of the work itself. It is important to stress, though, that if photography became integral to the contact of the artist with his work, it rarely intervened between the artist and life. Rodin worked with photographs in sculpting, but almost never from them.[11] Though sometimes obliged (in making portraits of men no longer living) to use photographs as partial sources, he disliked such situations, and tried wherever possible to substitute a living model.[12] Falguière, and no doubt many other sculptors of Rodin's day, welcomed photography as an expedient way to study and work from difficult poses of motion.[13] Rodin, despite his keen pursuit of unposed, ephemeral gestures and movements, spurned such aids. Arguing against the deforming treachery of stop-action images, he asserted to Paul Gsell that "it is the artist who is truthful and it is photography which lies, for in reality time does not stop, and if the artist succeeds in producing the impression of a movement which takes several moments for accomplishment, his work is certainly less conventional than the scientific image, where time is abruptly suspended." For all their forceful truth to life, many of Rodin's most dramatic gestures of movement are anatomically impossible assemblages of body fragments, synthetic inventions seeking freedom from, rather than truth to, the "photographic" moment. Similarly, the rapid line drawings of the moving model he undertook in the later 1890s were often called by his contemporaries *instantanés* (snapshots), but they are in fact anti-photographic in the way the lines scribe an immersion in a flowing process, rather than the analytic isolation of an instant.

If we are to find photographs that reflect the concerns of these later drawings, we should look not to stop-action images like those of Eadweard Muybridge, but to the interpretive photographs taken in the same period, under Rodin's guidance, by Eugène Druet. This collaboration came at one of the watershed points of Rodin's career, when he was completing the *Balzac* and winding up preparations for his one-man retrospective exhibition of 1900. Druet's work represents a turning point, too, in Rodin's involvement with photography. The first phase of Rodin's use of the medium, from c. 1878 to the early 1890s, had been perhaps the "purest." The personalities of the various photographers had been wholly subsumed under the imperatives of Rodin's direction, and the photographs conceived primarily as private documents, intimately connected with the working life of the studio. There had been no breach, furthermore, between the "working" imagery of the sculpture and its public illustration; for Rodin had selected as the basis of published reproductions—either via his own drawings or via wood engravings by others—the same photos of the (often unfinished) plaster and clay figures he had ordered initially for documentary/study purposes.[14]

In Druet's work, we begin to lose touch with the early working processes of Rodin's sculpture. Perhaps in reflection of his increased use of studio assistants for much of the manual labor, and of his frequent reediting of previously executed works, we find that the "working" photos of Rodin's later career (with the notable exception of a series showing the robe of the *Balzac* under construction in plaster[15]) have more often to do with secondary processes such as the translation of a figure from one material into another, the reworking or readaptation of older pieces, and the arrangements of draperies or pedestals (see fig. 9.37).[16] Druet's photos, like those of the photographers who followed him, deal primarily with the interpretation of finished works in plaster, bronze, or marble.[17]

There is in Druet's images, furthermore, a distinct stylistic shift away from the aesthetic of the photos of the 1880s, a shift that seems to owe both to Druet's contributions and to altered emphases on the part of Rodin. Whether with artificial illumination (whose potential in photography may first have been demonstrated to Rodin by Druet[18]) or by studio light, Druet's images abandon the warm chiaroscuro of the sepia- or green-toned albumen prints of Pannelier (figs. 9.12-9.17) and Bodmer (figs. 9.5-9.11), a coloration that had been a matter of Rodin's selection.[19] Druet used a silver gelatin paper to produce, via enlargement, matte prints whose light is cold, often washed-out or murky, and less transparent in the shadows. His pictures, far less legible in documenting form, seem more conscious of a palpable binding atmosphere, and of the camera's ability actively to charge the sculpture with drama.

When Rodin had chosen multiple viewing positions in earlier photos, it had usually involved simple rotation of the sculpture before the camera (see figs. 9.12-9.15), or—as in the case of *The Thinker* photographed from below on the scaffold structure of *The Gates of Hell*[20]—

the previsualization of a particular fixed relation of form to viewer. Druet's camera was, by contrast, mobile and adventurous, taking viewpoints radically above or below the pieces, pulling in extremely close, and often compressing forms into unexpected silhouettes. In this respect the vision of the Druet photos approaches that of the drawings of the later 1890s, for, in tracings and eventually through cut-outs, Rodin often similarly collapsed the perspective of a pose and transformed it into a more abstract, flattened pattern (see figs. 7.62-7.64). With respect to instances of Druet's lighting and selective development as well, the photographs of the later 1890s reflect Rodin's contemporary concern to achieve a final *synthetic* representation that would subsume and transform—rather than describe fully in naturalistic terms—the form considered. These Druet works embody a changed idea of sculpture, an expanded notion of its potential interaction with viewpoint and environment. They embody as well a more obvious exploitation of photography's ability to stylize, and to body forth a subjective vision.

Not only the aesthetic of Druet's photographs, but also the way in which Rodin used them, signaled a change in the artist's relation to the medium. Offering Druet's prints for sale in his 1900 exhibition, Rodin demonstrated his increased concern for the dissemination of his work and explicitly validated (by joining his signature to that of Druet in each image) the kind of arrangement he had earlier established implicitly with his marble carvers and with reproduction artists such as Leveillé the wood engraver or Clot the lithographer, whereby his work would reach the public via guided collaboration with a skilled interpreter.[21] The sale of documentary photographs of art by museums was widespread by 1900, but Rodin's venture in encouraging the circulation of carefully controlled photographic images of his work, as an extension of his exhibition, still evidenced an advanced understanding of a publicity system since become commonplace.

Rodin's subsequent break with Druet initiates the third and final phase of his involvement with photography. Although Rodin continued in this last period (after c. 1902) to order images made for purposes internal to the production of his sculpture, the great majority of the photographs made of his work after 1900 seem to have been motivated by external demand. The later photographs preserved in the Musée Rodin fall into two new distinguishable groups: one produced explicitly for trade and publicity purposes, at Rodin's behest; and the other made, with more self-consciously expressive intent, by artist-photographers acting on their own initiative, with Rodin's permission or encouragement.

In most of the images of the artist-photographers who worked with Rodin in this last period, such as Haweis and Coles (figs. 9.62–9.67) or Steichen (figs. 9.48–9.61), we see his work through the veils of a late symbolist aesthetic associated with the photo-secession style of the 1890s and early twentieth century. Cloaked in darkness, and/or in an active, swirling atmosphere, the sculpture is wholly divorced from the studio context and intensely, moodily idealized. The lighting and the rich surface manipulations of the prints themselves glamorize and homogenize the works, by blunting the differentiation of their material properties. It is appropriate that Rodin's work should have been visualized in these terms, since the artist himself—via the painterly, atmospheric qualities of his marble carvings particularly—had certainly contributed to the formation of this aesthetic in the 1890s. Especially as Rodin tended toward more misty, blurred effects in his later graphic work (notably his smudged pencil drawings, see figs. 7.76, 7.77), he must have found kindred photographic stylization—capable of reforming the vision of sculpture made long before under the dictates of wholly different considerations—highly appealing. These later photographs thus present, with regard to credit attributed for their style, a chicken-or-egg conundrum. While it is clear that Haweis and Coles, and Steichen, bring to the work a personal vision in tune with contemporary photographic aesthetics, it also seems undeniable that Rodin's sensibility greatly affected that vision, both directly and indirectly. This later imagery of his work is furthermore not inconsistent with aspects of Rodin's own, more personally controlled depictions of sculpture dating back to the 1880s.[22]

Like many men of his generation, Rodin sometimes used "photography" as a term denoting base, mindless copying of nature; he implicitly damned the medium as a manifestation of the debasement of taste brought on by the rise of materialist philistinism and industrialization. Placing himself in opposition to this mechanistic tide, he rhetorically opposed to photography the values of sentiment, feeling, and individual judgment which he felt produced true art. Yet the group of photographs he preserved shows that in *practice* he found photography to be a way of seeing and interpreting that was pliable to his will and adaptable to the changing demands of his vision, allowing latitude for a broad range of spirit. Although he came rather late to photography, Rodin was quick to understand how the camera could be used to his purposes, and to gain a fluent command of the medium by instinct and observation, without involving himself directly in its practical technicalities. As his

vision evolved and photographic processes changed, he continued, with a blend of experimental openness and sure creative control, to make it a more natural, flexible part of his ways of working and seeing. It is worth noting, too, that many of the principles of the works depicted in these photographs—repetition of identical forms, entertainment of chance, drastic editing of the whole in favor of the expressive fragment—are among the strategies that would eventually come to seem essential to the flowering of photography as a medium of modern artistic expression.

Yet these ideas shown in the photographs are not demonstrated by them. In this sense, it is clear that Rodin never saw the medium as a primary vehicle for his ideas, but rather as a means of translating or extending what he had done in sculpture. This was certainly not a perfunctory role. Rodin was exceptionally attentive to the "afterlife" of his work in secondary or tertiary forms, and considered it a significant part of his function as an artist to shape not just the sculpture itself, but the ways in which it would be seen and understood. In publishing a series of photos such as those of "The Expressive Hand" (figs. 9.31–9.34), he self-consciously used photography's power to persuade, to educate, and to shape public awareness of the qualities of his art.

Photographs could be extensions of his art in more personal, private senses as well, as he made clear in dedicating them as gifts to intimates and respected peers (see figs. 9.5, 9.82). Dedicating a prized Steichen portrait to the Duchesse de Choiseul, he referred to it in the inscription as "this bas relief"; and on one of his muted late pencil drawings he noted "Steichen photo" (see fig. 7.77). Such ready cross-referencing between photographs and his work in sculpture and drawing remind us—his conservative rhetoric notwithstanding—of Rodin's fruitful lack of concern for conventional hierarchies and boundaries within the field of artistic endeavor.

1. For a discussion of Rodin's recorded observations on photography, see Albert Elsen, *In Rodin's Studio: A Photographic Record of Sculpture in the Making* (Oxford: Phaidon Press in association with the Musée Rodin, 1980), 10–12. I would like to thank Albert Elsen for first bringing the Musée Rodin's photography collection to my attention and for inviting me to join in the work of organizing this resource, He has generously shared archival material with me. Mme. Hélène Pinet, curator of photography of the Musée Rodin, has also provided invaluable aid.

2. The invention of the wet collodion process for making negatives, in the early 1850s, brought on a major boom in professional photography. The 1850s and 1860s saw the expansion of photography as both art and business in France, and indeed these two decades are now seen as a kind of "golden age" of the medium. Although painters were frequently cited by critics as using photographic aids in these years, we have as yet no knowledge of sculptural practice that would allow us to compare Rodin's case with that of his contemporaries.

3. Rodin may have owned some photos of models in academic poses. Drawing No. 6325 in the Musée Rodin collection (a small sketch apparently related to the *Creation of Man* figure, c. 1877) is on the back of such a photo. Marconi, the photographer who made Rodin's first images of *The Age of Bronze*, also made a business of selling photos of models. No group of such images, however, seems to exist in the Musée Rodin archives.

4. There are for example in the Musée Rodin archives at least seventeen small photos, mounted on identical cards, of Michelangelo's work or copy images thereof. These are albumen prints—a technique that tended to die out after the advent of gelatin processes in the early 1880s—and their compact size and series nature argue for their having been souvenir purchases. Other works found with this series also include two details of the Maitani portal reliefs from the Cathedral at Orvieto (important for *The Gates of Hell*); an Alinari photo of a sculpture from the Museo delle Terme, Rome; and two photos of works from the Museo Nazionale in Naples.

5. The Musée Rodin archives holds large numbers of photos of medieval and Renaissance sculpture, especially entombment scenes. It is tempting to associate these with Rodin, but the gelatin-process nature of the prints dates them after the early 1880s, and the possibility exists that this collection was formed by a curator after Rodin's death.

6. See Elsen, *In Rodin's Studio*, plates 2-5.

7. It is intriguing to speculate on the relationship between Rodin's method of silhouette modeling and the techniques of photo-sculpture which had been so popular and widely discussed in previous decades. Photo-sculpture worked by taking numerous silhouette views and combining these into a solid matrix from which a sculpture could be cast or carved. See Peter Fusco's discussion of François Willème in

Peter Fusco and H. W. Janson, eds., *The Romantics to Rodin* (Los Angeles: Los Angeles County Museum of Art and New York: George Braziller, Inc., 1980), 360–361; and the article by Robert Sobieszek, "Sculpture as the Sum of its Profiles: François Willème and Photo-Sculpture in France, 1859–1868," *Art Bulletin* 62 (December 1980): 617–630.

8. These photos should be seen in the light of Rodin's frequent remarks about his preferred method of modeling from a figure seen in strong backlighting; and in regard to his practice of studying his figures by candlelight, in order to accentuate the modeling of light along the external contours. In regard to Rodin's directorial role, see Elsen's remarks on what Rodin taught his photographers, in the introductory essay to *In Rodin's Studio*.

9. An examination of the salon catalogues of the late 1870s and early 1880s shows that Rodin's method of presenting his figures (in drawings that dealt with heavy chiaroscuro, directional lighting, and enveloping atmosphere) was in marked contrast to usual practice, which favored a more bland, neutral linear style without shadow (see also note 22).

10. See the ink drawing on a photo of *Eustache de St.-Pierre* (fig. 9.13) and numerous other instances of drawing on photos in Elsen, *In Rodin's Studio*. Elsen also discusses photography's importance as a means of distancing Rodin from his own work and as an aid to editing.

11. Rodin drew a self-portrait from a photograph by Bergerac, fig. 9.78 (see Albert Elsen and J. Kirk T. Varnedoe, *The Drawings of Rodin* [New York: Praeger, 1971], frontispiece).

12. Rodin's activities in documenting Balzac's appearance by numerous drawn and painted images and the one known daguerrotype, is well-known (see Elsen, McGough, and Wander, *Rodin and Balzac*, Stanford University Art Museum, 1973); the Musée Rodin archives also holds photographs Rodin apparently used in his work on the posthumous portraits of Bastien-Lepage and Barbey d'Aurevilly.

13. The Musée Rodin archives holds a small group of photos obviously deriving from Falguière's studio. Among these is a photo of two female models wrestling in the nude that seems to be the source of Falguière's sculpture of two struggling *Bacchantes*. Similar instances in this group, as for example a photo-study of one male model carrying another, and a matching photo of a clay sketch of the same subject, suggest that Falguière used photographs frequently in making his sculpture.

14. All of the drawings Rodin did of his own sculpture for the commissioned illustration of Baudelaire's *Les Fleurs du Mal* in 1888 (see discussion in Elsen and Varnedoe, *The Drawings of Rodin*, 68; and in Victoria Thorson, *Rodin Graphics* [San Francisco: California Palace of the Legion of Honor, 1975], 82–105) can be shown to have been drawn from photographs; I will discuss this matter in a future article. The illustrations in T. H. Bartlett's articles on Rodin in *American Architect and Building News* (1889) are based on photos from the same basic group of studio documents (c. 1881–1883) that is the basis for the Baudelaire illustrations.

15. See Elsen, *In Rodin's Studio*, plate 112 and p. 182.

16. See the step-by-step sequence of the transformation of the figure of the *Martyr* from plaster to marble, plates 40–42 in Elsen, *In Rodin's Studio*.

17. It is important to stress, however, that by this time Rodin's definition of "finished" had itself changed, with regard to pieces to be shown in public exhibitions. See for example the peculiar assemblage of the Hugo monument photographed in exhibition, in Elsen, *In Rodin's Studio*, plate 89.

18. Laurent Vizzavona, in his article "Druet, Photographe des Impressionistes," cites G.-E. Blanche's reference to Druet's use of magnesium lighting. This article in *Nouvelles de l'estampe* is known to me via an undated clipping kindly communicated by Hugues Texier and François Braunschweig.

19. See the letter from Bodmer to Rodin, cited in the specific discussion of Bodmer, below.

20. See the photos of *The Thinker* on the scaffold of the *Gates*, in Elsen, *In Rodin's Studio*, plates 21 and 22.

21. For Rodin's work with Clot and also with Perrichon, in reproducing his drawings, see Thorson, *Rodin Graphics*, 106–135.

22. See for example the heavily shadowed depictions of sculpture in the Baudelaire illustrations of 1888 (Thorson, *Rodin Graphics*, 82–105); and even earlier the drawing of the *St. John the Baptist* for the 1880 salon catalogue (reproduced in John Tancock, *The Sculpture of Auguste Rodin* [Philadelphia: Philadelphia Museum of Art, 1976], 367). Perhaps the most telling anticipation of the vision of the later photos is found in the one lithograph Rodin executed, of the *Eternal Idol*, c. 1896–1905 (see Thorson, *Rodin Graphics*, 72–73). The chicken-and-egg problem with regard to this style of rendering becomes even more acute when we begin to speculate as to the effect that the qualities of *flou* and velvety chiaroscuro in certain photographs may have had on the development of this taste in the work of Carrière and/or Rodin himself. Certainly Rodin's change of taste in his drawing method c. 1906, when he switched to using pencil exclusively, with heavy rubbing of the contours for atmospheric effect (see figs. 7.76, 7.77), must have been strongly encouraged by his experience of Steichen's photos of his work.

CHARLES MICHELEZ

Michelez's letterhead identifies him as "Photographer of the Ministry of Fine Arts at the Annual Exhibitions of Paintings at the Palace of Industry" and locates him at 84, rue d'Assas. The only communications preserved in the Musée Rodin archives are bills, dating from 1881 through 1884 (although, as fig. 9.3 proves, Rodin used his services well before these dates). Rodin seems primarily to have employed Michelez in his official capacity, calling on him for photographs of works on view in salon exhibitions even while he was employing other photographers for work in the studio. As was customary with all the photographers Rodin employed, Michelez charged separately for first negatives and subsequent prints: twenty to twenty-five francs for the negative, depending on size, and including the two first proofs, and less than two francs per normal print. Rodin often requested large plates, specified by Michelez as twenty-five centimeters (given the size of fig. 9.3, it is possible that it is printed from an unspecified larger *grand format* negative also mentioned in Michelez's accountings); and ordered prints in groups of four to eight at a time.

9.3, cat. no. 88.

Fig. 9.3 *St. John the Baptist Preaching*, 1878. Salt print. M.R.ph959.

The publication in 1880 of a drawing done from this photograph (fig. 9.4) gives us a *terminus ante quem* for the negative.[1] The adhesion of the statue to its modeling stand at the base and the small nails protruding along the torso's midline and in the right elbow suggest that the final clay version, rather than a plaster, is shown here. The photo would thus date from 1878 and be the earliest known image of the sculpture.

The Musée Rodin also holds two prints from a closely related variant negative, in which the bust of *Bellona* in the left background is seen frontally. On one of these prints, Rodin added a gouache coating that obscured everything except the three images of *Bellona*, *St. John*, and the *Man with the Broken Nose* (on the shelf in the right background). The figure of a man atop the cabinet in the right background, concealed by this selective masking, has not been identified and may not be by Rodin.

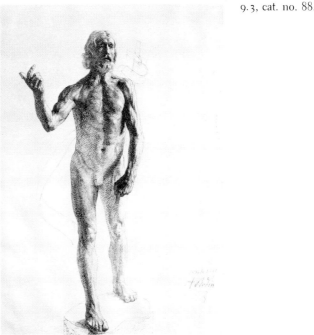

9.4 *St. John the Baptist*, 1880. Pen and ink. Grenville Winthrop Bequest, Fogg Art Museum, Cambridge, Mass.

NOTE

1. The drawing appeared in *L'Art*, 1880, p. 124. For a consideration of this and other drawings from sculpture, see Elsen and Varnedoe, *The Drawings of Rodin*, 59–60. It is now clear that the drawing of

the *St. John* in the Cabinet des Dessins of the Musée du Louvre also derives from a photo, reproduced by Elsen (*In Rodin's Studio*, plate 11); and that the drawing Rodin submitted to illustrate the work in the *Catalogue Illustré du Salon* of 1881 was also based on a photograph (*In Rodin's Studio*, plate 10—compare the drawing as reproduced in Tancock, *The Sculpture of Auguste Rodin*, 367).

CHARLES BODMER

Bodmer, a specialist in photographing works of art, advertised his principal office in Barbizon.[1] There are no bills or correspondence relating to either the important series of photos he took of clay studies for *The Gates of Hell* (for example, fig. 9.7) or the large prints of the nude studies for *The Burghers of Calais* (figs. 9.8–9.11). The one letter preserved in the Musée Rodin archives, dated 16 March 1884 (possibly 1889), relates to an unspecified group of large-format works whose appearance Rodin was apparently anxious to keep secret:

Dear Sir,
Because of the difficulties I have had in pulling your large prints, I have resigned myself to leaving for Barbizon where I have the equipment necessary for printing large negatives. You *can be sure that no one* will see your negatives and that I will bring them to you during the week as well as the prints which are giving me a lot of trouble in order to get what you want that is to say from the point of view of color. . . . (Bodmer's italics)[2]

Rodin used Bodmer extensively in the early 1880s. Some of the albums in which he pasted various-sized proofs of the negatives that Bodmer made in series (note the numbers in figs. 9.6, 9.8, 9.9) still exist in the Musée Rodin archives. One series of very small proofs of photos from studies for *The Gates of Hell*, apparently taken by Bodmer, was especially precious to Rodin. He drew on them, annotated them, used them for reproductions in an 1888 article, and used them again as the basis for several of his own illustrations for Baudelaire's *Les Fleurs du Mal*.[3]

Fig. 9.5 *St. John the Baptist Preaching*, 1881. Albumen print. Private collection. Courtesy Fischer-Kiener Gallery, Paris.

Shown here is the working plaster of the statue, from which the bronze version was cast (note mounting screws in the back and shoulder); this plaster still exists, in the Musée Rodin at Meudon. In the lower left of the photo we see a rough partial version (clay or wax over plaster?) of *The Kiss*. The Musée Rodin owns a proof from this negative (reproduced in Elsen, *In Rodin's Studio*, plate

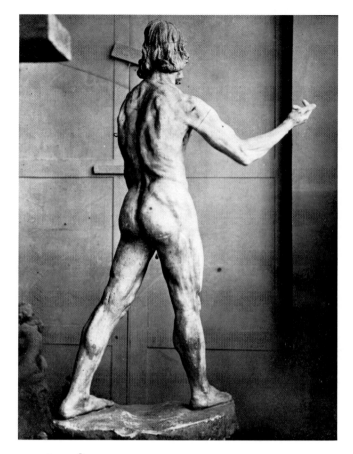

9.5, cat. no. 89.

12) with "No. 28" in the print; apparently these numbers were removed from the negative when printing "presentation" versions of the images. It is striking, and typical of Rodin's unconventionality, that he should choose a back view of the sculpture to give to an artist he greatly admired. Photos like this one and the Michelez (fig. 9.3) allow us to reconstruct the two or three viewpoints from which Rodin felt the sculpture worked best.

Fig. 9.6 *Eternal Springtime*, c. 1881. Albumen print. M.R.ph958.

The couple, perhaps originally intended for inclusion in *The Gates of Hell*, is shown still unfinished, particularly in the areas of the man's hair and the hands. A large relief panel, apparently part of the *Gates*, is visible in the right background. Another photo of the sculpture made at the same time, but with wholly different lighting, is reproduced in Elsen, *In Rodin's Studio*, plate 48.

Fig. 9.7 *The Thinker*, c. 1881. Albumen print. M.R.ph1020.

This photo is part of a series, taken near the completion

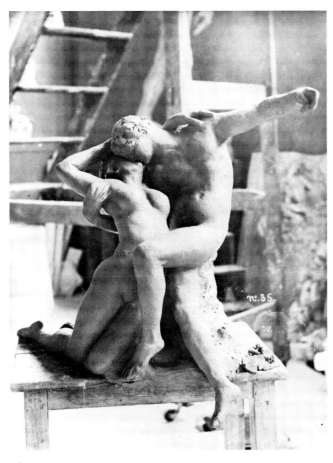

9.6, cat. no. 90.

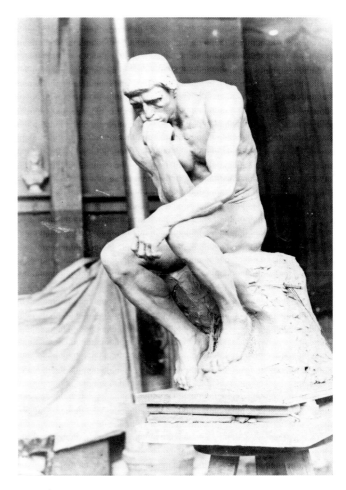

9.7, cat. no. 91.

of the original clay, in which Rodin experimented with differing orientations of the figure. His interest in studying it from this head-on point of view suggests that, even at this early stage, he was considering a sculptural life for the figure independent of its role in the elevated typanum of *The Gates of Hell*. See for comparison nos. 19–22 in Elsen, *In Rodin's Studio*.

Fig. 9.8 Nude study for *The Burghers of Calais*: Pierre de Wissant, 1886. Albumen print. M.R.ph953.

Fig. 9.9 Nude study for *The Burghers of Calais*: Pierre de Wissant, 1886. Albumen print. M.R.ph954.

Fig. 9.10 Nude study for *The Burghers of Calais*: Pierre de Wissant, 1886. Albumen print. M.R.ph955.

Fig. 9.11 Nude study for *The Burghers of Calais*: Jean d'Aire, 1886. Albumen print. M.R.ph956.

Rodin guided Bodmer in studying the same point of view with different lighting conditions (figs. 9.8, 9.9) and the same light source affecting two different points of view (figs. 9.9, 9.10). In the process, we are granted a scanning glimpse of the studio on the rue de Vaugirard where Rodin developed these life-sized clay studies. In the background of fig 9.8, we see partially obscured a smaller and a larger version of *Eustache de St.-Pierre* nude, as well as a draped study, possibly for the burgher with outstretched arms (sometimes called Jean de Fiennes). Most importantly, as Elsen has pointed out (see *In Rodin's Studio*, plates 55 and 56), fig. 9.10 also shows us an early arrangement of the figures in Rodin's second maquette for the *Burghers*, a group whose original appearance has been a source of debate. Here they stand on a packing crate that may well be the one in which they traveled to Calais for approval by the commissioners of the monument.

These figures, like the other works Bodmer photographed, seem to be in the very final stages of completion.

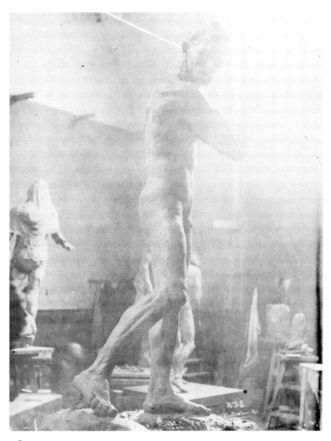

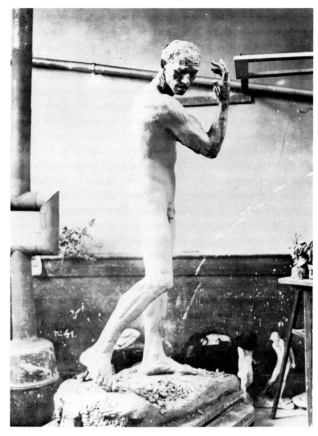

9.8, cat. no. 92. 9.10, cat. no. 94. 9.9, cat. no. 93. 9.11, cat. no. 95.

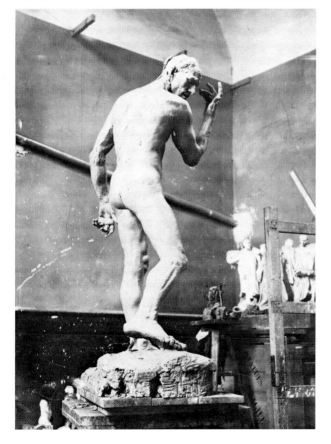

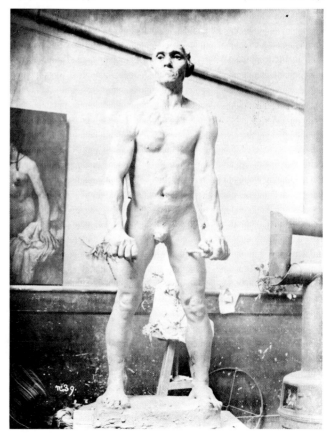

Rodin in this period consistently ordered the works to be photographed at just this penultimate moment, perhaps in order to make final adjustments on the basis of what the photos might reveal.

NOTES

1. He is possibly related to Karl Bodmer (1809–1893), a landscape painter and printmaker who worked in Barbizon.
2. "Cher Monsieur,
 En raison des difficultés que j'ai eu pour tirer vos grandes épreuves je me suis resigné à partir pour Barbizon ou j'ai un matériel nécessaire au tirage de grands clichés. Vous *pouvez être certain que personne* ne verra vos clichés et que je vous porterai ceux-ci dans le courant de la semaine aussi que les épreuves qui me donnent beaucoup de peine, pour avoir ce que vous desirez c'est à dire au point de vu de la couleur. . . ."
3. See "Rodin and Photography," above, note 14.

VICTOR PANNELIER

Pannelier's letterhead identifies him as a specialist not in photographing art but in *"Photographie Artistique de Plaisance,"* and states that his business was founded in 1871. The only correspondence preserved is in the form of bills, and these are in two blocks: 1882–1883, and 1902–1903. Rodin seems to have employed Pannelier for exactly the same purposes as he did Bodmer. The works of the two photographers—toned albumen prints of the *Burghers* studies and of various smaller studies for *The Gates of Hell*—would be all but indistinguishable if it were not for stamps on the mounts of several examples. It is curious that Bodmer should have been called on to do the nude *Burgher* studies, and then Pannelier to do the clothed versions in almost exactly the same fashion. The consistently greater size of the prints Rodin asked of Pannelier—especially after Bodmer's complaints about his difficulties with large-format work—may have decided the issue.

Fig. 9.12 Study for *The Burghers of Calais*: Eustache de St.-Pierre (profile), 1886. Albumen print. M.R.ph951.

Fig. 9.13 Study for *The Burghers of Calais*: Eustache de St.-Pierre (frontal), 1886. Albumen print with ink additions. M.R.ph317.

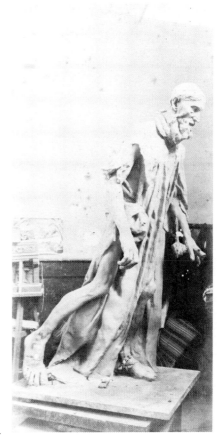

9.12, cat. no. 96.

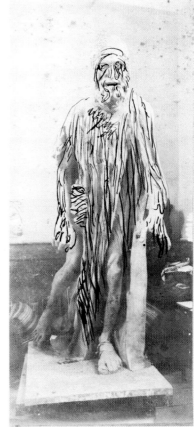

9.13, cat. no. 97.

Fig. 9.14 Study for *The Burghers of Calais*: Eustache de St.-Pierre (frontal), 1886. Albumen print. M.R.ph318.

Fig. 9.15 Study for *The Burghers of Calais*: Eustache de St.-Pierre (rear), 1886. Albumen print. M.R.ph320.

Fig. 9.16 Study for *The Burghers of Calais*: Andrieu d'Andres, 1886. Albumen print. M.R.ph952.

Fig. 9.17 Study for *The Burghers of Calais*: Jean d'Aire, 1886. Albumen print. M.R.ph958.

As Elsen points out (*In Rodin's Studio*, plates 51–54), the figure of Eustache de St.-Pierre was photographed more fully than any of the other *Burghers* figures. Not only thematically as the primary hero commemorated, but visually as well, Eustache would be a crucial element in the monument, from both front and back views. Hence the need to study him more completely in the round, rotating the modeling stand through more than 180 degrees as the camera stayed fixed (figs. 9.12–9.15). The extraordinary image of fig. 9.13, with Rodin's pen markings over a washed-out print, raises the question as to whether such reworkings by hand (there are numerous such instances in the Musée Rodin collection—see Elsen, *In Rodin's Studio*, plates 17, 19, 30, 75, etc.) indicate Rodin's instructions to the photographer to alter the next printing or notations to himself for changes in the sculpture itself. In the present case, it would seem clear that Rodin distinctly changed the neckline of Eustache's drapery, completed the fingers, and changed the lower fall of the cloak in a fashion that would mean little as guidelines to a reprinting of the photograph. The great majority of alterations and notes Rodin made directly on photos seem to be messages to himself, ideas for the alteration of the sculpture depicted.[1]

The head-on photograph of Eustache, fig. 9.14, seems to have been particularly appealing to Rodin. He submitted it, years later, to be the basis for a wood engraving of the sculpture in Léon Maillard's *Auguste Rodin Statuaire* of 1899 (facing p. 64). The image is also worth studying in its surprising revelation of a photograph of Raphael's *Disputà* tacked to the studio wall. Rodin's concern for the idea of a composition joining a line of heads in a single row (crucial to the *Burghers*) may have stimulated his interest in this fresco.

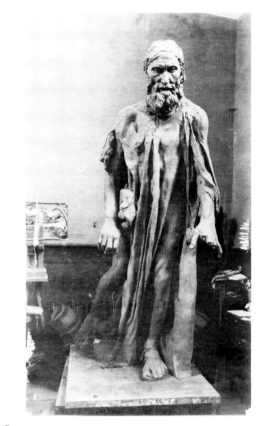

9.14, cat. no. 98.

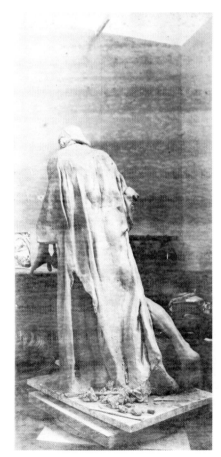

9.15, cat. no. 99.

9.16, cat. no. 100.

9.17, cat. no. 101.

1. Notes found on photos by Bodmer, in an album in the Musée Rodin, include: on a photo of the bust of Victor Hugo, "retirer le noir sous le nez"; on a photo of the nude study for the burgher Jean d'Aire, "le bourgeois nu reprendre"; and on a photo of the *Crouching Woman* in clay, "les traits de l'(?) son très bon à faire sur l'original"— this latter possibly referring to a change in the actual clay.

EUGENE DRUET

Druet is the first photographer of Rodin's sculpture from whom we have a body of work sufficiently complex and stylistically assertive to be considered an *oeuvre* in its own right. These photographs seem to have been conceived from the outset, not as working tools or private documents, but as images destined for public dissemination. Though Rodin had signed and given away works by other photographers (see fig. 9.5), these are the first photographs in which his signature appears as a regular adjunct to that of the photographer, fixed in each print by virtue of a transparent signature "stencil" overlaid on each glass negative. Druet's photographs were not only sold in Rodin's one-man exhibition at the Universal Exhibition of 1900, but also (to judge by customs stamps on their mounts) sent with other exhibitions to foreign countries. The Druet photos included in the present exhibition have been, as far as possible, selected from among those prints whose mounts show that they were chosen for exhibition by Rodin himself.

The first document of Rodin's relationship with Druet is a letter from the photographer dated 22 September 1899. Extremely friendly in tone, it indicates an acquaintance already well established (later correspondence, cited below, indicates that they met in 1896 or 1897). There is no mention of photography in this first letter, but only reference to a fish Druet had ordered sent to Rodin. This gift of food recalls Druet's principal occupation at the time, as proprietor of the Café du Yacht Club Français, at 3, place de l'Alma. Legend has it that Rodin, frequenting this cafe, first encouraged Druet to take up photography, but this has been denied by Laurent Vizzavona, who knew Druet personally.[1] Rodin and Druet were in any event working together in some capacity by October of 1898, as witnessed by a bill of 21 October 1899 from Moirinat, an art supply store and frame shop at 184, rue du faubourg St. Honoré. The bill charges Druet, "for the account of Monsieur Rodin," for hundreds of items, with notices dating back to the previous 29 October.

A letter of 5 December 1899 contains the first mention

of photography, as Druet announces his planned visit to the studio the next morning, to make photographs of the *Apollo* and of a figure of *Night* if it is out of its mold. The most substantial document joining the sculptor and the photographer is not a letter however but a contract, drawn up between them in 1900, and concerning Druet's activities as manager of Rodin's exhibition pavilion on the place de l'Alma during the Universal Exposition. Druet (who was to be aided by his associate Leclerc) was bound by this agreement to guard the building, inform visitors, and take care of sales of works and reproductions. Rodin kept the right to set prices and to decide which pieces would be sold. Druet's prime remuneration consisted of an exclusive authorization to sell his photographs of Rodin's work at the exhibition and to keep the entire profits from such sales, up to 31 October 1900. The expense of making and framing the photographs fell to Druet, and Rodin carefully maintained quality control, the text stating that "Monsieur Rodin will always have the right to forbid the sale of photographs that seem to him insufficiently artistic or photographs of this or that specific work, without his being able, in that case, before 31 October 1900 to give away the right of reproduction or sale to another person, or use it himself before the same date. . . ."[2] In addition, Druet was to receive a ten percent commission on all sales of works or reproductions made by him or by Leclerc, and a 1½ percent commission on all entry tickets to the exhibition. Wages for other necessary personnel and maintenance expenses were to be paid by Rodin. The contract's annulment clause specifically reserved for Druet, even in the event of Rodin's cancellation of the other aspects, the right to exclusive profit from the photographs, although they would in that event have to be sold outside the exhibition building.

Apparently something went badly wrong in the course of the arrangement envisioned by this contract, for on 10 March 1900, Druet addressed a stinging letter to Rodin, recalling their conversation of 4 March and instructing Rodin bluntly: "1. Do not put any of my prints in your pavilion on the place de l'Alma or other exhibitions you may subsequently make. 2. Do not make any reproductions of them. 3. Do not have them reproduced in any newspapers, reviews, etc."[3] Given the obvious rancor between the two men, Druet's wife then tried to intercede and arranged for them to meet over lunch (letter from Mme. Druet to Rodin, 13 March 1900). Despite her efforts, their conflicts were not finally resolved, as shown by Druet's letter of the following 18 September: "I have received your letter of 24 August last. You make allusion to the "nasty scene" of the

eighteenth of the same month. Not having heard from me, you're not permitted to pass judgment on it. In order to terminate these difficult relations: please draw up and send to me a detailed account of that which is due me. . . ."[4] Once again Mme. Druet acted as intercessor, apparently this time at Rodin's request. Agreeing by intra-city telegram (*pneumatique*) on 28 September 1900 to meet with Rodin on the following day, she begged him in a postscript to destroy her letter and by no means to reply to her at home, lest she have grave problems. Strained relations between the two men then apparently continued through the autumn, concluding with a stormy meeting in December. On 6 January 1901, Druet addressed a long and moving letter to Rodin, worth citing in full for the insights it offers into Rodin's role as the photographer's patron:

Monsieur Rodin,

I confess that I am surprised by your attitude; when you left me a little brusquely a month ago, I supposed that, on reflection, you would understand all the ways in which your conduct with regard to me is unfair, and I thought that, remembering what I had done for you, you would turn back very quickly from a movement taken in bad humor.

Today I see that I must take up my part, and since there only remain now our interests to settle, I'm coming to act in a friendly fashion toward you before turning to legal recourse.

You owe me, according to my accounts, the sum of 4,502.15 francs for the Exhibition; I ask you please to have this sum remitted to me.

Moreover, you confirmed this figure to me the last time we spoke about it; but you advanced the pretension of not reimbursing me without a release in which I would renounce the right that you accorded me, to sell photographs of your work.

I know very well that this idea is not yours; you know as well as I the name of the person who is pushing you along this path—but you know too that this pretension is neither just nor has any basis. Permit me to recall to you in a few words what has happened.

When I came to know you and you asked me to photograph your works, I bent myself to your demands. I accepted your advice and your direction, and I scrupulously conformed to your wishes.

You have told me on several occasions that you were satisfied and I find the mark of your contentment in the fact that you arranged to have my photographs figure in your exhibition at the place de l'Alma.

I don't need to recall to you all that those photographs cost to establish, you know that the total expenses were borne by me and that I never received anything from you.

You know as well all the time I spent on them.

For my part I neglected nothing to arrive at pleasing you.

I destroyed without complaining the negatives that did not entirely suit you, when you asked for prints, I put them at your disposition for free.

I gave you as many of them as were necessary for all the reproductions you thought useful: newspapers, reviews, books, etc.

You wanted to give to *La Plume* [a periodical] a series of negatives for the formation of volumes; I agreed to do it without retribution.

You even wanted me to deal with Monsieur Giraudon, rue

Bonaparte [a photo service still operating today in the same street, a block from the Ecole des Beaux-Arts], for the sale of my proofs under conditions that were burdensome for me; I submitted to it, placing in front of my own interest, the wish that you had to disseminate your work in the neighborhood of the Ecole des Beaux-Arts. You told me that there was an artistic advantage in that for you; I did not hesitate.

Why then today, after four years, do you want to forbid me to sell proofs for which I have made so many sacrifices?

Reflect and you will understand that your persistence would be ingratitude; I could add that your pretension would betray gravely my rights.

I would prefer to believe you haven't dreamed of it.

Thus, let's not confuse two separate things, please pay me what is due me by the terms of our agreements for the Exhibition.

As for the rest I hope that you will not persist in a pretension that is based on nothing.[5]

Rodin's chilly response (20 January 1901) to this plea is one of the few communications to a photographer of which a copied manuscript is preserved in the museum archives. Agreeing to pay Druet, Rodin still insisted that he had never intended to give Druet indefinitely the rights the photographer claimed. Ignoring the personal aspects of Druet's letter, Rodin offered—explicitly re-iterating that he was not obliged to do so—to extend Druet's rights of sale for three more years maximum, during which time Druet would be obliged to sell Rodin prints at the same price accorded Giraudon. Druet's reply of the following day recalled that Rodin had made this same offer the previous December during their meeting "chez Monsieur Peytel"—a person one gathers Druet disliked and believed to be influencing Rodin's attitudes. In refusing to accept Rodin's offer, Druet reminded him of their five years of association. He proposed to forget the sums Rodin owed him for frames and albums he had ordered (see the Moirinat bill mentioned above) if Rodin would simply restore the sales rights arrangements to the former status quo. Otherwise, all framing and other bills would be Rodin's to reimburse. Obviously stung by Rodin's bargaining over future prices, Druet retorted: "As for giving you prints at the price I sell them to Monsieur Giraudon, let me recall to you that at the time we were in accord, I always gave you *for free* all the proofs you could have desired. If I wanted to count up the number, it would go up today to several thousand. I told you and I repeat to you that I do not regret it, so great was the affection I had for you. But since you oblige me to stay on the grounds of our reciprocal rights, I will respond to you that the price fixed for Monsieur Giraudon was set at your request, that I only accepted it to be agreeable to you, and that as a result, I have today no reason to give you photographs at a loss."[6]

The archives leave us in the dark as to how this conflict was resolved. Nonetheless, it is clear that the two men managed in the following months to settle their griev-ances. In a letter of 6 May 1901, Druet announced the opening, in two days, of an exhibition of his photographs of Rodin's work, and recalled to the artist his promise to visit the show. On 1 June of the same year, Mme. Druet furthermore wrote to thank Rodin for the loan of frames, presumably for the same exhibition.

On 7 July 1903, Druet wrote to Rodin (on a letterhead no longer advertising his café, but indicating his occu-pation as "Reproduction of Works of Art by Photogra-phy," at 3, place de l'Alma), asking for a personal talk. The letter states that Druet's wife is tired and is obliging him to close the café and take up a calmer life. Druet wishes to talk over this change of life with Rodin and ask his advice. This letter provides suggestive support for the idea that Rodin was influential in advising Druet with regard to his subsequent, and very successful, career as an art dealer. The Druet folder in the Musée Rodin archives holds a clipping from *L'Occident* in December 1903, announcing "A new picture merchant: Druet, the photographer of Rodin's works, installs, 114 Faubourg St.-Honore, a sumptuous store where he shows Van Rysselberghe, Luce, Cross, Signac, Bonnard, Maurice Denis, Guérin, K.-X. Roussel, Séguin, Séruzier, etc., and also photographs after the pictures of these painters, after Rodin, and after some older works."

Despite the success of this new business, Druet per-sisted with photography, documenting the works that passed through his gallery and continuing to work for Rodin. However, the collaboration became more per-functory and impersonal in later years. Rodin's requests for photographs to be made were answered (as in a letter of 2 April 1912) by Druet's assistant, who in turn dispatched anonymous "operators" to make the pictures.

According to Laurent Vizzavona, Druet stopped pho-tographing soon after Rodin's death, around 1920, and his fund of prints and negatives was acquired by the Librairie de France. Vizzavona and his father then bought the collection in 1924, when the building in which it was stored had to be cleared. Although numerous negatives were broken in the process, about fifteen thousand were said to survive. Subsequently acquired by the Musée du Louvre, this large fund of material is inaccessible today but may eventually provide further revelations about Druet and his work.[7] Albums of Druet's specially mounted photos after the works of various artists including Rodin may be consulted in the Cabinet des Estampes of the Bibliothèque Nationale in Paris. A comparison of the images Druet made of the work of

9.18, cat. no. 102.

9.19, cat. no. 170.

other sculptors will confirm that his early collaboration with Rodin pushed him to higher levels of pictorial achievement than he was ever to reach elsewhere.

Fig. 9.18 Tympanum of *The Gates of Hell*, with *The Three Shades*, c. 1898. Gelatin silver print. M.R.ph396.

There are virtually no photographs from Rodin's lifetime of the ensemble of *The Gates of Hell*, although it was the largest presence in his studio and the longest ongoing project of his life. This tends to confirm our understanding of the way in which Rodin worked from fragments toward an additive whole, and our assessment of his relative disinterest (after the earliest stages of the *Gates*) in preorganizing an inclusive compositional schema. Although photography might have been a useful aid in studying the multi-figure composition of the *Burghers* as well, these groups seem to have been photographed in their totality only after their definitive forms had been established.

The Musée Rodin, however, does own two photographs of the *Gates* taken in 1900. One of these (the

other is reproduced by Elsen, *In Rodin's Studio*, plate 18) depicts the skeleton of the portal as shown in the 1900 exhibition, dramatically lighted from below by artificial means. The present photo, though it seems to share that same dramatic lighting, was probably made in Rodin's studio at the Dépôt des Marbres, well before 1900, when the top part of the portal was mounted with its complement of figures. It is remarkably close in light and viewpoint to the photograph used as a basis for a lithographic illustration in an article on Rodin by T.H. Bartlett in *The American Architect and Building News*, 11 May 1889, 223 (reproduced in Albert Elsen, ed., *Auguste Rodin: Readings on His Life and Work* [Englewood Cliffs, N.J.: Prentice-Hall, 1965], 71).

From a technical point of view, Druet's photographs preserved in the Musée Rodin may often seem flawed—unevenly developed, radically shallow in depth of field, oddly focused, poorly exposed, and either cloudy or bleached-out in contrasts. Perhaps, indeed, it was this kind of idiosyncratic look that caused others to advise Rodin to discontinue Druet's rights of sale. Yet this is a highly personal body of work, conceived in telling contact with one of the most intense and fertile periods of Rodin's creative life; and it contains images of exceptional impact and beauty.

Fig. 9.19 *Avarice and Lust*, c. 1898. Gelatin silver print. M.R.ph947.

The highlights and overall brightness here suggest Druet's work with artificial lighting, which shows the dark, reflective bronze to advantage. The arrangement of the paper and/or drapery around the group is typical of Druet

9.20, cat. no. 171.

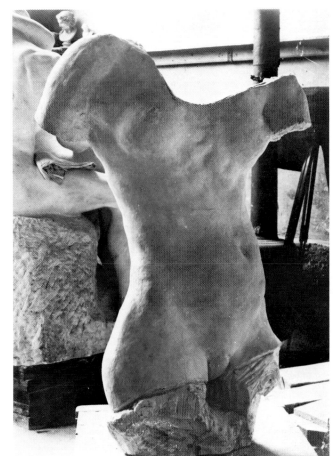

9.21, cat. no. 172.

(as opposed to earlier photographers, but consistent with Rodin's drawings after the sculptures) in its attempt to mask the studio surroundings and place the figure in a darker environment.

Fig. 9.20 *Meditation*, rear view, c. 1898. Gelatin silver print. M.R.ph943.

Fig. 9.21 Enlarged *Torso of the Martyr*, c. 1898. Gelatin silver print. M.R.ph310.

By using *contre-jour*, reflected light to relieve the shadows (and purposeful over-exposure in the case of *Meditation*), Druet turns the chalky paleness of these plasters to artistic capital, and creates silhouetted shapes as flat and crisply graceful as those of a watercolor wash, in dialogue with the volumetric modeling of the internal shadows. This combination of fine, stressed outline and unified interior tone directly reflects Rodin's aesthetic preoccupations of the late 1890s, as manifest for example in his watercolors (see figs. 7.59, 7.64, 7.69).

Fig. 9.22 *Despair*, c. 1898. Gelatin silver print. M.R.ph948.

This kind of radically foreshortened view does not appear in the photos Rodin had taken of his work in the 1880s. It reveals the interest in eccentric perspectives and the abstract silhouetting of compressed form that we find in Rodin's figure drawings of the late 1890s (see figs. 7.64, 7.68).

Fig. 9.23 *The Kiss*, 1898. Gelatin silver print. M.R.ph373.

Fig. 9.24 *Eve*, rear view, 1898. Gelatin silver print. M.R.ph946.

Fig. 9.25 *Eve*, profile, 1898. Gelatin silver print. M.R.ph945.

Fig. 9.26 *Eve* and *The Kiss*, 1898. Gelatin silver print. M.R.ph944.

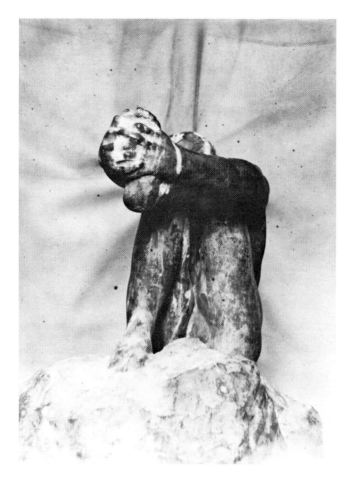

9.22, cat. no. 173.

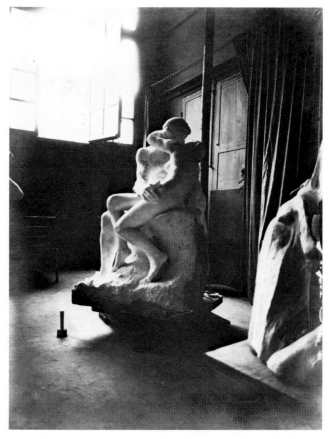

9.23, cat. no. 174.

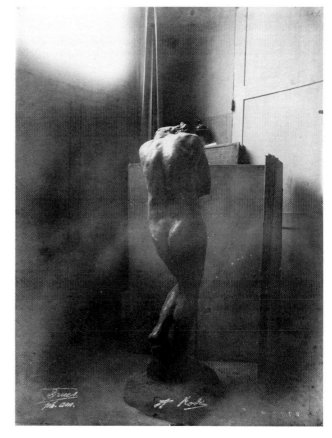

9.24, cat. no. 175.

Fig. 9.27 *Balzac*, 1898. Gelatin silver print. M.R. ph950.

Fig. 9.28 *Balzac*, half-length, 1898. Gelatin silver print. M.R.ph949.

It seems, given the studio and the objects in it, that this group of photographs was taken at the Dépôt des Marbres just prior to the Salon of 1898 in which Rodin showed the *Balzac* for the first time, together with a newly completed marble of *The Kiss*. This was a moment of tremendous import and tension for Rodin, and, as if in acknowledgment of the energy in the air, these are among the most stunning photographs of Rodin's work ever made. Unlike other of Druet's works, they are not carefully set up with drapery, and they are shot with (scant) available light, more in the spirit of the Bodmer and Pannelier work of the previous decade. But in their use of light, and in their location of the works in space, these images have an unprecedented drama. They fairly glow with emotion interpretive of the work they show: *The Kiss*, benignly radiant against the shadows; *Eve*, huddled in the most profound darkness, scourged by

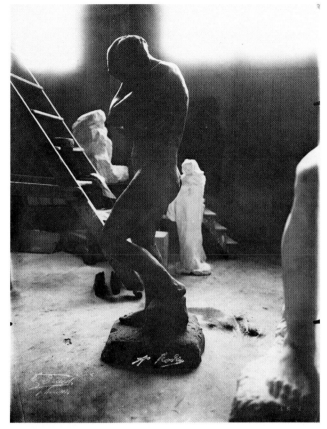

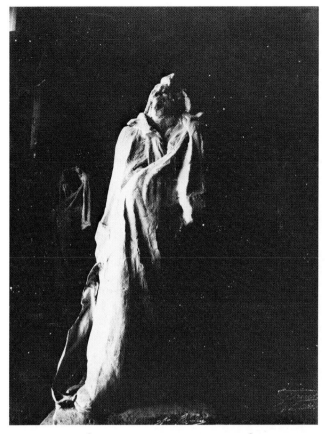

9.25, cat. no. 176. 9.26, cat. no. 177. 9.27, cat. no. 178. 9.28, cat. no. 179.

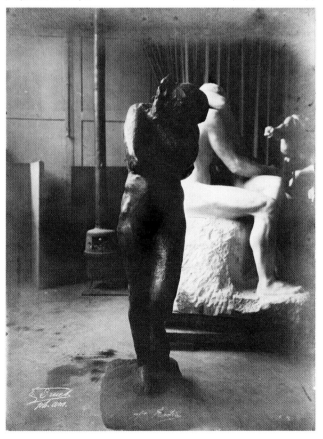

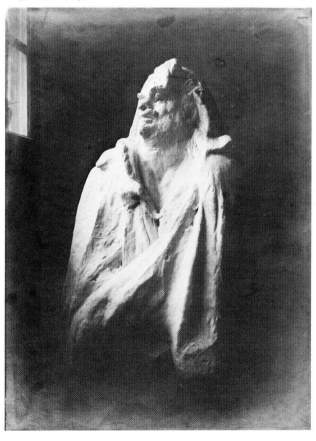

9.29, cat. no. 180.

9.30, cat. no. 181.

light from above; and finally *Balzac*, pressing closer than any of the others, seen from a lower viewpoint, looming out of the darkness like a mountainous specter. By the time Steichen came to photograph the *Balzac* (see figs. 9.56–9.61), it had become something more settled and remote, a dream set in nature, seen at a distance against the sky. Druet, in the gray light from a high window, gives us a *Balzac* before the world had known it, still tensely physical in presence, just emerging from the private darkness of an arduous creation, colossally dominant over the human space that spawned it.

Fig. 9.29 *Balzac* in the Salon of 1898, 1898. Gelatin silver print. M.R.ph375.

Fig. 9.30 *The Burghers of Calais* on a scaffolding, c. 1910(?). Gelatin silver print. M.R.ph938.

Rodin called on Druet, and on Bulloz as well, to document for his study an experiment in the elevated installation of this monument, after the initial bronze version had been installed at Calais (the setting is Meudon, where Rodin established residence after the Calais *Burghers* had been inaugurated). The experiment

seems to connect to two things: Rodin's continued ambivalence as to whether the *Burghers* would be best seen on a radically low or a radically high pedestal—an internal debate perhaps reawakened by the commission to install the *Burghers* in a London park; and his desire, witnessed by the outdoor placement of the *Balzac* as well (see especially figs. 9.56, 9.57, 9.61) to test his public sculpture against the backdrop of the sky.

Fig. 9.31 *The Clenched Hand* (horizontal and inverted), c. 1899. Gelatin silver print. M.R.ph939.

Fig. 9.32 *The Clenched Hand* (seen from back), c. 1899. Gelatin silver print. M.R.ph942.

Fig. 9.33 *The Clenched Hand* (horizontal with fingers to left), c. 1899. Gelatin silver print. M.R.ph941.

Fig. 9.34 *The Clenched Hand* (vertical), c. 1899. Gelatin silver print. M.R.ph940.

9.31, cat. no. 182.

9.32, cat. no. 183.

9.33, cat. no. 184.

9.34, cat. no. 185.

Rodin's photographic experiments with different points of view confirm his belief that the meaning and expressiveness of a form was not fixed, but variable and endlessly renewable according to context and manner of presentation. This series of photos represents a far more radical statement of Rodin's insistence on seeing from all sides than do Pannelier and Bodmer's multiple images of the *Burghers*. The Druet series is closer to the manipulations evident in the life drawings, in a series of reorientations such as that seen in figs. 7.65–7.68.

NOTES

1. L. Vizzavona, "Druet, photographe des impressionistes," in *Nouvelles de l'estampe*. See note 18, introductory section, above. Vizzavona states that Druet was already a professional photographer, working in the rue Alasseur, when he met Rodin.
2. "M. Rodin aura toujours le droit d'interdire la vente de photographies qui lui paraîtraient insuffisament artistiques ou des photographies de telle ou telle de ses oeuvres sans qu'il puisse, d'ailleurs, dans ce

cas, avant le 31 Octobre 1900, conceder le droit de reproduction ou de vente à une autre personne, ou en user lui-même avant la même date et sans qu'il y ait lieu à indemnité de part ni d'autre."
3. Monsieur,
 A la suite de notre conversation de dimanche 4 courant, voici ce que je vous demande:
 1° De ne mettre aucune de mes épreuves à votre pavillon de la Place de l'Alma et autres expositions que vous pourriez faire par la suite.
 2° De n'en faire aucune reproduction
 3° De ne les faire reproduire dans aucuns journaux, revues, etc.
 Je reserve d'ailleurs tous mes droits de propriété.
 Recevez, Monsieur, mes civilités.
 E. Druet
 Je désirerais que vous m'accusiez reception de la presente.
 Il est bien entendu que les épreuves annoncées plus haut sont des épreuves photographiques de vos oeuvres.

4. Monsieur,

J'ai reçu votre lettre du 24 août dernier. Vous y faites allusion à la 'scene facheuse' du 18 du même mois. Ne m'ayant pas entendu, il ne vous ait pas permis de donner sur elle une appreciation.

Pour terminer des rapports difficiles: veuillez me faire etablir et envoyer un compte detaillé de ce qui me revient.

Je vous prierai de fair diligence.

Je vous previens en outre que pour l'établissement et le reglement de ce compte je ne veux avoir aucun rapport avec M. Peytel, mon traité etant passé personnellement avec vous rend cette condition possible.

Dans l'attente d'une prompte reponse, agréez, Monsieur, salutations.

E. Druet

5. Monsieur Rodin,

Je vous avoue que je suis surpris de votre attitude; lorsque vous m'avez quitté un peu brusquement il y a un mois, je supposais, qu'à la reflexion vous comprendriez tout ce que votre conduite à mon égard a d'injuste et je pensais qu'en souvenir de ce que j'ai fait pour vous, vous reviendrez sur un mouvement de mauvaise humeur.

Aujourdhui je vois qu'il faut en prendre mon parti, et puis-qu'il n'y a plus maintenant que nos interets à regler, je viens faire auprès de vous une demarche aimable avant d'en venir à une reclamation en justice.

Vous me devez d'après nos comptes, pour l'Exposition un solde de 4,502 fr. 15; je vous prie de bien vouloir me faire remettre cette somme.

Au surplus, vous m'avez reconnu ce chiffre la dernier fois que nous en avons parlé; mais vous avez émis la pretention de ne me rembourser que contre une quittance dans laquelle je renoncerais au droit que vous m'avez consenti, de vendre les photographies de vos oeuvres.

Je sais bien que cette idée n'est pas de vous; vous connaissez comme moi le nom de la personne qui vous pousse dans cette voie—mais vous savez aussi que cette pretention n'est ni juste ni fondée. Permettez de vous rappeler en quelques mots ce qui s'est passé.

Lorsque je vous ai connu et que vous m'avez demandé de photographier vos oeuvres, je me suis plié à toutes vos exigences. J'ai accepté vos conseils et votre direction, et je me suis scrupuleusement conformé a vos desirs.

Vous avez bien voulu me dire à plusieurs reprises que vous étiez satisfait et je trouve le marque de votre contentement dans ce fait que vous avez tenu à faire figurer mes photographies dans votre Exposition Place de l'Alma.

Je n'ai pas besoin de vous rappeler tout ce que ces photographies ont couté a etablir; vous savez que les dépenses totales ont été supportés par moi et que je n'ai rien reçu de vous.

Vous savez aussi tout le temps que j'y ai passé.

De mon côté je n'ai rien negligé pour arriver à vous contenter.

J'ai détruit sans me plaindre les clichés qui n'était pas entierement à votre convenance. Lorsque vous avez desiré des épreuves, j'en ai mis gratuitement à votre disposition.

Je vous en ai donné autant qu'il en a fallu pour toutes les reproductions qui vous ont paru utile: journeaux, revues, livres, etc.

Vous avez voulu donner à la Plume une série de clichés pour la formation de volumes, j'ai accepté de le faire sans retribution.

Vous avez même desiré que je traite avec M. Giraudon, rue Bonaparte, pour la vente de mes epreuves à des conditions onereuses pour moi; je m'y suis soumis, faisant passer avant mon interêt propre, le desir que j'avais de répandre votre art dans le quartier de l'Ecole des Beaux-Arts. Vous m'avez dit qu'il y avait pour vous une avantage artistique; je n'ai pas hesité.

Pourquoi donc aujourd'hui, apres quatres années, voulez vous m'interdire de vendre des épreuves pour lesquelles j'ai fait tant de sacrifices.

Refléchissez et vous comprendrez que votre persistance serait de l'ingratitude; je pourrais vous ajouter que votre pretention leserait gravement mes droits.

J'aime mieux croire que vous n'y avez pas songé. Donc, ne confondons pas deux choses distinctes, veuillez me payer ce qui m'est du aux termes de nos conventions pour l'Exposition.

Quant au reste j'espère que vous ne persisterez pas dans une pretention qui ne repose sur rien.

Veuillez agréer, Monsieur, l'expression de mes meilleurs sentiments.

E. Druet

6. "Quant à vous ceder des épreuves au prix ou je les vendais à Monsieur Giraudon, laissez-moi vous rappeler qu'à l'époque ou nous marchions d'accord, je vous ai toujours remis *gratuitement* toutes les épreuves que vous avez pu desirer.

Si j'en voulais chiffrer le nombre, il s'élèverait aujourd'hui à plusieurs milliers. Je vous ai dit et je vous le répète que je ne le regrette pas, tant etait grande l'affection que j'avais pour vous.

Mais puisque vous m'obligez à rester sur le terrain de nos droits reciproques, je vous repondrai que le prix fixé à M. Giraudon l'a été sur votre demande, que je ne l'ai accepté que pour vous etre agréable, et qu'en conséquence, je n'ai aujourd'hui aucune raison pour vous ceder à perte des photographies. . . ."

7. Vizzavona, "Druet photographe des impressionistes" (see note 18, introductory section, above), gives this account of the history of Druet's legacy.

JACQUES-ERNEST BULLOZ

Rodin began in the spring of 1903 to look for a new photographer. On 23 March 1903 he wrote to the Adolphe Braun firm, Braun-Clement, proposing an arrangement with them. Apparently this had no issue, but he was able shortly thereafter to come to an agreement with the firm of J.-E. Bulloz. On 15 April 1903, Bulloz sent to Rodin a copy of a contract, based on a previous conversation between the two men. Rodin in turn submitted the contract to his attorney for legal scrutiny. His lawyer, who had apparently discussed the matter with him before, advised Rodin on 17 April that the contract "seems to me notably more advantageous than the ordinary conditions obtained by artists from other photographers." He nonetheless suggested that the contract specify that Rodin was restricted from giving authorizations to other photographers *from then on*, in

order to avoid confusion regarding authorizations already given. He also urged Rodin to add a clause allowing renunciation of the contract "in case you are not satisfied with the results whether artistic or financial and above all reserve for yourself all artistic direction of the lighting of your works, in order to remain absolute master of their presentation from an artistic point of view."

Rodin and Bulloz then signed on 15 May an agreement for the publication of a collection of 100 reproductions (to be sold separately or as a collection) that year, in varied formats "according to the importance of the work." Rodin was to pay all expenses of the endeavor, and to draw two-thirds of the profits. He insisted that special account books be kept and that a system of punch-marking the photos be worked out. The clauses suggested by his lawyer were added, notably the one stating that "Monsieur Rodin reserves for himself the artistic direction of the reproduction of his works relative to lighting and disposition." Bulloz was furthermore obliged to guarantee Rodin an annual income of not less than 200 francs from this enterprise and to furnish Rodin with any prints he wanted at cost.

Although no subsequent contract exists to enlarge the collaboration, the duration of the correspondence and its contents show that Rodin came to depend heavily on Bulloz as his primary source of reproductions for publication and as his agent in other services. A great deal of the correspondence concerns matters of accounting, but there are more broadly revealing moments as well. Rodin's practice of trying out assembled compositions and recording these in photographs (see for example fig. 9.67) is suggested by Bulloz's letter of 20 February 1904, in which he says he will send someone to Meudon to take "three or four negatives of the little assembled maquettes as you indicated." Rodin's attention to the quality of the Bulloz photos is indicated in Bulloz's reassurances of 13 March 1904, "As for the marbles I'm taking the greatest care and you can rest easy on this matter." Yet this continued to be a problem, and Bulloz had to defend himself in a letter of 12 January 1908: "As for the background I regret that it turned out still too black but if you remember it was almost white, a very slightly tinted grey; in spite of that, with the white marbles whose brilliance (éclat) is unique, it went to black. The next time I will have them take a white that will perhaps be sufficient. Moreover for the bronzes taken outside, I had placed no backdrop at all, but just the distance out of focus (des lointains flous)."

Besides remonstrations regarding quality, Rodin also gave instructions concerning works that could not be sold in reproduction. As late as 1904, for example, the availability of photos of the *Balzac* seems to have been purposefully limited; Bulloz wrote on 2 November: "Mr. Lawton came to ask me for a 'Balzac' on your behalf but I told him that there was some error, the only photographs that I know of being sold it seems, without your knowledge." Faced with a request for a photograph of the bust of a woman Rodin had exhibited at the Salon in 1909, Bulloz wrote to ask for permission, since "following your instructions, I have pulled no prints of the busts of women." On 17 July of the same year, Bulloz again asked for help in the face of a list of demands from a German magazine, "among which a certain number of busts you told me not to place on sale."

Bulloz, more than simply a supplier of photos, was a general watchdog for Rodin's copyright privileges, taking care to warn him of unauthorized publications of his work. The photographer made sure, even in the absence of Rodin's complaints, that his negatives were of sufficient quality to do the sculpture justice; hence his pleas (letter of 21 December 1907) to make a new negative of the *Eternal Springtime* in marble (see fig. 9.39), the old negative having been worn out by tremendous demand for prints.

Fig. 9.35 Overview of Rodin's studio at Meudon, c. 1912(?). Gelatin silver print. M. R. ph966.

Rodin had the specially designed building of his 1900 Place de l'Alma exhibition disassembled and then rebuilt as a studio beside his villa at Meudon. There it became not only a working space but also a "Musée Rodin" visited by a steadily growing tide of admirers. The building has since been replaced by a more solid structure. This view of a part of the space suggests a non-working orderliness, and may even have been taken after Rodin's death.

Fig. 9.36 *The Shade* (rear), c. 1908(?). Gelatin silver print. M.R.ph969.

Fig. 9.37 Study for the *Whistler Monument* (rear), c. 1906. Gelatin silver print. M.R.ph968.

Fig. 9.38 Head of *La France*, c. 1906. Gelatin silver print. M.R.ph970.

In addition to publicity photos, Bulloz continued to make documents for Rodin's own study, allowing him to judge the look of plaster-coated sheet being used to prepare drapery (fig. 9.37); to gauge the effect of afternoon

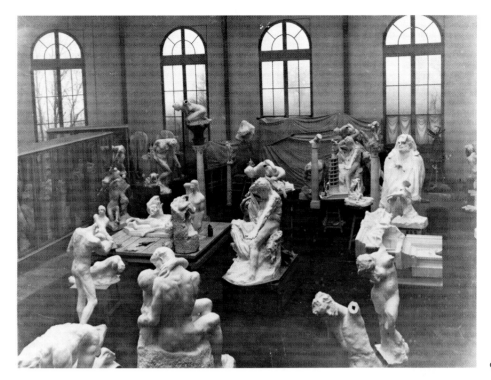

9.35, cat. no. 103.

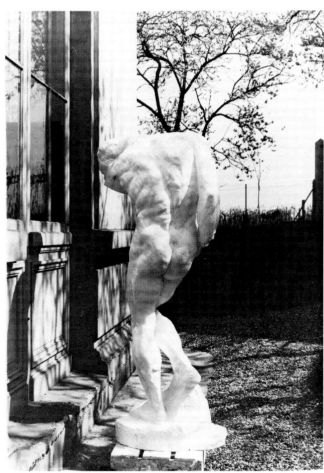

9.36, cat. no. 104.

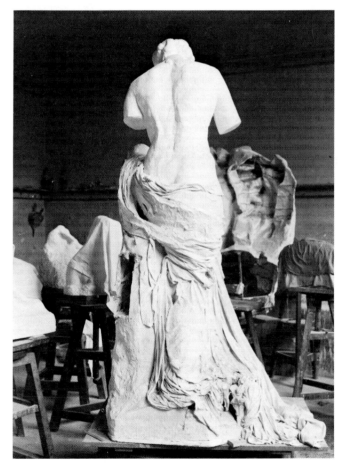

9.37, cat. no. 105.

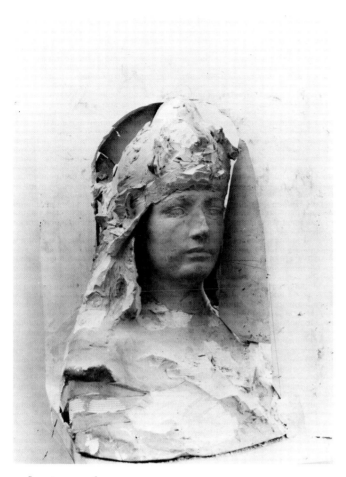

9.38, cat. no. 106.

sunlight on the modeling of a back (fig. 9.36); or to previsualize the transformation of a plaster portrait head into a three-quarter relief monument, via a simple cardboard shield and clay overworking (fig. 9.41). As Elsen has pointed out (*In Rodin's Studio*, 21–22), Rodin manifested his willingness to make public the private workings of his studio by selecting this latter image of the incomplete *La France* for replication in postcard form. (Bulloz published postcards of Rodin's work and lantern slides as well.)

Fig. 9.39 *Eternal Springtime*, c. 1910. Gelatin silver print, tinted. M.R.ph975.

Fig. 9.40 *The Evil Spirits*, c. 1910. Gelatin silver print, tinted. M.R.ph976.

Fig. 9.41 *Fallen Caryatid*, c. 1910. Gelatin silver print. M.R.ph967.

Fig. 9.42 *Joan of Arc (Head of Sorrow)*, c. 1910. Gelatin silver print. M.R.ph978.

A broad span of Rodin's career can be seen, and the range of his involvement with photography judged, by comparing the marble *Eternal Springtime* as seen by Bulloz (fig. 9.39) with the earlier Bodmer photograph of

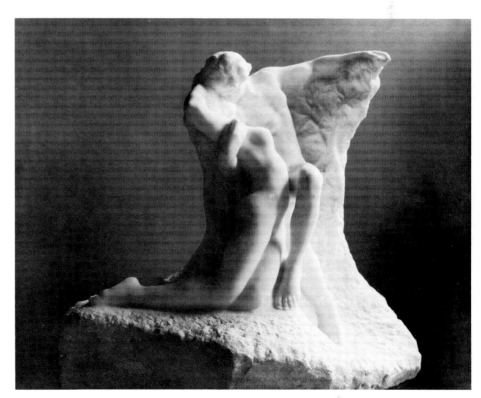

9.39, cat. no. 186.

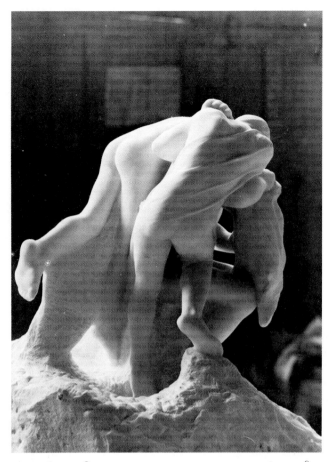

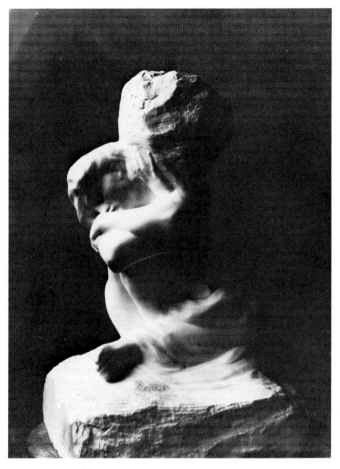

9.40, cat. no. 187. 9.42, cat. no. 189.

9.41, cat. no. 188.

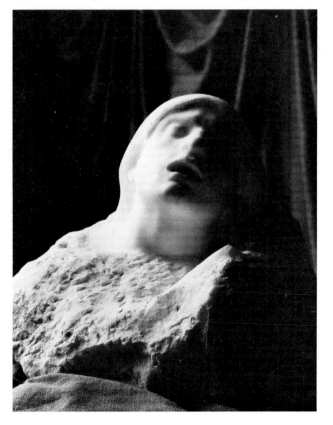

the same sculpture just coming to completion in clay (fig. 9.6). Similarly, one might compare the glamorous, shadowy illumination of Bulloz's photographs of these marble works with the lighting of Druet's photographs of c. 1898 (figs. 9.22–9.28). Such comparisons emphasize the ways in which the "rough edges" have been removed, not only from the forms themselves, but also from the photographic style that deals with them. Bulloz's glowingly tinted, wondrously suave images give us valuable access to the kind of taste that, in Rodin's lifetime, prized these marble sculptures as the high point of his achievement. The feeling cannot be escaped however that, in the photographic vision at least, the excellence of technique is informed by the certitude of formula, and that a certain depletion of vitality has occurred.

Fig. 9.43 Bust of *Eve Fairfax*, c. 1906. Gelatin silver print. M.R.ph977.

Fig. 9.44 Bust of *Mrs. Simpson*, c. 1904. Gelatin silver print. M.R.ph971.

9.43, cat. no. 191.

9.44, cat. no. 190.

The rich and the famous literally besieged Rodin, at the end of his career, with requests for portraits. The graciously idealizing qualities of these marbles suggest some of the reasons why, especially in the case of women, he should have been so sought after. Bulloz worked (despite the fact that such photos of women's portraits were apparently not to be sold—see above) to increase the muted qualities of the modeling and to stress the pale pure glow of the marble, by casting much of the form into shadow, and by avoiding a harsh contrast with the background. The backdrop of atmospheric *flou* was obtained, as is most evident in fig. 9.43, by having assistants agitate a cloth, which turned to blur during the relatively slow exposure of the film.

Mrs. John Woodruff Simpson, who inscribed the photograph of her portrait (fig. 9.44), was a benefactor of the National Gallery of Art, giving among other things drawings dedicated to her and her husband by Rodin in 1908 (see figs. 7.69, 7.73, 7.74).

Fig. 9.45 *Balzac*, 1908. Gelatin silver print. M.R.ph973.

Fig. 9.46 *Balzac* (profile), 1908. Gelatin silver print. M.R.ph972.

Fig. 9.47 *Balzac* (rear), 1908. Gelatin silver print. M.R.ph974.

When Rodin moved the plaster *Balzac* out of his studio into a nearby field at Meudon, it was not solely for the benefit of Edward Steichen. He also called in other photographers, Bulloz among them, to profit from the occasion. Bulloz's series of views lacks the nocturnal drama of Steichen's, having apparently been taken at dawn. More than Steichen's images, though, these reconfirm Rodin's desire to have the work seen from all possible viewpoints; they show us the turntable apparatus Rodin set up for this purpose, heavily masked with dark cloth. Consistent with Rodin's desire to see the figure in muted light, cloaked in atmosphere rather than simply contrasted with a bright ground, Bulloz has made the photographs in slow exposure under foggy or cloudy conditions—conditions he may have exaggerated (see fig. 9.45 especially) by some manipulation of the negatives or of the printing.

9.45, cat. no. 192.

9.47, cat. no. 193.

9.46, cat. no. 194. (9.45-9.47 Bulloz, cat. nos. 192-194)

EDWARD STEICHEN

Steichen recounted in later life the chain of events that brought him to Rodin: first, his discovery of the *Balzac* in a small reproduction in a Milwaukee newspaper ("Even from this little reproduction I felt it was one of the great achievements of an artist"); then, his glimpse of the master in the exhibition pavilion on the place de l'Alma, just after Steichen's arrival in Paris in 1900; and finally, his meeting with Rodin in 1901 through the good offices of the painter Frits Thaulow, when Steichen showed his portfolio and blurted out his desire to make a portrait of Rodin.[1]

The Musée Rodin archives contain the (undated) letter that undoubtedly followed immediately upon the first meeting. Steichen wrote in French, probably with the help of someone better versed in the language than he:

Dear Master,
 Permit me to offer you some of my photographic prints, from among those that you honored with your attention the other evening when I had the honor to be presented to you by Monsieur and Madame Thaulow.
 I very much appreciated the encouragements you gave me, and all the more so coming from you for whom I have been professing such a high admiration for a long time, the greatest master of our time.
 Would it be an indiscretion to ask you the favor of making some photographic portraits of you in your studio, this would be an honor that would make me very happy. . . ."[2]

Steichen later recounted that his famous portrait of Rodin seated in silhouetted profile facing *The Thinker*, with the white *Victor Hugo* monument behind, had been the product of a year's study.[3] The previously unpublished gum-bichromate image of *The Thinker* in the present exhibition (fig. 9.48), dated 1901, may be part of the preparatory work toward the portrait. By March of 1902, Steichen had made at least one portrait of Rodin.[4] Rodin's response to Steichen's work, including special approbation for Steichen's early self-portrait, were in the meantime no doubt crucial boosts to the young photographer's courage.[5]

Steichen in turn worked hard at promoting Rodin's work in the United States and was instrumental in arranging for Rodin's drawings to be the first avant-garde European art exhibited at Alfred Stieglitz's "291" Gallery in New York, in 1908. In 1903 (as is clear from the reference to a portrait of J. P. Morgan), Steichen wrote to Rodin from New York, to inform him and to ask a favor:

My Dear Master,
 I'm sending you (included herewith) some stereotype proofs that will soon appear in a book dedicated to my photographic work. I will send you several proofs of your portrait which will perhaps be useful for you and your friends.
 I'm extremely happy to see how your work is appreciated here in America—you yourself will be surprised. I hope that this will develop in a more material form and that we will have many of your beautiful creations in this country before long. It's always the people with the most money who have the least understanding of art. I've had a lot of success since my arrival. I have just made portraits of a lot of prominent people, among others Mr. Pierpont Morgan the man of millions who was very friendly toward me. I have the hope of interesting him in your work, to procure for you some big commissions for our new museum of sculpture.
 And Master if you would only write me a few words that I will cherish, and especially a line for Art, that I could have printed with your portrait for the frontispiece of my book—that would make us very happy and help us in the feeling that we are serious in our artistic intentions, even if the medium is only photography.
 I hold many memories, dear master, of you and your kindness toward me—but above all the influence of your great art. And your noble personality helps me and encourages me always. You will understand that in this city we often have a nostalgia, not only for Paris but for you master. . . ."[6]

The request in this letter may lie at the origin of the statement Rodin made in *Camera Work*, October 1908, regarding photography in general and Steichen in particular:

I believe that photography can create works of art, but hitherto it has been extraordinarily bourgeois and babbling. No one ever suspected what could be got out of it; one doesn't even know today what to expect from a process which permits of such profound sentiment, and such thorough interpretation of the model, as has been realized in the hands of Steichen. I consider Steichen a very great artist and the leading, the greatest photographer of the time. Before him nothing conclusive had been achieved. It is a matter of absolute indifference to me whether the photographer does, or does not, intervene. I do not know to what degree Steichen interprets, and I do not see any harm whatever, or of what importance it is, what means he uses to achieve his results. I care only for the result, which, however, must always remain clearly a photograph. It will always be interesting when it is the work of an artist.[7]

Rodin here shows himself—undoubtedly due to Steichen's priming—to be remarkably *au courant* of the debates surrounding the aesthetic viability of manipulated images, especially those resulting from gum-bichromate printing, that divided the photographic world in the pre–World War I period. Steichen's heavily stylized images were a particular focus of this controversy, and, as Weston Naef has pointed out, Steichen was accused of "faking negatives and prints or both."[8] Rodin's expressed disinterest in such questions to the contrary notwithstanding, the issue of process seems especially important in regard to the Steichen prints conserved at the Musée Rodin. Naef points out that Steichen "devoted much energy to devising ways of replicating in a second material (such as gelatin-silver or gelatin-carbon) qualities first

9.49, cat. no. 196.

9.48, cat. no. 195.

attained in experimental prints where each was unique (gum-bichromate, for example). The most accessible way of replicating unique originals was to photograph the experimental original and use the copy negative in combination with one or more printing methods such as gelatin-silver enlarging ("bromide") materials that were toned or overlaid with a single printing of pigmented gum-bichromate. The results were highly deceptive facsimiles of the original multiple gum prints few of which have survived."[9]

In the cases of the studies of the heads of Clemenceau (figs. 9.52–9.55) and Hanako (figs. 9.49–9.51), as well as in other series in the Musée Rodin collection (of the busts of Thomas Ryan and the Duchesse de Choiseul), Steichen seems to have given Rodin proofs printed in gelatin-carbon from copy negatives made from original gum-bichromate prints (the latter now lost). For the crucial series of the *Balzac* by moonlight, though, the Musée Rodin owns what appear to be the only surviving gum-bichromate prints, including several images heretofore unknown. With the other gum prints in the collection, these form an invaluable point of reference

for Steichen studies, as such unique prints from Steichen's early period are rare in the extreme, and the negatives for the images have been lost.

Fig. 9.48 *The Thinker*, 1901. Platinum gum bichromate print. M.R.ph229.

The mottled swirling atmosphere created by Steichen's selective development with a brush gives this print a strong resemblance to those earlier photos—by Bodmer for example—that Rodin elaborated with his own washes of ink or gouache. Many of the photos Steichen gave Rodin were undoubtedly mounted by the photographer on colored paper, but this is one of the few prints that still retain the original support.

Fig. 9.49 Head of *Hanako*, 1908. Carbon print. M.R.ph673.

Fig. 9.50 Head of *Hanako*, 1908. Carbon print. M.R.ph986.

9.50, cat. no. 197.

9.51, cat. no. 198.

Fig. 9.51 Head of *Hanako*, 1908. Carbon print. M.R.ph674.

Albert Elsen has elsewhere described the history behind Rodin's 1908 modeling of several small heads of the Japanese dancer Hanako (*In Rodin's Studio*, 183). As with Rodin's 1906 drawings from Cambodian dancers (and his employment of cancan dancers as models), these studies of fierce grimaces attest to the sculptor's continuing interest in movements and gestures whose expressiveness escaped the traditional canons of Western art.

Their intensity also far surpasses anything Steichen himself sought to obtain in his own figure studies and portraits of the time. These latter, while beautiful and sometimes powerful (like the portrait of J. P. Morgan), never dared such a close-in concentration on emotionally evocative features. The radical closeness of the subject to the lens is exaggerated by Steichen's selective development of the original print from which these copy images were apparently made. Watery blurring of the background area contracts the already shallow depth of field and sharpens the relief of the features, stressing a

myopic viewing distance that corresponds—likely in more than coincidental fashion—to Rodin's own working vision of the mask.

Fig. 9.52 Bust of *Clemenceau*, c. 1912. Carbon print. M.R.ph426.

Fig. 9.53 Bust of *Clemenceau*, c. 1912. Carbon print. M.R.ph680.

Fig. 9.54 Bust of *Clemenceau*, c. 1912. Carbon print. M.R.ph393.

Fig. 9.55 Bust of *Clemenceau*, c. 1912. Carbon print. M.R.ph987.

The project for a bust of the French statesman Clemenceau, begun with the subject sitting numerous times in 1911, was seemingly one of the most obsessively pursued of Rodin's later years. Rodin moved restlessly through numerous versions (Elsen counts thirteen of them in the

9.52, cat. no. 199.

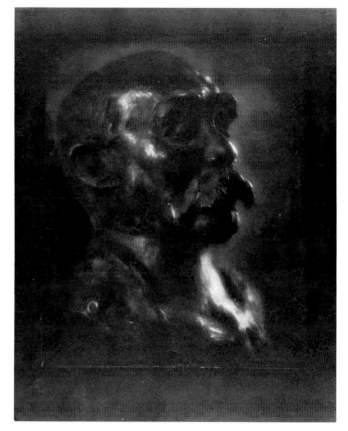

9.53, cat. no. 200.

9.54, cat. no. 201.

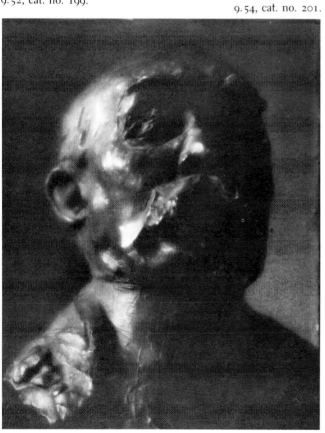

9.55, cat. no. 202.

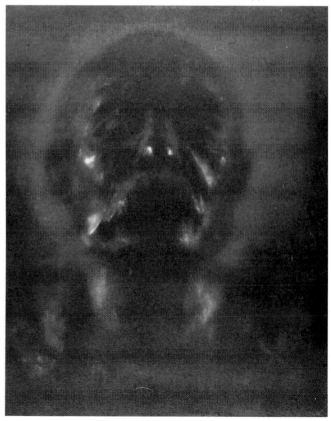

Musée Rodin reserves). Exploiting the resources of a well-staffed studio, he had each phase cast in plaster. In this and other such cases, Rodin's greater wealth and the resultant ease of intermediary castings may have reduced his interest in ordering photographs, like those of the 1880s, to document successive phases of the work. In any event, there are no such photographs relating to the Clemenceau project. The final bronze bust, rejected by Clemenceau, was photographed by Steichen in a series of images until recently unknown. By muting the lighting—real moonlight or its approximation—Steichen set the head in deep, velvety shadow, blunting the multiple roughness of the metal and picking out a few salient features in misted, ghostly highlights. The final effect, very much in keeping with tendencies in Rodin's aesthetic in later years, closely resembles that of the works (especially lithographs) of Rodin's contemporary, the painter Eugène Carrière. The craggy, pugnacious features of Clemenceau are thus subsumed in a nocturnal symbolist reverie. Here, as in the images of Hanako, Steichen seems to have made an original set of unique gum prints—emphasizing the *flou* and misted effects in their development—and then printed the present images from copy negatives of those originals.

Fig. 9.56 *Balzac* ("Toward the Light, Midnight"), 1908. Gum bichromate print. M.R.ph226.

Fig. 9.57 *Balzac* ("The Silhouette, 4 A.M."), 1908. Gum bichromate print. M.R.ph224.

Fig. 9.58 *Balzac* ("The Open Sky"), 1908. Gum bichromate print. M.R.ph255.

Fig. 9.59 *Balzac*, 1908. Gum bichromate print. M.R.ph223.

Fig. 9.60 *Balzac*, 1908. Gum bichromate print. M.R.ph222.

Fig. 9.61 *Balzac*, 1908. Gum bichromate print. M.R.ph235.

Steichen recalled in 1963:

Late in the summer of 1908, I received word from Rodin that he had moved his Balzac out into the open air so that I could photograph it. He suggested photographing it by moonlight. I immediately went out to Meudon to see it and found that by daylight the white plaster cast had a harsh, chalky effect. I agreed with Rodin that under the moonlight was the proper way to photograph it. I had no guide to refer to, and I had to guess at the exposure.

I spent the whole night photographing the Balzac. I gave varying exposures from fifteen minutes to an hour, and secured a number of interesting negatives. The three most important results are shown in [figs. 9.56, 9.57, 9.58 of the present exhibition].

In the morning, at breakfast, when I lifted my napkin from my plate, I found two one-thousand franc notes. That was four hundred dollars, a fabulous present for a night's work. It was typical of the generosity of Auguste Rodin. Instead of showing Rodin proofs, I immediately made enlarged negatives and commenced printing.

It wasn't until a week or two later, when I had fine pigment prints, that I turned up to show them to Rodin. The prints seemed to give him more pleasure than anything I had ever done. He said 'You will make the world understand my Balzac through these pictures. They are like Christ walking in the desert.'[10]

Steichen later gave another version of the story, in which the whole project originated as his idea.[11] It seems clear, though, that in fact Rodin himself took the initiative, both in placing the work outdoors (and not solely for the benefit of Steichen—see figs. 9.45–9.47, 9.75–9.77) and in suggesting moonlight. Dennis Longwell has cited a letter from Steichen to Alfred Stieglitz, written in 1908 and tending to confirm these points:

Been photographing and painting Rodin's Balzac—he moved it out in the open air and I have been doing it by *moonlight*—spent two whole nights—from sunset to sunrise—it was *great*—It is a commission from himself.[12]

Longwell further cites another letter to Stieglitz, apparently written near the time of Steichen's first dispatch of prints from the *Balzac* series to New York:

But the Balzacs—I wonder how they will strike you and Caffin—They are the only things I have done of recent that I myself can feel enthusiastic over—And they simply have hit everybody that has seen them here square between the eyes. . . . I hope you can give them a show to themselves if only for a week—The three big ones are a series and should be hung on one wall—The rest any way you choose.[13]

The "three big ones" are almost certainly the same three images Steichen later identified as the most important (figs. 9.56, 9.57, 9.58) and constitute a temporal series: "Toward the Light, Midnight"; "The Silhouette, 4 A.M."; and "The Open Sky." The prints shown by Stieglitz in New York are apparently the same he bought and gave to the Metropolitan Museum of Art.[14]

Rodin's desire to have the *Balzac* shown outdoors in the night undoubtedly owed both to his original vision of Balzac working in his long robe (as per the writer's legend) late into the night and to his belief that the qualities of unity and/or synthesis he had sought in the form would best be seen in such conditions.[15] His wish happily coincided with Steichen's own aesthetic, as the young photographer's earliest successes had been in

9.56, cat. no. 203.

9.58, cat. no. 205.

9.57, cat. no. 204.

9.59, cat. no. 206.

9.60, cat. no. 208.

9.61, cat. no. 207.

moodily moonlit landscape photos, conceived in a late symbolist fashion.[16] All of the *Balzac* prints kept by Rodin have now been removed from Steichen's original mounts, and some have been damaged by foxing and abrasion. The positive aspect of the separation from the mounts is the visibility of the notes with regard to color toning which Steichen made on the verso of each print (these may have related to the mount paper chosen as well): on fig. 9.56, *9 gray blue*; fig. 9.57, *green blue*; fig. 9.58, *4 gray blue*; fig. 9.59, *11 gray green*; fig. 9.60, *n°6 green blue*; and fig. 9.61, *8 gray blue*.

NOTES

1. Edward Steichen, *A Life in Photography* (New York: Doubleday, 1963).

2. (on letterhead of 83, Boulevard du Montparnasse, without date)

Cher Maître,

Permettez-moi de vous offrir quelques-unes de mes épreuves photographiques, parmi celles que vous avez bien voulu honorer de votre attention l'autre soir quand j'ai eu l'honneur de vous être presenté par Monsieur et Madame Thaulow.

J'ai été très sensible aux encouragements que vous m'avez donnés, et je les apprecie d'autant plus venant de vous pour qui je professais depuis longtemps une si haute admiration de vous, le plus grand maître du temps.

Serait-ce une indiscrétion de vous demander le faveur de faire quelques portraits photographiques de vous dans votre atelier, ce serait un honneur qui me rendrait très heureux.

Veuillex agréer, cher Maître, l'expression de mes sentiments respectueux.

Eduard Steichen

Jeudi

3. Edward Steichen, "Rodin's *Balzac*," *Art in America* (September–October 1969): 26.

4. An article in *The New York Herald* of 18 March 1902 announced the "Photo Club Exhibition" at 42, rue des Mathurins, and referred especially to Steichen's portraits ("scarcely recognizable as photographs") of himself, Thaulow, and Rodin.

5. Dennis Longwell, in *Steichen: The Master Prints 1895–1914* (New York: Museum of Modern Art, 1978), 44, cites a letter to Stieglitz from Steichen in Paris, undated:

I wish you could hear some of the fine things the big painters and artists here have to say when I can show something good . . . I could cite dozens of things—up to Rodin himself—who took my *hand in big silence* the first time he went through my portfolio—At another time when I had the honor to dine with him at his home—he said of one of the things that it was a remarkable photograph *and* a remarkable work of art—a chef d'oeuvre—as he would have it (a very recent print—a self portrait in Gum Bichromate). . . .

6. 291–5th Avenue New York
 U.S.A.

Mon cher maître

Je vous envoie (ici inclus) quelques épreuves stereotype qui vont bientôt paraître dans une livre devoué (?) à mes oeuvres photographique. Je vous enverrai plusieurs épreuves de votre portrait que peutêtre seront util pour vous et vos ami.

Je rejoui beaucoup de voir comme votre travail est apprecié ici en Amerique—vous vous même serez surprise. J'espère que cela se developera dans une forme plus materiel et que nous aurons beaucoup de vos belles créations dans ce pays avant peu.

C'est toujours les gens avec le plus d'argent qui ont le moindre comprehension d'art. J'ai eu beaucoup de succès depuis mon arrivé: Je viens de faire les portraits de bien des personnes prominentes entre autres M. Pierpont Morgan l'homme des millions qui a était très aimable pour moi. J'ai l'esperance de l'interesser en vous oeuvres, de vous procurer quelque grands commissions pour notre nouveaux musée de sculpture.

Et maître si vous voulez seulement m'écrire quelques mots que je chérriserez, et sourtout une ligne pour l'art que je puisse faire imprimer avec votre portrait pour le frontispis de mon livre—cela nous rendons bien heureux et nous aiderons à sentirent que nous sommes sérieux dans notre intentions d'art, même si la medium n'est que la photographie.

Je garde bien des souveniers cher maître de vous et de votre bonté pour moi—mais dessus tout l'influence de votre grand art. Et votre noble personalite m'aident et m'encouragent toujours vous comprendrez que dans cette ville on a souvent la nostalgie, non seulement pour Paris mais pour vous maitre.

Nous vous souhaitons tous ce que vous souhaitez pour vous et les votres.

Avec homage et devotion
Steichen

(Note: all errors in French grammar and spelling have been left in the text.)

7. Originally published in *Camera Work*, October 1908; cited by Elsen, *In Rodin's Studio*, 11.

8. Westen Naef, *The Collection of Alfred Stieglitz* (New York: Metropolitan Museum of Art, 1978), 443.

9. Naef, *The Collection of Alfred Stieglitz*, 443.

10. Steichen, *A Life in Photography*.

11. Steichen, "Rodin's *Balzac*," 26.

12. Longwell, *Steichen: The Master Prints 1895–1914*, 154.

13. Longwell, *Steichen: The Master Prints 1895–1914*, 154.

14. Naef points out (*The Collection of Alfred Stieglitz*, 443 and 457–459) that the Metropolitan's prints are gelatin-carbon prints, and that Stieglitz erroneously classed them as gum prints in his annotations on their mounts.

15. In 1898, at the time of the completion of the *Balzac*, Rodin had explained his ideas to Camille Mauclair, describing "the natural principles of sculpture made to be seen in the open air, that is the search for contour and for what the painters call *value*." Rodin continued to hold that "In order to understand this notion exactly, one should think about what one sees of a person stood up against the light of the twilight sky: a very precise silhouette, filled by a dark coloration, with indistinct details. . . ." (cited in Elsen and Varnedoe, *The Drawings of Rodin*, 86)

16. Longwell, *Steichen: The Master Prints 1895–1914*, has admirably stressed Steichen's links to symbolism.

STEPHEN HAWEIS and HENRY COLES

Haweis and Coles were English-speaking partners who worked with Rodin around 1903–1905. Their prints are frequently signed in pencil on the mounts, always with both names. The first communication from them to Rodin, dated 9 January 1904, refers to a body of work of 200 prints, prepared over an eight-month period ending at Christmas 1903. Haweis wrote to beg payment of back debts, and in so doing to plead against the deprivations their arrangement with Rodin (which gave them only about ninety centimes per print after expenses) had caused.

We are constrained to pay our suppliers every fifteen days; judge by that how much of a deficit I have had to fill myself. At this moment the money I had at my disposition is exhausted, and I cannot prolong this situation. I have sometimes been obliged to deprive myself of the models necessary for my personal work, and I find myself obliged to assure myself of regular returns, and on fixed dates, for my work.

An expert in the matter estimates at 20 francs each first print accepted by you; but we do not hope to see you pay this price, given the pleasure and the notoriety we find in executing your work.

Unfortunately our resources, or rather our lack of resources, oblige us to call on your willingness to suggest an arrangement permitting us to continue our work. . . .[1]

Haweis proposed to charge Rodin 100 francs per dozen new prints accepted (fifty francs for each subsequent dozen prints from an existing negative), plus the cost of materials for any rejected attempts. We have no indication as to Rodin's response to this letter, but it is clear that Haweis and Coles continued to work with Rodin.

Up to the point of the letter, it seems that the partners were primarily involved in working directly and solely for sale to Rodin when they photographed his work. Indeed, given the terms of the contract of 1903 between Rodin and Bulloz, they could not have been authorized to sell their prints in competition with Bulloz's photos of the same works. Perhaps in order further to defray their costs, or perhaps at Rodin's urging, in order that their special vision of the sculpture might reach a wider audience, they eventually signed a contract that would allow them to sell publicly. The contract, entered into by Rodin, Bulloz, and Haweis and Coles on 16 June 1904, held onerous conditions for the two partners. Every print they proposed to put on sale had first to be stamped by Bulloz. At the end of the year they were to match their supply of prints against Bulloz's records of stamping, and were to be obliged to pay Rodin (or Bulloz as his agent) one franc for each stamped print no longer

with them. In addition, Haweis and Coles had to agree to sell to Rodin for his use, and to Bulloz for public sale, any requested prints at five francs each. Perhaps Haweis and Coles intended to charge handsomely enough for their work to draw profit in spite of these terms; but it seems that only a strong desire to continue working with Rodin and an optimistic assessment of the possible public market could justify subscription to such an arrangement. By February of 1905 (as attested by a letter from Bulloz to Rodin of 27 February) they had paid a total of seventy francs for the 1904 accounting, suggesting a total sale of seventy prints over a six-month period.

Stylistically and materially, Haweis and Coles's photographs are among the most lavish images made of Rodin's sculpture. Smokily grainy gum prints, often mounted on high-quality colored papers, they have usually been manipulated by hand, often extensively. Heavy drapery backdrops (and/or outdoor settings) usually divorce the sculpture from the studio environment. For Haweis and Coles the graphic style of the print was the primary interest, and they did not hesitate, on numerous occasions, to flip their negatives and hence falsely reverse the works represented. The Musée Rodin archive contains numerous proofs of their negatives in simple gelatin silver prints, suggesting that they sought Rodin's approval of the basic image before going ahead with the labor-intensive gum print versions.

Haweis and Coles's taste was clearly affected by the aestheticism and love of organic curvilinearity in art nouveau. Their work is closely related to that of Steichen (see especially the Steichen *Thinker*, fig. 9.48, and the heads of Clemenceau, figs. 9.53–9.56) and reflects as well a broad trend in contemporary photographic aesthetics, embodied notably in the early 1900s work of Alvin Langdon Coburn.[2] Rodin's approval of Haweis and Coles's imagery is perhaps the clearest example of his decreased interest, in later years, in clarity of silhouette and/or strong definition of modeling along the external contours. In this respect, the Haweis and Coles treatments of the figure of *Meditation* (figs. 9.65–9.67) might be instructively juxtaposed to Druet's image of the same figure (fig. 9.20), to judge the change in Rodin's tastes in less than a decade; and the Haweis and Coles image of the reduced version of a Burgher (fig. 9.62) could be juxtaposed to the earliest photographs of the same figure (figs. 9.8–9.10) to measure an even more complete evolution in sensibility.

Among the exhibited works, fig. 9.67 is least characteristic of Haweis and Coles's style, but it is typical of Rodin's interest in the evocative power of unexpected juxtapositions and in creating new sculpture from such

combinations—if only by assemblage staged for the camera.

Fig. 9.62 Reduced figure of a *Burgher of Calais*, c. 1904. Gum bichromate print. M.R.ph960.

Fig. 9.63 *Crouching Woman* (frontal), c. 1904. Gum bichromate print. M.R.ph964.

Fig. 9.64 *Crouching Woman* (rear), c. 1904. Gum bichromate print. M.R.ph963.

Fig. 9.65 *Meditation*, c. 1904. Gum bichromate print. M.R.ph962.

Fig. 9.66 *Meditation* (with foliage), c. 1904. Gum bichromate print. M.R.ph961.

Fig. 9.67 Bust of *Victor Hugo* with two figures of *Meditation*, c. 1904. Gum bichromate print. M.R.ph965.

9.62, cat. no. 209. 9.65, cat. no. 212.

NOTES

1. Cher Maître,

Nous nous trouvons obligés à nouveau de venir vous troubler en vous parlant affaires, et nous regrettons, ne parlant pas suffisament francais, de ne pouvoir nous exprimer en peu de mots et de vive voix.

La rémunération que nous avons reçue pour la reproduction de vos oeuvres jusqu'à Noel, soit pour 200 épreuves, est d'environ of,90 par épreuve, ce que nous nous permettons de trouver trop peu pour payer huit mois d'occupation à deux travailleurs habiles.

Nous sommes contraints de payer nos fournisseurs tous les quinze jours; voyez par là combien j'ai eu à combler moi-même de deficit. En ce moment l'argent que j'avais de disponible est épuisé, et je ne peux prolonger cette situation. J'ai été quelquefois obligé de me priver de modèles nécessaires à mes travaux personnels, et je me trouve dans l'obligation de m'assurer des rentrées regulières et à dates determinées pour mon travail.

Un expert en la matière estime à 20f chaque première épreuve acceptée par vous; mais nous n'esperons pas vous voir payer ce prix, étant donné le plaisir et la notoriété que nous trouvons dans l'execution de vos travaux.

Malheureusement nos ressources, ou plutôt notre manque de ressources nous oblige à faire appel à votre obligeance pour suggérer un arrangement nous permettant de continuer nos travaux, que, dans le cas contraire et à notre grand désappointement, nous serions contraints de cesser. . . .

2. With regard to Steichen it should be noted that, for a 1907 exhibition poster, Rodin chose to have reproduced a Haweis and Coles image of *The Thinker* rather than the Steichen *Thinker* (fig. 9.48) he had long owned. There is no evidence in the photo archive

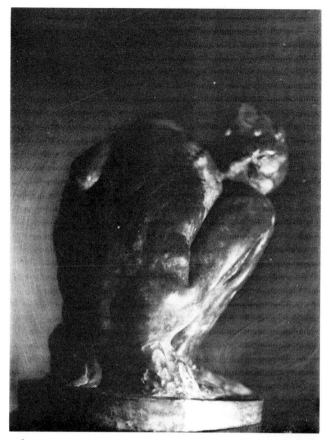

9.63, cat. no. 210. 9.66, cat. no. 213. 9.64, cat. no. 211. 9.67, cat. no. 107.

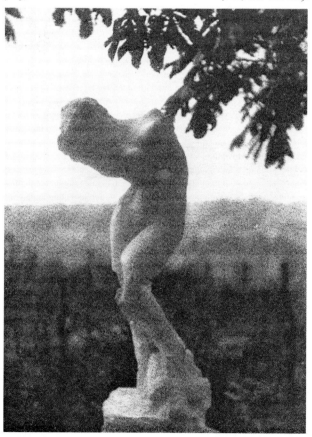

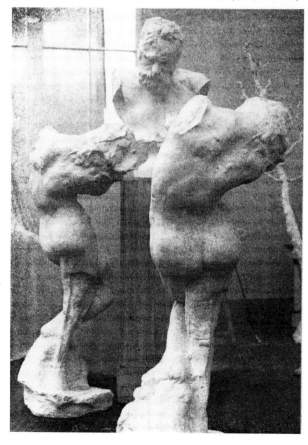

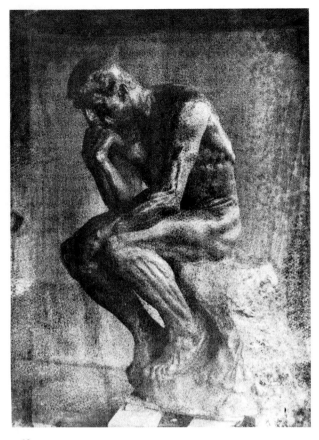

9.68, cat. no. 214.

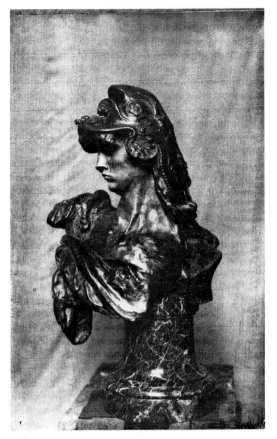

9.69, cat. no. 215.

of the Musée Rodin that Alvin Langdon Coburn ever collaborated with Rodin; however, the collection does contain a print of Coburn's spoof portrait of George Bernard Shaw posing nude as *The Thinker*, dedicated to Rodin by Coburn.

ANONYMOUS

No signature or stamp, nor any correspondence so far discovered, allows us to identify the author of these exceptional interpretations of Rodin's work. The general aesthetic of the gum-bichromate process might suggest a linkage to Haweis and Coles, but this body of work is consistently larger in format and more aggressive than theirs. These boldly colored, often powerfully abstracted images have a rough surface texture and strongly sculptural spatial sense that makes Haweis and Coles's work seem rather refined and even precious by comparison. The negatives of the *Balzac* at Meudon (figs. 9.75–9.77) are very close to those of Bulloz (see figs. 9.45–9.47), but it seems improbable that Bulloz would have committed himself, given his interests in steady public sales, to such a labor-intensive printing process. No negatives in Bulloz's repertoire, furthermore, have been found to

coincide with these gum-print images. Gelatin silver prints of the negatives also appear in the Musée Rodin collection, suggesting that this photographer, like Steichen and Haweis and Coles, usually submitted simple trial proofs for approval before going on to produce the (often radically different) gum prints.[1]

The obtrusive surface textures of the prints in figs. 9.70–9.74 do not permit us to decide whether the cast shown is a plaster or a bronze. The location depicted is equally uncertain, but it seems highly unlikely that this open-air session of photography was connected with the other display of the *Burghers* recorded by Druet (see fig. 9.30). In these studies of the *Burghers*, and in the same photographer's views of the *Balzac*, we can see an extreme dissolution of detail and internal modeling in favor of a melding of the figure with the surrounding atmosphere— a tendency remarked in Steichen's and Haweis and Coles's images as well and certainly congenial to Rodin's ideas in later years.[2]

Fig. 9.68 *The Thinker*, c. 1905–1910(?). Gum bichromate print. M.R.ph980.

9.72, cat. no. 218.

9.70, cat. no. 216.

Fig. 9.69 *Bellona*, c. 1905–1910(?). Gum bichromate
print. M.R.ph979.

Fig. 9.70 *The Burghers of Calais*, c. 1905–1910(?).
Gum bichromate print. M.R.ph984.

Fig. 9.71 *The Burghers of Calais*, c. 1905–1910(?).
Gum bichromate print. M.R.ph985.

Fig. 9.72 *The Burghers of Calais*, c. 1905–1910(?).
Gum bichromate print. M.R.ph329.

Fig. 9.73 *The Burghers of Calais*, c. 1905–1910(?).
Gum bichromate print. M.R.ph1023.

Fig. 9.74 *The Burghers of Calais*, c. 1905–1910(?).
Gum bichromate print. M.R.ph1024.

Fig. 9.75 *Balzac* (frontal), 1908. Gum bichromate
print. M.R.ph983.

Fig. 9.76 *Balzac* (left profile), 1908. Gum bichromate
print. M.R.ph981

9.71, cat. no. 217.

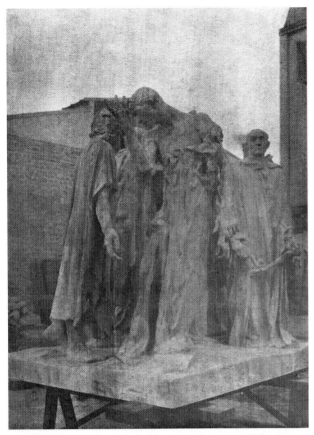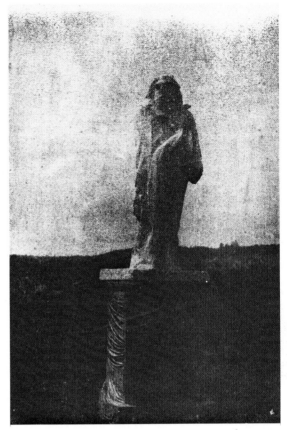

9.73, cat. no. 219. 9.74, cat. no. 220. 9.75, cat. no. 221. 9.76, cat. no. 222.

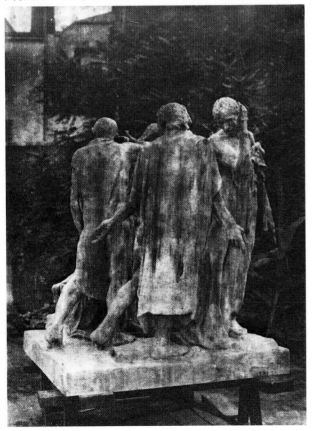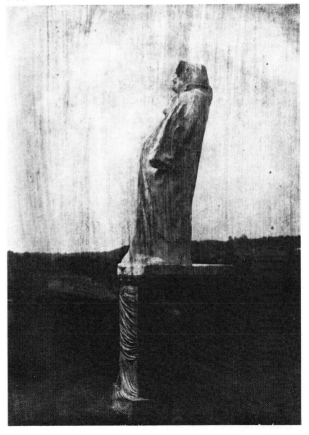

9.77, cat. no. 223.

Fig. 9.77 *Balzac* (right profile), 1908. Gum bichromate print. M.R.ph982.

NOTES

1. For a comparison of a gelatin silver print and a gum print from the same negative by this unknown photographer, see Elsen, *In Rodin's Studio*, plates 34 and 35.
2. See Elsen's discussion of the unknown photographer's treatment of the *Burghers*, in *In Rodin's Studio*, 173.

PORTRAITS OF RODIN

Rodin was photographed only occasionally in youth and early maturity. The small print by Bergerac of 1886 (fig. 9.78) gives us a rare, exceptionally piercing view of the intensity of the artist's gaze at a period when he was just beginning to break from the ranks and establish himself as the premier sculptor of his day. This image was especially meaningful to Rodin himself; he used it as the basis for one of the two explicit self-portraits he is known to have made (fig. 9.79).

After 1900, as the most renowned artist of his time,

Rodin came to be a prized, sought-after portrait subject. Although it obviously did not displease the aging artist to be thus flattered, he still exercised his right to deny access to those he deemed insufficiently serious in their artistic intentions. As Steichen's reminiscences emphasize, it was a privilege, and a significantly enriching experience, to obtain Rodin's cooperation in a portrait venture. The portraits Rodin kept of himself are not numerous, but they include choice examples from Steichen and from Gertrude Käsebier, two of the most accomplished portraitists in early twentieth-century photography. The prints selected for exhibition here are noteworthy both for their beauty and for their interest as unknown or relatively little-known works by these prominent American photographers.

In working with these young artists, Rodin showed himself a cooperative partner in his own mythification, characteristically adopting brooding, contemplative poses that seemed appropriate to the dark seriousness of his genius. The photo by Käsebier of Rodin with the *Adam*, fig. 9.85, is a rare example of the sculptor revealing, tentatively, a more light-hearted side.

Fig. 9.78 Bergerac. Rodin, 1886. Salt print. Private collection. Courtesy Harry Lunn.

Fig. 9.80 Edward Steichen. Rodin, c. 1902(?). Gum bichromate print. M.R.ph243.

Fig. 9.81 Edward Steichen. Rodin with *The Hand of God*, c. 1902(?). Gum bichromate print. M.R.ph215.

Fig. 9.82 Edward Steichen. Rodin, 1907. Platinum print. M.R.ph238.

Fig. 9.83 Gertrude Käsebier. Rodin in profile, c. 1900(?). Platinum print. M.R.ph241.

Fig. 9.84 Gertrude Käsebier. Rodin, hand on a bronze bust, c. 1900(?). Platinum print. M.R.ph249.

Fig. 9.85 Gertrude Käsebier. Rodin with the *Adam*, c. 1905(?). Platinum print. M.R.ph248.

9.78, cat. no. 163. 9.80, cat. no. 167.

9.79 *Self-portrait*, after 1886. 9.81, cat. no. 168.

9.82, cat. no. 169.

9.83, cat. no. 165.

9.84, cat. no. 164.

9.85, cat. no. 166.

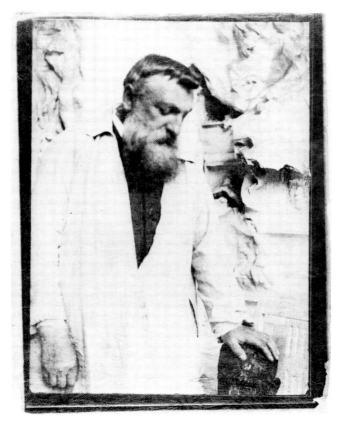

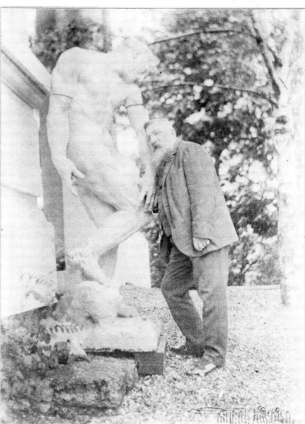

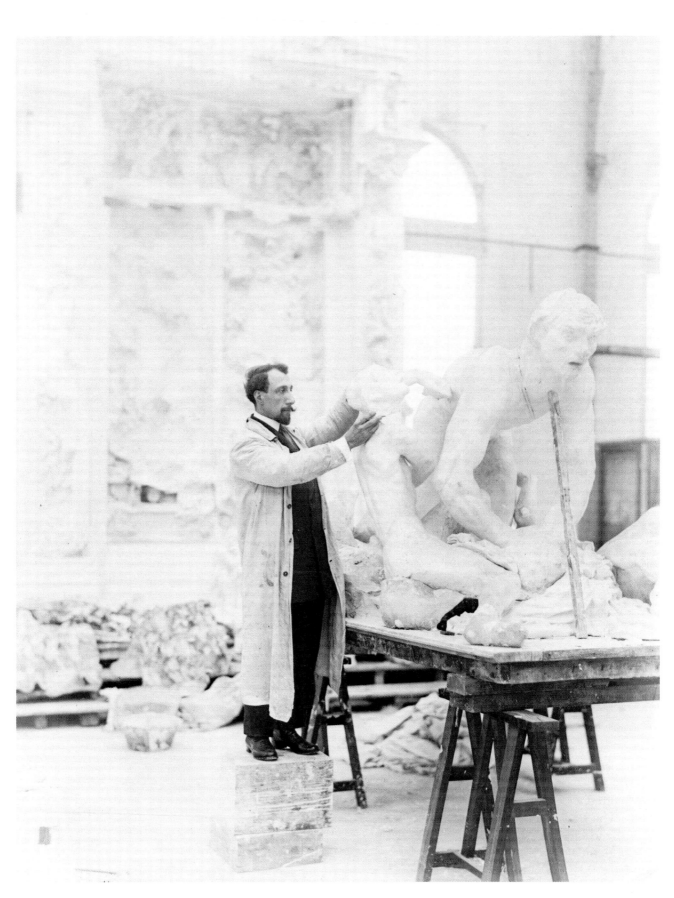

10.1 Lebossé attaching *The Head of Sorrow* to the enlargement of the Ugolino group at Meudon in 1906.

10. Rodin's "Perfect Collaborator," Henri Lebossé

Albert E. Elsen

No sculptor in history is more famous for having an inimitable touch than Auguste Rodin. Yet big public works like the *Monument to Balzac* and *The Thinker*, on which much of Rodin's reputation is based, in fact issued from the hands of Henri Lebossé. From the mid-1890s until his death, Rodin entrusted most if not all of his important enlargements and reductions to this dedicated and today unknown technician who referred to himself as Rodin's "sculpteur reproducteur habituel." Lebossé wrote to the master on 24 January 1903, "I would like to be your perfect collaborator" (fig. 10.1).

From at least the 1870s, Rodin's great productivity was predicated on a division of labor which put in his service well-trained assistants, some of whom were sculptors in their own right. He did not invent this system; it originated in antiquity and flourished in the nineteenth century. Thanks to mechanical inventions, greater public demand for sculpture—by 1900 in France, for example, it was a custom to give newlyweds reductions of famous sculpture—and a large pool of skilled artisans and sculptors looking for work, Rodin's art was seen on every continent, and his fame was worldwide. Division of labor freed Rodin to focus more time on creativity. During his lifetime, whether or not the "master" actually carved the stone, participated in or supervised the casting process, or even touched enlargements and reductions of his work, he was credited with being their creator. His approval of these reproductions certified that they represented his genius. He had provided the working models and standards and often trained and usually supervised the *praticiens* who carried out his ideas in different media and sizes and who submitted their final work for his approval. Rodin's clients always knew of this separation of skills. The studios of his assistants as well as his own were open to other artists and members of the public, who could see the various processes of reproduction taking place. Lebossé wrote to Rodin on 11 March 1904, "Many artists who are your admirers came to my studio and marveled at your last child of *Ugolino*." Far from

being diminished, Rodin's reputation was augmented by such knowledge, and his assistants often supplied him with new clients, who had observed their work on his behalf.

The archives of the Musée Rodin contain a full dossier of Lebossé's communications to Rodin, beginning in 1894 and continuing until August 1917. (Thereafter, there are letters from Lebossé to Léonce Bénédite, the first director of the Musée Rodin.) While we have almost none of Rodin's written instructions to Lebossé (they seem to have been lost when Lebossé's son died without heirs in 1956), it is possible to reconstruct something of their working relationship. We know little of Victor-Henri Lebossé, for *reducteurs*, as men of his profession were called, were not the stuff of biographies and articles. On his letterhead, Lebossé announced that his firm was established in 1865, for he followed his father in the profession, and that he engaged in reducing and enlarging objects of "art and industry" by a "mathematically perfected process" and employed a "special machine" for making these "counterparts" in "editions." By 1907, his stationery informed clients that he was a "statuaire," meaning a maker of statues, the highest professional rank; that he was an Officer of Public Instruction, who exhibited in universal exhibitions and annual Salons des Beaux-Arts; and that he could realize sculpture from drawings. In 1900, he won Honorable Mention in one of the salons for his "collaboration artistique," presumably working for Rodin on a project such as the enlargement of the *Monument to Balzac*. By 1907, he had capitalized the *b* to make his name "LeBossé," and on correspondence after 1917, he separated his last name into two parts, giving himself the more distinguished "Le Bossé." His studio always remained at 26, rue du Moulin Vert in the 14th arrondissement, which is where many sculptors and technicians lived and still work. (The original building has been replaced by a small apartment house.) Judging by the modest size of the lot, one can understand Lebossé's request of Rodin that the parts of

large projects be assembled in Rodin's studio, as his own did not permit sufficient viewing space.

We do not know for certain how, under what circumstances, and exactly when Lebossé came to work for Rodin. (A verbal tradition has it that Rodin himself encouraged Lebossé to use his machines for enlarging the master's work.) The Musée Rodin dossier does not show any correspondence or bills before 1894. According to the French artist and historian Stanislas Lami, Lebossé began to work for Rodin after 1891, and *The Burghers of Calais* were the last life-size statues that Rodin executed with his own hands.[1] (Even then, however, it seems to have been Rodin's practice to have help from some of his assistants.) From Lebossé's letters to Rodin we can reconstruct the general processes of his work and the problems he faced in trying to become, as he put it, "the perfect collaborator" with the world's greatest living sculptor.

After determining which works he wanted enlarged or reduced, sometimes prompted by what he wanted to show in the salon, or as the last stage in completing a commission, or for his own pleasure, Rodin would usually send plaster "models" to Lebossé. To all intents and purposes they were complete works of art done on a small or less than life-size scale. There are still some enlarged plasters at Meudon, such as the *Monument to Whistler*, that were not bronze cast. Rodin occasionally preferred Lebossé to work from the dried or fired clay original when he considered the plaster cast insufficiently accurate.

If a small sculpture was to be enlarged, Rodin sent the entire work to Lebossé. Large plaster figures, however, were sent in parts: first the legs, one at a time, then the arms, followed by the torso, and lastly the head. This procedure was used for the *Ugolino* group, *The Thinker*, and the walking figure of Victor Hugo (fig. 10.2). (It took two weeks to enlarge one of *The Thinker*'s legs.) As soon as the model arrived, Lebossé would mount it on his machine (one of which is still in use today by a Paris artisan and is shown in fig. 10.3).[2] Machines such as this derived from the engineer Collas's invention of 1830 and looked somewhat like lathes.[3] Collas had, in fact, mechanized the ancient pointing method, to which he added the mechanical means of actually cutting the enlargement or reduction in clay or soft plaster; he extended the principles of the pantograph to achieve the reproduction of volume. At either end of the machine were turntables that could be precisely rotated by hand cranks. The model was placed on one; the *ébauche* or rough sketch was installed on the other in the material for reproduction. Crucial to the process were a blunt "needle" and a sharp

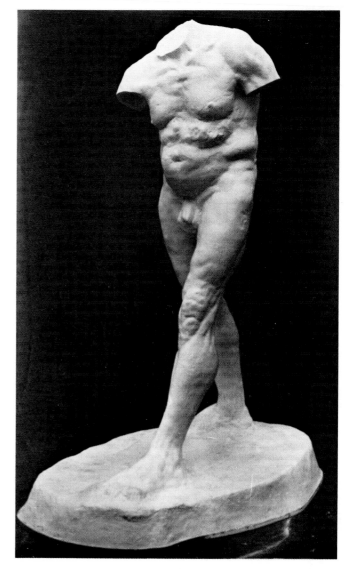

10.2 Lebossé's enlargement of the walking version of Victor Hugo, in 1901 or 1902 after he had joined the legs and torso in a *montage*. From an old photograph.

right: 10.3 A view of Lebossé's enlarging machine seen today in the Paris studio of Georges Bigel who is engaged in the same craft.

"needle," joined by an adjustable linkage, so that when the former styluslike instrument was passed vertically over the surface planes of the model, the latter would actually cut a series of vertical profiles in the clay sketch (figs. 10.4, 10.5, 10.6). For Rodin, Lebossé and/or his assistants roughed out the sketch in clay. On 16 March 1904, Lebossé complained to Rodin that his workers could scarcely make the rough sketch, "leaving me nine-tenths of the work to do."

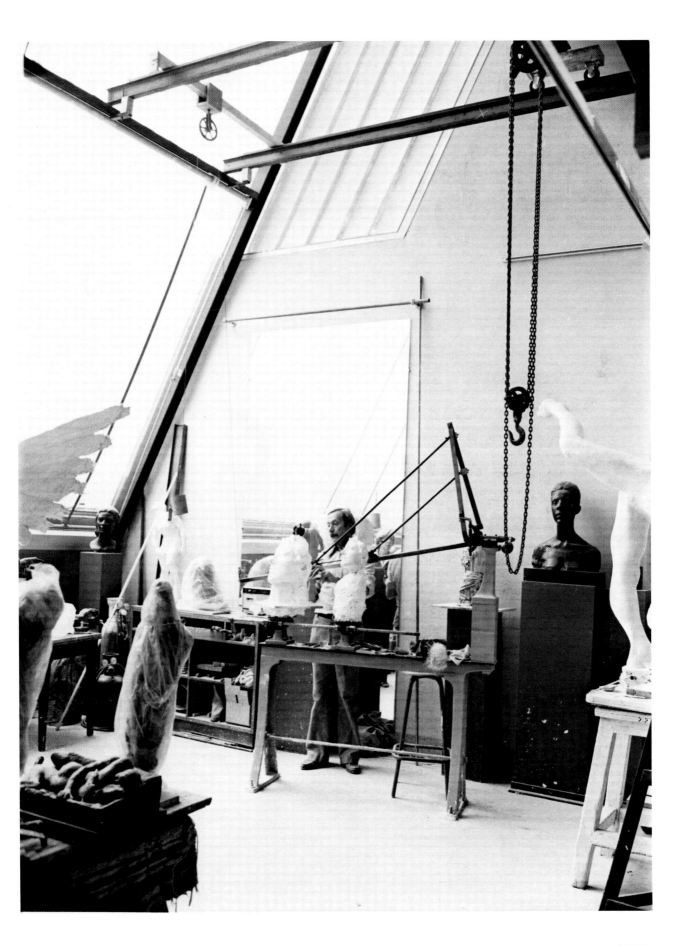

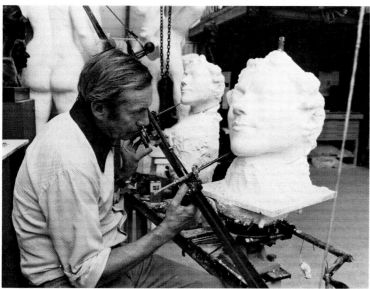

10.4 Checking the points of the cutting needles. Note the vertical cuts in the plaster head at the right.

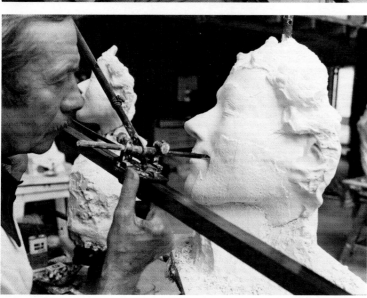

10.5 The slow process of eradicating the rougher vertical cuts to move to the final plaster surface.

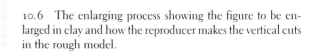

10.6 The enlarging process showing the figure to be enlarged in clay and how the reproducer makes the vertical cuts in the rough model.

Theoretically, the processes of enlarging and reducing sculpture were considered strictly mechanical. Lebossé's dossier shows, however, that this was not the case. Rodin had an aversion to strict, mathematically exact enlargements, reductions, and carving of his art. Much of Lebossé's work did involve pointing (plotting a succession of points on the surface of the *ébauche*) and making the vertical tracings, but then there seems to have been some manual translation of Rodin's modeling. Because of the complexity and subtlety of Rodin's modeling, very early in their relationship Lebossé found he had to take over from even his most experienced assistants most and often all of the work. On 20 August 1896, he wrote, "It is necessary that I complete your enlargement myself." This work required all of his skills as a sculptor. In 1898, he recorded that when he left the enlarging to his assistants, one of whom had worked with him for nineteen years, he had to destroy their month's work, as they did not "have any artistic understanding." By 1900, it seems Lebossé was personally doing most, if not all, of the enlargements in a separate part of the studio and probably left the less exacting reductions to others. He had at least three machines, which allowed simultaneous work on several commissions, whether from Rodin or other artists.

When Rodin wanted a model enlarged to, say, twice its size, the problem was not difficult, and the linkage system was accordingly set. It was when he wanted to enlarge a model six or seven times its original size that Lebossé found, from experience, it was necessary to make an intermediate version. Such considerable augmentations, "hors de mesure," produced "grave problems" and often became for Lebossé frightening leaps into the unknown. A roughly finished detail might seem inconsequential in a small sculpture, but blown up seven times it produced the kinds of difficulties about which he wrote on 23 February 1907: "Now I am undertaking a large augmentation, six or seven times, and which offers terrible surprises and difficulties, but I have good hopes of achieving it while proceeding in two operations." When on another occasion he was presented with some small torsos whose reproduction Rodin believed would be easy, Lebossé wrote on 26 September 1908, ". . . there is a superior modeling with the beautiful planes and it will be a veritable *tour de force* if I can give you satisfaction with this difference in size."

Repeatedly, Lebossé asked Rodin to visit the studio to check intermediary versions in progress, and apparently the master did. Often Lebossé wrote of redoing the work on his own initiative or to agree with Rodin's displeasure over what had been done. It is clear from the correspondence that Lebossé had to learn not only Rodin's style, but also his vision of what a finished work should look like in terms of its overall effect. Lebossé would write that he had achieved the detail without trouble, but only now had he "grasped the motif." Rodin taught his reproducer to study the emerging sculpture in terms of its planes and their relationship. On 6 January 1904, Lebossé wrote concerning his reduction of *The Age of Bronze*, "I make the corrections while carefully observing the planes as you have taught me to do." At times he would ask if Rodin wanted the same proportions of the model kept in the enlargement. From a rare surviving response, we know that Rodin might suggest putting more "matière" onto the form, making it thicker, as with the 1912 enlargement of *The Defense*. In the instance where Lebossé found that the two arms of *The Spirit of Eternal Repose* were of unequal length, he requested advice on whether or not to equalize them. After Rodin was "shocked" by the arms of the enlarged *Bacchante* and *Bather*, Lebossé destroyed them. On 6 February 1902, the harried technician cited his dilemma in enlarging a head for the statue of Victor Hugo. He had done the body, but Rodin's *mouleur* Guioché had brought him two heads of the writer by Rodin without instructions as to which he was to follow or what features to take from each. From the life-size rather than the small Hugo bust, Lebossé proposed an enlargement of the hair, beard, an ear, forehead, and cheeks, which he believed would help Rodin decide.

Consistently throughout the dossier comes the message that Lebossé was always aware of the rigorous standards to be met ("Your art does not admit half measures") and anxious that his efforts be worthy of Rodin's *oeuvre*. As he could not take the unfinished clay enlargements to Meudon for approval, he preferred to have Rodin visit the studio to check the final work before it was dismounted from the machine. Lebossé was anxious for the plaster mold maker to call for the finished work and cast it as quickly as possible lest it "suffer" or "deteriorate" in his client's studio. During the snows of March 1911, Lebossé fretted over a heavy limb Guioché was carrying back to Meudon. It was not simply breakage that concerned him, but fear that the enlargement would get too dry, shrink, crack, or disintegrate during cold winters, and even freeze.

On big projects such as the *Ugolino* group, Lebossé complained of not seeing all the parts at once while working on the legs and arms. The joining of the enlarged parts, or *montage*, took place in Rodin's studios. Usually Lebossé took charge of this operation. The first joinings might be crude, causing Rodin occasional concern about gaps between, say, a limb and a torso. Then Lebossé

would reassure him that he would fix this in a certain way. Despite his expressed concerns, Rodin did, in fact, exhibit the enlarged plaster of the proposed *Victor Hugo Monument* in the Salon of 1897 while the writer's extended arm was roughly joined to the shoulder by plaster-covered straps.[4]

Stanislas Lami, writing after Rodin's death about the relationship of the two men, pointed out that the great disadvantage of this reproductive process was that it prevented any change or improvement by Rodin upon completion. What Lami seems not to have known is that either during the enlarging process or when Lebossé's finished clay form arrived at his studio, Rodin could have intervened. Lami records, with some corroboration from eyewitnesses such as Ambroise Vollard, that at times Rodin would "mutilate" or violently edit enlargements in their plaster form because he was not satisfied with the translation of the modeling or proportions of a given part. (The mold was still available to make other plasters so Rodin did not risk losing the entire work.) Further, as we know from old photographs taken under his direction and from surviving works in the Meudon Reserve, Rodin did rework plasters both by subtraction in the form of cutting away and by addition through the joining of clay to plaster in order to augment thickness or to change characterization and modeling. In the additive process a new plaster would be made from the edited one. No matter the process or medium, for Rodin no sculpture was irrevocably finished or unalterable.

Undermining the view that Lebossé's work was purely mechanical are the letters that build the case for his doing a lot of actual modeling. In fact, he prided himself on reproducing Rodin's touch. Concerning the enlargement of *The Thinker*, he wrote on 1 March 1903: ". . . far from having lost by enlargement, your sculpture has taken on a grandiose and animated character, all the while scrupulously preserving your personal touch." Whether working large or small, it was Lebossé's practice not to impose his own touch, but to treat accurately and more broadly or succinctly, depending on the size required, the idiosyncratic nature of Rodin's surfaces. With the headless female *Torso* (fig. 10.7), given by Rodin to the Victoria and Albert Museum in 1914, Lebossé employed a type of vertical streaking with his fingers on the woman's back that is not found on the much smoother maquette (fig. 10.8). Even if he may not have encouraged this deviation in facture, Rodin, nevertheless, accepted it and had the enlargement bronze cast for this important donation.

No other *reducteur* worked for Rodin so long nor was held in such esteem as Lebossé. He therefore may have

10.7 Torso of a *Seated Woman*, enlarged 1907? Plaster. Musée Rodin, Paris.

been the individual most intimately aware of and knowledgeable about Rodin's modeling. In working on the reduction of *The Age of Bronze*, Lebossé noted, "The more I work on the statue, the more I find the modeling admirable." If his process had been truly mechanical, Lebossé would not have complained so often about working from 6:00 A.M. to midnight or 2:00 A.M. nor occasionally have affirmed "I put my soul into it." So demanding was the work that by 1902 he wrote that he worked only for Rodin, his old clients almost gone, and that he had turned down new ones, including some of Rodin's assistants, such as Peter, and the artist's former mistress, Camille Claudel.

Some assignments took more than a year, and the record shows Lebossé's frustrations in satisfying Rodin over the legs of *The Thinker*, and having to redo three times those of *The Walking Man*. *The Martyr* was a source of anxiety, especially in the area of the upper buttocks. Lebossé pointed out to Rodin that as presented to him it was a horizontal figure, but when it was

10.8 *Small Torso of a Seated Woman*, n.d. Plaster. Musée Rodin, Paris (S 532). Cat. no. 49.

10.9 *Meditation* or *Half-Length Figure of a Woman*, enlarged 1908-1909.

enlarged to be upright the anatomy seemed wrong and the parts in "disagreement." Since the enlarged *Martyr* is horizontal, Lebossé must have been talking about the sculpture called *Meditation*, or *Half-Length Figure of a Woman*, whose torso comes from that of *The Martyr* (fig. 10.9).

Apart from occasional approval from the master, what bolstered Lebossé's pride were the favorable comments of Rodin's artist friends, such as the sculptor Pompon, who praised the enlarger for preserving the beauty of the master's modeling on a large scale. Rodin so trusted Lebossé's work, seeing it as an extension of his own, that he caused him to invite Camille Claudel, after their emotional separation, to visit 26, rue du Moulin Vert in order to inspect the enlarged *Balzac* still on the machine. On 17 November 1897, Lebossé wrote of her warm reception of the piece. Her favorable comments were made as if Rodin himself had modeled the final form.[5]

Lebossé's greatest and perpetual worry for more than twenty years was over incurring Rodin's displeasure. Next

to that, it was getting the master's attention and business. The litany of the Lebossé letters comprises avowals of good work; detailed accounting and justification for prices; the need for payments, as machines must be repaired or equipment bought or assistants hired; turning down requests for work from others; progress reports of works "en machine"; and promises that deadlines would be met or dates for delivery set. When World War I came, all of Lebossé's assistants, including his son, were mobilized, and new tools were unavailable.

We know precious little about this talented and singularly dedicated man as a person. Photographs show him to have been tall, thin, and bearded, in fact, aristocratic in appearance. (By its legibility, his hand-

writing and also his style betray a more modest background.) Letters confirm that he suffered often and severely from the occupational hazards of working on his feet day after day in a humid and unheated studio. He was repeatedly stricken with bouts of bronchitis, lumbago, rheumatism, and skin problems. Worst of all, in 1912, he contracted anthrax, which necessitated eighty visits to his doctor. There were times when he could not go out or even walk because of neuralgia in his legs. Once, unable to talk, he reassured Rodin he could still work. At times he complained that he could not spend time with his family, but when on vacations he sent postcards to Rodin telling him when he would return. Most moving are those rare instances when Lebossé confided that he had reached the limit of what he could do and said that if Rodin was displeased, he was so discouraged he did not think he could do better. Once, while his wife and sick child were away and he was working under great pressure, he was not permitted to visit Rodin personally for instructions. Lebossé wrote, "It is ridiculous to live like this." Such human outbursts are rarer than expressions of pride in working for Rodin.

At the time of Rodin's death, Lebossé still had in his studio, if not on his machines, several works intended for enlargement. They included: two *Fallen Caryatids* (one carrying a stone, the other an urn); the torso of the man in *I Am Beautiful*; the torso of an adolescent from the *Ugolino* group; and *The Defense*. All but *The Defense* and the *Caryatids* were delivered to the Rodin Museum in the Hôtel Biron on 16 February 1918. In the accounting for *The Defense*, whose bronze version is installed in the rear of the Hôtel Biron garden, Lebossé noted that Rodin had first commissioned the enlargement in 1912, at which time he did the feminine figure of the "Spirit of War." His 1918 bill indicates that he had completed the figure of the warrior, the wings of the woman, the attributes, and the base or "terrasse" at a cost of 5,500 francs. There had been serious problems with the project, and Lebossé had pleaded with Rodin to save certain parts. It was Bénédite's decision not only to continue the enlargement after Rodin's death, but to make an even bigger one, because the Dutch government wanted this work erected at Verdun as a grateful tribute to French heroism. This project was carried out by Lebossé, who started it in 1918 and completed work in 1920. He increased the original scale of the sculpture four times. Following Bénédite's instructions, Lebossé engraved on the base of the Verdun version the dates 1882, 1917, and 1920, commemorating, in the first case incorrectly, the dates of the sculpture's various versions.[6] There was a storm of criticism directed at Bénédite for

undertaking the posthumous enlargement. Many people misunderstood the enlarging process and did not realize that for Rodin it was not to be strictly mechanical. There was published criticism that Lebossé had betrayed Rodin by not enlarging from the original model in a purely mathematical way. To justify his licenses with the model and his departure from mathematical exactitude, which he felt would have been a "professional error," Lebossé showed the press Rodin's letter of 1912 asking him to add more "matière" to thicken the enlargement of *The Defense*. Lebossé seems not to have pointed out that Rodin consistently checked his work and that this project had a prior history of failure on a smaller scale. Tragically for Rodin's "perfect collaborator," the Verdun enlargement became part of a 1920 scandal involving fake works, marble carvers who continued to turn out sculpture signed with Rodin's name, and unauthorized bronze casts by the Barbedienne foundry.

Why did Lebossé accept Bénédite's commission to make the huge posthumous version of *The Defense*? Did pride vanquish prudence? Certainly he had not forgotten the crucial decisions Rodin had had to make for him or approve. Lebossé's decision is more understandable, if not condonable, when one reads of his problems just after the war in putting his business back on its feet, even with the help of his son who had been demobilized. Finally, Bénédite had the legal, if not ethical authority as director of the Musée Rodin, and Lebossé had money coming to him after Rodin's death for other unfinished projects.

1. Stanislas Lami, "Auguste Rodin," in *Dictionnaire des sculpteurs de l'école française au dix-neuvième siècle*, vol. 4 (1921), 174.

2. This machine is owned by Georges Bigel, who is shown using it in the photographs. The machine itself was constructed by the Maison Rouvre and consists of unique parts, each of which was bronze cast from wooden models. I would like to thank the sculptor William Chattaway and Madame Giselle Delmotte for helping me to track down this machine.

3. For excellent information on this technique of enlarging, see the chapter "A Technical View of Nineteenth-Century Sculpture," by Arthur Beale in Jeanne L. Wasserman, ed., *Metamorphosis in Nineteenth Century Sculpture* (Cambridge, Mass.: Fogg Art Museum, 1975). See especially 47–49.

4. I have reproduced a photograph of this work thus exhibited in my book *In Rodin's Studio: A Photographic Record of Sculpture in the Making* (Oxford: Phaidon Press in association with the Musée Rodin, 1980), pl. 89.

5. The note that Camille Claudel passed to Rodin via Lebossé read: "Through Lebossé you have asked that I write you my opinion of your Balzac. I find it very great and very beautiful, and best of all the studies of the same subject. Above all, the very accentuated effect of the head which contrasts with the simplicity of the drapery. It is a real discovery and gripping. I also like very much the waving sleeves, which have captured all the negligent aspect of the man. In sum, I believe you can expect a great success, above all from the true connoisseurs, who will not be able to make any comparison between this statue and those that up to now decorate the city of Paris." This communication is in the archives of the Musée Rodin.

6. The Musée Rodin archives has a dossier on *The Defense* which contains a number of newspaper articles chronicling the uproar over Bénédite's decision to enlarge the work after Rodin's death. The defense in the trial of 1919, cited in note 11 of my essay "When the Sculptures Were White," went to great lengths to attack Bénédite for his action in causing Lebossé to make the third enlargement.

According to the notes of Lebossé, the following works were enlarged or reduced by him. Their titles are often descriptive and do not tell us specifically which works they represent. Unless otherwise indicated, enlargements were made.

1894:	"A study of a reclining figure seen from behind"
	Victor Hugo
	Bust of Balzac
	"Study of a woman"
	Three Hands
1895:	"Study of a woman with legs spread" (possibly *Flying Woman* or *Iris, Messenger of the Gods*)
	Group of three muses from the Victor Hugo Monument
1896:	"Standing women"
1897:	Enlargement of the full figure of the final monument to *Balzac*
1898:	Bust of Rochefort
	"Group"
	Work on bas-relief of Apollo from the base of the Sarmiento Monument
	Balzac
	A group with wings (possibly *The Benedictions*)
	A head of a woman (possibly the large head of *Iris*)
	Man holding a scroll of paper (possibly the figure flanked by women from the *Monument to Labor*)
	"Spirit" (*Génie*), two legs and thighs (probably *The Spirit of Eternal Repose* destined for the Monument to Puvis de Chavannes)

1899: Reduction of a Burgher of Calais
Doubled the size of the bust of Puvis de Chavannes
"Spirit" (*Génie*), torso and two arms
Torso of a Young Girl

1900: *The Martyr* made life-size
Reduction of two Burghers of Calais (one with his head in his hands)
Woman Combing Her Hair enlarged five times its original size
Orpheus was in the process of being enlarged three and one half times its original size
Woman Holding Her Foot (possibly *Despair*)
"Seated woman—leg, arm, and hand outstretched" (possibly *Iris, Messenger of the Gods*)

1901: "Woman with a book (probably *Ecclesiastes*)
Finished "Woman Holding Her Foot" (possibly *Despair*)
Large Torso
Head of Balzac
Began *Ugolino* group enlargement
The Thinker
Began the legs of the standing Victor Hugo
Enlarged a *Shade* from *The Gates of Hell*, twice its original size

1902: Continued work on the standing Victor Hugo
Worked on the torso of *The Thinker*
Worked on the *Ugolino* group
Finished enlargement of *The Shades* from *The Gates of Hell*
Reduction of a Burgher of Calais
Bas-relief (one of the flanking bas-reliefs of the *Gates*)

1903: Did the arms of *The Spirit of Eternal Repose*
Continued work on *The Thinker*, doing enlargements of the arms and legs, finishing the torso, and also doing a reduction
Reduction of a second bas-relief from *The Gates of Hell*
Reduction of a Burgher of Calais

Worked on a reduction of *The Age of Bronze*
A "small motif" from the *Gates*

1904: Worked on two reductions of *The Age of Bronze*
Did the last of the children of the *Ugolino* group
Seated Woman (probably the headless seated woman shown at the salon of that year)
The bust of Henri Becque
Large *Torso of a Man* (probably the torso from the male figure in *The Gates of Hell* who clutches the *Crouching Woman* in *I Am Beautiful*)
I Am Beautiful

1905: Torso with legs (*The Walking Man*)
Bust of Falguière
Reduction of a Burgher of Calais
"Basin with Bacchante and bust below"

1906: Still at work on *The Walking Man*
Enlarged three times its original size Falguière's bust of Rodin (Rodin obtained the permission of Falguière's widow)
Made a reduction of a relief called "St. George"
Two small anonymous heads
Head and arms
"Group"
"Head in a basin" (probably the severed head of *St. John the Baptist*)
Enlargement of *The Defense*

1907: Worked on the legs of *The Walking Man*
Worked on a leg for Victor Hugo
Enlarged the *Crouching Woman*
Torso
Fragments

1908: *Seated Figure* (for which Madame Abruzzezzi posed)
Crouching Woman
"Group of Furies"
A head of Hanako
Small torsos
Torso of the *Martyr* (probably for the work known as *Half Length Figure*, or *Meditation*)

1909: Continued work on the torso of *The Martyr*
Polyphemus
"The Furies"
Worked on an arm for the Whistler monument

1910: Still working on the torso and buttocks of
The Martyr
The Earth

1911: Still working on the *Crouching Woman*
Caryatid with a Vase
Benediction

1912: Enlargement of *Punishment* (exhibited in
1913 but present whereabouts unknown)
Enlarged Hanako masks
Worked on *The Defense*

1913: Enlarged *Venus*

1914: No titles given

1915: *Minotaur* enlarged three times original size
Kneeling Man (probably *The Prodigal Son*)
Torso of the man in *I Am Beautiful*

1917–1920: Worked on the second enlargement of *The
Defense* commissioned by Bénédite for
Verdun

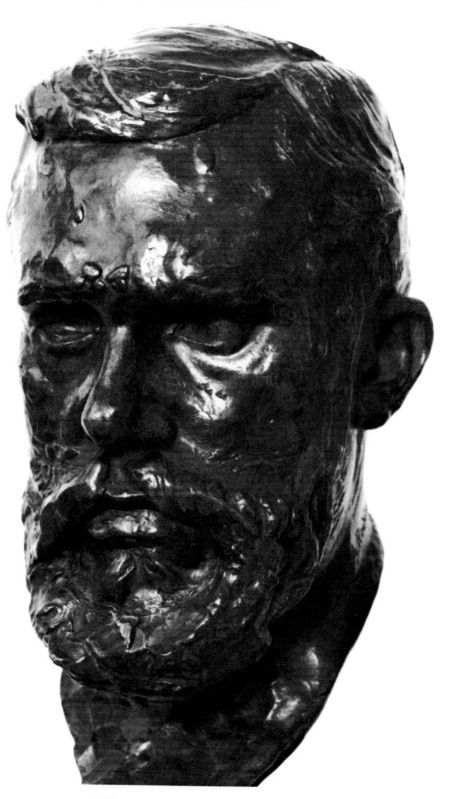

11.1 *Head of Gustave Geffroy*, 1905. Cast bronze. 12½ x 7⅛ x 9⅛ in.
The Stanford University Museum of Art.

11. *The Sculptor and the Critic: Rodin and Geffroy*

JoAnne Culler Paradise

No writer before Rilke wrote as perceptively and lucidly on Rodin as Gustave Geffroy. From the criticism he penned as a young journalist on Clemenceau's *La Justice* to his mature pronouncements as a revered *homme de lettres*, his writings established a repertoire of ideas, which were echoed in much of the contemporary French criticism and which are still fundamental to our understanding of the sculptor.[1] This is due, in part, to the fact that he was a close friend of Rodin and that, schooled in literary naturalism, he brought to his criticism a respect for the documentation of the artist's own thoughts.[2] His humility before his subject is apparent when he writes to thank Rodin for a gift of sculpture: "Alas! What could I ever give you in exchange for this solid substance, made to traverse the centuries [?] Some pages of perishable paper, some fragile thoughts, badly composed, badly printed," or, in a lighter vein, when he proposes an evening together, "We could dine. . . . You could talk sculpture and I would not talk journalism."[3]

In an age when there was no thought of "conflict of interest," Rodin would often express his gratitude to his ardent supporter with gifts of sculpture, such as the *Fauness* whom Geffroy dubbed "the hostess of my house, the muse of my work," or the bust of the critic executed in 1905 (fig. 11.1). Geffroy, in turn, might suggest a book on Balzac, make a trip with the sculptor to Jersey and Guernsey to rediscover the land of Hugo's exile, or include Rodin in literary evenings with his friends from the Académie Goncourt.[5] In 1913, as director of the Gobelins Tapestry Works, he asked Rodin to join other artists, such as Monet, Redon, and Bracquemond, in an effort to revitalize the *manufacture*, by contributing designs for furniture.[6]

When the artist and the critic met in 1884, the young Geffroy had already written the year before that the tortured forms of Rodin's female figures seemed "haunted by the memory of Delacroix's sketches," and that the sculptor's own path was not yet clear.[7] For more than the next two decades, however, the writer was to affirm Rodin as an "original artist" who had "changed received habits" and "created a new manner of seeing and understanding," as a "revolutionary armed with classical force."[8] Geffroy's catalogue essay for the Monet/Rodin exhibition at the Galerie Georges Petit in 1889, and his contributions to the special issue of *La Plume* dedicated to Rodin in 1900, were, in fact, summations of ideas developed in the preceding years in numerous reviews of the annual salons and other exhibitions.[9]

Geffroy begins the 1889 essay with a well-chosen quote from Stendhal, calling for a new Michelangelo who would restore to sculpture the strong passions that had been banished from the art by two centuries of politeness, and who would dethrone the antique.[10] Rodin's fellowship with the great art of the past is a leitmotif of the critic's writings. Not only do *The Gates of Hell* assure his position as a new Michelangelo, but *The Age of Bronze* and *General Lynch* rival Donatello; his portraits, Houdon; the *Bellona*, Puget and Rude; the *St. John the Baptist*, Barye; *The Burghers of Calais*, medieval sculpture; and the *Balzac*, Egyptian, Assyrian, and antique art.[11]

When seen in the context of the history of sculpture, Rodin's art is "classic," but when contrasted with the "official production" of the nineteenth century, it must be proclaimed revolutionary. Geffroy's readers of 1900 could test the latter contention by comparing the works on view at Rodin's private pavilion at the Pont de l'Alma with those in the centennial and decennial exhibitions of the Exposition Universelle. The critic complains that he is subject to an "insuperable lassitude" in the face of the mastery of *métier* and of the "correctness" of proportion, musculature, and movement which characterize "our glorious French School." The dreariness of this art, he explains, is due to the fact that it is predicated upon the "lies of the imitation of the antique and a disfigurement of nature." The false classicists, whose sculptures crowd the aisles of the salons, actually betray antique art when they "continually repeat the attitudes and gesticulations of the Ecole des Beaux-Arts." Only Rodin

continues the true spirit of Greek sculpture, which was an art of naturalism and not stylization.[12]

When Geffroy terms Rodin "a Self grappling with Nature," or when he writes of the creative process that the artist's individuality of intellect is mysteriously joined to the forms that his eyes see and his hands fashion, he echoes Zola's famous definition of art as "a corner of nature seen through a temperament" and reveals his own affinity with literary naturalism.[13] Indeed, in his writings on Rodin he articulates an aesthetic philosophy that is an elaboration of Zola's dictum. Rodin is the indefatigable recorder of nature:

The realities of life, the forms and postures furnished by nature are reproduced with a rigorous exactitude, with a science anxious to show that it can transmit to the material all the physical and intellectual manifestations of humanity, the movements through which it expresses its anger, its sadness, its desires, its passions, its need of agitation and of reverie.[14]

When this master of his *métier* seems most engaged in capturing appearances, in reproducing details of anatomical structure, his personality intervenes to create something more than a dispassionate likeness:

While the sculptor, with his strong and nervous hands of a good craftsman, imitates, reproduces, recreates, an ineluctable preference makes him compare, suppress, choose. He searches among all the confusion of details for that which corresponds to the thought he wants to express. . . . He is obsessed by the idea of gathering all this scattered life in a summation of such force and such distinctness that one glance will suffice for understanding the union of a thought and a temperament, an organism at rest or in action, a being that desires, meditates, loves, complains, resigns itself and dies. It is thus that the loftiest synthesis is born of the most scrupulous analysis.[15]

In his romantic emphasis on the artist's subjective response to nature, Geffroy stretches the concept of temperament, as it was conceived by Zola to account for the inevitable presence of the observer in any work of art, however detached and scientific.[16] The critic conjures a paradoxical image of Rodin the creator, one which parallels the aesthetic dichotomies of nature and temperament, and of analysis and synthesis. Rodin is not only the "good craftsman" with "strong hands," the "energetic worker," but also "the mystical poet," who possesses the "faculty of a seer."[17] He is able to portray Hugo—"the great pantheist poet"—because he, too, is "in love with nature, the evoker of forms present everywhere."[18] Not only does his sculpture represent an "identification of marble and bronze with the multifarious aspects of existence," but also each work is, magically, "an emanation of a thought transmitted by magnetic fingers."[19]

The worker and the poet are complementary in

Geffroy's aesthetic code. He insists that Rodin's divination of the meanings immanent in nature is only made possible by his relentless interrogation of the living human form. The critic is perspicacious in his understanding of how Rodin's naturalism leads him to a new kind of symbolism that eschews academic rhetoric:

One should not forget for a moment that the seer is also a maker of statues and that form is born in him at the same time as the idea and perhaps before the idea. . . . Observation is not sacrificed to any rhetorical effect. No vague literary intention, no insufficient illustration takes the place of animated life.[20]

The "literary intentions" of which he absolves Rodin are those underlying the predictable gestures and poses of the stock allegorical figures whose proliferation Geffroy laments time and again as he reviews the annual salons:

Leda is always pensive in contact with the swan. Mercury constantly needs to fasten his heel-wings. The young fauns smile and frisk. Fortune lightly touches a winged wheel and maintains a theatrical pose. Perseus brandishes the head of Medusa with the banal gesture of a foppish vanquisher. Magdalene cries and agitates her mannered hands. Judith looms like a tragedienne before the bed of Holofernes. Apollo presides over the torture of Marsyas. Bacchantes gesticulate in methodic drunkenness.[21]

This oppressive lack of originality can be attributed to the fact that the academically trained artist proceeds from a subject that entails a stylistic formula:

He began by taking the name of a figure, by appropriating a symbol, he continues and finishes by transposing the arrangement of drapery, the appearance of flesh, the musculature of the arms, the legs, and the torso, the meaning of features and gestures.[22]

Rodin, instead, allows his figures to reveal their subjects (fig. 11.2):

The figure sculpted by Rodin causes him to reflect, speaks to him softly and for a long time, like nature herself, tells him what feeling moves her, in what joy of flesh or in what anguish of mind she finds herself, whispers to him what name she must have.[23]

When Rodin does turn to a literary source, as in *The Gates of Hell*, he strips his subject of anecdotal incident in order to express eternal, human themes:

The Gates of Hell is the assemblage in animated movement of the instincts, the fatalities, the desires, the despair of all that cries out and moans in man. The Ghibelline's poem has retained no local color, has lost all its Florentine significance. It has been, as it were, denuded, expressed in its synthetic meaning, as a collection of all the non-changing aspects of humanity of all countries and all periods.[24]

Geffroy acclaims the modernity of Rodin's themes as well as their timelessness. He implicitly compares Rodin with Zola when he applauds the sculptor's expression of a very contemporary biological determinism:

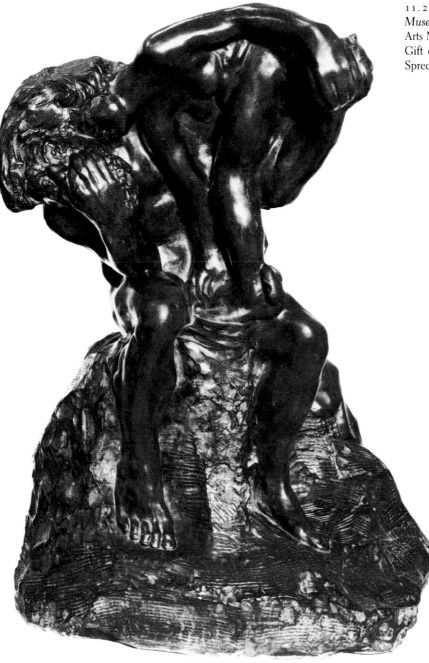

11.2 *The Sculptor and His Muse*, 1890. Bronze. The Fine Arts Museums of San Francisco, Gift of Mrs. Alma deBretteville Spreckels. Cat. no. 132.

Rodin comes at his appointed hour, at the end of this century, in order to portray physiological humanity in its various actions, in the fatality of its functions. He carries on the art where Barye left off; after the evocation of the life of animals, he undertakes to evoke the animal life of man.[25]

The critic assures his readers that the explicit eroticism of Rodin's sculptures is not pornographic, because it treats the tragic frustration rather than the satisfaction of desire:

Still it would be a serious mistake to imagine to find in these unrestrained postures the slightest invitation to lewd pleasure, the slightest consenting to obscenity. The emotion expressed, even among the couples where bestiality prevails, where lovers are joined, is always profound and mournful. Rodin is the sculptor of sorrowful lust. . . . It is always . . . the suffering of the first man and the first woman of the mythology of Israel, divided, uncoupled, pulled apart, who desire interminably, despite the impossibility, to reunite and commingle.[26]

The above passage was written in 1886. By 1900, Rodin's fauns and satyrs, and works such as *Eternal Springtime* and the *Waves*, prompt Geffroy to hail an optimistic paganism as the complement of the disturbing

fatality of the earlier work. He commends Rodin for a "serene acceptance of the laws of the universe" and for expanding his concept of existence to show "light as well as shadow, the joy of being at the same time as the terror of mystery."[27]

When Geffroy maintains that form and content are integrally related in Rodin's art, he generally means by "form" a configuration of the human body, and not the abstract elements of contour, surface, shape, and proportion. The passions and vices expressed in *The Gates of Hell*, for example, are "evoked by a gesture, a pose, an inclination of the head or by a facial expression."[28] And in his analyses of individual works, the critic usually stresses the communication of subject by these theatrical means; however, he also recognizes the expressiveness of purely sculptural "form," when he calls Rodin's *oeuvre* "a biography where the events are works, where feelings, passions, joys, longings, and moral crises are represented by plastic conceptions, by line and by modeling."[29] When he draws attention to specific features of Rodin's execution, it is to speak of them as the marks of personal style, as in the following passage on the bust of *Antonin Proust*:

A personal effort appears in the broad modeling, the hollowing of folds, the puckering of flesh, the accentuation of line. The bronze is treated with sureness and violence, and the antithetical expressions of rough skill and bold delicacy come to mind to characterize the sculptor's talent.[30]

Geffroy's discussions of Rodin's formal means most often emphasize the sculptor's ability to simulate life. Time and again he marvels at the fact that Rodin can transform "this moving, organic, substance into a solid substance and retain the shiver of life which is its beauty"; that he can "transmit to the material the physical and intellectual manifestations of humanity"; and that he creates "surfaces that quiver like flesh."[31] Even when the artist distorts his forms, the critic finds that it is done in the interest of verisimilitude and not of subjective expression: ". . . in order to give the sensation of life, it is necessary to exaggerate slightly, to amplify the form in order to obtain only a bit of exactitude."[32] The writer expresses his awe before the sheer anatomical existence of Rodin's figures as follows:

That which cannot be expressed in words is the quality of flesh, the bending of joints, the flexibility of vertebral columns, the differences in surface, the weight of pelvises, the softness of breasts, the crackling of elbows and knees, the correct placement of the skeleton, the tension of muscles, the thrill of nerves, the play of respiration.[33]

Rodin's single most important achievement, in Geffroy's eyes, is his liberation of sculpture from the tyranny of the academic pose:

Rodin did not stop for an instant at this notion that only a half-dozen conventional poses could represent all of life in sculpture. Nature by each of its decompositions of movement, by its nuances of expression, revealed to him at once that it would furnish more poses and statues than he could ever make, in profusion, in distressing quantity.[34]

The critic's sighs are almost audible as he catalogues the poses that characterize the sculptures exhibited at the Salon of 1890, each stamped in a mold of the Ecole des Beaux-Arts:

A straight body, a bent leg, a raised arm—an outstretched body, leaning on an elbow—hands clasped behind the head to make the bust project forward—a bowed head, one hand holding an elbow, the other at the chin—such are the principal arrangements of line, barely increased by a few insignificant variants, which render so monotonous this indistinguishable crowd of statues.[35]

Geffroy recognizes in Rodin an uncanny gift for "surprising nature" by capturing the most fugitive movements of the model through the artist's "comprehension of the logical movements of the body to the point of paying most attention to the unconscious poses taken by the models."[36] Not only does the slightest movement of

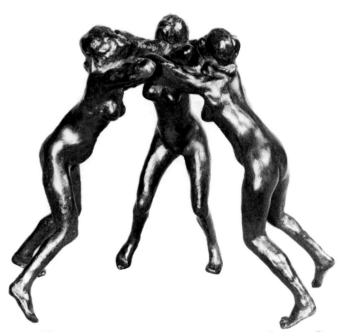

11.3 *Three Faunesses*, 1882. Bronze. B. G. Cantor Collections. Cat. no. 266.

any part of the human body engender a new pose for the sculptor to capture, but each of these movements, by virtue of its connection with the life-continuum, provides the artist with a harmonious "natural" composition (fig. 11.3):

All these movements follow one another, are linked to one another, govern one another . . . all these passages are of an infinite beauty for the quite easily understood reason that it is no longer a question here of a conventional pose, where the equilibrium is inevitably broken by an intention, by a gesture, by a fragmented movement that is not in accord with the general movement. . . . We readily understand that each movement creates a perfect agreement between all of the parts of the whole, since all of these parts obey each impulse at once.[37]

In a poetic vein, Geffroy compares the infinite number of possible natural poses to the waves in the sea, the grains of sand on a beach, and the stars in the sky.[38] This

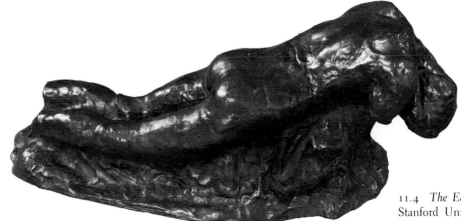

11.4 *The Earth*, 1884. Bronze. The Stanford University Museum of Art, Gift of the B. G. Cantor Art Foundation. Cat. no. 288.

is more than a fanciful simile, for it suggests the profound feeling for the unity of all nature which the writer believes links Rodin's sculpture to impressionist painting:

There the same thing happens with regard to the human figure as happens to landscape in continual movement under the passage of waves of light. . . . I have shown Rodin in the presence of the natural, easy transformations of his model, intoxicated with the truth, which reveals itself to him through all of the aspects of this form, at once fixed and changing, resembling all that exists, all the *fugitif durable* of nature, the sky, the sea, the universe animated by light.[39]

This passage is from an article of 1900 in which Geffroy contends that a kinship exists between the painters whom he spent much of his critical career defending and Rodin. Just as the impressionists suffered from accusations that their work showed no deliberation and lacked finish, so did Rodin. Like them, Geffroy asserts, the sculptor is concerned with fixing transitory impressions (*le fugitif durable*) and with harmonizing his forms through effects of light and atmosphere. Geffroy never claims that Rodin's luminous modeling dematerializes his forms—indeed, he insists that solidity and materiality are essential to sculpture—but he does believe that it creates an atmospheric unity of the figure with its surrounding environment:

. . . he is the master of sculpture of our times because he does not separate the creatures he represents from the atmosphere where they live, because he clothes them with the light and shadow that unifies them.[40]

The vibration of light not only brings Rodin's figures into accord with surrounding nature, but also creates harmony within the sculpture by investing the entire surface with life.[41] This principle, the critic avers, renders Rodin's fragments as complete as any of his statues.[42] This argument is adduced in a discussion of the fragmentary *Earth* (fig. 11.4), which Geffroy further justifies in the following manner:

It is a body stretched out on its stomach, a powerful piece, which is missing arms and legs, and it is a woman in hovering movement, the legs bent back, the arms extended, the body thrown forward. How can it be that in this last statue with its accentuated movement, its limbs projecting in such a manner, there is no bristling or mangling, but, on the contrary, force and equilibrium? It is because, in fact, all movements, all aspects of life are possible in sculpture and the great truth that matters is the realization of modeling in light.[43]

Rodin was criticized by both Roger Fry and Matisse for an attention to detail that mars compositional unity.[44] Geffroy, however, throughout his critical writings, repeatedly praises what he considers to be the sculptor's "preoccupation with the whole (*ensemble*) and with the key expression (*expression dominante*)."[45] At times he seems to be speaking of a psychological rather than formal unity, similar to that which Fry acknowledges when he writes that "every part of the figure is instinct with the central idea, every detail of hand or foot is an epitome of the whole."[46] The portraits are most often remarked by Geffroy for their psychological unity, as when he writes of the *Jules Dalou* in 1884:

The details are more than indicated; each feature of the face is marked with an incisive precision; and yet an astounding unity of expression

appears in this face. Each line, each hollow, each relief, concurs to express the character of the man; the artist saw all the peculiarities of the physiognomy of his model, but he also saw the life that animated it. [47]

A similar animation unifies the bust of *Antonin Proust*, where "a distinct vision of life is communicated by the whole," and also that of *Puvis de Chavannes*, whose pose, from any vantage point, is "physiologically and intellectually informative." [48] It is not a question of the parts reflecting the whole, however, when Geffroy extolls figures from *The Gates of Hell* for a subordination of physiognomic detail to a unity of expression:

The faces appear, hide, are precise or indistinct, according to whether they determine or submit to the law of the whole, the expression pursued from the head of hair to the big toe. [49]

While it is not clear that Geffroy is referring to overall design in the above passage—rather than a vaguer notion of "expression"—he certainly has formal unity in mind when he explains the public's hostility to the *Balzac* as the product of a vision conditioned by salon sculpture, in which details of figure and costume are represented "as in an inventory, to the detriment of unity of form"; [50] or when he lauds the "form" of the Victor Hugo for being "of a magnificent unity despite the infinite nuances." [51]

Rodin's inflection of surface and generalization of form must be distinguished from the anecdotal detail and simplistic reductions which render conventional portraiture expressionless:

In general, sculptors execute these commissions without bringing much passion to the modeling of these flat faces, these caricatural profiles, these bald skulls, made out of balls, eggs, and knobs. They reproduce details of costume and are far from forgetting the foreign decorations and the pearl necklaces. As for the face, it is haphazard. The factitious resemblance of photographs is barely guaranteed. As to the intimate, profound resemblance to moral being, it is useless to dream of it. The means to make this resemblance appear are absolutely scorned or, rather, not known. [52]

Rodin, however, is the rare artist who knows how to penetrate the psyche of his subjects, as in his bust of *Henri Rochefort:*

The forehead is restless, anxious, uneasy; the deep-set eyes are vacillating and searching; the nervous mouth with a deviation of an astounding accuracy of drawing is ready for smiling and for biting. Thought hovers about these mobile features, the courageous face of this pamphleteer. An extraordinary portrait that will endure as both the masterpiece of an artist and the page of an historian. [53]

More than any other artist, the portraitist is, for Geffroy, the recorder of his age. While fashionable practitioners of this genre are eager to preserve their subjects for posterity "as solemn wearers of frock-coats and majestic women in décolletage," Rodin captures Victor Hugo as "the aging genius" and Madame Morla-Vicuña as "the woman of today," with "the reserved countenance of a society woman, the physical suppleness of a living and nervous creature." [54]

The sculptor of public monuments, like the portraitist, is a historian who must transcend the anecdotal particulars of his subject in order to make an enduring statement. Geffroy commends Rodin for having achieved a multi-layered expression in *The Burghers of Calais*, where each burgher is:

a bronze giant incarnating the existence of a city, a marvel of historical comprehension, a kind of burgher Christ, emerged from the mud of the Middle Ages, conscious suffering, admirable expression of human sacrifice. [55]

This monument is also heralded as "a new conception of the decoration of public places," as "sculpture for public squares, for space, for air, for the street, for the surrounding houses." [56] What makes the *Burghers* so innovative is its unconventional composition:

He avoided constructing the ordinary pyramidal group, where the heroes are disposed in tiers, where some supernumeraries are applied in silhouette against the pedestal. He wanted a slow procession, the figures far apart, the walk towards death, with the step of feverish haste, and the steps that draw the strong and the aged, the angry and the resigned. The statues will pass there where those condemned to the gallows passed, there where the artist saw them, in echelon, focusing on their horrible end, or lingering over regrets. [57]

Amid the brouhaha created over the *Monument to Balzac* by Rodin's admirers and detractors alike, Geffroy stood as one of the artist's most steadfast and articulate defenders. [58] He calmly appealed to his readers with an explanation of how Rodin had arrived at his final conception through a long process of "naturalist" documentation and also with a demonstration of how the statue conformed to the logic of Rodin's artistic development and to the exigencies of the public monument. [59]

In an ingenious essay of 1900, Geffroy endeavors to combat objections to the sculpture by showing its connection with Rodin's method of drawing. After slyly pointing out how many of Rodin's drawings employ Old Master techniques, he shows how the bolder gestural drawings capture the fugitive poses that make Rodin's sculptures so lifelike. The nexus is clear:

Between the drawing made of a simple stroke and wash, which expresses a movement of the model, when the model has left the pose and unconsciously assumes a natural pose, and a work like the *Balzac*, which fixes the volume of a body during one of its fugitive movements, which forms a silhouette that moves and shivers under the light—between these drawings and this statue, there is a logical correspondence, an absolute correlation. It was at the very moment

when he was accused of exhibiting a sketch, that Rodin had realized more. It was when they called him hesitant, that he had made his definitive discovery.[60]

Most sculptors create "lifeless effigies" when they enlarge their models for public sites, the critic contends, because they do not understand the attendant problems of proportion. Because Rodin recognizes that adjustments must be made both in volume and in height, he is able to symbolize the grandeur of his subject as well as to evoke a living being:

Here the proportions are admirable, to the point of making the small stature of Balzac appear with a singular exactness, in this colossus two meters and seventy centimeters high. The massiveness of the person is expressed at the same time as his light carriage, precisely by this manner of directing, of uniting the planes, of modeling them with the totality in mind.[61]

The unprecedented breadth of the *Balzac* was justified by several of Rodin's apologists as the product of a necessary logic within the sculptor's *oeuvre*.[62] It is particularly natural for Geffroy to defend the monument in these terms, for it follows the logic of his own criticism. From the time of his earliest reviews, in the mid-1880s, of the portraits and works from the *Gates*, he claimed that "synthesis" and a concern for the *ensemble* were primary features of Rodin's aesthetic. Geffroy brings together his own aesthetic preoccupations with harmony, with light, and with life, in his singularly "formalist" evocation of the modeling of the *Balzac*:

The forms here, more than ever, are presented by simple planes, delicately and infinitely nuanced. They carry with them their own coloration, that is to say, their shadow and their light, and they appear to us in a blonde atmosphere, the transparent grey shadows and the graduated light resulting in brilliant softness. No sharp angles or ridges, a single envelope which brings together, harmonizes all of the individual details, which makes of it an amalgam, a whole, an image unified by life.[63]

Gustave Geffroy brought to his appreciation of Rodin a discerning eye and an analytical mind. Unlike other critics of the day, who rarely went beyond lionizing Rodin and inveighing against the art establishment, Geffroy was specific and penetrating both in his recognition of Rodin's original gifts and in his condemnation of salon sculpture. The critic enriched his perceptions with suggestive references to the history of art and to the intellectual currents of the time, doing so without forcing stylistic analogies. Geffroy need not have worried about his "pages of perishable paper," for today, nearly a century later, his language remains vivid and his judgments astute.

NOTES

1. I have found Geffroy's themes, and at times even his phrasing, repeated in much of the subsequent criticism, although I cannot prove this claim here. He wrote his first substantial comments on Rodin in 1884 and had already developed many of his ideas by the time of his important 1889 essay for the Monet/Rodin exhibition at the Galerie Georges Petit. A good sampling of Rodin criticism in general is available in Ruth Butler, *Rodin in Perspective* (Englewood Cliffs, N. J.: Prentice-Hall, 1980). Gustave Geffroy (1855–1926) achieved prominence not only as an art critic and historian, but also as a novelist, biographer, political essayist, and literary critic. As art critic for *La Justice* and *Le Journal*, he was an important champion of the impressionists and post-impressionists and wrote on a wide range of topics during the period from 1880 to about 1905. A close friend of Clemenceau, an officer of the Académie Goncourt and of the Syndicat de la Presse artistique, and from 1908 to 1926, director of the Manufacture du Gobelins, he was also an influential figure in the art politics of the day.
2. See Robert T. Denommé, *The Naturalism of Gustave Geffroy* (Geneva: Librairie Droz, 1963) for a discussion of Geffroy's relationship to the de Goncourt and to Zola.
3. Both quotations are from undated letters on *La Justice* stationery in the archives of the Musée Rodin, Paris. I have been permitted to consult only a few of the 217 letters from Geffroy to Rodin, whose existence is mentioned in the catalogue of the Musée Rodin, *Rodin et les écrivains de son temps* (Paris: Musée Rodin, 1976), 73.
4. Letter dated 12 May 1888, in the archives of the Musée Rodin, Paris. Articles on Geffroy frequently mentioned the many sculptures by Rodin that graced his home. Although a spirited and often mordant critic, Geffroy was characterized by his friends as gentle and shy. An unsigned article in *L'Avenir de la Dordogne* of 29 April 1926 recounts how Rodin asked a visitor to his studio if he did not find a resemblance between the bust of Geffroy and a famous antique portrait of the emperor Caracalla. When the visitor objected that Geffroy was hardly a monster, Rodin replied that he had not had the occasion to be one.
5. On the suggestions for reading, see letter quoted in Musée Rodin, *Rodin et les écrivains*, 74. Rodin and Geffroy made the trip with the painter Carrière in 1892. The sculptor is mentioned frequently in the extensive correspondence from writers and artists to Geffroy that is preserved in the archive of the Académie Goncourt in the Bibliothèque de l'Arsenal, Paris.
6. There is no evidence that Rodin actually accepted Geffroy's commission, which is mentioned in "Aux Gobelins," *La Vie parisienne*, 7 February 1914, and in "Aux Gobelins," *Le Cri de Paris*, 21 September 1913, as follows: "Sachez maintenant que le directeur des Gobelins nous réserve une grande surprise? . . . il vient de prier M. Auguste Rodin de lui dessiner des dossiers de fauteuils. Le maître

statuaire . . . s'est déclaré enchanté de travailler pour une autre manufacture nationale. Il va composer des médaillons dans le goût de l'antique des profils de dieux, de déesses et d'empereurs que sertiront des couronnes de lierre et de laurier."

7. Frederick Lawton, *The Life and Work of Auguste Rodin* (London: Fisher Unwin, 1906), 124, says they were introduced by Bazire of the *Intransigeant* before Geffroy was quite thirty. Gustave Geffroy, "Exposition des Arts Libéraux," *La Justice*, 5 March 1883. (All works cited hereafter are by Gustave Geffroy unless otherwise indicated.) All translations are my own. The only English versions of any writings on Rodin by Geffroy are those in Butler's *Rodin in Perspective*, where she reprints the 1889 translation from *Arts and Letters* of his essay for the Monet/Rodin exhibition. The flowery style of this Victorian translation does injustice to Geffroy's often spare prose, which is distinguished by precise descriptions and evocative and resonant language. The liberties the translator has taken often distort the meaning as well.

8. "Souvenirs de l'Exposition de 1900; l'exposition centennale de la sculpture française; Rodin," in *La Vie artistique*, 8 vols. (Paris, 1892–1903) (hereafter cited as *LVA*), série 7 (1901), 249 and 265. "Chronique: Rodin," *La Justice*, 11 July 1886.

9. Geffroy wrote articles on Rodin almost every year from 1883 to 1904. His non-collected articles in *La Justice* appeared on 3 March 1883, 20 June 1884, 9 May 1885, 11 July 1886, 19 and 20 May 1887, and 23 May 1888. The important 1889 essay was published in various sources: *Claude Monet, A. Rodin* (Paris: Galerie Georges Petit, 1889); reprinted as "Auguste Rodin," in *LVA*, série 2 (1893), 62–115; and in shortened form, as "Le Statuaire Rodin," *Les Lettres et les arts*, 1 September 1889, 289–304. His journalistic criticism from 1890 to 1901 is collected in the eight volumes of *La Vie artistique*. After a final essay—"Le 'Penseur' de Rodin au Panthéon," *Revue Bleue*, 17 December 1904—Geffroy wrote little criticism, devoting himself, instead, to art historical studies and, after 1908, to administration of the Gobelins.

10. "Auguste Rodin," 62.

11. "Souvenirs de l'Exposition de 1900," 264 and 273; "Auguste Rodin," 114; "Salon de 1894; Au Champ-de-Mars; Puvis de Chavannes," in *LVA*, série 4 (1895), 131.

12. "Renaissance par Rodin," in *Rodin et son oeuvre* (Paris: La Plume, 1900), 6. In "Souvenirs de l'Exposition de 1900," 246–247 and 286–289, Geffroy also attacks a contemporary sculpture of "pretend realism," which combines meticulous details of costume and skin texture, exact proportions, and obsessive finish to produce "a cold simulacrum," "a false double," "the inert image of a figure cast from life."

13. "Auguste Rodin," 115; "Hors du Salon: Auguste Rodin," *La Justice*, 19 May 1887.

14. "Hors du Salon."

15. "Hors du Salon." For stylistic reasons, I have translated the technical word *praticien*, which means "sculptor's assistant," or "rougher-out," as "craftsman." *Praticiens* were often skilled professional sculptors in their own right who worked for other sculptors on important commissions. There are complex aesthetic issues implicit in the passage quoted—such as the precise nature of Geffroy's notions of "synthesis" and "analysis," of the relationship between the artist-observer and the perceived object, and between meanings imposed by a "temperament" and those immanent in nature—which I am aware of having oversimplified for the purposes of this introductory essay to Geffroy's writings on Rodin. In my future study of Geffroy's criticism in general, I intend to provide a chronological treatment of

the interrelationship in his thought of ideas culled from romanticism, naturalism, and symbolism. Richard Shiff, "The End of Impressionism: A Study in Theories of Artistic Expression," *Art Quarterly*, New Series I, 4 (Autumn 1978): 338–378, makes a penetrating analysis of these issues in the context of impressionist painting.

16. Most critical evaluations of Zola note a discrepancy between his polemical allegiance to scientific documentation and to biological determinism and the visionary element in his fiction. Geffroy himself called the novelist "le poète qu'on se refuse généralement à voir, le poète panthéiste qui sait superbement augmenter et idéaliser les choses." Cited in Denommé, *The Naturalism of Gustave Geffroy*, 109. See John A. Frey, *The Aesthetics of the Rougon-Macquart* (Madrid: José Porrua Turanzas, 1976); J. H. Matthews, *Les Deux Zola* (Geneva: Librairie Droz, 1957); and Martin Turnell, *The Art of French Fiction* (New York: New Directions, 1959).

17. "Hors du Salon: Auguste Rodin," *La Justice*, 19 and 20 May 1887; "Salon de 1888; un buste de femme," *La Justice*, 23 May 1888.

18. "Salon de 1897; Au Champ-de-Mars; Le Victor Hugo de Rodin," in *LVA*, série 5 (1897), 351.

19. "Salon de 1895; Au Champ-de-Mars et aux Champs-Elysées; Un bourgeois de Calais," in *LVA*, série 4 (1895), 230.

20. "Auguste Rodin," 81.

21. "Souvenirs de l'Exposition," 284–285.

22. "Souvenirs de l'Exposition," 286.

23. "Le Statuaire Rodin," 297. In "Souvenirs de l'Exposition," 240–274, Geffroy argues in a less whimsical fashion for this inextricable relationship between form and content. He shows how Rodin arrives at his subjects by first making drawings of spontaneous poses from life, which may then suggest to the artist a dryad, nymph, siren, or fauness, or may seem to symbolize any of a variety of emotions. If one of these sketches inspires a sculpture, then the subject of the work is "an idea suggested naturally by a state of the human form," and not a preexisting mythological or allegorical type. The essay was written to defend Rodin against charges of being "too literary," a surprising accusation in view of the fact that *The Age of Bronze* had been attacked early in Rodin's career for its lack of a recognizable subject. See Butler, *Rodin in Perspective*, 77 and 81–82, for examples of critics who found Rodin too susceptible to the literary influences of his friends.

24. "Le Statuaire Rodin," 295.

25. "Chronique: Rodin," *La Justice*, 11 July 1886.

26. "Le Statuaire Rodin," 300–301.

27. "Souvenirs de l'Exposition," 267–268.

28. "Le Statuaire Rodin," 295.

29. "Auguste Rodin," 68.

30. "Salon de 1885; La Sculpture," *La Justice*, 9 May 1885.

31. "Souvenirs de l'Exposition," 258.

32. "Souvenirs de l'Exposition," 249.

33. "Chronique."

34. "Auguste Rodin," 83.

35. "Le Statuaire Rodin," 298.

36. "Auguste Rodin," 115.

37. "Souvenirs de l'Exposition," 256.

38. "Salon de 1890; Aux Champs-Elysées et au Champ-de-Mars; Rodin," in *LVA*, série 1 (1892), 228.

39. "Souvenirs de l'Exposition," 256. The multiplicity and unity of nature (*la vie universelle*) is an important concept in Geffroy's aesthetics, one which has implications of social harmony. Aesthetic harmony is always achieved by light and is the fundamental principle

of decoration. *Le fugitif durable* is the notion, formulated by Geffroy in his writings on the impressionists, that nature is both eternal and in continual flux and that the artist's goal is to make something enduring by capturing transitory impressions.

40. "Salon de 1896; Au Champ-de-Mars; Deux figures de Rodin," in *LVA*, série 5 (1897), 169.

41. "Salon de 1896," 169.

42. "Salon de 1897," 354.

43. "Salon de 1896," 169.

44. Roger Fry, in "The Sculptures of Maillol," *Burlington Magazine* (April 1910): 26–32, reprinted in Butler, *Rodin in Perspective*, 147, states that "for Rodin it is the unit that counts rather than the unity." Matisse in Raymond Escholier, *Matisse Ce Vivant* (Paris: Librairie Arthème Fayard, 1956), 163–164, reprinted in Butler, *Rodin in Perspective*, 149–150, contrasts Rodin's working method with his own: "I could not understand how Rodin worked on his *St. John*, the way he cut off a hand and fit it into a sleeve; then he worked on the details while holding it in his left hand. It seemed, more or less, that he had detached it from the whole and then he replaced it at the end of the arm, at which point he tried to position it to fit into the general flow of the movement. As far as I was concerned at that point I could only work on the general architecture of the whole, replacing exact details with a lively and suggestive synthesis."

45. "Salon de 1891; La Sculpture," *La Justice*, 10 July 1891.

46. Fry in Butler, *Rodin in Perspective*, 147.

47. "Salon de 1884," *La Justice*, 20 May 1884.

48. "Salon de 1885"; "Salon de 1891."

49. "Auguste Rodin," 96.

50. "Salon de 1898; à la Société des Beaux-Arts; le 'Balzac' de Rodin," 373.

51. "Souvenirs de l'Exposition," 270. He makes this claim with regard to *The Gates of Hell*, too: "Toutes ces oeuvres; placées dans le cadre de la *Porte de l'Enfer*, retirées, remises, au cours de la recherche d'harmonie générale qui a été, qui est toujours, la préoccupation de Rodin . . . ," ibid., p. 267. Of a *Burgher* exhibited in 1895, he writes, ". . . elle se présente en une masse harmonieuse où les pesanteurs et les allégements necéssaires ont été repartis d'une façon impeccable," "Salon de 1895," 211.

52. "Salon de 1888."

53. "Chronique."

54. "Auguste Rodin," 100.

55. "Salon de 1895," 213–214.

56. "Salon de 1895," 211; "Auguste Rodin," 107.

57. "Auguste Rodin," 109.

58. See Stephen C. McGough, "The Critical Reception of Rodin's Monument to Balzac," in *Rodin and Balzac* (Stanford: Stanford University Museum, 1978), 60–66.

59. "Salon de 1898"; "Salon de 1899; Le 'Balzac' de Falguière et le 'Falguière' de Rodin," in *LVA* série 7 (1901), 390–394; "Souvenirs de l'Exposition," 242–275.

60. "Souvenirs de l'Exposition," 242.

61. "Salon de 1898," 326.

62. See Camille Mauclair, "L'Oeuvre de M. Auguste Rodin," *Revue des revues*, 15 June 1898; and Georges Rodenbach, "Une Statue," *Le Figaro*, 17 May 1898.

63. "Salon de 1898," 326.

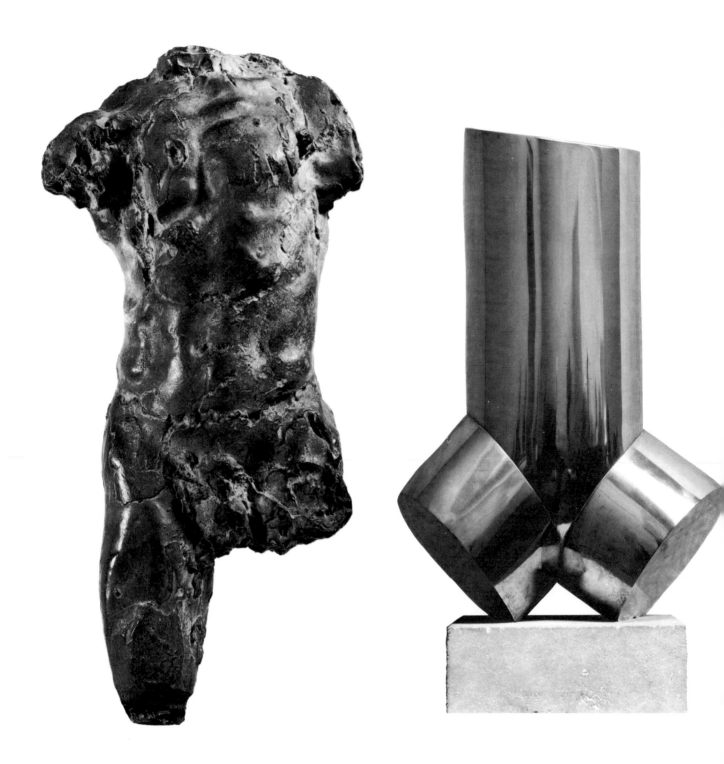

12.1 *Torso of the Walking Man*, before 1889. Bronze. Musée du Petit Palais, Paris. Cat. no. 358.

12.2 Constantin Brancusi, *Torso of a Young Man*, 1917. Brass. The Cleveland Museum of Art, Hinman B. Hurlbut Collection. Cat. no. 357.

12. *Rodin / Brancusi*

Sidney Geist

The complex relationship of Constantin Brancusi to Rodin surely began while he was a student at the Bucharest School of Fine Arts, during a period, 1898–1902, when the fame of Rodin was at its height. In 1900 the Rumanian sculptor Dimitrie Paciurea returned from a four-year stay in Paris, and it is altogether likely that he and the talented young sculptor met.[1] Paciurea, himself much influenced by Rodin, would have referred often to the work of the French master, and it is not difficult to suppose that Brancusi's interest was stirred more by these first-hand reports than by the record of Rodin's achievement that could be gained in the press of the day. This interest would have been an urgent reason for his journey to Paris in 1903–1904. Once in the French capital, Brancusi was charmed by the life of the city, but he must also have realized that Paris was the stage on which the drama of art would be enacted in his time—and he meant to be one of the chief players. Unlike Paciurea he did not return to Rumania; except for brief visits to the country of his birth he stayed in Paris for the rest of his long life.

While it becomes clear with the passage of time that Brancusi was open to influence from all quarters, that of Rodin was paramount and is evident at once on the skin of his sculpture which, for more than three years, reflected the gamut of Rodin's bravura handling of clay. But for a much longer period it was Rodin's bold truncation of natural forms that affected the very conception and structure of Brancusi's sculpture (figs. 12.1, 12.2). In his art truncation acquired the force of a principle: the *selection* of a fragment from a larger whole. We may see the focus on the significant fragment as leading directly to the Brancusian pursuit of essence.

This development lay in the future. In the meantime the young sculptor began to put his work before the Parisian public. At the Salon of 1906 Rodin admired his three entries and cautioned him not to work too quickly—advice he seems to have followed. It is likely that their conversation was made possible by the fact of a previous encounter between the two men. For it was in this same period that Brancusi was present at a luncheon in Rodin's Meudon studio, a visit arranged either by Maria Bengescu and Otilia Cosmutza, compatriots and writers who were friends of Rodin, or by the Queen of Rumania who, as Carmen Silva, was devoted to the arts and herself a writer. When questioned later about the works he had seen at Meudon, Brancusi replied, "I think that the wine was very good."[2]

The remark is indicative of the need of the generation of sculptors who came to maturity in Paris before the First World War to repudiate the colossus who had so long bestrode the world of sculpture. It was indeed by direct carving and specifically in creating *The Kiss*, 1907–1908, that Brancusi succeeded in freeing himself from many aspects of Rodin's influence and in opening up a new path. But he is still thinking of the realism of Rodin when he says to Margit Pogany in 1910 that "art is not copying nature."[3] There is a veiled criticism of Rodinian practice in Brancusi's aphorism, first published in 1925: "Direct carving is the true path in sculpture."[4] Another dictum, "Work is a Biblical curse," uttered in 1938,[5] is a comment on Rodin's ceaseless productivity. We may imagine that Rodin was implied in Brancusi's sarcasm on the subject of "beefsteak," ostensibly directed at the sculpture of Michelangelo.[6]

Was the proud and talented Rumanian ever employed by Rodin? Many early accounts refer to him as Rodin's disciple, student, or assistant; yet in 1953, on the occasion of an exhibition of sculpture held in honor of Rodin, Brancusi stated that when he was invited to work for the master at Meudon he refused, saying, "Nothing grows in the shadow of the great trees." Rodin, he claimed, said, "He's right. He is as stubborn as I am."[7]

On the other hand, some six decades after the event, Henri Coandă, a scientist and a pioneer of Rumanian aviation, said that in the spring of 1907 he worked for a time beside Brancusi at the Meudon studio.[8] Any doubts on this matter seem to be put to rest by a

271

document which has recently come to light. At the end of March or beginning of April, 1913, Edward Steichen, in a letter written from his home outside of Paris to Alfred Stieglitz in New York, gave his impressions of the current Salon des Indépendants.[9] In the course of his discussion he mentioned Brancusi's bronze, *Maiastra* (which he subsequently acquired and which is now in the Tate Gallery). To Stieglitz he wrote that he "asked the price they did not have it so I looked him up and discovered it was a fellow I knew well years ago had seen him often at Rodins. His work had never interested me as much as he did—." Since we have been told of only one "visit" by Brancusi to Meudon, the fact that Steichen had seen him "often" at Rodin's points to a period of employment.

According to a rule of the Ecole des Beaux-Arts, no student was permitted to remain beyond his thirtieth birthday. Since Brancusi had entered the school less than eight months before he was thirty, the rule was stretched and he was allowed to stay on through his thirtieth year. He would thus have left the Ecole by 19 February 1907. On 18 April he received a commission to do a monument for a grave in Rumania and immediately rented a studio. It seems altogether likely that, short of funds as he usually was, he worked for Rodin for some weeks before being rescued by the unexpected commission. The date coincides with Coandă's memory of "the spring of 1907"; the brief episode was one he preferred to forget; his remark about the "shadow of the great trees" could have been made as he took leave of Rodin.

Yet in spite of his early spirit of revolt, he was fully aware of the importance of Rodin. In 1928, to an American collector who was being critical of the master, he said, "Stop right there! Without the discoveries of Rodin my work would have been impossible."[10] Five years later, discussing his career with a Rumanian friend, he said, "What could I have done better than Rodin, and to what purpose?"[11] And in 1953 he made the handsome avowal: "Thanks to [Rodin] man became once again the measure, the module on which the statue organized itself. Thanks to him sculpture again became human in its scale and the significance of its content. The influence of Rodin was and remains immense."[12]

The strength of that influence and the energies that Brancusi summoned to deal with it may be observed at every stage of his career. His first bronze, *Pride*, 1905, could pass as a work of Rodin's. To escape Rodin he had to abandon clay and undertake *la taille directe*. At least six of his titles echo those of Rodin. Whereas Rodin modeled a *Hanako*, Brancusi carved a *White Negress*. To the former's gesturing *Hands*, he opposes his single marble *Hand*, the shape of a caress. In contrast to Rodin's impassioned, apocalyptic *Gates of Hell*, Brancusi late in his life erects his clear and measured *Gate of the Kiss*.[13]

If at first glance the art of Brancusi seems radically at variance with that of Rodin, this is so only if we overlook the areas of correspondence between them. The double relation reflects the love/hate attitude of Brancusi toward his towering predecessor. In the tug of admiration and dependence on his own pride and intelligence we see the tension of a tradition at once continuous and changing. Reaching over an intervening generation of sculptors whose closeness to Rodin left them bedazzled, it was Brancusi who caught the fire from his hands. What had been a flaming brand became an incandescent torch.

NOTES

1. Paciurea (1873–1932) and Brancusi (1876–1957) were both students and protégés of the sculptor Vladimir Hegel; I. Frunzetti, *Dimitrie Paciurea* (Bucharest, 1971), 13.

2. "New Works of Art, Native and Foreign" (by Frederick James Gregg?), *New York Herald*, 29 September 1918, sect. 3, p. 11. The story surely comes from Brancusi himself; it was reported at the time of The Armory Show, 1913, but unfortunately I can no longer find the reference.

3. S. Geist, *Brancusi: A Study of the Sculpture* (New York, 1968), 191–192.

4. *This Quarter* (Spring 1925), 235.

5. P. Pandrea, *Portrete şi controverse* (Bucharest, 1945), I, 173.

6. J. Epstein, *Let There Be Sculpture* (New York, 1940), 41.

7. *Hommage à Rodin*, exhibition catalogue (Paris, 1952), unpaginated; statement by Brancusi.

8. Interview with Coandă, *Cronica*, 25 October 1969, p. 3.

9. The letter is in the Stieglitz Archive, Beinecke Rare Book and Manuscript Library, Yale University; permission to quote kindly given by Georgia O'Keeffe. The quotation which follows is copied as written.

10. Quoted by Sally Lewis; Portland Art Association, *67th Annual Report* (Portland, Oregon, 1959), 2.

11. Ş. Georgescu-Gorjan, "Mărturii despre Brâncuşi," *Studii şi cercetări de istoria artei*, no. 1 (1965): 65–74.

12. *Hommage à Rodin*.

13. For a probing study of Brancusi's reaction to a number of works by Rodin, see J. Schmoll gen. Eisenwerth, "Brancusi und Rodin: Ein Beispiel kontradiktorischer Filiation," *Festschrift Luitpold Dussler* (Munich, 1972), 457–480. For a comparison of Rodin's and Brancusi's *The Kiss*, see S. Geist, *Brancusi/The Kiss* (New York, 1978), 22–24.

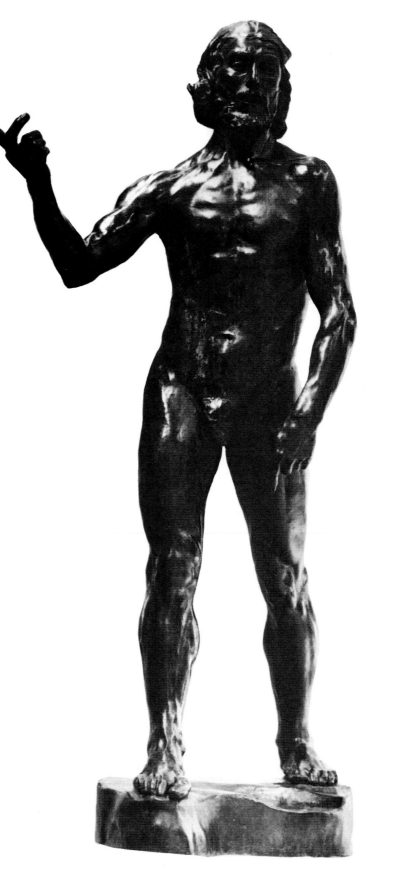

13.1 *St. John the Baptist Preaching*, 1878. Bronze. The Fine Arts Museums of San Francisco, Gift of Mrs. Alma deBretteville Spreckels. Cat. no. 22.

13. *An Original in Sculpture*

Jean Chatelain

The principal techniques in the plastic arts, by which objects are created, have not undergone significant modifications for many centuries. But the conception of the artist and of his social role changed dramatically in the course of the nineteenth century. As a consequence, a new classification and hierarchy arose for the plastic arts, which explains the advent and importance of the ideas of "original works" and "original editions."

In the eighteenth century, the notion of an artist was not clearly distinguishable from that of a craftsman. Naturally there were some masters who were more respected than others—within the various specialties—but a great cabinetmaker or goldsmith counted as much, or as little, as a great painter. At any rate, they were all skilled in delicate crafts, living in the shadow and under the protection of the rich and powerful, whose surroundings they embellished with pictures, furniture, tapestries, and curios, the decor of châteaux and mansions. The organization of work in all the crafts was based on the same principles, but adapted to the specific technical characteristics of each. It was a matter of organized professions, supervised by guilds or academies in which the idea of collective work, or the workshop, played an important role—even in the crafts which would later become the most individualistic. Thus the painter himself usually worked in a shop. For many years, he would have been the pupil of a master whom he would help, before becoming in turn—should his talent be recognized—a master himself, surrounded by pupils and assistants. He would labor slowly, seriously, over his works, like a good craftsman, in order to bring them to desired perfection. Little importance was attached to outlines and sketches, which were considered no more than still imperfect forms of the work. Eventually, if a work was crowned with success and its type lent itself to copying, the master would not balk at reproducing it himself or at having it reproduced by his assistants under his supervision, as would a cabinetmaker or silversmith.

The revolutionary upheaval which shattered the traditional workshop system and the advent of an individualistic philosophy, followed by the rise of romanticism and the development of the art market and speculation, destroyed this unity and substituted a hierarchy among the arts. All these factors contributed in fact to the emergence of a new concept, that of the artist as an inspired, exceptional being, endowed by Providence or by nature with a gift for creating, innovating—for doing what others had not yet done—and so personal, so spontaneous, was this endowment that it could blossom only within the context of total liberty, supporting neither guidance nor hindrance. This exaltation of the creative faculty, henceforth considered—much more than the mastery of a definite artistic technique—the fundamental characteristic of the artist, was to lead inevitably to a new classification of art works and the arts themselves.

Since it is the creative gift that makes the artist, it is by its innovative nature that a work of art is to be characterized. A true work of art is one which has never been done before: in short, an original work. Likewise, everything which bears witness to the creative steps of the artist will become a work of art. Since the modern artist no longer makes replicas, for to do so would be inconsistent with his very nature, each time he returns to the same subject or theme—be it twice, ten times, or a hundred times—he brings to it variations and subtleties which make the product an original work. We can distinguish such works with the aid of copious indexes and catalogues, which go so far as to specify their dates—first by year, then by season, then by month, and in a few cases by day, so very prolific were some masters.[1] On the other end of this chain of fertile production, the rough outlines and sketches, hitherto considered incomplete forms of a work undertaken by the artist, become witnesses to this creative process. They are all the more moving and important as they are more rudimentary and spontaneous; so they too are considered original works, worthy of being preserved and admired. It comes to the point where any work realized by the artist himself is an

original work. On the other hand, any reproduction of an artist's work made by someone else, no matter what the process might be, is without real artistic value and therefore of an inconsequential price, for it no longer gives direct evidence of the creative impulse. It is an object; it is not a work.

This new conception of a work of art inevitably brings about a classification of the arts which will tend to differentiate in more or less exact and telling terms between, on the one hand, the noble or fine arts, and on the other, the applied or decorative arts. Let us put forward other, less commonly used terms, yet ones which to our mind seem closer to the point: the "simple" arts and the "compound" arts.

The former are those where the work is brought to term by the creative artist himself. The painter, the draftsman, especially in the modern world, uses materials and instruments which were not made by him: canvas, paper, brushes, colors, pencils. Yet once he brings these elements together, he alone carries the work to its definitive form. By contrast, the compound arts are those where the achievement of the work requires the intervention of—in addition to the creating artist—one or more craftsmen who give the work its definitive form. Prints have to be pulled, tapestries woven, and bronzes cast, in order to become what the creating artist wants them to be but cannot realize singlehandedly. But the primacy given in defining the artist, and therefore art itself, to creativity in relation to all other aspects will necessarily tend to relegate the compound arts to an inferior rank.

First of all, it stands to reason that since art is the business of artists, the branches of activity which are assumed by artists on their own are more truly "artistic" than those where artists cooperate by necessity with artisans, whose technical skill should well be recognized. The simple arts, in the meaning given here, are therefore by their very nature purer and nobler than the compound arts, where the creative impulse of the artist is limited by the technical constraints imposed by the artisans, whose services must be used. Nevertheless, the real reason for the inferiority of the compound arts lies elsewhere; it resides in the fact that the simple arts exalt the original work, as we have already seen, whereas the compound arts, by their very nature, admit and invite reproduction and repetition.

What in fact is the role of the artisan who intervenes to complete the work of the artist? Although it is undoubtedly important, since without him the work—furniture, tapestry, bronze—cannot be brought to completion, it is secondary at the same time, for the artisan,

in relation to the creative artist, only fulfills the role of actualizer of the idea which belongs to the latter. He is an indispensable helper, but as such, no more than an executor. As his contribution is solely technical and not creative, it is open to repetition. The artist, by definition an inspired individual, will never give the same form to the same idea, while the craftsman can, and should, be able to repeat the technical activities to which he is limited. The weaver can weave the same tapestry several times, the caster can cast the same form several times, and the very proof of a job well done, that they have held to their true role and resisted the temptation to equal the creating artist, to innovate, is that the successive examples which they make of the same work resemble each other as much as the technical conditions to which they are subjected allow. Just as the exaltation of the creative power of the artist necessarily leads, for the simple arts, to the notion of the "original work," so does consideration of the artisans' part lead, for the compound arts, to the notion of repetition and reproduction. Moreover, the debate is not simply theoretical and abstract, for the compound arts require the intervention of highly qualified artisans using materials which are oftentimes considerable and costly. If one wants to ensure continuity of these craftsmen and their skills, they must be given a minimum amount of regular work, that is, reproduction. A tapestry or cast realized in a single example, of course, or a monotype, is the exception. Were one to limit himself in this way as a practice, workshops for tapestry, engraving, and bronze casting would have disappeared long ago.

Because the compound arts are arts of repetition, they find themselves exposed to the danger of no longer being considered real arts at all. At best they are regarded as "crafts," on a lower level than the noble arts. Some workshops have resigned themselves to the situation and become ordinary commercial operations, even though they nostalgically remember a more glorious past. Such has been the case in France, for example, with the craft of furniture making, which in the eighteenth century was at the very highest level. Other disciplines have endeavored to fight, to show that while turning out repetitions, they pursue a profession in art, in the full sense of the term. In order to succeed at this, they have come up with the notion of the "first edition."

The notion is seemingly quite simple and clear. Of all the technically possible editions of a work, the first is considered more noble and beautiful than those that follow. This original edition therefore constitutes for the reproductive arts an intermediate category between what in the simple arts are original works, and what in the

compound arts are simply reproductions. The carrying out of this notion gives rise to many difficulties in application, for it is based on an ambiguity which arises from the term "original edition" itself.

Simple etymology brings this equivocation to the surface. "Original" is what is at the origin, at the source, or, when it involves a series of identical objects, the first of them—the first link in the chain. Originality implies uniqueness; an edition implies diffusion, multiplication, and series. From this point of view alone the very formula "original edition" defies logic and linguistic accuracy. It therefore comes as no surprise that it gives rise to many difficulties in its application.

To escape this ambiguity, there are two courses of action: the first leads toward the demonstration that there is an identity between a work and series—either one being qualified as the original; the second goes beyond the apparent analogy to seek out the differences, without one being more worthy of interest than the other.

The first formula is especially common in, though not exclusive to, the area of printmaking. Corporate documents issued by professional organizations of editors or merchants and backed up, at least in France, by fiscal texts, dwell on the fact that an original engraving is one which is printed from a plate whose design is realized entirely by the creating artist. There are therefore two types of engraving: reproductive engravings which begin with a plate made by an engraver from a work which was realized by another artist, and the original engraving where the same man plays both roles. In the first case, to clarify, mention of both authors will be made in the prints: i.e., "painted or drawn by X, engraved by Y." In the second case, there will be only one name, usually indicated in modern prints by the artist's signature. The distinction is quite clear and therefore admissible on this point. However, it does not at all explain how the original edition, such as it is defined, differs from later editions made from the same plate. The real usefulness of the original edition idea ought to lie in its ability to explain this difference clearly. Even in the field of printmaking, this first definition gives rise to difficulties and arguments of principle and fact. Moreover and above all, because it is based on the fact that the "matrix" should be made by the creating artist's own hand, it cannot be applied to all the arts, especially in matters of bronze statuary, where casting techniques require the intervention of highly skilled technicians for making the molds and pouring the molten metal.

Along the lines of research into the relationship between an original work and an original edition, one can cite the recent efforts in France, in a very scholarly and well documented work, to distinguish within the original bronze editions that unique example which alone should be the original model, while the others would constitute production models for the editions.[2] Without even embarking on a detailed critique of the argument presented, one cannot help noticing that reducing it to a sole model destroys the notion of the original edition—which is a fact of life in the art trade.

Undoubtedly it is along other lines, therefore, that the solution must be sought, starting from a fundamental difference between the simple arts, producers of originals, and the compound arts, producers of editions. The same word, "original," although used in both cases, covers in fact two distinctly different ideas: there is no natural identity between the "original work," characteristic of the simple arts, and the "original edition," characteristic of the compound arts. In the case of the simple arts, determination of originality depends on authorship and uniqueness—whose work it is and whether there are other examples which are closely similar. This is a problem of authentication and dating, establishing which work is the first, hence the "original," and such challenges fall within the province of art historians.

The situation with the compound arts is different, for the problem is no longer one of distinguishing one original from later versions, but of distinguishing a first edition from subsequent ones and of justifying how the first differs appreciably from the others so as to give it particular value and importance. History suffices to answer the first question: a first edition, the so-called original, is of course the first to have been made. But this does not answer the second question: the differentiation among editions, even those made with equal care from the same matrix.[3] To our mind, historical, technical, or aesthetic research is not the only way to establish the material difference existing between an original edition and those that come after, for this difference is not *de facto* but *de jure*. It is not imposed by material limitations but willfully decided by men. The original edition owes history only one thing: to be the first. It then possesses a label of quality and offers a series of guarantees that later editions do not, or at least not to the same degree. In an attempt to show this, we need to know what these qualities are and who labels them.

First of all, what are these qualities? The answer, to be precise, necessarily differs according to the branch of art under consideration, for in each, the techniques are quite different. We will confine ourselves to rather general indications, except for emphasizing certain characteristics peculiar to bronze sculpture.

The first guarantee of an original edition, and without

doubt the most important in the eyes of most art lovers, is its rarity, which arises out of the purely arbitrary decision to limit examples to a given number. The limit may be more or less extensive; depending on the art, an original edition may number copies in the ones, tens, or hundreds. These may or may not be made exclusively by the same editor. Moreover, the limitation may be decided by different people in each case, for example, author, editor, or legislator. In every case the way that the value of published editions is established is the same: systematic rarefaction. It would be hypocritical or naive to find this surprising; whether an art work or something else, anything is more valued when it is rare. All things considered, it is quite normal for this formula of rarefaction to be used to boost the value of arts which might otherwise be underestimated due to the very fact that they are reproductive arts, producers of multiples. The effectiveness of this formula remains such in the eyes of the public at large that we can see it used to give greater value to editions which, for want of being originals, will at least have the appearance of being so, by being numbered. Thus we see how the editors of various works continue to reissue, in all seriousness, numbered editions which they present as artistic events—although the works have already been abundantly reproduced and have belonged for many years in the public domain. It can therefore be said that an edition's more or less strict, but at least sufficiently precise, limitation is a necessary condition for original editions. However, this is not adequate in itself, and must be accompanied by other guarantees.

The first of these fundamental guarantees concerns the origin of the examples: "original edition" implies that all the pieces originate from the same matrix, from the same model, which constitutes the original work. Of course, subsequent editions can be made without recourse to the matrix. An engraving can be reproduced by means of photographic techniques, a tapestry can be copied from one already made, and a bronze statue can be made by casting from an existing bronze. Through manipulation of these techniques, it is possible to achieve quite commendable results, but all things being equal, none of these secondary reproductions will have the same quality as those made from the original model itself. The difference will always be like that between a photograph of a photograph and one made from the original negative. Separated from the original by an intermediary, it will always be less faithful.[4] Other elements will also intervene, notably the choice of the maker. Compound arts require the intervention of numerous and specialized craftsmen. Their role is not to create but to carry through

the work conceived by the creating artist. The closer they are to him, by the relationship which they have with him and by the amount of time which they spend together, the more their intervention can be considered to be fully complementary. Here again, the best examples are certainly those made by craftsmen who are chosen and supervised by the master himself. After the master's death, the best ones are those made by a team selected and watched over by those who represent the master's mind and know best his work and ideas.

All these elements hold or may hold true for the compound arts, but once again their roles may be of more or less importance according to the complexity of each art. Sculpture, especially bronze statuary, is undoubtedly the most complex. The making of a bronze statue implies, in fact, a whole series of intermediaries. The creating artist alone makes the original model that is entirely and exclusively his work. This is most often made in unbaked clay—a material which is rather fragile. In fact, it is often destroyed after having fulfilled its purpose of expressing the definitive form of the artist's creative idea. From this clay model, a plaster cast is made, in an operation watched over by the artist but normally carried out by one or several specialized technicians. Their expertise is important because plaster can undergo changes in dimension through enlargement or reduction and can eventually be made in several sizes. From the plaster cast, which already is, technically, a new form of the work, another strong lasting mold is cast, to be used for the bronze casting. After this the work will be subjected to a whole series of operations—scraping, burnishing, patinating, etc.

This entire chain of operations is unavoidably long; the casting of a very large work might take a year or two and can be costly in both manpower and materials. As a result, the edition of bronzes is generally quite limited and spread out over time, in comparison to other art editions, especially since the market for large pieces is extremely restricted, because of their very size. While in other arts, such as printmaking, an edition runs into 150, 200, or 300 copies which technically can be made in a matter of days starting from the time that the original is finished, an original edition of bronzes, or at least of large bronzes, numbers six, eight, or twelve and may extend over several decades. The work of Rodin will be dealt with later, but let us point out as an example that certain original plaster models he left have never been cast, while others have been cast only a few times. Because of the unwieldiness and length of time involved, original editions in bronze inevitably assume a character all their own. Instead of a series of homogeneous examples

realized at the same time and by the same team, it is a collection which is limited to a certain number fixed especially for it. The examples are made from the same model but are eventually completed by different craftsmen at intervals of several years.[5] When the twelfth copy of The Burghers of Calais is cast, the same plaster model will be used as was used the first time in 1894, but of course different craftsmen will carry out the casting. In terms of the various conditions already mentioned, we shall be much more in the presence of a twelfth original copy here than number twelve of a real series.[6]

Therefore we see that the very idea of an original edition lends itself to varying interpretations. The decision of competent authorities to formulate these means, in other words, to define what is an original edition at a given moment and for a given art, only reinforces this feeling of relativism.

In a sytem of liberal rights the terms of a convention are fundamentally fixed by agreement between the interested parties. Governing bodies only intervene to impose certain limitations or certain forms, or eventually to codify certain types of agreements that are little by little extricated from longstanding and widely followed practices. It comes as no suprise then that government intervention has always been, and remains, highly cautious in our field. For a long time the art trade has not been fundamental to public opinion, yet it has made no secret of its rules and very sound professional practice. Legislation has taken care not to interfere directly except in one specific area: the protection of the creative artist, something which has concerned the legislature since the first years of the revolution.[7] They protect artists from their own weaknesses and prevent their exploitation by editors, entrepreneurs, and businessmen who act as middlemen between them and the public. The basis of the general regulations in this matter are still the law on literary and artistic property of 11 March 1957, the law of 9 February 1895, or Article 425 of the Penal Code.[8] However, some special provisions of limited scope do exist. Thus French fiscal law defines an original edition in terms which are very close to those mentioned above,[9] but however interesting this definition may be, its purely fiscal signification needs to be emphasized. It does not prevent an editor from defining an original edition differently; he merely knows that whether he abides by the definition as outlined in the tax code or not, he will be subjected to one fiscal ruling. In a more general manner, French legal doctrine emphasizes the specific character of fiscal law and the correlative impossibility of extending its definitions outside its proper field. Along these lines, a recent decree has provided a definition of

original editions in bronze, but it is a disposition which, for the moment, applies only to the Musée Rodin— for whom it is quite important.[10]

Nor is this almost total absence of official texts compensated for by professional custom or corporative abstract. Albeit that they play a subordinate role, French law is loath to recognize custom, and "common practice" confines itself to a method for interpreting the will of the contracting parties.[11] At any rate, hardly any definition exists, or in any case none that is precise and widely accepted enough so that at the present moment a codification, even a simple, semi-official one, can be put forward.

Once again, as is the usual formula in a liberal rights system, there remains the will of the parties involved: it is up to both sides to define what they mutually agree to and to express this in a clear enough way so as to avoid any difficulties in interpretation later on. Nevertheless this liberty and equality between parties to a contract should not be considered too abstractly for they vary according to the type of contract and the respective power of either party. In our field it is quite clear that the bidder, the seller that is to say, eventually the holder of the copyright of a certain work—be he the creating artist or his beneficiaries— he alone is in a position to set the characteristics of an edition about to be undertaken. He decides how many copies are to be made, what the technical characteristics are to be, and which specialists are to be called in. The buyer cannot help but take or leave the conditions thus layed out. The most he can do, aside from simply saying yes or no, is to try to bargain down the price or ask for some special secondary characteristic—in bronze, for example, for a certain type of socle. However, he is not unarmed, either when he concludes his purchase or afterwards. At the contract's closing he retains the fundamental option to buy or not; later on he will benefit from all the guarantees derived from the contract itself, according to how clearly and completely it is drawn up.

Here we touch upon a point which is both fundamental and final to these reflections. The special worth of an original edition does not come from an objective character of its originality, in the etymological meaning of the term, since every edition is in itself an operation of reproducing a model which is really the original, nor does this come about for want of a legal or customary definition. It arises from the agreements made by the edition's author with the buyers. Hence it will be more or less large, depending on how detailed and exact the commitments are, and more or less valuable according to the likelihood of the seller meeting his commitments.

He who buys an example from an edition which has been declared "original" without further inquiring into what is covered by the designation risks finding himself without real guarantees in case of contestation, since in the absence of sufficient specification, the very contents of a contract will remain uncertain. From the buyer's side, attention should be paid to the precision of the sales contact: one cannot claim to have been swindled unless it can be clearly established just what had been expected. On the editor's side, the effort should consist in foreseeing the buyer's demands by using a precise vocabulary and increasing the indications which will allow the sold copies to be identified and enable them to be judged beyond a doubt as corresponding exactly to what one would legitimately expect from the description made prior to the sale. In our field of bronzes, the serious modern editor will therefore specify in the case of an original edition, the piece from which it has been cast, the edition's size, and the shop in charge of the cast. Each piece will carry, among other specifications, those indications necessary for its identification: names of the artist and caster, number of the piece, size of the edition, and lastly, date of casting. Otherwise, there is nothing to keep the editor from undertaking supplementary commitments, such as agreeing, for example, not to carry out any further editions upon depletion of the original edition, until a given date, or maybe even never to do so.

This abundance of precisions is the materialization of a long evolution whose starting point and especially whose stages remain uncertain and confused. For a long while the buyer was most concerned with acquiring a piece which was to his liking; an artist or an editor to whom the former had relinquished his copyright had enough casts carried out to meet the demand.[12] It was not until later that one bothered about distinguishing the castings in order to give those considered better and more authentic privilege over others. Then importance began to be given to determining the foundry, the casting date, and the size of the series, and to synthesizing more or less clearly and conscientiously the overall idea of an original edition. But for want of a general codifying text which might have given exact contents and official date of birth to this formula,[13] it is impossible to present a complete and coherent history of it which would apply to all artists and editors of the same period. On the contrary, in order to be precise, we must go from the general to the particular and undertake the study of the conditions themselves under which the editions of the works of each individual master were made.

1. In all truthfulness this is already the case in classical art: the replica made by the artist himself is seldom rigorously faithful to the original and most often differs from it in a few details. When importance begins to be given to originality, these various details come under scrutiny in order to determine which should be considered the original example—without always being sure of the conclusions. Thus, there are several works in public and private collections whose owners claim them to be the only original copy. At the time of their execution, much less importance was given to this, and if replicas are bought cheaper than the original, this is because they require less work or they have not been entirely done by the master himself. For more recent works, the distinction between original and replica disappears since it is admitted that a modern artist only makes originals. There is no longer reason to distinguish originals and copies, only different versions, for which chronological classification remains an element of connoisseurship, though it assigns no value.

2. *Inventaire général des monuments et des richesses artistiques de la France, La Sculpture* (Paris: Imprimerie Nationale, 1978), 134.

3. The seemingly technical argument that editions become less and less fine as they become progressively numerous, because of wear on the materials and the maker's laxity, is not sufficient. For many years, techniques have been known which spare the original matrix and enable the work to be organized in such a way as to prevent carelessness and negligence.

4. This infidelity results, especially in the area of art bronzes, from a technical factor which is peculiar to casting; all molten metals undergo shrinking upon cooling. The mold made from a plaster original obviously has the exact dimensions of the plaster. The bronze, which has the same dimensions when it is hot, shrinks somewhat as it cools. Therefore the bronze casting will be slightly smaller than the plaster, whose difference will vary depending on various factors of weight, size, and shape of the piece, and alloy composition of the metal, by an average of one percent. Obviously the same phenomenon occurs if one takes a mold from the first casting. The cast made from this bronze will have the one percent difference in size from the other cast, that is to say, two percent in relation to the original plaster. This is one of the commonly used ways of distinguishing a mold made from a casting as opposed to the original plaster, although it is hard to apply to pieces with elaborate shapes and it of course supposes that one has at his disposal very exact dimensions for the plaster original. More generally speaking, one can say that casts made from other casts inevitably lose some subtleties and some faithfulness to the appearance of the original work.

5. Hence it becomes important to indicate on each example, not only the foundry, but also the year of the cast.

6. By "real" is meant a series completely realized in a very short

period of time by the same artisan, or the same team of artisans, as is the case in printing books or prints. The production of an edition of bronzes or tapestries, on the contrary, although limited to a greatly reduced number, of necessity takes much longer and may extend over a period of years, so much so that there can be a change of personnel from one example to the next. The results are no less of an "edition," for one begins each time with the same matrix. The limited number of examples are realized by the same techniques utilized in the same spirit.

7. The first French laws concerning copyright were those of 19 January 1791 on the right of representation and 19 July 1793 on the right of reproduction.

8. Article 425 of the Penal Code is formally distinct from the law of 11 March 1957 on literary and artistic property, but it is intellectually incorporated into it in so far as it reinforces its effectiveness. It is, in fact, conceived so that "All editions of written material, musical compositions, drawings, paintings or all other printed or engraved matter which are wholly or partially in defiance of the laws and regulations relative to the copyrights of the authors are counterfeits and any counterfeit is an offense."

9. Works of art and original editions are, as far as statuary is concerned, defined in the following manner: "Productions in any material of statuary art or of sculpture and assemblages, seeing that these productions and assemblages are executed entirely by the artist's hand; castings of sculpture in a series limited to eight copies and supervised by the artist or his beneficiaries. . . ." (General Code of Taxes, Appendix iii, Article 17.)

10. A joint decree by the Ministries of Culture and Finance issued on 5 September 1978 regulates the internal administration of the Musée Rodin. Article 1 of this text stipulates:

> The reproduction of the works of Rodin and the editions sold by the Musée Rodin consist of:
> 1) Original editions in bronze. These are executed from models in terra cotta or in plaster realized by Rodin and under the direct control of the museum, acting as the holder of the artist's rights of authorship; the casting from each one of these models cannot in any case exceed twelve examples.

11. Thus, Article 1135 of the civil code sets out that "the conventions oblige not only what is expressed therein, but also what equity, common practice, or the law dictates according to its nature"; Article 1159, "What is ambiguous will be interpreted in accordance with practice in the country where the contract is passed"; Article 1160, "One should supply in the contract any clauses which are customarily applied whether they are expressly set out or not."

12. It has already been remarked that statuary, as soon as it reaches certain dimensions, is a cumbersome art and difficult to use. Demand for it therefore remains relatively restricted and quite often spread out over time.

13. One proposed law is particularly involved here: placed before the French National Assembly, proposal no. 1224, ordinary session 1974–1975, by M. C.G. Marcus, M.P., it is intended to "insure the protection of purchasers of art works" by codifying the often uncertain vocabulary which is used in the art trade.

APPENDIX

After this essay was written, a decree (no. 81.255 of 3 March 1981) on the suppression of frauds in transactions involving art works and collector's items (*Journal Officiel*, 21 March 1981, 825) was passed which may not be a complete about-face in this matter but does extend it.

Article 9 of this decree is drawn up in this way:

> Article 9—All facsimiles, casts of casts, copies, or other reproductions of an original work of art as set out in Article 71 of Appendix III of the General Code of Taxes, executed after the date of effectiveness of the present decree, must carry in a visible and indelible manner the notation 'Reproduction'."

At first reading this new text incites the following remarks:

1. It incorporates into common law a definition given by Article 71, Appendix III, of the General Code of Taxes which had been useful previously only in fiscal matters and which from now on takes on a general application. (This fiscal definition is given in note 8 of the text.) Under the circumstances, the specificity of the fiscal law which is cited in the text no longer exists on this particular point since the ordinary legislator himself referred expressly to the fiscal text.

2. As for the basis for the law, the text is apparently clear, in that it sets out the conditions henceforth for the manufacture of facsimiles, casts of casts, copies, and other reproductions in France by stating that they must bear from now on in a visible and indelible manner the notation "Reproduction."

The article seems susceptible to two other more or less broad interpretations. In one, the mention "reproduction" would only be obligatory for proofs that were not made from the original model, that is to say, from the plaster in the case of a bronze. In this first reading, one could therefore make several editions from the original plaster, the first limited and numbered, called the "original edition" and one or more others which would no longer be entitled to be called part of the original edition, but which would be no less editions rather than reproductions.

In a second, more stringent interpretation, there could

only be one edition made from the original plaster, limited and numbered. All the others, whether made from the original plaster or from a proof already made, should bear the mention "reproduction."

Technically, only the first interpretation seems to us to be justified since it rests on a criterion which is itself technical. That which is made from the original plaster is a proof, an edition; that which is not made from the original plaster is a reproduction.

On the other hand, the overall spirit of the decree of 3 March 1981 is evidently to impose strict limits on the art trade as to the designation of objects. One can therefore think that the second interpretation, because it is restrictive, conforms more than the first to this spirit.

SPÉCIALITÉ
POUR
ORFÈVRES, JOAILLIERS
BIJOUTIERS

BRONZE D'ART
& Modèles
sur Plâtre et Cire

FONTE
D'ARGENT & D'OR
TOUS LES JOURS

Téléphone
220-51

FONDEUR MOULEUR
OR · ARGENT · CUIVRE

Alexis Rudier

Vve ALEXIS RUDIER & FILS, Succrs

45, Rue de Saintonge

Doit Monsieur Rodin

Paris, le 31 mai 1902

K.	C.	D.			
			24 mars		
			1 Buste de Monsieur Rodin par Falguière		325 .
			14 avril		
			1 groupe 2 femmes à Mucha		175 ..
			29 avril		
			1 groupe trois personnages 3 sujets		590 ..
			29 avril		
			1 petit sujet Homme et femme		130 ..
			17 mai		
			2 Bourgeois de Calais à 275		550 ..
			23 mai		
			1 Casque argenté et tête contrôle		465 ..
					2235

14. Observations on Rodin and His Founders

Monique Laurent

The present study deals with casting done during Rodin's lifetime and uses only the documentary resources of the archives of the Musée Rodin; it is therefore open to completion and change by other exterior sources.

The influence exerted by the art, the personality, and the thought of Rodin in the United States is demonstrated in concrete form by the existence in this country of the most important public and private collections after those given to France by the artist himself in 1916. These collections allow us to take the exact measure of an unfailing admiration which has given rise during the last few years to the publication of catalogues consistent with the criteria of modern criticism. And among the problems raised by art historians, anxious for precision, figures one which equally legitimately preoccupies the owners of bronzes by Rodin, whether organizations or private collectors: the founders who worked for the sculptor and the significance of their production. The subject, vast and very complex, is here addressed through documents from the personal archives of Rodin. It must be remarked that the frequent imprecisions of the texts make their use a delicate matter (see, for example, figs. 14.1–14.4). It is sometimes difficult, for example, to distinguish an estimate from an invoice, and therefore to determine whether the work mentioned was only the object of a proposed price or was actually realised. The very vague titles which for the most part designate the castings and the absence of dimensions (even though one work often exists in several states) increase the uncertainties which cannot always be settled by comparative study of the prices. These facts, as well as certain gaps (stopping of orders to a founder or missing archives), impose great prudence and explain the impossibility of arriving at an exhaustive inventory of the castings made in the artist's lifetime; they allow, however, an approach to the circumstances surrounding the working of a piece through casting.

From the beginning of his personal career and parallel to his work in decorative sculpture made for the accounts of others, Rodin strove to obtain the reproduction of his works in bronze. His conduct in this respect was completely in accord with the nineteenth century since it saw the art of sculpture—until then especially private and reserved for the creator and his pointer—to orient itself, thanks to technical progress, towards multiples which were accessible to a new clientele. But, as Jacques de Caso has remarked, Rodin represents the most complete and most complex range of the different attitudes of an artist as regards the reproduction of his works, for he obtained at the same time contracts for editions with no numerical limitations, castings made to order with occasional promise of exclusivity, and castings limited to a few examples.[1] Let us indicate right away on this subject that he never fixed a precise limit to the number made. The only indication on this point occurs in the text of the donation of 1 April 1916, according to which "notwithstanding the transfer of artistic ownership authorized to the State by M. Rodin, the latter expressly reserves for himself the enjoyment, during his life, of the reproduction rights of those objects given by him, being well understood that the said right of reproduction will remain strictly personal to the donor who is forbidden to cede it for whatever reason to any third party. He will have, in consequence, the right to reproduce and to edit his works and to make impressions or molds for the usage which suits him. In the event that M. Rodin, exercising the right that he has thus reserved, contracts with an art editor for the reproduction in bronze of one or several works included in the present donation, the contract of publication cannot be made for a period of more than five years and the number of reproductions of each work shall not exceed ten."

Rodin never exercised the right that he had reserved for himself. Later, the Musée Rodin, managing the *oeuvre* in the name of the state, imposed a limit of twelve to the number of casts made, but the artist himself never made the least indication of requirement or condition on this subject in the three successive acts of donation

drawn up on 1 April, 13 September, and 25 October 1916 to make official the transfer of his goods to the state.

Rodin's conduct illustrates his concern for responding to the varied needs of a diverse clientele; in consequence, the artist was led to make demands on the foundries of equally diversified nature and importance. From 1875 to 1917, one can count in the archives twenty-eight founders who worked for him, with the documents remaining uncertain for four other firms. Chronologically, the oldest documents conserved in the museum date from May 1875; they originate from the Compagnie des Bronzes, 22, rue d'Assaut, Brussels. Their contents do not allow confirmation of the date of 1872 put forth by John Tancock[2] instead of 1875 as indicated by Georges Grappe[3] for the beginning of the working of the busts of *Dosia* and *Suzon*. Rather, this vague correspondence alludes to a bust of a young girl in marble and to the *washing* of it. Did the Compagnie des Bronzes serve as intermediary for the sale of examples in marble? In any case, it could readily work with this material as a decorative ensemble composed of a bust of Dosia, whose socle is carved from a marble identical to that of the two accompanying vases, as a Belgian private collection bears witness. Is this a marble which served as the initial model from which the molds destined for the casts would have been executed, whence the need to wash the model in order to rid it of the mastic and layers of soap which ran the risk of turning it yellow? The museum's archives also do not shed light on the conditions for the assignment of the working rights for these two fantasy heads. It must be noted on this subject that historians who have studied Rodin's output in Belgium place both works on the same level. However, it seems that *Suzon* was much more widely reproduced than *Dosia*. In 1927, she was still found among the pieces offered by the Compagnie des Bronzes in five sizes, either the original one (0.30 meters) or four mechanical reductions of 0.26, 0.21, 0.16, and 0.12 meters. These bronzes of diverse formats and also the numerous examples in marble, terra cotta, and biscuit instigated many decorative combinations, such as mounting above clocks or on fanciful bases, found most often in Belgian and Dutch private collections.

The year 1880, of primary importance for Rodin since it was the year of the commission for *The Gates of Hell* by the state, is the same which sees appear in the preserved archives the first name of a Parisian founder, Gruet. From 1880 to 1883, Gruet Jeune, 195, avenue du Maine, Paris, billed to Rodin thirteen castings, of which the most important was a *St. John the Baptist*. Its price and the mention of the cross and the vineleaf

designate it as the very first cast of the work, exhibited at the Salon of 1881 and acquired by the state. It bears no founder's mark. Among the twelve other castings are six heads of the *Man with the Broken Nose* and six others, unidentified but at the same price.

Billing from the Gruet firm at the same address begins again in 1889 and 1890 with three subjects, *Reclining Woman*, *Sketch of a Seated Woman*, and an unidentified group.

From 1891 to 1895, under the name of Adolphe Gruet Fils Aîné, at the same address, twenty-four castings are charged to Rodin, among which are two busts of *St. John the Baptist*, two groups, *Young Mother at the Grotto*, and a large *The Kiss* for which the patina was begun in January 1893. The rest—statuettes, masks, busts, and groups—remain anonymous.

At the beginning of the century, Adolphe Gruet abandoned his activities as founder to specialize in "artistic and Japanese patinas, natural oxidations with neither color or varnish." In 1904, a lawsuit pitted him against the great founder Hébrard, for whom he had executed patinas since 1902.

In 1902, it is E. Gruet Jeune, 44*bis*, avenue de Châtillon, Paris, who furnishes Rodin with a group, a *Seated Figure*, and two *Heads of a Cleric* (R. P. Eymard?).

F. Liard was probably an artisan of particularly modest circumstances who did not even have a commercial letterhead. A founder installed at 5, rue du Pont Louis-Philippe, Paris, he executed for Rodin from April 1882 to January 1883 three masks, a bust, and a head (for an identical price which leads us to suppose that the designations could be imprecise) and made the patinas for a group of children, for the head of J. P. Laurens, and for two masks.

Eugène Gonon, 80, rue de Sèvres then 18, rue Pérignon in Paris, was the son of Honoré Gonon who worked for Barye and Gérôme. It was he who cast the *Bust of Jean-Paul Laurens*, paid for on 25 April 1882, for which Liard made the patina and which belonged to Laurens himself. In 1885, he executed a "statuette" for the high price of 800 francs, which again allows us to presume an approximate designation. Consulted about the casting by the lost wax method of *The Gates of Hell*, he estimated the price in June 1884 at 40,000 francs and the weight of the necessary metal at 4,000 kilograms. The museum's documents do not allow confirmation of Bartlett's indication about the attribution to Gonon of the *Bust of Victor Hugo* exhibited at the Salon of 1884.[4]

Between 1884 and 1889, Rodin turned to Pierre Bingen, who also worked for Carrier-Belleuse, Dalou, Falguière, Cordier, and Barrias. During these six years,

nine small-scale pieces were listed in the accounts of this founder who was installed at 74, rue des Plantes in Paris. There are three (or four?) reductions of the *Bust of Victor Hugo*,[5] another bust of Hugo, differing in price from the preceding, a *Bust of Dalou*, a female bust, and two statuettes. The casting of *Eve and the Serpent* reported by Grappe does not appear in the conserved documents.[6] By contrast, Rodin's comments on Bingen's correspondence allow us to suppose that most of the castings were delivered unpolished and were given to Jean Limet for patinating.

In 1900, Pierre Bingen, established at 8, villa Collet, applied for the job, without estimates, of sand-casting the *Bust of Puvis de Chavannes*. His heirs, Bingen Jeune and Costenoble, 26, rue Bezout in Paris, do not appear to have won the commission.

Surprisingly, given the reputation of its workshops, the Susse foundry does not seem to have produced for Rodin. The conserved correspondence dates from between June and September 1885 and is limited to the conditions of storage and sale in the shop at 31, place de la Bourse, Paris, of casts of the *Bust of Victor Hugo* in its original size and of the reduction cast by Pierre Bingen (see above). The Susse firm also proposed to Rodin that it make the casts of the models itself, but no follow-up appears to have been given the offer.

The first mention of the name of Griffoul in the archives bears the date of 1881, where it is found associated with that of François Rudier (see below), but it is from 1887 to 1894 that Griffoul, associated with Lorge, 6, passage Dombasle in Paris, did abundant work for Rodin. One hundred five bills for bronzes show this, with identifiable subjects such as *The Kiss*, *Faun and Nymph*, the head of *Mrs. Russell* in silver (perhaps the cast presented at the Monet-Rodin exhibition at the Galerie Georges Petit), the *Kneeling Fauness*, *Spring*, *The Sphinx*, *Young Mother at the Grotto*, the group *Ugolino*, *Standing Fauness*, the *Bust of Castagnary* (probably for his funerary monument in the Montmartre Cemetery in Paris), *Eve*, the *Caryatid with a Stone*, *The Genius of War*, and "a group *Victor Hugo*" which could be a project for the first monument to Victor Hugo conserved at the Musée Rodin. In 1884, the foundry offered to execute the monument of *The Burghers of Calais* in 125 days for 15,000 francs, but the dispersal of the enterprise prevented the completion of the order, then given to Leblanc-Barbedienne (see below).

The firm J. B. Griffoul, 25, rue Au Maire in Paris, covers the period 1895 to mid-1898 during which eighteen castings were executed, including four "masks of Michelangelo" (*Man with the Broken Nose*) and diverse groups. From June 1898 to March 1899, the bills have as heading A. (Auguste) Griffoul et Cie, 26, rue Au Maire and indicate the completion of twenty-one casts

including a *Bust of Rochefort*, four heads of *Balzac*, and a "portrait of an American" which probably designates Arthur Jerome Eddy.

Crushed by material difficulties, Auguste Griffoul emigrated to the United States at the end of 1899. After staying in Chicago and then New York, in 1912 he was the owner of a prosperous foundry situated at 280–286 Chestnut St. in Newark, New Jersey, the firm known as A. Griffoul and Bros. Co.

In 1903, the foundry Pierre Griffoul, at 37, rue Olivier de Serres, Paris, appears, whose relationship with the preceding firms has not been established and who furnished in that year a *Bust of Mme. Rodin*, a *Bust of Dalou*, a sketch of *St. John the Baptist*, and a maquette of *Romeo and Juliet*.

In 1895, the art foundry Thiebaut Frères, with its store at 32, avenue de l'Opéra, and its workshops at 32, rue Guersant in Paris, already represented almost a century of world renown thanks to its marvelous castings and perfect patinas. They made Rodin a trial offer to work for a year, without a true contractual bond, on the following subjects: *Fate* or *Youth Triumphant*, *Bellona*, and *Andromeda*. The project seems not to have been carried out, but in 1898, the firm divided into two enterprises, each of which entered into a ten-year contract with Rodin: an agreement with the Société Anonyme de Fonderie Artistique, 32, rue Guersant, was signed on 4 April 1898 and dealt with the reductions of *St. John the Baptist* in three sizes (which would bear the mark of Thiebaut Frères, Fumière et Gavignot, successors). When the contract was renounced by Rodin at the end of ten years, seven casts of the 0.80 meter size had been sold, thirteen of the 0.50 meter size, and four of the 0.20 meter size.

On 24 October 1898, another contract with MM. Fumière et Gavignot, 32, avenue de l'Opéra, was concerned with an edition of *Youth Triumphant* in its original size of 0.50 meters. It is difficult to evaluate its success, for if the museum's documents show that twelve casts were sold between 1899 and 1915, an outside source, unverified, establishes fifty or so castings, of which five were ordered by Loïe Fuller in 1915, to be given to the largest subscribers to the construction of the California Palace of the Legion of Honor in San Francisco.

It is to be noted that two founders claimed to be heirs to Thiebaut Frères, L. Gasne, 28*bis*, rue Guersant, who made a large *St. John the Baptist* for Rodin in 1901, and René Fulda, at the same address, in 1913. The Musée Rodin has an *Iris Waking a Nymph* by this founder, who doubtless worked for Loïe Fuller.[7]

14.3 Invoice from Léon Perzinka

The activity of Léon Perzinka, caster and carver, installed at 29, then 11-13, rue de Montreuil at Versailles, took place between 1896 and 1901, with an interruption or a lack of documents in 1898. It resulted in a large number of castings—seventy-three pieces invoiced—but probably was limited to small-scale subjects whose identification is mostly difficult except for fourteen reductions of figures from the monument to *The Burghers of Calais* and some busts (*Falguière, Dalou, Laurens, Hugo*); the group *The Hero* of the Rodin Museum in Philadelphia does not appear under any discernible title. The only subjects on a larger scale entrusted to Perzinka were an *Iris, Messenger of the Gods* cast in 1899; an "Apollo bas-relief," a *Bellona*, and *The Call to Arms* in 1900; an *Age of Bronze* probably in the original size in 1901 and another in the following year. The imperfection of this

last cast was perhaps the cause of the founder's disgrace, because no trace of a commission is preserved after that date, in spite of his wish to become Rodin's exclusive founder. It was Eugène Rudier who, from 1902 on, achieved this distinction.

The same year that he made a contract with Fumière et Gavignot (see above), Rodin reached an agreement of the same kind for twenty years with the foundry Gustave Leblanc-Barbedienne, which was directed by the nephew of its founder, Ferdinand Barbedienne. Leblanc-Barbedienne thus owned exclusive rights to the working of reductions of the *Eternal Spring* and of *The Kiss* except for the original size which the sculptor reserved for himself, but with the obligation to reserve the casting for the same firm.

For *Eternal Spring*, with the reservation of some uncertainties, the division of the castings from 1899 to 1919 is the following: fifty casts with a height of 0.40 meters; sixty-nine examples at 0.23 meters; the 0.52 meter size model did not appear until 1908 and thirty-two casts were made of it up to 1919.

For *The Kiss* one finds from 1899 to 1919: fifty examples of the 0.73 meter height; 105 of the 0.38 meter height; ninety-five of the 0.24 meter height; the 0.61 meter size was not processed until 1904, with sixty-nine casts made over the next fifteen years.

Other than these commercial editions, two major works by Rodin were made by Leblanc-Barbedienne, the first a bronze of the monument to *The Burghers of Calais*, cast in the beginning of 1895 for 12,000 francs and paid for by the city of Calais, and the second the figure of President Sarmiento. The foundry's correspondence indicates clearly that its casting was undertaken in January 1900 and invoiced in July 1904, which invalidates the dates of 1895 for the casting and 1898 for the installation of the monument in Buenos Aires advanced by Grappe.[8]

After the group installed at Calais in 1895, the two following casts were executed by the Société Nationale des Bronzes, formerly J. Peterman, 23, rue Fontainas, Saint-Gilles, Brussels: the group destined for the Danish patron Carl Jacobsen and now installed at the Ny Carlsberg Glyptothek in Copenhagen, and the group commissioned by the Belgian collector Warocqué for his château Mariemont near Brussels. Since the plaster model furnished by Rodin was destroyed after the second casting, the foundry was forced to ask him for a fresh plaster when it made separately the *Burgher with Raised Arm* for the Antwerp Salon of 1908. The piece, patinated by Limet, was bought by the Antwerp museum.

Rodin's relations with the famous founder Hébrard seem to have been imbued with a certain reticence and the correspondence of the latter shows that as a shrewd businessman and an active organizer of exhibitions, he often aroused the mistrust of an anxious and perfectionist Rodin. Covering the period from January 1904 to January 1906, the file contains only letters, no bills; it therefore does not give a clear account of the castings made and alludes only to different casts of *The Thinker* in the original size and the enlargement, notably the cast sent to the exhibition in St. Louis in 1904 and that of the Jacobsen collection in Copenhagen. Instead, the documents show that in spite of Hébrard's insistence, Rodin, refusing to entrust him with the commercial edition of reductions of *The Thinker*, intended to give up the traditional commercial circuit of the art founders and considered it essential that he assume personal relations with the collectors.

From 1898 to 1914, several names appear in the accounts for only a few productions: Camille Groult, heir to Dargenton et Groult, 38, rue Pastourelle, Paris, cast *The Earth* in 1899. G. Sévin, 6, rue Vandal in Paris, delivered five subjects in 1902. In 1904, Philippet, 3, rue Cochin in Paris, furnished three heads and a torso in "métalor" (gold-metal); the same year, he executed three casts of the *Bust of Eugène Guillaume* and perhaps the *Bust of the Baron d'Estournelles de Constant*.

No document specifically affirms the collaboration of Schmoll, maker of bronze groups installed at 71, rue de Turenne in Paris, but only the anonymity of several casts of a *Horse* by Rodin put on sale. H. Gonot et E. Joret, 145, rue de la Croix Nivert in Paris, seems only to have made two unidentified busts in 1906 and a third in 1908. The production of C. Durant (once associated with Lorge) is attested by three bills from 1910 concerning a statuette, six busts, and a head, about which no details are known. In 1912, the Valsuani foundry was directed by Claude Valsuani, who submitted to Rodin the estimates for three major pieces: a *Crouching Woman* or "Woman with broken knees," a large *Eve*, and a large *St. John the Baptist*, but the museum has no proof that Rodin ever actually ordered these works.

As for Philippe Montagutelli, founder, 54, avenue du Maine in Paris, he worked in 1912 and 1913 on *Clémenceau*, *France*, and *Carrier-Belleuse*, among others, but in September 1913, Rodin challenged him and filed a complaint for counterfeiting. This first affair would be followed in 1918–1919 by a famous trial for fakes and counterfeits in which the sculptor Archilles Fidi, of Italian origin, was also implicated.

We will only touch on here, without being able to study in detail because of the large numbers of works involved and its complexity, the problem of the famous

Rudier castings. Study of the existing archives brings out a curious paradox: not a single document is found from Alexis Rudier, so that this prestigious mark, long considered Rodin's ideal standard in bronze and symbolizing for amateurs the old cast acknowledged and endorsed by him, is actually a label of little significance.

Certainly the bronzes cast by the Rudier family are the most numerous, but the actual and personal role which Alexis could have played seems nonexistent in light of the accounts conserved in the museum. The facts, such as they can be reconstituted from the archives and the only published biographical materials,[9] are the following: the Rudier family was composed of three brothers, Alexis, Victor, and François. Victor and François seem to have worked together without Alexis, who specialized in the small castings of art and gold-smithing. The oldest conserved documents are bills dated 1881 from the firm F. Rudier, Griffoul et Cie., 41, rue Vavin in Paris. In 1883, the foundry became F. Rudier et Cie., until May 1886; from June 1886 to October 1904, date of the last invoice, only the name of François is mentioned in the commercial documents (from the beginning, he alone always signed the correspondence). In this period of twenty-three years, one notes several gaps—in 1882, 1889–1890, 1895, 1898–1899, and 1902—due to lapses in orders or missing documents. But the reckoning remains considerable since about 150 castings were made. Do they bear a mark, and if so which? There does exist in the Rodin Museum of Philadelphia a *Kneeling Fauness* marked F. Rudier, but the case seems to have been just about exceptional and the casts must not ordinarily have been marked; because of the number of pieces made, many more traces should remain.[10] It also seems that one cannot conclude that François made casts under the mark of Alexis, since the latter had his own business, independent of his brothers', and after all, he died in 1897.

To repeat: the Musée Rodin owns no proof of a collaboration between Alexis and Rodin. Even more, his name appears for the first time on 24 March 1902, five years after his death, with the formula "Alexis Rudier, Veuve Alexis Rudier et Fils Successeur" (Alexis Rudier, Widow of Alexis Rudier and his Son and Heir), followed in 1907 by the appellation "Alexis Rudier, Eugène Rudier Fils, Successeurs"; the commercial letterhead which specifies "specialty in goldsmithing, jewelry-making, casting in silver and gold" confirms the orientation of Alexis towards gold trinkets and small precious objects.

Therefore, starting in March 1902, the uninterrupted production of the firm concerned in reality the activity of Alexis's son Eugène, born in 1875. As though to test his technical capability, Rodin seems to have entrusted him right away with pieces of very different formats: *Damned Women*, reduction of *The Burghers of Calais*, but also a large *Age of Bronze* and a large *St. John the Baptist*. He made comparisons with the prices quoted by the other founders for the identical subjects and even though Eugène Rudier's charges were always slightly higher than those of his competitors, the commissions each year became larger until reaching exclusiveness in 1913, except of course for the edition contracts which were still in effect. The consequences of World War I were perhaps not irrelevant to this triumph of Eugène Rudier. In fact, most of the other founders were called up and, even though he was also a male nurse, he had the good fortune to be assigned to the Paris region which allowed him to maintain contact with his business; he had on hand an elderly workforce, free from military obligations, and he knew how to establish a hoard of combustible material so that he could continue casting.[11]

After the death of Rodin in 1917, Eugène Rudier remained until his death in 1952, the sole founder for the museum, still using the mark of his father Alexis. This mark would continue until Georges Rudier, Eugène's nephew, took over the directing of the business and made casts under his own name. (Questioned by us, he was not in a position to specify whether the change of mark was effected in 1952 or whether it took place only a year or two later.)[12]

At the risk of tarnishing the legend, and with the caution that documents to the contrary could come to light, one can suggest that Alexis Rudier probably never worked for Rodin, that the universally famous mark designates in fact that activity of Eugène, and that, contrary to the widely prevalent idea, the casts of Alexis Rudier are in the great majority posthumous since the mark was used for at least thirty-five years after the sculptor's death. It had been thought that a dating element could be found thanks to the cachet A. RODIN, cast in relief on the interior of certain casts by Alexis Rudier. According to the founder Georges Rudier, the addition of this mark would have been agreed on with the Rudier foundry after the trial of 1919 in which Montagutelli was implicated (see above) in order to betray illicit castings; but there exist several casts made during Rodin's lifetime bearing this signature: *The Helmet-Maker's Once Beautiful Wife*, which was given by Thomas F. Ryan to the Metropolitan Museum, New York, in 1910; the *Mask of Mme. Rodin*, which entered the Musée du Luxembourg in 1908, and the *Mask of Hanako* which entered the Luxembourg in 1911 (bearing no founder's mark).

F. RUDIER

Fondeur d'Argent et de Cuivre

BRONZE D'ART

SPÉCIALITÉ POUR ARTISTES

Doit Monsieur Rodin

Paris, le 10 octobre 189_

12-93.— Impr. Watelet, 48, rue d'Odessa Paris

1896				
octobre	3	1 Buste Bronze Dalou		330
»	30	2 masque à 20 f		40
1897 Janvier	27	1 grouppe Bronze		300
fevrier	11	3 tête Bronz à 30 f l'une		90
»	20	4 » à 30 f		120
»	27	3 » à 30 f		90
mars	13	5 masque à à 20 f		100
»	19	3 têtes à 30 f		90
avril	7	»		90
»	26	1 Ève		300
Mai	17	1 statuette frère et sœur		300
»	22	1 Ève	1	500
Juin	12	1 Buste Victor Hugo		125
»	16	1 Statuette frère et sœur		300
»	21	1 Torse Bronze		70
Juillet	5	1 grouppe Faune		300
»	19	4 Satyresse		300
»	29	1 Ève	1	500
»		la Défense	1	100
Septembre	4	1 statuette Faune		300
»	20	1 »		300
				9.045

14.4 Invoice from F. Rudier

* * * * * *

In the terms of this study, one cannot fail to remark that the documents analyzed often pose more questions than they resolve. However, several facts assert themselves which give better information on the relationship between Rodin and his founders. According to the general plan of the profession, these relations should on many occasions have been disturbed by the materially precarious position of the founders. Except for the large firms— Leblanc-Barbedienne, Hébrard, Susse, Thiebaut-Fumière—which themselves assured fabrication and commercial handling and who owned stores in the elegant quarters of Paris where they organized exhibitions, the other founders whom Rodin used were most often modest artisans exposed to great financial difficulties from which the continuity of work could suffer. Competition was severe and delays in delivery constituted an imperative determinant. Plentiful manpower and the length of the workday allowed foundries to execute

monumental pieces in surprisingly brief periods of time. Perzinka cast *The Age of Bronze* in five weeks; the monument to *The Burghers of Calais* was cast, carved, and patinated in four months by Leblanc-Barbedienne; and a monumental *Thinker* was delivered in three months by Hébrard.

The founders who did not sell their own productions seem most often not to have marked their casts and the artists apparently did not have requirements on this subject. As it concerns Rodin, the absence of a mark does not constitute, as has sometimes been said, an indication of an early cast. Similarly, the study of the handwriting of his signatures hardly allows the assignment of a cast to one or another period since the signatures were traced by the founders and not by the artist himself.

As for the patinas, they could be executed outside the founder's workshop, at a specialist's or at another founder's: the *Bust of Jean-Paul Laurens* cast by Gonon was patinated by Liard in 1882. J. B. Griffoul patinated diverse subjects which he had not cast, and Limet patinated almost all of Rodin's bronzes from 1900 to 1915, including the castings of Eugène Rudier. The importance of the role played by this patinator for the sculptor merits a pause here, for his correspondence shows that a climate of great confidence, hardly the rule for Rodin, whose several collaborators deplored his distrust and changeable humor, reigned constantly between the two men. In spite of Limet's installation at several hundred kilometers from Paris until 1909 and the problems posed by the packing and transport of the bronzes, it was he who not only executed the patinas but also suggested the tonality for them, having learned from the artist the destination of the works and wishing to individualize their appearance. Since the castings were sent directly by the founders to Limet, Rodin, who had not seen them, asked him about the quality of the casts as this letter of 3 September 1903 bears witness: "I was waiting for the bronzes which Autin sent me to examine the head of Mme. Rodin. The cast is not bad, but the chiseling in my opinion leaves much to be desired. One can judge this piece, which is very simple, with difficulty. . . ." It can be remarked, therefore, that the notion of strict control of the casts and the patinas by Rodin himself needs to be shaded, at least from 1900.

By contrast, the sculptor's vigilance was trained on the models which he entrusted for the execution of the bronzes, and which he took care to recover once a piece was delivered. Several allusions, notably in Hébrard's correspondence, lead us to suppose that Rodin feared illicit castings which the absence of a caster's mark could only encourage.

✳ ✳ ✳ ✳ ✳ ✳ ✳

Such is the panorama which is sketched in the light of the artist's archives. Let us repeat that it is incomplete; several casts by Bingen, Gruet, Hébrard, Griffoul, and Lorge, located in diverse public collections or conserved in the Musée Rodin itself, do not appear in the documents consulted. Similarly, several names cited by the most recent reference work, such as Banjean and Poleszynski, are unknown to us.[13] We desire only that this first approach to a subject whose breadth equals its complexity, be perceived as the assurance of the efforts undertaken by the Musée Rodin, trustee of the oeuvre, to make better known and understood the man, his method, and the conditions of the exercise of his art.

NOTES

1. Jacques de Caso, "Serial Sculpture in Nineteenth-Century France" in *Metamorphoses in Nineteenth-Century Sculpture* (Cambridge, Mass.: Fogg Art Museum, 1975), 1-27.

2. John Tancock, *The Sculpture of Auguste Rodin* (Philadelphia: Philadelphia Museum of Art, 1976), 34 and 57, note 53.

3. Georges Grappe, *Catalogue du musée Rodin* (Paris, 1944), nos. 29 and 30.

4. T. H. Bartlett, "Auguste Rodin, Sculptor," *American Architect and Building News*, 9 March 1889, 113–114.

5. The Musée Rodin owns one which came from the collection of Gustave Dreyfus, Inv. S.497.

6. Grappe, *Catalogue*, no. 121.

7. *Rodin et l'Extrême-Orient* (Paris: Musée Rodin, 1979), 27, no. 2.

8. Grappe, *Catalogue*, no. 274.

9. P. Moreau-Vathier, "Le maître fondeur Eugène Rudier," *L'Art et les Artistes* (March 1936): 203–209.

10. Perhaps the Rudier mark on the *Bust of Dalou*, Detroit Institute of Arts, is due to François Rudier and not to Eugène, as Patricia B. Sanders suggests ("Auguste Rodin" in *Metamorphoses in Nineteenth-Century Sculpture*, 148 and 174), because François made a cast of it in 1896.

11. Correspondence of the patinator Limet, 30 March 1915, Musée Rodin archives.

12. Since that time, Georges Rudier has been one of the founders making posthumous casts, under the authority of the Musée Rodin. The Musée has also entrusted the foundries of Godard (since 1969) and Coubertin (since 1973) with the production of these casts. Several bronzes were cast by the Susse firm between 1964 and 1978.

13. Sanders, "Auguste Rodin," 148.

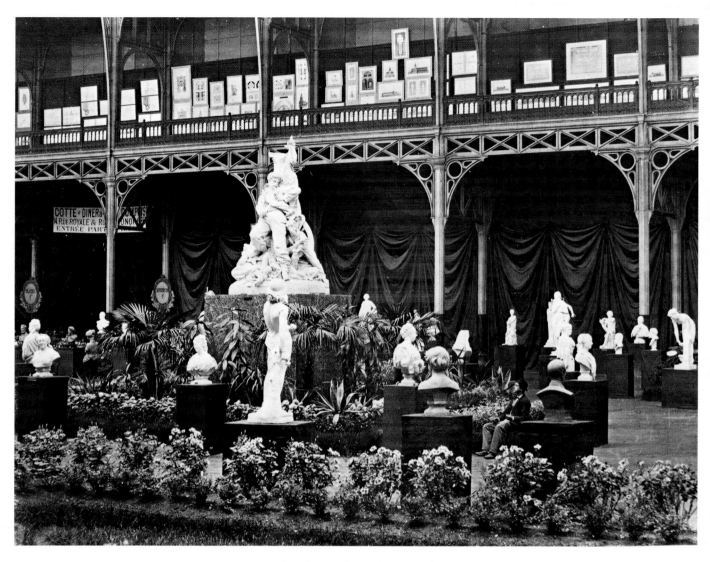

15.4 Salon of 1873, the Sculpture Garden.

15. *The Paris Salons of the 1870s: Entries for Exhibited Works*

Anne Pingeot

BARTHOLDI, FRÉDÉRIC-AUGUSTE
1834 COLMAR—PARIS 1904

1. *Lafayette Arriving in America*, 1872–1875

Bronze statue
3.25 x 1.09 m (128 x 43 in.)
Signed and dated on the base at right: A BARTHOLDI 1873; inscribed on the base: "*As soon as I heard of American Independence, my heart was enlisted*" / 1776 / *to the city of New York* / *France* / *In remembrance of sympathy* / *in time of trial* / 1870–1871 / *Erected 1876*.
LENDER: Art Commission of the City of New York
PROVENANCE: Cast commissioned for 8,000 francs from F. Barbédienne by decree of 30 January 1874. Executed in bronze and finished on 27 March 1875; paid for on 1 May 1875. Arrived in New York in May 1876. Erected on the base donated by the French residents of New York. Inaugurated on 6 September 1876 (Lafayette's birthday) for the Centennial of American Independence. (see fig. 1.14)
DOCUMENTATION: National Archives, F 21 216 (two files).
SKETCHES: Submitted in March 1872 to the Administration des Beaux-Arts.
PLASTER: Ordered by retroactive decree of 30 November 1871 from Bartholdi (actually in March 1872) for 6,000 francs. Paid for on 4 April 1874. Exhibited in Paris, Salon of 1873, no. 1511. Published by Ministère de l'Instruction publique et des Beaux-Arts, *Ouvrages d'art commandés ou acquis par l'administration des Beaux-Arts* (1880), F° 28 and 22 (fig. 15.1). In September 1884 the model was once again in the artist's possession and in October, M. Lucas was commissioned to make a reproduction.
REDUCTIONS: Bronze, two casts (0.50 and 0.60 m) in Colmar, Musée Bartholdi.

15.1 Bartholdi. *Lafayette Arriving in America*, 1872-1875. Plaster. Cat. no. 1.

Bartholdi was one of the great entrepreneurs of the nineteenth century. We wonder what connection his trip to America in 1871 had to the solicitation received in France soon after Bartholdi left New York. In January 1872, the Prefect of Seine et Oise wrote the Ministre de l'Instruction publique et des Beaux-Arts that the American committees for aid to the war victims of 1870–1871 had requested, in recognition of their effort, a statue of Lafayette for Central Park. Competition, the great incentive of statue-mania, was doubtless at the origin of this astonishing proposition. The Scottish residents of America had just offered a statue of Walter Scott to New York. The inaugural ceremonies and the idea of a future "open-air Pantheon" shook the French colony. Did they find their catalyst in the person of Bartholdi? The French administration

had difficulty refusing. They searched for images of Lafayette, finding only two busts at Versailles. There had been a statue of Lafayette at the Hôtel de Ville, but that had been burned during the Commune. Happily, the sculptor Jean-Chenillon (1810–1875) still had his model, which he had shown at the Salon of 1867, but the Inspector of Fine Arts Paul de Saint-Victor's report was unfavorable: "The statue must be transformed in all respects before it could be worthy of representing French sculpture in the public square of a capital like New York."

Bartholdi seems to have planned everything. He wrote to the Director of Fine Arts on 17 February 1872: "With great pleasure I would undertake the statue of Lafayette which you have proposed to me; I especially know what would be suitable since I know Central Park. It does not seem appropriate to make an equestrian statue, since there is only one other in New York, that of Washington, and it would not be seemly on our part to give our hero an equal importance. I would also find it easier, perhaps, to give meaning to a statue of a standing man through gesture and attributes. I would like to propose to you that I describe as completely and simply as possible the act of arrival and the ardor and devotion of the hero. The right height would be three meters without the plinth—or ten American feet. I will submit the sketches of the statue and of the pedestal as soon as they are made."

Bartholdi returned to the subject of his hero four more times: in a bust exhibited at the Salon of 1886, no. 3477; in a group with Washington shown at the Salon of 1892, no. 226 (bronze offered to the city of Paris by M.J.P. of New York, erected in 1895; replica in New York, erected in 1900); as a standing figure in his *Monument to the Memory of Lafayette and American Independence*, exhibited at the Société des Artistes français, 1899, no. 3190 (illustrated catalogue); and finally in a youthful bust exhibited in the Salon of 1901, no. 2979.

CABET, PAUL
1815 NUITS SAINT GEORGES—PARIS 1876

2. *Mil-huit-cent-soixante-et-onze*, 1872–1877

Marble statue
1.25 x 0.66 x 1.01 m (49¼ x 26 x 39¾ in.)
Signed on the seat to the right: P. CABET; title on the front of the plinth: MDCCCLXXI
LENDER: Musée du Louvre, Paris
PROVENANCE: Commissioned by decree of 14 June 1873 for 8,000 francs. In 1874, a slab of the highest quality Italian marble was placed at Cabet's disposal by the state. In 1875, the sculptor's assistant, Daumas, put on the final touches and the work was completed on 17 January 1877 (after Cabet's death). Turned over to the Louvre on 28 February 1886, inv. no. R.F. 747. Deposited at the Musée de Douai by decree of 31 May 1886. Decree revoked 28 April 1890 and the work was

15.2 Clesinger. *La Mélancolie*, 1846. Drawing. Private Collection.

then sent to Dijon. 1970, loaned to Nuits Saint Georges by the Musée de Dijon.
DOCUMENTATION: National Archives, F 21 200. Louvre Archives, S² 1886, 30 April.
EXHIBITIONS: Paris, Salon of 1877, no. 361. 1878, Paris, Universal Exhibition, no. 1118. 1970, Nuits Saint Georges, "Centennial of the Battle of Nuits Saint Georges."
ORIGINAL PLASTER: Paris, Salon of 1872, no. 1573. Acquired by retroactive decree of 30 November 1871 for 3,500 francs. 1873, Vienna, Universal Exhibition, no. 847. 1900, Paris, Universal Exhibition, Centennial, no. 1494. Beaune, Musée des Beaux-Arts, inv. no. D. 879. 1. 1. (see fig. 1.8)
OTHER LIFE-SIZE PLASTER CASTS: Edition by the casting shop of the national museums, C 3992. Copies in Douai and Paris (Dépôt de l'Etat, Musée des Monuments français).

Cabet was a student of Rude and a man of violent emotions. His work includes classic draped figures, like those found at each corner of the Stock Exchange Building in Paris or on monuments such as that to Pedro IV in Lisbon by Elias Robert, and it creates a strong image of despair. Matis picked up on this idea from Dürer in an allegorical figure of "Strasbourg, 28 September 1870" which appeared in *L'Illustration* in 1871 (1 semester, 365). The many phases in the pose taken by Mil-huit-cent-soixante-et-onze were studied by W. Hauptman, " 'La Mélancolie' in French Romantic

15.3 Braquemond. Bartholdi's *Funerary Genius*. Engraving.

Sculpture" (24th International Congress of Art Historians, Bologna, 1979).

We can most closely compare Cabet's work to Clesinger's drawing for *La Mélancolie* (1846) (fig. 15.2) and Bartholdi's *Funerary Genius*, seated upon the ground with its head on its knees (Tomb of the Nefftzer youth, Montmartre cemetery). A bronze cast of the latter work can be seen at the Bartholdi Lycée in Colmar (engraving by Braquemond, fig. 15.3).

CARRIER-BELLEUSE, ALBERT-ERNEST
1824 ANISY-LE-CHÂTEAU—SÈVRES 1887

3. *Psyche Abandoned*, 1872

Marble statue
1.65 x 0.60 m (65 x 23⅝ in.)
Signed and dated on the right of the column shaft: A. *Carrier-Belleuse 1872*
LENDER: Musée des Beaux-Arts, Marseilles
PROVENANCE: Acquired by the state at the Salon of 1872 by retroactive decree of 30 November 1871; placed on deposit at the Musée de Marseille in 1874 in exchange for the copy of *Mercury* from the Farnesina, Auquier catalogue, 1908, no. 985.
DOCUMENTATION: National Archives, F 21 201 and F 21 488.
EXHIBITIONS: Paris, Salon of 1872, no. 1589.
BIBLIOGRAPHY: June Ellen Hargrove, *The Life and Work of Albert Carrier-Belleuse* (New York: Garland Press, 1977), 57–58, pl. 19.

At the close of the salon in July 1872, the Ministre de l'Instruction publique des Cultes et des Beaux-Arts proposed that the state buy one work each from twenty-seven sculptors. Carrier-Belleuse was one of them. Lightheartedly he wrote to "Dear Director": "I have just arrived from Brussels. I have stupidly twisted a back paw. This requires of me an unaccus-

tomed immobility. Once I am better, I shall thank you personally. . . ."

The *Psyche* was acquired for 9,000 francs. Except for two other works—*The Soul* by Loison and *The Naiad* by Renaudot—it fetched the highest price among the works purchased by the state that year. The titles themselves indicate the need for "reassuring" purchases. Carrier-Belleuse's *Psyche*, with its pose simpler than that of Pajou's eighteenth-century *Psyche* and its hairstyle equally complicated as one of Allegrain's *Bathers*, was in complete harmony with this tendency.

CHAPU, HENRI
1833 LE MÉE—PARIS 1891

4. *Joan of Arc*, 1870–1872

Marble statue
1.17 x 0.92 x 0.83 m (46⅛ x 36¼ x 32⅝ in.)
Signed on the plinth at left: *h. Chapu.*
LENDER: Musée du Louvre, Paris. Usually on view in the City Hall of Amboise.
PROVENANCE: By a decree of 18 July 1870, the state gave Chapu a block of the best white marble from Italy, and by a decree of 21 December 1871 acquired his statue for 10,000 francs after the Salon of 1872. It was entered at the Musée du Luxembourg on 17 January 1874 (LUX 23) and turned over to the Louvre on 10 February 1908, inv. no. R.F. 166, after which it was deposited in the city of Amboise, decree of 28 October 1967.
DOCUMENTATION: National Archives, F²¹ 126, 202; 368 AP 1. Louvre Archives, S 4 1874, 18 January; Z 11X 1878, 23 January; S 17, 1886, 24 January and 2 February.
EXHIBITIONS: Paris, Salon of 1872, no. 1595. 1873, Vienna, Universal Exhibition, no. 874. 1878, Paris, Universal Exhibition, no. 1136.
BIBLIOGRAPHY: Anne Pingeot, "80 ans de Jeanne d'Arc sculptées," *Images de Jeanne d'Arc*, exhibition catalogue (Paris: Hôtel de la Monnaie, 1979), 186–188, nos. 32 *bis* and 33.
DRAWINGS: Musée de Melun, grouped in an old frame under the title *Jeanne d'Arc*, nos. 912.1.558 to 574 (standing in armor, holding a sword, holding a flag, standing dressed as a shepherdess, kneeling, and seated; 572 and 574; see also 912.1.446).
SKETCHES: Valenciennes, Musée des Beaux-Arts, unbaked clay (0.24 m), gift of Mlle. Valez in 1926. Paris, Lafrance sale, 19 May 1881, terra cotta, no. 84.
ORIGINAL PLASTER: Exhibited at the Salon of 1870, no. 4342. Acquired by the state on 8 June 1870 for 3,500 francs. Deposited by decree of 25 August 1875 in the Musée de Belfort; sent 2 December 1875.
OTHER LIFE-SIZE PLASTERS: Numerous editions by the Réunion des musées nationaux (molds not found in 1967). The following old casts can be cited: 1900, Paris, Universal Exhibition, Centennial, no. 1532; Rome, Villa Medici, cat-

alogue of 1933, no. 47; Le Mée, Musée Henri Chapu, gift of Chapu's widow.

LIFE-SIZE BRONZES: Published by Barbedienne (contrary to the customary clauses in his contracts limiting the height to two-thirds of the original). A cast was exhibited by Barbedienne at the Vienna Universal Exhibition, 1873; another is in the Musée de Châlons-sur-Marne; a third in the Albertina, Copenhagen (1182).

LIFE-SIZE MARBLES: Chantilly, château; Copenhagen, Ny Carlsberg Glyptothek (inv. no. IN 494), replica executed in 1886; Paris, Oppenheim sale, 23 April 1877, no. 94; Melun, 1930. (see fig. 1.11)

REDUCTIONS: Bronze: Barbedienne catalogue, 1875, p. 39; 1880, p. 46 (six reductions); 1884, p. 48 (six reductions); 1900, p. 4 (six reductions).Biscuit: Rouen, library.

It was little noticed in 1870: "If the *Joan of Arc* had not been placed on the ground, M. Chapu's statue would have had a greater success than it appears to have." (Report of the Inspector of Fine Arts, Henry d'Escamp, 10 May 1870.)

But the work was elevated to the level of an icon by the Defeat. For the monarchists, Joan of Arc was sent by God to save the throne; for the Republicans, she was a daughter of the people who liberated France from the invader and was opposed to the hierarchy of the Church.

The simplicity of the treatment is more in keeping with the second cause. The plaster deposited at Belfort in 1875 rewarded the heroism of the city, besieged from 4 November 1870 to 18 February 1871, which did not surrender.

The composition was so simple that it could be reproduced easily. "If some seams remain in the draperies, I authorize you to have them removed. There is no iron anywhere so you can cut wherever you like." (Chapu to Barbedienne, 26 February 1879.) This ease led to counterfeits. Legal action was brought in 1913 in the name of the heirs of Chapu and Barbedienne; the state joined them as owner of the work, even though no special agreement had been passed at the time of the purchase.

DUBOIS, PAUL
1829 NOGENT-SUR-SEINE—PARIS 1905

5. *Newborn Eve*, 1873

Bronze statute, cast by the lost wax method
1.80 x 0.55 x 0.55 m (70⅞ x 21⅝ x 21⅝ in.)
Signed on the base at left: P. DUBOIS; on the back of the plinth at right: JABOEUF et ROUARD / Fondeurs PARIS
LENDER: Musée du Petit Palais, Paris
PROVENANCE: Gift of the sculptor's sons, L. and P.F. Paul-Dubois to the city of Paris in 1910, inv. no. PPS 946.
DOCUMENTATION: Family archives. National Archives 368 AP 3.
EXHIBITIONS: 1908, London, "Franco-British Exhibition," no.

62. 1957, Paris, Musée Rodin, "Rodin, ses collaborateurs et ses amis," no. 63. 1967–1968, Nice, Palais de la Méditérranée, "Rodin et son temps," no. 5.

BIBLIOGRAPHY: Jane Marcelle Delahaye, *Paul Dubois Statuaire, 1829–1905* (thesis for the Ecole du Louvre, 1973), I, 107–112; III, 122–131.

DRAWINGS: In 1976, Françoise du Castel, granddaughter of the sculptor, gave 247 drawings to the Cabinet des Dessins and all her photographic documentation to the sculpture department of the Louvre, thanks to the intervention of Jacques Foucart.

More than one hundred drawings on sixty-one sheets deal with *Eve*. Dubois was working out the pose of the arms without modifying that of the legs. (Arms crossed high across the chest as for the Virgin Annunciate; arms behind the back or asymmetrically elongated in front; holding out the apple; raised behind the head; combing or twisting the hair, etc.)

SKETCHES: Four in wax at Troyes, Musée des Beaux-Arts (0.21, 0.50, 0.58, 0.58 m).

WAX MODEL: Troyes, Musée des Beaux-Arts (1.82 m).

PLASTER: Paris, Salon of 1873, no. 1627 (fig. 15.4) and 1878, Paris, Universal Exhibition, no. 1208 (does not appear among the original plasters in the museum at Troyes). Nogent-sur-Seine, museum, with pointing marks.

MARBLE: Executed in 1882 for Carl Jacobsen, Ny Carlsberg Glyptothek, Copenhagen, inv. no. IN 525 (1.82 m). Replica made in 1885 since a spot in the marble spoiled the throat of the preceding example, inv. no. IN 526 (1.83 m), exhibited at Brasseries Carlsberg in Copenhagen.

15.4 Salon of 1873, the Sculpture Garden, detail. Dubois's *Newborn Eve* can be seen at center. Cat. no. 5.

In 1873 Francion described *Eve*: "One feels the creature who comes from nothingness the air has not yet had time to make the flesh firm the dazzled eye has just opened to the light." This description in *L'Illustration* (1873, 295–443) seems more suited to *The Age of Bronze*, in which the flesh is much less firm, than to Dubois's variant of a chaste Suzanna. Yet, in 1873, the *Eve*, in fact, appeared unfinished (see comic review of Bertall, *L'Illustration*, 364) (fig. 15.5).

15.5 Bertall. Comic review. *L'Illustration* (1873, first semester, 364). Titled: *Eve formed from water and the ribs of the first man, by Dubois.* Caption reads: "My dear friend, I believe Dubois was wrong to depict Eve before the creator had completely finished her. A little more time and one could give her the apple."

Some thoughts of the sculptor scrawled on the documents given by Mme. du Castel to the Louvre could refer to this work: "Standing statuary: the first condition is that it hold itself well, solid and firm posture, sober gesture . . . state of dignity. Simplicity of gesture greatly helps the grandeur."(see fig. 1.15)

DUBOIS, PAUL
1829 NOGENT-SUR-SEINE—PARIS 1905

6. *Narcissus*, 1862–1867

Marble statue
1.85 x 0.67 x 0.62 m (72⅞ x 26⅜ x 24⅜ in.)
Signed on the plinth of the socle at right: P. DUBOIS
LENDER: Musée du Louvre, Paris
PROVENANCE: Replica of the statue of 1862–1866. Executed for the Universal Exhibition of 1867 (where Dubois received second prize), then presented at the Salon of 1874. Acquired in the form of a commission, so that the very elevated price of 15,000 francs could be paid in two installments, decree of 5 June 1874. Assigned to the Musée du Luxembourg by decree of 20 June 1874, inv. no. LUX 40. Exhibited at the Pantheon in July 1918. Turned over to the Louvre 11 April 1923, inv. no. R.F. 2221.
DOCUMENTATION: National Archives, F21 135, 174 (Protheau file), 212, 523. Louvre Archives, S. 30, 1896, 14 December; L. 4. 1874, 20 June.
EXHIBITIONS: 1867, Paris, Universal Exhibition, gr. 1, cl. III, no. 74. 1873, Vienna, Universal Exhibition, no. 908. Paris, Salon of 1874, no. 2823. 1878, Paris, Universal Exhibition, no. 1209. 1879, Munich, International Exhibition of Fine Arts, no. 193. 1882, Vienna, Universal Exhibition, no. 190.
BIBLIOGRAPHY: Jane Marcelle Delahaye, *Paul Dubois statuaire, 1829–1905* (thesis for the Ecole du Louvre, 1973), I, 90 and 94; II, 21-1 to 21-7, figs. 23–28 (manuscript in the Louvre archives). Anne Pingeot, "Le décor de la Cour carrée du Louvre: les statues des niches du rez-de-chaussée," *24th International Congress of the History of Art* (Bologna, 1979) (in press).
PLASTERS: Executed in Italy in 1862; exhibited in the Salon of 1863, no. 2339 (2nd class medal); then sent by the state to Troyes, Musée des Beaux-Arts, in 1878. 1900, Paris, Universal Exhibition, Centennial, no. 1615. August 1905, gift of Mme. Paul Dubois to the Musée de Nogent-sur-Seine, with pointing marks.
ORIGINAL MARBLE: Commissioned for 8,000 francs by decree of 17 July 1863 for the Cour carrée of the Louvre. To be executed in marble from Saint-Beat furnished by Derville at 425 francs. Finished in May 1866 and paid for on 2 June. Presently in the Cour carrée of the Louvre. (see fig. 1.17)
REPLICA: Authorized for the Ny Carlsberg Glyptothek, Copenhagen, by the Director of Fine Arts in 1896 with the specification that "M. Dubois undertakes to carry out all necessary modifications," inv. no. IN 521 (1.87 m).

In 1862, a bronze was discovered at Pompeii which was called *Narcissus Listening to Echo* (Naples Museum). Now known as *Bacchus*, it could have inspired Paul Dubois even though he initially vacillated between depicting a satyr and an allegorical figure.

It is interesting for the history of taste to consider the high price paid for this work when it was over ten years old and had already been exhibited three times. We might also consider the value that the nineteenth-century public and critics attached to "quotations." It is the Italian Renaissance which Dubois was recreating with a grace which Hiolle in his turn would seize upon when sculpting his own *Narcissus* in 1868 (Musée des Beaux-Arts, Valenciennes).

FALGUIÈRE, ALEXANDRE
1831 TOULOUSE—PARIS 1900

7. *Switzerland Welcoming the French Army*, 1873
1873

Bronze group
1.25 x 0.80 x 0.70 m (49¼ x 31½ x 27½ in.)
Signed and dated: A. *Falguière 1873*
LENDER: The Swiss Confederation
PROVENANCE: Offered by the city of Toulouse to Switzerland; found by H. W. Janson at the Military Clinic in Novaggio.
DOCUMENTATION: Toulouse Archives: the records of deliberations of the Conseil municipal de Toulouse from 1874–1880 do not mention the gift made by the city of Toulouse to

Switzerland (as the salon booklet of 1875 does).
EXHIBITIONS: Paris, Salon of 1875, no. 3065.
SKETCH: Terra cotta, Paris, Petit Palais, inv. no. PPS 870.
PLASTER CASTS: Gift of the artist to the Musée des Augustins, Toulouse; signed and dated at right: A. *Falguière 1874*; included in Rachou's catalogue of 1912, no. 952. 1898, Paris, Nouveau Cirque, "Exposition A. Falguière," no. 10. 1902, Paris, Ecole des Beaux-Arts, "Exposition Falguière," no. 10. 1930, Paris, Falguière estate sale, 14 April. These could all be the same cast. (see fig. 1.21)

Before Falguière, Carrier-Belleuse created a monument of *Gratitude to Switzerland*. The model for this important project was presented on 21 April 1873 to the Administration des Beaux-Arts; the commission was awarded to him by decree of 10 May 1873 and paid for on 25 August 1875. "France, clutching her children in her arms, seeing her future and her hope in all little children, bows before the hospitable figure of Switzerland and gives thanks to this generous country" (report of the Inspector of Fine Arts; National Archives, F21 201). The execution in permanent form never took place. Falguière's group was more limited in its intentions. A pretty Swiss woman supports a young soldier—brother to so many figures of Orestes dying on the altar of Pallas—carefully and accurately dressed in a contemporary army uniform.

In 1882 Mercié borrowed Falguière's composition for his group *Quand même!*, in which the Swiss girl has become an Alsatian. The strong breath of patriotism animates the group which can still be seen on the Place d'Armes in Belfort. The replica that stood in the Tuilleries Gardens can be seen at the military fort of Mont Valérien.

After the Salon of 1895 Bartholdi received the medal of honor for his *Switzerland Relieving the Suffering of Strasbourg During the Siege of 1870*, which was inaugurated in Basel in October 1895, more than twenty years after Carrier-Belleuse and Falguière created their groups.

PRÉAULT, AUGUSTIN
1809 PARIS 1879

8. *Ophelia*, 1842–1876

Bronze relief
0.75 x 2.00 x 0.20 m (29½ x 78¾ x 7⅞ in.)
Signed on the frame at lower right: AUGUSTE PREAULT; title at lower center: OPHELIE
LENDER: Musée des Beaux-Arts, Marseilles
PROVENANCE: Bronze commissioned from Thiebaut & fils by decree of 18 January 1876. Placed on deposit at the Musée de Marseille by decree of December 1878. Catalogue Auquier, no. 1130 (1908).
DOCUMENTATION: National Archives, F 21 248. Charles Millard, catalogue raisonné in progress.
EXHIBITIONS: Paris, Salon of 1876, no. 3554. 1900, Paris,

15.6 Préault. *Ophelia*, 1842-1876. Bronze relief. Cat. no. 8.

Universal Exhibition, Centennial, no. 1774. 1959, London, Tate Gallery, "The Romantic Movement," no. 495. 1971, Louisville, J.B. Speed Art Museum, "Nineteenth Century French Sculpture: Monuments for the Middle Class," no. 77. 1979, Marseille, Musée Cantini, "Daumier et ses amis républicains," no. 167.
PLASTER: Described in *L'Artiste* of 8 January 1843. Exhibited at the Galerie des Beaux-Arts, Boulevard Bonne Nouvelle, in 1844. Refused by the Salon of 1849 (information courtesy of Charles Millard). Presented at the Salon of 1850–1851, no. 3567. Deposited in the Musée de Saint Florentin (Yonne) by decree of 24 January 1879. Destroyed during the last war.

In 1875, the committee which considered purchases by the state hesitated between a commission for a piece in bronze of *Jacques Coeur* by Préault (of which the sketch and marble are now in Bourges) and an order for his *Ophelia*. In the end they chose the plaster relief for 2,000 francs. The firm Thiebaut & fils made a sand-casting for 1,000 francs (fig. 15.6).

The romantic generation ordered the successes of their youth to be preserved in permanent form. We think of the bronze *Roland furieux* by Jehan du Seigneur or the marble replica of *Velleda* by Maindron. Both are in the Louvre, thus saved from destruction, as was this "tumultuous dream" (Baudelaire) by Préault.

FRÉMIET, EMMANUEL
1824 PARIS 1910

9. *Saint Michael*, 1879

Bronze statuette
0.59 m (23¼ in.)
Signed between feet: E. *Frémiet*; founder's mark on bottom of bronze base: F. *Barbedienne fondeur*.
LENDER: Mr. David Daniels, New York
PROVENANCE: New York, Michael Hall Fine Arts. New York, David Daniels Collection.
EXHIBITION: 1971, Louisville, J. B. Speed Art Museum, "Nineteenth Century French Sculpture: Monuments for the Middle Class," no. 68.
BIBLIOGRAPHY: Robert Kashey and Martin L. H. Reymert, *Western European Bronzes of the Nineteenth Century: A*

Survey, exhibition catalogue (New York: Shepherd Gallery, 1973), no. 33. H. W. Janson in Peter Fusco and H. W. Janson, eds., *The Romantics to Rodin* (Los Angeles: Los Angeles County Museum of Art, 1980), no. 148 (different cast; the devil has the human head which appears in the engraving published in Jacques de Biez, 1910, unnumbered). Anne Pingeot in *Le moyen âge et les peintres français de la fin du 19e siècle, Jean Paul Laurens et ses contemporains*, exhibition catalogue (Cagnes sur Mer, 1980), no. 52.

GILDED BRONZE STATUETTE: Paris, Salon of 1879, no. 5033. 1882, Vienna, Universal Exhibition, no. 207 (0.55 m). We do not know if these are actually the same cast. As with the *Saint George* of Frémiet, the statuette preceded the colossal work.

EDITION BY F. BARBEDIENNE: in bronze and gilded bronze. The Leblanc-Barbedienne catalogue, undated but published sometime after 1892, offered *Saint Michael* in three different sizes: 0.55 m, 0.27 m, and 0.195 m. In bronze, the first size listed for 300 francs; in gilded bronze, for 400 francs. The second size listed for 180 francs in bronze and 225 francs in gilded bronze, and the third size, available only in gilded bronze, listed for 125 francs. The Musée des Beaux-Arts, Dijon, has a gilded bronze (0.60 m) (*Catalogue*, 1960, no. 490) and the master cast with pins of the same size, both given by the Faure-Frémiet family in 1955.

COLOSSAL PLASTER: 1896, Salon of the Société des Artistes français, no. 3455. Model for the work destined for Mont Saint-Michel. Given by Frémiet's widow to Dijon, Musée des Beaux-Arts. Formerly exhibited in the kitchen of the ducal palace, today it is in the reserves with wings and arms removed.

The colossal work which still stands on the spire of Mont Saint-Michel differs in several respects from the statuette: the feathers of the wings are constructed and divided, the rays of the halo are drawn out, and the ornamentation of the helmet is not the same as is the boss of the "derisory" pointed shield. The tunic is undecorated, the legs are thicker and more supple. The halo, the socle, and the demon are gilded, the face of the angel is natural.

It is interesting to compare the *Saint Michael* of Frémiet with Viollet-le-Duc's drawing for the Saint Michael on top of the chapel at Pierrefonds (1866).

GUILLAUME, EUGÈNE
1822 MONTBARD—PARIS 1905

10. *Monseigneur Darboy, Archbishop of Paris*, 1874

Marble bust
0.92 (including 0.135 for the pedestal) x 0.58 x 0.34 m (36¼ x 22⅞ x 13⅜ in.) Signed and dated at right on the base: E GVILLAVME / 1874
LENDER: Musée du Louvre, Paris
PROVENANCE: First quality Italian marble given by the state

by decree of 18 December 1873. Bust acquired at the Salon of 1875, by decree of 19 June 1875 for 3,000 francs. Entered the Musée du Luxembourg on 16 July 1875 (LUX 55). Turned over to the Louvre on 8 August 1916, inv. no. R.F. 222.
DOCUMENTATION: National Archives, F 21 223.
EXHIBITIONS: Paris, Salon of 1875, no. 3138. 1878, Paris, Universal Exhibition, no. 1271. 1882, Vienna, Universal Exhibition, no. 212. 1889, Paris, Universal Exhibition (does not appear in the catalogue however). 1932, Paris, Grand Palais, "Cinquantenaire de la fondation des Artistes français" (does not appear in the catalogue but was transported to the Grand Palais).
PLASTER: Paris, Salon of 1873, no. 1707. Acquired by the state by decree of 11 June 1873 for 1,500 francs. Present location unknown.
BRONZE: Authorization given to Guillaume (then Director of the Ecole des Beaux-Arts) on 20 April 1876 by the Director of Fine Arts to have a bronze cast made from the model belonging to the state. (The model may have remained with the founder.) Exhibited in 1900, Paris, Universal Exhibition, Centennial, no. 1678 *bis*.

"Let us not forget the admirable bust of Darboy by M. Guillaume. The plaster looked superb when it was exhibited, the marble looks better still. There is everything in this head so astonishingly carved: it has life, sentiment, depth, and tranquillity. Without exaggeration we might say that this marble is as sharp and as tight as a Holbein while still betraying the caressed look of a Leonardo." (Jules Claretie, *L'Art et les artistes français contemporains* [Paris: Charpentier, 1876], 381.)

Monseigneur Darboy, who succeeded Monseigneur Morlot on 12 January 1863, was shot by the Commune in 1871. For the famous martyr, Guillaume gave the full measure of his conscientious talent, creating a realistic face, but one that is idealized in its energy. He meticulously rendered the details— the embroidery of the cope and the quatrefoil buckle.

Although he worked very slowly as we see from the spacing of the payments he received, the Administration of Fine Arts did not hesitate to shower Guillaume with commissions. He achieved the most outstanding career in terms of honors that any sculptor had in nineteenth-century France. From 1871 to 1880 he obtained 92,300 francs in commissions, while Rodin in his best decade ever (that of *The Age of Bronze, The Gates of Hell*, the *Saint John the Baptist*, the *Danaid, The Kiss*, etc.) only received 68,200 francs from the state.

MERCIÉ, ANTONIN
1845 TOULOUSE—PARIS 1916

11. *Gloria Victis*, 1872–1875

Bronze group
3.11 x 1.82 x 1.51 m (124⅞ x 70⅞ x 59½ in.)

15.7 Visit of the empress of Russia to the Villa Medici. *L'Illustration* (1873, first semester, 415).

Inscribed on the front of the plinth: GLORIA VICTIS; on the left: A. MERCIE; on the back: F^{du} par THIEBAUT & FILS
LENDER: Musée du Petit Palais, Paris
PROVENANCE: Commissioned in bronze for 8,500 francs. Exhibited at the Salon of 1875. Placed in June 1879 on the Square Montholon and then on 12 January 1884 in the central court of the city hall. 6 June 1934, placed on deposit by the city of Paris at Auteuil. 18 November 1976, exhibited again at the Petit Palais, peristyle of the interior court, inv. no. PPS 3351.
DOCUMENTATION: National Archives, AJ 52 202, F° 2, 8, 28; AP 368-2. Archives of the Seine, VR 105, 10 624/72/1, bundle 129.
EXHIBITIONS: Paris, Salon of 1875, no. 3271.
BIBLIOGRAPHY: Peter Fusco, in *The Romantics to Rodin*, Peter Fusco and H. W. Janson, eds., exhibition catalogue (Los Angeles: Los Angeles County Museum of Art, 1980), no. 167.
SKETCH: A "unique and original" proof was offered on 19 September 1890 to the museum of Copenhagen by Mercié, who withdrew his offer on 29 January 1891 (information provided by Christiane Vogt, who is finishing her thesis for the Ecole du Louvre on Mercié). A bronze sketch dedicated to May was bequeathed by him to the Louvre, decree of 28 February 1924, inv. no. R.F. 1835.
ORIGINAL PLASTER: Executed in 1872, exhibited in Rome in May 1873 under the loggia of the Villa Medici where the empress of Russia saw it (fig. 15.7) (*L'Illustration*, 1873, first semester, 415). Sent to Paris 14 June 1873. Exhibited at the Salon of 1874, no. 3043. Acquired by the city of Paris for 12,000 francs, paid 29 October 1874. Exhibited at Magasins de la Ville de Paris, boulevard Morland. 1878, Paris, Universal Exhibition, no. 1351. In 1893 the Art Institute of Chicago

requested a plaster cast. This was not executed because in making a second cast for itself, the city of Paris discovered the task too difficult.

The original, though very damaged, was removed from storage on 25 October 1920 for refurbishing in order to be included in the celebration of the fiftieth anniversary of the Republic. It was returned to storage on 21 December and was never mentioned again. Undoubtedly it has been destroyed.

There are two heads for the Victory, one in bronzed plaster and the other in plaster with a terra-cotta patina in the sculpture depot at Ivry.
LARGE BRONZES: One at Niort, 1881, cast by Thiebaut frères. Others at Agen, 1883; Bordeaux, 1885; Châlons sur Marne, 1890–1891; Cholet, 1901; Copenhagen, 1906 (3.03 m), on deposit at the convalescent home Lysglimt at Gilleleje. Because of the patriotic character of the work, no French bronzes were melted down to recover the metal during the Occupation. (see fig. 1.16)
EDITIONS: F. Barbedienne was authorized to make some reductions in May 1877 on the condition that he return the model intact to the city and that he give it the largest cast. In 1879, three reductions were made. The catalogue of 1880 offered the original size and three reductions; that of 1881, four; and that of 1900, seven. According to the customs files of the Louvre, the reduction which had the greatest success was the one which was 0.93 m in height, followed by the one which was 1.10 m.
ENGRAVING: Jules Jacquet, 1874.

Mercié's medal of honor from the Salon of 1874 was not the only reward that he received for his *Gloria Victis*. The whole nation thanked him for the image which he had made of her.

Here was a "Christ Descended from the Cross" carried by the Victory on her shoulder or *Anchises Carried by Aeneas*, as represented by Pierre Lepautre in the eighteenth century. The provincial cities requested authorization to have replicas made for their monuments to the dead of the War of 1870–1871. The first to do so was Antonin Proust, Deputy Mayor of Niort in 1881. The city of Paris then established a principle: the same authorization would be accorded to all the cities of France and the colonies which requested it. In order to prevent the lessening of the artistic character of the work and to assure good execution, the reproduction was made with the help of Mercié and under the control of the administration of the city of Paris.

BARRIAS, LOUIS-ERNEST
1841 PARIS 1905

12. *Henri Regnault, Painter*, 1871

Bronze bust
0.53 x 0.25 x 0.25 m (20⅞ x 9⅞ x 9⅞ in.)
Signed and dated on the back at left: *E. Barrias / 1871*; title on the panel: *Henri* REGNAULT
LENDER: Musée du Louvre, Paris
PROVENANCE: Gift of Mme. de Villeneuve, sister of the painter Clairin, to the Louvre, decree of 31 March 1931, inv. no. R.F. 2037.
DOCUMENTATION: National Archives, F 21 193. Louvre Archives, S.8 1931, 31 May.
EXHIBITIONS: 1873, Vienna, Universal Exhibition, no. 833. 1957, Paris, Musée Jacquemart-André, "Le Second Empire," no. 282. 1973, Paris, Grand Palais, "Salon des Artistes français: Tricentenaire du Salon" (no number). 1978–1979, Paris, Palais de Tokyo, "Autour de quelques oeuvres du Second-Empire" (no number).
PLASTER: Copenhagen, Ny Carlsberg Glyptothek, inv. no. IN 482 (0.54 m). Published in *A Guide to the Department of Modern Works of Art*, 2nd ed. (1936), no. 518; does not appear in the guide, *Moderne Skulptur* (1964).
BRONZES, OTHER CASTS: Acquired by the state by retroactive decree of 21 December 1871 for 2,500 francs, paid for in May 1872; 1878, Paris, Universal Exhibition, no. 1089; now in the Lycée Henri IV, Paris. Paris, Petit Palais, inv. no. PPS 833, gift of Mme. E. Barrias, 1907; identical to that in the Louvre; included in the 1927 catalogue by C. Gronkowski, no. 14, and exhibited in 1978, Paris, Musée Bourdelle, "Les Barbus," no. 47.
REDUCTION: Bronze, Switzerland, private collection.

Regnault was killed at Buzenval at the age of 27 on 19 January 1871. He is seen full-face in an engraving on the first page of *L'Illustration* (first semester, 81) after a photograph by M. Helios, which may have well served the various sculptors who made his portrait.

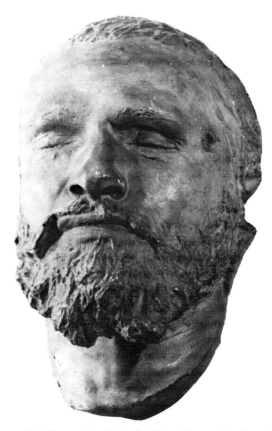

15.8 Chapu. *Death Mask of Henri Regnault*, after 1870.

DEATH MASK: Henri Chapu (1833–1891). Original plaster sold in 1945, Paris, Hôtel Drouot, 29 January, no. 157. Acquired by Boudot-Lamotte, 782 francs. 1980, gift of M. J. Boudot-Lamotte to the Musée de Beauvais, cat. no. 194 (fig. 15.8). This published mask was found in the studios of the artist.
BRONZE BUST: Prosper d'Epinay (1836–1914). Head modeled from life in 1868; reworked in 1871 with addition of allegorical pedestal; terra cotta and bronze, private collection; included in Patricia Roux, *Prosper d'Epinay*, exhibition catalogue (Saint Omer, 1981).
BRONZE BUST: Charles Jean-Marie Degeorge (1837–1888). Paris, Salon of 1876, no. 3200. Now in Paris, Ecole des Beaux-Arts, Cour du Murier.
BRONZE MEDALLION: Charles Jean-Marie Degeorge (1837–1888). Paris, Salon of 1881, no. 3789. Two examples are in the Louvre: gift of J. Renaudot to the Musée du Luxembourg (inv. no. R.F. 2148) and Le Masle bequest, 1972–1974 (inv. no. R.F. 3033).
STONE STATUE: Jules Clément Chaplain (1839–1909). 1883, Paris, façade of the city hall.
POLYCHROME SANDSTONE FRIEZE: Messrs. Fagel, Sicard and Baralis. 1900, Universal Exhibition, Grand Palais.

CARPEAUX, JEAN-BAPTISTE
1827 VALENCIENNES—COURBEVOIE 1875

13. *Bruno Chérier,* 1875

Plaster bust with terra-cotta patina
0.626 x 0.300 x 0.274 m (24⅝ x 11⅞ x 10¾ in.)
Signed, dated, and dedicated on the right side of the base:
Souvenir fraternel / offert à mon vieil / ami Bruno Cherier /
peintre / son compatriote Carpeaux 1875
LENDER: Musée du Louvre, Paris
PROVENANCE: Acquired by the Louvre from M. Hendrieks,
grandnephew of Chérier, decree of 22 December 1924, inv.
no. R.F. 1844.
EXHIBITIONS: 1955, Paris, Petit Palais, "Carpeaux," no. 229.
BIBLIOGRAPHY: (in reference to another cast) André Hardy and
Anny Braunwald, *Catalogue des peintures et sculptures de
Jean-Baptiste Carpeaux à Valenciennes* (Valenciennes: Musée
des Beaux-Arts, 1978), nos. 240–241, pl. 56.
DRAWING: Valenciennes, Musée des Beaux-Arts, charcoal
(0.33 x 0.24 m); André Hardy and Anny Braunwald, *Dessins
de Jean-Baptiste Carpeaux à Valenciennes* (1975), no. 83.
PAINTING: Valenciennes, Musée des Beaux-Arts (0.39 x 0.31
m); acquired at the Carpeaux sale, June 1894, no. 37;
published in the Valenciennes Carpeaux catalogue (1927), no.
146.
ORIGINAL PLASTER: Paris, Carpeaux studio sale, 30 May 1913,
no. 47. (see fig. 1.5)
OTHER PLASTERS: Valenciennes, Musée des Beaux-Arts; pub-
lished in Hardy and Braunwald (1978), no. 241. Casts also
recorded in French private collections in 1956, 1963, etc.
BRONZES: Paris, Salon of 1875, no. 2926, bequest of Bruno
Chérier to the Musée de Saint-Quentin (according to the
Valenciennes Carpeaux catalogue [1927], but the work is not
actually in the Saint-Quentin museum). Valenciennes, Musée
des Beaux-Arts, bequest of Bruno Chérier, 1880; included in
Hardy and Braunwald (1978), no. 240, pl. 56.

Chérier was Carpeaux's friend, with him when his daughter
was born and faithful to the last days of his life. He painted
the sculptor while the latter was modeling his face. "Tell me
whether Duzzi distinguished himself in the casting of your
bust. . . . Is your bronze bust well-patinated? Have you
finished my superb portrait?" Carpeaux wrote to Chérier from
Nice in March 1875, and then on 18 April, "Refused by the
salon! Is it believable, is it possible? Never have I seen an
equal injustice. No, it is not your work which is refused. It is
I whom they reject by rank prejudice. I have disrupted the
sacred teachings. They do not want to see this revolutionary."
(Cited by Ernest Chesneau, *Le statuaire J.-B. Carpeaux* [Paris,
1880], 172, 175–176.)

In return, the bust of Chérier by Carpeaux received the
homage of the public at the salon. As Madame Gustave Fould
put it, "In the middle of these more or less beautiful works,
there is the head of a living man. One stops short, one is

moved and one cannot find praise worthy of the work. One
mentions the name of the author and that is all." (Cited by
Louise Clément Carpeaux, *La Vérité sur l'Oeuvre et la vie de
J.-B. Carpeaux,* vol. 2 [Nemours, 1935], 210.)

MERCIÉ, ANTONIN
1845 TOULOUSE—PARIS 1916

14. *David,* 1869–1872

Bronze statue (see fig. 1.10)
1.84 x 0.76 x 0.83 m (72½ x 29⅞ x 32⅝ in.)
Signed on the base at right: Mercié; on the plinth at left in
stamped letters: F DU PAR V^OR THIEBAUT & FILS
LENDER: Musée du Louvre, Paris
PROVENANCE: Cast ordered from Thiebaut & fils 9 August
1872 at a price of 1600 francs. Entered the Musée du
Luxembourg in January 1874; acquisition decree of 3 May
1874; decree of conferment to the Musée du Luxembourg of
20 June 1874 (LUX 74); exhibited outside in front of the
entrance façade. Turned over to the Louvre on 13 May 1927,
inv. no. R.F. 186.
DOCUMENTATION: National Archives: AJ 52–201 f° 148–202
f° 28; F 21 239. Louvre Archives: S 16 1803–1890; L. 4 1874,
20 June.
EXHIBITIONS: 1873, Vienna, Universal Exhibition, no. 983.
1878, Paris, Universal Exhibition, no. 1786.
BIBLIOGRAPHY: Peter Fusco, in *The Romantics to Rodin,* Peter
Fusco and H.W. Janson, eds., exhibition catalogue (Los
Angeles: Los Angeles County Museum of Art, 1980), no. 166.
SKETCH: Copenhagen, Ny Carlsberg Glyptothek, wax study
(0.42 m), inv. no. IN 599.
ORIGINAL PLASTER: Executed in 1869 and exhibited in Rome in
June 1870, then sent to Paris in July. Exhibited at the Salon of
1872, no. 1786 (fig. 15.9). Acquired by retroactive decree on 30
November 1871. Deposited by the state in the Musée de Cusset
by decree of 20 January 1879 (according to the National Arc-
hives) or in the Musée de Toulouse in June 1874 (according
to Henri Rachou, *Catalogues des collections de sculptures et
d'épigraphie du Musée de Toulouse* [1912], no. 982.
OTHER LIFE-SIZE PLASTERS: The Direction of Fine Arts pre-
served a mold which permitted numerous casts to be made.
These are now located in: Rome, Villa Medici, included in
the *Catalogue* of 1933, no. 57; Gap, Musée de Gap, state
deposit, no. 3286, formerly in the Hôtel des Invalides; Dijon,
Musée des Beaux-Arts, gift of MM. Fernand and Georges
Mercié in 1939.

Others mentioned are the cast made by Mercié in January
1874; the cast given by Mercié to Goupil, father-in-law of
Gérôme the painter (this could be the same cast as the
preceding); the cast presented in 1900 at the Paris Universal
Exhibition, Centennial, no. 1736.
LIFE-SIZE BRONZES: Thiebaut & fils received the order for
David from the state after 24 May 1872. The first cast was

15.9 Salon of 1872, the Sculpture Garden. Mercié's *David* can be seen in the foreground.

delivered on 7 January and entered the Musée du Luxembourg in January 1874. A second cast was ordered from the Thiebaut firm at the same price on 6 June 1874 (payment 11 August 1874), unspecified location. Were the two bronzes exchanged?

On 23 December 1876, Mercié was authorized to make a cast at his expense for his own personal use—"exceptional authorization (although already agreed to, as it is specified in a note) which does not imply the right to reproduce his work of which ownership belongs to the state."

A late cast, draped, is in Copenhagen at the University Studiegaarden.

EDITIONS: Barbedienne published reductions by Achille Collas of the *David* with growing success; three sizes appear in the catalogue of 1875 and 1880, four in 1884, and six in 1900.

LATER DRAWING: Paul Cézanne, on the back of Petit Paul; Paris, Petit Palais, inv. no. 79,257 (fig. 15.10).

"This heroic scamp, who, with his foot on the severed head of the giant, puts his bloody sword back in its sheath with an ease that is frightening . . . comes in a direct line from the

15.10 Cézanne. *The "David" of Mercié*. Musée du Petit Palais, Paris.

Bargello," and, Lafenestre adds in his review of the salon, "to enchant the eyes with beautiful curves is the first duty of a sculptor" (*L'Illustration*, 1872, 22). The two trump cards of success in the Second Empire were in Mercié's hand: the explicit reference to the Renaissance fulfilled the learned, the beautiful curves pleased others. The outbreak of war in 1870 added a third: *David* represented conquered France who would one day throw the Prussian Goliath to the ground.

Mercié was supposed to have had only three years as a pensioner in Rome, but his *David* earned him a fourth. When still a student, he received a first class medal and the cross of the Legion of Honor.

This typical Second Empire work had enormous influence even abroad, as can be seen in the *David* of Ch. Van der Stappen (1876–1879) in the Musée d'Anvers, or the *Icarus* of Alfred Gilbert (1884).

LENOIR, ALFRED
1850 PARIS 1920

15. *Mademoiselle Jeanne Balze at the Age of Twenty*, 1878

Marble bust
0.75 (including 0.15 for the pedestal) x 0.407 x 0.325 m (29½ x 16 x 12⅞ in.)
Signed and dated on the plinth of the base at left: ALFRED·LENOIR·1878·
LENDER: Musée du Louvre, Paris
PROVENANCE: Acquired by decree of 2 December 1903 for 2,000 francs. This price corresponds to the first payment received by Lenoir on 29 October 1881 for executing *Repose* (*Le Repos*) in marble (group presented in plaster at the Salon of 1880), a commission which was canceled. 1904, marble storage; assigned to the Musée du Luxembourg by decree of 21 January 1904; entered on 19 March (LUX 205). At the Pantheon on 3 July 1918. Turned over to the Louvre (does not appear in the catalogue of the Luxembourg for 1931); appears in the supplement to the catalogue of sculpture in the Louvre in 1933, no. 1830; inv. no. R.F. 1413.
DOCUMENTATION: National Archives, F21 2093, F21 4235. Louvre Archives, L.4, 1904, 21 January.
EXHIBITIONS: Paris, Salon of 1878, no. 4401.
BIBLIOGRAPHY: Maurice Testard, "Alfred Lenoir," *L'Art décoratif* (1911): 357.
TERRA COTTA: 1961, Paris, private collection.

Designated in the catalogue of the Musée du Luxembourg of 1914 as "Bust of a Young Girl" and in the one of 1927 as "Portrait of Mlle. Louise Pelissier de Malakoff," Jeanne Balze, daughter of the painter Raymond Balze who was a pupil and collaborator of Ingres, recovered her identity in 1961 thanks to one of her nephews by marriage, M. Jean de Senilhes.

It is through Edmond de Goncourt that Alfred Lenoir,

grandson of Alexandre Lenoir who founded the Musée des Monuments français and son of Albert Lenoir, the architect who assembled the baths of Julien at the Hôtel de Cluny, is best known to us as a portraitist:

One can only discover while posing for one's bust before a probing and conscientious sculptor, what there are in the planes of a face of ledges, small protuberances, thickenings and thinnings which appear in a *raking* light, and what is necessary of clay pellets and rough-chiseling to render the imperceptible hollows and indiscernible juttings of a fullness or of a bend in the flesh, which appears flat. (*Journal*, 3 December 1889.)

But that was not enough for a Gustave Geffroy who was taken to visit Lenoir:

No, I have never seen a critic show himself so ferocious at an artist's place by his silences, by the miserly alms of his compliments, by the boredom of his person and the despair of his back in the studio of the poor devil who received him. Ah, this fellow is a very singular individual, with his exclusive admiration for Rodin and Monet with absolutely nothing left for the others. (*Journal*, 30 January 1890.)

CARPEAUX, JEAN-BAPTISTE
1827 VALENCIENNES—COURBEVOIE 1875

16. *Alexandre Dumas fils*, 1873

Bronze bust
0.797 x 0.587 x 0.401 m (31⅜ x 23⅛ x 15¾ in.)
Signed, dated, and dedicated on the right side of the base: *All Sommo Pensieroso / Alexandre Dumas fils / Suo amico JB^{te} Carpeaux 1873*
LENDER: Hirshhorn Museum and Sculpture Garden, Smithsonian Institution, Washington, D.C.
PROVENANCE: Private collection, France. Sale, Paris, Hôtel Drouot, "Terres cuites, bronzes, marbres de Carpeaux," 28 December 1874, no. 77 (0.85 m). Paris, Feuillard. London, Mallet at Bourdon House. New York, Wildenstein and Co., 1965. Washington, D.C., Hirshhorn Museum and Sculpture Garden, inv. no. 66,831; included in the catalogue of the museum (1974), no. 41.
EXHIBITIONS: 1965, London, Mallet at Bourdon House, "Sculptures and Sketches by Jean-Baptiste Carpeaux," no. 25. 1965–1966, New York, Wildenstein and Co., "Carpeaux," no. 28.
BIBLIOGRAPHY: (in reference to another cast) André Hardy and Anny Braunwald, *Catalogue des peintures et sculptures de Jean-Baptiste Carpeaux à Valenciennes* (Valenciennes: Musée des Beaux-Arts, 1978), nos. 219–220.
ORIGINAL PLASTER: Paris, Louvre, acquired from the widow of Carpeaux, decree of 1 May 1895, inv. no. R.F. 1054 (0.81 m). Exhibited in 1975, Paris, Grand Palais, "Sur les traces de Jean-Baptiste Carpeaux," no. 227.
MARBLE: Paris, Salon of 1874, no. 2727. Bequeathed by Alexandre Dumas *fils* to the Comédie française by his will of

27 July 1895. Included in the following exhibitions: 1912, Paris, Jeu de Paume, "Exposition des oeuvres de Carpeaux et de Ricard," no. 144; 1935, Paris, Bibliothèque Nationale, "3ème Centenaire de l'Académe française," no. 434, 1955–1956, Paris, Petit Palais, "J.-B. Carpeaux," no. 218, pl. 67. (see fig. 1.4)

BRONZES: In 1931, 1932, and 1933, Mlle. Jeanne Dulac, then living at Luchon, offered the Louvre a life-size bronze bust of Carpeaux's *Dumas fils* which had been in her family since the nineteenth century. Was this the Hirshhorn bust? Mlle. Dulac also pointed out that the Paris founder Colin made an edition of Carpeaux's *Alexandre Dumas fils*.

LIFE-SIZE PLASTER EDITIONS: Copenhagen, Ny Carlsberg Glyptothek, inv. no. IN 1443; included in the *Guide* of 1936, no. 595. Valenciennes, Musée des Beaux-Arts, a cast made in 1930 from the molds given to the museum by Louise Clément Carpeaux (0.82 m); included in Hardy and Braunwald (1978), no. 219. Paris, Petit Palais, since 1938, gift of Louise Clément Carpeaux, inv. no. PPS 1549; exhibited in 1953, "Un siècle d'art français," no. 154.

PLASTER REDUCTIONS: Valenciennes, Musée des Beaux-Arts, plaster with terra-cotta patina (0.55 m), gift of the sculptor's widow in 1882; included in Hardy and Braunwald (1978), no. 220. Paris, Haro sale, 18–20 March 1912, no. 337. Paris, sale, 30 March 1938, no. 33. Paris, Louvre, Holfeld Bequest of 1967, decree of 29 October 1968, inv. no. R.F. 2925 (0.465 m).

BRONZE REDUCTIONS: Houston, Museum of Fine Arts, Francis G. Gate Memorial Fund, no. 73.171 (0.458 m). Paris, sale, 6 April 1878, no. 118. London, sale, 20 December 1972, no. 22.

TERRA COTTAS: An edition in three sizes, according to the *Guide* of the Ny Carlsberg Glyptothek (1936); one cast was sold in Paris at the Leon Gauchez sale, 20 April 1892 (0.45 m).

"There is not and there never has been a plaster by Carpeaux on the market and I will gladly pledge myself to continue in this direction for the future. It is I who am in my turn very surprised by your reproach. Since you came here with my excellent friend, M. Courajod, you ought to have seen that I submitted to him, among other models, two plasters of Dumas which would both be considered as originals for they were executed and retouched by Carpeaux himself. One served as a model for the marble, the other for the bronze. M. Courajod chose the first because of the traces of corrections; and I promised not to make any commercial use of the other. If you now prefer that one, I am ready to make an exchange, at your convenience," wrote Amélie Carpeaux on a 26 October (after 1895) to the curator of sculpture at the Louvre. She does not specify, unfortunately, whether the bronze was executed during Carpeaux's lifetime.

From the very beginning, confusion reigned between the bust of Alexandre Dumas *père* and that of the son. To the Director of Fine Arts who asked her on 28 June 1876 what became of the commission received by Carpeaux in 1872, the sculptor's widow replied, "The bust . . . is, I think, enough advanced so that one can very easily turn it to account. This work should be now at Puys with M. Alexandre Dumas. It is there that it was executed by my husband who was very satisfied with it according to what he wrote me in September 1873." As a result, Louise Clément Carpeaux, daughter and biographer of the sculptor, accused Dumas of having enjoyed for twenty years a bust paid for by the Direction of Fine Arts and of then having "donated" it to the Comédie française, which already owned it (Louise Clément Carpeaux, *La Vérité sur l'Oeuvre et la vie de J.-B. Carpeaux*, vol. 1 [Nemours, 1935], 379–380). Even though the commission of 1872 does not specify whether it is of the father or the son, it is beyond doubt that the Direction of Fine Arts could not have ordered from Carpeaux, in 1872, a bust other than that of Dumas *père*. Indeed, the successes of Dumas *fils* did not begin at the Comédie française until 1874, as is pointed out by Mlle. Guibert, curator of the library of the Comédie française.

CHAPU, HENRI
1833 LE MÉE—PARIS 1891

17. *Alexandre Dumas père*, 1876

Marble bust (see fig. 1.29)
1.03 (including 0.15 for base) x 0.70 x 0.43 m (40½ x 27½ x 16⅞ in.)
Signed on the cut of the right shoulder: *h. Chapu*; title on the front panel: ALEXANDRE DUMAS / 1803–1870
LENDER: Comédie Française, Paris
PROVENANCE: Acquired by the state for the Comédie française at the Salon of 1876 for 3000 francs, decree of 17 July 1876.
DOCUMENTATION: National Archives, F 21 201 (Carpeaux); F 21 202.
EXHIBITIONS: Paris, Salon of 1876, no. 3133. 1882, Vienna, Universal Exhibition, no. 190. 1889, Paris, Universal Exhibition, no. 1744. 1974, traveling exhibition, "Comédie française, Collection et documents," no. 75.
PLASTER: Cast from a strong lasting mold, Le Mée, Musée Chapu, no. 36.
TERRA COTTAS: Paris, Théâtre national de l'Odéon. Paris, private collection, signed on the cut of the right shoulder (0.52 m).

Two years after the death of Alexandre Dumas *père*, by decree of 30 April 1872, the state commissioned from Carpeaux a bust of the writer for the Comédie française. This commission was canceled by the death of the artist. On 17 June 1876, M. Perrin, general administrator of the Comédie française to whom an Alexandre Dumas had been promised since 1872, addressed the problem of the commission: "An opportunity presents itself today to fill the void . . . since the work which Carpeaux could not execute has been undertaken of his own

accord by Chapu with admirable success." If M. de Chennevières would consent to carry over to Chapu the commission given to Carpeaux (and to give to this commission the same destination), the bust of the writer would soon find its place in the French Theater "and that would be only just."

MARQUET DE VASSELOT, ANATOLE
1840 PARIS—NEUILLY-SUR-SEINE 1904

18. *Honoré de Balzac*, 1868–1875

Marble bust (see fig. 1.3)
0.90 (including 0.19 for base) x 0.45 x 0.32 m ($35\frac{3}{8}$ x $17\frac{3}{4}$ x $12\frac{5}{8}$ in.)
Signed and dated at right: M. DE VASSELOT. 1875; in front: 1799 H. DE BALZAC † 1850
LENDER: Comédie Française, Paris
PROVENANCE: Commissioned by the state on 27 July 1872 for 2,400 francs, a first quality white statuary marble block from Italy having been assigned by retroactive decree of 25 July 1872. According to Marquet de Vasselot (letter of 23 March 1878), this marble was found to be defective. He had begun the bust again at his own expense in a new block. Bill paid on 25 May 1875. Assigned to the Théâtre français. (Intervention of the actor Got before the Committee on 5 August 1875: "This completely finished bust, forgotten in the exhibition storage area, has not arrived. M. l'Administrateur général, who was unaware of this circumstance, promised to take the necessary steps to inform M. de Chennevières. . . .")
DOCUMENTATION: National Archives, F 21 258. Archives of the Comédie française. Louvre Archives, S 30 Vasselot.
EXHIBITIONS: Paris, Salon of 1875, no. 3426. 1974–1976, traveling exhibition of the Direction of the Museums of France, "La Comédie française, collections et documents," no. 73.
BIBLIOGRAPHY: Jacques de Caso, "Rodin and the Cult of Balzac," *Burlington Magazine* (June 1964): 279–284, note 17.
PLASTER: Paris, Salon of 1868, no. 3872, cast with terra-cotta patina; signed and dated on the cut of the left shoulder: A DE VASSELOT 68; now in the Maison de Balzac, Paris.
TERRA COTTA: Identical cast also in the Maison de Balzac. Another exhibited in 1933, Paris, Pavillon de Marsan, "Le décor de la vie sous le 3ème République, 1870 à 1900," no. 933; collection of Pierre Lièvre.
MARBLE: Larger bust, clothed (hooded robe, closed by a large round button at the neck); signed and dated 1876; gift of the artist to the Musée de Tours, 1881.
BRONZE: Paris, Salon of 1870, no. 4897. A nude bust cast by Bingen in 1883 belongs to the Société des gens de lettres, Paris, placed in the office of the president. In 1886 Vasselot wrote: "I have just now read in *La Liberté* that you are going to have a bust of Balzac at the Société des gens de lettres. . . . Which one? I *want* and I *hold* that it is to be mine: I offer it to the society with all my heart, and it would be very bad,

15.11 Photograph from the dossier in the National Archives on Marquet de Vasselot. Inscribed by Charles Blanc, 11 June 1879.

very bad to take another, since I hope soon to be one of you. . . . I had first offered the plaster. . . . At the moment of having it sent . . . I found that this plaster was not worthy of Balzac nor of you. . . . Therefore I am taking the liberty of offering in its place the magnificent lost-wax bronze which I made according to the indications of Balzac's own niece, Mme. Duhamel née de Surville, who died three years ago and who had desired very much to help me with her precious advice." (Chronique de la Société des gens de Lettres, March 1886, cited by J. de Caso.)
OTHER WORKS DEDICATED TO BALZAC: Project for a monument for the Centennial, exhibited in 1896, Paris, Société nationale des Beaux-Arts, no. 99 (illustrated catalogue). *The Human Comedy of Balzac*, plaster bas-relief, exhibited in Paris, Salon of 1901, no. 3584.

Judith Cladel was very scornful of Marquet de Vasselot. She spoke of him as a skillful amateur in publicity as well as in sculpture. During the decade 1871–1880, Marquet de Vasselot received 34,400 francs from the state in purchases and commissions. Playing upon his birth ("we belong to the same world"), his religion ("we have the same faith"), as well as his

connections was a practice that sometimes did him a disservice. But when he succeeded he forgot the means by which he had been employed and that art had not always been in the forefront. His *Balzac* was commissioned from him with the backing of the Deputy L. de Jouvenel, who recommended "his young friend who had abandoned the career to which he belonged in order to affirm his real vocation in the arts." Charles Blanc annotated a photo of Marquet's *Balzac* (National Archives, fig. 15.11) as follows: "This bust has life and accent, and anyway the artist deserves to be encouraged for his fine conduct during the siege."

To show appreciation for *Balzac* the Comédie française gave Marquet de Vasselot a free pass for a whole year (3 August 1876).

HUGUES, JEAN
1849 MARSEILLES —PARIS 1930

25. *Shades of Francesca da Rimini and Paolo Maletesta*, 1877

Patinated plaster sketch
0.53 x 0.21 x 0.23 m (20⅞ x 8¼ x 9 in.)
LENDER: Musée du Louvre, Paris
PROVENANCE: Gift of Messrs. Hugues, grandsons of the sculptor, to the Louvre, decree of 22 October 1879, inv. no. R.F. 3445. (see fig. 1.55)
DOCUMENTATION: National Archives, AJ52. 202 fº 56.
EXHIBITIONS: Never before exhibited.
LARGE PLASTER: "Envoi de Rome," exhibited at the Villa Medici, 1 April 1878. Sent to Paris, exhibited at the Salon of 1879, no. 5105. (Published by the Ministère de l'Instruction publique et des Beaux-Arts, Salon of 1879, Palais des Champs Elysées, Ouvrages d'art commandés ou acquis par l'administration des Beaux-Arts à la date du 1er août 1879 [Paris, Imprimerie nationale, 1879], fº 30.) Present location unknown.

Winner of the Grand Prix de Rome in 1875, Hugues took his subject from the *Inferno* of Dante—as had Carpeaux twenty years earlier. For the composition, however, he relied on Bernini, as well as on Alessandro Puttinati who had also followed Bernini in his *Paolo and Francesca* (1872) (Milan, Galeria civica di arte moderna). In Hugues's group, the dynamic body of the man in flight contrasts with the woman's heavy, static body, one that recalls certain figures of Dalou, without benefiting from the latter's prodigious modeling.

The overlapping of two volumes in movement—a problem that also interested Damé this same year (1877), as the plaster model of his *Fugit Amor* makes evident—looks forward to Rodin's *Fugit Amor*. Three years earlier, with his *Siren*, Aubé had offered the best demonstration of the limits of overlapping a semi-reclining figure in motion, at the same time trying to preserve a style that was basically rococo.

CROISY, ARISTIDE ONESYME
1840 FAGNON 1899

26. *Paolo and Francesca*, 1876

Plaster group (see fig. 1.30)
1.67 x 1.02 x 0.75 m (65¾ x 40⅛ x 29½ in.)
Signed and dated on the lower right of the bench: A. CROISY 1876
LENDER: Musée de l'Ardenne et Musée Arthur-Rimbaud, Charleville-Mézières
PROVENANCE: Acquired at the salon by the state by decree of 26 April 1876 for 3,500 francs (fig. 15.10). Placed on deposit at the Musée de Charleville by decree of 20 January 1879. Exhibited at the municipal library of Charleville from 1898 to 1912.
DOCUMENTATION: National Archives, F 21 207 and 539.
EXHIBITIONS: Paris, Salon of 1876, no. 3180. 1878, Paris, Universal Exhibition, gr. 1, cl. III, no. 1170.
BIBLIOGRAPHY: Marie-Claude Chaudonneret, "Ingres, Paolo et Francesca," *Galerie d'essai* (Bayonne: Musée Bonnat), 10.
OTHER PLASTER CAST: Sold in Paris, 31 March 1879, no. 46.
MARBLE: Paris, Salon of 1878, no. 4159.
BRONZE EDITION: Casts found in France and the United States (0.68 m).

The Senator from Ardennes intervened in the name of the Conseil général on 26 April 1876 so that the group which his compatriot presented at the salon would be well placed. Croisy then put pressure on the Marquis de Chennevières, Director of Fine Arts. He paid him a visit in January and wrote in June, pointing out that he had had no commission or purchase by the state since 1870. He won his case and the group was commissioned retroactively.

BARTLETT, TRUMAN H.
1835 DORSET, VERMONT—BOSTON 1922

27. *Lincoln*, 1877

Bronze statuette (see fig. 1.41)
0.96 x 0.29 x 0.27 m (38 x 11½ x 10¾ in.)
Signed and dated: *Bartlett. 1877.*
LENDER: The Louis A. Warren Lincoln Library and Museum, Fort Wayne, Indiana
PROVENANCE: Not known when the bronze cast was taken. Purchased in the nineteenth century by the New York firm of Mitchell, Vance and Co., maker of bronze chandeliers. By 1907, when Bartlett himself was looking for it, they had sold it and did not know where it was. It turned up in an antique shop (Erwin Forschheimer) in Baltimore in the 1940s and was purchased by The Louis A. Warren Lincoln Library and Museum in 1957 from Joseph Katz of Baltimore.
BIBLIOGRAPHY: Truman H. Bartlett, "The Physiognomy of

Lincoln," *McClure's Magazine*, August 1907, 391–407. Truman H. Bartlett, article in *Forum Magazine*, 1909.

PLASTER: Made during the summer of 1877 when Bartlett was staying in Port Marley near S. Germain. Exhibited in the Salon of 1878. Present location unknown.

Between 1867 and 1881 Bartlett lived in Europe. It was a period when he was particularly interested in the physiognomy of Lincoln. In 1873 or 1874, while he was visiting Washington, he saw two photographs of Lincoln in a studio and purchased both of them from Mr. Gardner, the photographer. This was the beginning of what was to become one of the most complete collections of Lincoln portraits in nineteenth-century America (part of this collection is now housed in the Boston University Library). Bartlett took the photographs back to Paris and showed them to Frémiet, with whom he had been studying. Frémiet "wanted to know all about Lincoln. He said the man was more like a Greek god than a human being. He thought Lincoln's head was the finest head he had ever seen—noble, thoughtful, dignified. And he thought the pose of this portrait was perfect." (From an unidentified newspaper clipping in the possession of The Louis A. Warren Lincoln Library and Museum.)

AUBÉ, JEAN-PAUL
1837 LONGWY—CAPBRETON 1916

28. *Dante*, 1879

Bronze statue (see fig. 1.54)
1.95 x 0.60 x 0.60 m (76¾ x 23⅝ x 23⅝ in.)
Signed and dated in the hollow of the socle, to the right: P. AUBE-1879; on the back left: H. MOLZ *Fondeur, Paris*
LENDER: The City of Paris
PROVENANCE: Casting granted by decree of 23 September 1879 for 3,000 francs to H. Molz, over the bids of the elder Voruz of Nantes (2,900 franc bid) and Thiebaut and Sons (3,500 franc bid). Salon of 1880, no. 6061 (fig. 15.12) (Photo: Michelez, *Ouvrages d'art commandés ou acquis par l'Administration des Beaux-Arts* [Paris, 1880], f° 36, "Jardin sculpture milieu"). Placed in the square of the Collège de France in December 1880.
DOCUMENTATION: Archives de la Seine, VR 105, 10 624/72/1, bundle 5.
BIBLIOGRAPHY: Claude Allut-Jacolin, *Le Statuaire Paul Aubé, né à Longwy en 1837*, exhibition catalogue (Musée municipal de Longwy, 1979), no. 4.
DRAWINGS: Graphite, five head studies of Dante in profile, Paris, private collection. Drawing of the plaster by Aubé appeared in *L'Art* (1879), 291.
ORIGINAL PLASTER: 2 May 1879, Aubé applied to the Préfet de la Seine for acquisition of Dante, presented at the salon, no. 4765: "Out of competition for the past few years, I have not had the honor of participating in municipal public works." 14 June

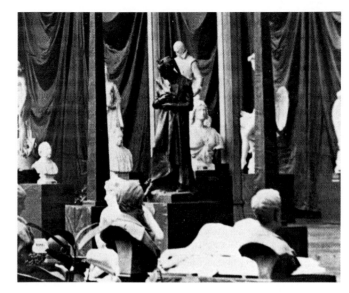

15.12 Aubé. *Dante*, 1879. Bronze. Photograph of the Salon of 1880. The City of Paris. Cat. no. 28.

1879, his work was purchased for 5,000 francs. 1882, Vienna, Universal Exhibition, no. 181. Paris, Petit Palais, inv. no. PPS 3. On deposit at Ivry, no. 313.
PLASTER MODEL: A small bronzed plaster model was given to the Louvre in 1948 by Mme. Delage, born Hélène Aubé (daughter of Aubé by his first marriage), decree of 2 September 1948, inv. no. R.F. 2622.
EDITION: Thiebaut Brothers produced bronze reductions starting in 1880, whose size was not allowed to exceed two-thirds of the original. A sample was received by the Paris municipal administration. In a catalogue published sometime after 1900, *Dante* was still offered by Fumière and Company, late Thiebaut Brothers, in four different sizes.

In a photograph kept by Aubé's youngest daughter, Marcelle Bertein, we see a small *Dante* in plaster behind the door, almost under the Hiolle medallion of Aubé at 22 years of age. The sculptor himself, who is leaning against the doorway, shows the same profile here that he did thirty-three years earlier (fig. 15.13).

Madame Delage, "who could not help her sorrow at seeing her father's works disappear from Paris," offered a similar model to the Louvre in 1946. She thought *Dante* had been melted down during the German occupation (1940–1945). In fact, eight other statues by Aubé had met with that fate: the *Bailly* (1884), the bronzes of *Gambetta* (1888), the *Siren* (1874), *Joubert* (1885), *Borda* (1891), *Pelletan* (1892), *Raoult* (1892), and *Goujon* (1910).

Claude Allut-Jacolin has remarked that the sitter for the Dante could have been Dalou, a fellow student of Aubé at the Petite Ecole: "I was watching my new comrade (Dalou). His face, of a slightly dead pallor, showed me a profile which recalled, by the accentuated form of the nose and brow ridge, the profile of Dante and which bore witness to a singular will." (Journal, 13; private collection, manuscript.)

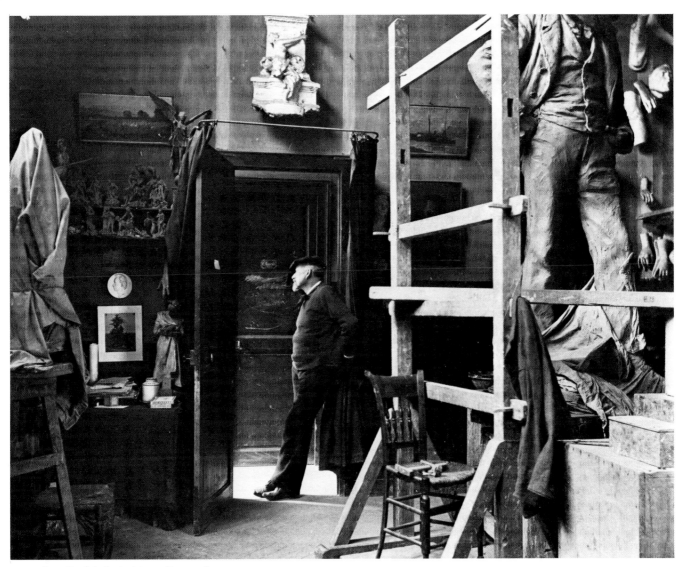

15.3 Jean-Paul Aubé in his studio, c. 1892.

FALGUIÈRE, ALEXANDRE
1831 TOULOUSE—PARIS 1900

29. *Eve*, 1880

Marble statue
2.02 x 0.74 x 0.68 m (79½ x 29⅛ x 26¾ in.)
Signed and dated: A. *Falguière* 1880
LENDER: Ny Carlsberg Glyptothek, Copenhagen
PROVENANCE: Acquired for 12,000 francs by Carl Jacobsen at the Secretan sale, 1 July 1889, no. 207. Copenhagen, Ny Carlsberg Glyptothek, inv. no. IN 542. Included in the *Guide* of 1936, no. 652.
EXHIBITIONS: Paris, Salon of 1880, no. 6415.
BIBLIOGRAPHY: Anne Pingeot, "Le Fonds Falguière au musée du Louvre," *Bulletin de la Société de l'Histoire de l'Art français*

(1978), 272, no. 8. Ruth Butler, "Religious Sculpture in Post-Christian France," in Peter Fusco and H. W. Janson, eds., *The Romantics to Rodin* (Los Angeles: Los Angeles County Museum of Art, 1980), 93–94. Albert E. Elsen, *In Rodin's Studio: A Photographic Record of Sculpture in the Making* (Oxford: Phaidon Press in association with the Musée Rodin, 1980), 31; photograph of the live model posing for *Eve*.
SKETCH: Terra cotta, exhibited in 1902, Paris, Ecole des Beaux-Arts, *Catalogue des oeuvres de Falguière*, no. 139.
PLASTER MODEL: Paris, Louvre, gift of G. Sins, decree of 28 March 1953, inv. no. R.F. 2692.
EDITIONS: Marnyhac sale, 11 February 1895, "Eve debout près de l'arbre," two-thirds life-size marble, sold with reproduction rights.

In 1902, Léonce Bénédite, curator of the Musée du Luxem-

bourg, credited Marynhac with the foundation of the Société de Photosculpture after the War of 1870: "Establishment for pointing and finishing, and especially for reducing or translating models into marble . . . made by the sculptors in vogue, among them Falguière, the most successful of the day. . . . Various large works were even sketched into marble by this firm, including the *Corneille* and the *Eve*. . . ."

Falguière succeeded once again in joining the ancients and the moderns. His *Apollo* was transformed into a young woman with a contemporary stomach. Having made his reputation during his lifetime particularly on the strength of these two works, he would be rejected by the twentieth century as an imposter. Today, nevertheless, we observe with a less severe eye the sensuality of his modeling and the cutting of the marble which Ph. Burty admired so much: "We saw—a rare and moving spectacle—M. Falguière, who, with shining eyes, a slightly impassioned hand, cigarette between his lips, disengaged momentarily from the process of pointing out, the figure still obscured by the rapid marks of the sketch, a figure that was a flower of feminine beauty. . . ." ("Le Salon de 1880," *L'Art*, 1880, 270.) In 1884, Ernest Guilbert would pastiche Falguière with an *Eve* picking the apple from a curved limb above her head (fig. 15.14).

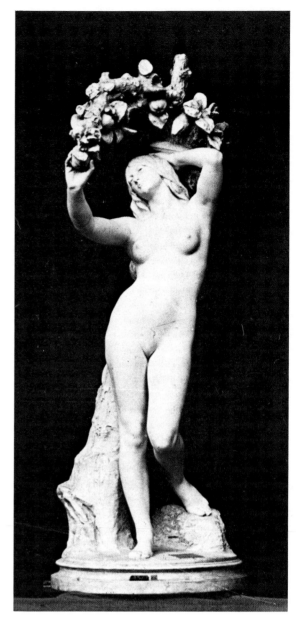

15.14 Guilbert. *Eve*, 1884.

CATALOGUE OF THE EXHIBITION

*Owing to changes in installation, certain works listed here may
not always be on view in the exhibition.*

I. *Rodin and the Paris Salons of the 1870s*

*Most of the information which follows has been provided by the lenders
to the exhibition.*

FRÉDÉRIC-AUGUSTE BARTHOLDI (1834–1904)

1. *Lafayette Arriving in America*

 Bronze, 1874–1875
 Plaster, 1872–1873
 2.99 x 1.09 m (118 x 43 in.)
 Signed and dated on the base at right: A BARTHOLDI
 1873; inscribed on the socle: "*As soon as I heard of
 American Independence, my heart was enlisted*" /
 *1776/to the city of New York / France / In remembrance
 of sympathy / in time of trial / 1870–1871 / Erected
 1876*
 Courtesy Art Commission of the City of New York

PAUL CABET (1815–1876)

2. *Mil-huit-cent-soixante-et-onze (1871)*

 Marble, 1873–1877
 Plaster, n.d.
 1.25 x 0.66 x 1.01 m (49¼ x 26 x 39¾ in.)
 Signed on the seat to the right: P. CABET; title on the
 front of the plinth: MDCCCLXXI
 Musée du Louvre, Paris, on loan to Nuits Saint Georges

ALBERT-ERNEST CARRIER-BELLEUSE (1824–1887)

3. *Psyche Abandoned*

 Marble, 1872
 Plaster, n.d.
 1.65 x 0.60 m (65 x 23⅝ in.)
 Signed and dated on the right of the column: A. Carrier-
 Belleuse 1872
 Musée des Beaux-Arts, Marseilles

HENRI CHAPU (1833–1891)

4. *Joan of Arc*

 Marble, 1870–1872
 Plaster, n.d.
 1.17 x 0.92 x 0.83 m (46⅛ x 36¼ x 32⅝ in.)
 Signed on the plinth at left: h. Chapu
 Musée du Louvre, Paris, usually on view in the City
 Hall of Amboise

PAUL DUBOIS (1829–1905)

5. *Newborn Eve*

 Bronze, 1873
 Plaster, n.d.
 1.80 x 0.55 x 0.55 m (70⅞ x 21 ⅝ x 21⅝ in.)
 Signed on the base at left: P. DUBOIS; on the back of
 the plinth at right: JABOEUF et ROUARD / Fondeurs
 PARIS
 Musée du Petit Palais, Paris

PAUL DUBOIS (1829–1905)

6. *Narcissus*

 Marble, executed 1862–1867
 Plaster, n.d.
 1.85 x 0.67 x 0.62 m (72⅞ x 26⅜ x 24⅜ in.)
 Signed on the plinth of the socle at right: P. DUBOIS
 Musée du Louvre, Paris

ALEXANDRE FALGUIÈRE (1831–1900)

7. *Switzerland Welcoming the French Army*

 Bronze, 1873
 Plaster, n.d.
 1.25 x 0.80 x 0.70 m (49¼ x 31½ x 27½ in.)
 Signed and dated: A. *Falguière* 1873
 The Swiss Confederation

AUGUSTIN PRÉAULT (1809–1879)

8. *Ophelia*

 Bronze relief, after 1876
 Plaster, 1842–1876
 0.75 x 2.00 x 0.20 m (29½ x 78¾ x 7⅞ in.)
 Signed on the frame at lower right: AUGUSTE PREAULT;
 title at lower center: OPHELIE
 Musée des Beaux-Arts, Marseilles

EMMANUEL FRÉMIET (1824–1910)

9. *Saint Michael*

 Bronze, n.d.

Plaster, 1879
0.59 m (23¼ in.)
Signed between feet: *E. Frémiet*; founder's mark on
 bottom of bronze base: *F. Barbedienne fondeur*
Mr. David Daniels

EUGÈNE GUILLAUME (1822–1905)
10. *Monseigneur Darboy (1813–1871)*

Marble, 1874
Plaster, n.d.
0.92 (including 0.135 for the pedestal) x 0.58 x 0.34 m
 (36 ¼ x 22⅞ x 13⅜ in.)
Signed and dated at right on the base: E GVILLAVME/
 1874
Musée du Louvre, Paris

ANTONIN MERCIÉ (1845–1916)
11. *Gloria Victis (Glory to the Vanquished)*

Bronze, n.d.
Plaster, 1872
3.11 x 1.92 x 1.51 m (124⅞ x 75⅝ x 59½ in.)
Title on the front of the plinth: GLORIA VICTIS; signed
 on the left: A. MERCIE; founder's mark on the back:
 F^{du} par THIEBAUT & FILS
Musée du Petit Palais, Paris

LOUIS-ERNEST BARRIAS (1841–1905)
12. *Henri Regnault, Painter (1843–1871)*

Bronze, 1871
Plaster, n.d.
0.53 x 0.25 x 0.25 m (20⅞ x 9⅞ x 9⅞ in.)
Signed and dated on the back at left: *E. Barrias* / *1871*;
 title on the panel: *Henri* REGNAULT
Musée du Louvre, Paris

JEAN-BAPTISTE CARPEAUX (1827–1875)
13. *Bruno Chérier (1819–1880)*

Plaster bust with terra-cotta patina, 1875
Original plaster, n.d.
0.626 x 0.30 x 0.274 m (24⅝ x 11⅞ x 10¾ in.)
Signed, dated, and dedicated on the right side of the
 base: SOUVENIR FRATERNEL / *offert à mon vieil* / *ami*
 Bruno Cherier / *peintre* / *son compatriote Carpeaux*,
 1875
Musée du Louvre, Paris

ANTONIN MERCIÉ (1845–1916)
14. *David*

Bronze, n.d.
Plaster, 1869
1.84 x 0.76 x 0.83 m (72½ x 29⅞ x 32⅝ in.)

Signed on the base at right: *Mercié*; founder's mark
 on the plinth at left: F DU PAR V^{or} THIEBAUT & FILS
Musée du Louvre, Paris

ALFRED LENOIR (1850–1920)
15. *Mademoiselle Jeanne Balze at the Age of Twenty*

Marble, 1878
Plaster, n.d.
0.75 x 0.407 x 0.325 m (29½ x 16 x 12⅞ in.)
Signed and dated on the plinth of the base at left:
 ALFRED•LENOIR•1878
Musée du Louvre, Paris

JEAN-BAPTISTE CARPEAUX (1827–1875)
16. *Alexandre Dumas fils (1824–1895)*

Bronze, 1873
Plaster. n.d.
0.797 x 0.587 x 0.401 m (31⅜ x 23⅛ x 15¾ in.)
Signed, dated and dedicated on the right side of the
 base: *All Sommo Pensieroso* / *Alexandre Dumas fils*
 / *Suo amico JB^{te} Carpeaux 1873*.
Hirshhorn Museum and Sculpture Garden, Smithson-
 ian Institution, Washington, D.C.

HENRI CHAPU (1833–1891)
17. *Alexandre Dumas père (1803–1870)*

Marble, 1876
Plaster, n.d.
1.03 (including 0.15 for base) x 0.70 x 0.43 m (40½
 x 27½ x 16⅞ in.)
Signed on the cut of the right shoulder: *h. Chapu*; title
 on the front panel: ALEXANDRE DUMAS / 1803–1870
Collections de la Comédie française, Paris

ANATOLE MARQUET DE VASSELOT (1840–1904)
18. *Honoré de Balzac (1799–1850)*

Marble, 1875
Plaster, n.d.
0.90 (including 0.19 for the base) x 0.45 x 0.32 m (35⅜
 x 17¾ x 12⅝ in.)
Signed and dated at right: M. DE VASSELOT. 1875; in
 front: 1799 H. DE BALZAC † 1850
Collections de la Comédie française, Paris

19. *Bust of M. Garnier*

Terra cotta, 1875
0.65 x 0.45 x 0.27 m (25⅝ x 17¾ x 10⅝ in.)
Musée Rodin, Paris (S744)

20. *Bust of the Man with a Broken Nose*

Plaster, c. 1871–1872
0.50 x 0.40 x 0.23 m (19¾ x 16 x 9 in.)
Signed: "Rodin" in surface of work, lower inside back
The University Art Museum, The University of Texas at Austin, Archer M. Huntington Museum Fund

21. *The Age of Bronze*

Bronze, before 1915
Plaster, 1876
1.81 x 0.54 x 0.64 m (71½ x 21¼ x 25½ in.)
Signed on base, top right: *Rodin*; founder's mark on base, left side: *Alexis Rudier, Paris*
The Fine Arts Museums of San Francisco, Gift of Mrs. Alma deBretteville Spreckels

22. *St. John the Baptist Preaching*

Bronze, before 1915
Plaster, 1878
2.01 x 1.31 x 0.98 m (79½ x 51⅝ x 38⅝ in.)
Signed on base, top right: *Rodin*; founder's mark on base, at back: *A. Rudier, Paris*
The Fine Arts Museums of San Francisco, Gift of Mrs. Alma deBretteville Spreckels

23. *The Call to Arms (La Défense)*

Bronze, before 1915
Plaster, 1879
1.13 x 0.58 x 0.40 m (44½ x 22¾ x 15⅞ in.)
Signed on base, right side: *A. Rodin*; stamped on left rear: *Alexis Rudier, Paris*
The Fine Arts Museums of San Francisco, Gift of Mrs. Alma deBretteville Spreckels

24. *Bellona*

Bronze, c. 1894
Plaster, 1879
0.81 x 0.47 x 0.45 m (32 x 18½ x 17¾ in.)
Signed on back, lower left: *A. Rodin*; founder's mark on back, lower left: *A. Gruet aine Fondeur / Paris*
The Stanford University Museum of Art, Gift of the B. G. Cantor Art Foundation

JEAN HUGUES (1849–1930)
25. *Shades of Francesca da Rimini and Paolo Malatesta*

Patinated plaster sketch, 1877–1878
Original plaster, n.d.
0.53 x 0.21 x 0.23 m (20⅞ x 8¼ x 9¹⁄₁₆ in.)
Musée du Louvre, Paris

ARISTIDE ONESYME CROISY (1840–1899)
26. *Paolo and Francesca*

Plaster group, 1876
Original plaster, n.d.
1.50 x 1.02 x 0.75 m (59 x 40⅛ x 29½ in.)
Signed and dated on the base and to the right of the seat: A. CROISY 1876
Musée de l'Ardenne et Musée Arthur-Rimbaud, Charleville-Mézières

TRUMAN BARTLETT (1835–1922)
27. *Lincoln (1809–1865)*

Bronze, 1877
Plaster, 1877
0.96 x 0.29 x 0.27 m (38 x 11½ x 10¾ in.)
Signed and dated on base; *Bartlett Sc c 77*; *Mitchell Vance & Co/77*
Louis A. Warren Lincoln Library and Museum, Fort Wayne, Indiana

JEAN-PAUL AUBÉ (1837–1916)
28. *Dante*

Bronze, 1879
Plaster, n.d.
1.95 x 0.60 x 0.60 m (76¾ x 23⅝ x 23⅝ in.)
Signed and dated in the hollow of the socle, to the right: P. AUBE - 1879; on the back left: H. MOLZ *Fondeur, Paris*
The City of Paris, in front of the Collège de France

ALEXANDRE FALGUIÈRE (1831–1900)
29. *Eve*

Marble, 1880
Plaster, n.d.
2.02 x 0.74 x 0.68 m (79½ x 29⅛ x 26¾ in.)
Signed and dated: A. *Falguière* 1880
Ny Carlsberg Glyptothek, Copenhagen

II. *In Rodin's Studio*

30. *Nude Crouching Woman with a Grotesque Head*

Plaster, 1900–1912(?)
0.59 x 0.27 x 0.37 m (23¼ x 10⅝ x 14½ in.)
Musée Rodin, Paris (S704)

31. *Nude Woman Without Head or Arms, Her Torso Twisted*

Plaster, n.d.
0.65 x 0.34 x 0.37 m (25⅝ x 13⅜ x 14⅝ in.)
Musée Rodin, Paris (S677)

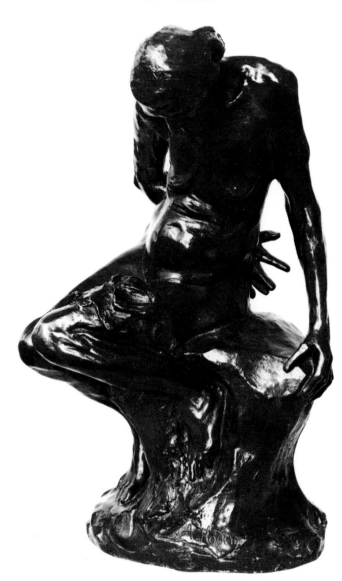

The Helmet Maker's Old Wife, 1885. Bronze. The Stanford University Museum of Art, Gift of the B. G. Cantor Art Foundation. Cat. no. 258.

32. *The Earth with the Small Head of the Man with the Broken Nose*

 Plaster, after 1884
 0.29 x 0.53 x 0.18 m (11½ x 21 x 7⅜ in.)
 Musée Rodin, Paris (S703)

33. *Prayer* (small version)

 Plaster, 1883–1884(?)
 0.38 x 0.14 x 0.11 m (15¼ x 5⅝ x 4½ in.)
 Musée Rodin, Paris (S685)

34. *Prayer* (without the right leg)

 Plaster, 1883–1884(?)
 0.33 x 0.13 x 0.10 m (13 x 5⅜ x 4⅛ in.)
 Musée Rodin, Paris (S684)

35. *Prayer* (life-sized)

 Plaster, by 1909
 1.23 x 0.49 x 0.46 m (48½ x 19½ x 18⅜ in.)
 Musée Rodin, Paris (S709)

36. *A Couple Intertwined*

 Plaster, 1870s(?)
 0.09 x 0.05 x 0.04 m (3¾ x 2 x 1⅝ in.)
 Musée Rodin, Paris (S691)

37. *A Couple Intertwined*

 Plaster, 1870s (?)
 0.1 x 0.05 x 0.04 m (4 x 2 x 1⅞ in.)
 Musée Rodin, Paris (S692)

38. *A Couple Intertwined*

 Plaster, 1870s(?)
 0.09 x 0.06 x 0.04 m (3½ x 2⅜ x 1⅞ in.)
 Musée Rodin, Paris (S693)

39. *A Couple Intertwined*

 Plaster, 1870s (?)
 0.10 x 0.06 x 0.06 m (4 x 2½ x 2½ in.)
 Musée Rodin, Paris (S694)

40. *A Couple Intertwined or The Embrace*

 Plaster, 1870s (?)
 0.21 x 0.11 x 0.10 m (8½ x 4⅝ x 4⅛ in.)
 Musée Rodin, Paris (S696)

41. *Drawer Containing Twenty-seven Pieces (arms and legs, etc.)*

 Plaster, n.d.
 0.37 x 0.76 m (14⅝ x 30 in.)
 Musée Rodin, Paris (S710 to S736)

42. *A Couple Intertwined: The Man's Outstretched Arm Entwined Around a Seated Woman*

 Plaster, n.d.
 0.17 x 0.22 x 0.11 m (6⅝ x 8⅝ x 4½ in.)
 Musée Rodin, Paris (S698)

43. *Lesbian Couple*

 Plaster, n.d.
 0.24 x 0.32 x 0.23 m (9⅜ x 12⅝ x 9⅛ in.)
 Musée Rodin, Paris (S705)

44. *Standing Faun With Seated Woman*

Plaster, n.d.
0.38 x 0.27 x 0.20 m (15 x 10⅞ x 7⅞ in.)
Musée Rodin, Paris (S700)

45. *Standing Faun*

Plaster, n.d.
0.46 x 0.18 x 0.12 m (18¼ x 7 x 4⅞ in.)
Musée Rodin, Paris (S687)

46. *Nude Seated Woman with her Left Thigh Raised*

Plaster, n.d.
0.24 x 0.12 x 0.19 m (9⅝ x 4⅞ x 7¾ in.)
Musée Rodin, Paris (S682)

47. *Young Woman and Infant (Fortune?)*

Plaster, 1865–1870 (?)
0.36 x 0.21 x 0.28 m (14⅛ x 8⅜ x 11 in.)
Musée Rodin, Paris (S293)

48. *Meditation without Arms*

Plaster, 1883–1884 (?)
0.54 x 0.18 x 0.16 m (21¼ x 7⅜ x 6¼ in.)
Musée Rodin, Paris (S680)

49. *Small Torso of a Seated Woman*

Plaster, 1880–1885 (?)
0.19 x 0.12 x 0.13 m (7½ x 4¾ x 5 in.)
Musée Rodin, Paris (S532)

50. *Small Torso of a Seated Woman with a Base*

Plaster, 1880–1885 (?)
0.19 x 0.17 x 0.13 m (7½ x 6⅝ x 5 in.)
Musée Rodin, Paris (S675)

51. *Small Torso of a Seated Woman with a Pot*

Plaster, n.d.
0.15 x 0.12 x 0.21 m (5⅞ x 4¾ x 8¼ in.)
Musée Rodin, Paris (S343)

52. *Mask of Hanako*

Plaster, 1907–1911
0.20 x 0.14 x 0.09 m (7⅞ x 5½ x 3½ in.)
Musée Rodin, Paris (S553)

53. *Mask of Hanako*

Plaster, 1907–1911
0.20 x 0.12 x 0.09 m (7⅞ x 4¾ x 3½ in.)
Musée Rodin, Paris (S541)

54. *Mask of Hanako with a Supporting Plaque*

Plaster, 1907–1911
0.28 x 0.24 x 0.17 m (11 x 9⅜ x 6¾ in.)
Musée Rodin, Paris (S544)

55. *The Tragic Muse*

Plaster, 1884 (?)
0.55 x 0.29 x 0.25 m (21⅝ x 11½ x 9⅞ in.)
Musée Rodin, Paris (S701)

56. *Iris, Messenger of the Gods* (small version)

Plaster, 1890 (?)
0.19 x 0.14 x 0.07 m (7½ x 5½ x 2⅝ in.)
Musée Rodin, Paris (S695)

57. *Iris, Messenger of the Gods, without a Head*

Plaster, 1890 (?)
0.42 x 0.28 x 0.16 m (16¾ x 11 x 6¼ in.)
Musée Rodin, Paris (S699)

58. *Iris, Messenger of the Gods, with a Head*

Plaster, 1890 (?)
0.60 x 0.27 x 0.25 m (23⅝ x 10¾ x 10 in.)
Musée Rodin, Paris (S706)

59. *Study for the Portrait of Etienne Clémentel*

Plaster, 1916
Musée Rodin, Paris

60. *Study for the Portrait of Etienne Clémentel*

Plaster, 1916
Musée Rodin, Paris

61. *Study for the Portrait of Etienne Clémentel*

Plaster, 1916
Musée Rodin, Paris

62. *Study for the Portrait of Etienne Clémentel*

Plaster, 1916
Musée Rodin, Paris

63. *An Old Man on a Capital*

Plaster, n.d.
0.59 x 0.21 x 0.21 m (23¼ x 8½ x 8½ in.)
Musée Rodin, Paris (S340)

64. *Head of the Warrior from La Défense*

Plaster, 1878
0.24 x 0.19 x 0.24 m (9½ x 7½ x 9½ in.)
Musée Rodin, Paris (S702)

65. *Study for the Head of St. John the Baptist*

Plaster, 1877–1878
0.15 x 0.12 x 0.10 m (5¾ x 4¾ x 3⅞ in.)
Musée Rodin, Paris (S304)

66. *Study for the Head of St. John the Baptist*

Plaster, 1877–1878
0.13 x 0.13 x 0.13 m (5 x 5 x 5 in.)
Musée Rodin, Paris (S679)

67. *Study for Eve*

Plaster, 1880–1881
0.22 x 0.20 x 0.22 m (8⅝ x 8 x 8⅝ in.)
Musée Rodin, Paris (S707)

68. *The Last Vision, Study for the Monument to Maurice Rollinat*

Plaster, 1902
0.16 x 0.16 x 0.04 m (6½ x 6½ x 1⅝ in.)
Musée Rodin, Paris (S697)

69. *Standing Woman With Her Shift Raised*

Plaster, n.d.
0.45 x 0.18 x 0.16 m (17⅞ x 7¼ x 6⅜ in.)
Musée Rodin, Paris (S683)

70. *Small Head of an Old Man*

Plaster, n.d.
0.11 x 0.10 x 0.09 m (4⅜ x 3⅞ x 3½ in.)
Musée Rodin, Paris (S674)

71. *Large Head of an Old Man*

Plaster, n.d.
0.62 x 0.29 x 0.29 m (24⅜ x 11⅜ x 11⅜ in.)
Musée Rodin, Paris (S676)

72. *Seated Woman, Her Arms and Legs Crossed*

Plaster, n.d.
0.33 x 0.15 x 0.15 m (13 x 6 x 6 in.)
Musée Rodin, Paris (S708)

73. *A Torso of a Woman with the Hand of a Skeleton on her Stomach*

Plaster, 1883–1884(?)
0.21 x 0.13 x 0.09 m (8⅜ x 5 x 3¾ in.)
Musée Rodin, Paris (S678)

74. *Fauness Standing in a Vase*

Plaster, n.d.
0.19 x 0.12 x 0.12 m (7⅝ x 4¾ x 4¾ in.)
Musée Rodin, Paris (S686)

75. *Nude Woman Seated on an Alabaster Vase*

Plaster, n.d.
0.24 x 0.13 x 0.12 m (9⅜ x 5¼ x 4⅝ in.)
Musée Rodin, Paris (S681)

76. *Mask of Mrs. Simpson*

Plaster, 1909
0.18 x 0.19 x 0.15 m (7 x 7¾ x 6 in.)
Signed on left side of face near neck: *Mme. K Simpson equisse pour le portrait 12 septembre 1909, A. Rodin*
National Gallery of Art, Gift of Mrs. John W. Simpson, 1942

77. *Statuette of a Woman*

Terra cotta, n.d.
0.35 x 0.17 x 0.18 m (13¾ x 6¾ x 7⅜ in.)
Signed on base at left: *Rodin*
National Gallery of Art, Gift of Mrs. John W. Simpson, 1942

78. *Aurora and Tithonus*

Plaster, 1907
0.26 x 0.18 m (10½ x 7¼ in.)
Signed on left side: *L'Aurore se leve de la / couche du beau Typhon / Metamorphose d' Ovide / hommage à Mme Kate Simpson / A. Rodin / 1907*
National Gallery of Art, Gift of Mrs. John W. Simpson, 1942

79. *Embracing Couple*

Plaster, n.d.
0.11 x 0.07 m (4⅜ x 2⅞ in.)
National Gallery of Art, Gift of Mrs. John W. Simpson, 1942

80. *Head of St. John the Baptist*

Plaster, 1887 (?)
0.06 m (2⅝ in.)
Inscribed on back: *en souvenir de Paris / l'an 1907 / a monsieur J / W / Simpson de / New York en grande*

sym / pathie / A. Rodin
National Gallery of Art, Gift of Mrs. John W.
Simpson, 1942

81. *Head of a Woman*

Plaster, n.d.
0.06 x 0.04 x 0.05 m (2½ x 1¾ x 2 in.)
National Gallery of Art, Gift of Mrs. John W.
Simpson, 1942

82. *Right Foot*

Plaster, n.d.
0.07 m (2¾ in.)
National Gallery of Art, Gift of Mrs. John W.
Simpson, 1942

83. *Study for Hand*

Plaster, n.d.
Greatest extension 0.10 m (4 in.)
National Gallery of Art, Gift of Mrs. John W.
Simpson, 1942

84. *Study for Hand*

Plaster, n.d.
Greatest extension 0.08 m (3⅛ in.)
National Gallery of Art, Gift of Mrs. John W.
Simpson, 1942

85. *Study for Hand*

Plaster, n.d.
Greatest extension 0.06 m (2½ in.)
National Gallery of Art, Gift of Mrs. John W.
Simpson, 1942

86. *Study for Hand*

Plaster, n.d.
Greatest extension 0.04 m (1⅝ in.)
National Gallery of Art, Gift of Mrs. John W.
Simpson, 1942

87. *Study for Hand*

Terra cotta, n.d.
Greatest extension 0.13 m (5¼ in.)
Inscribed on wrist: *Rodin*
National Gallery of Art, Gift of Mrs. John W.
Simpson, 1942

CHARLES MICHELEZ
88. *St. John the Baptist Preaching*

Salt print, 1878
0.33 x 0.22 m (13¼ x 8⅞ in.)
Musée Rodin, Paris (M.R.ph959)

CHARLES BODMER
89. *St. John the Baptist Preaching*

Albumen print, 1881
0.25 x 0.18 m (9⅞ x 7¼ in.)
Inscribed on the mount: *hommage d'admiration / au
grand maître Puvis de Chavannes / Auguste Rodin*
Private Collection, Courtesy of the Fischer-Kiener Gal-
lery, Paris

CHARLES BODMER
90. *Eternal Springtime*

Albumen print, c. 1881
0.25 x 0.18 m (9⅞ x 7¼ in.)
Musée Rodin, Paris (M.R.ph958)

CHARLES BODMER
91. *The Thinker*

Albumen print, c. 1881
0.18 x 0.13 m (7⅛ x 5⅛ in.)
Musée Rodin, Paris (M.R.ph1020)

CHARLES BODMER
92. Nude study for *The Burghers of Calais*: Pierre de Wissant

Albumen print, 1886
0.25 x 0.19 m (9¾ x 7½ in.)
Musée Rodin, Paris (M.R.ph953)

CHARLES BODMER
93. Nude study for *The Burghers of Calais*: Pierre de Wissant

Albumen print, 1886
0.25 x 0.18 m (9⅞ x 7¼ in.)
Musée Rodin, Paris (M.R.ph954)

CHARLES BODMER
94. Nude study for *The Burghers of Calais*: Pierre de Wissant

Albumen print, 1886
0.25 x 0.18 m (9⅞ x 7¼ in.)
Musée Rodin, Paris (M.R.ph955)

CHARLES BODMER
95. Nude study for *The Burghers of Calais*: Jean d'Aire

Albumen print, 1886
0.25 x 0.19 m (9⅞ x 7½ in.)
Musée Rodin, Paris (M.R.ph956)

VICTOR PANNELIER
96. Study for *The Burghers of Calais*: Eustache de St.-Pierre (profile)

Albumen print, 1886
0.38 x 0.18 m (15⅛ x 7¼ in.)
Musée Rodin, Paris (M.R.ph951)

VICTOR PANNELIER
97. Study for *The Burghers of Calais*: Eustache de St.-Pierre (frontal)

Albumen print with ink additions, 1886
0.38 x 0.17 m (14⅞ x 6½ in.)
Musée Rodin, Paris (M.R.ph317)

VICTOR PANNELIER
98. Study for *The Burghers of Calais*: Eustache de St.-Pierre (frontal)

Albumen print, 1886
0.35 x 0.20 m (13¾ x 7⅞ in.)
Musée Rodin, Paris (M.R.ph318)

VICTOR PANNELIER
99. Study for *The Burghers of Calais*: Eustache de St.-Pierre (rear view)

Albumen print, 1886
0.39 x 0.18 m (15⅜ x 7⅛ in.)
Musée Rodin, Paris (M.R.ph320)

VICTOR PANNELIER
100. Study for *The Burghers of Calais*: Andrieu d'Andres

Albumen print, 1886
0.36 x 0.18 m (14⅛ x 7¼ in.)
Musée Rodin, Paris (M.R.ph952)

VICTOR PANNELIER
101. Study for *The Burghers of Calais*: Jean d'Aire

Albumen print, 1886
0.40 x 0.19 m (15¾ x 7½ in.)
Musée Rodin, Paris (M.R.ph958)

EUGÈNE DRUET
102. Tympanum of *The Gates of Hell* with *The Three Shades*

Gelatin silver print, c. 1898
0.40 x 0.30 m (15¾ x 11⅞ in.)
Musée Rodin, Paris (M.R.ph396)

JACQUES-ERNEST BULLOZ
103. *Rodin's Studio at Meudon* (an overview)

Gelatin silver print, c. 1912 (?)
0.37 x 0.27 m (14¾ x 10⅝ in.)
Musée Rodin, Paris (M.R.ph966)

JACQUES-ERNEST BULLOZ
104. *The Shade* (rear view)

Geltain silver print, c. 1908 (?)
0.36 x 0.25 m (14⅛ x 9⅞ in.)
Musée Rodin, Paris (M.R.ph969)

JACQUES-ERNEST BULLOZ
105. Study for the *Whistler Monument* (rear view)

Gelatin silver print, c. 1906
0.36 x 0.28 m (14¼ x 11¼ in.)
Musée Rodin, Paris (M.R.ph968)

JACQUES-ERNEST BULLOZ
106. Head of *La France*

Gelatin silver print, c. 1906
0.36 x 0.26 m (14⅛ x 10⁷⁄₁₆ in.)
Musée Rodin, Paris (M.R.ph970)

STEPHEN HAWEIS AND HENRY COLES
107. *Bust of Victor Hugo* with two figures of *Meditation*

Gum bichromate print, c. 1904
0.22 x 0.16 m (8⅞ x 6¼ in.)
Musée Rodin, Paris (M.R.ph965)

108. *The Clenched Hand*

Bronze, 1971
Plaster, 1888
0.47 x 0.27 x 0.15 m (18¾ x 10¾ x 6 in.)
Signed on finger side: A. *Rodin*; on thumb side, back: *Georges Rudier Fondeur Paris*
The Stanford University Museum of Art, Gift of the B. G. Cantor Art Foundation

109. *Despairing Adolescent (Imploring Woman)*

Bronze, n.d.
Plaster: 1882
0.44 x 0.15 x 0.14 m (17¼ x 6 x 5¾ in.)
Inscribed: A. *Rodin—Godard—Cast No. 3*
B. G. Cantor Collections

110. *Large Clenched Left Hand with Imploring Figure*

Bronze, n.d.
Plaster: c. 1890

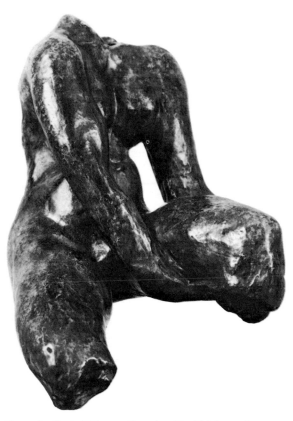

Torso of a Seated Woman Grasping Her Thigh, c. 1890.
Bronze. B. G. Cantor Collections. Cat. no. 289.

0.45 x 0.30 x 0.26 m (18 x 12 x 10½ in.)
Inscribed: A. *Rodin—Godard Fondeur, Paris (cast no.*
 12)
Mr. and Mrs. Howard Berkowitz

111. *Study for the Monument to General Lynch*

Bronze, 1975
Plaster, 1886
0.44 x 0.33 x 0.18 m (17½ x 13¼ x 7 in.)
Signed on top left front of base: A. *Rodin;* founder's
 mark on back: *Georges Rudier Fondeur, Paris*
The Stanford University Museum of Art, Gift of the
 Cantor, Fitzgerald Art Foundation

112. *Centauresse*

Bronze, 1970
Plaster, 1889–1890
0.40 x 0.45 x 0.18 m (15¾ x 17¾ x 7 in.)
Signed on right at back, top surface of base: A. *Rodin;*
 foundry mark on base, back left: *Godard*
The Stanford University Museum of Art, Gift of the B.
 G. Cantor Art Foundation

113. *Despair*

Plaster, 1890
0.28 x 0.15 x 0.17 m (11 x 5¾ x 6¾ in.)
The Stanford University Museum of Art, Gift of the
 B. G. Cantor Art Foundation

114. *Despair*

Bronze, 1971
Plaster, 1890
0.28 x 0.15 x 0.25 m (11 x 5¾ x 9¾ in.)
Signed on base left side: A. *Rodin;* foundry mark on
 base, back: *L. Persinska, Versailles, fondeur 1971*
The Stanford University Museum of Art, Gift of the B.
 G. Cantor Art Foundation

115. *Despair*

Stone, 1914
Plaster, 1890
0.94 x 0.34 x 0.78 m (37 x 13½ x 31 in.)
Signed on base top right front: A. *Rodin 1914*
The Stanford University Museum of Art, Gift of the
 B. G. Cantor Art Foundation

116. *Helen von Nostitz*

Plaster, n.d.
0.22 x 0.22 x 0.12 m (8⅝ x 8⅝ x 4¾ in.)
Musée Rodin, Paris (S688)

117. *Helen von Nostitz*

Dipped plaster, n.d.
0.22 x 0.22 x 0.12 m (8⅝ x 8⅝ x 4¾ in.)
Musée Rodin, Paris (S689)

118. *Helen von Nostitz*

Plaster mold, n.d.
0.29 x 0.32 x 0.21 m (11½ x 12¾ x 8½ in.)
Musée Rodin, Paris (S908)

119. *Man and his Thought*

0.33 x 0.34 x 0.26 m (13 x 13⅜ x 10⅜ in.)
Musée Rodin, Paris (S618)

120. *Tempest*

Marble, 1901
Plaster, 1898
0.34 x 0.37 x 0.18 m (13½ x 14½ x 7 in.)
Signed on the base left rear: A. *Rodin*
The Metropolitan Museum of Art, Gift of Thomas F.
 Ryan, 1910

121. *Tempest*

Bronze, 1902
Plaster, 1898
0.35 x 0.29 x 0.28 m (13¾ x 11¾ x 11 in.)
Signed on right side: A. *Rodin*
The Stanford University Museum of Art, Gift of the
 B. G. Cantor Art Foundation

122. *Eustache de Saint-Pierre* (reduced version)

Bronze, c. 1899
Plaster, 1886–1887
0.48 x 0.25 x 0.15 m (19 x 10 x 6 in.)
Inscribed: A. *Rodin—Alexis Rudier, Fondeur, Paris*
B. G. Cantor Collections

123. *Eustache de Saint-Pierre*

Bronze, n.d.
Plaster, 1886–1887
2.21 x 1.22 x 0.75 m (87 x 48 x 29¾ in.)
B. G. Cantor Collections

124. *Pieces Showing the Casting Process*

B. G. Cantor Art Foundation

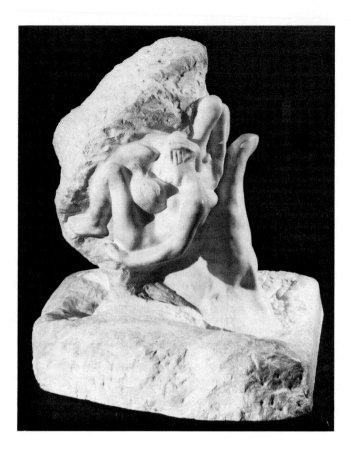

III. *Rodin: Creation and Creators*

125. *Bust of Puvis de Chavannes*

Bronze, n.d.
Plaster, 1890
0.44 x 0.25 x 0.25 m (17½ x 10 x 10 in.)
Signed: A. *Rodin*
B.G. Cantor Collections

126. *Head of Baudelaire*

Bronze, n.d.
Plaster, c. 1892
0.20 x 0.20 x 0.24 m (8 x 8 x 9½ in.)
Ben C. Deane Collection

127. *Portrait of Victor Hugo*

Bronze, n.d.
Plaster, 1891
0.38 x 0.17 x 0.17 m (15 x 6¾ x 6¾ in.)
Signed on base, right side: A. *Rodin*; dated at rear: *1891*;
 dedicated: *A Mon Ami / Arsene Alexandre*
The Fine Arts Museums of San Francisco, Gift of Mrs.
 Alma deBretteville Spreckels

128. *Portrait of Jules Dalou*

Bronze, 1969
Plaster, 1883
0.52 x 0.38 x 0.22 m (20½ x 15 x 8⅝ in.)
Signed on left shoulder: A. *Rodin*; founder's mark on
 back: *Georges Rudier*
The Stanford University Museum of Art, Gift of the
 B.G. Cantor Art Foundation

129. *Barbey D'Aurevilly*

Bronze, n.d.
Plaster, 1909
0.85 x 0.70 x 0.56 m (33½ x 27½ x 22¼ in.)
Founder's mark on back of base to left: *Alexis Rudier
 Fondeur, Paris*
Philadelphia Museum of Art: Given by Jules Mastbaum

130. *Head of Tragic Muse*

Bronze, 1973
Plaster, 1880–1882
0.29 x 0.18 x 0.23 m (11⅜ x 7⅛ x 9¹/₁₆ in.)
Stamped: ©*Musée Rodin, 1973* and A. *Rodin No. 1*
The Stanford University Museum of Art, Gift of the
 B.G. Cantor Art Foundation

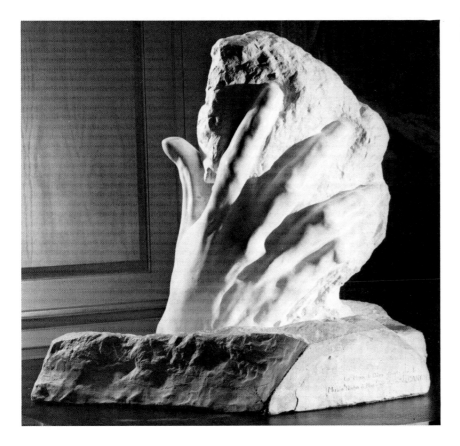

left: *Hand of God*, 1898. Plaster. B. G. Cantor Collections. Cat. no. 139.

right: *Hand of God*, 1898. Plaster. B. G. Cantor Collections. Cat. no. 139.

131. *Apotheosis of Victor Hugo*

Bronze, n.d.
Plaster, 1890–1891
1.12 x 0.52 x 0.61 m (44 x 20½ x 24 in.)
Founder's mark on lower back of base to left: *Alexis*
 RUDIER MR/*Fondeur. Paris. No 1*
Philadelphia Museum of Art: Given by Jules Mastbaum.

132. *The Sculptor and His Muse*

Bronze, n.d.
Plaster, c. 1890
0.66 x 0.48 x 0.50 m (26 x 18⅞ x 19⅝ in.)
Inscribed on base, front right: A. *Rodin*; stamped on
 inside, front: A. *Rodin* and at rear: *Alexis Rudier/
 Fondeur, Paris*
The Fine Arts Museums of San Francisco, Gift of Mrs.
 Alma deBretteville Spreckels

133. *Christ and Mary Magdalene*

Plaster, after 1894 (cast from marble in the Thyssen-
 Bornemisza Collection)
1.04 x 0.58 x 0.68 m (41 x 23 x 27 in.)
Signed on base, at front beneath Christ's feet: A. *Rodin*
The Fine Arts Museums of San Francisco, Gift of Mrs.
 Alma deBretteville Spreckels

134. *Orpheus*

Bronze, n.d.
Plaster, 1892
1.50 x 0.82 x 1.27 m (59 x 32½ x 50 in.)
Signed: A. *Rodin*
B.G. Cantor Collections

135. *The Creation*

Bronze, n.d.
Plaster, 1909
0.19 x 0.25 x 0.15 m (7½ x 10 x 5⅞ in.)
Inscribed, front of base: A. *Rodin*; founder's mark at
 back: *Alexis Rudier, Fondeur, Paris*
Museum of Fine Arts, Boston, Gift of Fiske Warren
 and Edward Perry Warren, by exchange

136. *Study for the Monument to E. Carrière, "The Hero"*

Bronze, n.d.
Plaster, 1912
0.44 x 0.17 x 0.18 m (17⅜ x 7 x 7¹⁄₁₆ in.)
Signed lower right side: A. *Rodin*/No. 2; founder's
 mark at rear: *Alexis Rudier, Paris*
The Fine Arts Museums of San Francisco, Gift of Mrs.
 Alma deBretteville Spreckels

137. *Whistler's Muse*

 Bronze, 1967
 Plaster, c. 1903–1908
 0.65 x 0.33 x 0.34 m (24¾ x 13 x 13½ in.)
 Inscribed, front right side of neck: A. *Rodin no. 1*;
 founder's mark left side of base: *Georges Rudier*
 The Stanford University Museum of Art, Gift of the
 B.G. Cantor Art Foundation

138. *Hand of Rodin with Female Figure*

 Plaster, 1917
 Greatest extension 0.247 m (9 in.)
 National Gallery of Art, Gift of Mrs. John W. Simpson,
 1942

139. *Hand of God*

 Plaster, 1898
 0.73 x 0.63 x 0.66 m (28¾ x 25 x 26 in.)
 Inscribed: *La Main de Dieu offerte par le Musée Rodin
 à Monsieur B. Gerald* CANTOR
 B.G. Cantor Collections

140. *Maquette for Monument to Bastien Lepage*

 Bronze, 1973
 Date of plaster, 1887
 0.35 x 0.18 x 0.18 m (13¾ x 7 x 7 in.)
 Inscribed on base, top left: A. *Rodin no. 3*; founder's
 mark on base, back left: *Godard*
 The Stanford University Museum of Art, Gift of the
 B.G. Cantor Art Foundation

141. *First Maquette for the Monument to Claude Lorrain*

 Bronze, 1972
 Plaster, 1889
 0.36 x 0.14 x 0.17 m (14¼ x 5½ x 6¾ in.)
 Inscribed on base at left: A. *Rodin no. 1*; founder's mark
 on base, back left: *Godard*
 The Stanford University Museum of Art, Gift of the
 B.G. Cantor Art Foundation

142. *Vulcan Creating Pandora*

 Bronze, n.d.
 Plaster, c. 1889
 0.20 x 0.18 x 0.16 m (7⅞ x 7 x 6¼ in.)
 Inscribed, left side of base: A. *Rodin*
 Museum of Fine Arts, Boston

143. *Naked Balzac With Folded Arms*

 Bronze, 1969
 Plaster, 1893

1.27 x 0.52 x 0.63 m (50¼ x 20½ x 24¾ in.)
Inscribed on top of base, front left: A. *Rodin*; founder's
 mark on base, back right: *Georges Rudier*
The Stanford University Museum of Art, Gift of the
 B.G. Cantor Art Foundation

144. *Naked Headless Study of Balzac*

 Bronze, n.d.
 Plaster, 1896
 0.93 x 0.40 x 0.36 m (36⅝ x 15¾ x 14⅛ in.)
 Inscribed: A. *Rodin—Georges Rudier, Fondeur, Paris
 (cast #6)*
 Mr. and Mrs. A. Steinberg

145. *Final Study for the Balzac Monument*

 Bronze, n.d.
 Plaster, 1897
 1.06 x 0.45 x 0.38 m (41¾ x 17¾ x 15 in.)
 Inscribed: A. *Rodin—Georges Rudier Fondeur Paris
 (cast #12)*
 B.G. Cantor Collections

146. Not in exhibition.

IV. *Rodin: The Marbles*

147. *Bellona*

 Marble, 1889
 Plaster, 1878–1879
 0.68 x 0.48 m (27 x 19 in.)
 Signed on left shoulder, rear: A. *Rodin*
 Dr. and Mrs. Jules Lane

148. *Despair*

 Marble, c. 1889–1893
 Plaster, c. 1889
 0.35 x 0.58 x 0.44 m (13¾ x 23 x 17¼ in.)
 Signed, bottom left: A. *Rodin*
 The St. Louis Art Museum 58:1921

149. *Eve*

 Marble, after 1900
 Plaster, 1881
 0.78 x 0.23 x 0.30 m (30¾ x 9¼ x 11¾ in.)
 Signed, lower left: *Rodin*
 Collection of Mr. and Mrs. James W. Alsdorf, Chicago

150. *Fleeting Love*

Marble, after 1900
Plaster, after 1900
0.43 x 0.44 x 0.33 m (17 x 17½ x 13 in.)
Signed on base at right: A. *Rodin*
National Gallery of Art, Gift of Mrs. John W.
 Simpson, 1942

151. *Danaid*

Marble, 1890 (?)
Plaster, 1885
0.23 x 0.28 x 0.26 m (9 x 11 x 10¼ in.)
Signed on side of base, below water: A. *Rodin*
The Art Museum, Princeton University (bequest of
 Mrs. Sam A. Lewisohn)

152. *Orpheus and Eurydice*

Marble, 1893
Plaster, 1888
1.27 x 0.76 x 0.71 m (50 x 30 x 28 in.)
Signed and dated on the base: A. *Rodin*/1893
The Metropolitan Museum of Art, Gift of Thomas F.
 Ryan, 1910

153. *Fallen Caryatid*

French limestone, 1894
Plaster, c. 1881
0.40 x 0.62 x 0.40 m (15¾ x 24⅜ x 15¾ in.)
Signed on base: A. *Rodin*
The Andrew H. and Walter R. Beardsley Foundation,
 Ruthmere, Elkhart, Indiana

154. *The Evil Spirits*

Marble, c. 1906
Plaster, c. 1897
0.71 x 0.75 x 0.59 m (28 x 29¾ x 23¼ in.)
Signed on base at left: A. *Rodin*
National Gallery of Art, Gift of Mrs. John W.
 Simpson, 1942

155. *Fallen Caryatid*, called *Crouching Woman*

Marble, 1886
Plaster, c. 1882
0.45 x 0.35 x 0.28 m (17¾ x 13¾ x 11 in.)
Signed at front right side of base: *Rodin*
Museum of Fine Arts, Boston, Gift of the Estate of
 Samuel Isham

156. *Romeo and Juliette*

Marble, 1906

Plaster, 1902
0.79 x 0.54 x 0.40 m (31 x 21¼ x 15¾ in.)
Signed on lower right side: A. *Rodin*
Collection of Mr. and Mrs. James W. Alsdorf, Chicago

157. *Mrs. John W. Simpson*

Marble, 1903
Plaster, 1902
0.55 x 0.69 x 0.41 m (21¾ x 27⅛ x 16⅜ in.)
Signed on right side: A. *Rodin*
National Gallery of Art, Gift of Mrs. John W.
 Simpson, 1942

158. *Pygmalion and Galatea*

Marble, 1910
Plaster, 1900–1901
0.97 x 0.89 x 0.76 m (38¼ x 35 x 30 in.)
Signed on the base: A. *Rodin*
The Metropolitan Museum of Art, Gift of Thomas F.
 Ryan, 1910, in memory of William M. Laffan

159. *Morning*

Marble, c. 1906
Plaster, before 1886
0.60 x 0.28 x 0.33 m (23¾ x 11¼ x 13⅛ in.)
Signed and dated on base: A. *Rodin* 1906
National Gallery of Art, Gift of Mrs. John W.
 Simpson, 1942

160. *Beside the Sea*

Marble, 1907
Plaster, 1907
0.59 x 0.87 x 0.59 m (23½ x 34½ x 23½ in.)
The Metropolitan Museum of Art, Gift of Thomas F.
 Ryan, 1910

161. *Madame X (The Countess of Noailles)*

Marble, 1908
Plaster, 1907
0.49 x 0.56 x 0.38 m (19½ x 22 x 15 in.)
Signed, right rear of base: A. *Rodin*
The Metropolitan Museum of Art, Gift of Thomas F.
 Ryan, 1910

162. *Lady Sackville-West*

Marble, 1913–1917
Plaster, 1913
0.57 x 0.75 x 0.57 m (22⅜ x 29½ x 22⅜ in.)
Musée Rodin, Paris

V. Rodin and Photography

BERGERAC
163. *Rodin*

Salt print, 1886
0.127 x 0.10 m (5 x 3⅞ in.)
Private Collection, Courtesy Harry Lunn

GERTRUDE KÄSEBIER
164. *Rodin in Front of The Gates of Hell, His Hand on a Bronze Bust*

Platinum print, c. 1900 (?)
0.22 x 0.16 m (8⅝ x 6¼ in.)
Signed on the print, lower right
Musée Rodin, Paris (M.R. ph249)

GERTRUDE KÄSEBIER
165. *Rodin in Profile*

Platinum print, c. 1900 (?)
0.22 x 0.16 m (8⅝ x 6¼ in.)
Stamped on print, lower left: *Copyright by / Gertrude Kasebier 189(8?)*
Musée Rodin, Paris (M.R. ph241)

GERTRUDE KÄSEBIER
166. *Rodin with the Adam*

Platinum print, c. 1905 (?)
0.22 x 0.16 m (8⅝ x 6⅜ in.)
Signed on the print, lower right
Musée Rodin, Paris (M.R. ph248)

EDWARD STEICHEN
167. *Rodin*

Gum bichromate print, c. 1902 (?)
0.20 x 0.15 m (7⅞ x 6⅛ in.)
Signed in print, upper left (partially obliterated)
Musée Rodin, Paris (M.R. ph243)

EDWARD STEICHEN
168. *Rodin with the Hand of God*

Gum bichromate print, c. 1902 (?)
0.21 x 0.16 m (8¼ x 6¼ in.)
Musée Rodin, Paris (M.R. ph215)

EDWARD STEICHEN
169. *Rodin*

Platinum print, 1907
0.35 x 0.25 m (13¾ x 9⅞ in.)
Signed in pencil on the mount: STEICHEN MDCCCCVII; inscribed in ink on the mount: *En souvenir d'une*

sincère amitié/j'offre ce bas relief à la Marquise de / G. Choiseul/ Aug. Rodin / 1908
Musée Rodin, Paris (M.R. ph238)

EUGÈNE DRUET
170. *Avarice and Lust*

Gelatin silver print, c. 1898
0.30 x 0.40 m (11¾ x 15¾ in.)
Musée Rodin, Paris (M.R. ph947)

EUGÈNE DRUET
171. *Meditation* (rear view)

Gelatin silver print, c. 1898
0.40 x 0.30 m (15¾ x 11¾ in.)
Musée Rodin, Paris (M.R. ph943)

EUGÈNE DRUET
172. *Enlarged Torso of The Martyr*

Gelatin silver print, c. 1898
0.38 x 0.28 m (15 x 11 in.)
Musée Rodin, Paris (M.R. ph310)

EUGÈNE DRUET
173. *Despair*

Gelatin silver print, c. 1898
0.39 x 0.30 m (15⅜ x 11⅜ in.)
Musée Rodin, Paris (M.R. ph948)

EUGÈNE DRUET
174. *The Kiss*

Gelatin silver print, 1898
0.39 x 0.30 m (15⅜ x 11¼ in.)
Musée Rodin, Paris (M.R. ph373)

EUGÈNE DRUET
175. *Eve* (rear view)

Gelatin silver print, 1898
0.40 x 0.30 m (15¾ x 11¾ in.)
Musée Rodin, Paris (M.R. ph946)

EUGÈNE DRUET
176. *Eve* (profile)

Gelatin silver print, 1898
0.39 x 0.29 m (15½ x 11⅝ in.)
Musée Rodin, Paris (M.R. ph945)

EUGÈNE DRUET
177. *Eve and The Kiss*

Gelatin silver print, 1898
0.40 x 0.30 m (15¾ x 11¾ in.)
Musée Rodin, Paris (M.R. ph944)

EUGÈNE DRUET
178. *Balzac*

Gelatin silver print, 1898
0.38 x 0.29 m (15⅛ x 11½ in.)
Musée Rodin, Paris (M.R. ph950)

EUGÈNE DRUET
179. *Balzac* (half-length)

Gelatin silver print, 1898
0.40 x 0.30 m (15¾ x 11¾ in.)
Musée Rodin, Paris (M.R. ph949)

EUGÈNE DRUET
180. *Balzac in the Salon of 1898*

Gelatin silver print, 1898
0.39 x 0.29 m (15½ x 11½ in.)
Musée Rodin, Paris (M.R. ph375)

EUGÈNE DRUET
181. *The Burghers of Calais on a Scaffolding*

Gelatin silver print, c. 1910 (?)
0.38 x 0.29 m (15 x 11½ in.)
Musée Rodin, Paris (M.R. ph938)

EUGÈNE DRUET
182. *The Clenched Hand* (horizontal and inverted)

Gelatin silver print, c. 1899
0.29 x 0.39 m (11⅝ x 15½ in.)
Musée Rodin, Paris (M.R. ph939)

EUGÈNE DRUET
183. *The Clenched Hand* (seen from the back)

Gelatin silver print, c. 1899
0.30 x 0.39 m (11¾ x 15½ in.)
Musée Rodin, Paris (M.R. ph942)

EUGÈNE DRUET
184. *The Clenched Hand* (horizontal with fingers to the left)

Gelatin silver print, c. 1899
0.30 x 0.39 m (11¾ x 15½ in.)
Musée Rodin, Paris (M.R. ph941)

EUGÈNE DRUET
185. *The Clenched Hand* (vertical)

Gelatin silver print, c. 1899

0.40 x 0.30 m (15¾ x 11¾ in.)
Musée Rodin, Paris (M.R. ph940)

JACQUES-ERNEST BULLOZ
186. *Eternal Springtime*

Gelatin silver print, tinted, c. 1910
0.35 x 0.45 m (13¾ x 17⅞ in.)
Musée Rodin, Paris (M.R. ph975)

JACQUES-ERNEST BULLOZ
187. *The Evil Spirits*

Gelatin silver print, tinted, c. 1910
0.35 x 0.25 m (14 x 10 in.)
Musée Rodin, Paris (M.R. ph976)

JACQUES-ERNEST BULLOZ
188. *Fallen Caryatid*

Gelatin silver print, c. 1910
0.36 x 0.27 m (14⅜ x 10⅝ in.)
Musée Rodin, Paris (M.R. ph867)

JACQUES-ERNEST BULLOZ
189. *Joan of Arc (Head of Sorrow)*

Gelatin silver print, c. 1910
0.33 x 0.26 m (13 x 10¼ in.)
Musée Rodin, Paris (M.R. ph978)

JACQUES-ERNEST BULLOZ
190. *Bust of Mrs. Simpson*

Gelatin silver print, c. 1904
0.35 x 0.27 m (13¾ x 10⅝ in.)
Inscribed in ink, lower right: A Monsieur Rodin/Mon
 Sculpteur/Paris le 20/Septembre 1904
Musée Rodin, Paris (M.R. ph971)

JACQUES-ERNEST BULLOZ
191. *Bust of Eve Fairfax*

Gelatin silver print, c. 1906
0.32 x 0.26 m (12⅝ x 10½ in.)
Musée Rodin, Paris (M.R.ph977)

JACQUES-ERNEST BULLOZ
192. *Balzac*

Gelatin silver print, 1908
0.27 x 0.20 m (10⅝ x 7⅞ in.)
Musée Rodin, Paris (M.R.ph973)

Bulloz. *Bust of Eve Fairfax*, c. 1906. Gelatin silver print. Musée Rodin, Paris (M.R.ph977). Cat. no. 191. Detail.

JACQUES-ERNEST BULLOZ
193. *Balzac* (rear view)

Gelatin silver print, 1908
0.35 x 0.25 m (14 x 10 in.)
Musée Rodin, Paris (M.R.ph974)

JACQUES-ERNEST BULLOZ
194. *Balzac* (profile)

Gelatin silver print, 1908
0.27 x 0.21 m (10⅝ x 8¼ in.)
Musée Rodin, Paris (M.R.ph972)

EDWARD STEICHEN
195. *The Thinker*

Platinum gum bichromate print, 1901
0.19 x 0.15 m (7⅜ x 5⅞ in.)
Inscribed on the mount: RODIN *sculpt* STEICHEN
 MDCCCCI
Musée Rodin, Paris (M.R.ph229)

EDWARD STEICHEN
196. *Head of Hanako*

Carbon print, 1908
0.24 x 0.20 m (9½ x 7⅞ in.)
Musée Rodin, Paris (M.R.ph673)

EDWARD STEICHEN
197. *Head of Hanako*

Carbon print, 1908
0.24 x 0.20 m (9½ x 7⅞ in.)
Musée Rodin, Paris (M.R.ph986)

EDWARD STEICHEN
198. *Head of Hanako*

Carbon print, 1908
0.24 x 0.20 m (9½ x 7⅞ in.)
Musée Rodin, Paris (M.R.ph674)

EDWARD STEICHEN
199. *Bust of Clemenceau*

Carbon print, c. 1912
0.32 x 0.24 m (12¾ x 9⅝ in.)
Musée Rodin, Paris (M.R.ph426)

EDWARD STEICHEN
200. *Bust of Clemenceau*

Carbon print, c. 1912
0.25 x 0.20 m (9⅞ x 7⅞ in.)
Musée Rodin, Paris (M.R.ph680)

EDWARD STEICHEN
201. *Bust of Clemenceau*

Carbon print, c. 1912
0.25 x 0.20 m (9⅞ x 7⅞ in.)
Musée Rodin, Paris (M.R.ph393)

EDWARD STEICHEN
202. *Bust of Clemenceau*

Carbon print, c. 1912
0.25 x 0.20 m (9⅞ x 7⅞ in.)
Musée Rodin, Paris (M.R.ph987)

EDWARD STEICHEN
203. *Balzac* ("Toward the Light, Midnight")

Gum bichromate print, 1908
0.19 x 0.21 m (7⅝ x 8¼ in.)
Musée Rodin, Paris (M.R.ph226)

EDWARD STEICHEN
204. *Balzac* ("The Silhouette, 4 A.M.")

Gum bichromate print, 1908
0.17 x 0.22 m (6⅝ x 8⅝ in.)
Musée Rodin, Paris (M.R.ph224)

EDWARD STEICHEN
205. *Balzac* ("The Open Sky")

Gum bichromate print, 1908
0.23 x 0.18 m (9⅛ x 7⅛ in.)
Musée Rodin, Paris (M.R.ph255)

EDWARD STEICHEN
206. *Balzac*

Gum bichromate print, 1908
0.22 x 0.17 m (8⅞ x 6⅞ in.)
Musée Rodin, Paris (M.R.ph223)

EDWARD STEICHEN
207. *Balzac*

Gum bichromate print, 1908
0.15 x 0.19 m (6⅛ x 7½ in.)
Musée Rodin, Paris (M.R.ph235)

EDWARD STEICHEN
208. *Balzac*

Gum bichromate print, 1908
0.26 x 0.23 m (10¼ x 9 in.)
Musée Rodin, Paris (M.R.ph222)

STEPHEN HAWEIS AND HENRY COLES
209. *Reduced Figure of a Burgher of Calais*

Gum bichromate print, c. 1904
0.22 x 0.17 m (8½ x 6⅝ in.)
Musée Rodin, Paris (M.R.ph960)

STEPHEN HAWEIS AND HENRY COLES
210. *Crouching Woman* (frontal)

Gum bichromate print, c. 1904
0.22 x 0.16 m (8⅞ x 6½ in.)
Musée Rodin, Paris (M.R.ph964)

STEPHEN HAWEIS AND HENRY COLES
211. *Crouching Woman* (rear view)

Gum bichromate print, c. 1904
0.22 x 0.17 m (8⅞ x 6⅝ in.)
Musée Rodin, Paris (M.R.ph963)

STEPHEN HAWEIS AND HENRY COLES
212. *Meditation*

Gum bichromate print, c. 1904
0.22 x 0.17 m (8¾ x 6⅝ in.)
Musée Rodin, Paris (M.R.ph962)

STEPHEN HAWEIS AND HENRY COLES
213. *Meditation* (with foliage)

Gum bichromate print, c. 1904
0.23 x 0.16 m (9 x 6½ in.)
Musée Rodin, Paris (M.R.ph961)

ANONYMOUS
214. *The Thinker*

Gum bichromate print, c. 1905–1910(?)
0.37 x 0.27 m (14½ x 10¾ in.)
Musée Rodin, Paris (M.R.ph980)

ANONYMOUS
215. *Bellona*

Gum bichromate print, c. 1905–1910(?)
0.38 x 0.24 m (14⅞ x 9⅜ in.)
Musée Rodin, Paris (M.R.ph979)

ANONYMOUS
216. *The Burghers of Calais*

Gum bichromate print, c. 1905–1910(?)
0.37 x 0.26 m (14¾ x 10¼ in.)
Musée Rodin, Paris (M.R.ph984)

ANONYMOUS
217. *The Burghers of Calais*

Gum bichromate print, c. 1905–1910(?)
0.39 x 0.28 m (15¼ x 10⅞ in.)
Musée Rodin, Paris (M.R.ph985)

ANONYMOUS
218. *The Burghers of Calais*

Gum bichromate print, c. 1905–1910(?)
0.30 x 0.40 m (11¾ x 15½ in.)
Musée Rodin, Paris (M.R.ph329)

ANONYMOUS
219. *The Burghers of Calais*

Gum bichromate print, c. 1905–1910(?)
0.30 x 0.40 m (11¾ x 15½ in.)
Musée Rodin, Paris (M.R.ph1023)

ANONYMOUS
220. *The Burghers of Calais*

Gum bichromate print, c. 1905–1910(?)
0.30 x 0.40 m (11¾ x 15½ in.)
Musée Rodin, Paris (M.R.ph1024)

ANONYMOUS

221. *Balzac* (frontal)

Gum bichromate print, 1908
0.38 x 0.26 m (15 x 10⅛ in.)
Musée Rodin, Paris (M.R.ph983)

ANONYMOUS

222. *Balzac* (left profile)

Gum bichromate print, 1908
0.40 x 0.28 m (15½ x 11⅛ in.)
Musée Rodin, Paris (M.R.ph981)

ANONYMOUS

223. *Balzac* (right profile)

Gum bichromate print, 1908
0.39 x 0.28 m (15⅛ x 11 in.)
Musée Rodin, Paris (M.R.ph982)

VI. *Rodin: Early Drawings and Studies for The Gates of Hell*

224. Study of *The Borghese Gladiator*

Pencil, pen and ink, c. 1856
0.17 x 0.14 m (6⅝ x 5½ in.)
Musée Rodin, Paris (M.R.2028)

225. Study of a fragment cast of Puget's *Milo of Crotona*

Pencil, c. 1857
0.33 x 0.24 m (13⅛ x 9½ in.)
Musée Rodin, Paris (M.R.2067)

226. Study of an *Entombment* by Germain Pilon

Pencil, pen and ink, ink wash, c. 1855 (partially reworked at a later date)
0.13 x 0.19 m (5¼ x 7½ in.)
Musée Rodin, Paris (M.R.2036)

227. *The Mastbaum Sketchbook*

Pencil, pen and ink, sepia wash, n.d.
Contains 37 drawings, each 0.09 x 0.15 m (3¾ x 5⅞ in.)
Private Collection

228. *Montage Sheet of 17 Studies*

1875–1878
Musée Rodin, Paris

M.R. 205 Nude Male Figure, pen and ink, 0.06 x 0.02 m (2¼ x ¾ in.)
M.R. 206 Nude Male Figure, pen and ink, 0.05 x 0.02 m (2¼ x ¾ in.)
M.R. 207 Study of Donatello's *Gattemalata*, pencil, 0.10 x 0.07 m (4 x 2⅞ in.)
M.R. 208 Male Figure, pen and ink, inscriptions: On mount: Cornée / bucheron
M.R. 209 Male Figure, pen and ink, 0.06 x 0.03 m (2¼ x 1⅛ in.), inscribed on mount: *le torse divise en / 2 parties aux / muscles droites du ventre / Benvenuto Cellini dit / M.A. faisait voir l'astrologue / me rappeler la tête que j'ai faite / à l'ebauchoir plat chez M.B. / draperies saillantes du / le saillant* (?)
M.R. 210 Studies of a Horse Tamer and Two Figures, pencil, 0.07 x 0.06 m (2¾ x 2⅜ in.), inscribed: *St. Paul / buste* (illegible) / *seppent*
M.R. 211 Nude Male Figure, pen and ink, 0.06 x 0.03 m (2¼ x 1 in.)
M.R. 212 Nude Male Figure, pen and ink, 0.07 x 0.03 m (2⅞ x 1⅛ in.), inscribed: *Promethée*
M.R. 213 Study of a Horse Tamer, pen and ink, 0.08 x 0.09 m (2⅞ x 3⅝ in.)
M.R. 214 Nude Male Figure, pen and ink, 0.06 x 0.02 m (2¼ x ¾ in.)
M.R. 215 Two Figures, pencil, 0.08 x 0.11 m (3 x 4¼ in.), inscribed: *posta / venus / Christ du Composanto / de Michel Ange / Chef d'oeuvre de M. Ange / Florence / Borgo Ognisanti No. 20 / Ristorante la Toscana / via calzajoli*
M.R. 216 Nude Male Figure, pen and ink, pencil additions, 0.14 x 0.05 m (5¾ x 2 in.), inscribed: illegible word at top / *Creation de l'homme / platre*
M.R. 217 Study of Roman portrait busts and study of Raphael's *Atilla and Leo the Great*, pencil, pen and ink, 0.07 x 0.10 m (2¾ x 4⅛ in.), inscribed: *atilla bas relief de raphaelle / portait de L d d* (obscured) / *Michelangesque*
M.R. 218 Study of Michelangelo's *David/Apollo*, with added figure, pencil, 0.07 x 0.03 (2¾ x 1⅜ in.), inscribed: *portage de* (?); inscribed on mount: *Ulysses et / sa mere aux / enfers / chambre / roumaine / reste*
M.R. 219 Study of Michelangelo's *Victory*, with added figure, pencil, 0.08 x 0.05 (3¼ x 2⅛ in.), inscribed: *Ulysse / Sirene / l'inspiration*
M.R. 220 Leda and the Swan, pen and ink, 0.04 x 0.05 m (1⅞ x 2⅛ in), inscribed: *Leda /* (illegible)
M.R. 221 Marsyas, pen and ink, 0.06 x 0.02 m (2⅜ x ¾ in.)

229. recto: *Montage of 10 Studies* (M.R.264–273)
verso: *Montage of 6 Studies* (M.R.274–279)
c. 1875–1878
Musée Rodin, Paris

M.R. 264 Unidentified study, pencil, 0.08 x 0.07 m (3¼ x 2⅞ in.) inscribed on mount: *coiffure formant la casque toujours / epaule assise basse la plus / saillante comme plan*

M.R. 265 Two Equestrian Figures, pen and ink, 0.05 x 0.08 m (2 x 3⅛ in.)

M.R. 266 Unidentified study, pencil, 0.03 x 0.05 m (1⅛ x 2 in.)

M.R. 267 Unidentified study, pencil, 0.03 x 0.05 m (1¼ x 2 in.)

M.R. 268 Study of Michelangelo's *Tomb of Lorenzo de Medici*, pencil, 0.07 x 0.09 (2¾ x 3⅜ in.)

M.R. 269 Study of Michelangelo's *Tomb of Lorenzo de Medici*, with two additional sketches, pencil, 0.13 x 0.10 (5 x 4 in.), inscribed: *bas relief*

M.R. 270 Study of Michelangelo's *Night*, pencil, 0.11 x 0.07 m (4⅜ x 2⅝ in.)

M.R. 271 Study of Donatello's *Gattemalata*, pencil, 0.08 x 0.06 m (3¼ x 2¼ in.)

M.R. 272 Study of Vicenzo di Rossi's *Tomb of Angelo Cesi*, pencil, pen and ink, 0.05 x 0.10 m (2⅛ x 4 in.)

M.R. 273 Detail study of head of Rossi's *Angelo Cesi*, pencil, irregularly shaped, 0.07 m high (2⅞ in.)

M.R. 274 Seated Mother with Standing Child, with inverted sketch of horse and rider, ink and ink wash over pencil, 0.23 x 0.13 m (9 x 5¼ in.)

M.R. 275 Reclining Figure, ink and ink wash over pencil, 0.06 x 0.09 m (2⅜ x 3¾ in.)

M.R. 276 Infant, ink and ink wash over pencil, 0.05 x 0.03 m (2⅛ x 1⅛ in.)

M.R. 277 Dancing Figure with Cupid, ink and ink wash over pencil, 0.14 x 0.08 m (5½ x 3⅜ in.)

M.R. 278 Reclining Figure, ink over pencil, 0.07 x 0.05 m (2⅞ x 2 in.)

M.R. 279 Standing Adult and Infant, ink, 0.13 x 0.08 m (5 x 3⅜ in.)

230. recto: *Life Studies of Michelangelo's Poses* (M.R. 280–284)
verso: *Life Studies of Michelangelo's Poses*, with appended sheet of sketches after Rossi's *Cesi Tombs* (M.R. 285–288)

Pencil, n.d.
0.30 x 0.23 m (12 x 9 in.)
Inscribed on *verso*: *malade / Para* (?)
Musée Rodin, Paris

231. *The Golden Age (L'Age d'Or)*

Black chalk heightened with white, c. 1875–1880
0.47 x 0.30 m (18½ x 12 in.)
Signed in upper right corner of *recto: l'âge d'or / A. Rodin*
Metropolitan Museum of Art, Rogers Fund, 1963

232. *Third Architectural Sketch for the Gates of Hell*

Plaster, 1880
1.00 x 0.63 x 0.18 m (39½ x 25 x 7¼ in.)
Hirshhorn Museum and Sculpture Garden, Smithsonian Institution

233. *Architectural Study for the Gates of Hell*

Pencil, pen and ink, 1880
0.19 x 0.15 m (7¾ x 6 in.)
Musée Rodin, Paris (M.R. 1963)

234. *Reclining Figure with Child, with Architectural Study for the Gates of Hell*

Pencil, pen and ink, ink wash, c. 1880–1881
0.14 x 0.16 m (5½ x 6¼ in.)
Inscribed: *bas relief à executer*
Musée Rodin, Paris (M.R. 1966)

235. *Nude Male Figure*

Pencil, pen and ink, ink wash, c. 1881
0.18 x 0.13 m (7¼ x 5¼ in.)
Inscribed: *homme / renversé / à changer les / jambes*
Musée Rodin, Paris (M.R. 5584)

236. *Two Nude Men Struggling*

Pencil, pen and ink, c. 1882
0.14 x 0.10 m (5½ x 3¼ in.)
Inscribed: *on s'y t (ue)* or *(ire)*
Musée Rodin, Paris (M.R. 1946)

237. *Seated Figure with Child*, with added sketch of a face

Ink and ink wash, c. 1880
0.13 x 0.10 m (5⅛ x 4³⁄₁₆ in.)
Mrs. Katharine Graham

238. *Ugolino*

Pencil, pen and ink, c. 1870–1880
0.15 x 0.19 m (6 x 7¾ in.)
Inscribed: *Ugolin Victor Hugo / Guidon*
Philadelphia Museum of Art

239. *Ugolino/Icarus*

Pencil, pen and ink, ink wash, c. 1880–1882
0.19 x 0.14 m (7½ x 5½ in.)
Inscribed: *icare / reprend ces chairs / que tu nous / a donnés / icare / le genie*
Musée Rodin, Paris (M.R. 1993)

240. *Ugolino*

Pen and ink, ink wash, gouache, c. 1882
0.19 x 0.15 m (7¾ x 6 in.)
Inscribed: *Ugolin*
Musée Rodin, Paris (M.R. 5624)

241. *Ugolino*

Pencil, pen and ink, ink wash, gouache, c. 1875–1882
0.15 x 0.10 m (5⅞ x 4⅛ in.)
Signed lower right: *Aug Rodin*
Musée Rodin, Paris (M.R. 7208)

242. *Two Nude Male Figures Struggling*

Pen and ink, ink wash, c. 1882
0.15 x 0.13 m (6 x 5⅛ in.)
Musée Rodin, Paris (M.R. 6895)

243. *Seated Male Nude*

Ink, c. 1880–1882
0.15 x 0.08 m (5⅞ x 3½ in.)
Inscribed upper right: *intestins pendant*
Mrs. Katharine Graham

244. *Le Sabbat*

Gouache, pen and ink, c. 1882
0.15 x 0.19 m (5¾ x 7½ in.)
Inscribed: *le sabbat*
The Art Institute of Chicago, Gift of Robert Allerton
Not in exhibition.

245. *Chevalier (Horseman)*

Gouache, pen and ink, 1889
0.22 x 0.17 m (8⅝ x 7 in.)
Dated and signed lower left: *1889/. . ./Rodin*
The Art Institute of Chicago, The Alfred Stieglitz
 Collection 1949

246. *Study for the Gates of Hell: Circle of Lovers*

Gouache, pen and ink on graph paper, c. 1882
0.17 x 0.08 m (6¾ x 3¼ in.)
Menil Foundation Collection, Houston, Texas

247. *Michelangelo Modeling the Slave*

Pen and ink, ink wash, gouache, c. 1882
0.15 x 0.10 m (6 x 4⅛ in.)
Musée Rodin, Paris (M.R. 5618)

248. *Two Male Figures as Architectural Caryatids*

Ink heightened with white gouache, c. 1885
0.18 x 0.09 m (7 x 3½ in.)
Signed upper right: *A. Rodin*
Mrs. Katharine Graham

249. *Seated, Twisting Male Figure*

Ink, ink wash, and gouache over pencil, c. 1878–1882
0.14 x 0.11 m (5½ x 4½ in.)
Signed lower right: *A. Rodin*; inscribed upper center:
 dans la (?) and middle left: *il faut / ici / quelque
 distinction / Guidon*
Mrs. Katharine Graham

250. *Mother and Child (Seated Figure with Child)*

Ink, ink wash, and gouache over pencil, c. 1880
0.15 x 0.07 m (5⅞ x 3 in.)
Signed upper right: *A. Rodin*
Mrs. Katharine Graham

251. *Reclining Couple (Le Sabbat) (Reclining Figure Embracing a Child)*

Ink, ink wash, and gouche over pencil, c. 1880
0.10 x 0.23 m (4 x 9 in.)
Inscribed on mount: *Le Sabbat*; signed lower right: *Aug
 Rodin*
Mrs. Katharine Graham

252. *Centaur and Woman (Centaur and Satyr)*

Ink, ink wash, and gouache over pencil, c. 1880
0.20 x 0.15 m (8 x 6 in.)
Mrs. Katharine Graham

253. *La Ronde*

Drawing, c. 1880
0.07 x 0.12 m (2¾ x 5 in.)
Private Collection, Paris. Former Collection, Roger
 Marx

VII. *Rodin: The Gates of Hell and their Offspring*

254. *The Gates of Hell*

Bronze, 1980–1981
Plaster, 1900
Stamped: *Coubertin Fondeur-Cast No. 5*
B. G. Cantor Collections

255. *Adam*

Bronze, n.d.
Plaster, 1880
The Art Institute of Chicago
Robert Allerton Collection

256. *Eve*

Bronze, n.d.
Plaster, 1881
1.70 x 0.47 x 0.59 m (67 x 18½ x 23¼ in.)
Founder's mark, back of base to right: *Alexis Rudier
 Fondeur, Paris*
The Philadelphia Museum of Art: Given by Jules
 Mastbaum

257. *The Kiss*

Bronze, 1967
Plaster, 1886
0.86 x 0.43 x 0.56 m (34 x 17 x 22 in.)
Signed right side of base: A. *Rodin*; founder's mark back
 of base: *Georges Rudier / Fondeur. Paris*
The Stanford University Museum of Art, Gift of the
 B. G. Cantor Art Foundation

258. *The Helmet Maker's Old Wife*

Bronze, 1967
Plaster, 1885
0.50 x 0.30 x 0.23 m (19¾ x 12⅛ x 9 in.)
Signed on front left of base: A. *Rodin*
The Stanford University Museum of Art, Gift of the
 B. G. Cantor Art Foundation

259. *Caryatid*

Bronze, n.d.
Plaster, 1880–1881
0.42 x 0.31 x 0.29 m (16½ x 12¼ x 11½ in.)
Signed back right: A. *Rodin*
Los Angeles County Museum of Art, Gift of Howard
 Young

260. *Kneeling Fauness*

Bronze, n.d.
Plaster, 1886
0.54 x 0.23 x 0.29 m (21¼ x 9 x 11½ in.)
Founder's mark back center of base: *Georges Rudier
 Fondeur Paris*
Los Angeles County Museum of Art, Gift of the B. G.
 Cantor Art Foundation

261. *The Thinker*

Bronze, n.d.
Plaster, 1880
0.71 x 0.36 x 0.59 m (28⅛ x 14⅜ x 23½ in.)
Signed on base at right: A. *Rodin*
National Gallery of Art, Gift of Mrs. John W.
 Simpson 1942

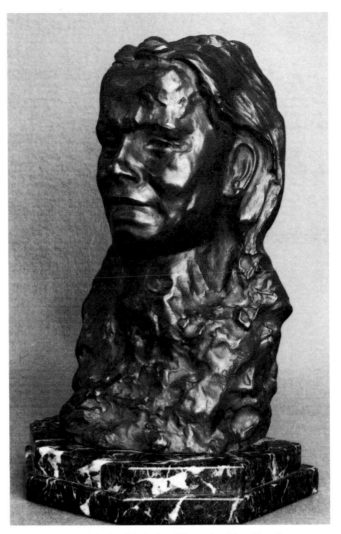

Crying Woman (Mask of Grieving Woman), 1881-1882. Bronze.
The Stanford University Museum of Art, Gift of the Cantor, Fitzgerald
Foundation. Cat. no. 269.

262. *Metamorphosis of Ovid*

Bronze, 1972
Plaster, 1886
0.33 x 0.40 x 0.26 m (13 x 15¾ x 10¼ in.)
Signed on front left corner of base: A. *Rodin*; founder's
 mark back right of base: *Georges Rudier, Fondeur,
 Paris 6/12*
The Stanford University Museum of Art, Gift of the
 B. G. Cantor Art Foundation

263. *Damned Woman*

Bronze, 1967
Plaster, 1885
0.20 x 0.39 x 0.26 m (8 x 15½ x 10¼ in.)
Signed left side of torso: A. *Rodin*; founder's mark center
 back of torso
The Stanford University Museum of Art, Gift of the
 B. G. Cantor Art Foundation

264. *The Martyr*

Bronze, 1960
Plaster, 1885
0.15 x 0.40 x 0.63 m (6 x 15¾ x 24¾ in.)
Inscribed on the base: A. RODIN N. 3 by MUSEE RODIN
 1960 GEORGES RUDIER FONDEUR PARIS
Indianapolis Museum of Art, Gift of B. Gerald Cantor

265. *The Sirens*

Bronze, n.d.
Plaster, c. 1888
0.43 x 0.46 x 0.32 m (17 x 18 x 12½ in.)
National Gallery of Art, Gift of David Baron in
 memory of his wife Mary F. Baron, 1978

266. *Three Faunesses*

Bronze, n.d.
Plaster, 1882
0.25 x 0.25 x 0.25 m (9¾ x 9¾ x 10 in.)
Signed: A. *Rodin*
B. G. Cantor Collections

267. *The Three Shades*

Bronze, n.d.
Plaster, 1881–1886
0.98 x 0.90 x 0.45 m (38½ x 35½ x 17¾ in.)
Signed: A. *Rodin*; stamped: *Georges Rudier Fondeur,*
 Paris, Cast No. 8
B. G. Cantor Collections

268. *Head of Sorrow*

Bronze, 1963
Plaster, 1882
0.24 x 0.21 x 0.20 m (9½ x 8½ x 8 in.)
Signed left side of neck: A. *Rodin*; founder's mark back
 right of neck
The Stanford University Museum of Art, Gift of the
 B. G. Cantor Art Foundation

269. *Crying Woman (Mask of Grieving Woman)*

Bronze, n.d.
Plaster, 1881–1882
0.32 x 0.17 x 0.11 m (12½ x 6¾ x 4½ in.)
Signed; no foundry mark given
The Stanford University Museum of Art, Gift of the
 Cantor, Fitzgerald Art Foundation

270. *Small Head of Man with Broken Nose*

Bronze, n.d.
Plaster, 1882

0.12 x 0.07 x 0.10 m (5 x 3 x 4 in.)
Signed left side of neck: A. *Rodin*; founder's mark left
 side of base
The Stanford University Museum of Art, Gift of the
 B. G. Cantor Art Foundation

271. *Mercury*

Bronze, n.d.
Plaster, 1888
0.37 x 0.40 x 0.40 m (14½ x 15¾ x 15¾ in.)
Signed: A. *Rodin*; stamped: *Georges Rudier Fondeur,*
 Paris (cast #9)
Jay S. Cantor

272. *Polyphemus and Acis*

Bronze, n.d.
Plaster, 1888 (?)
0.28 x 0.15 x 0.22 m (11⅛ x 5⅞ x 8⅞ in.)
Signed on base: A. *Rodin* (9 or 2); founder's mark on
 edge of base: *Alexis Rudier, Paris*
The Fine Arts Museums of San Francisco, Gift of Mrs.
 Alma deBretteville Spreckels

273. *Old Man with a Beard*

Bronze, n.d.
Plaster, c. 1886
0.35 m (13¾ in.)
Mrs. A. N. Pritzker

274. *Fugit Amor (Fleeting Love)*

Bronze, n.d.
Plaster, 1881
0.37 x 0.19 x 0.44 m (14½ x 7⅝ x 17½ in.)
Inscribed on front of base: A. *Rodin*; founder's mark on
 base, right rear: *Alexis Rudier, Paris*; stamped inside:
 A. *Rodin*
The Fine Arts Museums of San Francisco, Gift of Mrs.
 Alma deBretteville Spreckels

275. *Paolo and Francesca*

Bronze, 1972
Plaster, 1889
0.30 x 0.63 x 0.30 m (11¾ x 25 x 12 in.)
Signed on bottom: A. *Rodin*; stamped on right side of
 rock: ©*Musée Rodin,* 1972 and near woman's feet:
 Georges Rudier, Fondeur, Paris
Los Angeles County Museum of Art, Gift of the B. G.
 Cantor Art Foundation

276. *Prodigal Son*

Bronze, before 1914
Plaster, n.d.
1.37 x 0.71 x 0.87 m (54 x 28 x 34½ in.)
Signed on base, top right front corner: A. *Rodin*;
founder's mark at right rear: *Ais Rudier, Paris*; stamped
inside: A. *Rodin*
The Fine Arts Museums of San Francisco, Gift of Mrs.
Alma deBretteville Spreckels

277. *Meditation*

Bronze, 1980
Plaster, 1886
1.58 x 0.80 x 0.66 m (62¼ x 30¾ x 26 in.)
Stamped: *Coubertin Fondeur—cast No. 8*
B. G. Cantor Collections

278. *Avarice and Lust*

Bronze, n.d.
Plaster, 1880–1882
0.20 x 0.39 x 0.40 m (8 x 15½ x 16 in.)
The Stanford University Museum of Art, Gift of the
B. G. Cantor Art Foundation

279. *I Am Beautiful (Je Suis Belle)*

Bronze, n.d.
Plaster, 1882
0.75 x 0.40 x 0.30 m (29½ x 15¾ x 11¾ in.)
Signed: A. *Rodin*; stamped: *Georges Rudier Fondeur,
Paris, Cast No. 5*
Jay S. Cantor

280. *Falling Man*

Bronze, 1972
Plaster, 1882
0.58 x 0.38 x 0.28 m (23 x 15 x 11 in.)
Stamped right side of base toward back: *susse Fondeur
Paris* and left side of base toward back: © *by Musee
Rodin, 1972*
Los Angeles County Museum of Art, Gift of the B. G.
Cantor Art Foundation

281. *Crouching Woman*

Bronze, 1962
Plaster, 1908 (?), an enlargement of the work made in
1880–1881
0.97 x 0.69 x 0.61 m (38⅛ x 27¼ x 24¼ in.)
Incised on right side of base: A. *Rodin*
Hirshhorn Museum and Sculpture Garden, Smith-
sonian Institution

VIII: *Rodin: The Partial Figure and Late Drawings*

282. *Iris, Messenger of the Gods*

Bronze, 1966
Plaster, c. 1890
0.95 x 0.79 x 0.40 m (37½ x 31¼ x 15¾ in.)
Signed on sole of foot: A. *Rodin*; founder's mark back
of attached base: *Georges Rudier Fondeur, Paris, 1966*
Los Angeles County Museum of Art, Gift of the B. G.
Cantor Art Foundation

283. *Crouching Woman*

Bronze, 1913 or 1914
Plaster, c. 1891
0.53 x 0.95 m (20⅞ x 38 in.)
Victoria and Albert Museum, London (A. 40-1914)

284. *Hand of Rodin with Torso*

Bronze, n.d.
Plaster, 1917
0.18 x 0.23 x 0.14 m (7 x 9 x 5½)
Inscribed: A. *Rodin - Georges Rudier Fondeur, Paris,
cast no. 10*
Mr. and Mrs. John P. Terranova

285. *Half-length Torso of a Woman*

Bronze, 1969
Plaster, 1910
0.74 x 0.47 x 0.61 m (29 x 18 x 24 in.)
Signed near left hip: A/ *Rodin*; founder's mark, lower
edge of right buttock: *Georges Rudier Fondeur Paris*
The Stanford University Museum of Art, Gift of the B.
Gerald Cantor Art Foundation

286. *The Walking Man* (original scale)

Bronze, n.d.
Plaster, 1877–1878
0.85 x 0.43 x 0.60 m (33¼ x 16⅜ x 21⅞ in.)
Inscribed on base: A. *Rodin*
National Gallery of Art, Gift of Mrs. John W.
Simpson, 1942

287. *Torso of Adèle*

Bronze, n.d.
Plaster, 1882
0.44 x 0.19 x 0.14 m (17½ x 7½ x 5½ in.)
Signed at head, under right arm: *Alexis Rudier, Fondeur,
Paris*
Courtesy of Sam Weisbord

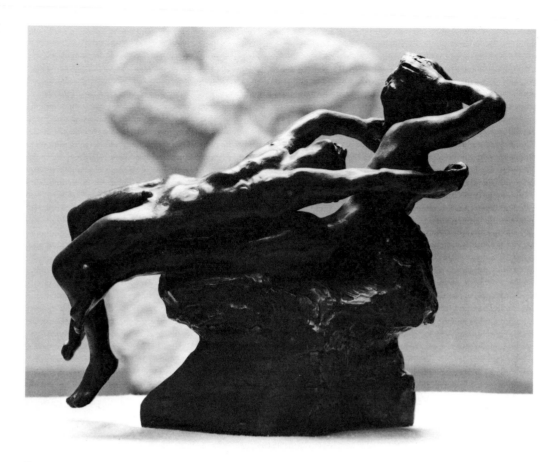

Fugit Amor (Fleeting Love), 1881. Bronze. The Fine Arts Museums of San Francisco, Gift of Mrs. Alma deBretteville Spreckels. Cat. no. 274.

288. *The Earth*

Bronze, 1967
Plaster, 1884
0.20 x 0.47 x 0.15 m (8 x 18½ x 6½ in.)
Signed in hollow below torso, right side: A. *Rodin / no. 8*; founder's mark on rocks, below legs: *Georges Rudier Fondeur, Paris (8/12)*
The Stanford University Museum of Art, Gift of the B. G. Cantor Art Foundation

289. *Torso of a Seated Woman Grasping her Thigh*

Bronze, n.d.
Plaster, c. 1890
0.37 x 0.25 x 0.25 m (14½ x 10 x 10 in.)
Signed: A. *Rodin*; stamped: *Georges Rudier Fondeur, Paris (cast no. 11)*
B. G. Cantor Collections

290. *Flying Figure*

Bronze, 1966
Plaster, c. 1891
0.21 x 0.40 x 0.12 m (8½ x 15¾ x 5 in.)

Signed on base: *Rodin*; founder's mark on base: *Georges Rudier, Fondeur Paris 1966*
The Stanford University Museum of Art, Gift of the B. G. Cantor Art Foundation

291. *Life-size Study for the Naked Pierre de Wissant, without Head and Hands*

Bronze, n.d.
Plaster, 1886
1.86 x 0.98 x 0.63 m (73½ x 38½ x 25 in.)
Signed on top of base, right rear corner: A. *Rodin No. 1*; inscribed on back right side of base: *Alexis Rudier, Fondeur, Paris*
The Minneapolis Institute of Arts, Given in memory of Walter Lindeke

292. *Blessing Hand*

Bronze, n.d.
0.11 x 0.07 x 0.15 m (4½ x 2⅞ x 6 in.)
Signed on wrist, finger side: A. *Rodin*
The Stanford University Museum of Art, Gift of the B. G. Cantor Art Foundation

293. *Right Hand*

Bronze, 1968
0.28 x 0.16 x 0.11 m (11 x 6¼ x 4½ in.)
Signed on wrist, thumb side: A. *Rodin*; stamped on base, finger side: *Georges Rudier Fondeur Paris*
The Stanford University Museum of Art, Gift of the B. G. Cantor Art Foundation

294. *Large Left Hand*

Bronze, 1967
0.33 x 0.16 x 0.18 m (13 x 6½ x 7 in.)
Signed on wrist, left side: A. *Rodin*; stamped under base, thumb side: *Georges Rudier Fondeur Paris*
The Stanford University Museum of Art, Gift of the B. G. Cantor Art Foundation

295. *Large Left Hand of a Burgher*

Bronze, 1967
0.28 x 0.19 x 0.15 m (11 x 7½ x 6 in.)
Signed on wrist, finger side: A. *Rodin*; stamped on wrist, thumb side: *Georges Rudier Fondeur Paris*
The Stanford University Museum of Art, Gift of the B. G. Cantor Art Foundation

296. *Small Clenched Right Hand*

Bronze, n.d.
0.13 x 0.10 x 0.20 m (5¼ x 4 x 7¾ in.)
Signed on wrist: A. *Rodin*
The Stanford University Museum of Art, Gift of the B. G. Cantor Art Foundation

297. *Right Hand, Fingers Close Together Slightly Bent*

Bronze, n.d.
0.12 x 0.05 x 0.04 m (4¾ x 2¼ x 1¾ in.)
Signed on inside of wrist: A. *Rodin*
B. G. Cantor Collections

298. *Half-closed Right Hand, Index Finger Slightly Extended*

Bronze, n.d.
0.08 x 0.03 x 0.04 m (3⅛ x 1¼ x 1⅝ in.)
Signed on right side of wrist: A. *Rodin*
B. G. Cantor Collections

299. *Right Hand, Index Finger Pointing Upward*

Bronze, n.d.
0.11 x 0.07 x 0.04 m (4¼ x 3 x 1¾ in.)
Inscribed: A. *Rodin, Georges Rudier Fondeur*
B. G. Cantor Collections

300. *Right Hand, Fingers Joined*

Bronze, n.d.
0.06 x 0.04 x 0.02 m (2⅝ x 1½ x ¾ in.)
Signed on inside of wrist: A. *Rodin*
B. G. Cantor Collections

301. *Open Hand*

Bronze, n.d.
0.11 x 0.06 x 0.02 m (4¼ x 2¼ x 1 in.)
Signed on right side of wrist: A. *Rodin*
B. G. Cantor Collections

302. *Study for Right Hand*

Bronze, n.d.
0.10 x 0.05 x 0.05 m (4 x 2 x 2 in.)
Signed on front of wrist: A. *Rodin*
B. G. Cantor Collections

303. *Hand of Eustache de St.-Pierre*

Bronze, n.d.
0.28 x 0.14 x 0.14 m (11 x 15½ x 15¾ in.)
Inscribed: A. *Rodin; Valsuani Foundry*
B. G. Cantor Collections

304. *Left Hand, Third and Fifth Fingers Bent*

Bronze, 1974
0.13 x 0.07 m (5¼ x 3 in.)
Signed on right side of wrist: A. *Rodin*; stamped: E. *Godard Fondeur, Musée Rodin, 1974, No. 1*
B. G. Cantor Collections

305. *Grasping Left Hand*

Bronze, n.d.
0.14 x 0.09 x 0.05 m (5¾ x 3¾ x 2¼ in.)
Signed on rear of wrist: A. *Rodin*
B. G. Cantor Collections

306. *Kneeling Female Nude*

Pencil, pen and ink, watercolor wash, c. 1890–1893
0.18 x 0.11 m (7 x 4½ in.)
Musée Rodin, Paris (M.R. 4312)

307. *Standing Female Nude*

Pencil, watercolor wash, c. 1894–1895
0.16 x 0.10 m (6¼ x 3¼ in.)
Musée Rodin, Paris (M.R. 4315)

308. *Two Studies of Female Nude with One Leg Raised*

Pencil, watercolor wash, n.d.
0.17 x 0.22 m (6¾ x 8⅝ in.)
Musée Rodin, Paris (M.R. 4271)

309. *Two Nude Figures*

Pencil and watercolor, n.d.
0.16 x 0.24 m (6⅜ x 9½ in.)
Leon and Molly Lyon

310. *Seated Nude*

Pencil and watercolor, n.d.
0.17 x 0.11 m (6¾ x 4¼ in.)
Leon and Molly Lyon

311. *Male Nude, Foreshortened*

Pencil, c. 1898
0.36 x 0.25 m (14¼ x 10 in.)
Musée Rodin, Paris (M.R. 474)

312. *Two Female Nudes Reclining*

Pencil, c. 1898
0.31 x 0.20 m (12¼ x 7⅞ in.)
Musée Rodin, Paris (M.R. 891)

313. *Female Nude Reclining*

Pencil, c. 1898
0.31 x 0.20 m (12¼ x 7⅞ in.)
Musée Rodin, Paris (M.R. 736)

314. *Female Model Reclining, in Chemise*

Pencil, c. 1898
0.20 x 0.31 m (7⅞ x 12¼ in.)
Musée Rodin, Paris (M.R. 2483)

315. *Female Model Reclining, Lifting Chemise*

Pencil, c. 1898
0.31 x 0.20 m (12⅛ x 8 in.)
Musée Rodin, Paris (M.R. 2702)

316. *Female Nude, Gesture of Masturbation*

Pencil, c. 1898
0.31 x 0.20 m (12⅛ x 8 in.)
Musée Rodin, Paris (M.R. 5402)

317. *Male Nude in Bridge Position*

Pencil, c. 1898
0.36 x 0.23 m (14⅛ x 9⅛ in.)
Inscribed: *bas / Georges Victor / rue / 11 nice la frontin*
Musée Rodin, Paris (M.R. 478)

318. *Male Nude in Bridge Position, Inverted*

Pencil, watercolor wash, n.d.
0.32 x 0.25 m (12¾ x 9⅞ in.)
Signed lower right: *A. Rodin*
Musée Rodin, Paris (M.R. 5124)

319. *Female Nude Kneeling*

Pencil, c. 1900
0.31 x 0.20 m (12⅜ x 8 in.)
Musée Rodin, Paris (M.R. 2349)

320. *Female Nude Kneeling*

Pencil, watercolor wash, c. 1900
0.33 x 0.25 m (12⅞ x 9⅞ in.)
Inscribed: *bas.*
Musée Rodin, Paris (M.R. 4248)

321. *Female Nude Kneeling*

Pencil, watercolor wash, cut-out, c. 1900
0.25 x 0.14 m (9⅞ x 5½ in.)
Musée Rodin, Paris (M.R. 5212)

322. *Female Nude, Hands on Floor, Left Leg Raised*

Pencil, watercolor wash, c. 1900
0.32 x 0.23 m (12⅞ x 9 in.)
Musée Rodin, Paris (M.R. 4404)

323. *Female Nude, Hands on Floor, Left Leg Raised*, inverted

Pencil, watercolor wash, c. 1900
0.32 x 0.24 m (12¾ x 9⅝ in.)
Inscribed: *bas / trepied / change en arbre*
Musée Rodin, Paris (M.R. 4419)

324. *Female Nude, Hands on Floor, Left Leg Raised*, re-oriented horizontally

Pencil, watercolor wash, c. 1900
0.24 x 0.23 m (9⅝ x 9 in.)
Inscribed: *eros / arc-en-ciel*
Musée Rodin, Paris (M.R. 4403)

325. *Female Nude, Hands on Floor, Left Leg Raised*

Pencil and watercolor wash, cut-out, c. 1900

0.33 x 0.17 m (13⅛ x 6¾ in.)
Musée Rodin, Paris (M.R. 5202)

326. *Two Female Nude Figures*

Pencil and watercolor wash, c.1900–1905
0.49 x 0.32 m (19½ x 12½ in.)
Musée Rodin, Paris (M.R. 4692)

327. *Seated Nude*

Pencil, 1908
0.31 x 0.20 m (12¼ x 7⅞ in.)
Inscribed: *Auguste Rodin à son ami l'eminent / avocat*
 John Woodruff / Simpson / Aug Rodin / 1 juillet 1908
National Gallery of Art, Gift of Mrs. John W.
 Simpson, 1942

328. *Seated Nude*

Pencil, 1908
0.31 x 0.20 m (12¼ x 7⅞ in.)
Inscribed: *dessin fait / cette matinée 1 juillet / 1908 /*
 et dedié / à mon ami / John Woodruffe / Simpson Aug
 Rodin
National Gallery of Art, Gift of Mrs. John W.
 Simpson, 1942

329. *Female Nude with Legs Behind Head*

Pencil, c. 1905
0.20 x 0.31 m (7⅞ x 12¼ in.)
Musée Rodin, Paris (M.R. 2824)

330. *Reclining Female Nude*

Pencil, c. 1906–1910
0.32 x 0.21 m (12½ x 8¼ in.)
Musée Rodin, Paris (M.R. 2774)

331. *Female Model Opening Robe*

Pencil, c. 1908
0.31 x 0.20 m (12¼ x 8 in.)
Inscribed: *Steichen / photo / antique*
Musée Rodin, Paris (M.R. 2963)

332. *Female Model's Silhouette Transformed into Architectural Molding / Cornice*

Pencil, c. 1900–1910
0.32 x 0.20 m (12⅝ x 8 in.)
Musée Rodin, Paris (M.R. 3482)

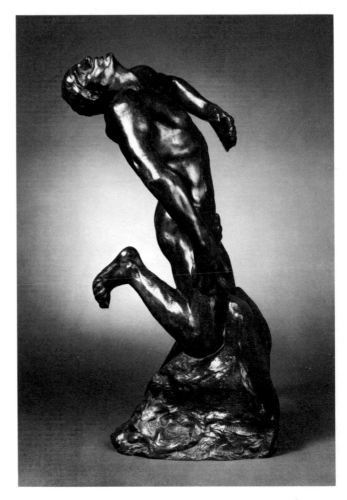

Falling Man, 1882. Bronze. Los Angeles County Museum of Art, Gift of the B. G. Cantor Art Foundation. Cat. no. 280.

IX. *The Figure in Motion*

333. *Dance Movement "A"*

Bronze, n.d.
Plaster, 1910–1911
0.66 x 0.17 x 0.31 m (26 x 6¾ x 12¼ in.)
Signed: *A. Rodin;* stamped: *Alexis Rudier, Fondeur, Paris*
B. G. Cantor Collections

334. *Nijinsky*

Bronze, n.d.
Plaster, 1912
0.19 x 0.09 x 0.08 m (7½ x 3¾ x 3½ in.)
Musée Rodin, Paris

335. *The Juggler*

Bronze, n.d.
Plaster, 1892–1895
0.30 x 0.15 m (12 x 6 in.)
Signed on sole of left foot of small figure: A. *Rodin no.*
 11; founder's mark on back of juggler's head: *Georges*
 Rudier, Fondeur, Paris
The Stanford University Museum of Art, Gift of the B.
 G. Cantor Art Foundation

336. *Dance Movement "B"*

Bronze, n.d.
Plaster, c. 1910–1911
0.32 x 0.09 x 0.12 m (12½ x 3½ x 4¾ in.)
Signed: A. *Rodin*; stamped: *Georges Rudier Fondeur,*
 Paris (cast #7)
B. G. Cantor Collections

337. *Dance Movement "D"*

Bronze, n.d.
Plaster, c. 1910–1911
0.33 x 0.20 x 0.12 m (13 x 7¾ x 5 in.)
Signed: A. *Rodin*; stamped: *Georges Rudier, Fondeur,*
 Paris (cast #5)
B. G. Cantor Collections

338. *Dance Movement "E"*

Bronze, n.d.
Plaster, c. 1910–1911
0.35 x 0.11 x 0.20 m (14 x 4½ x 8 in.)
Signed: A. *Rodin*; stamped: *Georges Rudier Fondeur,*
 Paris, (cast #5)
B. G. Cantor Collections

339. *Pas de Deux "G"*

Bronze, 1969
Plaster, 1910–1913
0.34 x 0.18 x 0.17 m (13½ x 7 x 6¾ in.)
Signed on sole of woman's left foot: A. *Rodin*; founder's
 mark on sole of right foot: *Georges Rudier, Fondeur,*
 Paris (cast #11)
The Stanford University Museum of Art, Gift of the B.
 G. Cantor Art Foundation

340. *Dance Movement "H"*

Bronze, 1967
Plaster, c. 1910
0.28 x 0.07 x 0.11 m (11¼ x 3 x 2½ in.)
The Stanford University Museum of Art, Gift of the
 Cantor-Fitzgerald Art Foundation

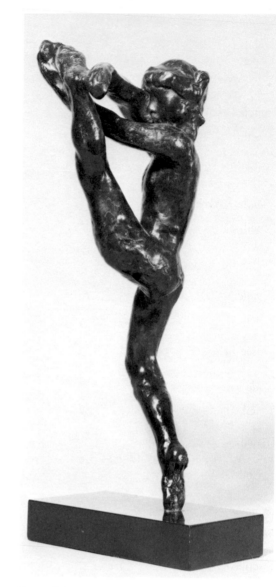

Dance Movement "B", 1910-1911. Bronze. B. G.
Cantor Collections. Cat. no. 336.

341. *Female Nude Dancing*

Pencil, c. 1900
0.31 x 0.20 m (12¼ x 8 in.)
Musée Rodin, Paris (M.R. 518)

342. *Female Nude Dancing*

Pencil, c. 1900
0.31 x 0.20 m (12¼ x 8 in.)
Musée Rodin, Paris (M.R. 1014)

343. *Female Nude Dancing*

Pencil, c. 1900
0.31 x 0.20 m (12¼ x 7⅞ in.)
Musée Rodin, Paris (M.R. 2362)

344. *Female Nude Dancing*

Pencil, c. 1900
0.31 x 0.19 m (12⅜ x 7½ in.)
Musée Rodin, Paris (M.R. 2943)

345. *Female Nude Dancing*

Pencil, c. 1900
0.31 x 0.20 m (12¼ x 7⅞ in.)
Musée Rodin, Paris (M.R. 5612)

346. *Female Nude Dancing*

Pencil, c. 1900
0.31 x 0.20 m (12¼ x 7⅞ in.)
Musée Rodin, Paris (M.R. 2391)

347. *Female Nude Dancing*

Pencil, c. 1900
0.31 x 0.20 m (12⅜ x 7⅞ in.)
Musée Rodin, Paris (M.R. 2951)

348. *Nude with Draperies*

Pencil, watercolor wash, c. 1900–1905
0.44 x 0.31 m (17½ x 12⅜ in.)
Signed *recto*, lower right, in graphite: *A. Rodin/A Rodin*
The Art Institute of Chicago, The Alfred Stieglitz
Collection (1949.900)

349. *Dancing Figure*

Pencil, watercolor wash, c. 1900–1905
0.31 x 0.25 m (12¼ x 9¾ in.)
Inscribed: *Hommage à Madame / K. Simpson / A Rodin / 11 octobre 1905*
National Gallery of Art, Gift of Mrs. John W.
Simpson, 1942

350. *Assemblage of Two Female Nude Figures*

Pencil and watercolor wash with collage, c. 1900–1905
0.33 x 0.28 m (13⅛ x 10⅞ in.)
Musée Rodin, Paris (M.R. 5188)

351. *Montage Sheet with Three Cut-Out Figures*

Cut-outs in pencil and watercolor wash, glued down,
c. 1900–1905
Full sheet: 0.57 x 0.72 m (22½ x 28½ in.)
Princeton University

X. *Rodin and the Beginnings of Modern Sculpture*

352. *The Walking Man* (enlarged version)

Bronze, n.d.
Plaster, 1877
2.23 x 0.75 x 1.35 m (87⅞ x 29½ x 53⅛ in.)
Inscribed: A. *Rodin—Georges Rudier Fondeur, Paris*
B. G. Cantor Collections

RAYMOND DUCHAMP-VILLON
FRENCH, 1876–1918

353. *Torso of a Young Man*

Bronze, 1932–1953 (?)
Plaster, 1910
0.55 x 0.34 x 0.40 m (21¾ x 13⅜ x 15¾ in.)
National Gallery of Art

354. *Monumental Head of Iris*

Bronze, n.d.
Plaster, 1890–1891
0.61 x 0.33 x 0.33 m (24 x 13 x 13 in.)
Signed on left side of neck: A. *Rodin*; back right side:
 Georges Rudier/Fondeur
Des Moines Art Center, Gift of the B. G. Cantor Art
 Foundation

PABLO PICASSO
SPANISH, 1881–1973

355. *Cubist Head of 1909*

Bronze, 1960
Plaster, 1909
0.41 x 0.24 x 0.26 m (16 x 9⅜ x 10⅜ in.)
Incised on back, lower left: PICASSO
Hirshhorn Museum and Sculpture Garden, Smithsonian Institution

UMBERTO BOCCIONI
ITALIAN, 1882–1916

356. *Unique Forms of Continuity in Space*

Bronze, 1913
Plaster, 1913
1.23 x 0.86 m (48½ x 34 in.)
Lydia and Harry L. Winston Collection (Dr. and Mrs.
 Barnett Malbin), New York

CONSTANTIN BRANCUSI
RUMANIAN, 1876–1957

357. *Male Torso*

Brass, 1917
0.46 x 0.30 x 0.17 m (18⅜ x 12 x 6⅝ in.)

Signed and dated on bottom: *C. Brancusi / Paris, 1917*
The Cleveland Museum of Art, Hinman B. Hurlbut
 Collection

358. *Torso of the Walking Man*

Bronze, before 1889
Plaster: 1877–1878
0.53 x 0.27 x 0.19 m (20⅞ x 10⅝ x 7½ in.)
Musée du Petit Palais, Paris

ALEXANDER ARCHIPENKO
RUSSIAN, 1887–1964
359. *Walking Woman*

Bronze, 1912
Plaster, 1912
0.67 x 0.20 x 0.18 m (26½ x 8 x 7 in.)
Signed, dated on the lower right side: *Archipenko, Paris
 1912*
The Denver Art Museum, Museum Purchase

HENRI GAUDIER-BRZESKA
FRENCH, 1891–1915
360. *Female Torso I*

Marble, 1913
0.35 x 0.10 x 0.07 m (14 x 4⅛ x 3 in.)
Victoria and Albert Museum, London (A. 96–1915)

361. *Torso of a Young Girl*

Bronze, 1962
Plaster, 1909
0.84 x 0.44 x 0.30 m (33 x 17½ x 12 in.)
Stamped: © Musée Rodin 1962 Georges Rudier Fon-
 deur, Paris
Mr. and Mrs. Harry W. Anderson

JACQUES LIPCHITZ
LITHUANIAN, 1891–1973
362. *Half-Standing Figure*

Bronze, 1918 (?)
Plaster, 1918
0.94 x 0.28 m (37 x 11 in.)
Signed and numbered on back near bottom: 3/4 *J Lipchitz*
The Baltimore Museum of Art, Fanny B. Thalheimer
 Memorial Fund

ARISTIDE MAILLOL
FRENCH, 1861–1944
363. *Torso of the Ile de France*

Bronze, 1921 (?)
Plaster, 1921
1.20 x 0.33 x 0.51 m (47½ x 13 x 20 in.)

Signed with monogram and numbered 5/6 on top of
 base; foundry mark at rear of base: *Alexis Rudier,
 Paris*
The Fine Arts Museums of San Francisco, Gift of the
 Mildred Anna Williams Fund to the California Palace
 of the Legion of Honor

JACOB EPSTEIN
AMERICAN/BRITISH, 1880–1959
364. *The Rock Drill*

Bronze, 1962
Plaster, 1913–1914
0.71 x 0.66 m (28 x 26 in.)
The Museum of Modern Art, New York, Mrs. Simon
 Guggenheim Fund, 1962

WILHELM LEHMBRUCK
GERMAN, 1881–1919
365. *Torso of a Woman Bending Forward*

Bronze, 1913 (?)
Plaster, 1913
0.82 m (32¼ in.)
Professor Andrew S. Keck

HENRI MATISSE
FRENCH, 1869–1954
366. *The Serf*

Bronze, n.d.
Plaster, 1903
0.92 x 0.35 x 0.31 m (36¼ x 14 x 12¼ in.)
Inscribed at back of base: *HM 6/10*; also *Cire/C. Val-
 suani / Purdue*; at front of base: *Le Serf*
San Francisco Museum of Modern Art, Harriet Lane
 Levy Bequest

Maillol. *Torso of the Ile de France*, 1921.
Bronze. The Fine Arts Museums of San Francisco, Gift of the Mildred Anna Williams Fund to the California Palace of the Legion of Honor. Cat. no. 363.

Lipchitz. *Half-Standing Figure*, 1918.
Bronze. The Baltimore Museum of Art, Fanny B. Thalheimer Memorial Fund. Cat. no. 362.

APPENDIX

Since 1919, the Musée Rodin has exercised, in the name of the state, the copyright over the works given by Rodin in 1916 and continues, within the limits of this mandate, to make bronzes. In this matter, the conditions in which the proofs are realized have undergone a progressive and constant tightening which is summed up here:

a) The texts of the three successive donations by Rodin contain no indication of limitations (cf. M. Laurent, "Observations on Rodin and His Founders").

b) Between the two world wars, it seems that certain subjects, mainly reductions of famous pieces, were made without numerical limitations (it must be emphasized, concerning this point, that the museum has never made reductions or enlargements and that we are dealing here with reductions which were already finished and marketed by Rodin himself).

On the other hand, the casts of other less well-known pieces have been limited since that time to twelve.

c) After 1945, the limitation to twelve examples was formalized. The editions of subjects of which earlier casts were known were eventually continued up to the twelfth cast. But, given the uncertainty which can remain about the exact number of early proofs, the later casts are not numbered. By contrast, those subjects which had never been cast in bronze are numbered from 1 to 12. The notation "© by Musée Rodin" which appeared optionally at this time became obligatory as of 1 January 1968.

d) These measures which resulted from internal decisions made at the museum are now backed up and completed by regulatory decisions. A first text pertaining specifically to the Musée Rodin, the decree of 5 September 1978, defines in the first article the original edition of bronzes as:

> executed from the terra-cotta or plaster model made by Rodin under the direct control of the museum acting in its capacity as holder of the artist's copyright; the casting of each of these models cannot, in any case, exceed twelve examples.

A second text, with a more general application, the decree of 3 March 1981, Article 9, defines henceforth the original edition by reference to the General Code of Taxes (Appendix III, Article 71) in the following conditions: eight numbered casts controlled by the artist or his beneficiaries. Those known as "artist's proofs" bearing the special notations come under the definition of the original edition and are limited to four.

In accordance with these stipulations, it must be expressly understood that the original editions undertaken by the Musée Rodin beginning on 1 April 1981, will be limited to twelve casts comprising

a) eight casts numbered from 1 to 8 to be placed on the open market;

b) four casts numbered from I to IV in Roman numerals reserved either for the Musée Rodin or for French or foreign cultural institutions approved by it.

INDEX OF WORKS

This index refers to works discussed and illustrated in the essays.

SCULPTURE
Works listed alphabetically by artist; then by title.

PHOTO CREDITS